CHARLES RENNIE MACKINTOSH
The Complete Furniture,
Furniture Drawings
& Interior Designs

CHARLES RENNIE

THE COMPLETE FURNITURE,

MACKINTOSH

FURNITURE DRAWINGS & INTERIOR DESIGNS

ROGER BILLCLIFFE

LUTTERWORTH PRESS
Guildford and London

Produced by Carter Nash Cameron Limited, 25 Lloyd Baker Street
London WC1X 9AT.
Published by Lutterworth Press, Luke House, Farnham Road,
Guildford, Surrey, GU1 4XD.

Filmset by SX Composing Limited, 22 Sirdar Road, Weir
Industrial Estate, Rayleigh, Essex.
Monochrome reproduction by Tenreck Limited, 172a Brent Crescent,
London NW10.
Colour reproduction by Gateway Platemakers Limited,
1 Pardon Street, London EC1.
Printed by de Lange/van Leer b.v., Deventer, Holland.

First published 1979.
Second edition 1980.

Printed and bound in Holland.

ISBN 0 7188 2513 6

Designed by Tom Carter.
House editor: Elizabeth Kingsley-Rowe.

CONTENTS

Note on the Addenda
Information and photographs that have become available
since the first edition of this book went to press are included
in the Addenda (p. 256). Entries in the Addenda are indicated
in the main text only where new objects or major new
pieces of information are involved.

FOR BRONWEN.

PREFACE

My first real contact with Mackintosh's work was in 1968, when I saw the Centenary Exhibition arranged for the Edinburgh Festival Society by Andrew McLaren Young. It was, naturally, an exhibition which concentrated on Mackintosh's talents as an artist, draughtsman and designer, as his buildings could only be represented by photographs and the few surviving drawings. At that time the only serious works available on Mackintosh, by Pevsner and Howarth, concentrated on his architecture, and both were limited by a shortage of illustrations. Mackintosh's furniture and other designs accordingly took second place in their books, although both authors emphasised his skills as a designer of interiors and as a watercolourist. For me and countless others, McLaren Young's exhibition and catalogue was therefore a revelation. For instance, at that time there was no white-painted furniture in the Victoria & Albert Museum collection or even at Glasgow Art Galleries & Museums. The Glasgow School of Art had the Windyhill bedroom furniture, but it was not then adequately shown, and the University collection was, as it had always been, available only by appointment. The best pieces from all these collections were brought together at Edinburgh alongside a fine selection of the architect's drawings for furniture.

Many of the finest items included in that exhibition came from the collection at Glasgow University. In 1969, I was appointed Assistant Keeper of that collection, and one of my duties was to prepare a catalogue of it. Apart from the furniture and furniture drawings, there are hundreds of sketches and designs covering all the different aspects of Mackintosh's work, from cutlery to gravestones, book-jackets to wiring-diagrams, public houses to cathedrals.

This volume, however, is not a catalogue of the whole of the University's collection. As time passed, I became more and more interested in two particular aspects of Mackintosh's work, his furniture designs and his watercolour paintings. The University owns over two hundred designs for furniture and interiors. In cataloguing them, I was taken outside of the collection in my search for the pieces shown in the drawings. Slowly, I began to amass information about furniture which had long since disappeared, as spectacular in many cases as the items which have survived. My work gradually crystallised into a general book on the furniture and other applied designs, commissioned by Ian Cameron of Carter Nash Cameron, but it eventually was confined to a catalogue of all of the designs for furniture and the executed pieces that I could trace.

Howarth, Macleod, Pevsner and McLaren Young and many others have placed Mackintosh in his context at the turn of the century, and Howarth went much further by listing almost all of Mackintosh's projects. I have tried to build on these admirable foundations and particularise one facet, a not unimportant one in Mackintosh's *oeuvre*. This catalogue of the furniture should throw more light on Mackintosh's development as an architect and designer; it might at least provide readers with the detailed information on his furniture which is lacking in the other volumes. It does not attempt to provide a biography of Mackintosh, nor does it discuss his architecture except where this has a direct relevance to the interiors and furniture. Above all, I hope that those who use it for reference will gain some pleasure from the process.

The salerooms certainly know who Mackintosh is, and the collectors who have paid high prices for his furniture have probably done more to bring his name to public attention than any book like this ever will. In Glasgow, at least, every table with a heart-shaped cut-out, every high-back chair, every white-painted settle or cabinet inlaid with stained woods is claimed as 'Rennie Mackintosh'. I wish they were, and if this catalogue has no other purpose I hope it will at least bring to light many of the pieces I have not been able to trace and even those of which I have never heard.

No book such as this is solely the product of the person whose name it bears. Countless people have helped me compile what follows—owners and collectors, fellow curators, architects, scholars, librarians, photographers, dealers and many enthusiasts have all been generous with time, information and assistance. Many people are listed separately in individual catalogue entries but below I note those who have been of considerable and repeated assistance.

My deepest debt, not just because of his Keepership of the collection at Glasgow University but for all his other kindnesses, is to the late Professor Andrew McLaren Young. His guidance and encouragement will be long remembered. His knowledge and understanding of Mackintosh went far beyond his published thoughts, and I am grateful to him for sharing his ideas and discussing mine. Also at Glasgow University, Averil Walker and later Joan Hughson were colleagues without whose help the mass of drawings and photographs might never have been sorted. I am grateful to Professor Frank Willett, Director of the Hunterian Museum and Art Gallery, for his enthusiastic encouragement of the project, also to my successors (since 1977) at the Hunterian Art Gallery, Chris Allan and Pamela Reekie. At the Glasgow School of Art, the Director, H. Jefferson Barnes, answered all my questions and gave me free access to the School's records and collections. Without such kindly interest and generous help my task would have been much more difficult. His assistant, Drew Perry, and successive Librarians, Robin Rennie and Ian Monie have also provided me with access and information.

The third major collection of Mackintosh's work is at Glasgow Art Gallery & Museum and I am grateful to the Director, Trevor Walden, for his encouragement to complete this catalogue after I joined the Gallery in 1977. My colleagues, Brian Blench and Steven Elson, have been most helpful, and I also have to thank Norman Tennant for his researches for me into the early plastics which Mackintosh used.

At The Hill House, Helensburgh, I owe a debt of gratitude to the late T. Campbell Lawson, who acquired the house from Walter Blackie and who gave me easy access to it. The house was later acquired by the Royal Incorporation of Architects in Scotland, and I am indebted to its former Secretary, the late Peter Clark, and to successive Chairmen and members of the Board of Trustees of The Hill House for permission to reproduce works from their collection.

At the Victoria & Albert Museum, Elizabeth Aslin and Simon Jervis were most helpful in giving me access to their files. Mackintosh's job and account books still remain with his successors, Keppie Henderson and Partners, and Geoffrey Wimpenny and his colleagues most kindly allowed me to abstract and publish relevant parts.

In Toronto, Kathy Jordan generously offered to list and photograph the drawings in Thomas Howarth's collection. Without her kind and efficient assistance, none of these would have been included as I was unable to visit Toronto personally. As many owners of furniture and drawings wish

to remain anonymous, I shall not list them as such here. To all the people who allowed me into their homes, who patiently answered what may have seemed trivial or pointless questions and allowed me to illustrate their possessions, I am extremely grateful. The credit line at the end of each entry hides a host of new acquaintances and some new, as well as old, friends; their interest in Mackintosh's work helped inspire the completion of this catalogue.

I am indebted to the many other people who have given freely of their time and knowledge: Miss Agnes Blackie; the late Hamish Davidson and the late Dr Cameron Davidson, and their families; Dr Bruno del Priore; Mrs Janet Dicks for much information about the Northampton work; Mrs Patricia Douglas, Honorary Secretary of the Charles Rennie Mackintosh Society; L. A. Dunderdale; Philippe Garner and Nicola Redway of Sotheby's Belgravia; John Gerrard; Mrs Ruth Hedderwick; Dr Thomas Howarth; Dr David Lloyd-Jones; Andy MacMillan; Isi Metzstein; Andrew McIntosh Patrick of The Fine Art Society; Jessica Rutherford at Brighton Museum & Art Gallery; George Smith; Mrs Mary Newbery Sturrock; Allan Ure; Peter Vergo; Mrs Alison Walker; David Walker; Mrs Dorothy Walton.

The many photographs used in this book come from a variety of sources and photographers, but I should like to express my thanks to Robert Cowper, Bill Leitch and Grace Watson at Glasgow University; to Rupert Roddam, Raymond G. Fulton and Ina Graham at Glasgow Art Gallery & Museum; and to Eric Thorburn, Graham Metcalfe, and Ian Cameron. Brian McKerracher and Hector Grant helped me to understand the traditions and idiosyncracies of generations of Glasgow joiners, cabinet makers and other tradesmen. Ian Cameron and Bettina Tayleur organised the production of the book, a thankless task, but one which they performed with calm thoroughness. Ian Cameron patiently dealt with innumerable matters of detail and by a mixture of patient and firm but friendly encouragement helped me to keep to my schedule.

My manuscript was typed by June Barrie who made sense of an illegible hand and corrected my inconsistencies and mistakes.

Nobody, however, has been more patient or offered more encouragement than my wife. The last two years have seen the birth of our son, the compilation of this and other works on Mackintosh and a move to another job. Throughout all this time, Bron has listened to first, second and more drafts, and made many helpful suggestions; she has shared the excitement of new discoveries and lightened the tedium of checking innumerable references. Without her help, advice and continual support this book would never have been completed.

Roger Billcliffe
Glasgow, April 1978

INTRODUCTION

In the fifteen years before the outbreak of war in 1914, Charles Rennie Mackintosh was better known in Europe than in Scotland, or even Britain as a whole. Of all British architects of the period, with the sole exception of M. H. Baillie Scott, Mackintosh's designs were the best publicised, the most produced and certainly the most widely imitated in Europe. But his reputation did not, in fact, rest on his achievement as an architect, since his most important building, the Glasgow School of Art, was never published over its designer's name either at home or abroad, and was known only to a small group of his friends who had visited Glasgow and returned home to tell of it. Even his two major houses, Windyhill and The Hill House (both published abroad), were admired at least as much for their interiors and furniture as for their external features and planning. It is apparent from his commissions abroad that it was as a designer of furniture, fully integrated with its setting, that Mackintosh was so well received; exhibition rooms, interiors, and even individual pieces of furniture were sought after by his European clients and colleagues, but he never designed anything abroad on the scale of Windyhill, let alone that of the Glasgow School of Art or Scotland Street School.

Mackintosh himself would not have considered his interior furniture designs necessarily less important than the design of complete buildings, because his approach was the same whatever the size of the commission: there are as many surviving drawings for a single spoon as there are for a complex chair, as many for the interior of a bedroom as for the exterior of a whole house, and all are executed with the same care, the same skilfully applied washes, so that they are as much works of art as the objects they represent. In Mackintosh's view architecture was the consummate art, encompassing all others; he did not consider himself merely a designer—he was an architect and, as such, responsible for all the arts, many of which he did in fact practise, being in particular an accomplished watercolourist. Mackintosh's interiors and furniture were important elements of his buildings; they were, after all, the areas in which his clients spent most of their time, and he went to great lengths to ensure that the interior planning functioned well and that the design pleased the client before beginning serious work on his exterior elevations.[1]

This concept of working from the inside out became a modern movement cliché but for Mackintosh it was a tenet of faith. This did not necessarily mean that the exterior massing was totally dictated by internal arrangements, for Mackintosh was not so short-sighted a designer that he would not always consider the project as a whole. In fact, dated drawings indicate that the final decorative schemes and detailed designs for furniture were devised when the structure was almost complete as at The Hill House where, despite Mr Blackie's memories, the interior settings all date from the autumn of 1903 or later, when the house was almost finished. However, these interiors were obviously not afterthoughts, no matter what date the final designs for their detailed finishings were produced: the decorations and furniture enhance the rooms, emphasising each particular function and delighting the eye, just as the exteriors indicate the internal division of the house and the functions of its separate parts.

Mackintosh designed well over 400 pieces of furniture in a working life of only 25 years. These figures seem all the more impressive when one considers that the great majority of designs are contained within the periods 1897–1905 and 1916–18, and that there is very little repetition of any one design (unlike, for instance, the stock designs which Voysey repeated many times). When one removes the Glasgow School of Art from the works of this period, as very little furniture was designed specifically for it, it becomes apparent that the vast majority of the designs were domestic in scale and context. Most commissions included very detailed interiors; indeed, with the exception of the Willow Tea Rooms, Scotland Street School, Windyhill, and The Hill House, interiors and their furniture account for almost all Mackintosh's output in the seven years from 1900. Virtually all the interiors were designed with the same total control over the varying elements in the composition: chairs, tables, hat-stands, beds, wardrobes, clocks, mirrors, carpets, wall decorations, light fittings, keys, even cutlery and cruet sets, all came out of the same fertile imagination that at the same time was controlling structural steelwork or sophisticated ventilation systems, the planning of a large art school and the design of a three-roomed gatehouse, as well as churches and even gravestones.

Unlike Hoffmann, who had the Wiener Werkstätte, or Ashbee, who had the Guild and School of Handicraft, both employing gifted artists and craftsmen, Mackintosh produced his interiors and furniture using local tradesmen, furniture makers and joiners like Francis Smith or Alexander Martin, who were running prosaic businesses rather than idealistic craft workshops. Although his craftsmen had been trained to the highest standards of workmanship in the shipyards of the Clyde, his designs had to be understood by men who were not accustomed to making art furniture, and that they failed to convince Mackintosh of their superior knowledge of furniture construction is shown in the poor condition of many of the pieces today; for what made Mackintosh different from an Ashbee, and even a Hoffmann, was his concern not with materials, craftsmanship, nor construction, but only with final appearance. Perhaps no guild-like body of artist-craftsmen would have worked with him,[2] and he might not readily have tolerated the pursuit of traditional methods and materials for their own sakes. In fact, the only artistic manufacturer or collaborator he consistently used was his wife, Margaret Macdonald, and her influence and assistance had an appreciable impact only during the years 1901–03.

Mackintosh was not an Arts & Crafts designer and the Arts & Crafts Exhibition Society made that all too clear when his work was accepted for their 1896 exhibition. It was not, contrary to some writers' beliefs, the last time Mackintosh exhibited with them, for he showed at their following exhibition in 1899, but it was probably a crucial experience for the young Mackintosh, who must have decided that the ways of the Arts & Crafts designers were not for him after seeing the 1896 show. In his earliest designs there does appear some of that enthusiasm for the guiding principles of the Arts & Crafts movement which made it so attractive to the younger generation of architects and designers. Kornwolf[3] has admirably summarised the movement's aims: 'First, and most obvious, the Arts and Crafts emphasised the artistic potential of everyday objects. Second, vastly higher standards of craftmanship were applied to these objects, and the ideal of craftsmanship was realised much more widely than had been possible before. . . .Third, new stress was given to the importance of function in the creation of forms—what Voysey was to call "fitness for purpose"'. Mackintosh readily accepted the first and third of these principles, but 'craftsmanship' was too often for him synonymous with old-fashioned methods and techniques of construction: if

traditional craftsmanship stood between him and the realisation of a design, then it was craftsmanship which had to go. This meant that many of his pieces have not stood the test of time and that, in Glasgow at least, his furniture acquired a reputation for shoddy construction as well as providing an inhuman lack of comfort. But his early furniture was well made, at least in the sense that it is sturdy and that it takes cognisance of the limitations of its basic material—wood. It was not made, however, with the elegant craftsmanship of a piece by Gimson, Ashbee or Day; its structure is often brutally displayed, as it is more the work of a joiner using strong but coarse-looking joints, than of a cabinet-maker, who would produce strength and beauty in more equal proportions.

Mackintosh and the Free Style

Mackintosh travelled back beyond the Arts & Crafts style of the day, to search for the traditional furniture which formed the basis of his work in the 1890s, as they had provided a starting point for William Morris. However, much of the furniture he designed from 1900 to 1918 does not have an easily identifiable source and it becomes increasingly difficult to relate, say, the Wärndorfer Salon furniture to the vernacular tradition. While Voysey remained within the tradition, or expanded on it, Mackintosh moved away from it.

Howarth has pointed out the influence of Japan on Mackintosh (pp. 224–25). In his basement room in 1896 Mackintosh hung up reproductions of Japanese prints (*see* 1896.A); the houses depicted in them would undoubtedly have had a great effect upon him, particularly in the interpenetration of spaces, the use of open screens and slender partitions. The careful positioning of his furniture within a space and its delicate relationship with the vases of twigs and flowers which decorated his rooms is perhaps the most important element of the Japanese style to be seen in his work. The unerring skill of the Japanese in assembling a perfectly balanced composition from straight lines and simple forms combined with Mackintosh's own imagination to produce a totally new style.

The white furniture of 1901–03, however, was by no means Japanese in inspiration. Its symbolism derived from European literature and painting—from the Pre-Raphaelite Brotherhood, Beardsley, Toorop and Maurice Maeterlinck. The visual and literary images of these artists' works were synthesised by Mackintosh, who added to them his own particular genius. The result was a style with recognisable roots, the individual motifs of which can be traced to specific sources, though the final effect is nonetheless individual and inventive. It is the work of a man aware of the past, but who did not want his work dominated by it; it was Mackintosh's solution to that *fin-de-siècle* problem that so many artists, writers and architects faced—the search for a new style, independent of the past, through which to express modern ideas.

The age of the 'free-style', as it has come to be called, had no greater exponent than Mackintosh; Glasgow, Vienna, Brussels, Darmstadt, Paris and Chicago all produced their own free-style designers, many of whom sought the same solution as Mackintosh and almost achieved it. Only in Chicago was there a genius as receptive and, at the same time, as inventive as Mackintosh in Glasgow. Frank Lloyd Wright and Mackintosh never met, but their furniture design has strange parallels up to about 1901. If there was any interchange of ideas through the journals it can only have been one way, because Wright's work was not published in Europe until 1910, while Mackintosh's work would have been known in America through the magazine *The Studio* which was readily available there.

Early Furniture and Interiors, 1893–96

Howarth[4] has recorded Herbert MacNair's memories of how he first started to design furniture, and there can be little doubt that Mackintosh would have followed his friend's example (if he had not actually introduced the practice to MacNair). By placing a piece of tracing paper over illustrations of furniture in magazines and catalogues, he would try to improve on the original design or devise new forms of decoration for it. This practice probably accounts for the somewhat traditional shapes of the earliest known furniture which Mackintosh designed, the bedroom suite for David Gauld of 1893. By reducing commercial designs to their basic outlines, he would have arrived at the plain and simple massing of the items in this set of furniture. He still used bead mouldings to define different elements in the composition, but machine-made ornamentation has been removed entirely and the designs depend for their effect on broad expanses of wood relieved by a little carved decoration and simple metal fittings. The timber is oak and its broad grain is emphasised by the dark-green glossy stain applied to it. These are not particularly successful designs but, as an attempt to avoid the overwhelming moulded and machine-run decoration common on most contemporary furniture available commercially, they make an impressive beginning.

The furniture designed c1894 continued in this vein, often using simple beaded mouldings where doors meet around glass panels, but otherwise having only hand-carved decoration or panels of leaded-glass featuring organic motifs. But Mackintosh did not feel able to rid his designs of all traditional forms of decoration, and on the Gladsmuir cabinet and a bookcase, both of 1894, a strangely detached *cyma recta* capital is used; in the former piece (1894.1) it is combined with a completely new motif which can only be described as an apple pip around a central post, surrounded by an inset form in the shape of an apple. The use of organically inspired decoration was a prominent feature of Mackintosh's furniture for the next ten years. Roses, trees, birds, cabbages, apple pips, tulips, bulbs and corms were all noted in his sketch books and provided a vocabulary not only for his furniture: watercolours, posters, fabrics, beaten metal panels and, most of all, architectural sculpture were all based on the natural shapes he drew in the countryside, the garden, or the kitchen. Organic decoration gradually replaced the traditional mouldings and beads, but a *cyma recta* profile cap remained a favourite device for some years to come.

In about 1896, Mackintosh was commissioned by a Glasgow firm of decorators, cabinet-makers and stained-glass designers and manufacturers to design a number of items of bedroom furniture. This furniture for Guthrie & Wells went a little further along the line he had been following at Gladsmuir but, probably because the furniture was intended for a commercial market, there were no major changes in style. The emphasis remained on broad, unmodelled expanses of timber, relieved only by metal handles and hinges (*see* 1895.1–3, 1896.5). In a number of other items, however, Mackintosh began to develop a more individual style still using simple stained timbers and metal fittings, but incorporating *repoussé* metal panels and introducing more varied outlines and decorative detail than were used in the Guthrie & Wells pieces. One such design is the large settle (1895.5) which was probably made specifically for the 1896 Arts & Crafts exhibition where it was offered for sale. The stylised plants stencilled on the back-rest and the lead panel above, showing three peacocks, would have undone the good work of the rest of the settle, with its sturdy utilitarian and solid appearance, for it was all too easily identified with the metal work exhibited at the same time by the Macdonald sisters; this was anathema to the Society, being too close, they thought, to the depravity of Art Nouveau. The outcry against the Glasgow exhibits must have affected the impressionable Mackintosh, but I doubt that it was the cause of the now widening gap between the appearance of his furniture and that of the furniture of the Arts & Crafts movement. The settle and the linen cabinet for John Henderson (1895.6) indicate that he had already begun to experiment with more

expressive and symbolic motifs. These continued to take the form of applied patterns or *repoussé* panels for a year or more, but gradually the whole piece began to take on the expressive line and sculptural massing of the individual details. Few pieces displayed the imagery of the Spook School (as the Glasgow designs were christened by the Arts & Crafts movement), but the symbolism inherent in such decoration was transferred from details to the whole design.

In 1895, in an article in *The Studio*, Baillie Scott wrote: 'It is difficult for the architect to draw a fixed line between the architecture of the house and the furniture. The conception of an interior must naturally include the furniture which is to be used in it and this naturally leads to the conclusion that the architect should design the chairs and tables as well as the house itself. Every architect who loves his work must have had his enthusiasm damped by a prophetic vision of the hideous furniture with which his client may fill his rooms, and which looks all the more incongruous if the rooms themselves are architecturally beautiful'.[5] If Mackintosh had had the same access to the press as Baillie Scott did he would doubtless have published similar statements, but in January 1895 he had had neither the opportunity to write about such interiors nor to design them.

His room at Regent Park Square (1896.A) shows how he wished to control fittings like fireplaces and the decorations as well as the furniture. And at Queen Margaret Medical College he was given his first chance to integrate interior fittings and furnishings with the architecture. It is not really a fair example upon which to base firm conclusions, however, as the brief and available funds would undoubtedly have restricted him, as would the partner in charge of the design, John Keppie. The structure was completed in 1895—the date inscribed on a stone in the wall—and the photographs appear to have been taken in 1896. The interiors would almost certainly have been designed in 1895. and, although the furniture is simple and unexceptional, the pierced motifs on the ends of the benches indicate Mackintosh's involvement in the design. The panelling on the walls and the overall dark tonality of the interiors also suggest his hand; indeed, the interiors have a distinct similarity with those of the School of Art, designed at the end of the following year, where cost was also a major factor. The interiors at the School of Art, however, were probably re-worked in 1899, because they are far more refined than the rather traditional fittings at the Medical School.

Tea Room and Domestic Design, 1896–98

Mackintosh did not actually receive a domestic commission which combined architectural and furniture design until William Davidson asked him to prepare plans for a new house at Kilmacolm in *c*1899. This was Windyhill, for which the furniture was designed in 1901, but before that Mackintosh designed a few pieces for Queen's Cross Church in 1899, as well as several schemes for the conversion and decoration of interiors, including the provision of furniture. The largest and most important of these commissions was the Argyle Street Tea Rooms, designed 1896–97. Miss Cranston, the owner of the premises, had employed Mackintosh to design wall decorations and light fittings at her Tea Rooms in Buchanan Street in 1896. George Walton (1867–1933) had designed all of the furniture and some other decorations at Buchanan Street, but at the Argyle Street Tea Rooms their roles were reversed. The relationship between Walton and Mackintosh has been explored by both Pevsner and Howarth,[6] but in 1897 the two men were clearly moving away from each other. The rather delicate refinement of Walton was not emulated by Mackintosh, and the furniture for the Argyle Street Tea Rooms demonstrates his more aggressive manner. All the pieces are made of oak with an emphasis on broad unmoulded planes, the timber being clear-varnished or, more usually, dark-stained. The tub chairs and sturdy coffee and domino tables are all very heavy and give the impression of being made of timber straight off the saw. They do have, however, quite subtle details such as tapering or splayed legs, carved organic decoration, or the use of gently curved strips of timber along structural members to draw a distinction between the carcase of a piece and less functional in-fill panels. Traditional details have gone altogether, although the structural methods employed are normal, partly because the designs were generous with timber and provided wide enough sections and rails to sustain strong joints.

All the items designed for Argyle Street can be readily identified from their bold outlines and boxy shapes. One chair, however, stands out from all the other designs: that is the dining chair from the Luncheon Room with a high back and oval back-rail (1897.23). These high-backed chairs broke away completely from the Arts & Crafts Movement, vestiges of whose influence can still be found in most of the other furniture at Argyle Street. Although the exaggerated proportions of these chairs can in part be attributed to their function, Mackintosh was obviously interested in the design for its own sake, and he developed the theme of the high-backed chair beyond functional needs until it became one of the most assured elements in his *oeuvre*. Although these Argyle Street chairs helped to define and divide the room, later high-backed chairs often had no such specific function, as at the Wärndorfer Salon where their positioning round the walls was more decorative than spatially necessary. In other interior schemes Mackintosh was able to control both the architecture and the furniture but here, where he had to contend with an existing building and Walton's sub-division of the rooms, he used his furniture for the first time to reinforce his own spatial composition. The chair also introduced the lath and stylised natural, almost abstract, decoration. Springy laths, light and airy, were used in several later designs for tea room furniture and, until *c*1904, organically-based decoration appeared on almost every single piece of furniture Mackintosh designed.

The style evolved for Argyle Street changed little over the next three years, although Mackintosh received more domestic commissions, either for whole rooms or single pieces of furniture. Rectangular shapes dominated many of his designs up to 1900, with an emphasis on broad panels of timber, relieved by gentle curved aprons, pierced or carved decoration and *repoussé* metal panels. These panels were rarely as bold in their relief as on the hall settle (1895.5) or the Gladsmuir desk (1897.1), and their imagery slowly turned towards that which Mackintosh was using in his watercolours of the period: delicate and attenuated female figures, often fairy-like and certainly more benign than the malevolent women of the Macdonald sisters' work. Mackintosh's courtship of Margaret Macdonald was not reflected in his designs of this period. There was little softening of the bold and aggressively masculine shape and mass of his designs and no obvious co-operation with Margaret before the design of the chair and smoker's cabinet (1899.16 and 1); and even in these two pieces, Margaret's contribution amounted only to the provision of decorative panels and had no real effect on the overall appearance of the furniture.

Few new chair designs were produced after the Argyle Street Tea Rooms commission until 1900, but Mackintosh developed several new designs for cabinets and similar pieces during this period. The heaviness of the sideboard/cabinet (1896.1) for his own bedroom was gradually reduced in a series of designs in 1897 and 1898, most of which have one specific feature in common: they all have overhanging caps, usually of *cyma recta* profile, often projecting as much as 10cm. over the front and sides of the body of the cabinet. Starting with the linen cupboard (1896.8), he introduced a wide panel at the back of, and placed at 90° to, the side gables; in this example these panels rise to the top of the cupboard and

terminate in two decorative lugs, but on most others they rise to meet the cap which overhangs by the same width. This back panel emphasises the flat planes of the designs, and is seen at its most effective in the smoker's cabinet (1899.1) where the broad planks of timber, all placed at 90° to each other, are disturbed only by the insertion of a carved panel on the front apron. The doors of the cabinets are sometimes glazed, usually with a pattern in leaded-glass; others have *repoussé* metal panels or even an embroidered (or stencilled) curtain (*see* D1898.9). Cabinets like these were used in two small, but quite important, commissions for the decoration of complete rooms, a dining-room in Munich and a bedroom in Glasgow, both of 1898.

The dining-room for H. Bruckmann, publisher of *Dekorative Kunst*, initiated a formula for the decoration of dining-rooms which Mackintosh followed for several years. The walls of the room, where they were not hidden by fitted cupboards, were covered with a dark wallpaper to the height of the picture-rail, here a projecting flat shelf for the display of busts and china. Above this rail Mackintosh introduced a stencil decoration based on his sketchbook drawings of flowers, but stylised to produce a repetitive pattern. The background of this frieze and the ceiling was white and the furniture and floor covering were dark. This formula, usually with a plain frieze, was repeated in his own dining-room at 120 Mains Street in 1900 and thereafter in almost all his domestic dining-rooms, occasionally with wooden panelling substituted for the wallpaper, but always retaining the dark walls and light ceiling. Mackintosh was not asked to design the tables and chairs for Bruckmann—these were by Karl Bertsch—but this minor disappointment would have been tempered by the publicity the commission received.

The White Rooms, 1898–1900

Mackintosh's work had been illustrated in *Dekorative Kunst* in 1898, at Bruckmann's instigation. He would have seen the article by Gleeson White in *The Studio* in 1897[7] and, having made contact for his 1898 article, he went on to commission the dining-room. He was obviously an influential client and there is no doubt that Mackintosh's reputation would have as easily spread by word of mouth through his contacts in Germany and Austria as it would through the rather inadequate illustrations in the magazine itself (the text referring to the dining-room was separated by several pages from the illustrations). Unfortunately, the other commission of 1898, at Westdel in Glasgow for another publisher, J. Maclehose, was not illustrated until 1902, again in Bruckmann's *Dekorative Kunst*. This bedroom was much more important in the development of Mackintosh's mature style than the Munich dining-room; had it also been published in 1899, Mackintosh's reputation as one of the leading furniture designers in Europe would have been established before he participated in the Vienna Secession exhibition in the autumn of 1900.

The Westdel bedroom (with its adjoining bathroom and all its furniture) was painted white. It may not have been the first time Mackintosh actually painted his furniture (one or more of the Guthrie & Wells designs may also have been enamelled white), but it was certainly the first occasion on which a whole room and its contents were painted white rather than being simply stained and waxed. It was not, of course, an entirely novel departure: much so-called art furniture for bedrooms was painted white and Baillie Scott and Walton had both advocated the choice of white if an architect wished to paint his furniture. Walton had actually recommended it as a colour for bedrooms in a lecture in Scotland (probably in Glasgow) which Mackintosh would almost certainly have heard.[8] Mackintosh repeated the Bruckmann motif of a stencilled frieze above the picture-rail, and the lower parts of the wall seem to have been painted a light grey or other pale colour; this latter was repeated in

his own drawing-room at 120 Mains Street in 1899–1900. The furniture is, on the whole, similar to the Argyle Street designs, solid and boxy, but a number of features point to new interests leading away from the somewhat heavier tea room style.

The carving on the foot of the bed (1898.15) is much more delicate than the bold shapes used on the Argyle Street furniture. It takes its form from the wild flowers which Mackintosh sketched at every opportunity, building up a vocabulary of organic details for use in his three-dimensional designs. The more gentle curve of the top of the board and the subtle swell of its outer posts all mark a change towards a more fluid style, echoed in the ogee curves of the fireside cupboard. The decoration and shape of this cupboard suggests, however, that Mackintosh wanted to break away from the usual associations of wood, and its design is not influenced by specific wood-working techniques. In contrast, the wardrobe (1898.11) is a solid rectilinear piece, but one element of the design again points to Mackintosh's apparent desire to force timber to perform unusual, even unnatural, tasks. In the upper part of each door a panel of beaten metal relieves the stark simplicity of the design; these panels are not fitted flush, however, but are raised proud of the plane of the doors as if they were framed and sitting on the surface, yet they still appear part of the same structure. Mackintosh achieved this effect by raising the wood of the doors around each panel; if the doors had been unpainted it would have been possible to detect the change of grain and the mitred joints of the raised frames, but, as all the timber is covered with the same hard white surface, one has the impression that the raised panels simply flow out of the material of the door. In stained timber, the motif would have had much less impact, indeed it would probably have been regarded as an aesthetic failure, but it is acceptable here because it is painted and because the distorted appearance of the wood is not apparent. This was the first of several such experimental details used by Mackintosh, part of a search for a style where the observer would not be aware of the material beneath the paint. A major problem which now faced him was how to come to terms with wood, a material with ancient associations and normally used in traditional forms dictated by its structural strength and weaknesses.

Mackintosh's next use of white was not in a bedroom but in the Headmaster's (now Director's) room at the Glasgow School of Art (*see* 1899.H). If his use of white at Westdel had not been entirely original, then its use here was definitely more adventurous. Some of the woodwork in the hall of the School and the interiors of the studios had also been painted white, but the rest of the woodwork in the building was predominantly dark. The white paint of the Director's room, combined with the more generous provision of cupboards and the imposing fireplace, served to indicate the status of its occupant. The room was also larger than the Westdel bedroom and the painted surfaces glinted and reflected the greater amount of light which entered through the large north window. The shiny paint made the room larger and more imposing, and at the same time prevented the expanse of cupboards from becoming too dominant a physical feature. Mackintosh had a greater area to work with and, what is more, was able to control it entirely, unlike at Westdel and in the Bruckmann room where he had to work within existing structures.

The Director's room was given a greater spatial complexity, but it is basically a square with a wide bay added along the north side. The bay has a vaulted ceiling much lower than the rest of the room and the wall panelling dips in an ogee curve to emphasise its lower height; this end of the room was intended as a business area, with provision for Newbery's desk and even a dumb-waiter to carry papers from the School Office below. The centre of the room was to be occupied by a circular table (not, in fact, provided until 1904). To the east

of the desk bay is a cloakroom, the door of which is set into the remaining part of the north wall of the square. On the east side is a staircase to the Director's studio above. This staircase runs parallel with the east wall but behind its line, and the integrity of the wall is retained by use of a panelled screen; the lower half of this is formed in Mackintosh's usual manner of wide boards with cover slips, but a gentle ogee curve cuts across the boards indicating the rise of the staircase behind. Above the curve, the cover slips become square posts and the spaces between them are left open giving a view of the staircase and wall behind. The use of vaulted ceilings and open screens to indicate changes of function within an otherwise homogeneous space became a favourite device used with increasing skill and subtlety in commissions such as The Hill House, the Willow Tea Rooms, Hous'hill and 78 Derngate, Northampton.

120 Mains Street, 1900

Shortly after designing the interiors at the Glasgow School of Art, Mackintosh turned to furnishing and decorating a flat for himself in anticipation of his marriage to Margaret Macdonald in August 1900. This was at 120 Mains Street (now Blythswood Street), Glasgow, and it gave Mackintosh little, if any, scope for structural alteration; but here he was able to experiment with and put into practice many of the theories he had been developing while working on earlier and smaller projects. For instance, movable furniture was also painted white, not just in the bedroom, but also in the drawing-room which included his first example of a white-painted chair (1900.11); more atmospheric lighting was used, with emphasis on candles in the dining-room; and in the bedroom he was able to design furniture far more graceful than that at Westdel and again unified and enhanced by the all-enveloping hard white enamel, relieved by inlays of purple, rose and green glass and stencilled hangings of the same colours. The drawing-room was the most important room in the flat for, although Mackintosh was unable to alter its physical structure, his treatment of the walls and windows and the placing of the furniture was masterly. As Howarth remarks (p. 44): 'by contemporary standards the drawing room . . . was positively bare'; it was furnished entirely with furniture of the architect's own design arranged with exceptional care. Mackintosh retained the original moulded cornice, although he removed the central plaster rose which once adorned the ceiling. The lighting was provided by three groups of four gas fittings, and a fourth lighting point near the door seems to have been left unused. The skirting, window architraves and door were all retained, but enamelled white, and a deep white rail supporting a flat shelf encircled the room at picture-rail height, even cutting across the openings for the three windows. Broad vertical straps were fixed at intervals between this rail and the skirting, and the panels thus created between these uprights were covered with grey-painted canvas. Each of the four walls had some major focal point: a wide fireplace (1900.1), a double bookcase (1900.7), and a large desk (1900.9), all painted white, were placed against each of the walls, while on the fourth the dark-stained oval back-rail chair (1897.23) was silhouetted against the grey wall and framed by the soft light pouring in through the windows. In the centre of the room no more than three or four pieces occupied the whole floor area of this six metre square apartment. The dining-room was also sparsely furnished and its walls, as at Munich in 1898, were covered with a coarse dark wrapping paper. Here the fireplace (1900.17) was painted black, a tall, narrow fitting more like the bedroom fireplace than the wide, elegant design for the drawing-room.

The bedroom, although smaller than the drawing-room, contained almost as much furniture, including a four-poster bed (1900.28), a large double wardrobe (1900.24) and a cheval mirror (1900.26). The organic decoration on these pieces, offset by inlays of coloured glass, was much more fluid and sculptural than anything else Mackintosh had designed to date and it formed the foundation for the elegant and sophisticated furniture for which Mackintosh became renowned in Europe.

The Vienna Secession and the 'Haus eines Kunstfreundes', 1900–01

In the summer of 1900, Mackintosh sent photographs of some of his work to Carl Moll, President of the Vienna Secession, probably in response to a request from Moll to contribute to *Ver Sacrum*,[9] the magazine of the Secession, and to the eighth exhibition of the Secession in the autumn of 1900. Mackintosh's flat had been photographed by Annan in March 1900, so he would almost certainly have included prints of the interiors in the parcel he sent to Vienna. These would have had a profound effect upon the Secessionists whose own work did not, at that time, display such precise control over the layout of their furniture and interiors. Mackintosh's contribution to the eighth exhibition would no doubt have confirmed the promise of the earlier magazine articles, for his display was as particular and elegant as his own drawing-room.

The effect of his room at the Secession can be seen in the design contributions to later exhibitions from Hoffmann and his colleagues. Many of the earlier Secession shows had been cluttered and poorly presented, notwithstanding the clear lines and adaptable spaces which Olbrich's superb building gave the exhibitors. Mackintosh seems to have made no new pieces specifically for his exhibition room, apart from the door and fireplace, although the large cabinet (1900.78) might have been a speculative piece, as was the settle shown at the Arts & Crafts Society in 1896. This cabinet was a variant of the large desk Mackintosh had made for his own flat, typical of the period, with beaten metal panels designed by Margaret Macdonald. One of the most influential features of the room was the use of the two gesso panels designed for the Ingram Street Tea Rooms; these were placed at a high level, above the deep picture-rail, anticipating the gesso panels to be designed for Wärndorfer's music room. These large panels, which face each other across the room, made a profound impression on Gustav Klimt, evident in his own designs for the Beethoven frieze in 1902.[10] The only pieces which remained in Vienna were an oval back-rail armchair (1899.16) acquired by Moser, who later became a good friend of Mackintosh, and Mackintosh's own smoker's cabinet (1899.1), which was bought by Hugo Henneberg and fitted into a study in a house being designed for him by Josef Hoffmann.

Mackintosh's work had a profound influence upon the young Viennese designers. Even Hoffmann assimilated some of his ideas, but it was his students who were most impressed by the work of the Scottish architect. The style they evolved bore little resemblance to the pieces Mackintosh had actually exhibited in Vienna, but their growing dependence upon white paint, coloured inlays, and the use of the square as a decorative motif, points to their considerable knowledge of other pieces designed by Mackintosh which were not shown at Vienna in 1900. Obviously he had sent quite a number of photographs to Moll in the summer of 1900 and probably he took more with him when he visited Vienna with Margaret in October or November that year. After that, his work received much more publicity in the German art periodicals, and he was also in correspondence with Moser, Hoffmann and Wärndorfer, all of whom would have known of his plans and dreams.

There is no doubt that after 1900 the aims of Mackintosh and the Viennese designers were similar, and I believe that the increasing use of geometrical motifs in the Secessionists' designs was inspired by Mackintosh. A popular Viennese motif was a group of four pierced or incised squares: this had

been used by Mackintosh at Westdel as early as 1898 (*see* D1898.18 and 1898.16), and single squares were used in the Ingram Street furniture and in the picture-rails both at Mains Street and the Secession display. Lattice panelling became another Viennese motif, one which Mackintosh had used in his exhibition stand for the School of Art early in 1901 and which was implicit in the mullions and transoms of the School of Art studio windows, completed in 1899. While the Viennese eventually used the square, the oblong, the lattice and the triangle in an excessively mannered style, Mackintosh continued to explore the challenge of integrating organic decoration into his furniture while at the same time working along a parallel course with more geometrical motifs. The latter eventually came to dominate his work, but from 1900 to 1903, he concentrated on the white-painted, almost symbolist furniture on which much of his fame as a designer rests.

Mackintosh used white enamel more frequently after completing the furniture for his own flat. Apart from the Secession Exhibition, it was used in the drawing-room and bedroom at Dunglass and on some of the movable pieces as well as much of the woodwork at the Ingram Street Tea Rooms for Miss Cranston designed in 1900. Early in 1901, he drew up his entry for the competition to design a house for an art lover, the *Haus eines Kunstfreundes*, sponsored by the German magazine *Zeitschrift für Innendekoration*, published by Alexander Koch in Darmstadt. In two rooms of the house, the bedroom and the combined music and reception-room, Mackintosh made extensive use of white paint. The single elevation of the bedroom shown on Mackintosh's competition design is very different from the Mains Street bedroom, the treatment being more like that of the fireplace wall of the Director's room at the Glasgow School of Art. Simple wardrobes were painted and embellished with decorative stencilled squares, while above the fireplace, the medicine cupboard was decorated with pierced squares. The wash-stand was very similar to the simple rectilinear shapes produced for the Dunglass bedroom, and no other furniture is shown; as this arrangement was repeated in the Windyhill bedroom, it seems likely that, if built, the movable furniture for the *Haus eines Kunstfreundes* would have been similar to that designed for Windyhill.

If the bedroom was basically a masculine design, at least in its fitted furniture, then the music and reception room was overtly feminine. It was the most ornate room Mackintosh had so far designed, for, although the furniture was sparsely distributed, the walls, especially the east and west walls, were extremely elaborate (by Mackintosh's standards, that is). The south wall was broken by a series of shallow, curved window bays, each containing a tall stencilled or embroidered panel designed by Margaret Macdonald. At the west end of the room was a piano or organ above which was suspended one of the most elaborate of Mackintosh's decorative sculptures, combining motifs of birds, trees and flowers, a white-painted elaboration of the Craigie Hall organ of 1897. At the other end of the room the fireplace, again with ornate applied decoration, was flanked by two cabinets supported on spindly legs; these faced two large figurative panels on the west wall which flanked the piano. The whole treatment of the room, with its crisp white furniture offset by tints of rose, purple and green in the light shades and inlays, was much more consciously elegant—even contrived—than anything Mackintosh had previously designed. Apart from the panels specifically designed by Margaret, the entire room reflects her influence, or at least a more feminine point of view than is apparent in the rest of the designs for the house. There can be little doubt that, of all the interior views, it was the music room which attracted the most attention. It was, for instance, almost certainly the inspiration for Wärndorfer's request to Mackintosh for the design of a music room for his own house; that room, as finally executed with its frieze of gesso panels, is very close to the design for the *Haus eines Kunstfreundes* and

is the apogee, and virtually the final example, of Mackintosh's work in this new style.

At Windyhill there is little of this style to be seen, and even the white bedroom is somewhat severe. In the series of designs for stalls for the Glasgow International Exhibition of 1901, however, the two extremes of Mackintosh's style can be seen: the rigid white lattice-work of the School of Art kiosk stands in stark contrast to the more curvilinear designs for Pettigrew & Stephens, the Rae Brothers, or Francis Smith, which come closest to the extravagant piano proposed for the *Haus eines Kunstfreundes* earlier that year.

14 Kingsborough Gardens, 1902

In the following year, 1902, Mackintosh had the opportunity to put into practice some of the ideas seen in his earlier competition designs. At the beginning of the year he designed furniture for Mrs Rowat at 14 Kingsborough Gardens, Glasgow, to complement the elaborate fittings and wall decorations he had designed for her late in 1901. The new pieces made a complete break with the more robust furniture, usually stained, which can be traced back to designs for the Argyle Street Tea Rooms. The emphasis here was on more delicate motifs and structural members, producing a lightness and elegance, particularly in the designs for chairs which were in total contrast with, for instance, the Ladies' Room chair at Argyle Street (1897.19) and even the later lug chair for Mackintosh's own flat (1900.5). The chairs, tables and cabinets designed for 14 Kingsborough Gardens all reflected the more fluid style of the *Haus eines Kunstfreundes* music room and were in harmony with the floral stencilling which Mackintosh produced for the drawing-room and bedrooms. This in itself was a break with the practice he had adopted at 120 Mains Street. There was no stencilling of patterned decoration there, and at Dunglass it was only used over the fireplace. At Windyhill such decoration was confined to the bedroom, while at Kingsborough Gardens it was applied from skirting to picture-rail, and not just on the walls, but also on the backs of the fitted seating. After the carefully controlled interiors of Mains Street, this comes as a shock and might be considered a retrograde step.

Several commentators have seen the influence of Margaret Macdonald in the tea room interiors particularly the Willow, designed in 1903. While not denying that Margaret collaborated with her husband on that project I believe that the most productive period of their joint work was concentrated in the years 1901–02. Margaret's fairy-tale world of myth and legend, of princesses being rescued by gallant knights (seen in her over-pretty later style, i.e. post 1898), and her fascination with Arthurian legend and Maeterlinck's stories is reflected in the interiors of 1902. The Rose Boudoir, shown at the Turin Exhibition, was built around her three gesso panels based on the romance of the rose. Roses were used in the stencils at Kingsborough Gardens, too, and at the Wärndorfer Salon her influence can be seen not only in the decoration of the furniture, but in the frieze of gesso panels based on Maeterlinck's *Seven Princesses* which again made much use of the rose motif. In the Rose Boudoir, the backs of the chairs (1902.7) were stencilled with roses, and the colour scheme of pink, purple, green and white echoed that of the drawing-room at Kingsborough Gardens. However, I do not believe that Margaret played a direct part in the design of the furniture for any of these rooms. Her part was played through the choice of the decorations and the emphasis on the creation of a fairy-tale or romantic setting for the furniture. This influence percolated through to the furniture of course, in that Mackintosh designed it in keeping with the mood of the room, but the physical design was surely his. Margaret never showed any real flair for working in three dimensions; her work was basically flat and linear and the only piece of furniture attributed to her (a three-cornered cabinet given

by W. Davidson to Queen's Cross Church) is of uncertain, even clumsy, design.

The importance of these more romantic and feminine designs lies in the methods Mackintosh used to break with the robust style of much of his earlier furniture. At Westdel he had discovered that the use of paint helped in itself to create elements of a new style; it freed him from the accepted associations of timber, the emphasis on grain and on traditional cabinet-making construction and decoration. The new furniture was painted white not just to reinforce the concept of the unified interior, but also to conceal and deny the construction of the pieces themselves. The delicate legs and stretchers of the chairs, the wide legs of tables, often placed tangentially to circular or oval tops and shelves, all provided insufficient timber to make good joints. The decoration of these structural and even non-structural members was often of a kind alien to the nature of wood. Had the timber been exposed all the faults, as the Arts & Crafts designers would have termed them, would have been exposed and they would, at the very least, have detracted from the design. At worst, they would have destroyed it. To overcome this, Mackintosh gave his new designs a coat of icy white enamel, applied over a filter which obliterated all trace of the grain of the timber below. Ideally, he would probably have preferred to use a totally new material, a substance which was not expected to conform to accepted and well-tried, even hackneyed, rules of design and construction. Mackintosh saw no virtue in the use of materials for their own sake: the distortions of form and structure applied to the timber of these designs shows that where there was no aesthetic value to be gained from the material he would pragmatically hide it; where it had a contribution to make, it would just as emphatically be exposed. There was, however, no other material available. The question is often asked, 'What would Mackintosh have done with malleable plastics, considering what he did with unmalleable timber?' By painting wood white, black, or occasionally silver, he was able to release it from its traditional restrictions: it could be carved and planed in new ways and made acceptable by its homogeneity of surface; joints and sections are visually (if not structurally) acceptable, because the hard painted surface suggests they are not made of wood— we understand and accept the structural limitations of wood, but not of this elegant new substance.

After two or three years of frenetic experimentation with painted and carved surfaces, Mackintosh gave them up and returned to a more traditional use of timber for his furniture. This was coupled with a rejection of the literal use of organic decoration in his work; but was it also connected with his failure to produce furniture which had the structural strength of the earlier pieces? It is a fact that the most delicate of his furniture is that which was painted, produced between c1899 and 1903, and it is all in more or less the same style. But this does not answer the question whether Mackintosh painted his furniture to help conceal the structural inadequacies enforced on him by the demands of style, or whether he really did wish to create the illusion of using a new, yet non-existent, material.

Working so closely with Margaret during those years, Mackintosh's approach to the problems of furniture and interior design became less experimental. White furniture and white walls, with organic decoration on both, was a simplistic solution, as limited as Margaret's imagery in her watercolours and gesso panels. It limited the architectural control of his interior spaces and gave designs an over-refined sophistication which would all too soon have become mannered and sterile. Without an alternative to wood, even his inventive powers would soon have become exhausted, for there was a limit to the distortion he could impose on his raw materials. In the two years that he concentrated on this particular style, Mackintosh, on the whole, achieved great success, but he obviously realised that it was an end in itself and it imposed upon him just as many restrictions as it released him from. When he came to the next suitable occasion to use these new motifs, he seems to have realised their limitations and he began to evolve a more reasoned and mature style.

The Hill House and the Willow Tea Rooms, 1903–04

In 1903, Mackintosh began to work on two commissions in which one would have expected to see more of Margaret's influence: the Willow Tea Rooms and the interiors of The Hill House. Howarth (pp. 145–46) sees Margaret's influence at its most effective in the Room de Luxe at the Willow Tea Rooms. In its theme, with its associations with the Pre-Raphaelite concepts of love and anguish, he is no doubt correct, but in the handling of the spaces and the design of the furniture there is a move away from the limitations of such a dream world. In the rest of the tea rooms there is an undoubted architectural emphasis: the placing of the furniture, the division of spaces by screens of translucent glass or metal and wood, combine with a more masculine approach to the decorative motifs of panelling and furniture. The colour scheme of purple and silver in the Room de Luxe is obviously feminine, as befits the Ladies' Room (as Mackintosh called it on his drawing, D1903.22). There is even the repetition of wall decorations using organic motifs, but here they are set in leaded-glass and are far less frivolous in their linear patterns than the stencils at Kingsborough Gardens. As with all the other furniture designed for the Willow Tea Rooms, organic motifs are banished from the decoration of chairs and tables in the Room de Luxe, with the exception of a stylised leaf inset in the legs of the tables. The emphasis is on ovals and squares, but the heaviness of the Argyle Street—and even some of the Ingram Street—furniture has also gone. The elegance of the 1902 designs remains, but it is by no means as emphatic or mannered. All these new designs are somewhat understated, more subtle and quiet than anything produced for Turin or the Wärndorfer Salon. White walls and table-cloths contrast with dark-stained or ebonised chairs; in the Room de Luxe, purple silk, purple and white glass, and silvered mirrors reflect the choice of purple and silver for the chairs and tables. The all-white rooms of 1902 have given way to a deliberate contrast of an architectural, rather than pictorial, composition. This does not mean though, that Mackintosh totally rejected the achievements of 1902. Some furniture is still painted and stretches the limits of traditional methods of construction; roses still appear in leaded-glass and stencilled hangings, balls of glass hang over the staircases, beads and crystal balls in the Room de Luxe. Yet all these trivia are kept in their place and not allowed to take over the interiors; they complement the furniture and do not overpower them.

The tea room furniture, of course, had to be stronger than much of the domestic furniture designed in 1902; as Mackintosh could not easily combine strength with that style, then he would have been forced to look for a more robust mode of expression. Strength was no more important an element of the designs for The Hill House than it had been at Kingsborough Gardens, but still Mackintosh chose to move away from that more feminine style. There are still stencil decorations on the walls, but the rose motif is combined with the lattice in the bedroom, and in the drawing-room it is contained within a more obviously architectural framework. The stencils in the hall are the work of the adventurous Mackintosh rather than the predictable Margaret Macdonald, for they are yet another abstract composition like the panels at the Willow Tea Rooms.

The only room at The Hill House to have movable white furniture is the bedroom; in the drawing-room only the fitted furniture was painted white, such as the window seat and the fireplace. One might have expected the bedroom to be an ideal situation for Mackintosh to continue the style of the Rose Boudoir, but again the final design is tempered by a

greater restraint and simplicity of decoration. There is a stronger emphasis on straight, clean lines, and such carved decoration as is used on the furniture is less literal in its imagery than, say, the Wärndorfer chairs (1902.21) or the Kingsborough Gardens cabinets (1902.3). There is again a contrast between black furniture, for example the chairs and stool, and white fittings such as the fireplace and wardrobes. The chairs (1903.58) are perhaps the most delicate items Mackintosh ever designed, but their elegant appearance is not achieved by using any of the stylistic devices of 1902. The grain is exposed, the stretchers and legs are as thin as, if not thinner than those of the Turin chairs (1902.7) and they are as attenuated as the Wärndorfer chairs (1902.21). But the design is simply stated, the fragility of the construction is accepted, not hidden by enamel, and no new structural techniques are used or even implied by the appearance of the chair. Above all, there is no trace of any organic decoration. From the careful use of traditional ladderback and its combination with a pattern of pierced squares, Mackintosh produced a radically new stylistic vocabulary. One could say that this bedroom was transitional: the screen with figurative panels proposed in some drawings was not used, and squares appear alongside naturalistic motifs in some items, such as the mirror and wardrobes. Most important of all, the furniture relates to the architectural spaces of the room: it does not overpower it or try to disguise the shape of the apartment, as at Kingsborough Gardens.

In exhibition work more or less contemporary with the Helensburgh bedroom Mackintosh was prepared to go even further. The bedroom designed for the Dresdener Werkstätten approached the total exclusion of organic decoration and its replacement by geometrical motifs. Here the walls were not even white, unlike all his earlier bedrooms, and the stencil decoration took the form of squares, not roses. The cursive, more feminine elegance of the Rose Boudoir was replaced by a linear precision, an elegance of a more Germanic, or Austrian, nature. Was the choice of motif deliberately made to influence possible clients in Dresden, or did Mackintosh truly wish to forsake the natural forms which he had used so beautifully in earlier work? At Hous'hill there was again a mixture of organic and geometrical styles, but there can be little doubt that it was the latter which intrigued Mackintosh by then.

During the following spring and summer Mackintosh was working on the rest of the furniture for The Hill House and the furnishing of Hous'hill for Miss Cranston. At the same time he was presumably supervising the installation of the fittings at the Willow Tea Rooms. The furniture designed in 1904 for Walter Blackie repeats the somewhat transitional state reached in the bedroom, designed late in 1903. Some pieces relate to the more linear style of the bedroom chairs (1903.58). At Hous'hill there are similar disparities: the drawing and music room is more consciously feminine, but the hall and bedroom furniture is predominantly rectilinear and sets the tone for much of the work of the next few years. The Kingsborough Gardens chair (1902.2) appears yet again in a slightly different guise at The Hill House. Four were made for the drawing-room but all were painted black (1904.10). All the movable furniture in the drawing-room is, in fact, painted black or stained dark, while the fitted pieces are painted white. The large couch (1904.11), and easy chair (1904.9)—now missing—are cubic pieces with an emphasis on broad, unmodelled planes relieved by simple incised decoration. In the hall Mackintosh provided three sturdy, well-proportioned chairs (1904.6), using the pierced square as his major decorative motif. This was repeated in the table (1904.7) where the oval top counters the more emphatic impact of the square.

These designs gradually drew Mackintosh to the opposite extreme from the Wärndorfer Salon furniture. As with much of the Willow Tea Room furniture, the emphasis on unmodelled surfaces and exposed grain gave an impression of sturdy utility. This could have been acceptable in a tea room, perhaps, but Blackie obviously required something a little more elegant, something which would not be totally at variance with the white woodwork of the drawing-room. Mackintosh's solution can be seen in the cabinet (1904.20) and writing desk (1904.13). In both these pieces ebonised timber in broad expanses is set against subtle curves of glazed doors, inlays of coloured glass and mother-of-pearl and discreet carved decoration. The decorative features, however, are not allowed to influence the basically linear design. The inlays, in particular, are confined to repetitions of geometrical shapes, mainly squares, with little or no reference to organic forms. The squares of mother-of-pearl both emphasise the rectilinear outlines which Mackintosh was using and also relieve the otherwise plain flat surfaces of doors, legs and shelves. Incised squares in gables, and even a strange boss carved with overlapping inverted triangles on the cabinet (1904.20) similarly complement the boxy shapes of this furniture. The carving and inlays give the cabinet a more luxurious appearance, and Mackintosh gradually refined this new style over the next few years. The severity of outline and massing was very different from the white furniture of 1902, but it could be softened by the use of other materials to produce a more sophisticated appearance.

The following year, 1905, Mackintosh produced other designs for furniture for Blackie which applied the same principles in a slightly different way. The lamp (1905.17) is unpainted and, apart from its elegant shade, relies for its effect upon the manipulation of the grain of the timber. A pattern of squares is created, not by the use of inlay, but by transposing the direction of the grain of each square of wood. This rigid but elegant pattern was not used again by Mackintosh until he designed some bedroom furniture at 78 Derngate in 1917 and 1919 for W. J. Bassett-Lowke. Its use at this date is untypical, and he seems to have been moved to offset the severity of the design by the apparently random placing of a piece of mother-of-pearl, almost like an ink blot, on the base of the lamp. At the same time, he designed two more easy chairs for the drawing-room (1905.20). These are again made in ebonised timber, but this time are upholstered in a rich velvet.

The construction of the chairs lays great emphasis on the square-sectioned sticks of timber used in much of the bedroom furniture at Hous'hill. Here these sticks are paired, an oriental motif repeated in the coupled columns and beams of the Library and Flower Composition Room at the School of Art in 1909. Mackintosh has slung his upholstery across this framework of timber rails which appear to be joined by dowelling pins. This apparently exposed construction and the use of timber rails fixed at right-angles seems strangely prophetic of the furniture of Gerrit Rietveld. The members of De Stijl knew and admired Mackintosh's work, but this particular chair was never published and no other furniture used quite the same techniques of construction. Mackintosh was not totally honest about his construction, however, for the pins are not structural and perform no function other than mere decoration. But the principles behind the design, of elegant luxury in the padded upholstery and more severe use of plain timbers in the structure, reflected the ideas first seen in the pieces of furniture designed in 1904.

The Hous'hill, 1904

The Hous'hill, if anything, gives us a better opportunity of seeing Mackintosh's skills and ingenuity as a furniture designer than even The Hill House. He was concerned only with the interiors at the Hous'hill and designed much more furniture for that job than he did for Blackie. Apart from hall and billiards room pieces, he also designed all the furniture for the drawing and music room as well as for two large bedrooms. With the exception of that for the drawing-room,

all the furniture is more geometrical and severe, ranging from the extremely simple and rigid trellis in the vestibule to the more substantial and elegant wardrobes and cabinets of the Blue Bedroom, and the fine hall dresser (1904.35). The latter is in the style of the rather more luxurious pieces at The Hill House, but its effect is achieved by careful selection of grain in the timber and subtle arrangement of curves and lines in the design. It also places emphasis on the use of several squares to form a lattice, a feature used more frequently in later years, not only in furniture, but also in the fittings of larger rooms, particularly the tea rooms.

The White Bedroom at Hous'hill was virtually the last white room Mackintosh designed and the last occasion on which he used white enamel on his furniture. The shapes of the furniture are all strongly oblong or square and the decorative motifs take the form of pierced or incised squares. A new motif here, often seen in later pieces, is the use of a tapering square knob on the bedside table (1904.90); its black surface contrasts with the white enamel of the drawer and it is itself decorated with inlaid mother-of-pearl.

In the Blue Bedroom the furniture is either ebonised, or more simply stained dark and waxed. Again the emphasis is on simple boxy shapes, with decorative relief provided by metal or glass inlays. Many of the ideas developed in this room were used in later furniture and they are as much the hallmark of a Mackintosh design as the use of white paint, purple glass and stencilled roses are in the designs of 1901–03. Stretcher rails on dressing-tables and wash-stands are arranged to form a lattice pattern; handles are recessed and backed with white metal or coloured glass; the timber is stained and polished smooth with wax to emphasise the grain, or ebonised with a black stain, again leaving the grain of the wood exposed. Sycamore, plane and maple were as likely to be used as oak, especially if the piece was to be polished. By using woods with a finer grain, Mackintosh was able to use finer details, sharper edges and thinner sections, the decoration being solely the random variation of the grain of the timber itself. Thus the ebonised chairs (1904.93) from the White Bedroom appear, at first glance, rigidly and unimaginatively rectilinear. The aprons, however, have a delicate curve and the back of the chair itself is curved across its width. Mackintosh also created a subtle pattern in the lattice-work in the back of the chair: the vertical and horizontal slats are cross-checked so that, seen from the front, the verticals are unbroken, with the grain running along the length of each rail, while on the back the horizontals are dominant, cutting across each of the vertical rails.

Later tables followed the pattern of the Blue Bedroom table (1904.72) with a square top and legs set on the diagonal; the paired diagonal stretchers were often joined by small bracing pieces to make a pattern of squares between the pairs of rails. The free-standing cabinets (1904.67) repeated the niches used on the bedside cupboards at The Hill House, but here they formed an integral part in the design of the piece, their curves contrasting with the pierced squares and rectangular outline of the cabinet.

While the bedroom furniture at Hous'hill set the pattern for the future design of individual pieces, the drawing-room points to a more considered and inventive manipulation of space. Mackintosh had always treated spaces in such a way as to express the function of a room. The bedroom and drawing-room at The Hill House are subtly divided, by the different ceiling heights or variations in windows, to suggest specific uses for specific areas of the room. The same techniques were used at the Willow Tea Rooms, the exhibition rooms at Vienna and Turin, and in the Wärndorfer music salon. At Hous'hill, in the later tea rooms and, above all, in the School of Art Library, spatial manipulation became even more expressive and complicated. Just as one must evaluate Mackintosh's furniture as sculpture as well as functional items of everyday use, so should one also acknowledge his approach

to spatial composition in these late works as being primarily sculptural. Many of the later jobs involved internal alterations to existing buildings: Hous'hill, the Oak, Chinese and Cloister Rooms at Ingram Street, and the Northampton work were all such commissions. Given a restricting shell with a defined internal volume, Mackintosh could only impose his character on the work by creating ever more daring and ingenious arrangements of individual features such as screens, balconies and ornament. As sculptors release images from blocks of stone or wood, so he carved the simple rectangular spaces of the rooms he was given to provide exciting vistas, subtle variations of light and texture, and powerful modelling of structural elements. The result was a series of expressive and dynamic interiors culminating in his masterpiece, the Library at the Glasgow School of Art.

In the drawing-room at Hous'hill Mackintosh was faced with a simple rectangular space with windows on two sides, one of which was in an apsidal addition to the room. He may even have created this apse, but, whatever its history, he made use of its curve to divide the large room to provide a music room for Miss Cranston within the drawing-room. At the opposite end from the music room was the fireplace area which he treated much as he had at Mains Street, Windyhill, or The Hill House (see 1904.I). The music room was enclosed in such a way that it could be used either as part of the drawing-room or as a room within a room. For the *Haus eines Kunstfreundes*, Mackintosh had provided removable screens between the Music Room and the Drawing Room, thus giving the option of two separate spaces or one large room. At Hous'hill, the division is permanent but transparent, thus creating a subtle ambiguity, an illusion of two separate and finite spaces or, almost simultaneously, of one room contained within another with the two spaces flowing into each other and becoming one (see 1904.G and H).

The window in the apse occupied one small segment of the perimeter; the rest of the semicircle was fitted with seating curved to the profile of the wall. At the point where the walls of the drawing-room take off tangentially to this apse, Mackintosh introduced a short length of open screen, repeating the curve of the bay. Two openings are provided in the screen, which then continues to complete the full circle. The screen itself is open, consisting of a number of tall vanes (about 10cm. broad by 1cm. thick) placed radially along the circle and secured between two curved top and bottom rails. These vanes are spaced about 10cm. apart, and at intervals shorter vanes were inserted, each supporting an oval tray. This device quickened the rhythm of the composition, which was further enhanced by the insertions of square or oval panels of coloured glass between the vanes. Mackintosh had used screens before—on the staircase at The Hill House and elsewhere—but none of them was as elaborate or as successful as this.

The Ingram Street Tea Rooms and the Glasgow School of Art West Wing, 1907–11

The staircase at the Oak Room was also screened, but in a much more straightforward way, so that it helped to define the staircase and emphasise it as an important element of the room (see 1907.D). Mackintosh ran a balcony around three sides of the awkwardly tall and oblong space in an attempt to obtain the effect that the room was divided into a series of interlocking rectangular volumes. The staircase, enclosed by its screen, became another such unit linking the upper and lower floors and breaking into the full-height void created by the three-sided balcony. This balcony was supported on a series of timber posts, each with a wide 'capital' on which its joists appear to sit. From this capital rose smaller square posts which cut through the front of the balcony and ended at the ceiling. Wherever they passed through the balcony, the posts were crossed by a lath; this was bent in a wavy line

to accommodate each post, returning afterwards to the plane of the balcony front. This type of post and beam structure, used with a wavy lath, was repeated in the Library at the Glasgow School of Art, on which Mackintosh started work in the same year (1907).

The Library has retained the dark-brown stain which was originally applied to the Oak Room as well, and which helped to reinforce the expressive modelling of both rooms. Because Mackintosh controlled the shape of the spaces with which he had to work, his interiors at the School of Art in 1907–09 are naturally more assured and successful. Many of the individual motifs with which he had experimented in the period 1904–07 were brought together in the Library in a single harmonious design. It is Mackintosh at his most inventive, but he does not lose control of his inspiration and the final composition is one of his most ingenious and, at the same time, controlled works.

Into the height of one of the first-floor studios, Mackintosh fitted three floors in the west wing to create the Library. The top floor provides a book store and is, in fact, suspended on steel stirrups from the main east–west beams which support the second floor of the wing. By diverting the enormous weight of this store, Mackintosh made possible a more open use of the spaces below, since he did not have to provide in the main Library a substantial structure to support the book store. In fact, his interior handling of the Library was subjected to only one structural restraint—the position of the two main east–west beams which supported the weight of the Library. He positioned three oriel windows on the west elevation, separated by the beams, and these rise the full height of the Library and its gallery and also light the book store above. Where they cut into the gallery, it was shaped to match the three sides of the windows, thus forming a hexagon; this shape was repeated in the book store where internal glazed lattice windows completed the hexagon.

In order to support his gallery, Mackintosh had to place his columns over the main beams, just as he had proposed in his original 1896 plans for the School. The major change which he made to those early plans, however, was to narrow the width of the gallery, thereby creating a larger central well and also requiring the support beams to be pushed out beyond the gallery to meet the fixed main posts. This was a stroke of genius, for he was able to introduce a more elegant form of construction on which he could place greater sculptural emphasis; he thus created an exposed construction which was perfectly functional and did not require any additional ornament.

The broad central post which rises from the floor breaks into three parts at gallery level, the two outer parts turning through 90° to become the beams which support the gallery, while the central—and now much thinner—post rises to the ceiling. None of these structural elements received any applied decoration; the framework of the Library is thus plain and fully exposed, the beauty of its materials and the detailing providing all the decoration it needs.

But the Library is not a plain room. Although the framework of the exciting new space was left unadorned, other surfaces were treated in a much more decorative manner. As if to emphasise the distance between the main posts and the gallery, Mackintosh placed three balusters along the exposed twin beams; the corners of these were scalloped, or waggon-chamfered, and the exposed wood painted with bright primary colours. Along the front of the gallery he applied another bent lath, as at the Oak Room, and the wavy line of this is repeated in another plane in a beam running above the gallery. This is the only curved element in a ceiling which is otherwise of simple lattice construction. The lath on the front of the gallery bends over a series of panels fitted to it, echoing those used at Queen's Cross Church in the way they project down below the floor of the gallery. As at Queen's Cross, Mackintosh pierced the pendants, but here the pattern in

each is different, a play on fluting and ovals not unlike the pilasters in the Board Room of 1906. This ingenious pattern is incorporated in the stretchers of the periodical desk (1910.5) and the legs of the tables (1910.8) designed for the room, but nowhere is exactly the same combination of pierced holes repeated.

The lighting also contributes to the spatial effects, with the pools of light concentrated in the gallery, over the tables beneath it, and in one central flood of light over the periodicals table. Mackintosh's ingenious down-lighters control the spread of light, creating an alternating pattern of light and shade which enhances the rhythm of the decorations.

On entering the Library for the first time, many people are surprised by its intimate scale, especially if they already know it from photographs (usually taken with a wide-angle lens). It is a small room only 11 metres square, but by skilful manipulation of the space, Mackintosh created an open, airy apartment which continually surprises even the habitual user with new vistas and rediscovered details.

In 1910 Mackintosh was faced with problems at Ingram Street similar to those of the Oak Room, but he solved them in an entirely different way. Inside the plain oblong space behind the Oak Room he created two new rooms, the Ladies' Rest Room and the Oval Room. The latter was a mezzanine at the same level as the Oak Room balcony, and he designed the oval inside the plain rectangle presented to him. It is not a simple oval, however, as curved bays and a bow window of different radii break its line. At one end is an open screen—like that used at Hous'hill in 1904—which admits light to the room, but effectively hides its patrons from the sight of those in the room below. This lower room has the line of the upper oval imposed on it by the columns which support the mezzanine floor. It was stained dark and had another bow window at its east end but, on the whole, was not as successful a design as the Oval Room.

Two further rooms at Ingram Street show that Mackintosh's powers of invention were not failing, even if his ability to attract new commissions had begun to wane. In the Chinese Room and the Cloister Room, both designed in 1911, can be seen elements of his own form of modernism that is apparent in the Library at the School of Art. The crispness of detail in the Library and the novel solution it offers to the problems posed are modern in approach, although not (as Macleod[11] notes) revolutionary in intent. In these two rooms for Miss Cranston, Mackintosh went further than he had in the Library, laying the basis for the style he perfected at Northampton five years later. This new style, though virtually ignored by the generation to follow, solved the persistent problems of the modern use of decoration in a simple and quiet manner, without the dogmas of the Arts & Crafts movement or the polemic of the protagonists of the Bauhaus and the International Style.

In the Chinese Room, Mackintosh used a lattice motif to hide and model the plain walls. Overhead, using a series of open sections of lattice-work, he screened the rather ugly ceiling from view and deflected the upward gaze of the diners. The walls were covered with canvas over which the open lattice was fixed. At intervals this lattice was made to form shallow projections, the square openings of which were filled with coloured or mirror-glass and plastic, either flat or in the shape of curved niches similar to those used in the bedside cupboards at The Hill House (1903.53) and Hous'hill (1904.67). This is the first recorded instance of Mackintosh's use of a synthetic material—probably a casein-based plastic—in place of glass. It is interesting to note that he used it only in sheet form, not taking advantage of its malleable nature to return to the more sculptural style of 1902.

One of the most dominant features of the Chinese Room was its use of colour. The fittings were apparently painted in bright blues and reds, a new element in Mackintosh's work. At the School of Art colour had been very restrained; although

there is more in the Library than anywhere else in the building, even there it is restricted to the balusters in the gallery. Apart from white paint, colour was normally used by Mackintosh only in glass inserts or in the stencil decorations he designed for many of his domestic commissions. At the Willow Tea Rooms there was a more conscious attempt to make a greater use of colour, especially in the Room de Luxe where the dado was of purple silk and the furniture was painted silver. Before 1911, colour was always very carefully controlled in his work, its use being restricted to dabs of intense hue on the furniture or the pastel colours used in upholstery or ornament. In the Chinese Room this policy was abandoned in one of the most 'modern' gestures Mackintosh ever made; but later in the year, in the Cloister Room, he returned to a more controlled, but still extensive, use of colour.

The alterations made in the Cloister Room were more extensive and elaborate than in any of the other rooms at Ingram Street. The ornate plaster ceiling and frieze (see 1900.K) were hidden by a new and lower vaulted ceiling. Three deep 'domes' in this plaster vault accommodated ventilation grilles and light fittings. The rest of the ceiling was smooth except for a series of raised bands of diaper pattern which spanned it at about every 1.5 metres. These raised bands related to the pattern Mackintosh designed for the walls; they were placed above flat wall panels, and where the ceiling was smooth the walls were raised in a pattern of superimposed panels of timber. Thus' the smooth/raised rhythm of the ceiling was reversed on the two long walls of the room. These walls were of plain waxed timber panels, decorated with strings of painted diapers, again in primary colours, which ran vertically in pairs, dividing the flat panels and also defining the edges of each of the superimposed timber panels. At the junction of wall and ceiling, a horizontal cornice of painted diapers ran the full length of the longer walls of the room. Mackintosh retained the open screen at the east end of the room (see 1900.K), but at the west end he divided the wall into ten equal panels. The central two formed a single niche, backed with leaded mirror-glass strips and crowned by an elaborately carved canopy. Above this was a panel of chamfered rails which rose to the vault, projecting forwards as it approached the ceiling. Three other panels of this west wall had similar niches, arranged asymmetrically with three similar panels at the west end of the south wall (see 1911.D).

The wavy line created by the diaper thus appears in two and three dimensions: in the painted wall pattern and the moulded plaster of the ceiling, and even repeated in the metal grid of the umbrella stands. While the Chinese Room is predominantly rectilinear, the Cloister Room is restless and somewhat unresolved. But it is important in that it shows the fruit of Mackintosh's break with the more organic style of the early 1900s. Here he was able to reintroduce curves and pattern into his work without the feminine overtones of the Turin or Wärndorfer furniture.

Mackintosh was on the verge of perfecting a style which would allow him to repeat the triumph of the Library at the School of Art on a more modest scale. He had virtually arrived at a formula which would have allowed him to synthesise the successful elements of that design into a truly modern style. The Cloister Room is totally new, it does not depend on specific historical precedents and it shows that Mackintosh was prepared to progress from the apparently unsurpassable work in the Library. The Library is Mackintosh's greatest achievement only because he was not given the opportunity to repeat it or improve on it. It was designed before he was forty, so he cannot have intended it to be his last great work. The Chinese Room and the Cloister Room show that the Library interior was the beginning of a new phase, which the west elevation of the School of Art confirms. In these two small commissions for Miss Cranston Mackintosh returned almost to the position he was in in the late 1890s, when he began

to develop the ideas which culminated in the design for The Hill House.

The Library would not have been, in Mackintosh's eyes, an unrepeatable pinnacle or a fitting crown to his career. He must have intended to work from it to a mature style, a style admittedly conscious of the past, as in the west elevation of the School of Art, but not dependent on it for its vocabulary.

While his interior designs of 1907–11 became more adventurous and accomplished, there was little development in his furniture. The boxy shapes of 1904 remained, and the late Tea Room furniture was simple in the extreme. Even if wavy patterns were allowed to soften the box-like effect of the pieces, they were firmly contained within a severely rectilinear outline. The more expensive cabinets and chairs designed for The Hill House and Hous'hill were not often repeated after 1904, but that was probably more the result of a lack of commissions than any definite change in approach. Indeed the table for Hous'hill (1909.11) shows that Mackintosh had not forsaken more luxurious designs and, in 1912, when given another opportunity, he designed one of the most elaborate and elegant tables of his career (1912.3). But there was no furniture of this period (1907–11), which adequately reflected the new ideas evident in his architecture and interior design. Even at Ingram Street in 1911 he seems to have been restrained, perhaps by the need for economy or the particular requirements of tea room furniture, and it was not until after he had left Glasgow that equivalent changes in his furniture designs became apparent.

Designs for W. J. Bassett-Lowke, 1916–20
When the Mackintoshes left Glasgow in 1914 they settled in Walberswick, close by the Newberys who often spent holidays there sketching and painting. Mackintosh seems to have left his firm in 1913, but he did not make a success of working on his own in Glasgow and, with no new commissions, and little prospect of any in the near future, he decided to leave the city in which he had created so much of his best work. Newbery's daughter, Mary Newbery Sturrock, was in Walberswick in 1914 and she believes that Mackintosh was about to leave for Vienna; the War began however, and effectively prevented any escape. Vienna might have offered no greater opportunities for new work, but it did have a thriving artistic community which would have provided Mackintosh with the moral support he lacked in Glasgow. The furniture he produced at Northampton in 1916–19 also shows that his new ideas were extremely close to some of the developments in furniture design which had taken place in Vienna since his last recorded visit there in 1900. In the years after his work was shown at the Secession exhibition, many of the younger designers looked as much to him as they did to Hoffmann and Moser, and, if there was a 'Mackintosh School' anywhere, it was in Vienna as much as in Glasgow.

At home, apart from the work of his friends Salmon and Gillespie, Mackintosh's style was diluted in the form of shop-commissioned designs prepared by men like E. A. Taylor, George Logan and John Ednie. In Vienna, the young designers built upon Mackintosh's ideas and gradually developed a style of their own. This was on the whole rather more lavish, using expensive and luxurious materials with an emphasis on exquisite craftsmanship, which Mackintosh rarely asked of his furniture-makers. Ironically, such men as Otto Prutscher,[12] who had been one of the most ardent of Mackintosh's Viennese disciples, produced in about 1907–10 much the same kind of designs as Mackintosh turned to in 1916–17. He was obviously aware of Prutscher's work, although there are rarely any literal correspondences between his own and Prutscher's earlier designs, other than the Derngate clock for the guest bedroom (1919.7). Plagiarism might almost be a justified claim were it not for the way in which Mackintosh reacted to the Viennese work and the totally

different approach he adopted to interior design and decoration during the War. Mackintosh had always been ready to absorb ideas from other sources, but he was not a true eclectic. His own furniture, from 1905 onwards, gradually progressed towards the same conclusions that were reached by the Viennese in about 1908–10. Unfortunately, Mackintosh had little opportunity to put the new ideas which became apparent in his interior designs into practice in his designs for furniture. From the illustrations of Prutscher's and his colleagues' furniture Mackintosh was able to extract what he needed to transform his own tentative experiments into the fully-fledged new style of 1916–17. To Mackintosh it would have been similar to the processes of extracting motifs from nature, from vernacular and medieval buildings. The result was pure Mackintosh, for, from whatever source he took his ideas, they were not literally regurgitated, but absorbed into a new and coherent set of designs.

There can also be little doubt that his major client during the War years, W. J. Bassett-Lowke, would have been aware of recent developments in Austria and Germany. Bassett-Lowke was unlike any other patron Mackintosh knew. He was an early member of the Design & Industries Association, had contacts with the Deutscher Werkbund before 1914, and was above all, anxious to foster new standards and to commission new—to him at least—designers. Bassett-Lowke had not heard of Mackintosh before 1914, when a friend he met on holiday recommended the Glasgow architect for a new project he had in mind. This was the conversion of a small terraced house in Northampton; but Mackintosh had left Glasgow when Bassett-Lowke travelled north to find him, although he would undoubtedly have taken the opportunity to see at first-hand the work Mackintosh had carried out there. Mackintosh was traced to London, and work on the new commission was probably begun late in 1915 or early in 1916.

Bassett-Lowke knew what he wanted and his awareness of new developments in Europe would have acted as a catalyst for Mackintosh. Here was a client who was open to new ideas, who could give him the opportunity to develop the theories he had begun to elaborate in Glasgow. How much Bassett-Lowke led Mackintosh to his new style, and how much Mackintosh forced it upon him, we shall never know. It is quite obvious, however, that Mackintosh made a greater change in his furniture design than he had ever done before. While much of the Glasgow work can be seen as a steady progression, there is an enormous gulf between the furniture of 1910–11 and that designed for the Northampton jobs. Ideas tentatively expressed at Ingram Street appeared as a mature style at 78 Derngate, yet there was no intervening work in which Mackintosh was able to develop his Glasgow designs. Two years rest, and the enthusiasm of Bassett-Lowke, were no doubt responsible for these radical changes.

As an engineering model-maker, Bassett-Lowke was conscious of all the new developments in technology and keenly aware of efficiency in all things, particularly design. Just as strict economy was responsible for the modernity of Mackintosh's austere designs for the School of Art, so Bassett-Lowke's insistence on clean lines, unfussy decoration and solid construction would have speeded Mackintosh's reaction to the Viennese work of the pre-War period. There was another major difference between this commission and much of the Glasgow work: while in Glasgow Mackintosh would have stood over his furniture-maker, amending the design as work progressed: once he left the city, he had to rely upon his drawings to convey his requirements to the craftsmen. And Bassett-Lowke did use craftsmen. Many items were made by German immigrant workers, probably with experience of Werkbund methods and materials: others were made by local or London cabinet-makers (probably Heals, who made the carpets at 78 Derngate) or by Bassett-Lowke's own craftsmen in his factory. Accordingly,

the Northampton furniture is better made than any of the Glasgow pieces, although this is also in part due to the design. Plain, simple pieces, with little emphasis on complicated curves and awkward changes of section, provided enough timber to use sound, strong traditional techniques. Indeed, many of these pieces would have been ideal for mass production, with their clean lines and simple applied decoration.

With the exception of the more expressionist furniture in the hall at 78 Derngate, much of the furniture designed for Bassett-Lowke's house relies for its effect on its mass, its severe outlines and plain surfaces. Decoration takes the form of manipulation of the grain of the timber, transposing it in adjacent doors of wardrobes and drawers of dressing-tables. Other decoration is achieved by piercing square holes through the panels of beds and cabinets, by introducing lattice-work gables, or by inlaying pieces of mother-of-pearl or, occasionally, one of the synthetic materials, usually Erinoid. Timber—oak, mahogany or sycamore—is chosen for its grain and is simply waxed and polished, rarely stained. In the main bedroom, and in the later suite for the guest bedroom of 1919, a simple stencilled strip is applied to the edges of the pieces; in 1919 this was extended to include the divisions between drawers, and even the junctions of different panels of the bedheads and feet. Only in the hall furniture is the wood stained; here it is black to match the wall decorations and it is altogether more expressive. Curves combine with lattice patterns on the chairs and settle, and the fireplace adopts the moulded architraves of the door in the west elevation of the School of Art. Nowhere is there any reference in the decoration to organic motifs. Even the hall stencils (which, if they do bear any resemblance to trees, then it is to trees with chequered trunks and triangular leaves) make a break with all Mackintosh's earlier stencilled work except that for the Cloister Room of 1911. The emphasis is entirely on geometrical forms—squares, triangles, oblongs and, only rarely, circles.

This is as much furniture for the second machine age as anything designed by Mies, Marcel Breuer or Le Corbusier, but it relies upon traditional materials. Like the Library at the School of Art, it is modern without being rebellious, Mackintosh did not feel the need to use chrome steel, leather or plate glass to make new statements. In a curious way, just as the International Style has come under attack by contemporary architects, so has the new generation of furniture designers returned to timber and more traditional materials, often producing furniture which is quite close to many of these Derngate pieces. But, unlike his furniture of 1897–1910, Mackintosh's designs for Derngate are virtually unknown and what is now recognised in young designers' work as a good, straightforward approach to the problems of designing with traditional materials had been accomplished by Mackintosh 60 years ago.

Mackintosh's last furniture was designed when he was only 52. There were no other commissions, just as there were none for buildings. In 1923 he gave up any faint hope he may still have had of making a new career in London and left for the South of France to paint watercolours, living in genteel poverty on what was left of his savings and Margaret's small private income. What he had achieved since leaving Glasgow was virtually unknown outside a small circle of friends, and even the three extensive articles on his work for Bassett-Lowke at Northampton never mentioned his name. He was possibly less bitter than he had been at his failure to overcome the enemy in Glasgow in 1913, where he had fought for 20 years, but it was all the same a grave disappointment for him and a tragic loss for British architecture and design.

In the 1920s and 1930s Mackintosh, like so many of the designers and architects of 1890–1914, was forgotten and his work neglected, passed over by the frivolous practitioners of Art-Deco. Even Bauhaus-trained students were, not un-

naturally, looking up to Mies and Gropius and they ignored those men of the earlier generation like Mackintosh who had helped make possible the Bauhaus and all it stood for. In the late 1930s, and with some detachment, Nikolaus Pevsner recognised Mackintosh's contribution and extracted him from the mire into which all those connected with Art Nouveau had been thrown. For whatever else Mackintosh was, he was no Art Nouveau designer.[13] He and Margaret both disliked the wild gyrations of that florid French and Belgian furniture and metalwork, but too often their work was linked with it and their reputations suffered the consequence. One can see how perhaps the Room de Luxe at the Willow Tea Rooms might at first glance seem to fall under the umbrella of Art Nouveau but, taken as a whole, Mackintosh's work stands outside the mainstream of much of the work of the period, whatever tag or soubriquet one tries to give it.

Other architects believed, as Mackintosh did, in the total environment: the design of all the individual components in a room or even a whole building. Hoffmann, Voysey and Baillie Scott achieved it, but in a manner totally different from that adopted by Mackintosh. While much of Hoffmann's furniture, for instance, works well in the spaces for which it was designed, once removed from those rooms it often has little impact or appeal. On the other hand, Baillie Scott's furniture, when seen out of context, is often pedestrian; well-made, handsome but all too often dull. Voysey's furniture is repetitive, based on well-tried combinations of structure and decorative motif; worthy perhaps, but unexciting. Mackintosh's interiors are a harmonious orchestration of many individual pieces, each of which is a fine work in its own right and which has an existence beyond its function as chair, table or bed.

Mackintosh's furniture is exciting in its approach to the problems of design, the manipulation of mass and space, line and colour. His approach is that of the artist, and while form might follow function, that form is never automatically reduced to an ergonomic formula. Individual pieces of his furniture are conceived as such, as separate works of art: Mackintosh's genius lay not just in his ability to create such forms, as in the skill with which he could bring them together in unison with the spatial compositions of his buildings. Whether working within the confines of traditional technology or exploring its outer limits, he applied the same principles. His furniture was conceived as art, as sculpture; for Mackintosh, beauty lay in art, not mindless utility, and whenever possible he exhorted his fellow artists, architects and craftsmen to work for the same ideals. He preached individuality, others searched for uniformity and all too often found it in mediocrity. He sought a new vocabulary independent of historicism, yet at the same time aware of precedent. He achieved both and by doing so acted as, in the words of Mies van der Rohe, 'a purifier in the field of architecture'.[14]

References

1. See Walter Blackie 'Memories of Charles Rennie Mackintosh' *Scottish Art Review*, XI, 1968, pp. 6–11.

2. Mackintosh's requirements of a craftsman, or art-worker, are contained in his lecture 'Seemliness', collection: Glasgow University.

3. J. D. Kornwolf, *M. H. Baillie Scott and the Arts and Crafts Movement* 1972, p. 28.

4. Howarth, pp. 18–19.

5. M. H. Baillie Scott 'An Ideal Suburban House' in *The Studio*, IV, 1895, pp. 127–32.

6. Nikolaus Pevsner, 'George Walton', *Journal of the RIBA*, XLVI, 1939, also reprinted in Pevsner 1968, pp. 178–88; Howarth, pp. 233–38.

7. Gleeson White, 'Some Glasgow Designers and their Work' *The Studio*, XI, 1897, pp. 86 *et seq* and 226 *et seq*.

8. See N. Pevsner, 1968, 'George Walton' p. 188. Pevsner cites the occasion as a lecture to the Scottish Architectural Association but it is more likely to have been to the Glasgow Institute of Architects, to whom Mackintosh had also lectured.

9. A complete issue of *Ver Sacrum*, no 23, 1901 was devoted to the work of the Glasgow designers.

10. See Peter Vergo, 'Gustav Klimt's Beethoven Frieze' in *The Burlington Magazine*, CXV, 1973, pp. 109–13.

11. Robert Macleod, *Charles Rennie Mackintosh*, 1968, p. 133.

12. See Roger Billcliffe and Peter Vergo, 'Charles Rennie Mackintosh and the Austrian Art Revival', in *The Burlington Magazine*, CXIX, pp. 739–46. Work by Prutscher and many of his contemporaries could have been seen by Mackintosh in Special Numbers of *The Studio* and in *Studio Yearbooks of Decorative Art* from 1906 onwards.

13. Mary Newbery Sturrock 'Remembering Charles Rennie Mackintosh'; a recorded interview in *The Connoisseur*, vol 183, 1973, pp. 280–88.

14. Letter from Mies to Andrew McLaren Young, quoted by Young in Edinburgh Exhibition catalogue, 1968, p. 5.

The Job-books

Many details of the various buildings and interior design schemes which involved Mackintosh are contained in the job-books completed by the partners of his firm, Honeyman and Keppie, now Keppie Henderson and Partners, Glasgow. Before Mackintosh became a partner, he was not allowed to make entries in these books, and few of the jobs carried out by the practice are entered in any detail. In some cases, they are identified only by the name of the client, with no address. As these jobs cannot now be traced, it may be that there are several more executed Mackintosh designs which have not come to light. The later work at Craigie Hall (of 1897) is only listed by the name of the client, Thomas Mason, and several jobs of similar size, which one might expect to have been given to Mackintosh, are similarly recorded. While these remain unidentified, we cannot either know their designer or identify the scale of the work involved.

After he was made a partner in 1901, Mackintosh's handwriting appears more frequently in the job-books, and it is therefore far easier to identify jobs which he controlled or with which he was connected (although nowhere is there any reference to the building of Windyhill). Mackintosh also completed the job-books in a more detailed manner than did Keppie, listing both tender price and final payment for almost every aspect of the job, from thousands of pounds for masonry or general contracting down to a few shillings for an embroidered table runner. This is indeed fortunate for it tells us with some degree of accuracy and authority how many Tea Room chairs were made, for instance, and allows us to date the sequence of designs for an apparently homogeneous project such as The Hill House or the Willow Tea Rooms.

The most detailed accounts are those of 1902–07. After this, Mackintosh's entries become less specific or are simply left incomplete. Many of the details of the work at the School of Art in 1907–09 are omitted, and there is very little information about the work carried out at Ingram Street after 1909–10.

Reproduction Furniture

Although large numbers of identical chairs and tables were produced for the Tea Rooms and other similar projects, most of Mackintosh's furniture designs were intended for specific locations and only one or two examples might therefore be made. There are obvious exceptions, such as dining chairs for domestic or exhibition rooms. On the whole, though, the numbers of items made can be documented with some degree of accuracy. Because so few examples of each design were made and because Mackintosh only occasionally repeated a design for another job, his furniture is rare and thus all the more expensive when it comes on the market.

Reproductions of some of the designs have been circulating for a number of years. These were usually made in quite small quantities and were not claimed to be, as indeed they were not, accurate reproductions. The items most commonly encountered were the order-desk chair from the Willow Tea Rooms (1904.24) and the armchair Mackintosh made for himself (1899.16). The owners of Mackintosh's copyright, Glasgow University, had hoped that some of the designs might be copied in a more legitimate way, with a greater degree of accuracy, but this was not achieved until 1973, five years before the expiry of the copyright.

Working from drawings made by Filippo Alison, Cassina of Milan launched a series of facsimiles to coincide with Alison's Mackintosh exhibition at the Triennale in Milan in 1973. These chairs and other items were chosen with the co-operation of the owners of the original pieces, and the reproductions were closely compared with the originals before being put into full production. Although the shape of all the items is identical with the original pieces, there are some differences in materials: ash is used instead of oak, the stains are of different colours and finish, and the upholstery is usually a modern fabric rather than the horsehair often used by Mackintosh. Such differences do not really detract from the aims or achievements of the reproductions, however, as the sculptural shapes which so concerned Mackintosh are faithfully copied.

At the time of writing, four chairs are available (1897.23, 1903.8, 1903.58 and 1904.24). In addition, Cassina have produced a dining set, consisting of gate-leg table, coffee table, chair, armchair and sideboard from one of Mackintosh's later drawings (D1918.12). At present Cassina have an agreement with the owners of the original pieces and the copyright owners to reproduce several other items, namely: 1897.11, 1897.19, 1899.4, 1900.5, 1900.11, 1900.54, 1900.55, 1900.56, 1901.29, 1901.31, 1901.38, 1902.3, 1902.7, 1902.12, 1903.20, 1903.25, 1903.26, 1904.6, 1904.26, 1904.93, 1907.4. These will presumably be appearing on sale over the coming years. All Cassina reproductions are stamped with their mark and have an incised number, which tallies with an identification card provided with each piece.

The University also authorised an Edinburgh firm, William Martin, to make reproductions of two lampshades, a clock (1905.24) and a dresser (1906.39). These are similarly stamped and incised with the maker's name and edition number and were, like the Cassina furniture, approved by the University before production began. Martin has also marketed, without the approval of either the copyright owner or the owner of the individual original works, a number of other pieces, including 1897.19, 1897.23, 1900.20 and 1903.31. The edition of these reproductions is not known, but there should be no cause for confusion with the original pieces (as indeed there should not be with the Cassina furniture) which are documented in this volume.

More recently, pastiche furniture has been appearing on the market and will no doubt continue to do so once manufacturers realise that any protection afforded the original pieces by the Copyright Act has expired (which it did on 31 December 1978). At present, the most convincing (or confusing) of these pastiches are the designs produced by McIntosh's of Kirkcaldy. Their dining furniture is an amalgam of various Mackintosh designs. Once these items have lost their obvious newness and acquired the battered patina of so many genuine pieces, they may cause confusion. Other manufacturers have, over the years, produced similar items and a survey of some of these is included in an article by Elizabeth Aslin in the Newsletter of the C. R. Mackintosh Society, December 1977.

Bibliography

The most useful books or articles which discuss specific works by Mackintosh are noted in each catalogue entry; those referred to most frequently are listed in the abbreviations at the beginning of the catalogue.

Thomas Howarth's *Charles Rennie Mackintosh and the Modern Movement* (2nd edition, 1977) contains a very thorough bibliography, to which the reader is referred for more general reading. Listed below are relevant works published since Howarth's second edition or omitted from it.

Billcliffe, Roger: 'J. H. MacNair in Glasgow and Liverpool' in Annual Report and Bulletin of the Walker Art Gallery, Liverpool, 1970–71, pp. 48–74.

Billcliffe, Roger: *Architectural Sketches and Flower Drawings by Charles Rennie Mackintosh,* London, 1977.

Billcliffe, Roger: *Mackintosh Watercolours,* London, 1978.

Billcliffe, Roger and Vergo, Peter: 'Charles Rennie Mackintosh and the Austrian Art Revival', Burlington Magazine, CXIX, 1977, pp. 739–46.

Bird, Elizabeth: 'Ghouls and gaspipes: Public reaction to early work of The Four', Scottish Art Review, XIV, pp. 13–16.

Cooper, Jackie (ed): *Mackintosh Architecture,* London, 1978. (with an introduction by Barbara Bernard)

Kossatz, Horst-Herbert: 'The Vienna Secession and its early relations with Great Britain', Studio International, January, 1971, pp. 9–21.

Larner, Gerald and Celia: *The Glasgow Style,* Edinburgh, 1979.

Sekler, Eduard: 'Mackintosh and Vienna', Architectural Review, CXLIV, 1968, pp. 455–56.

Spencer, Isobel: 'Francis Newbery and the Glasgow Style', Apollo, 1973, pp. 286–93.

Vergo, Peter: *Art in Vienna, 1898–1918,* London, 1975.

COLOUR PLATES

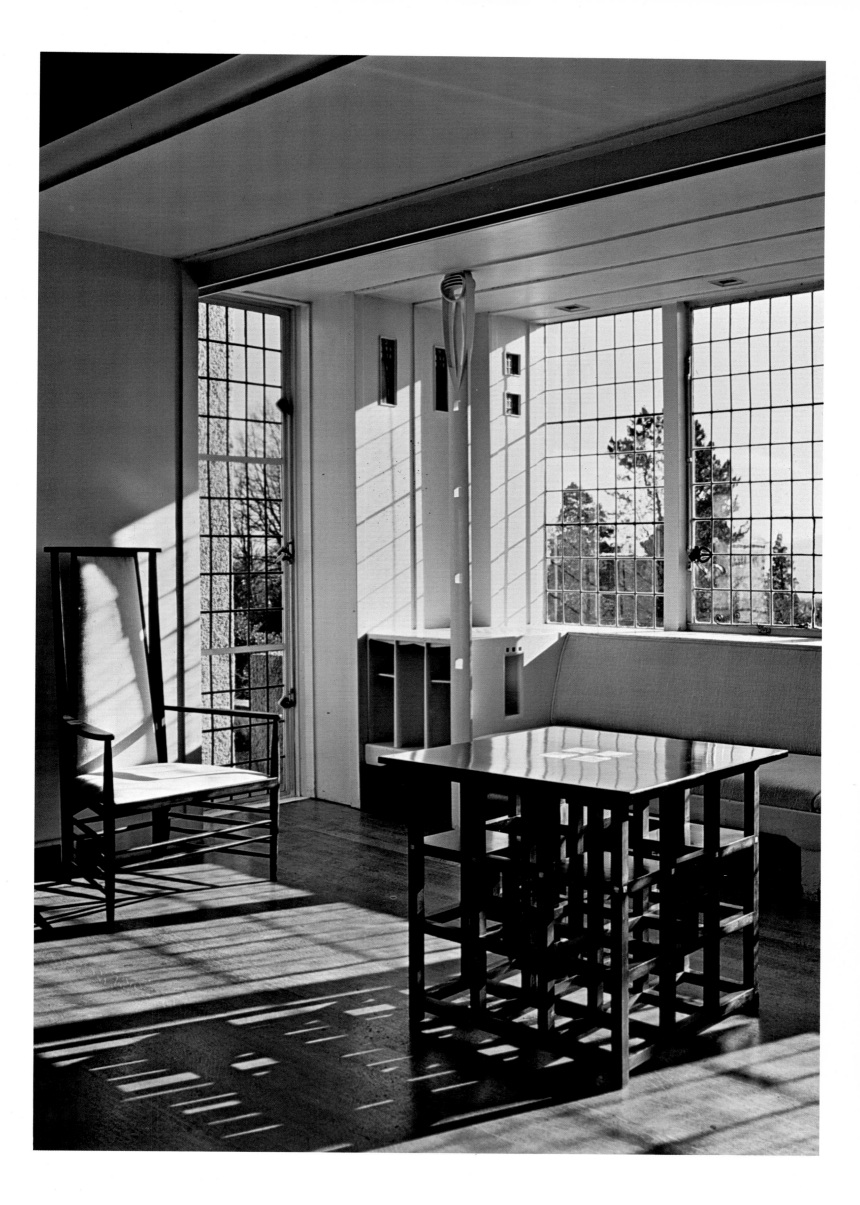

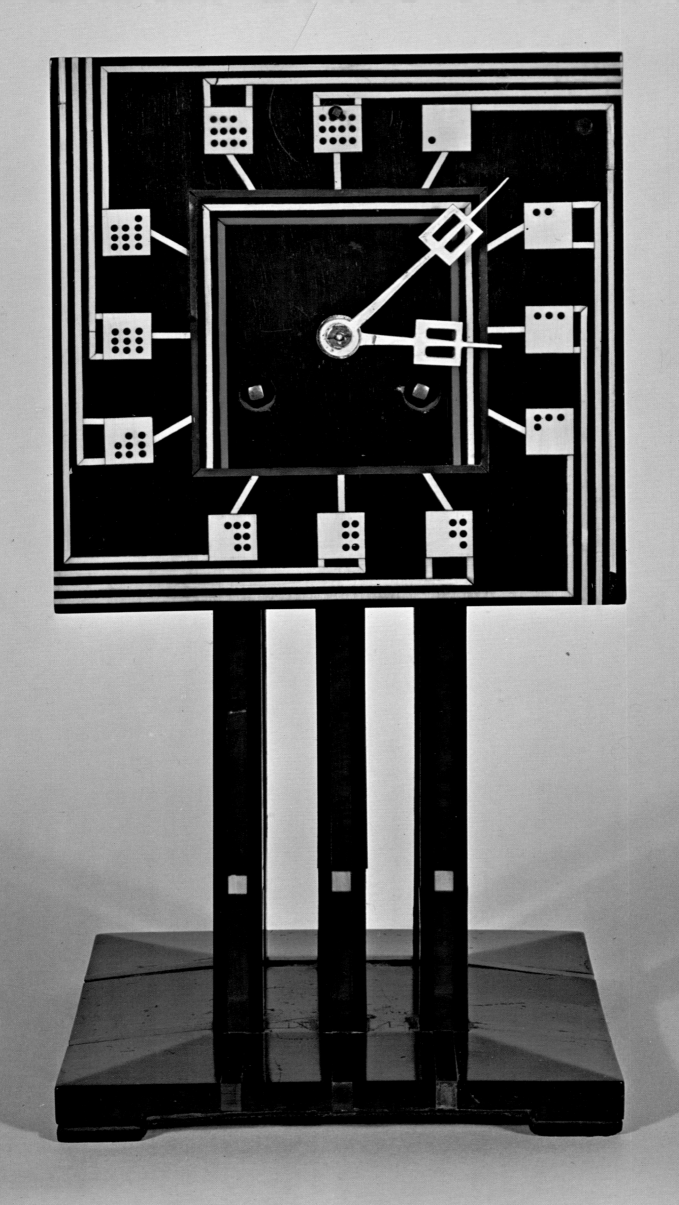

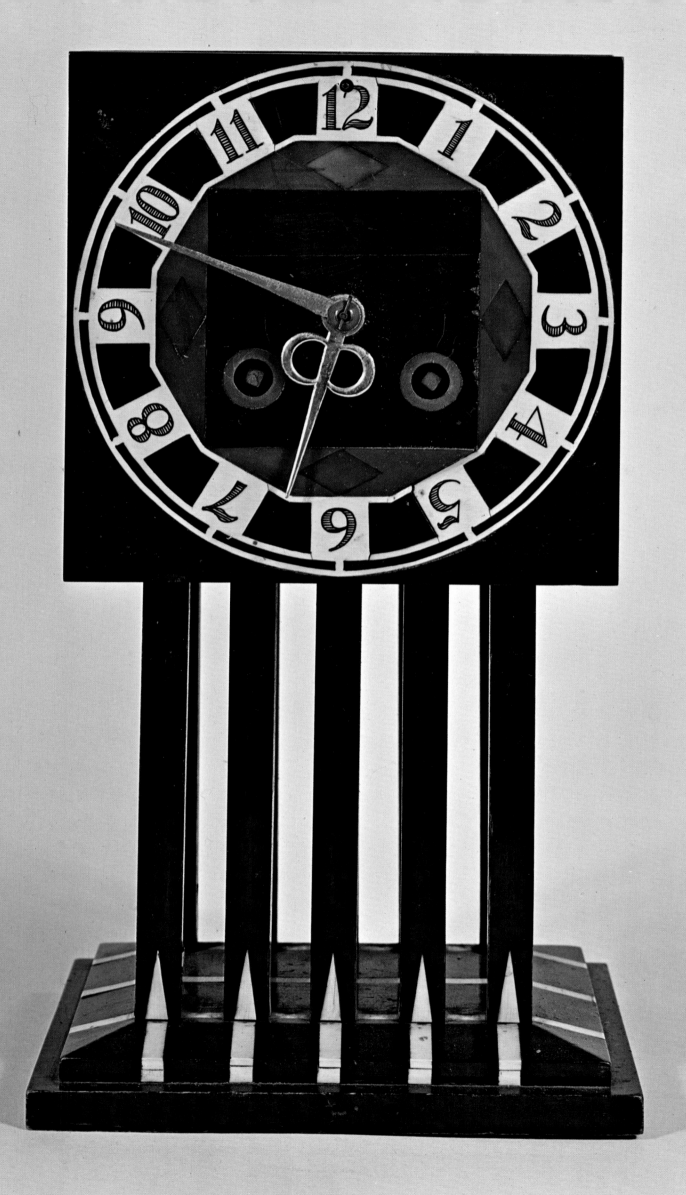

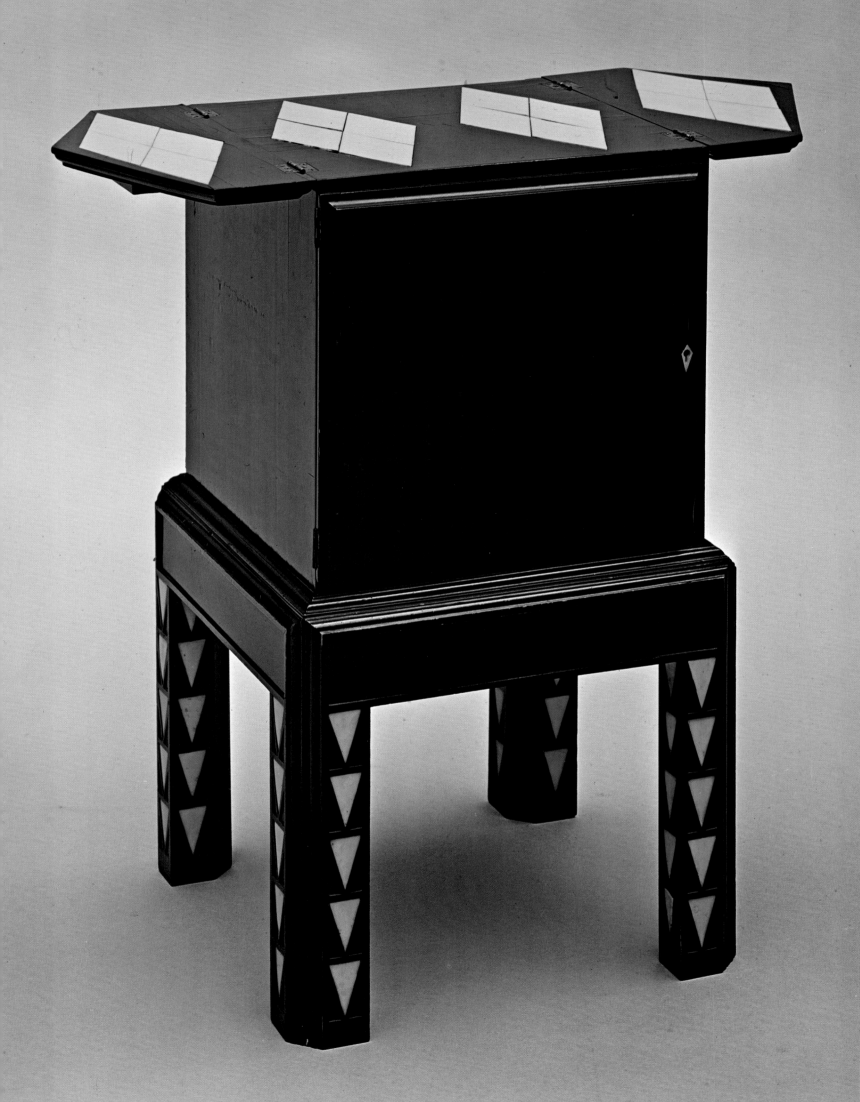

CATALOGUE

The catalogue is arranged in chronological order with an entry for each individual drawing or piece of furniture. The more important commissions are described in introductory sections set in large type and accompanied by the entries for individual items. Each drawing or piece of furniture is given a number according to the year in which it was produced; drawings are differentiated by the prefix D. Thus, were there any examples for 1890 and 1891 they might be numbered 1890.1, 1890.2, D1890.3, 1891.1, D1891.2, 1891.3 etc. Photographs of interiors are given letters instead of numbers, e.g. 1890.A, 1890.B, 1890.C, etc. The dates given to these photographs relate to the date of the works shown and not to the actual date when the photograph may have been taken.

The medium or materials are given where known. Wood is given as the material when the author cannot ascertain the exact timber used; it is likely to have been pine or oak. All drawings are on white paper unless otherwise stated. Dimensions are in centimetres, height × width (× depth for objects). Following the materials and dimensions of the objects, where relevant, is an abstract from the job books of Honeyman and Keppie (later Honeyman, Keppie and Mackintosh and now Keppie Henderson and Partners); this gives details, where known, of price, maker, number of pieces made and dates of quotation and payment. Page references in italics indicate an illustration in the book, article or catalogue listed.

Alison	Filippo Alison, *Charles Rennie Mackintosh as a Designer of Chairs,* London, 1974; this is the English language edition, trans. Bruno and Christina del Priore, of Alison's catalogue to the Milan (q.v.) exhibition, *Le Sedie di Charles Rennie Mackintosh,* 1973; with photographs of original drawings and of reproductions of some of Mackintosh's chairs.
Annan, Glasgow	T. & R. Annan, Glasgow, photographers of many of Mackintosh's early works.
Billcliffe and Vergo	Roger Billcliffe and Peter Vergo 'Charles Rennie Mackintosh and the Austrian Art Revival', Burlington Magazine, CXIX, 1977, pp. 739–46.
Bliss	Douglas Percy Bliss, *Charles Rennie Mackintosh and the Glasgow School of Art,* Glasgow, 1961.
Darmstadt, 1976–77	*Ein Dokument Deutscher Kunst 1901–76,* exhibition at Darmstadt.
Davidson Estate	The provenance for a number of items in the collection at Glasgow University which had previously been acquired by William Davidson and which were presented to the University by his sons, Hamish and Cameron, after his death in 1945. The collection included works designed for Davidson at Gladsmuir and Windyhill, items he acquired from Mackintosh when he purchased 78 Southpark Avenue and other Mackintosh pieces purchased at the Memorial Exhibition in 1933 and from other sources.
Das Englische Haus	Hermann Muthesius, *Das Englische Haus,* Berlin, 1904–05, 3 vols. Translation edited by Dennis Sharp, London, 1979.
Edinburgh, 1968	*Charles Rennie Mackintosh: Architecture, Design and Painting,* an exhibition sponsored by the Edinburgh Festival Society and arranged by the Scottish Arts Council, selected and catalogued by Andrew McLaren Young. The exhibition was afterwards shown at the Victoria & Albert Museum, London, and then a reduced version travelled to Vienna, Darmstadt and Zurich.

Glasgow School of Art, Furniture	*Some examples of Furniture by Charles Rennie Mackintosh in the Glasgow School of Art Collection,* introduction by H. Jefferson Barnes, Glasgow, 1968.
Glasgow School of Art, Metalwork	*Some examples of Metalwork by Charles Rennie Mackintosh at Glasgow School of Art,* introduction by H. Jefferson Barnes, Glasgow, 1968.
Glasgow University	Mackintosh Collection, Hunterian Art Gallery, University of Glasgow.
Howarth	Thomas Howarth, *Charles Rennie Mackintosh and the Modern Movement,* second edition, London, 1977. This is a facsimile reprint of the 1952 first edition supplemented by an enlarged bibliography and a new introduction; the original pagination has been retained and so page and plate references used here (except for Roman numerals which relate only to the 1977 edition) apply to both editions.
Mackintosh Estate	The provenance for the collection of furniture, drawings and other objects in the possession of C. R. Mackintosh in 1928, when the collection passed to his wife; on her death in 1933, certain items were sold. The remainder were stored in Glasgow awaiting a decision about their future from her heir, Sylvan MacNair. On the death of William Davidson in 1945, his sons and the remaining trustees of the Estate asked Sylvan MacNair to relinquish his claim to the Estate in favour of Glasgow University, which he did in 1946.
Macleod	Robert Macleod, *Charles Rennie Mackintosh,* Feltham, 1968.
Memorial Exhibition	*Charles Rennie Mackintosh, Margaret Macdonald Mackintosh, Memorial Exhibition,* McLellan Galleries, Glasgow 1933; an exhibition of items from the Mackintosh Estate, some of which were sold.
McLaren Young	Catalogue of the Edinburgh Festival Mackintosh Exhibition, 1968 (*see* Edinburgh, 1968).
Milan, 1973	*Le Sedie di Charles Rennie Mackintosh,* Triennale di Milano, 1973. An exhibition arranged by Filippo Alison including original drawings by Mackintosh and reproductions of some of his chairs produced by Alison from his own detailed drawings of the originals.
Paris, 1960	*Sources of the 20th Century,* exhibition at the Musée National d'Art Moderne, 1960–61.
Pevsner, 1968	'Charles Rennie Mackintosh' in *Studies in Art, Architecture and Design,* Vol. II, London, 1968. This is a translation by Adeline Hartcup of Pevsner's pioneering study first published by Il Balcone, Milan, 1950.
RCAHMS	Royal Commission on the Ancient and Historical Monuments of Scotland (holders of the negatives of the photographs of Mackintosh's work taken by Bedford Lemere, London).
Royal Incorporation of Architects in Scotland	The owner of The Hill House, Helensburgh and used here to denote the provenance of pieces of furniture via Walter Blackie and T. Campbell Lawson, the only previous owners of the house and its contents.
RIBA	Drawings collection of the Royal Institute of British Architects.
Saltire, 1953	Saltire Society and Arts Council of Great Britain, *Charles Rennie Mackintosh,* an exhibition catalogue, 1953.

| Sekler | Eduard Sekler, 'Mackintosh and Vienna' in The Architectural Review, CXLIV, 1968, pp. 455–56; reprinted and enlarged as the introduction to the Viennese catalogue of the 1968 Edinburgh Festival Mackintosh Exhibition. |

| Studio Special Number | The Studio Special Number, *Modern British Domestic Architecture and Decoration*, London, 1901. |

| *Studio Year Book* | *The Studio Year Book of Decorative Art.* |

| Toronto, 1967 | *Charles Rennie Mackintosh,* an exhibition drawn from the collection of Professor Thomas Howarth, shown at the School of Architecture, University of Toronto, 1967. |

| Turin, 1902 | International Exhibition of Modern Decorative Art, Turin, 1902. |

| VEDA | *Victorian and Edwardian Decorative Arts,* an exhibition at the Victoria & Albert Museum, London, 1952. |

| Vienna, 1900 | Eighth Exhibition of the Vienna Secession, 1900. |

The guest bedroom, 78 Derngate, Northampton, 1919.

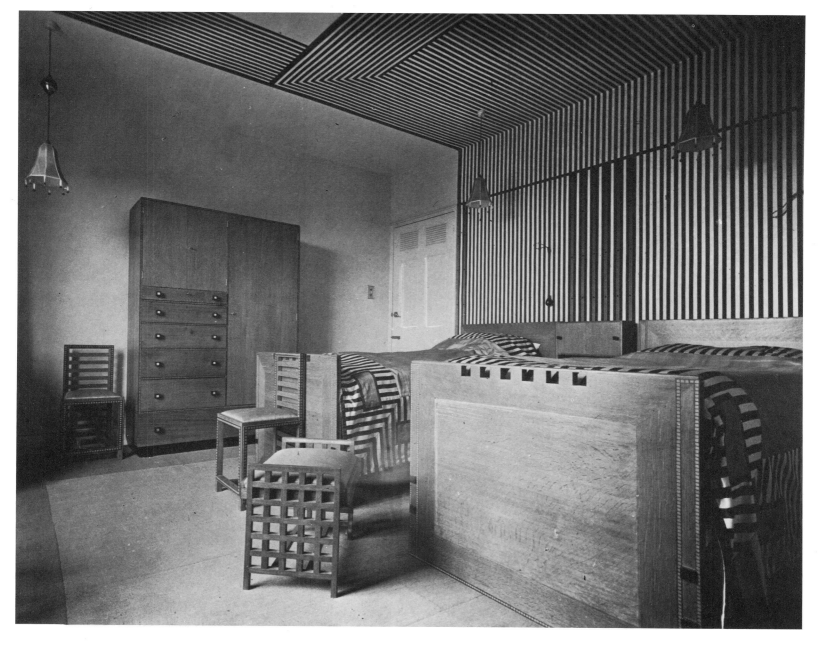

1892–93 The Glasgow Art Club

Honeyman & Keppie were commissioned by the Glasgow Art Club in 1892 to produce designs for the remodelling of the interiors of their new club premises in Bath Street, and for a large gallery/concert hall/smoking room for members at the back of the existing building. Keppie was the partner in charge and there is little doubt that he was responsible for the choice of style for the various fittings. The details of the job, however, were left to Mackintosh and, with the 1893–94 work at Craigie Hall and the Glasgow Herald, the Art Club is the best surviving example of the close co-operation between the two men. The rather debased classical style was Keppie's, but the rich ornament was Mackintosh's. The somewhat perverse treatment of classical features, seen in the strange columns of the fireplaces (repeated at Craigie Hall), did not reappear in Keppie's work after Mackintosh began to concentrate on his own commissions, so one is forced to conclude that the columns were indeed Mackintosh's work. Other features used at the Art Club can be seen again at Craigie Hall, such as the ventilator grilles and the figurative carvings. Certainly, the only drawings which survive for the project are in Mackintosh's hand.

However, it is by no means a true Mackintosh design. If the Gauld bedroom suite was designed in 1893—as suggested by Gauld's daughter—then it was contemporary with the Art Club, and earlier than Craigie Hall. Nowhere in that set of furniture do these curious sculptural forms appear; even in the Gladsmuir furniture, the decoration is much more restrained. The commission can, therefore, be seen as Mackintosh's personal response to the limitations of an accepted and expected office style. David Walker has shown that this style appears again in various Honeyman & Keppie projects of the early- and mid-1890s, when Mackintosh was allowed (or instructed) to prepare competition drawings, especially those involving a lot of sculptural detail.

Much of the work remains *in situ*, with very few alterations.

Literature: *The Baillie*, 'Men You Know' (Glasgow), 7 June 1893; David Walker, 'Charles Rennie Mackintosh', *Architectural Review*, CXLIV, 1968, pp. 355–63, *356–57* (reprinted in *The Anti-Rationalists*, 1973, ed. J. M. Richards and Nikolaus Pevsner, and *Edwardian Architecture and its Origins*, 1975, ed. Alastair Service).

△1893.A 1893.B detail ▽

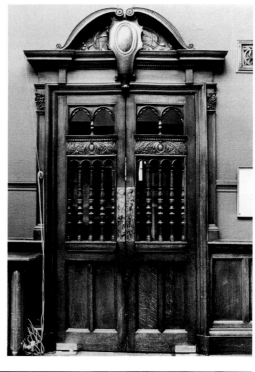

1893.A Hall at Glasgow Art Club

1893.B The smoking room, Glasgow Art Club

1893.C Chimney-piece in the Glasgow Art Club

1893.D Chimney-piece in the Glasgow Art Club

D1893.1 Details of the Glasgow Art Club
(?) Pen and ink.
Inscribed, upper right, *THE | NEW GLASGOW ART | CLUB*; lower left, *JOHN KEPPIE. ARCHITECT*; signed, lower right, *C.R.McI. delt.*

This drawing, by Mackintosh, specially produced for *The Baillie*, shows details like the ventilator grilles, finger plates and bell-push, as well as larger items like the hall door and the gallery chimney-piece.

Literature: *The Baillie* (Glasgow), 7 June 1893, cartoon supplement, p. *1*; David Walker, 'Charles Rennie Mackintosh', *Architectural Review*, CXLIV, pp. *356–7*.
Collection: untraced.

D1893.2 Design for the hall, Glasgow Art Club
Pencil 23.1 × 16.2cm.

As pointed out by Andrew McLaren Young in his introduction to Alison's book, this

▽1893.B ▽1893.C

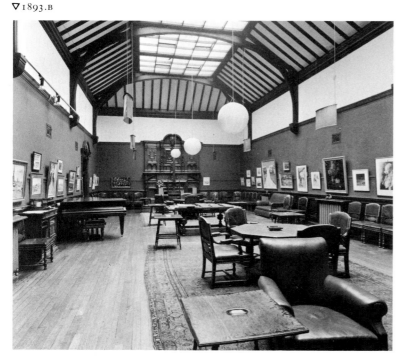

drawing, which is very close to the executed scheme, is based upon a sketch Mackintosh had made at S. Maria delle Grazie, Milan, in 1891.

Literature: Alison, pp. 8, 9.
Provenance: bought in 1930 from Keppie, Henderson & Partners (Mackintosh's old firm) by Professor W. J. Smith; by whom presented, 1959.
Collection: Glasgow School of Art.

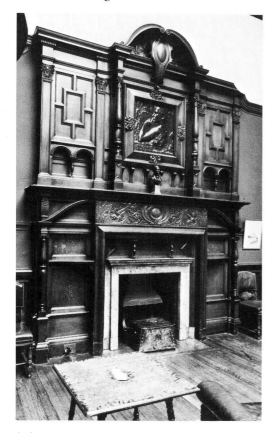

△1893.D

1893–94 Alterations to the entrance hall and library at Craigie Hall, Glasgow

Craigie Hall was designed by John Honeyman in 1872 for Thomas Mason, a Glasgow Master Builder who was responsible for building many of the large villas in Pollokshields and Dumbreck, Glasgow. This commission in 1893 was dealt with by Keppie, but the decorative detail leaves no doubt that Mackintosh was responsible for designing the fittings. The most obviously avant-garde features are the four doorcases in the hall, with their stylised pilaster architraves and the overhead panels of carved foliage and flowers. In the library, the restrained pattern of the leaded glass again suggests Mackintosh's hand rather than the more florid style of Keppie. The pediments and capitals have a stylised tongue motif, as seen on the Glasgow Herald building—another Keppie and Mackintosh joint project. Much of the carved decoration, with its distortion of natural forms such as flowers and stems and even birds' wings, must have been detailed

D1893.3 Design for doorway, Glasgow Art Club
Pencil 23.1 × 16.2cm.

Provenance: as D1893.2.
Collection: Glasgow School of Art.

▽D1893.3

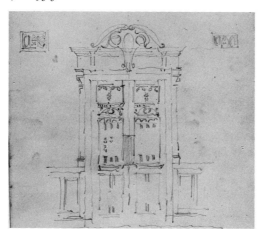

1893.E Door frames in entrance hall, Craigie Hall, Glasgow

1893.E ▽

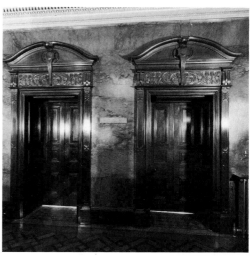

D1893.1▽

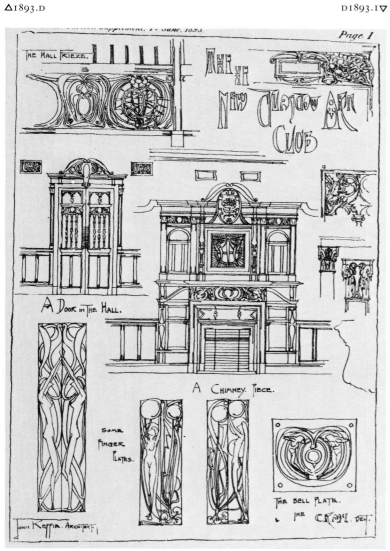

D1893.2▽

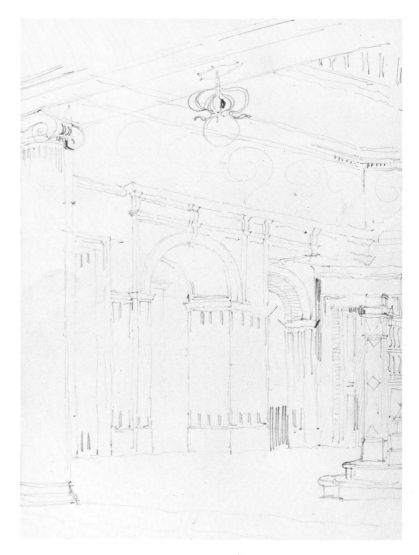

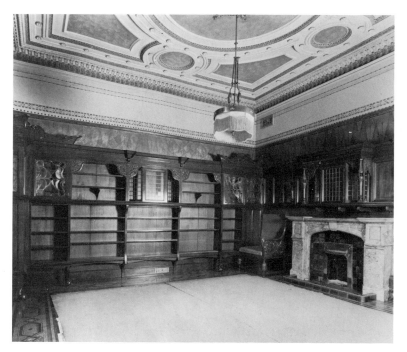

△1893.4

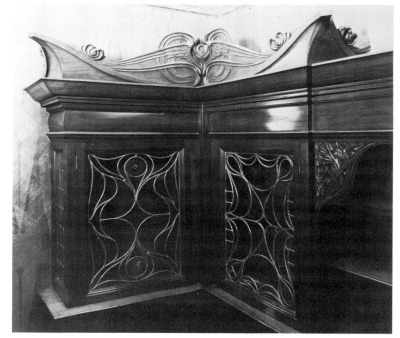

△1893.4 details ▷

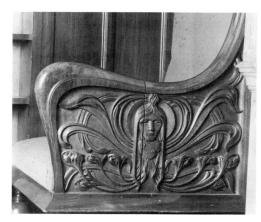

by Mackintosh. The face on the side of the fitted armchair leaves no doubt as to its author, so close is it to some of the Spook School watercolours of the period. Another specific feature which points to Mackintosh's involvement is the use of a detached *cyma recta* capital on the bookcases; he used this again on at least two pieces, the Gladsmuir cabinet (1894.1) and another bookcase (1894.2).

1893–1897

The dating of the furniture designed during this period can be supported by little precise documentary evidence and, as none of Mackintosh's furniture was exhibited or illustrated before 1896, one can only be definite about dates *before which* the items must have been made. Several of the dates put forward by Howarth must now be questioned, in the light of new evidence or different interpretations

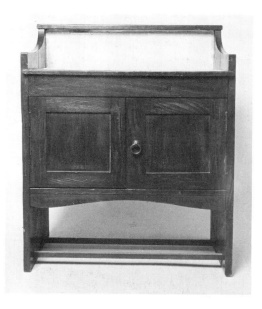

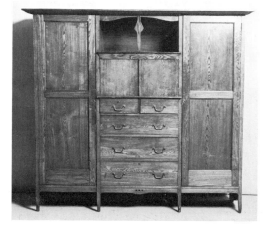

◁1893.6

◁1893.5

1893.4 Bookcases and fireplace in the library, Craigie Hall, Glasgow
Mahogany, french-polished, with panels of leaded glass. North wall, 273 × 506.5 × 30.5cm.; east wall, 273 × 302 × 37cm.
Made by John Craig, Glasgow.

Collection: *in situ* (1978).

1893.5 Wash-stand for David Gauld
Oak, stained green 90 × 71 × 52cm.

The simplest of the pieces designed for Gauld in 1893; the curve of the top of the sides was repeated in a number of items designed in 1897 and later. The tiles are modern.

Provenance: Given by Mackintosh as a wedding present to David Gauld, 1893; presented by Gauld's daughter, Mrs Marie Dunn, 1961.
Collection: Glasgow University.

1893.6 Wardrobe for David Gauld
Oak, stained green 183 × 198 × 61cm.

The most elaborate piece of the Gauld bedroom furniture. Although the use of traditional details and construction techniques is clearly evident, the decorative spar in the centre is of Mackintosh's invention. It probably represents a bird's head, a motif used in many later designs, but the overall impression of the piece confirms that Mackintosh probably followed MacNair's youthful practice of tracing furniture from illustrations, and then adding decorative details to improve the original design (Howarth, pp. 18–19).

Provenance: as 1893.5.
Collection: Glasgow University.

1893.7 Dressing-table for David Gauld
Oak, stained green 146 × 104.5 × 43.5cm.

Part of the same set as 1893.5, 6 and 8.

Provenance: as 1893.5.
Collection: Glasgow University.

▽1893.7

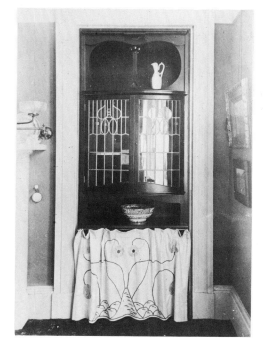

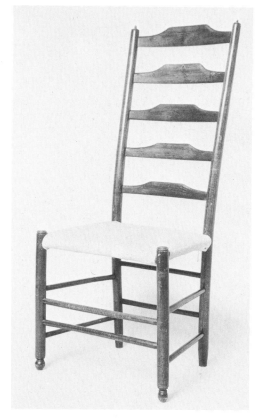

△1893.8 1894.1 ▽

of contemporary photographs. Howarth did not discuss all the pre-1896 designs, and his identification of the Dunglass interior of *c*1899 as Gladsmuir of *c*1894–95 and the dating of Mackintosh's own bedroom to 1890 led him to different conclusions from those reached here. The dating of individual items of later periods will usually be discussed in the relevant catalogue entries, but for this period, which is somewhat complicated, I have arranged my arguments in this introductory section.

Howarth (pp. 20–21, plate 5a) dates Mackintosh's own studio bedroom (1896.A) to 1890 on the basis of Herbert MacNair's identification of it as the house in Dennistoun where the Mackintosh family lived until 1892. The style of the stencilled frieze alone brings this date into some doubt: the earliest Spook School drawings date from 1893 and Mackintosh did not wholeheartedly adopt the style until 1894. Howarth claims that the date of 1892 for *The Harvest Moon* justifies his early date for the frieze, yet the main figure in *The Harvest Moon* is quite realistically drawn and the pattern of the rest of the drawing is, as described by McLaren Young, 'a prelude to the "Spook School"' (See Howarth, pp. xxx–xxxi; McLaren Young, no 53.). The large central figure in the frieze with her hair streaming in the wind is much closer to the watercolours of 1895 and the decorative stencils of 1896 at the Buchanan Street Tea Rooms (D1896.11) than to any of the works of 1891–92. The motif of a solid circular sun or moon is also repeated at Buchanan Street. Howarth himself (p. 33) records the memories of Mackintosh's family of the way he decorated his basement room at 27 Regent Park Square in 1896. He covered the walls with a coarse brown wrapping-paper and produced a stencilled frieze; he ripped out the built-up fireplace and uncovered a simple wrought-iron grate (*see* D1896.4). Surely this is the room shown in 1896.A, dating from 1896, not 1890. Further proof comes from the photographs of the nursery at Gladsmuir (1896.B) with its frieze of cats—the same one as he used in his own bedroom—also dating from *c*1895–97. Mackintosh is unlikely to have used again a design which was supposedly five years old.

If the sideboard/cabinet and bed (1896.1 and 1896.2) are not the first of Mackintosh's designs for furniture, the most likely contenders for that distinction still extant seem to be the pieces of bedroom furniture designed for David Gauld *c*1893. They are hesitant and somewhat disappointing pieces—perhaps what one might expect from someone inexperienced in furniture design—and are by no means as assured as the well-proportioned bed and cabinet from Regent Park Square.

The remaining pieces fall into three basic groups: for Gladsmuir, for Guthrie & Wells, and for his own or family use or for his buildings, principally the Glasgow Herald offices. Howarth (p. 33) states that Mackintosh was introduced to the Davidsons at Gladsmuir, Kilmacolm, about 1895. Some of the Gladsmuir furniture was illustrated in *Dekorative Kunst*, III, 1898–99, pp. 69–75, but, strangely, none

1893.8 Ladderback chair for David Gauld
Oak, with rush seat 114 × 48 × 45.7cm.

According to Gauld's daughter, this chair formed part of the same bedroom suite as 1893.5, 6 and 7. If so, it is the earliest known chair designed by Mackintosh, although it is so traditional that without the provenance one would be tempted to disregard it. An identical chair appears in illustrations of the Windyhill nursery, but Davidson is likely to have acquired it earlier (*c*1895) for Gladsmuir.

Literature: *Dekorative Kunst*, IX, 1902, p. *198*.
Exhibited: Edinburgh, 1968 (176).
Provenance: as 1893.5.
Collection: Glasgow University.

1894.1 * Cupboard for Gladsmuir, Kilmacolm
Cypress, with glazed doors 210.8 × 78.7 × 30.4cm.

Probably the earliest piece of furniture designed for Gladsmuir, the home of Mr and Mrs William Davidson and their son William and

his family. William Davidson Jr gave the commission for Windyhill, also in Kilmacolm, to Mackintosh in 1900.

This cupboard was designed to fit an alcove next to the fireplace in the drawing-room. The use of narrow bead mouldings suggests that this is quite an early piece, as such mouldings soon disappeared from Mackintosh's work. The cluster of four pip-like swellings on the central post are reminiscent of those which appear on the roof truss at Martyrs School, Glasgow *c*1895 (*see* Macleod, plates 19, 20).

In 1901, the cupboard was moved to Windyhill and painted white to match the colour scheme of the drawing-room where it still remains (1977).

Literature: *Dekorative Kunst*, III, 1898–99, p. 75; Howarth, p. 34.
Provenance: William Davidson, at Gladsmuir and Windyhill, where it has remained *in situ*.
Private collection.

1894.2 Bookcase
Cypress, french-polished, with glazed doors 213 × 230 × 40.8cm.

It is not known for whom this bookcase was designed, and it may be that the lower half is a later addition. It seems unlikely that Mackintosh would have been making furniture for the Macdonald family in 1894, when he was still associated with Jessie Keppie, but stylistically the piece cannot be any later than this. The

detached *cyma recta* capitals and the pattern of the leaded glass are similar to those in 1894.1. Perhaps Mackintosh designed the bookcase for himself, as it was later in the possession of Charles Macdonald, his brother-in-law.

Provenance: with Charles Macdonald before 1932; by family descent.
Collection: L. A. Dunderdale, Esq.

1894.2 ▽

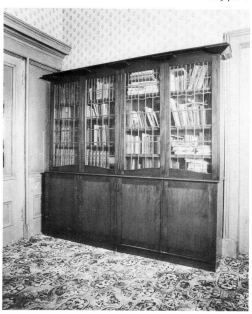

of it was reproduced in *The Studio* in 1897. The Gladsmuir furniture was probably produced over a period of about three years, and stylistically the earliest piece is the alcove cabinet (1894.1) which fitted into a recess at the side of the fireplace (an arrangement repeated at Windyhill with the same cabinet). It has a number of rather strange and somewhat awkward features: conventional beaded mouldings are used around the edges of the glass panels and the doors, while the pattern at the top (as pointed out by Howarth) is like a giant apple with four pip-like protuberances clustered around the central column, several inches above which is a detached—almost floating—*cyma recta* capital which supports, and is supported by, nothing. (Following this is the bookcase [1894.2] which eventually found its way to Dunglass and may have been made for either Mackintosh himself or the Macdonald family.)

The wardrobe (1894.3), possibly made for Gladsmuir, has similar beading around its doors and, apart from its metal fittings, is a somewhat conventional piece. The broad metal hinges and simple handles of this wardrobe were repeated on the items made by Guthrie & Wells to Mackintosh's design. As these were commercial pieces, he probably had to restrain himself. It is not known how popular these designs were; certainly none has ever come to light other than those owned by William Davidson. This bedroom furniture was probably produced over the period 1895–96; it seems likely that the bed at Regent Park Square was part of the same design—it certainly has stylistic features in common with the chest-of-drawers (1896.5), such as its green stain and the way the curve of the foot of the bed mimics that of the upper apron of the top shelf of the chest. The chest is probably the latest of the Guthrie & Wells designs and 1896 seems to be the most likely date.

All the furniture so far described is relatively simple, making use of broad planes of timber, occasionally stained green, but otherwise unrelieved except by simple fittings like handles or hinges used in much the same way as other Arts & Crafts designers used them. Parallel with these pieces, however, are a series of more adventurous, almost experimental designs. What they have in common is the incorporation of beaten metal panels of either abstract or figurative pattern, and an attempt to get away from the simple rectangularity of the other furniture. The first of them is probably the design for a bookcase (D1895.4) which still has a number of quite conventional features, and which is heavily overlaid with stylised plant forms, presumably to have been executed in metal relief rather than in carved wood. It is difficult to date the others with any certainty, although a tentative order might be: first, the linen cabinet (1895.6), where the long stems with heart-shaped leaves above are reminiscent of the jewel box for Jessie Keppie (whom Mackintosh deserted in 1896 for Margaret Macdonald), and the raked apron with its central pendant leaf motif anticipates the more subtle curve of the sideboard of 1896; second, the hall settle (1895.5); third, the linen press for William Davidson (1896.8); and finally the writing desk for Gladsmuir (1897.1).

1894–96 Queen Margaret Medical College, Glasgow

Known only from Mackintosh's original perspective (Howarth, fig. 11), Queen Margaret Medical College has always been assumed to be one of those joint Keppie–Mackintosh projects in which Mackintosh was given a considerable amount of free rein. In Glasgow University Archives, however, are a set of photographs and some drawings which shed a great deal more light on the project (the author is grateful to Mrs Anne Ross, deputy Archivist at Glasgow University, for drawing his attention to these documents). The architectural drawings suggest that there were other different schemes put forward before acceptance of the final design; few, if any, of these drawings seem to be by Mackintosh. The photographs

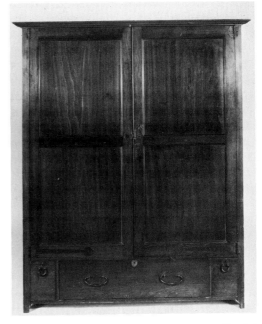

1894.3 △

1894.3 Wardrobe
Cypress, stained dark, with brass hinges and handles 186 × 147 × 49cm.

A very simple design, continuing the use of narrow, beaded mouldings, although the strap-work hinges and simple handles anticipate the Guthrie & Wells furniture of 1895–96.

Made either for Gladsmuir or Mackintosh's own use; it was in the collection of William Davidson at his death, but it is not known whether he acquired it from Mackintosh in 1919, along with other furniture from 78 Southpark Avenue.

Literature: Howarth, p. 35, note 2.
Provenance: (? C. R. Mackintosh); William Davidson; Professor John Walton; Sotheby's Belgravia, 5 July, 1974 (lot 78).
Collection: John Reid.

D1894.4 *

1895.A Queen Margaret Medical College, Glasgow: exterior
One of only two known photographs of this view of the building, corresponding to Mackintosh's perspective drawing of the college.

Collection: Glasgow University Archives.

1895.B Queen Margaret Medical College, Glasgow: interior, the museum

Collection: Glasgow University Archives.

1895.C Queen Margaret Medical College, Glasgow: interior, the Chemical laboratory

Collection: Glasgow University Archives.

1895.1 Wardrobe
Part of a bedroom suite commissioned by Guthrie & Wells, who were decorators, stained-glass designers and manufacturers and cabinet-makers in Glasgow. They exhibited at the Arts & Crafts Exhibition Society's shows in the 1890s.

No example of this design has been traced and the illustration comes from one of the firm's catalogues, dating from the late 1890s or even post-1900 (collection: Glasgow University). In the illustration it seems as if the wardrobe might have been painted white, although one would have expected it to have been stained green like 1895.2 and 1895.3.

Literature: Guthrie & Wells, Glasgow, stock catalogue, p. *39* (Glasgow University).
Collection: untraced.

◁ 1895.A

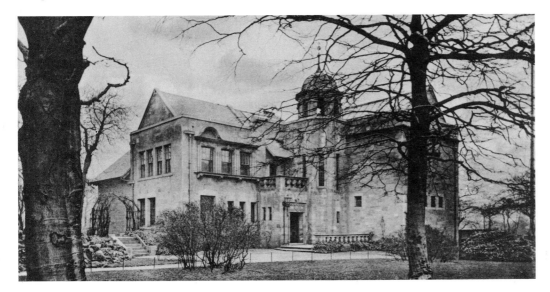

*See addenda

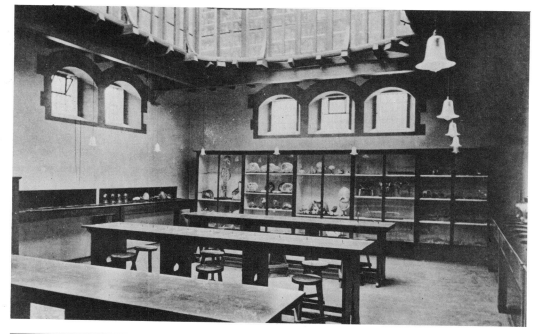

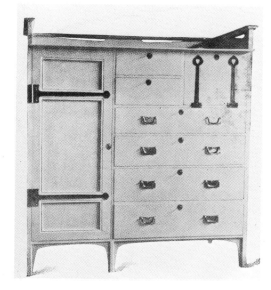

1895.B ▷

1895.1 △

1895.3 ▽

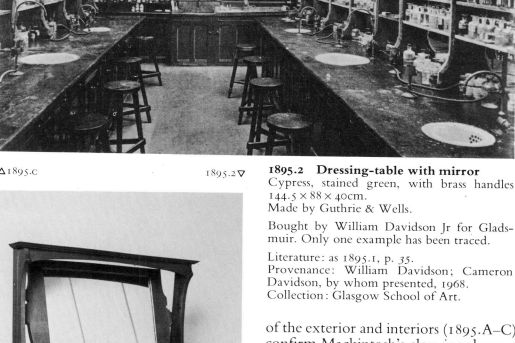

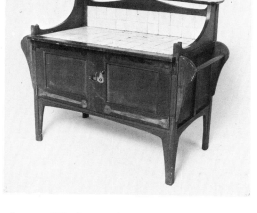

△1895.C

1895.2 ▽

1895.3 Wash-stand

Cypress, stained green, with brass handles and tiled top 97.3 × 115 × 57.8cm.
Made by Guthrie & Wells.

The long strap hinges and simple metal latch are derived from those used on 1894.3. Conventional mouldings are still being used on doors, but the design is less traditional than the work of 1894. Only one example has been traced.

Literature: as 1895.1, p. *34*.
Provenance: as 1895.2.
Collection: Glasgow School of Art.

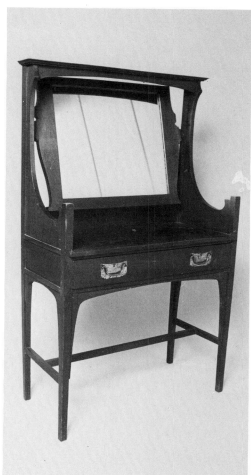

1895.2 Dressing-table with mirror

Cypress, stained green, with brass handles 144.5 × 88 × 40cm.
Made by Guthrie & Wells.

Bought by William Davidson Jr for Gladsmuir. Only one example has been traced.

Literature: as 1895.1, p. *35*.
Provenance: William Davidson; Cameron Davidson, by whom presented, 1968.
Collection: Glasgow School of Art.

of the exterior and interiors (1895.A–C), which have never been published before, confirm Mackintosh's close involvement with the interior design of the building.

The museum, for instance, confirms Howarth's comment on the plans of the building that it was a forerunner of the early design for the School of Art Library (1896). The upper gallery was panelled with cupboards for the storage of specimens and below were work benches and more specimen cupboards. The benches are undoubtedly of Mackintosh's design, with inverted heart-shaped cut-outs in the gables rather like the thistle motif in the bench seats for Gladsmuir (1897.4). The stools, too, look like his work, simple as they are, with a roughly attached foot-rail not unlike the connecting spars between the legs of the Argyle Street domino table (1897.22).

Similar fittings were provided in the chemical laboratory (which seems to have been contained in the existing Northpark House), but here the walls were panelled with tongued and grooved boards which were stained dark. The University would not have had a lot of money to spend on the building, although it was obviously a proportionately more expensive job than the Art School; Mackintosh would, therefore, have gained valuable experience in designing to a strict financial limit, an experience which was to prove invaluable for the design of the Glasgow School of Art the following year.

All the interiors have now disappeared, and what remains of the exteriors has been enclosed by extensions to the B.B.C. building.

Literature: Howarth, pp. 63–65, fig. 11.

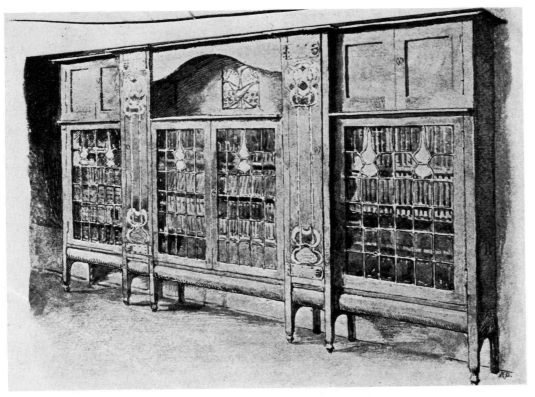

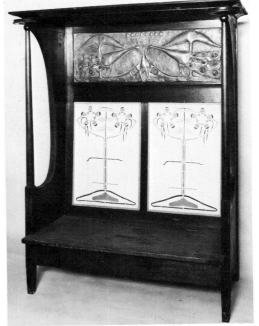

1895.5 △

◁ D1895.4

D1895.4 Bookcase

No executed piece based on this design has been traced: a bookcase was made for Gladsmuir in 1898, and this may be a design for an earlier and more elaborate version. The design has a number of somewhat conventional features, particularly the legs, which appear ill at ease alongside the elaborate applied decoration; perhaps this is why it was never made. This is the first piece to incorporate such decoration, but the peacock motif seen on the central panel was often used again.

Literature: *Dekorative Kunst*, III, 1898–99, p. 69.
Collection: untraced.

1895.5 Hall settle

Oak, stained dark, with beaten lead panel and stencilled linen upholstery 181.5 × 142 × 65cm.
Made by Guthrie & Wells, Glasgow.

Pevsner says the metal panel was made by Margaret Macdonald, but at this date it is more likely to be by Mackintosh himself. A number of Voysey-like features appear in this settle, particularly the tapering turned columns capped by disc-like capitals, and the sweeping curve of the side panels. There are few other such explicit references to Voysey, although his general influence can be seen in most of these early designs.

It is not known for whom the settle was designed; it may have been made speculatively, as it remained in Mackintosh's possession until it was acquired by the Macdonald family at Dunglass.

The stencilled seat covers are modern, based on contemporary photographs and the remains of the original fabric.

Literature: *The Studio*, IX, 1896, pp. 202, 205; Pevsner, 1968, plate 7; Howarth, pp. 36, 38.
Exhibited: London, Arts & Crafts Exhibition Society, 1896 (509); Edinburgh, 1968 (177).
Provenance: C. R. Mackintosh; the Macdonald family, Dunglass Castle; by family descent to Mrs L. A. Dunderdale, from whom bought, 1959.
Collection: National Museum of Antiquities of Scotland, Edinburgh.

1895.6 Linen press

Cypress, stained green, with brass handles and candlesticks, and two beaten lead panels 183 × 132.5 × 39.2cm.

One of the earliest surviving pieces with *repoussé* panels. The panels are designed by Mackintosh, unlike those in some later pieces where they are the work of Margaret Macdonald, and they are stylistically similar to a drawing of 1895, *Winter* (collection: Glasgow University; reproduced in McLaren Young, plate 4, no 67). Although 1895.6 was probably made by cabinet-makers such as Guthrie & Wells, it has none of the more traditional mouldings that appear on the commercial bedroom units: this is probably because Mackintosh was designing directly for a client, John Henderson, and did not have to please a more general public.

The pendant leaf motif at the bottom—which appeared here as a rather awkward addendum, and has since been broken off—was slowly transformed in later pieces into a characteristic dip in the lower stretcher or apron based upon a favourite Mackintosh motif, the swooping bird (e.g. 1896.1 and 6).

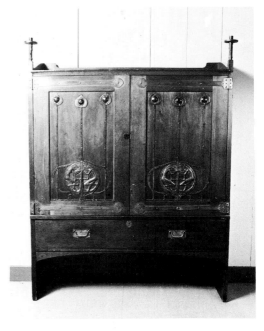

▽ D1895.7 1895.6 ▷

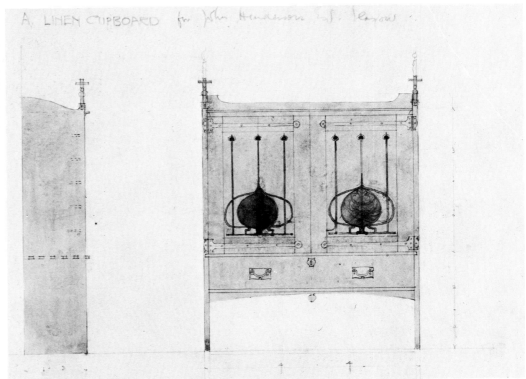

1896.A ▷

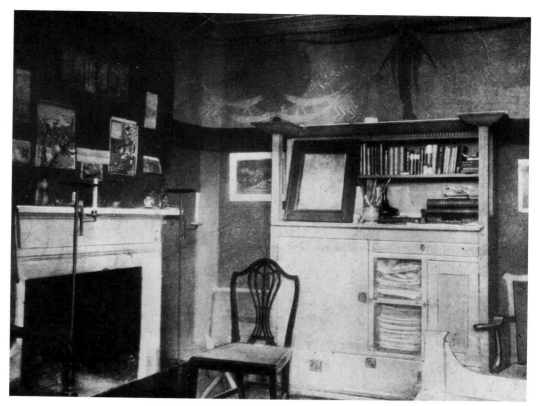

Literature: *The Studio*, XI, 1897, p. *96*, 97;
Howarth, p. 35, fig. 6; Glasgow School of
Art, *Furniture*, no 26.
Exhibited: Edinburgh, 1968 (178).
Provenance: John Henderson; A. Graham
Henderson, by whom presented.
Collection: Glasgow School of Art.

D1895.7 Design for a linen cupboard for John Henderson Esq., Glasgow

Pencil and watercolour 304 × 486cm.
Inscribed, upper left, *A LINEN CUPBOARD
for John Henderson Esqr Glasgow*, and various
other notes and measurements.

As executed.

Literature: Glasgow School of Art, *Furniture*,
no 26a.
Provenance: Mackintosh Estate.
Collection: Glasgow University.

1895.8 Jewel box for Jessie Keppie

Wood, mounted externally with beaten brass
and set with pieces of opalescent glass 14.3 ×
25.4 × 17.8cm.

Mackintosh's close friendship with Jessie
Keppie broke up *c*1896, when he transferred
his affections to Margaret Macdonald whom
he later married; this jewel box, therefore,
must date from before their parting. The
stems of *repoussé* metal topped by glass 'flowers'
are reminiscent of the decoration of the linen
press, 1895.6, and the box almost certainly
dates from the same year.

Literature: *The Studio*, XI, 1897, p. *96*; M.
Rheims, *L'Objet 1900*, Paris, 1964, p. 92.
Exhibited: London, Goldsmiths Hall, 'Modern
Jewellery 1899–1961', 1961 (542a); Edinburgh,
1968 (183, plate 7).
Provenance: Lady Hutchison, London.
Collection: Victoria & Albert Museum,
London.

D1895.9 Subjects unknown — four drawings

Pencil on tracing paper.

Four unidentified drawings from this col-
lection were exhibited in Toronto, 1967;
they have not been available for photography
and the author has not seen them.

Exhibited: Toronto, 1967 (63).
Collection: Dr Thomas Howarth.

1896.A Contemporary photograph of Mackintosh's bedroom at 27 Regent Park Square, Glasgow

Although dated 1890 by Howarth and identi-
fied as a house in Dennistoun, Glasgow, a date
of 1896 seems more likely. Included in the
photograph are the cabinet (1896.1) and bed
(1896.2), and the fender with candle-holders
later used at 120 Mains Street (D1896.3).

This is the earliest surviving photograph of a
room designed by Mackintosh and it shows
several features which later became standard
motifs in his work. The most common of these
is the broad horizontal wall-plate, about

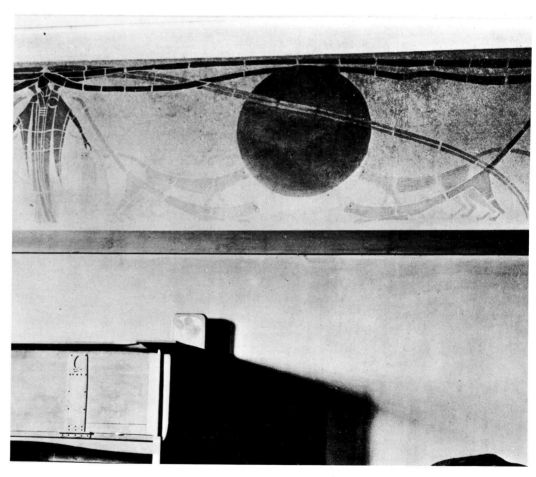

1896B △

seven feet above the floor, which replaces a
narrow moulded picture rail. Several of his
later dining-rooms, for example 120 Mains
Street and The Hill House, had dark brown
wrapping-paper (or dark stained panelling)
as a wall covering, but it was only here and at
Gladsmuir (1896.B) that the frieze above the
wall-plate was dark and stencilled. At Brück-
mann's house and at Westdel the stencilled
frieze has a white background, and after 1900
stencilling is confined to the wall surface
below the wall-plate.

The only chairs to be seen in the room are
conventional, which suggests that Mackintosh
had not yet turned to designing chairs; this
impression is borne out by the lack of any
examples (with the exception of 1893.4)

which can be reliably dated before 1897.
Some of the pictures are obviously Mack-
intosh's own work, but those over the fireplace
reflect his interest in the art of the Pre-Raphael-
ite Brotherhood and of Japan.

Literature: Howarth, pp. 20–21, 32, plate 5a.

1896.B The Nursery at Gladsmuir, Kilmacolm

A contemporary photograph taken by Wil-
liam Davidson in which can be seen the stencil
decoration repeated from Mackintosh's own
room (*see* 1896A). The cabinet in the fore-
ground is a linen press (1896.8).

Collection: Glasgow University.

1896.1 Sideboard/cabinet

Oak, stained dark 186.5 × 154.7 × 53.5cm.

This seems to be the first piece of furniture designed by Mackintosh for his own use; its maker is unknown. It was used at 27 Regent Park Square as a bookcase and cabinet for drawings, but later, at 120 Mains Street and 78 Southpark Avenue, it was moved to the dining-room and used as a sideboard.

The *cyma recta* moulding above two square tapering columns was used many times by Mackintosh in designs for furniture and interiors, but this is its first appearance in such a combination. The row of dentils (seen below the moulding in 1896.A) had been removed by the time it was taken to the Mains Street flat.

Herbert MacNair designed a number of similar cabinets (*see* Billcliffe, *MacNair*, figs. 36–38), all dating from 1895–97, which have a number of features in common with 1896.1. Both designers began to introduce the motif of a swooping bird at around this date, occasionally as carved decoration, but more often as a completely stylised motif of a sudden downward projection on stretchers or, as here, on the lower aprons of cabinets and tables. In a sketchbook at Glasgow University is a drawing of a hawk by Mackintosh of 1896 which gives an indication of how the motif originated; a more stylised drawing (ex-Hamish Davidson) is also at Glasgow University.

Literature: Howarth, pp. 20–21, 32, plates 5a, 15a.
Provenance: C. R. Mackintosh; William Davidson; Hamish Davidson, by whom bequeathed, 1972.
Collection: Glasgow University.

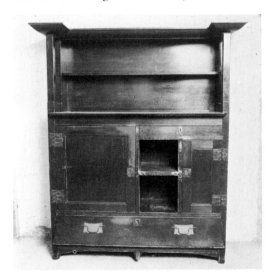

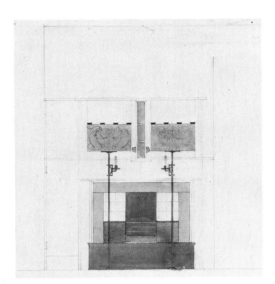

△ D1896.4

1896.2 Bed

Cypress, stained green 92 × 140.5 × 199.5cm.

Designed for Mackintosh's own bedroom at 27 Regent Park Square.

Literature: Howarth, plate 5a.
Provenance: C. R. Mackintosh; William Davidson; Cameron Davidson, by whom presented.
Collection: Glasgow School of Art.

1896.3 Fender with candle-holders

The fender was designed for Mackintosh's bedroom at 27 Regent Park Square, Glasgow, but was later used as part of the studio fireplace furniture at 120 Mains Street. It does not seem to have been used at 78 Southpark Avenue, however, and cannot now be traced. The candle-holders have a friction device which allows them to be raised and lowered on the uprights. Obviously based upon a traditional design, this piece is in line with a general Arts & Crafts style which influenced much of Mackintosh's work of this period. *See* 1896.A and 1900.D.

Literature: Howarth, p. 46, plates 5a, 14a.
Collection: untraced.

D1896.4 Design for a fireplace

Verso: design for an appliqué curtain.
Pencil and watercolour 31.6 × 39.7cm.
Scale, 1:12.

The fender and candlesticks shown in the drawing are identical to 1896.3; the fireplace, however, is not that shown in 1896.A. This drawing

◁ 1896.1 1896.2 ▽

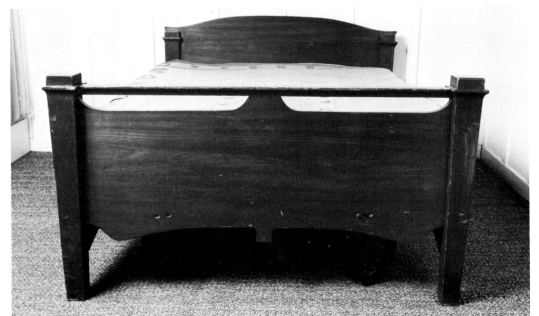

probably shows Mackintosh's intentions for the Regent Park Square fireplace, which may or may not have been fully carried out. It is possible, however, that the drawing dates from c1898, as Mackintosh used the same decorative panels on two pieces of furniture in that year.

Provenance: Mackintosh Estate.
Collection: Glasgow University.

1896.5 Chest of drawers

Cypress, stained green, with brass handles
121 × 151.5 × 49.7cm
Made by Guthrie & Wells, Glasgow.

Probably designed to match the bed, 1896.2. The two pieces have a number of features in common: same wood, same stain, and the upper curve of the foot of the bed is repeated below the top shelf of the drawers. A date of 1896 is also supported by a feature this piece has in common with 1896.1: the bottom drawer does not close flush with the upper drawers, and its bottom edge sweeps out to cover the two side-gables in a manner similar to the bottom drawer of 1896.1. Only one example has been traced.

Literature: as 1895.1, p. *38*; *The Studio*, XI, 1897, p. *97*.
Provenance: (? C. R. Mackintosh); William Davidson; Cameron Davidson, by whom presented.
Collection: Glasgow School of Art.

1896.5 ▽

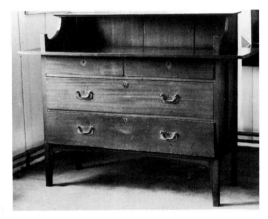

1896.6 * Table for the offices of The Glasgow Herald

Oak, with brass handles 75.5 × 189.5 × 131cm.

The job-books for the practice (now with Keppie Henderson) show that there was not just one commission at The Glasgow Herald, but several, and that work continued at Mitchell Street throughout the 1890s. There are no specific entries relating to the furniture for the main block, but office equipment and other furnishings are mentioned in the accounts for 1896.

1896.6 is said to have been designed as a conference table for the Editor's office, where it proved most unpopular, because the lower stretchers interfered with the users' feet and restricted their movements; perhaps this was the origin of much of The Herald's editorial disdain for Mackintosh's work. It is not an elegant piece, but its style was probably influenced by the client and the taste of John Keppie who controlled the job.

Provenance: J. Outram, publishers of The Glasgow Herald, by whom presented.
Collection: Glasgow Art Galleries and Museums.

1896.7 Cabinet for the offices of The Glasgow Herald

Oak, with brass locking plate and handles
101 × 59.2 × 38cm.

*See addenda

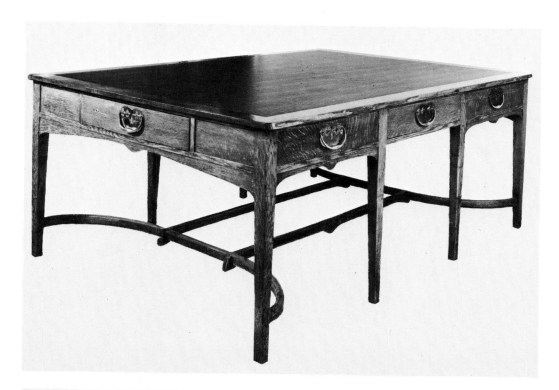

An interesting design, combining practicality with typical Mackintosh motifs. The hinged locking plate, which serves as a single lock for all the drawers, has none of the Spook School *repoussé* decoration often found on pieces of this period, but the upper part of the cabinet, with the pierced gables and the miniature posts supporting the top, repeats motifs to be found in 1895.5 and 1896.1.

Provenance: as 1896.6.
Collection: Glasgow Art Galleries and Museums.

1896.8 Linen-press
Cypress, stained green, inlaid with coloured woods and white metal, and metal handles
195 × 158.5 × 455cm.
Probably made by Guthrie & Wells.

Designed for the nursery at Gladsmuir and the most assured design of this period, this cabinet is a transitional piece incorporating two new motifs, which reappeared frequently in later designs, and the usual broad metal hinges, seen here at their best, but rarely used again. Howarth dates it to 1895–96; the later year seems more likely, especially as one of the preparatory designs (D1896.10) shows that Mackintosh at one time intended to decorate the lower doors with two statuesque figures reminiscent of the decorations at the Buchanan Street Tea Rooms.

Mackintosh uses an inlay for decoration for the first time here although it became a common feature of his later furniture, particularly that designed after 1901; here he uses stained woods, but in later pieces it is usually glass, ivory or mother-of-pearl. Another motif which distinguishes this from earlier pieces, but which, again, was used frequently in later work, is the introduction of vertical panels, about 7.5cm. wide running the full height of the piece, on either side at the back of the cabinet; these panels terminate here in two decorated lugs, but in later pieces they stop at the cornices of the cabinets which overhang to meet them, as on the smoker's cabinet, 1899.1, for example.

Literature: *Dekorative Kunst*, III, 1898–99, p. 77, and IV, 1902, p. 197; Howarth, pp. 35, 36, plate 35b.
Provenance: a) William Davidson; by family descent; b) unknown.
Collection: a) private collection; b) private collection.

D1896.9 Design for linen cupboard for William Davidson
Pencil 29.2 × 44.7cm. (irregular).
Signed and inscribed, lower right, *Chas. R. Mackintosh/140 Bath Street*, and inscribed, upper left, *Scale drawing of Cabinet*.
Scale, 1:12.

As executed, but not showing details of the inlay or the metal hinges.

Provenance: Mackintosh Estate.
Collection: Glasgow University.

D1896.10 Design for linen cupboard for William Davidson
Pencil 40.6 × 30.5cm.
Inscribed, centre right, *Panel 20¼″ · 3′/¾″*; and with various other measurements.
Scale, 1:12.

An earlier design than 1896.9, this drawing shows some of the preliminary ideas for the decoration of the metalwork, and suggests that Mackintosh had considered introducing carved wooden ornament at the centre below the upper cupboard, such as appeared on later pieces like the smoker's cabinet, 1899.1. The

△1896.6
◁1896.7
▽1896.8

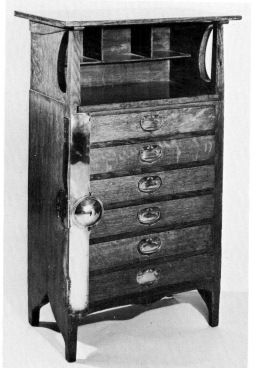

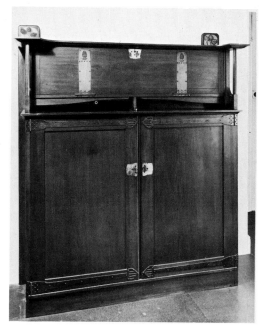

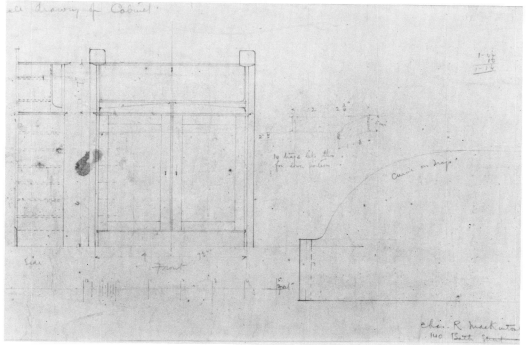

◁D1896.9

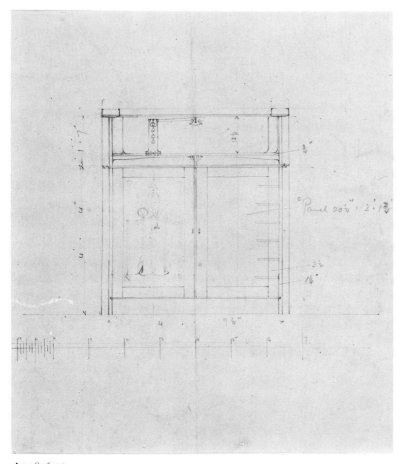

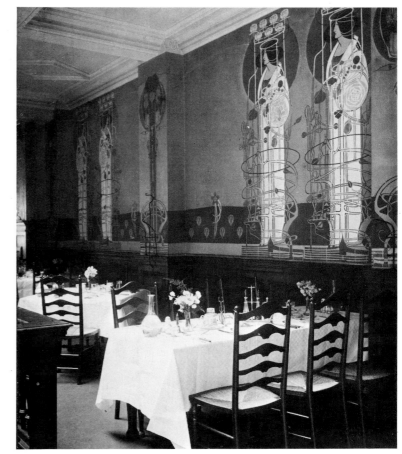

△ D 1896.10 1896 .C △

▽ 1896.D 1896.E ▽

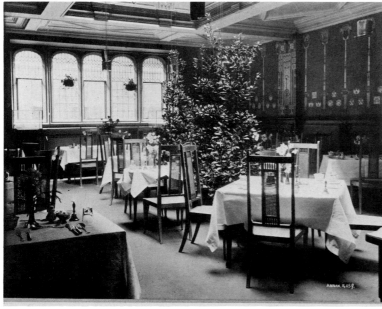

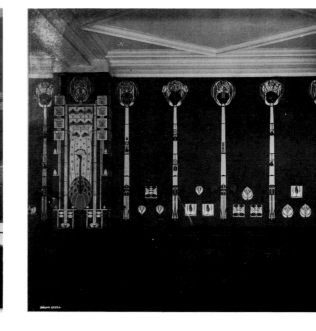

▽ 1896.F 1896.G ▽

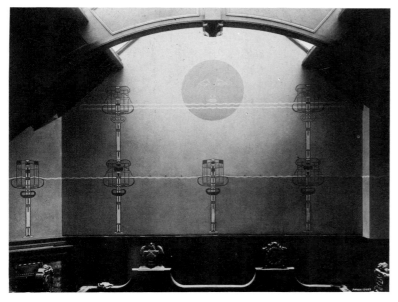

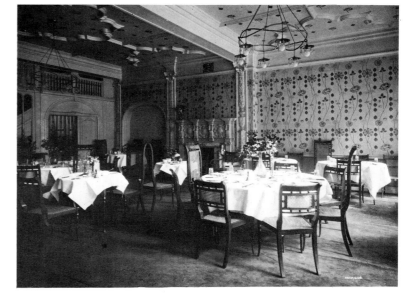

38

two lugs which were decorated with an inlay of stained woods and white metal are seen here only lightly sketched in. The most interesting variation from the finished cabinet, however, is the incorporation of two decorative panels, each 3′ 0¾″ × 1′ 8¼″ (94 × 51cm.) on the lower doors. The rough sketch of one of these is very similar in style and subject matter to the huge female figures stencilled on the walls at the Buchanan Street Tea Rooms in 1896.

Provenance: Mackintosh Estate.
Collection: Glasgow University.

1896.C Stencil decorations in the Ladies' Tea Room, Buchanan Street Tea Rooms, Glasgow

Collection: Annan, Glasgow.

1896.D The Luncheon Room, Buchanan Street Tea Rooms, Glasgow
Apart from the wall decoration, the light fittings in this room were possibly designed by Mackintosh.

Collection: Annan, Glasgow.

1896.E Stencil decoration in the Luncheon Room, Buchanan Street Tea Rooms, Glasgow

Collection: Annan, Glasgow.

1896.F Stencil decoration in the Smoking Gallery, Buchanan Street Tea Rooms, Glasgow

Collection: Annan, Glasgow.

1896.G A dining-room at the Buchanan Street Tea Rooms, Glasgow
The light fittings correspond with Mackintosh's drawing, D1896.14. The stencil decorations were designed by George Walton.

Collection: Annan, Glasgow.

1896.H A dining-room at the Buchanan Street Tea Rooms, Glasgow
The light fittings were possibly designed by Mackintosh, but the stencil decorations are definitely the work of George Walton.

Collection: Annan, Glasgow.

1896.I A dining-room at the Buchanan Street Tea Rooms, Glasgow
The light fitting is possibly the work of Mackintosh.

Collection: Annan, Glasgow.

1896–97 The Buchanan Street Tea Rooms, Glasgow

Miss Catherine Cranston acquired the premises at 91–93 Buchanan Street in 1895. It was one of the city's main thoroughfares, a street of fashionable shops. According to Howarth (p. 123), she commissioned George Washington Brown of Edinburgh to rebuild the premises in 1896 and they were opened to the public in the summer of 1897 when the Annan photographs were taken. The results were not outstanding and Gleeson White, in his article for *The Studio*, declined to mention the architect's name because the building suffered many criticisms. Miss Cranston asked George Walton to oversee the decorations and the provision of furniture, all of which work was carried out by his own firm. In three areas, however, Mackintosh produced designs for stencil decoration of the walls—whether at Miss Cranston's or Walton's commission is not known. These stencil decorations filled the walls of the Ladies' Tea Room, the Luncheon Room and the Smokers' Gallery. The Tea and Luncheon Rooms extended around an open well containing a staircase, and Gleeson White described how the background colours of green, 'greyish-greenish yellow' and blue here could be seen as a progression from earth to sky.

Although work was completed in 1897, designs were probably drawn up in 1896. Certainly the inspiration for the decoration of the Ladies' Tea Room is a drawing entitled *Part Seen, Imagined Part*, dated April 1896 (collection: Glasgow Art Galleries and Museums). This drawing was translated into a frieze of tall figures arranged, not in repetitive rows, but in groups of two facing each other across a stylised tree. These statuesque ladies are dressed in white, their heads silhouetted against a gold nimbus, and their bodies wreathed in tendrils of stylised plants. The trees reappear in the Luncheon Room (1896.E), arranged in groups of five between the broad pilasters, which are themselves painted with a representation of peacocks. Totem-like, the trees all look identical, but their tops are variations upon the theme of formalised leaves and flowers. On the top floor, in the Smoking Gallery, the trees are rendered even more skeletal; their shape has been reduced to the most basic forms which have been re-worked to provide a series of mysterious totems connected by a rippling line. The latter is repeated at a higher level across a circular sun, or moon, given drooping eyes, a nose and lips.

All this work was carried out by Guthrie & Wells, for whom Mackintosh had designed some pieces of furniture. The colour was applied in flat graduated washes, but the uneven plaster surface caused the paint to shimmer with light.

Mackintosh rarely worked on this scale again, probably by choice rather than lack of opportunity. With the exception of the tall banners at Turin in 1902, his decorative work for other houses and tea rooms is on a smaller scale. These Buchanan Street decorations relate closely to the designs for posters which Mackintosh produced in the mid-1890s, using similar imagery and the same large-scale elements. Posters were another art form he did not return to after 1900.

The Buchanan Street commission gave him his first opportunity to produce interior decorations on such a large scale. At the Glasgow Herald building, Queen Margaret Medical College and Martyrs Public School there was no scope for such imaginative schemes. He had used stencils in his own bedroom and in the Gladsmuir nursery; why, then, did he not return to them in other jobs? Even at the School of Art, where space was certainly available (if not money) he chose to cover his walls with panelling, a feature repeated at Ingram Street in 1900. Perhaps we should ask not 'Why did he not use such stencils again?', but 'Why did he use such stencils at Buchanan Street?'. In almost all his later decorative commissions, Mackintosh had total control of all the elements of the design, furniture, carpets,

▽ 1896.H

1896.I ▽

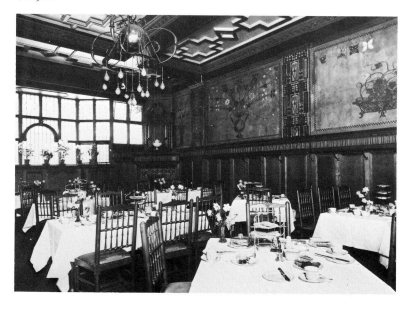

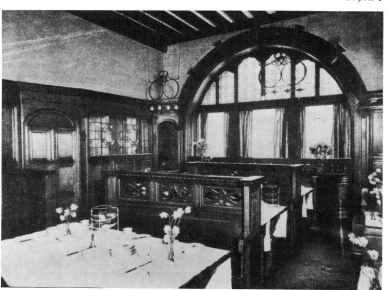

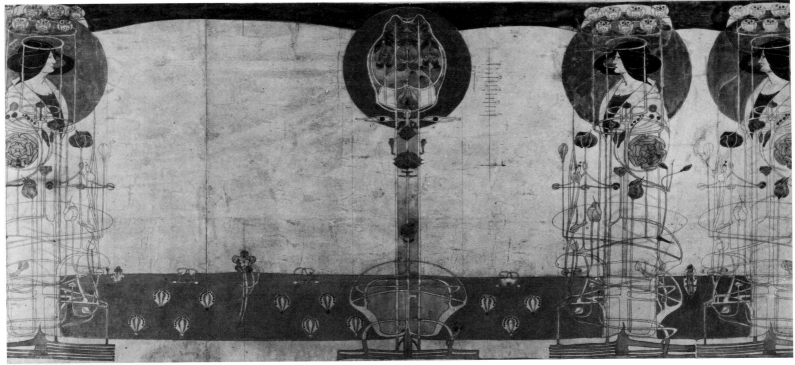

DI896.II △
DI896.I3 ▽

△ DI896.I2

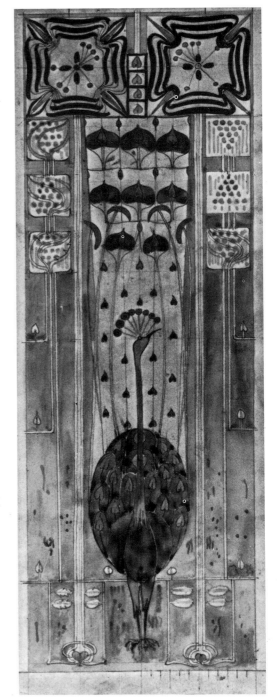

lighting and decorations. At Buchanan Street his designs had to compete with Walton's furniture, sensitive but not particularly original, and most of all with the heavy details of the architecture. Like posters, these wall decorations were intended to stand out from their surroundings rather than to harmonise with them, to make a loud clamour for attention amidst the distractions of the other designers' work. In this they no doubt succeeded, for people remember Mackintosh's decorations and not those by Walton. But Mackintosh was hardly ever faced with such a situation again, except at Turin, where he returned to the large-scale figure, almost twice as large as those used at Buchanan Street, in order to draw attention to and define the area of the Scottish exhibits.

Howarth suggests (p. 124, note 1) that Mackintosh probably designed the chairs in the Billiards Room at Buchanan Street. In fact he did not: they were one of Walton's most individual and successful designs; however, Mackintosh does seem to have had a hand in the design of some of the light fittings for the Tea Rooms. Again, whether this was at Walton's request or Miss Cranston's is not known, nor is the extent of Mackintosh's involvement with the lighting. Apart from the fitting in 1896.G, that shown in 1896.D has some resemblance to fittings later produced for the lecture theatre at the School of Art. Other fittings, seen in 1896.H and I, may also be his designs, but no documentary evidence confirming this has been found, and Mackintosh's output of lighting designs to date is too slender to support any firm conclusions.*

Literature: Howarth, pp. 123–28, plate 48; Gleeson White, 'Some Glasgow Designers and their Work', *The Studio*, XI, 1897, pp. 92–97.

*See addenda

D1896.11 Design for stencilled mural decoration for the first floor of the Buchanan Street Tea Rooms, Glasgow

Pencil and watercolour 36.2 × 75.6cm.
Scale, 1:6.

As executed.

Literature: P. Selz *et al., Art Nouveau*, 1960, pp. *68–69, 92*; N. Ponente, *The Structures of the Modern World*, 1965, p. *178* (detail); Alison, p. *24*.
Exhibited: Memorial Exhibition, 1933 (117); New York, Museum of Modern Art, 'Art Nouveau', 1960–61 (177); Arts Council of Great Britain, 'Decade 1890–1900', 1967 (88); Edinburgh, 1968 (81).
Provenance: Mackintosh Estate.
Collection: Glasgow University.

D1896.12 Preliminary design for mural decorations at the Buchanan Street Tea Rooms, Glasgow

Pencil on a page of a sketchbook 11.2 × 17.4cm.

An early sketch for the design incorporating standing women. See D1896.11.

Provenance: Mackintosh Estate.
Collection: Glasgow University.

D1896.13 The peacock: preliminary design for wall stencil at the Buchanan Street Tea Rooms, Glasgow

Pencil and watercolour on tracing paper 38.2 × 19.6cm.
Scale, 1:6.

Virtually as executed, except that the peacock's head was eventually reversed.

Literature: Macleod, plate 41.
Exhibited: Memorial Exhibition, 1933 (137); Edinburgh, 1968 (82).
Provenance: Mackintosh Estate.
Collection: Glasgow University.

D1896.14 Design for pendant light fitting for the Buchanan Street Tea Rooms, Glasgow

Blue pencil on a page of a sketchbook 22.8 × 18.1cm.
Inscribed, upper left, *Miss Cranston's/Buchanan Street/4 light pendants.*

This design was executed and appears in contemporary photographs (1896.G).

Provenance: Mackintosh Estate.
Collection: Glasgow University.

D1896.15 Design for light fittings for the first floor window tables, Buchanan Street Tea Rooms, Glasgow

Pencil and watercolour 42.8 × 27.7cm.
Inscribed, upper left, *MISS CRANSTONS/ BUCHANAN STREET*, and, lower right, *LAMPS FOR / WINDOW TABLE / FIRST FLOOR.*

No light fittings like these appear in any of the contemporary photographs, but these show by no means all the different parts of the tea rooms. The shade itself is of a type generally thought to have been first used at Argyle Street (*see* D1897.41), but even that drawing shows a fitting slightly different from this. The bracket supporting the lamp, however, does have more in common with the other wrought ironwork at Buchanan Street. The lettering of the drawing was used *c*1897–99, so it is also possible that Mackintosh later returned to Buchanan Street at Miss Cranston's request to provide extra lighting.

Provenance: Mackintosh Estate.
Collection: Glasgow University.

1896.16–19 *

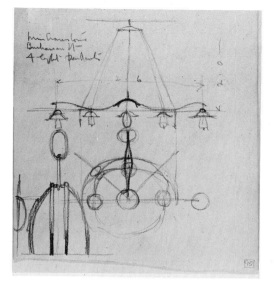

△ D1896.14

D1896.15 ▽

1897.1 Desk with hinged top for Gladsmuir, Kilmacolm

Oak, stained dark, with beaten metal panel and brass handles 96.5 × 91.5 × 50.8cm.

A relatively simple design, similar in style to some of the pieces made for the Argyle Street Tea Rooms; the ogee curves of the side panels can be seen, for instance, on the armchair, 1897.19. See 1901.D.

Exhibited: Edinburgh, 1968 (179).
Provenance: William Davidson; by family descent.
Private collection.

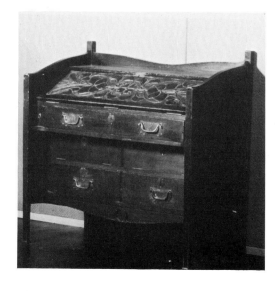

1897.1 ▷

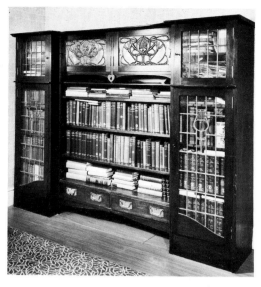

1897.2 △

1897.2 Bookcase for Gladsmuir, Kilmacolm

(?) Oak, stained dark, with two beaten metal panels and glazed doors 167.7 × 152.4 × 45.7cm.

No precise date can be documented for this piece, but stylistically it must follow 1896.8, as it repeats the motif of continuing the overhang of the cornice down the two outer sides; it obviously cannot be later than November 1898, the date it was first published. Late 1896, or 1897, are both equally possible, but as Mackintosh repeated the same two metal panels in the Westdel wardrobe designed in 1898, even such a late date cannot be ruled out. The same two panels first appear in the design for the fireplace and fender (D1896.4).

Literature: *Dekorative Kunst*, III, 1898–99, p. *70*.
Provenance: William Davidson; by family descent.
Private collection.

1897.3 Schoolroom table for Gladsmuir, Kilmacolm

Pine, stained dark 76.2 × 129.6 × 67.3cm.

Two tables and two benches (1897.4) were made for the nursery at Gladsmuir, probably at the same time as the bookcase (1897.2). The thistle motif pierced in the sides of the legs of the bench is repeated in the leaded-glass doors of the bookcase.

Exhibited: Edinburgh, 1968 (180).
Provenance a) William Davidson; Hamish Davidson, by whom bequeathed; b) William Davidson; by family descent.
Collection: a) Glasgow School of Art; b) private collection.

1897.3 ▽

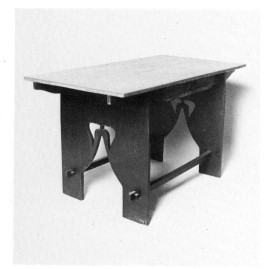

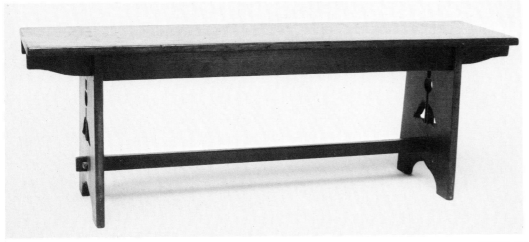

△1897.4 D1897.5 ▽

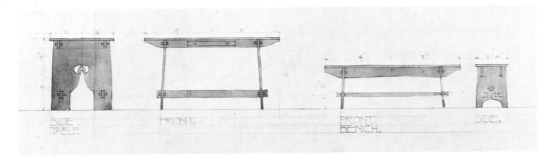

1897.4 Schoolroom bench for Gladsmuir, Kilmacolm
Pine, stained dark 46 × 127 × 30.8cm.

See 1897.3.

Provenance: William Davidson; Hamish Davidson, by whom bequeathed.
Collection: Glasgow School of Art (2 examples).

D1897.5 Designs for a bench and table for the schoolroom, Gladsmuir, Kilmacolm
Pencil and watercolour 21.3 × 47.2cm.
Inscribed, along lower edge, *SIDE | TABLE; FRONT.; FRONT. | BENCH.; SIDE.*; and inscribed with various measurements; verso inscribed, lower right, *7 [or 9] Virginia Street.*
Scale, 1 : 12.

Virtually as executed.

Provenance: Mackintosh Estate.
Collection: Glasgow University.

▽1897.7

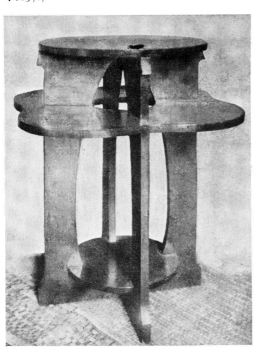

1897/9.6 Side table for Gladsmuir, Kilmacolm
Oak, stained dark.

This table is illustrated in the article on Windyhill in *Dekorative Kunst*, V, 1902; it does not, however, appear in the final accounts of 1902 where all the furniture designed for Windyhill is listed. Stylistically, it can be assigned to the period 1897–99, and it seems likely that it was originally designed for Gladsmuir. The handles are similar to those used on other Gladsmuir and Guthrie & Wells pieces, and the broad back legs, extended to align with the overhanging top, are similar to those of the smoker's cabinet which Mackintosh designed for his own use (*see* 1899.1).

Literature: *Dekorative Kunst*, IX, 1902, p. *198*.
Collection: untraced.

1897.7 Domino table
Wood, (?) varnished.

Possibly intended for the Argyle Street Tea Rooms, or even for those at Buchanan Street, but it does not appear in any of the contemporary photographs and no surviving example has been traced. This table relates to the domino table used at Argyle Street (1897.22), but is certainly an earlier version of that design. The central shelf (for three are used here) again extends beyond the legs, but instead of being broken by the legs, it continues beyond them, forming a single clover-leaf pattern surface.

Literature: *The Studio*, XI, 1897, p. *230*.
Collection: untraced.

D1897.8 Design for a domino table
Pencil and watercolour 25.5 × 23.7cm.
Signed and inscribed, lower right, *Chas. R. Mackintosh/140 Bath St*, and (partially erased), *Sketch Nº 2/to* [? *be exec*] *uted*; inscribed, upper left, *Scale drawing of Table*; and various other notes.
Scale, 1 : 12.

The drawing for 1897.7, as executed.

Provenance: Mackintosh Estate.
Collection: Glasgow University.

◁1897/9.6 D1897.8 ▽

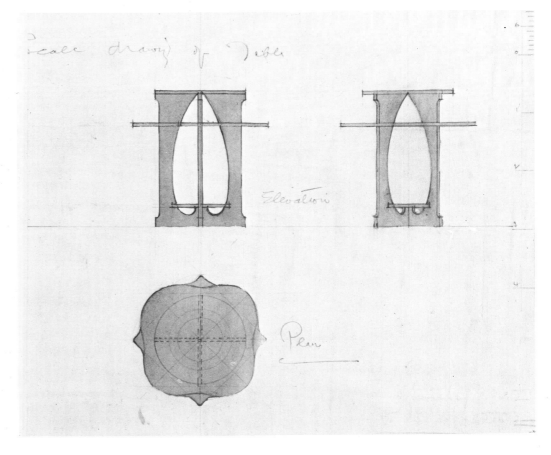

1897.A Smoking Room at the Argyle Street Tea Rooms, Glasgow

All the movable furniture was designed by Mackintosh; George Walton was responsible for the stencil decorations, the fireplace, the fitted settle and the dividing screens.

1897.B The Luncheon Room at the Argyle Street Tea Rooms, Glasgow

The chairs, tables and hat-stand were designed by Mackintosh; George Walton designed the decorations on the walls and screens as well as the fireplace.

1897.C Billiards Room at the Argyle Street Tea Rooms, Glasgow

George Walton designed the billiards tables, the fireplace and the stencil decoration, while Mackintosh was responsible for the movable furniture and the lighting over the billiards tables.

1897.D Billiards Room at the Argyle Street Tea Rooms, Glasgow

1897.E Luncheon Room at the Argyle Street Tea Rooms, Glasgow

Fitted screen and wall decorations were designed by George Walton; Mackintosh designed the chairs, tables and hat-stands, and possibly the hanging light fitting.

1897 The Argyle Street Tea Rooms, Glasgow

The roles adopted by Mackintosh and Walton at the Buchanan Street Tea Rooms in 1896 were reversed a year later at Miss Cranston's new suite of rooms in Argyle Street. Howarth (pp. 121–25), has recorded the early history of Miss Cranston's Tea Rooms and provides crucial information from the records of Annan and Francis Smith (now no longer available) showing the relevant dates of the interior at 114 Argyle Street. The photographs of the interior reproduced in *The Studio* (1906, XXXIX, pp. 31–36), were taken in April 1897, thus providing a *terminus ante quem* for all the items of furniture designed by Mackintosh which appear in them. According to Howarth, other furniture was provided by Smith in 1898 and 1899, but no photographic record of this exists, although there are a few items of furniture, such as the side table (1897.31), which do not appear in the early photographs and could therefore be later than 1897. The article by Taylor in *The Studio* states that Mackintosh was responsible only for the lighting over the billiards tables, but a number of drawings at Glasgow University (nos D1897.35–43) suggest that he also designed other light fittings for Argyle Street. The 1897 photographs are obviously of unfinished room settings, because a number of bare wires and lamps can be seen, presumably waiting for fittings—possibly the same fittings as appear in these drawings.

The furniture for Argyle Street, which appears sturdy and solidly made and is usually quite heavy and difficult to move, has indeed lasted well. All of it is made of oak, sometimes simply varnished or even scrubbed, but more often stained dark. The construction is usually traditional and the legs and stretchers, and sections in general, are generous enough to provide good joints. Decoration is by simple cut-outs in broad panels, often in the shape of a flying bird, or by the

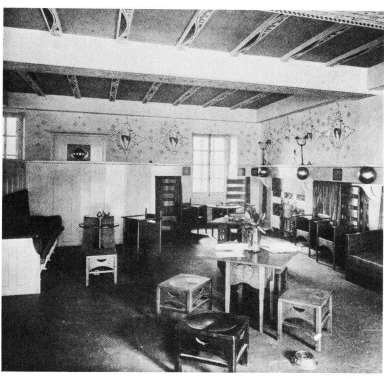

△1897.A

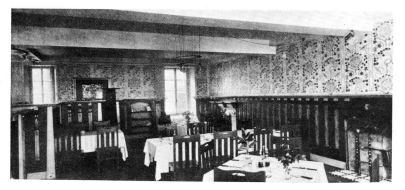

1897.B ▷

1897.C ▷

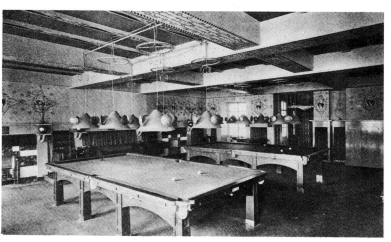

▽1897.D

1897.E ▷

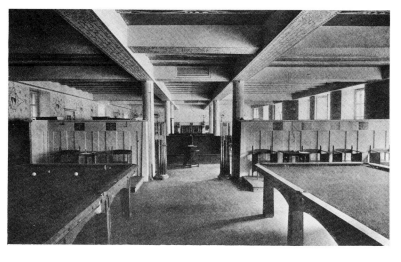

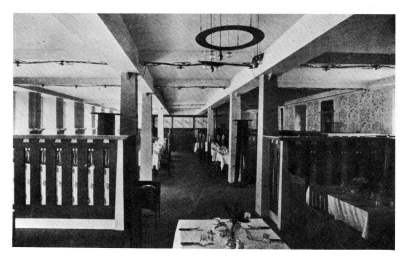

addition of raised carved panels—the first time that carving was used successfully by Mackintosh.

The ground floor room was not illustrated at all, and no unpublished photographs of it have survived. No drawings exist of furniture designed specifically for the ground floor rooms, and, with the exception of the side table (1897.31) and the armchair (1897.19), no furniture has been traced which was not illustrated in *The Studio* in 1906.

The Argyle Street work, like that at Buchanan Street, does not appear in the books of Honeyman & Keppie. However, several of the drawings are inscribed with the firm's address, so Mackintosh was obviously allowed to undertake such private jobs with the knowledge of his employers; perhaps his winning the competition for the Glasgow School of Art increased his status in the office. Whatever the exact situation, the Argyle Street Tea Room furniture was the first large commission received by Mackintosh where he was unlikely to be restrained by the tastes of his office superiors or by the rather limited pockets of patrons like young William Davidson. His style flowered at Argyle Street and laid the pattern for most of his designs for furniture until the furnishing of his own flat at 120 Mains Street in 1900.

Literature: *The Studio*, XXXIX, 1906, pp. 32–36; Howarth, pp. 128–31, plate 49.

1897.9 Armchair with ladderback for the Argyle Street Tea Rooms, Glasgow
Oak, stained dark 135 × 61.5 × 49.5cm.

One of the most satisfactory of the chairs designed for Argyle Street, it was used in the Billiards Room and Smoking Room. Both of these areas were intended for male patronage, and this solid looking chair is ideally designed for its setting. The broad arms, solid side panels and curved apron front all reappeared in other pieces designed for these Tea Rooms. At least five examples are shown in contemporary photographs.

Literature: *The Studio*, XXXIX, 1906, pp. *32, 33*; Howarth, p. 140, plate 49b; Alison, pp, 30, 31, 87, 88.
Collection: a) Dr Thomas Howarth (2); b) Sotheby's Belgravia, 20 November, 1974 (lot 136); c) E. Sloane, Esq.

D1897.10 Design for ladderback armchair, for the Argyle Street Tea Rooms, Glasgow
Pencil and watercolour 34.3 × 31.8cm.
Signed and inscribed, lower right, *CHAS R*

1897.9 ▽

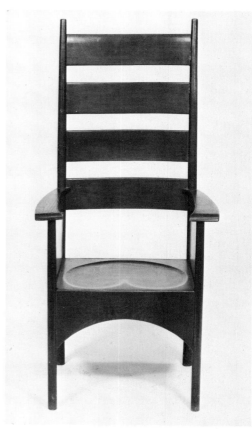

△ D1897.10 1897.11 ▽ D1897.12 ▽

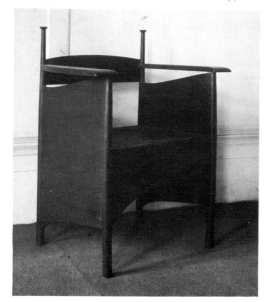

MACKINTOSH DES / 140 BATH STREET and, upper left, *MISS CRANSTONS. / ARGYLE STREET. / HIGH BACK CHAIRS / FOR SMOKING ROOM*; and verso *Miss Cranstons*.
Scale, 1 : 12.

As executed.

This type of drawing, one-twelfth scale, showing front and side elevations, the timber coloured with a dark wash and the design set against a larger area of a lighter wash, became a standard for the drawings of individual pieces taken from the context of their room settings. The careful positioning of the design on the sheet of paper and the equally deliberate placing of the lettering show how Mackintosh was conscious of the appearance of even ephemeral sketches such as these, which were intended as much for the manufacturer as the client.

Literature: Alison, pp. *30*, 77 (no 1).
Exhibited: Milan, 1973 (1).
Provenance: Mackintosh Estate.
Collection: Glasgow University.

1897.11 Armchair with low back for the Argyle Street Tea Rooms, Glasgow
Oak, stained dark 84 × 63 × 46cm.

Used in the Smoking and Billiards Rooms. A variant of 1897.9, without the high ladderback and with small knob-like terminations to the rear upright (which have been removed in the Glasgow University example, possibly by Mackintosh). At least twelve examples appear in contemporary photographs.

Literature: *Das Englische Haus*, I, 1904, plate 172; *The Studio*, XXXIX, 1906, pp. *32, 34*; Howarth, p. 130, plates 13a, 14a, 49b; Alison, pp. 30, *31*, 87, 88.
Provenance: a) Davidson Estate.
Collection: a) Glasgow University; b) Dr Thomas Howarth (4); c) private collection, Glasgow.

D1897.12 Design for benches for the Billiards Room, Argyle Street Tea Rooms, Glasgow
Pencil and watercolour 28 × 48cm. (sight).
Signed, lower right, *Chas. R. Mackintosh / 140 Bath Street Glasgow*; inscribed, upper left, *MISS CRANSTONS / ARGYLE STREET / DRAWING OF BENCHES / FOR BILLIARD ROOM*; and below, *Front view of Billiard Room Benches round wall in groups of 2–3–4– and 5 seats*.
Scale, 1 : 12.

This drawing shows that Mackintosh was originally proposing to use fitted seating in the Billiards Room, using a chair similar to 1897.23, with the addition of a canopied top. Into this were to be set lead plaques; one of these, which can be seen on the studio fireplace at 120 Mains Street (1900.D), is now at Glasgow University. Eventually, individual chairs were designed to sit on the raised dais around the billiards table (see 1897.9 and 11). No table identical with that shown in this drawing was made, but it is very similar to 1897.13.

Exhibited: Toronto, 1967 (80).
Collection: Dr Thomas Howarth.

1897.13 Square card table for the Argyle Street Tea Rooms, Glasgow
Oak 71.3 × 80.5 × 82cm.

Used in the Smoking Room alongside a variant (1897.14). Another solid piece of furniture used with the stools (1897.15). The overhanging top, however, makes the table unsteady if any pressure is exerted at the edges—not an asset in a card table. The panels between the legs are decorated with relief carving, an abstract shape not dissimilar to one of the finials of the railings at the School of Art

(see Glasgow School of Art, *Metalwork*, plate 6, a–e). Only one of these tables can be seen in contemporary photographs, but Mackintosh kept one for himself and later painted it white (1900.8); the Tea Room version is untraced. See 1897.A.

Literature: *The Studio*, XXXIX, 1906, p. *32*; Howarth, plate 49b.
Collection: untraced.

1897.14 Circular card table for the Argyle Street Tea Rooms, Glasgow
Oak 70.5 × 76cm. diameter.

A variant of 1897.13; this example has a scrubbed oak top, but it seems more likely that both were originally varnished or even stained dark.

Literature: *The Studio*, XXXIX, 1906, p. *32*; Howarth, plate 49b.
Provenance: a) Miss Cranston's Tea Room; Messrs Coopers; Glasgow Corporation; b) as (a), by whom presented.
Collection: a) Glasgow Art Galleries and Museums; b) Glasgow School of Art.

1897.15* Stool for the Argyle Street Tea Rooms, Glasgow
Wood, (?) stained dark.

Used in the Smoking Room with the table, 1897.13. Contemporary photographs suggest that this was made in both stained and natural—(?) varnished—versions. See 1897.A. At least five examples appear in contemporary photographs, but none has been traced.

Literature: *The Studio*, XXXIX, 1906, p. *32*; Howarth, p. 140, plate 49b.
Collection: untraced.

1897.16 Upholstered settee for the Argyle Street Tea Rooms, Glasgow
Oak, stained dark, with horsehair upholstery 70.7 × 121.2 × 66cm.

Used along the walls in the Smoking and Billiards Rooms. A very sturdy and quite heavy piece of furniture with slab-like sides, upholstered in horsehair, which became a favourite material with Mackintosh and was used on several designs about this time. At least two examples appear in contemporary photographs.

Literature: *The Studio*, XXXIX, 1906, pp. *32, 33*; Howarth, p. 150, plate 49b.
Provenance: Mrs McNeill, by whom presented.
Collection: Glasgow School of Art (1).

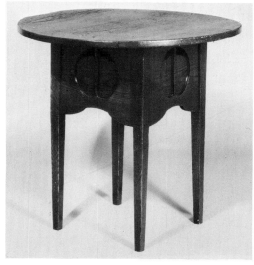

1897.14△

D1897.17 Design for a settee for the Smoking Room, Argyle Street Tea Rooms, Glasgow
Pencil and watercolour on tracing paper 14.3 × 22.8cm.
Signed and inscribed, lower right, *C R Mackintosh / 140 Bath Street*; inscribed, upper left, *Couches for Smoking Room*, and bottom centre, *hair cloth*.
Scale 1 : 12.

A sketch which seems to indicate the narrowing of the width of the settee from the 1.7 metres or so of D1897.18 to that of the executed piece. The stencilled or embroidered decoration was not used, and the back rest was covered in plain horsehair cloth, as indicated here for the seat. As in D1897.18, the front of the seat is still shown quite deep, but this was modified to expose the front cross-piece of the frame, thus halving the original depth of the seat.

Provenance: Mackintosh Estate.
Collection: Glasgow University.

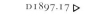
▽1897.16 · D1897.17 ▷

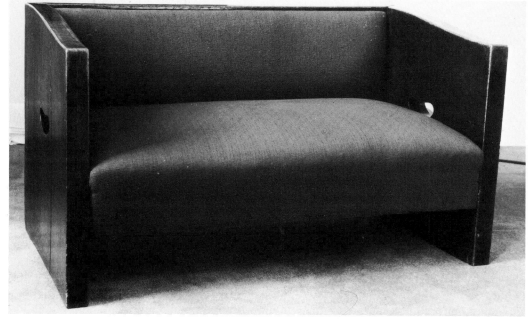

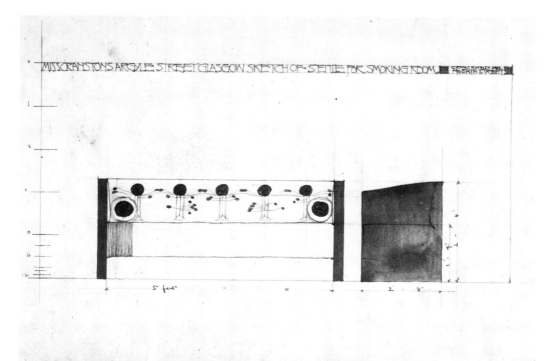

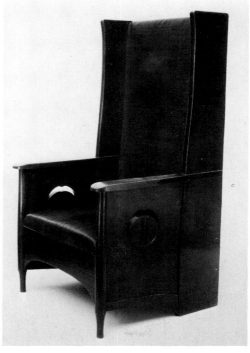

△D1897.18

D1897.18 Design for a settee for the Smoking Room, Argyle Street Tea Rooms, Glasgow

Pencil and watercolour 24.6 × 39.2cm.
Signed and inscribed, top, *MISS CRANS-TONS ARGYLE STREET GLASGOW SKETCH OF SETTLE FOR SMOKING ROOM. CR MACKINTOSH DES/140 BATH STREET*, and, upper right, *23*.
Scale, 1 : 12.

An early scale drawing for 1897.16. The final design was narrower, and the timber frame across the front was exposed, not covered by upholstery as shown here.

Provenance : Mackintosh Estate.
Collection : Glasgow University.

1897.19 Armchair with high upholstered back for the Argyle Street Tea Rooms, Glasgow

Oak, stained dark, with horsehair upholstery
121.5 × 66.5 × 64cm.

One of the more successful and comfortable pieces from Argyle Street; the drawing D1897.21 indicates that it was intended for the Ladies' Reading Room, of which no photographs survive. The carved decoration on the side panels is similar to that on 1897.13, except that here it is raised in front of the plane of the panel as well as being cut into it, as in the table.

Literature : Glasgow School of Art, *Furniture*, reproduced opposite 17a; Alison, pp. *34, 35*.
Provenance : Mrs McNeill, by whom presented.
Collection : Glasgow School of Art (2).

▽D1897.21

1897.20* Table for the Argyle Street Tea Rooms, Glasgow

Wood, (?)stained dark.

The drawing D1897.21 indicates that this was to be used in conjunction with 1897.19 in the Ladies' Reading Room, but contemporary photographs show it·in use in the Billiards Room. The device of setting broad plank-like legs on the diagonal, and connected by double stretchers on a square shelf, was used in several later tables at The Hill House and Hous'hill, but is used for the first time here. Four examples appear in contemporary photographs, but none has been traced. *See* 1897.D.

Literature : *The Studio*, XXXIX, 1906, pp.*32, 34*; Howarth, plate 49b.
Collection : untraced.

D1897.21 Design for a table and chair for for the Ladies' Reading Room, Argyle Street Tea Rooms, Glasgow

Pencil and watercolour 21.3 × 32.4cm.
Inscribed, upper right, *TABLE AND CHAIR FOR/LADIES READING ROOM*, and *27*.
Scale, 1 : 12.

Designs for 1897.19 and 1897.20. The decoration on the upholstered back of the chair does not seem to have been carried out on the surviving examples—these appear to have retained their original horsehair upholstery. The decoration on the legs of the table was not carved but simply pierced.

Literature : Alison, pp. *34*, 77 (no 3).
Exhibited : Milan, 1973 (3).
Provenance : Mackintosh Estate.
Collection : Glasgow University.

1897.19△

1897.22 Domino table with quadrant shelves for the Argyle Street Tea Rooms, Glasgow

Oak, stained dark 77 × 64cm. diameter.

Used in the Smoking and Billiards Rooms. One of the simplest yet most practical of Mackintosh's designs; the legs are planks of oak mortised into the table top and pinned to four lower quadrant shelves. These lower shelves held the cups and plates and unused dominoes of the four players. Although at first sight a rather crude piece, there are elements in the design which mark it unmistakably as Mackintosh's, such as the pattern made by the five square tenons which are allowed to come through the top; the deliberate shaping of the inner face of the legs and the gradual outward sweep of the outer faces; and the emphasis on the separation of the four lower shelves, which project beyond the legs, while the width of the legs is emphasised by the gap left between each shelf and its neighbour. At least four examples appear in contemporary photographs.

Some of these tables also appear in photographs of the Ingram Street Tea Rooms taken in the 1940s. It is not known whether Mackintosh specified them for the Cloister Room *c*1911, or, which seems more likely, whether they were taken there after the closure of the

1897.22▷

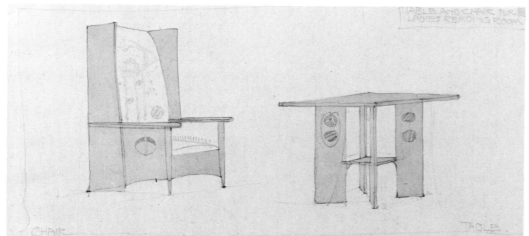

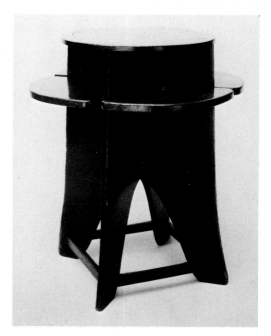

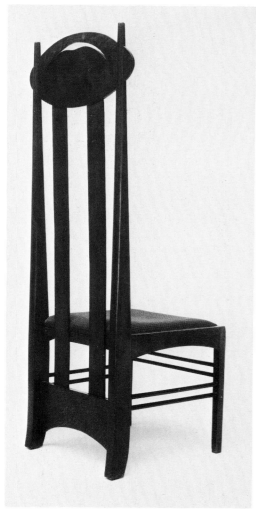
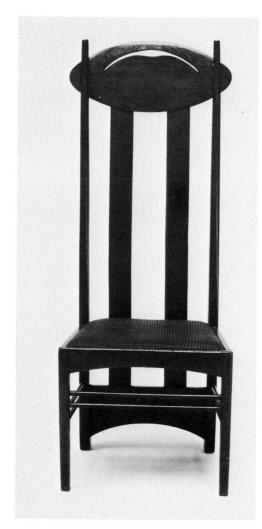
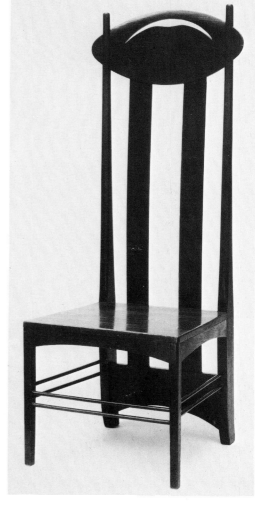

1897.23△

Argyle Street premises in 1920. Glasgow Art Galleries and Museums also owns examples with the lower shelf forming a complete circle and no tenons appearing on the top. These were almost certainly made by Coopers to replace damaged tables, or simply to provide extra accommodation for their patrons.

Literature: *The Studio*, XXXIX, 1906, pp. *32, 33*; Howarth, plates 49b, 51c; Glasgow School of Art, *Furniture*, no 12.
Exhibited: Paris, 1960 (1082); Saltire, 1953 (B7); Edinburgh, 1968 (262).
Provenance: a) as 1897.14 b) as (a) and then presented.
Collection: a) Glasgow Art Galleries and Museums (8); b) Glasgow School of Art (2).

1897.23 High-backed chair with pierced oval backrail for the Argyle Street Tea Rooms, Glasgow

Oak, stained dark, with rush or horsehair upholstered seat 136.8 × 50.5 × 46.2cm.

Used in the Luncheon Room. This chair is one of the best known of the whole of Mackintosh's oeuvre and certainly the most advanced, stylistically, to be designed for Argyle Street. Most of the other furniture at the Tea Rooms can be said to have some basis in tradition, or at least to have stylistic connections with the Arts & Crafts Movement, but this chair is quite different. It is the first of the high-backed chairs, a motif which became Mackintosh's own and which distinguished his Tea Room chairs from those of a host of other designers. The high backs have no practical function, other than in the context of the design of the whole room. At Argyle Street Mackintosh was faced with a long narrow room, divided by George Walton by partitions about 1.5m. high. In order for his chairs not to be overwhelmed by the room, with its screens and heavy, decorated beams and columns, Mackintosh increased the height of their backs. When the room was empty of people the

chairs stood like sentinels at the tables; and when the customers were seated, the oval panels would appear over their heads, emphasising the pattern of the layout of tables and chairs in the somewhat rigid and formal architecture of the dining-room.

This chair is worth analysing in some detail, for although individual motifs may appear in earlier pieces, this is the first time they are brought together in one design. The wood is dark-stained oak, and the upholstery usually of horsehair. The seat narrows towards the back, and the square front legs taper at the bottom. The back legs are more complicated, as Alison shows in his plan and sections. At the bottom they are rectangular, but as they rise they gently curve toward the front of the chair, the rear surface more quickly becoming vertical than the front of the leg. The hard corners become softer, disappearing gradually as the section changes through ellipse until it finally tapers to a circle. At front and sides the legs are connected by two circular stretchers, tapering as they enter the legs, but the back has a solid spar connecting the back legs. This is curved at the bottom, echoing the curve of the front of the seat. From this spar rise two broad splats—not connected to the back of the seat—terminating in a large oval backrail which also connects the two upper parts of the back legs. This rail, cut from a single piece of timber, has been machined to display a curve through its section; it is located in slots in the uprights, with no fixing by pins or glue. The stylised shape of a flying bird, wings outstretched, is cut through this oval.

Mackintosh was undoubtedly pleased with this chair, for he used it, or variations of it, in his own flat and exhibited it at Vienna in 1900. A variant was probably shown at the Arts & Crafts Exhibition in 1899 (*see* 1899.16), but it would probably have been less well received than the settle shown in 1896.

In this piece, Mackintosh breaks away from Arts & Crafts tenets. There is no 'truth to

materials': he does not use his timber in a natural or organic way; its limitations seem to have forced him away from Morris, but as there was no alternative material to be used, soon after this Mackintosh adopted the practice of painting or ebonising his wood to conceal its grain.

A small number of chairs exist where the back splats are thicker and are attached to the back of the oval panel rather than mortised into it. These were probably ordered directly by Miss Cranston from a firm like Francis Smith to provide extra seating. Their detailing suggests that Mackintosh was not involved in their manufacture.*

Literature: *Ver Sacrum*, 1901, issue 23, p. *385*; *Dekorative Kunst*, VII, 1901, pp. *172, 175*; Studio Special Number, 1901, pp. *110, 111*; *Das Englische Haus*, I, 1904, pp. *110, 111*; *The Studio*, XXXIX, 1906, p. *34*; Howarth, plates 13a, 14a, 15a, 59a, 59c; Macleod, plates 37, 74; Alison, pp. 32, *33*, 89–91.
Exhibited: Vienna Secession, 1900; VEDA, 1952 (R6); Paris, 1960 (1076); Saltire, 1953 (B6); Edinburgh, 1968 (211); Darmstadt, 1976–77, vol. 2, no 92.
Provenance: a) Davidson Estate; b) C. R. Mackintosh; M. M. Mackintosh; Mrs Napier, 1933, by whom presented; c) as (b) Glasgow School of Art, by whom presented.
Collection: a) Glasgow University (2); b) Glasgow School of Art (5); c) Victoria & Albert Museum (2). Others belong to the Museum of Modern Art, New York (1); Dr Thomas Howarth (1). Also at Sotheby's, 10 November, 1970 (lots 133, 134 and 135, 6 chairs). In addition to these, there exist six smaller variants in a private collection in London. It has proved impossible to trace the provenance of these beyond c1920, but, apart from their dimensions (110.3 × 48.8 × 45.5cm.), the only differences are that the backrail is attached to the rear uprights by pins through

See addenda 47

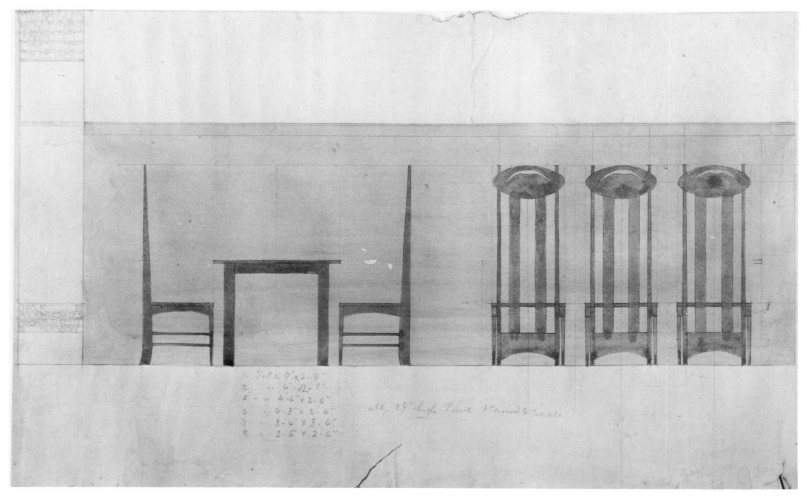

the face of the upright, and that the seats are cut out at the rear corners to accommodate the uprights. I have reached no definite conclusions about these chairs, but they are at the very least extremely faithful, albeit smaller, facsimiles. Other chairs exist, made c1904–06, which are traceable to a Leeds furniture store, Wolfson's (the Wolfsons in Leeds seem to have had business and family connections in Glasgow and could therefore have been familiar with the Argyle Street furniture). These chairs, an amalgam of 1897.23 and 1899.16, are definitely pastiches made for a commercial market.

D1897.24 Design for oval backrail chairs and tables for the Dining-room, Argyle Street Tea Rooms, Glasgow
Pencil and watercolour 26.6 × 46.8cm
Signed and inscribed, lower left, *CHAS. R./ MACKINTOSH DES/140 BATH STREET/ GLASGOW*, and, upper left, *MISS CRANS-TONS/ARGYLE STREET/DRAWING OF /CHAIRS FOR/CENTER* [sic] *TABLES*; inscribed, in another hand, bottom, *1 Table 9' × 2' 9"/2 ditto 6' × 2' 8"/5 ditto 4' 6" × 2' 6"/6 ditto 4' 3" × 2' 6"/7 ditto 3' 4" × 3' 4"/8 ditto 2' 6" × 2' 6"/all 29" high Pine stained to shade.*
Scale, 1:12.

The drawing for the chairs (1897.23) and tables (1897.25) used in the Luncheon Room, as executed. This drawing gives some indication of the design—which was quite simple—and the number of tables used at Argyle Street. The tables cannot be identified in the surviving contemporary photographs, and none of them has been traced.

Literature: Glasgow School of Art, *Furniture*, no 7a; Alison, pp. *32, 77* (no 2).
Exhibited: Milan, 1973 (2).
Provenance: Mackintosh Estate.
Collection: Glasgow University.

1897.25 Dining table for the Argyle Street Tea Rooms, Glasgow
Wood.

Used in the Luncheon Room with the chairs 1897.23 and 1897.26. *See* note to D1897.24.

Collection: untraced.

1897.26 Chair with curved top rail for the Argyle Street Tea Rooms, Glasgow
Oak, stained dark 99 × 48.3 × 42.5cm.

Used at one end of the Luncheon Room; about twenty chairs appear in contemporary photographs. Mackintosh developed the design for a chair at Ingram Street (*see* 1900.54) retaining the hand-hole in the top rail but using only two splats.

Literature: *The Studio* XXXIX, 1906, p. *32, 34*.
Collection: Private collection (6).

1897.27 Armchair with pierced side panels for the Argyle Street Tea Rooms, Glasgow
Oak, stained dark, with horsehair upholstery
96.4 × 57.2 × 45.8cm.

One example of this armchair appears in contemporary photographs of the Luncheon Room, but several others, possibly used in the ground floor apartments at Argyle Street, have survived. The design is very much in harmony with the other chairs used at Argyle Street, and may well have been used in other commissions (*see* D 1898.21). The pierced motif in the side panels is the same as that in the chair 1897.23.

Literature: *The Studio*, XXXIX, 1906, p. *34*; Glasgow School of Art, *Furniture*, no 9; Alison, p. *49*.
Provenance: a) Davidson Estate.
Collection: a) Glasgow University (1); b) Glasgow School of Art (2)—one stained, one ebonised; c) Dr Thomas Howarth (?); d) Mrs Bennett, Glasgow (2); e) private collection, Glasgow (2); f) private collection, Glasgow (2).

1897.28 Hat, coat and umbrella stand for the Argyle Street Tea Rooms, Glasgow
Wood, (?) stained dark, with metal hooks and drip trays.

Used in the Luncheon, Smoking and Billiards Rooms; at least seven appear in contemporary photographs of Argyle Street and one in Mackintosh's Mains Street flat. None has been traced. A solid piece, in keeping with the other

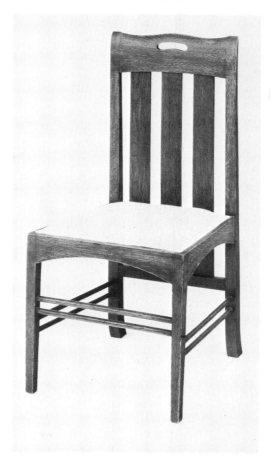

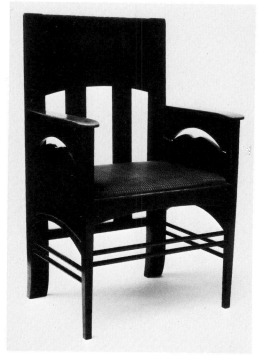

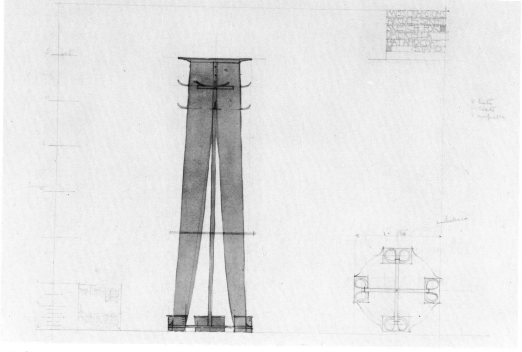

△1897.27　　　　　　1897.28▽　　　▽D1897.30　　　　　　　　　　　　　　　　　　　D1897.29△

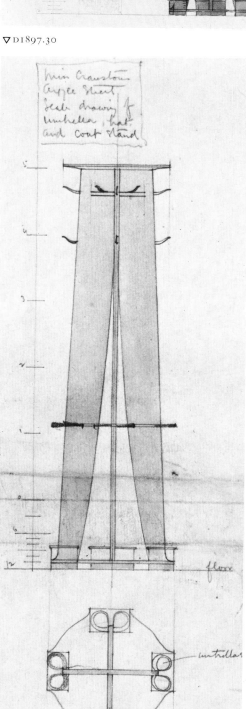

Argyle Street designs. The arrangement of the legs, as seen in D1897.29, suggests that it is basically an enlargement of the structure of the domino table, 1897.22; the ogee curves of the base, shown in the plan, are reminiscent of the earlier domino table, 1897.7.

Literature: *Moderne Stil*, IV, 1902, plate 23; *The Studio*, XXXIX, 1906, pp. *32, 34*.
Collection: untraced.

D1897.29 Design for a hat, coat and umbrella stand for the Argyle Street Tea Rooms, Glasgow
Pencil and watercolour　30.3 × 30.8cm.
Signed and inscribed, lower left, *C R/MACK-INTOSH / DES / 140 BATH STREET / GLASGOW*, and inscribed, upper right, *MISS CRANSTONS / ARGYLE STREET / SKETCH FOR / UMBRELLA / HAT AND COAT / STAND*; and various notes and measurements.
Scale, 1:12.

Design for 1897.28, probably as executed, making the executed piece about 1.5m. high by about 60cm. square.

Provenance: Mackintosh Estate.
Collection: Glasgow University.

D1897.30 Design for a hat, coat and umbrella stand for the Argyle Street Tea Rooms, Glasgow
Pencil and watercolour　28 × 9.5cm. (sight).
Inscribed, top, *Miss Cranstons / Argyle Street / Scale drawing of / umbrella, hat / and coat stand* and other notes and measurements.
Scale, 1:12.

A slightly more worked-up version of D1897.29.

Exhibited: Toronto, 1967 (72).
Collection: Dr Thomas Howarth.

1897.31　Side table for the Argyle Street Tea Rooms, Glasgow
Oak, with metal handles and decoration
86.3 × 152.4 × 53.3cm.

Probably used in the Luncheon Room. The sheet metal decoration is in the style of the Guthrie & Wells furniture of 1895–96, but otherwise the style is typical of the Tea Room pieces of 1897.

Provenance: W. Abell, Glasgow (1933).
Private collection.

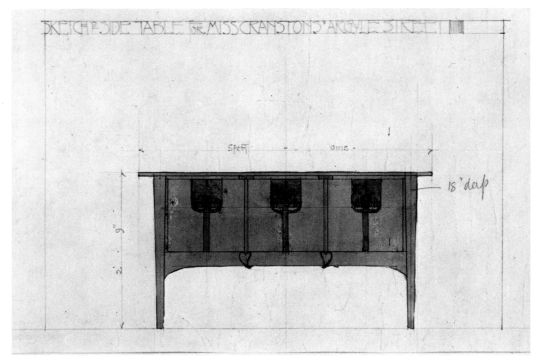

△ D1897.32

D1897.34 ▷

D1897.32 Design for a side table for the Argyle Street Tea Rooms, Glasgow
Pencil and watercolour 18.1 × 38.6cm.
Signed and inscribed, lower right, *CHAS. R. MACKINTOSH. DES. 140 BATH STREET*; and inscribed, upper left, *SKETCH OF SIDE TABLE FOR MISS CRANSTONS ARGYLE STREET*; and various other notes and measurements.
Scale, 1 : 12.

The drawing for 1897.31, as executed.

Provenance: Mackintosh Estate.
Collection: Glasgow University.

D1897.33 Design for a newspaper rack for the Argyle Street Tea Rooms, Glasgow
Pencil and watercolour 24.4 × 40cm.
Inscribed, upper left, *SKETCH FOR NEWSPAPER RACK FOR MISS CRANSTONS ARGYLE STREET*; and various other notes and measurements.
Scale, 1 : 12.

It is not known whether this piece was ever made, as it does not appear in any of the contemporary photographs; it may have been used in the Ladies' Reading Room, or one of the ground floor apartments at Argyle Street. At almost eight feet (2.4m.) wide, it seems to have been the largest single piece made for the Tea Rooms and would not easily have found a domestic resting place after the closure of the premises in 1920.

Provenance: Mackintosh Estate.
Collection: Glasgow University.

D1897.34 Design for light fittings over billiards table, Argyle Street Tea Rooms, Glasgow
Pencil and watercolour 45.2 × 24cm.
Signed and inscribed, lower right, *C R MACKINTOSH | 140 BATH STREET,* and inscribed, upper left, *MISS CRANSTONS ARGYLE ST | ELECTRIC LIGHTS | FOR BILLIARD TABLES*; and various other notes.

The only documented light fittings designed by Mackintosh at Argyle Street. The shades were executed more or less as drawn here, but the arrangement of the upper supporting wires and decoration was altered. Two sets of six lamps were made for the two billiards tables, designed by George Walton.

Literature: *The Studio*, XXXIX, 1906, p. *33*; Alison, p. 77 (no 3).
Exhibited: Milan, 1973 (3).
Provenance: Mackintosh Estate.
Collection: Glasgow University.

D1897.35 Design for light fittings for the Billiards Room, Argyle Street Tea Rooms, Glasgow
Pencil 20.8 × 38.3cm.
Signed and inscribed, lower right, *Chas R Mackintosh | 140 Bath Street*; inscribed, centre, *Reflectors for lights on partitions* and, below, *Front | to be made of iron painted white with amber jewels—|Side.*

Mackintosh is supposed only to have designed fittings for the billiards tables at Argyle Street, but a number of drawings (D1897.35–43) suggest that he was involved in other lighting designs, which may not all have been accepted by Miss Cranston. This drawing seems to relate to the partition in the Billiards Room, which is shown with loose wires protruding from it in contemporary photographs (*The*

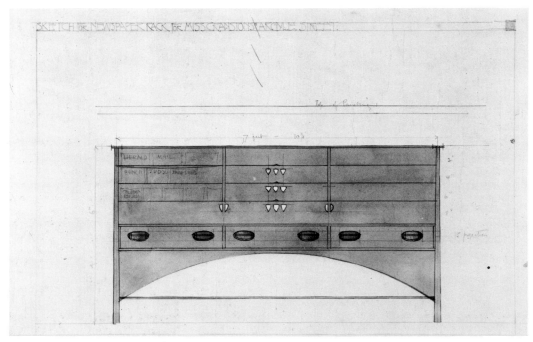

△ D1897.33

D1897.35 ▽

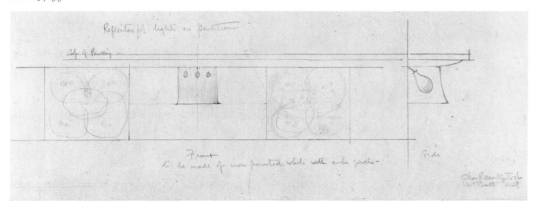

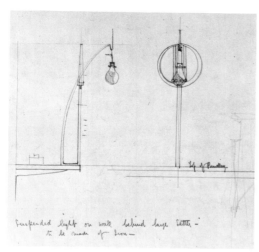

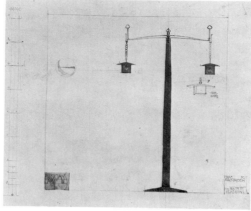

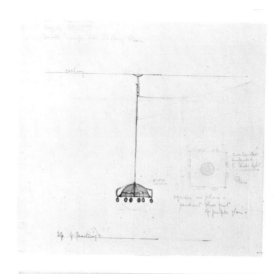

◁D1897.36 △D1897.38 D1897.40▷
◁D1897.37 ▽D1897.39 D1897.41▷

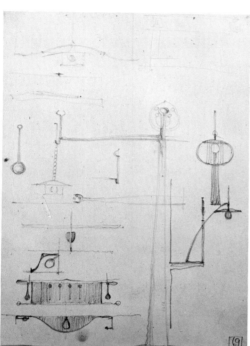

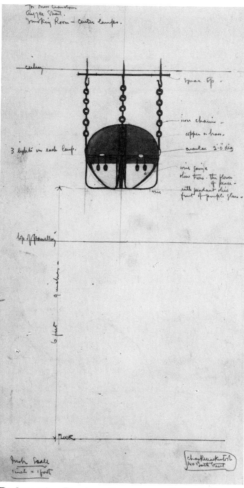

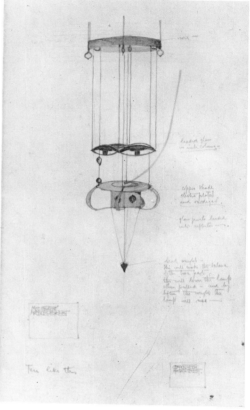

Studio, XXXIX, 1906, p. *34*). These photographs show unfinished wiring in several places, and it seems likely that Mackintosh's lamps, if they were accepted, were intended for these sites. As Walton had designed the screen, this would account for the sketchy indications of its decoration shown on this drawing.

Provenance: Mackintosh Estate.
Collection: Glasgow University.

D1897.36 Design for a light fitting for the Argyle Street Tea Rooms, Glasgow

Pencil 32.5 × 21.5cm.
Inscribed, lower centre, *Suspended light on wall behind large settle—/to be made of Iron.*

Probably intended to be used over the settees in the Billiards and Smoking Rooms, where unfinished wiring can be seen in contemporary photographs (*The Studio*, XXXIX, 1906, p. *34*). *See also* D1897.35.

Provenance: Mackintosh Estate.
Collection: Glasgow University.

D1897.37 Designs for light fittings

Pencil on page of a sketchbook 18.4 × 13.4cm.

This page of rough sketches of light fittings includes one definitely intended for the Argyle Street Tea Rooms (*see* D1897.36) as well as a preparatory sketch for the partition lighting (D1897.35). The musician's lamp seen in D1897.38 also appears here, again in an earlier version, and it seems probable that all the designs on this sheet were intended for Argyle Street.

Provenance: Mackintosh Estate.
Collection: Glasgow University.

D1897.38 Design for a musician's lamp

Pencil and watercolour 39.4 × 27.6cm.
Signed and inscribed, lower right, *CHAS R / MACKINTOSH / 140 BATH STREET / GLASGOW*, and inscribed, lower left, *MUSICIANS / LAMP.*
Scale, 1:12.

The style of both the drawing and the lamp itself suggest that this design was intended for the Argyle Street Tea Rooms. This is supported by the inclusion of the lamp on a page of sketches of light fittings including two definitely intended for Argyle Street (D1897.37). It is not known whether the lamp was ever made, or for which room it was intended.

Provenance: Mackintosh Estate.
Collection: Glasgow University.

D1897.39 Design for light fittings for the Smoking Room, Argyle Street Tea Rooms, Glasgow

Pencil and watercolour 35.1 × 17.9cm.
Signed and inscribed, lower right, *Chas R Mackintosh / 140 Bath Street*, and inscribed, upper left, *For Miss Cranstons / Argyle Street / Smoking Room—center* [sic] *lamps*; and various other notes and measurements including

olive trees—the flower / of peace / with pendant olive / fruit of purple glass.
Scale, 1:12.

Not shown in contemporary photographs, which appear to have been taken before many of the light fittings were installed. Apart from the lights over the billiards table, this was the largest fitting he had designed. The drawing indicates that a number of these were planned, but, if any were ever made, none has survived.

Provenance: Mackintosh Estate.
Collection: Glasgow University.

D1897.40 Design for light fittings for the Smoking Room, Argyle Street Tea Rooms, Glasgow

Pencil and watercolour 35.2 × 17.7cm.
Signed and inscribed, lower right, *Chas R Mackintosh / 140 Bath Street*, and inscribed, upper left, *Miss Cranstons / Argyle Street / Small lamps for Smoking Room*; and various notes and measurements, including *pendant olive fruit / of purple glass.*
Scale, 1:12.

See D1897.39.

Provenance: Mackintosh Estate.
Collection: Glasgow University.

D1897.41 Design for light fittings for the Argyle Street Tea Rooms, Glasgow

Pencil and watercolour 40.3 × 18.4cm.

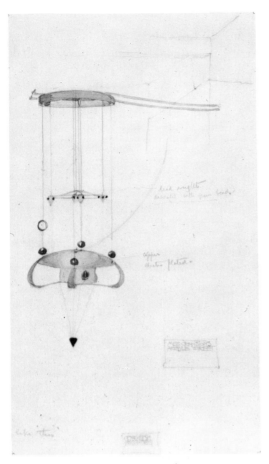

◁D1897.42 D1897.43△

lead weight—| This will make the balance | of the two parts | this will lower the lamp | when pulled— and by | lifting the weight the | lamp will rise.

Signed and inscribed, lower right, *C R MACK-INTOSH | 140 BATH STREET*, and inscribed, lower left, *MISS CRANSTONS | ARGYLE STREET*; and various other notes, including *Ten like this; leaded glass | in rich colours; glass jewels leaded | into reflector*; and

Again, there is no evidence to show that these fittings were made, but this design is quite interesting in that it develops the simple square metal shade used in the musician's lamp (1897.38). Mackintosh was eventually to adopt this square fitting with its curved over-

hanging top as one of his standard designs, although he almost always made some minor variations to the leaded-glass decoration in the side.

Provenance: Mackintosh Estate.
Collection: Glasgow University.

D1897.42 Design for light fittings for the Argyle Street Tea Rooms, Glasgow

Pencil and watercolour 38 × 21.8cm.
Signed and inscribed, lower right, *C R MACK-INTOSH | 140 BATH STREET*, and *MISS CRANSTONS ARGYLE STREET*; inscribed, *lead weights | decorated with green beads, copper | electro-plated*, and *Ten like this*.

A variant of, or preliminary study for, D1897.41.

Provenance: Mackintosh Estate.
Collection: Glasgow University.

D1897.43 Design for a light fitting for the first floor, Argyle Street Tea Rooms, Glasgow

Pencil and watercolour 41.7 × 17.2cm.
Signed and inscribed, lower right, *Chas R Mackintosh | 140 Bath Street*; inscribed, upper left, *Miss Cranstons | Argyle Street | Center* [sic] *lamp first floor*.
Scale, 1:12.

The first floor was occupied by the luncheon room, which appeared to have light fittings designed by Walton. Perhaps Miss Cranston rejected this design, or, as with some of the other fittings, the photographs could have been taken before this fitting was installed. If any were made, none has survived.

Provenance: Mackintosh Estate.
Collection: Glasgow University.

▽1897.44

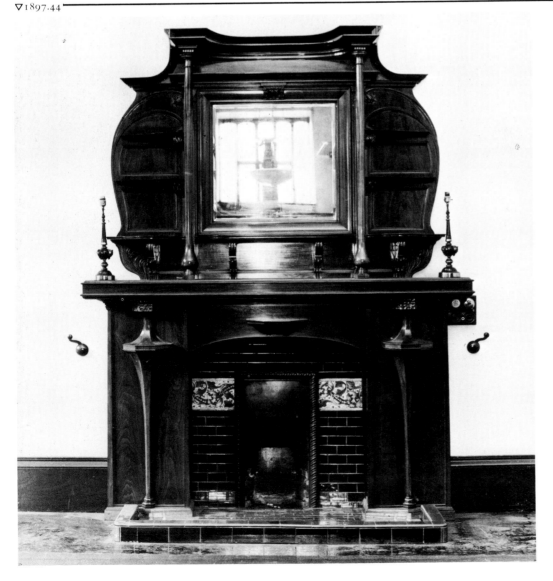

1897.44 Fireplace in the Music Room, Craigie Hall, Glasgow

Mahogany, french-polished 273 × 205.5 × 31cm.
Probably made by Thomas Brown, Glasgow.

Here, if anywhere in the Music Room, is evidence of Keppie's involvement with the commission. Mason was a Master Builder and therefore an influential client, and Keppie, as a partner in the practice, would have had at least some contact with the project; this fireplace is closer in style to the earlier work at Craigie Hall (*see* 1893.4) than it is to the organ case.

Collection: *in situ* (1978).

1897.45 Organ case for Craigie Hall, Glasgow

Mahogany, french-polished 380 (approx.) × 495 × 153cm.
The organ was made by Brindlay & Foster (Sheffield and London, dated 1897) and the case was probably made by Thomas Brown, Glasgow. The plaster figures which stood on plinths around the organ pipes were made by Miss M. McGechan, who was paid £38.5.0d. (17 February, 1898) for them.

This is the only organ designed by Mackintosh which was ever made, but it formed the basis for the organs shown in the Concert Hall design for the Glasgow International Exhibition (drawn 1898) and, in slightly more elaborate form, in the Music Room of the *Haus eines Kunstfreundes* design in 1901. The keyboard cabinet and the cupboards which contain the bellows are quite simple, but they betray their designer through the applied metalwork and mouldings. Above the keyboard rises a decorated column, tree-like, and supporting a square *cyma recta* cap like those on top of the four staircase posts in the Museum of the Glasgow School of Art. This stylised tree, which is decorated with carved and pierced

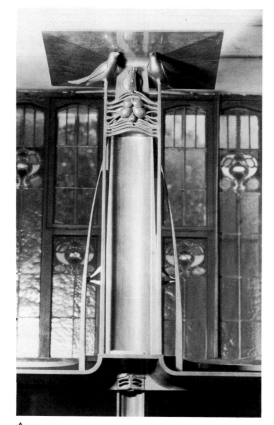

△▽ 1897.45 detail 1897.45 ▷

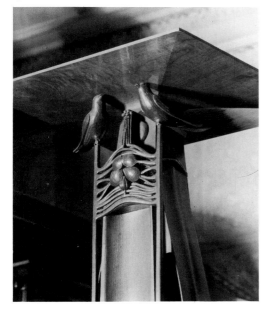

▽ 1897.46 1897.45 detail ▷

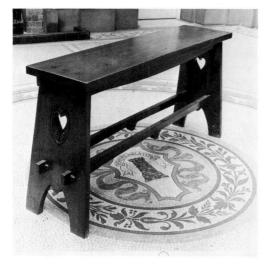

1897 Music Room at Craigie Hall, Glasgow

Mackintosh had earlier worked with Keppie at Craigie Hall for Thomas Mason, but late in 1897 he produced a design entirely his own for an organ and fireplace in the Music Room. Keppie does not seem to have been as closely involved in the job as he was in 1893–94, although the fireplace suggests that he did keep an eye on the project. The organ case is the major feature in the room, which does not otherwise seem to have been decorated by Mackintosh; indeed, the only new features in the room (designed by John Honeyman in 1872) were the organ, its stool and the fireplace.

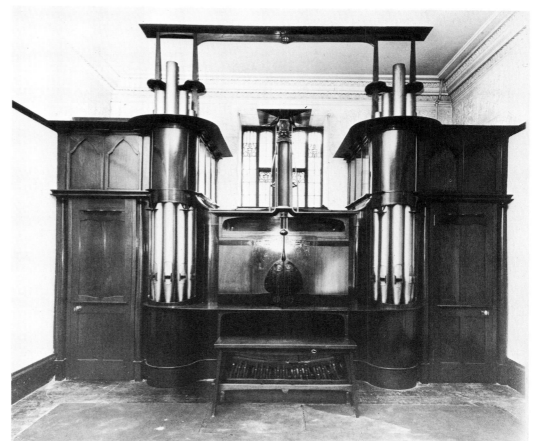

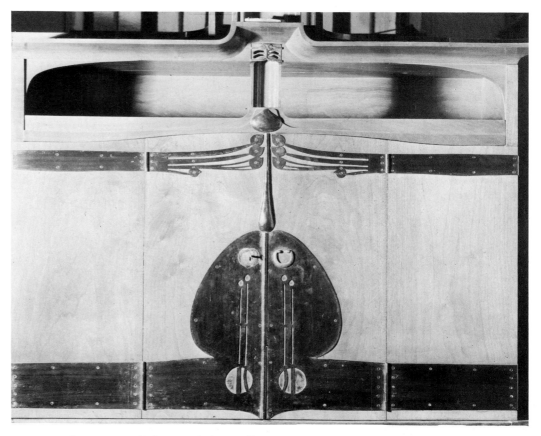

ornament including flying birds and leaf and heart motifs, is one of the most literal interpretations of organic forms in Mackintosh's work.

Collection: *in situ* (1978).

1897.46 Organ stool for Craigie Hall, Glasgow

Mahogany, french-polished 65.5 × 124 × 33cm.
Probably made by Thomas Brown, Glasgow.

A simple design with a high seat which fitted over the organ pedals. The pierced decoration and wedged joints are similar to the Gladsmuir nursery benches (1897.3 and 4).

Collection: *in situ* (1978).

1898 Dining-room for H. Bruckmann, Munich

This was Mackintosh's first documented commission outside Scotland, and it was almost certainly inspired by the Gleeson White article in *The Studio* in 1897. Bruckmann, editor of *Dekorative Kunst*, illustrated some pieces by Mackintosh in his magazine in November 1898, and it seems likely that the commission for the dining-room came during the negotiations for the November article, probably in the late spring or early summer of 1898. If so, this would pre-date the other major commission of 1898, the bedroom at Westdel; the stylistic evidence also suggests that Westdel was the later of the two.

Contemporary photographs show a dark room, with fitted furniture or a dark-coloured wallpaper reaching up to the picture rail, a white ceiling and frieze, the latter with stencilled decoration. The tables and chairs were designed by K. Bertsch, but Mackintosh was responsible for the fitted cupboards and side table, the free-standing cabinet and the double doors to the room. The design of these pieces looks back to the furniture of Guthrie & Wells and the Argyle Street Tea Rooms: there is little that is radically different. The decorated frieze, however,

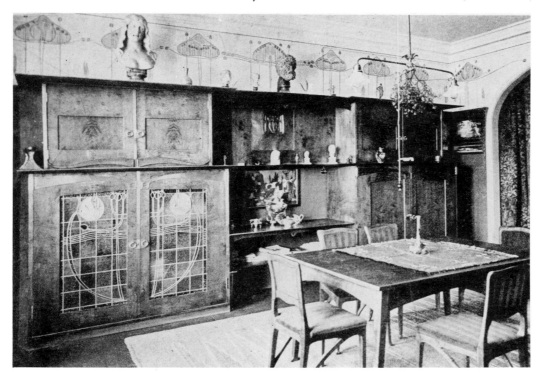

1898.A Dining-room for H. Bruckmann, Munich

1898.B Dining-room for H. Bruckmann, Munich

1898.1 Fitted cupboards and side table for H. Bruckmann, Munich
Wood, glass and metal.

This composite piece took up one wall of the dining-room. The cupboards at either end are identical, except that the left-hand one has lower doors that are glazed rather than solid; the pattern in the glass of stylised flowers and leaves was often used later, with variations in its arrangement. Mackintosh is still using wide metal hinges here, and the metal handles are also of a pattern used on earlier designs. The table top, spanning the two cupboards, has the downward projection at the centre of its apron. Untraced. *See* 1899.A.

Literature: *Dekorative Kunst*, III, 1899, p. *78*; *L'Art Décoratif*, II, 1899, p. *82*; Howarth, p. 149, plate 58a.
Collection: untraced.

D1898.2 Design for a cupboard for H. Bruckmann, Munich
Pencil and watercolour 30 × 49.3cm.
Signed and inscribed, lower right, *Chas. R. Mackintosh | 140 Bath Street | Glasgow; Cabinet for H Brückmann Esqr. Munich* and *silver panels*. Scale, 1 : 12.

The final drawings for the dining-room would have been sent to the contractor in Munich, and only preparatory studies now remain. This one shows an almost finalised design with only minor details to be altered, such as the position of the handles; the glass is not shown here, but Mackintosh has indicated two decorative metal panels in the upper doors. These panels do not appear in the contemporary photographs of the finished cupboards, but there are two recesses clearly visible which may have been intended for these, possibly

◁1898.A 1898.B▽

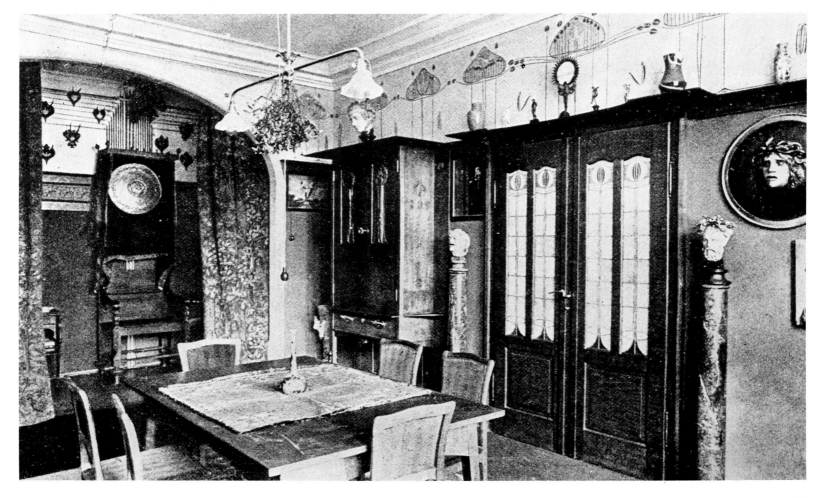

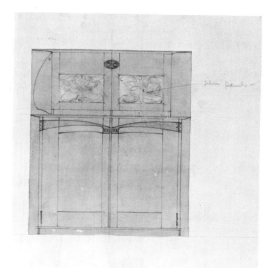

△ D1898.2 ▽ 1898.4 D1898.3 ▷

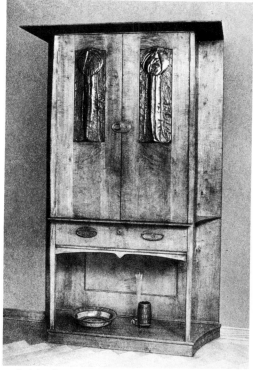

was to be used again at Westdel in a different and more successful form, and the large cabinet is obviously a prototype of the smoker's cabinet of 1899 (1899.1). The one completely new departure is the involvement of Margaret Macdonald in the scheme: the two beaten metal panels in the cabinet are probably hers, and the large panel over the side table is definitely one of her designs (an identical one was shown at Vienna in 1900 and another, or possibly the same, is at Glasgow University).

Literature: *Dekorative Kunst*, III, 1899, pp. *78–79*.

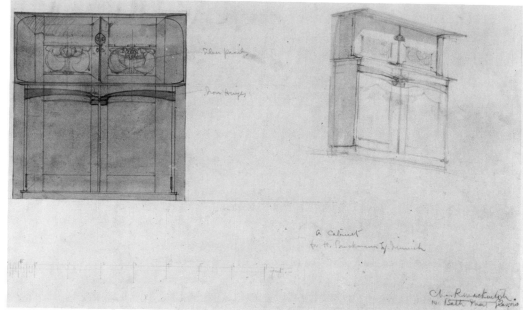

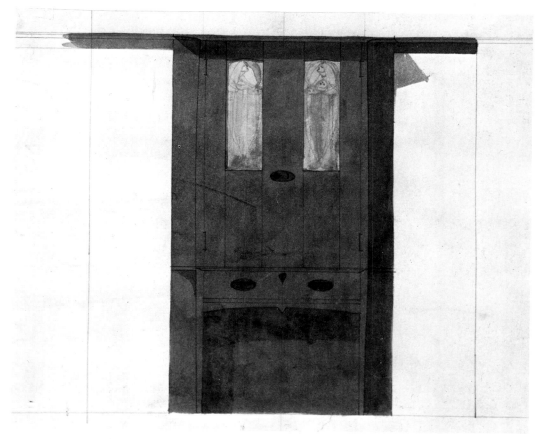

unfinished, panels. The design on the panels is the same as that on D1896.4, 1897.2 and 1898.11.

Literature: Howarth, p. 149.
Provenance: Mackintosh Estate.
Collection: Glasgow University.

D1898.3 Design for a cupboard for H. Bruckmann, Munich
Pencil and watercolour 28.2 × 44cm.
Signed and inscribed, lower right, *Chas R. Mackintosh / 140 Bath Street Glasgow*; inscribed, centre right, *A Cabinet / for H. Bruckmann Esqr. Munich*; and *silver panels; Door hinges.*
Scale, 1 : 12.

An earlier version of D1898.2.

Literature: Howarth, p. 149.
Provenance: Mackintosh Estate.
Collection: Glasgow University.

1898.4 Cabinet for H. Bruckmann, Munich
Oak, stained dark.

Possibly a smoker's cabinet, as its general shape and decoration are very close to that of Mackintosh's own smoker's cabinet (1899.1); the similarities and differences between the two are worth examining more closely. Two major features they have in common are the wide overhanging cornice connected to the flanking back panel, and the use of beaten metal panels as decoration on the doors. There

is no carved-wood decoration in 1898.4, however, and it is basically a simply stated design using flat pieces of timber for the maximum effect. The two front legs, which carry through to the cornice, taper at the top and bottom and gently swell out in the middle, a motif used on the Pickering cabinet, at Westdel, and on other pieces designed c1898. By 1899 these legs had been replaced by broad pieces of timber—in effect the downward continuation of the sides of the cupboard.

Literature: *Dekorative Kunst*, III, 1899, p. *79*; *L'Art Décoratif*, II, 1899, p. *83*; Howarth, p. 149.
Collection: Kenneth Barlow, Esq., Munich.

D1898.5 △

D1898.5 Design for a cabinet for H. Bruckmann, Munich
Pencil and watercolour 38.2 × 30.4cm. (irregular).
Signed, lower right, *Chas . . . / 140B . . .* (sheet cut), and inscribed, upper left, *Cupboard for H. Bruckmann Munich*.
Scale, probably 1 : 12.

The design for 1898.4, almost as executed.

Literature: Howarth, p. 149.
Provenance: Mackintosh Estate.
Collection: Glasgow University.

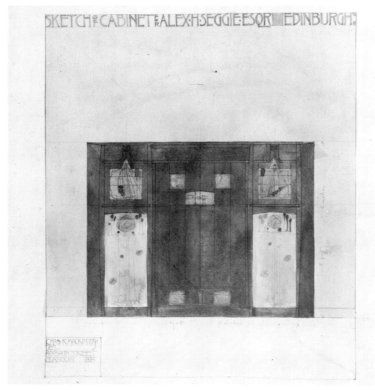

△D1898.6

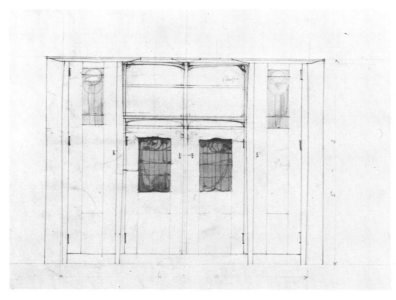

D1898.8▽

△D1898.7

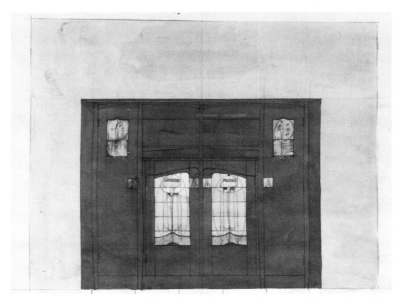

D1898.8a▽

D1898.6 Design for a cabinet for Alex Seggie, Edinburgh

Pencil and watercolour 43.4 × 34cm.
Signed, inscribed, and dated, lower left, *CHAS. R. MACKINTOSH / DES / 140 BATH STREET / GLASGOW. 1898*, and inscribed, upper centre, *SKETCH OF CABINET FOR ALEX. H. SEGGIE. ESQR. EDINBURGH.*
Scale, 1:12.

There are few pieces for which so many designs, both preparatory and final (including alternatives), still exist. D1898.6 is the only signed and dated drawing finished in the style of the Argyle Street Tea Room drawings, although D1898.7 is also signed. These two were possibly the final alternatives from which the client made his choice, although no executed cabinet is documented, nor has any been traced.
The differences between this drawing and D1898.7 are interesting. New motifs appear here alongside old ones: the type of latch and the drawer handles are like those used on the Guthrie & Wells furniture, but the stencilled panels are new (with the exception of the suggestions in D1896.10), as are the four square panels of leaded-glass with the pointed projection at the top. The device of repeating the overhang of the cornice down the two sides is used again and the four main vertical supports

of the cornice swell in the middle and taper at each end, as do the legs of 1898.4. This motif can be seen in all the designs for the Seggie cabinet and in one or two other pieces which are likely to date from 1898.

Provenance: Mackintosh Estate.
Collection: Glasgow University.

D1898.7 Design for a cabinet for Alex Seggie, Edinburgh

Pencil and watercolour 41.5 × 32.7cm.
Signed and inscribed, lower right, *Chas R Mackintosh / 140 Bath Street*, and inscribed, upper left, *CABINET FOR ALEX SEGGIE ESQR EDINBURGH.*
Scale, 1:12.

Probably an alternative to D1898.6, rather than a preliminary study. The main differences from D1898.6 are that the upper centre of the cabinet is shown here as open shelving, and that the two side cupboards are hinged and shown without the lower stencilled panels. In the upper parts of these doors are decorative metal panels, similar to those in 1898.4, and the motifs in leaded-glass on the central doors are similar to those used on the Brückmann cabinet (1898.1).

Provenance: Mackintosh Estate.
Collection: Glasgow University.

D1898.8 Design for a cabinet for Alex Seggie, Edinburgh

Pencil and watercolour 30.8 × 37.8cm.
Scale, 1:12.

An early version of D1898.7. The two central leaded-glass panels are closer to the final design, and the carved bird's head of D1898.8a has been omitted; however, a central floating *cyma recta* capital—a rather mannered feature not used for some years—is included (*see* 1894.1).

Provenance: Mackintosh Estate.
Collection: Glasgow University.

D1898.8a Design for a cabinet for Alex Seggie, Edinburgh

Pencil and watercolour 41.5 × 29.6cm.
Scale, 1:12.

Probably the first design for D1898.7: the square panels in the outer doors have been extended into vertical oblongs; there is a carved bird's head at the centre of the stylised outstretched wings above the central part; the leaded-glass panels are totally different in shape and content from those finally used; and there is a carved ogee moulding over these panels which was eventually omitted.

Provenance: Mackintosh Estate.
Collection: Glasgow University.

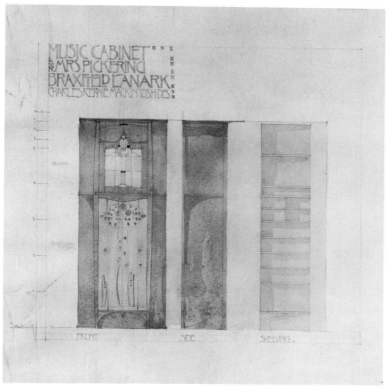

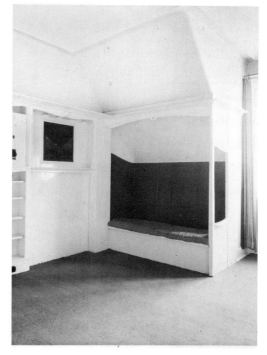

D1898.9 △
D1898.10 ▷

D1898.9 Design for a music cabinet for Mrs Pickering, Braxfield, Lanark

Pencil and watercolour 38.3 × 29.4cm.
Signed and inscribed, upper left, *MUSIC CABINET | FOR MRS PICKERING | BRAXFIELD LANARK | CHARLES RENNIE MACKINTOSH DES*; and various notes and measurements.
Scale, 1:12.

Almost certainly drawn in 1898. There are considerable similarities with D1898.6: the legs taper at their ends and swell in the centre; the leaded-glass panel has a pointed projection at the top; the cornice is continued as a solid band down the two sides; and the panel at the bottom, either stencilled or embroidered, echoes the two in D1898.6 and also that in the similar fireside cupboard at Westdel (*see* D1898.18). It is not known whether the design was executed.

Provenance: Mackintosh Estate.
Collection: Glasgow University.

D1898.10 Design for a linen cupboard for Alfred Spotteswoode Ritchie, Edinburgh

Pencil and watercolour 35.5 × 30.9cm (irregular).
Signed and inscribed, lower right, *CHAS. R. MACKINTOSH. DES | 140 BATH STREET GLASGOW*; and inscribed, upper left, *LINEN CUPBOARD | FOR ALFRED SPOTTESWOODE RICHIE ESQUIRE. EDINBURGH*, and, right, *DARK FUMED OAK | SILVER PANELS*; and various notes and measurements.
Scale, 1:12.

It is not known whether this design was executed. Howarth (p. 35, note 1) mentions a linen cupboard in the collection of a Mrs Ritchie in Edinburgh, but, even if it is the same family, the ambiguity of Howarth's note does not make it clear whether or not the piece concerned was identical to 1896.8. The style of both the design of the cabinet and the drawing itself appear to be later than 1896, as the use of metal panels like those shown does not begin until 1898. The handles and latches were also still used in 1898 (*see* D1898.6), but the organic inlaid decoration at the top is reminiscent of the coloured wood inlays in the Gladsmuir cabinet (1896.8).

Provenance: Mackintosh Estate.
Collection: Glasgow University.

1898 Bedroom for J. Maclehose at Westdel, Glasgow

Westdel, 2 Queen's Place, Glasgow was the home of the Glasgow printer and publisher, J. Maclehose. Mackintosh designed only one room in his house, a second floor bedroom with a dormer window, and its adjoining bathroom. The room has survived intact, although the bed and wall decorations have long since disappeared, and it was dismantled and transferred to the Glasgow University collection in 1976. One drawing for the scheme was exhibited in Glasgow in January 1899. It is the first recorded 'white room' to be designed by Mackintosh, and was probably designed late in 1898, concurrently with, or just before, the director's room at the Glasgow School of Art. The frieze is very similar to that used at Brückmann's house (1898.A) but, like most of his dining-rooms, Mackintosh made that room quite dark and used no white painted furniture in it.

▽1898.C
1898.D ▽

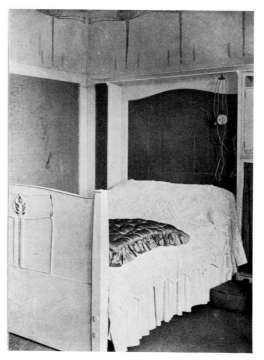

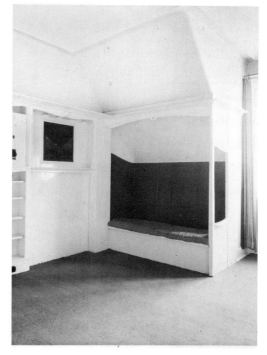

1898.C Bedroom at Westdel, Queen's Place, Glasgow

A contemporary photograph showing the bed (1898.15), now lost, and the stencilled wall decoration.

1898.D Bedroom at Westdel, Queen's Place, Glasgow

This photograph was taken in 1968; the original fireplace has been boxed in and the wall decorations painted out.

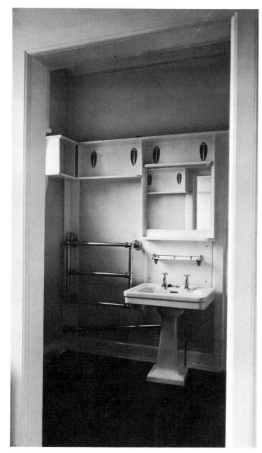

△1898.E

1898.E Bathroom fittings at Westdel, Queen's Place, Glasgow

1898.11 Wardrobe for Westdel, Queen's Place, Glasgow
Cypress, painted white, with metal handles and two beaten metal panels 207.5 × 159.8 × 56.8cm.

The beaten metal panels are identical with those on 1897.2, and those in the fireplace design D1896.4. Here they are used to give relief to the rather stark but bulky lines of this white-painted wardrobe. The doors erupt to form a frame around them, an unusual motif rarely found in Mackintosh's furniture, but it produces an effect like that achieved in his picture frames. The broad hinges above them have an Arts & Crafts lineage, but the raised carving of the architrave and cornice are a distinct advance on the carving of the Argyle Street furniture. See D1898.20.

Literature: *Dekorative Kunst*, IX, 1902, p. *209*.
Provenance: J. Maclehose.
Collection: Glasgow University.

1898.12 Bathroom fittings for Westdel, Queen's Place, Glasgow
Pine, painted white, with coloured glass inlays.
See 1898.E

Provenance: J. Maclehose.
Collection: Glasgow University.

1898.13 Fireplace for Westdel, Queen's Place, Glasgow
Pine, painted white 210 × 107 × 17cm.

Mackintosh repeats the carved motif of the wardrobe in the centre of the mantelpiece and also forms a frame around the metal panel in an identical manner to those on the wardrobe doors. The panel, a stylised peacock, has more in common with the desk and settle (1897.1 and 1895.5) than the delicate panels in the Brückmann cabinet; it seems likely that this, and the two wardrobe panels, are of his own design and execution rather than Margaret's. The

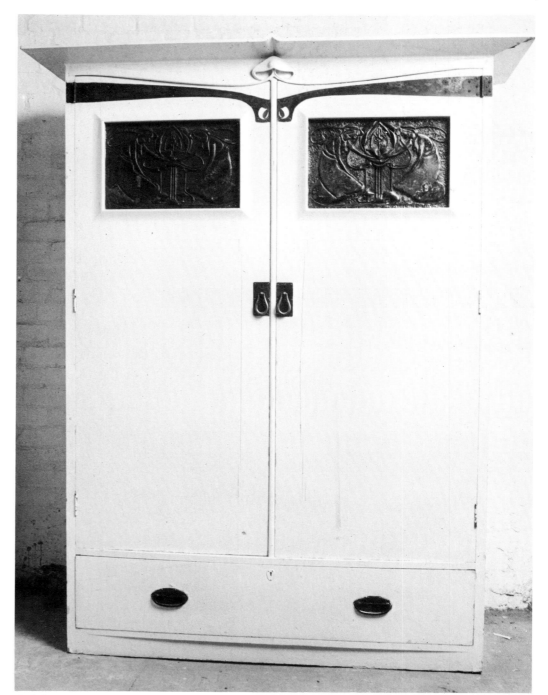

△1898.11

1898.11 detail ▽

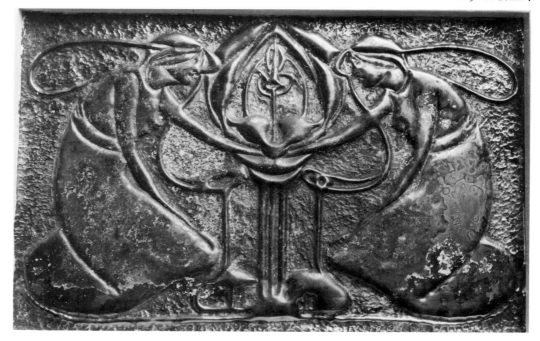

grate was of a simple design, possibly the original one, but more likely a Caird Parker grate (which Mackintosh used in several later jobs); it was surrounded by ceramic tiles and

not the elaborate stonework shown on D1898.18. See 1898.D.

Provenance: J. Maclehose.
Collection: Glasgow University.

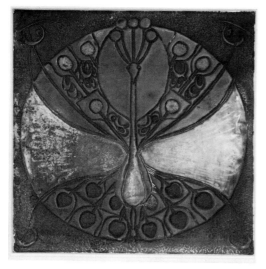

△1898.13 detail

1898.17▷

1898.14 Cupboard for Westdel, Queen's Place, Glasgow
Pine, painted white 210 × 46 × 23cm.

Mackintosh used vertical cupboards at the side of the fireplace on other jobs (e.g. The Hill House, 1903). This cabinet is quite similar to the music cabinet designed for Mrs Pickering (D1898.9), which may also have been intended to stand at the side of a fireplace. Originally a curtain was used to cover the lower shelves. *See* 1898.D.

Literature: *Dekorative Kunst*, IX, 1902, p. *209*.
Provenance: J. Maclehose.
Collection: Glasgow University.

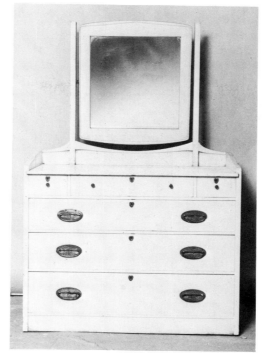

1898.15 Bed for Westdel, Queen's Place, Glasgow
Wood, painted white.

A prototype of the white beds at 120 Mains Street, Windyhill, and The Hill House. No bedhead was designed; the top of the bed fitted into a recess, and the wall above it was decorated with an embroidered panel (an arrangement similar to that used at The Hill House in 1903).

The foot of the bed was decorated with raised carving, which was similarly used on most of the later beds.

This bed was acquired along with the rest of the furniture in the room when Westdel became the property of Glasgow University, but it disappeared during the subsequent tenancy of one of the professors and has not been traced. *See* D1898.18 and 1898.C.

Literature: *Dekorative Kunst*, IX, 1902, p. *209*.
Provenance: J. Maclehose.
Collection: untraced.

1898.16 Settle, with high upholstered back, for Westdel, Queen's Place, Glasgow
Pine, painted white 210 × 196 × 62cm.

The settle was ingeniously fitted under the sloping roof of the bedroom, at the side of the dormer window. The back rest was stencilled or embroidered with stylised plant forms, but the original covering has now disappeared. Mackintosh has used a motif of four squares, cut out of the upper part of the side of the settle; this is the earliest appearance of this particular motif which was used in many later designs and was taken up by the Viennese designers. *See* 1898.D.

Literature: *Dekorative Kunst*, IX, 1902, p. *208*.
Provenance: J. Maclehose.
Collection: Glasgow University.

1898.17 Dressing-table for Westdel, Queen's Place, Glasgow
Oak, painted white with metal handles 90 × 71 × 52cm.

Provenance: J. Maclehose.
Collection: Glasgow University.

D1898.18 Design for the upper bedroom, Westdel, Glasgow: elevation of the south wall
Pencil and watercolour 23.6 × 42.9cm.
Scale, 1:12.

This is probably the final design for the south wall. It is the first time that such prominent carved decoration is used on Mackintosh's bedroom furniture, and looks forward to the Windyhill and Mains Street pieces of 1900–1901. One of the most interesting features is the use of a group of four small squares pierced in the gable of the settle; this motif was later used by the Viennese designers, but Mackintosh used it here before he had any contact with Vienna and before any such motif seems to have been illustrated in the journals.

Literature: Alison, p. 77 (no 9); Billcliffe and Vergo, fig. 2.
Exhibited: (?) Institute of Fine Arts, Glasgow, 1899 (702); Edinburgh, 1968 (142); Milan, 1973 (9).
Provenance: Mackintosh Estate.
Collection: Glasgow, University.

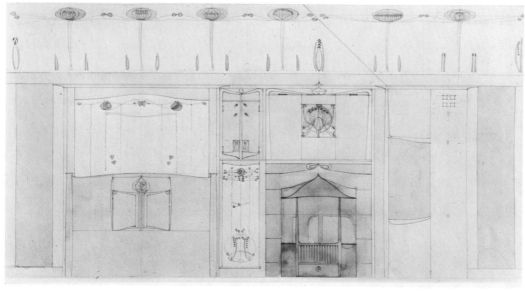

△D1898.18

D1898.19▽

D1898.19 Design for the upper bedroom, Westdel, Glasgow: elevation of the south wall
Pencil and watercolour 32.4 × 50cm.
Scale, 1:12.

A preliminary sketch for D1898.18. The only differences seem to be in the treatment of the fireplace and the size of the decorative panel over it; in fact the larger panel, shown in this drawing, was eventually made.

Literature: Alison, p. 77 (no 10).
Exhibited: Milan, 1973 (10).
Provenance: Mackintosh Estate.
Collection: Glasgow University.

D1898.20 Design for a fireplace for the upper bedroom, Westdel, Glasgow
Pencil and watercolour 31.6 × 40.5cm. (ir-regular).

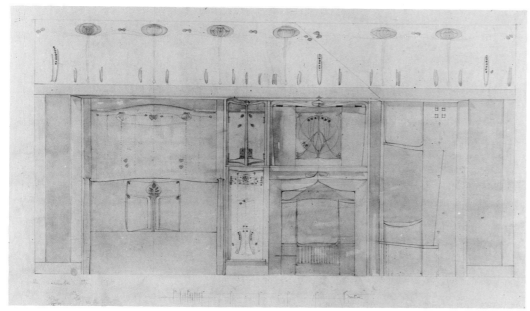

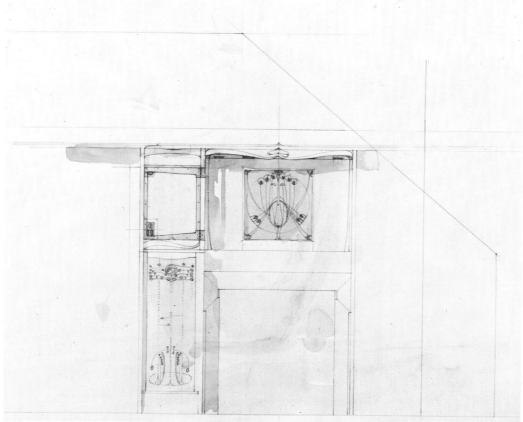

△ D1898.20

Signed and inscribed, lower right, *Chas R Mackintosh Des. / 140 Bath Street*, and inscribed, upper right, *20*.
Scale, 1:12.

The earliest surviving design for this scheme. The metal bands on the cupboard echo those on the wardrobe (*see* 1898.11), but the design which was finally adopted can be seen lightly sketched in on top of these.

Provenance: Mackintosh Estate.
Collection: Glasgow University.

D1898.21 Design for the upper bedroom, Westdel, Glasgow: elevation of the north wall

Pencil and watercolour 23.6 × 42.9cm.
Scale, 1:12.

Virtually as executed, the only differences being the absence of candle-holders on the finished chest-of-drawers, different panels in the bath-room and wardrobe doors, and a different chair. The wardrobe (1898.11) has closer ties with Mackintosh's earlier work than any of the pieces in this room; the chair is similar to others designed for the Argyle Street Tea Rooms in 1897 (1897.27), but it was intended here to have had a much higher back, which was erased by Mackintosh. This type of chair was never used at Westdel, for the contemporary illustrations show a rush-seated chair in the room.

Literature: Alison, p. *48*, 77 (no 11).
Exhibited: (?) Institute of Fine Arts, Glasgow, 1899 (702); Milan, 1973 (11).
Provenance: Mackintosh Estate.
Collection: Glasgow University.

D1898.22 Design for the upper bedroom, Westdel, Glasgow: elevation of the west wall

Pencil and watercolour 23.6 × 34.1cm.
Scale, 1:12.

Virtually as executed, although candle-holders were omitted from the finished chest-of-drawers, and Mackintosh was unable to change the window in the room, which was narrower and ran through almost to the ceiling.

Literature: Alison, p. 77 (no 12).
Exhibited: (?) Institute of Fine Arts, Glasgow, 1899 (702); Milan, 1973 (12).
Provenance: Mackintosh Estate.
Collection: Glasgow University.

D1898.23 Design for a settle for upper bedroom, Westdel, Glasgow

Pencil and watercolour 27.5 × 39.2cm.
Inscribed, upper centre, *make this 6½*.
Scale, 1:12.

D1898.21▽

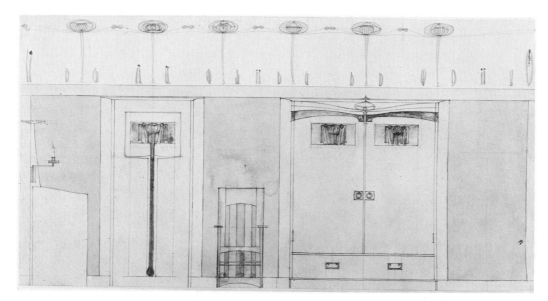

◁ D1898.22

D1898.23▽

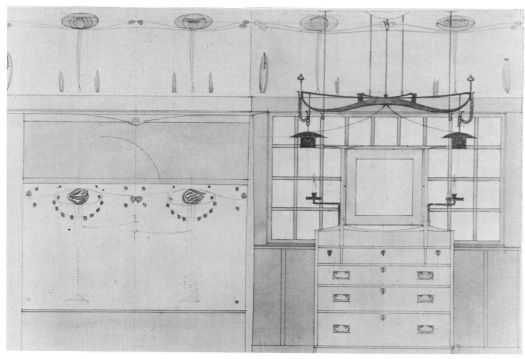

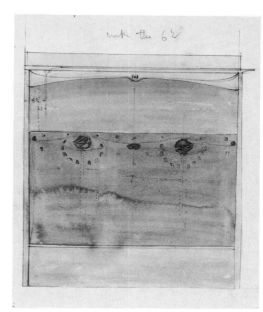

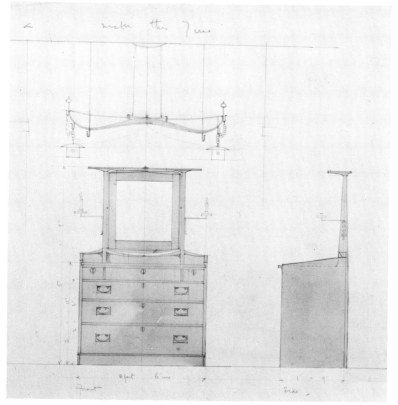

△D1898.24

D1898.25△

Possibly later than D1898.22, because it incorporates the same kind of carved detail that was used in the executed settle, 1898.16.

Provenance: Mackintosh Estate.
Collection: Glasgow University.

D1898.24 Design for a dressing-table and pendant light fitting for upper bedroom, Westdel, Glasgow

Pencil and watercolour 31.1 × 35.8cm.
Inscribed, upper centre, *make this 7 ins*; and with various notes and measurements.
Scale, 1:12.

Virtually as executed, but with minor differences in dimensions; the candle-holders are only lightly pencilled in here (*see* D1898.21).

Provenance: Mackintosh Estate.
Collection: Glasgow University.

D1898.25 Design for a dressing-table for upper bedroom, Westdel, Glasgow

Pencil and watercolour 34.5 × 26.4cm.
Scale, 1:12.

Possibly the earliest design for the dressing-table, 1898.17.
Provenance: Mackintosh Estate.
Collection: Glasgow University.

1899.1 Smoker's cabinet

Oak, stained dark, with beaten copper panels by Margaret Macdonald (? 194.8 × 106 × 38.8cm.).

A development of the design made for Bruckmann (*see* 1898.4), but far more assured and successful. The broad planes of the legs, the gables and the rear panels are broken only by the raised carved decoration beneath the doors, which rises through a central rib to the leaf motif at the apex of the curved cornice. Presumably designed for Mackintosh's own use, it is the first piece to incorporate metal panels signed by Margaret Macdonald (dated 1899). It was later exhibited at Vienna, where it was bought by Hugo Henneberg and incorporated in the house on the Hohe Warte designed for him by Josef Hoffmann. Mackintosh replaced it in his own home by an exact replica (*see* 1903.1), including the two panels which on this occasion are signed *Margaret Macdonald Mackintosh 1903*.

Literature: *Ver Sacrum*, 1901, issue 23, p. *384*; *Dekorative Kunst*, VII, 1901, p. *172* (panels only, *171*); *Das Interieur*, IV, 1903, p. *139*; Howarth, plate 59c; Sekler, p. *455* (in the Henneberg House; this photograph is also included in Sekler's introduction to the catalogue of the Vienna version of the Centenary Exhibition); Billcliffe and Vergo, fig. *5*.
Exhibited: Vienna Secession, 1900.
Provenance: C. R. Mackintosh; Hugo Henneberg.
Collection: untraced.

D1899.2 Design for a smoker's cabinet

Pencil and watercolour 32.2 × 35.6cm. (irregular).
Signed and inscribed, lower right, *Chas R*

Mackintosh / 140 Bath Street Glasgow, and inscribed, upper left, *SKETCH DESIGN FOR SMOKERS CABINET*.
Scale, 1:12.

This drawing is almost certainly for the first of the two executed smoker's cabinets (*see* 1899.1 and 1903.1); it differs in small details like the form of the carving, and the decorative detail shown here on the side was omitted from the finished pieces.

Literature: Glasgow School of Art, *Furniture*, no 27a.
Provenance: Mackintosh Estate.
Collection: Glasgow University.

D1899.2▽

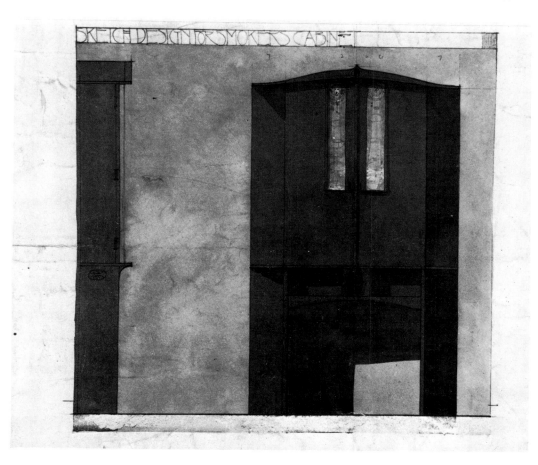

D1899.3 Designs for a smoker's cabinet and the entrance light fitting for the Glasgow School of Art
Verso: designs for light fitting over entrance staircase, Glasgow School of Art.
Pencil on paper, a loose sheet contained in a sketchbook 10.2 × 15.1cm.

The earliest design for 1899.1. The date of 1899 is confirmed by its juxtaposition with the sketches for the suspended light fitting over the steps to the School of Art, which was opened in 1899. The design is quite close to that finally

executed, except that there is a great deal more carved decoration. Mackintosh seems to have originally intended to continue the body of the cupboard to the outer edges—as opposed to his final confinement of the cupboards within the line of the legs—and to apply a raised carved ring over the cupboards, its diameter being the width of the cabinet. The two metal panels can be clearly seen even in this early stage of the design.

Provenance: Mackintosh Estate.
Collection: Glasgow University.

△1899.A
◁D1899.3 1899.B ▽

1899.A Door at 233 St Vincent Street, Glasgow

1899.B Panelling in 233 St Vincent Street, Glasgow

1899.C Roof timbers at 233 St Vincent Street, Glasgow

1898–99 Office premises at 233 St Vincent Street, Glasgow
This commission was for an extension to existing offices on the site, with a new street door and area window and some new panelling in the existing building. Apart from the door (1899.A) made by Guthrie & Wells, the most interesting features of the design are the two small rooms in the rear extension, both of which have roof beams which echo the arrangement of the roof timbers in the Museum at the School of Art. Mackintosh was not as daring here, however, as at the School, and the design of the timbers has overtones of Keppie—polished wood and more conventional decoration. More typical Mackintosh motifs can be seen in the wall panelling. The commission was not a major one, and is outside the mainstream of Mackintosh's development as seen at Westdel, Queen's Cross Church, and the School of Art in 1898–99.

Tenders were received in the office in December 1898, and payments were made up to March 1900. The main contractor and joiner was Hutcheson & Grant, and the total cost of the job was £1474.8.2½d.

▽1899.C 1899.C▽

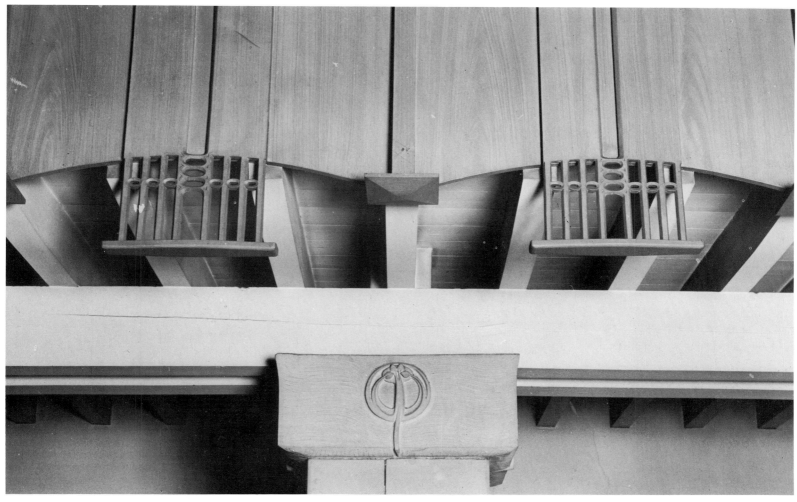

△1899.D

1899.D Details of pendants in the gallery balustrade, Queen's Cross Church, Glasgow

1899.E The Chancel, Queen's Cross Church, Glasgow

1899.F Roof trusses in the hall, Queen's Cross Church, Glasgow
Mackintosh designed a simplified version of the roof trusses at the School of Art Museum for the church hall. Here he has used a stylised tree as decoration.

▽1899.E 1899.F ▷

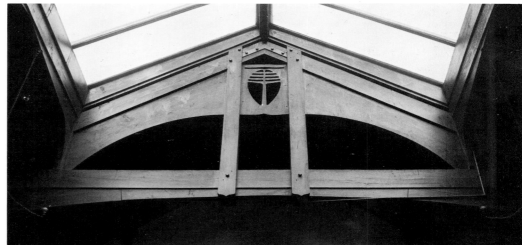

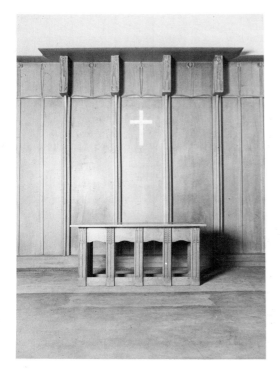

1899 Queen's Cross Church, Glasgow

Howarth recounts the history of the church (pp. 175–76), which was designed by Mackintosh in 1897–98 and opened for worship on 10 September 1899; it seems likely that much of the furniture was designed in 1899, contemporary with the fitting-out of the School of Art (*see* D1899.5). Apart from the individual pieces described below, there are a number of other features in the church which are relevant to Mackintosh's development as a designer. The church and the School of Art have the first panelled interiors to appear in his work. At the School, the panelling is rather more simple—even crude—but the basic unit of broad boards butt-jointed, with a narrow cover slip, is common to both buildings. Both were stained dark, although the staining has been removed at the church, and some panelling at the School was always painted white. At the church, particularly in the chancel, the panelling is decorated with floral motifs, and the reredos has stylised tulips on its projecting capitals. Some of the doors at Queen's Cross Church have three tall, narrow panes of glass, above which is often a kidney-shaped panel of coloured glass (Macleod, plate 46). A similar motif has been used along the fronts of the two galleries, where it becomes far more elaborate, projecting down below the bottom of the balcony as an openwork carved pendant, a motif which was later used on a number of occasions, culminating in the *tour de force* of the Library pendants at the School of Art in 1909.

Literature: Howarth, pp. 175–80, plates 70, 71.

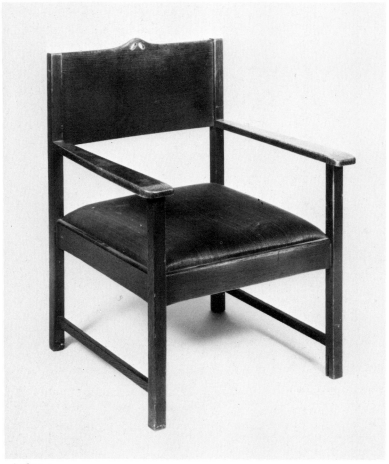

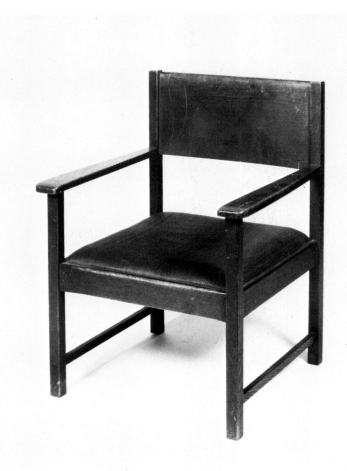

△1899.4

1899.6△

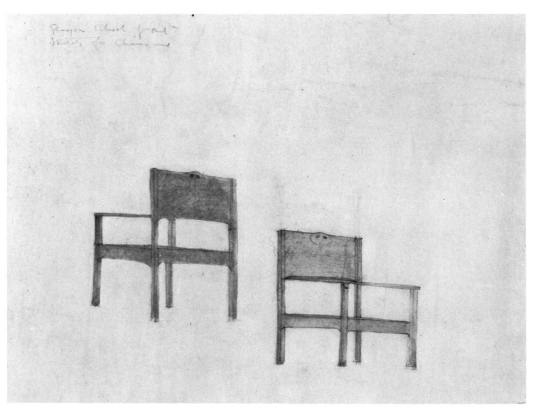

△D1899.5

1899.4 Armchair for Queen's Cross Church, Glasgow

Oak, stained dark, with horsehair upholstery
90.5 × 65 × 61cm.
Francis Smith was paid £16.16.6d. for the 'communion table, chairs etc.' in 1899 (no day or month given).

A very simple design, which seems to have been intended for the Glasgow School of Art as well (see D1899.5). The only difference between this chair and 1899.6 is the inclusion here of a pierced petal motif in the centre of the back rest.

Literature: Studio Special Number, 1901,

p. *113*; *Das Englische Haus*, I, plates 172, 174; Howarth, plates 12a, 13a, 71a; Alison, pp. 46, 47.
Exhibited: Edinburgh, 1968 (216).
Provenance: a) Davidson Estate; b) Queen's Cross Church; Sotheby's Belgravia, 10 November, 1976 (lot 72), bought by Philippe Garner.
Collection: a) Glasgow University; b) Philippe Garner.

D1899.5 Design for an armchair for the Glasgow School of Art and Queen's Cross Church

Pencil and watercolour 26.8 × 39.5cm.
Inscribed, upper left, *Glasgow School of Art / Sketch for Chairs—*.

The design for 1899.4, which was used at Queens' Cross Church. These chairs never seem to have been used at the Glasgow School of Art; perhaps Newbery turned them down or could not afford them and the design was put to use at the church instead.

Provenance: Mackintosh Estate.
Collection: Glasgow University.

1899.6 Armchair for Queen's Cross Church, Glasgow

Oak, stained dark, with horsehair upholstery
87.7 × 63.8 × 60.8cm.
Francis Smith was paid £16.16.6d. for the 'communion table, chairs etc.' in 1899 (no day or month given).

A variant of 1899.4. Two were made for Queen's Cross Church.

Provenance: Queen's Cross Church; Sotheby's Belgravia, 10 November, 1976 (lot 73, two chairs).
Private collection.

1899.7 Stand for the collection dish, Queen's Cross Church, Glasgow

James Hutchison was paid £2.5.0d. for copper plates (7 February, 1900).

A very simple design, but the carved motif of a bird and a bee seems unusual for a piece of church furniture, although the bird was used in the pulpit and was by now a favourite Mackintosh motif. Two examples were made.

Provenance: Queen's Cross Church: transferred to Ruchill Church, Glasgow, in 1976.
Collection: Ruchill Church, Glasgow (on loan to Queen's Cross Church).

1899.8 Pulpit for Queen's Cross Church, Glasgow

Oak, 385cm. high.
The Bennett Furnishing Company was paid £25.14.0d. for a desk and seat on 8 February, 1900; this may refer to the pulpit, because the

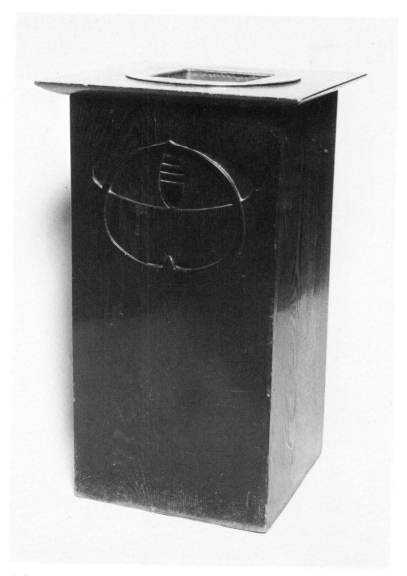

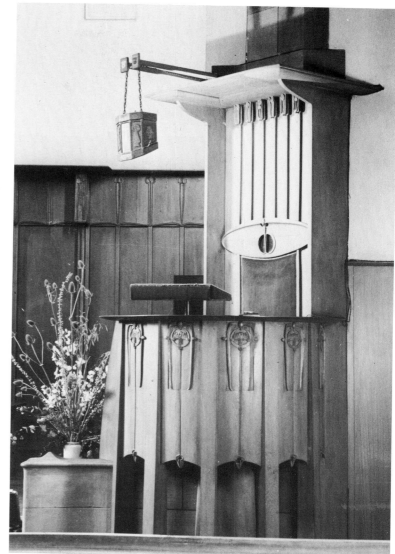

△1899.7

△1899.8

1899.8 detail▽

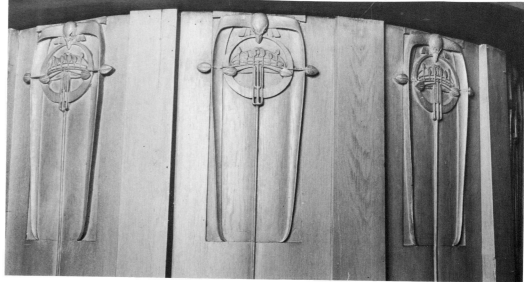

same firm had made pulpits and chancel fittings for other Honeyman & Keppie churches.

One of the largest pieces of furniture designed by Mackintosh at this date, the pulpit is supported on a stone column and positioned against the liturgical south pier of the chancel arch. It curves out from the pier towards the nave, supported on six stout wooden posts which terminate beneath a cornice-like shelf. The velvet upholstered seat is crowned by a wide oval panel, spanning the full width of the rear panelling which in turn supports the sounding board. The pulpit is decorated with carvings of birds and leafy stems, the bird becoming most stylised in the oval back panel which is reminiscent of the oval backrail chairs designed for Argyle Street (*see* 1897.23).

Literature: Howarth, p. 179, plate 71a; Macleod, plates 45, 46, 47.
Collection: Church of Scotland (still in Queen's Cross Church, now leased to the Charles Rennie Mackintosh Society).

1899.9 Communion table for Queen's Cross Church, Glasgow

Oak, stained dark 72.5 × 152.3 × 67.8cm.
Francis Smith was paid £16.16.6d. for the 'communion table, chairs etc.' in 1899 (no day or month given).

Mackintosh's version of a medieval, and probably English, altar.

Literature: Howarth, plate 71a; Macleod, plates 45, 46.
Provenance: as 1899.
Collection: Ruchill Church, Glasgow (on loan to Queen's Cross Church).

1899.9 ▷

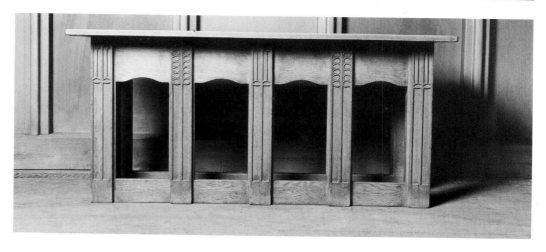

1899 The Glasgow School of Art

The first phase of the School of Art was opened in December 1899, and there is no evidence to suggest that Mackintosh did other than follow his usual practice of designing the loose furniture and fittings in the last few months before completion. Stylistically, the interiors and the few pieces of furniture are more advanced than those of the Argyle Street Tea Rooms and are closer to the work at Westdel and Queen's Cross Church. There is not a lot to add to Howarth's description of the interiors (pp. 85–92), but one must always bear in mind that Mackintosh was working to a tight brief and budget. Most of the interior is panelled as at Queen's Cross, with butt-jointed pine boards (sometimes with a cover slip at the joint), a *cyma recta* cornice and a low skirting. The main staircase has four square, tapering posts, joined by open balustrading with a single continuous horizontal cornice which ignores the rake of the stair. Virtually the only decoration was in the panels of leaded-glass in many of the doors and some pierced shapes in the beams of the Museum roof. In the Board Room and the Headmaster's Room, however, Mackintosh had a little more licence. The original Board Room was in the east wing, and was probably never used as such, because space was at a premium in the half-finished building and it was pressed into service as a studio. It contains four tall bow windows and a large stone fireplace around a traditional grate. Presumably the surviving early furniture (1899.13, 14) was intended for use in here, but until their new Board Room was completed in 1906, the Governors met in the Secretary's office.

The Headmaster's Room (*see* 1899.H) is the second white room which Mackintosh designed, and it is altogether more ambitious than the, admittedly somewhat cramped, bedroom at Westdel of 1898. No movable furniture seems to have been designed for it on this occasion, and Newbery had to wait until 1904 for furniture to match his surroundings.

There are a number of odd pieces of furniture in the School which, if designed by Mackintosh at all, are difficult to date with any accuracy. The attenuated easels (Macleod, plate 97) do not appear in contemporary photographs (*The Studio* XIX, 1900, pp. 53–55) and probably date from 1909–10. Various other simple stools and palette tables, although rather crude, are not out of keeping with the interiors, and it seems likely that Mackintosh had a hand in their design (*see The Studio*, XIX, 1900, pp. 54–55; Bliss, plates 40, 58).

Literature: Howarth, pp. 69–92, plates 21–31; Bliss.

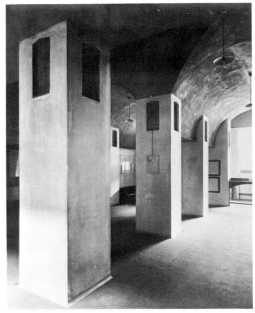

1899.G △

1899.G Entrance hall, Glasgow School of Art
Photographed in 1910 by Bedford Lemere.

Collection: RCAHMS.

1899.H The Director's Room, Glasgow School of Art
This photograph, which shows the armchair (1904.27), was taken by Bedford Lemere in 1910. The rest of the Director's furniture, designed in 1904, had been taken to the Board Room (*see* 1906.A).

Collection: RCAHMS.

1899.H ▽

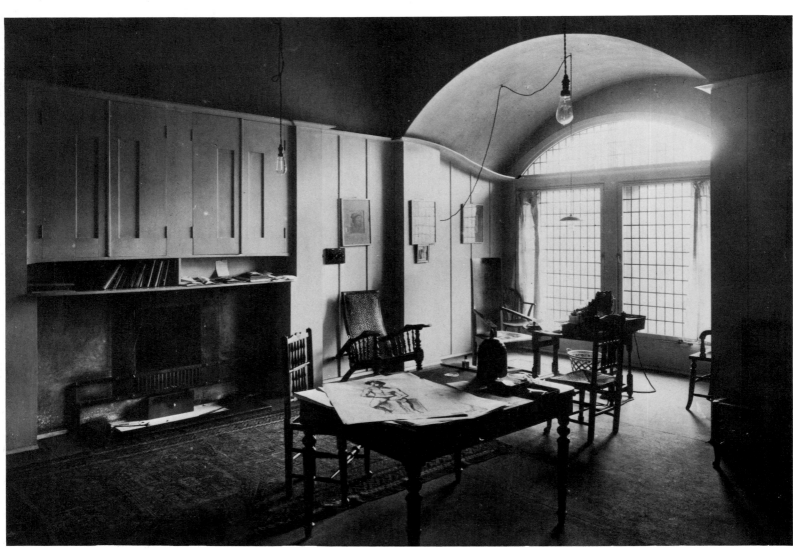

1899.I The Museum, Glasgow School of Art

Photographed by Bedford Lemere in 1910.

Collection: RCAHMS.

1899.J Board Room, Glasgow School of Art

This photograph was taken in 1910 by Bedford Lemere; it shows the old Board Room in use as a design studio.

Collection: RCAHMS.

1899.K Board Room, Glasgow School of Art

A photograph taken around 1906, showing the fireplace, wall panelling and Board Room chair (1906.2).

Collection: Glasgow University.

1899.L East corridor, Glasgow School of Art

Photographed in 1910 by Bedford Lemere.

Collection: RCAHMS.

1899.10 Fitted cupboards in the Director's Room, Glasgow School of Art

Pine, painted white, with leaded glass panels and metal handles 272 × 235 × 92.5cm.

Fitted within the depth of the staircase from the office to the private studio. When the doors are closed the impression given is that the panelling carries around the room unbroken, but the cover strip is in fact attached to one of the doors. The simple motif in the four leaded-glass panels, and the door to the washroom, was later developed in a more elaborate fashion in the screen at the Ingram Street Tea Rooms in 1900. To the left of the cupboards is the staircase to the private studio, and Mackintosh again makes a play on his cover strip motif, here turning it into a balustrade so that the solid boards between the strips become voids between the balusters along the line of an ogee curve.

Literature: Howarth, p. 89, plate 27a; Bliss, plates 35, 36.
Collection: Glasgow School of Art.

△1899.I

1899.J▽

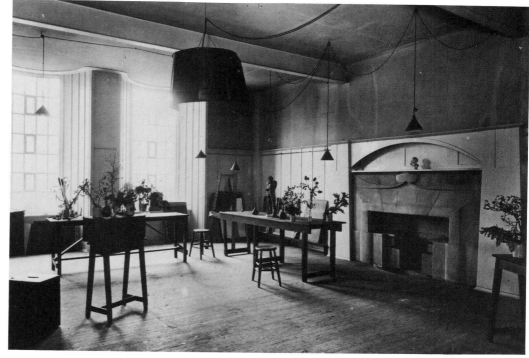

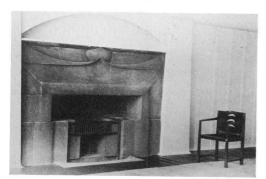

△1899.K ▽1899.L 1899.10▷

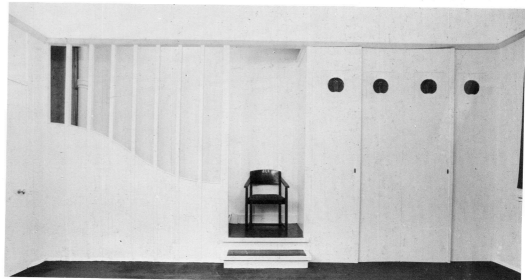

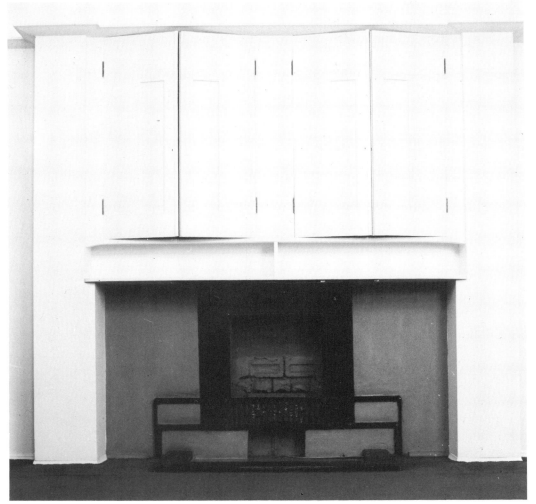

1899.11 Fireplace for the Director's Room, Glasgow School of Art

Pine, painted white 272 × 289 × 26.5cm.

The first, and largest, of a series of fireplaces which were to be major features of Mackintosh's designs for interiors, others being at 120 Mains Street (1900.1), Dunglass (1900.36), Windyhill (1901.35), The Hill House (1903.71) and Hous'hill (1904.60).

The grate is black-painted steel and is Mackintosh's version of a traditional design. Either side of it is plain cement rendering, often decorated in later designs with coloured glass inlays. Above the wide shelf are four cupboards reaching up to the cornice. The fireplace is the most dominant feature in the room, taking up over a third of the west wall.

Literature: Bliss, plate 34; Pevsner, 1968, plate 17.
Collection: Glasgow School of Art.

1899.12 Settle for the entrance hall, Glasgow School of Art

Pine, stained dark 71 × 163 × 48.5cm.

Three examples of this most simple design were made to fit into the three bays of the entrance hall.

Literature: Bliss, plate 24.
Collection: Glasgow School of Art (3).

1899.13 Armchair for the Board Room, Glasgow School of Art

Oak, stained dark, with upholstered seat 75.3 × 56.2 × 46.8cm.

Designed for the original Board Room in the east wing of the School of Art. The Governors never used the room for meetings; space was at a premium in the half-finished building, and the Board Room was used as a studio, while the Governors met in the secretary's office.

Literature: Glasgow School of Art, *Furniture*, no 1; Alison, pp. 36, 37.
Collection: Glasgow School of Art (7).

1899.14 Settle for the Board Room, Glasgow School of Art

Oak, stained dark, with upholstered seat 74.3 × 183 × 46.8cm.

This piece is basically a compilation of three examples of 1899.13, without intermediate arms and with the pierced hand-hole motif repeated three times in each back rest.

Literature: Glasgow School of Art, *Furniture*, no 2; Macleod, plate 37.
Collection: Glasgow School of Art.

△1899.11 1899.12▽

▽1899.14 1899.13▷

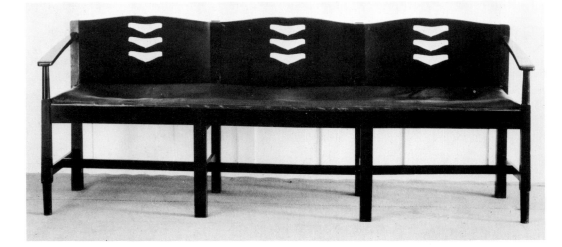

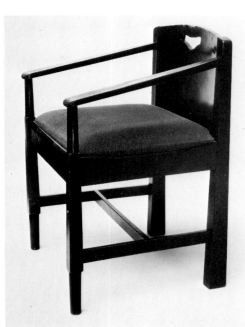

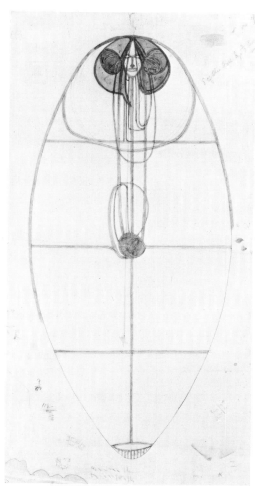

△D1899.15

D1899.15 Design for leaded-glass for doors at the Glasgow School of Art
Verso, a tracing with colour notes.
Pencil and watercolour 103.5 × 55.5cm.
Inscribed, by another hand, upper right, *8 of This Full Size* ⅜ *covers.*; verso, *Leaded Glass*.
Scale, full size.

Used in studio and other doors in the first phase of the School of Art, completed in 1899.

Provenance: Mackintosh Estate.
Collection: Glasgow University.

1899.16* High-backed armchair with oval backrail
Oak, stained dark, with horsehair upholstery
137.5 × 52.2 × 48.4cm.

In 1899, at the Arts & Crafts Exhibition in London, Mackintosh showed an armchair with 'lacquer panel by Miss Margaret Mackintosh' (*sic*). The only chair which fits this description (although it is possible that it applies to another design untraced by the author) is that exhibited at the Vienna Secession in 1900 and acquired by Koloman Moser. This is an armchair version of 1897.23, and instead of the cut-out motif in the oval backrail, a circular plaque, executed by Margaret, has been inserted. Another version of this chair is in the Glasgow School of Art collection, but this one has no plaque, although the backrail has been recessed to accommodate one. These chairs were probably made as a pair for use in the Mackintosh's Glasgow flat, or the Glasgow School of Art example may have been made *c*1901 as a replacement for the one Moser bought (for a discussion of Mains Street furniture and dates of photographs *see* p. 70).

Another chair was exhibited at the Arts & Crafts in 1899 (no 436) but it cannot be identified from the catalogue description. It is possible, however, that this chair was similar to 1899.16, with the same kind of plaque in the oval backrail, but no arms, as two such chairs are in the collection of Dr Thomas Howarth.

D1897.17▷

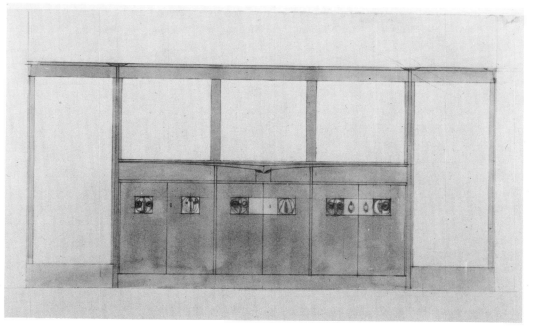

A white-painted version of this chair appears in some more recent illustrations of the bedroom at The Hill House. It is a recent copy found by Mr Lawson in a shop in London and bought by him for The Hill House in the 1960s.

Literature: a) *Ver Sacrum*, 1901, issue 23, p. *384*; *Dekorative Kunst*, VII, 1901, p. *173*; *Innendekoration*, I, 1902, p. *31*; *Das Englische Haus*, I, 1904, plate 174; Billcliffe and Vergo, fig. 10; b) Howarth, plate 12a.
Exhibited: a) London, Arts & Crafts Exhibition Society, 1899 (444); Vienna Secession, 1900; b) Saltire, 1953 (B5).
Provenance: a) C. R. Mackintosh; Koloman Moser; Christian Nebehay, Vienna; b) C. R. Mackintosh; Mrs Napier by whom presented.
Collection: a) Copenhagen Museum of Decorative Arts; b) Glasgow School of Art.

D1899.17 Design for a sideboard, a bookcase, or cupboards
Pencil and watercolour 27.9 × 52.8cm.
Scale, 1:12.

An unidentified subject, dating from *c*1899–1901.

Provenance: Mackintosh Estate.
Collection: Glasgow University.

1899.18 Pulpit and choir stalls, Gourock Parish Church
Light oak; pulpit 190cm. high.

The job books do not list the items designed for this church (which were made by Francis

◁1899.16 1899.16 detail▽

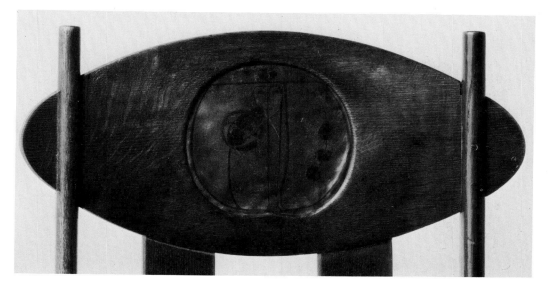

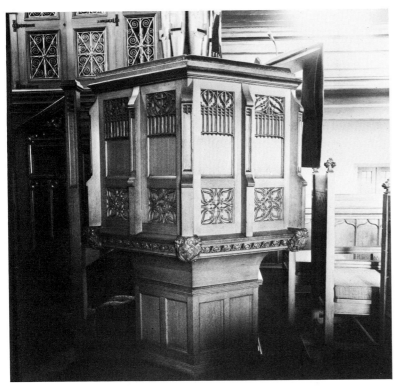

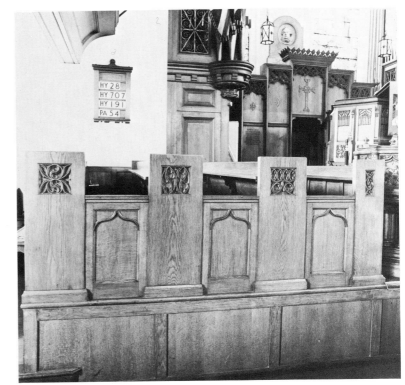

△△1899.18

1900.A ▷

1900 120 Mains Street, Glasgow and Dunglass Castle, Bowling

Howarth suggests that Dunglass Castle was designed before Mackintosh's own flat in Mains Street, and was, in fact, a kind of prototype for it (p. 47). However, the evidence of drawings and photographs does not support this view, and 120 Mains Street seems to be the earlier of the two, designed in the months before March 1900, when it was first photographed by Annan.

1899.M was identified by Howarth as the drawing room of Gladsmuir. Another print of the photograph was in the collection of Hamish Davidson, which he bequeathed to Glasgow University, but he was unable to identify the subject. Dr Cameron Davidson could not identify it either, other than negatively, for he said it was not Gladsmuir. L. A. Dunderdale, who lived at Dunglass for over 25 years while the Mackintosh fittings were still *in situ*, believed the photograph to be of the drawing-room at Dunglass Castle before the conversion. The corner seat, the gas lighting, and the likely positions of door and window (which cannot be seen in this photograph) correspond to those at Dunglass; the pictures on the wall are all by Margaret and Frances Macdonald and some were in the Macdonald family collection, as was the small table in the foreground, designed by Herbert MacNair and now in Mr Dunderdale's possession. If this room was at Gladsmuir, there is no logical way the contents could have passed from the Davidsons to the Macdonalds. If further evidence is required, it is contained in the drawing for the new fireplace at Dunglass (D1900.37). Mackintosh shows not only the new fireplace but also the old one that he is covering: rather than move the large marble piers which support the mantelpiece, he has extended his fireplace

Smith) and only a pulpit and choir stalls survive. A communion table, chairs and an organ screen were made in the 1930s; these replaced other oak fittings thought to have been provided in 1899.

Mackintosh has not repeated the Queen's Cross pulpit, but the carved tracery with oval lozenges is obviously a forerunner of the carved decoration used at Holy Trinity, Bridge of Allan, in 1904. The choir stalls are plainer, relieved only by panels of stylised foliage like those also used in the face of the pulpit.

Collection: *in situ*.

1899.M Drawing-room at Dunglass Castle, Bowling

This photograph was taken before Mackintosh carried out his alterations to the fireplace and ceiling in 1900. The pictures on the walls are by either Frances or Margaret Macdonald and the square table was designed by Herbert MacNair. The marble pillars of the old fireplace, which was virtually hidden by an arrangement of firescreen and linen mantel-cloth, were covered by the new wooden structure (*see* 1900.A) but the gas lighting used the same supply points with different fittings.

Collection: Glasgow University.

1900.A Drawing-room at Dunglass Castle, Bowling

This photograph was taken after the completion of the new fireplace and other decorative works in the drawing-room.

1900.B The drawing-room at 120 Mains Street, Glasgow

According to Howarth this photograph was taken in March 1900. Howarth reproduced similar views which must, however, be later as his illustrations (plates 12a, 13a) show the fireplace with a steel panel to hide the junction of cement and timber, a different embroidered design at the foot of the curtains, and a pelmet curtain suspended from the rail which crosses the windows, none of which appears in this photograph.

Collection: Annan, Glasgow.

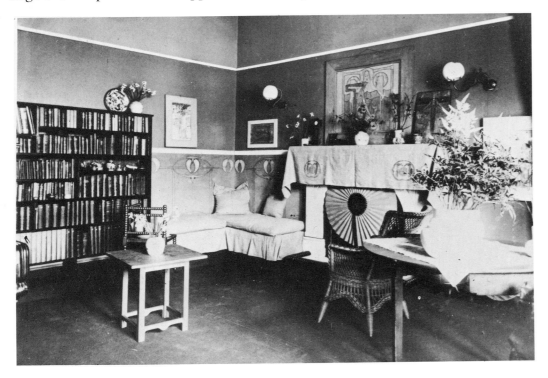

◁1899.M

1900.B ▷

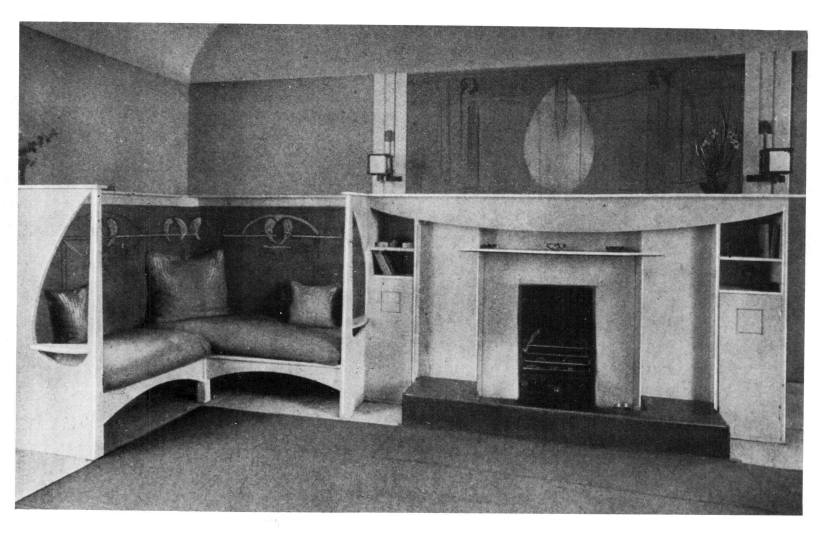

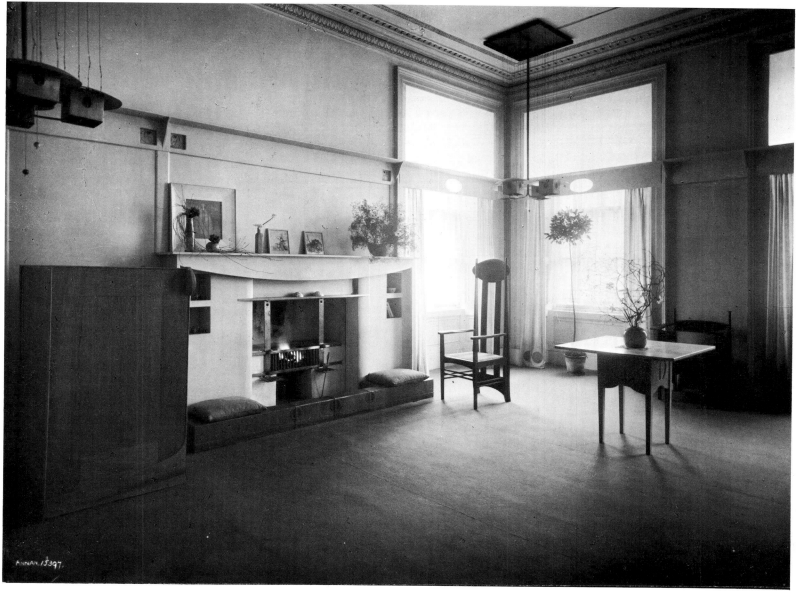

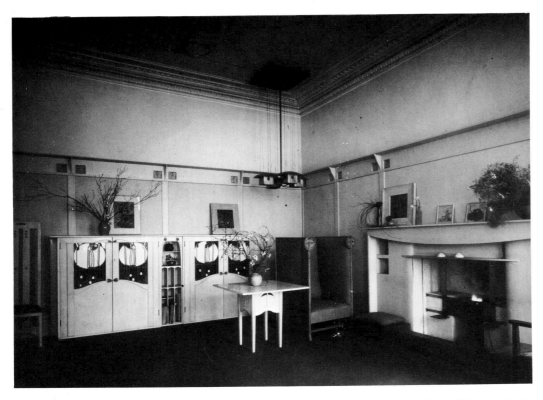

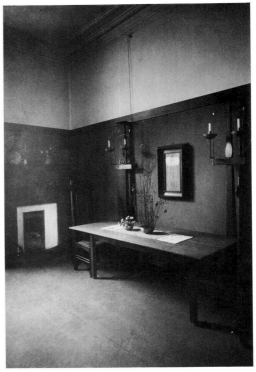

◁1900.C 1900.E △

◁1900.D 1900.F ▽

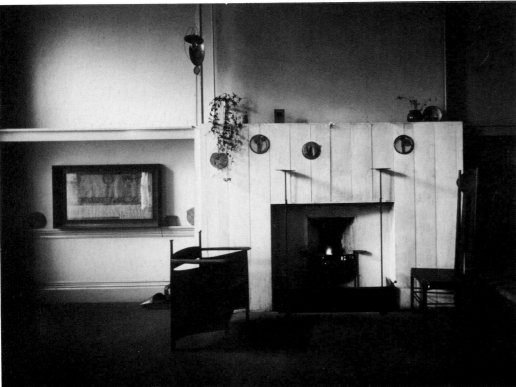

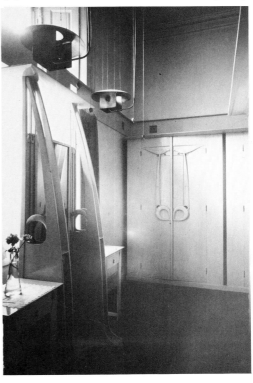

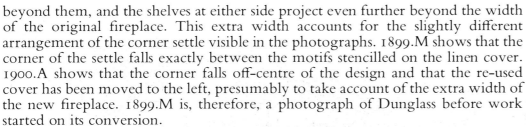

beyond them, and the shelves at either side project even further beyond the width of the original fireplace. This extra width accounts for the slightly different arrangement of the corner settle visible in the photographs. 1899.M shows that the corner of the settle falls exactly between the motifs stencilled on the linen cover. 1900.A shows that the corner falls off-centre of the design and that the re-used cover has been moved to the left, presumably to take account of the extra width of the new fireplace. 1899.M is, therefore, a photograph of Dunglass before work started on its conversion.

The Macdonald family moved to Dunglass in July 1899 (Howarth, p. 47), but the earliest dated drawing by Mackintosh for Dunglass is of June 1900 (D1900.39); the stencilled seat cover (now in the Glasgow University collection) was probably designed by one of the Macdonald sisters, and not by Mackintosh.

The flat at 120 Mains Street was photographed by Annan in March 1900 (Howarth, p. 46, note 1) and although Annan's records have been destroyed, the numbers on surviving negatives indicate that about 30 photographs were taken. This terminal date for the flat suggests that the furniture was designed in the latter part of 1899 and the early months of 1900, while Mackintosh was still working on the interior schemes and furniture of the School of Art. It has not been possible to discover when he moved into 120 Mains Street, but he was presumably living in it alone before his marriage to Margaret in August 1900.

1900.C Drawing-room at 120 Mains Street, Glasgow

Collection: Annan, Glasgow.

1900.D Studio at 120 Mains Street, Glasgow

Collection: Annan, Glasgow.

1900.E Dining-room at 120 Mains Street, Glasgow
The watercolour hanging on the wall is *Reflections*, painted by Mackintosh in 1898.

Collection: Annan, Glasgow.

1900.F Bedroom at 120 Mains Street, Glasgow

Collection: Annan, Glasgow.

1900.I Fireplace for the drawing-room, 120 Mains Street, Glasgow
Wood, painted white 156 × 254.5 × 33cm.

A very large, but quite simple structure, providing a large flat top for vases and pictures, and a number of square insets on the front to display other decorative work. The two front panels curve gently inwards to the fire surround and the lower shelf emphasises the curve by cutting into them, rather than stopping at the edge of the surround. Mackintosh later fixed three strips of bright steel—with inset glass jewels—to hide the junction of the timber and the rendered surround. The grate, with its iron front grille, projecting steel grids, and semicircular fire-brick, is based on a traditional design.

The fireplace was moved to 78 Southpark Avenue in 1906, where it was modified to accommodate the narrower, but projecting, chimney breast; extra pieces, incorporating more square niches, were added on to the sides to provide the necessary depth. The grate arrangement was also changed and a simpler grate, perhaps like that at Hous'hill, was devised. The original grate was transferred to the studio fireplace (see 1906.7).

Literature: Studio Special Number, 1901, pp. *114, 115*; *Das Englische Haus*, I, 1904, plate 174; Howarth, plate 12a.
Provenance: C. R. Mackintosh; W. Davidson, from whose estate purchased, 1945 (*in situ* at 78 Southpark Avenue).
Collection: Glasgow University.

D1900.2 Design for fireplace for the drawing-room, 120 Mains Street, Glasgow

Pencil and watercolour 27 × 58cm.
Inscribed, lower left, *Drawing Room Mantlepiece at 120 Mains Street | for Chas R Mackintosh* [*140* deleted], and *Elevation of west wall*.
Scale, 1:12.

As executed, and showing the skirting-board, window and wall-plate with square glass inserts (see D1900.1).

Provenance: Mackintosh Estate.
Collection: Glasgow University.

D1900.3 Preparatory design for the fireplace for the drawing-room, 120 Mains Street, Glasgow

Pencil 37.3 × 54.5cm.
Signed and inscribed, lower right, *Chas R Mackint* [paper torn] / *140 Bath Street*, and various other notes and measurements including *Bedroom—2' 11" × 4' 0"*.
Scale, 1:12.

Similar to D1900.2 but with the addition of a rather crude pigeon-hole rack along the top. Even at this stage, Mackintosh has already decided upon the basic arrangement of the grate. The carved decoration in the transom of the window frame is reminiscent of the decoration on some of the panelling in the hall at Queen's Cross Church, but it was eventually omitted at Mains Street.

Provenance: Mackintosh Estate.
Collection: Glasgow University.

1900.4 Fender for the drawing-room, 120 Mains Street, Glasgow

Beaten lead over a timber frame 18 × 234 × 36cm.

Provenance: as 1900.1.
Collection: Glasgow University.

1900.5 Lug chair for 120 Mains Street, Glasgow

Oak, with linen upholstery 131 × 74 × 72cm.

Used as a fireside chair. An extremely simple, box-like design relieved only by the applied curve at the base and the two carved plaques at the front. When it was exhibited at the Memorial Exhibition in 1933, the plain up-

Howarth reproduces two other views of the drawing-room at Mains Street (plates 12a, 13a) and suggests that these were also taken no later than March 1900. As they contain a totally new piece of furniture (the white oval table) in a style radically different from much else that was designed in 1900 for the flat, this date must be carefully considered. Annan's March 1900 photographs were taken over a period of a few days, as the deteriorating state of the cut flowers in the vases indicates; although the furniture was moved around the room to obtain different

△1900.1

D1900.2▽

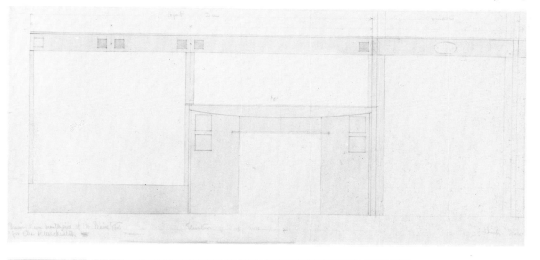

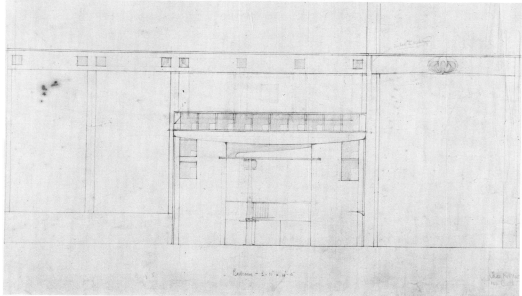

D1900.3▷

effects in the alternative views of the room, this does not account for the non-appearance of the oval table in these photographs. There are a number of other differences between the March 1900 photographs (as used in *The Studio* Special Number in 1901) and Howarth's plates, which point to a somewhat later date for the latter: different embroidery on the curtains; a patterned pelmet where before there was none; different flowers arranged in vases which do not appear in the earlier photographs; a different arrangement of pictures, with the appearance of a beaten metal panel by Margaret in the later views; a different arrangement of books in the bookcase; and the introduction of a steel strip to conceal the junction between the wooden fireplace and the cement render of the grate. A more likely date for these two photographs is late 1901 or 1902, for the table otherwise appears first at 14 Kingsborough Gardens and Turin in 1902. Howarth (p. 46) links the table with the two chairs also shown at Turin, but mistakenly dates these to 1900 by stating that they were first shown at Vienna.

The rooms at 120 Mains Street set a pattern for many later decorative schemes. Contemporary photographs show only four rooms—the dining-room, drawing-room, studio, and main bedroom—but the other rooms in the flat probably followed the same general principles. In the drawing-room, Mackintosh introduced a broad horizontal plate at the height of the door architrave; this encircled the room like a picture rail, but it cut across the windows where necessary. Straps of similar width ran down from this rail to the skirting, creating large panels on the wall which were painted light grey, while the woodwork was all white. The furniture was carefully spaced about the room, each piece being allowed, even encouraged, to make its own impact without having to compete visually with the other pieces in the room. Three of the walls were provided with wide pieces to punctuate the plane of the wall: the fireplace, the bookcase and the writing desk. The chairs and tables appeared isolated, but each had its correct and calculated place, so that any change of position would upset the balance of the room. The windows were covered with fine muslin to filter the light, and Margaret's embroidered curtains were hung from the picture rail. The frieze and ceiling were white. Artificial light was supplied by twelve gas jets, each with a square shade and hung in three groups of four.

The dining-room was much darker, like the room for Brückmann of 1898. Again a broad plate, stained black this time, encircled the room at door architrave height. On a side wall, against the dining table, two tapering square posts reached up to this plate, carrying candelabra. These posts were repeated on either side of the fireplace, a timber construction stained black. Above the picture rail, the frieze and ceiling were painted white, but the walls were covered with a dark grey-brown wrapping paper. The furniture was simple and sparse and all made of stained oak.

The bedroom and studio were painted white, as was all of the bedroom furniture. The bedroom does not appear to have been a large room and much of the furniture in it was quite expressively modelled, from the carvings on the canopied bed and the double wardrobes to the rather exotic cheval mirror.

Literature: *Studio* Special Number, 1901, pp. *112–115*; *Das Englische Haus* I, 1904, plates 172, 174; Howarth, pp. 43–48, plates 11–16.

∇D1900.6

holstered back was relieved by four square panels of chequer decoration (*see* 1909.E).

Literature: *Das Englische Haus*, I, 1904, plate 174; Howarth, plate 12a; Alison, pp. *30–31, 88*.
Exhibited: Memorial Exhibition, 1933 (not in catalogue).
Provenance: C. R. Mackintosh; M. M. Mackintosh; acquired after 1933 by W. Davidson; presented by his sons, 1945.
Collection: Glasgow University.

D1900.6 Design for a lug chair for the drawing-room, 120 Mains Street, Glasgow
Pencil 28 × 53.4 cm. (irregular).
Inscribed, upper left, *Lug Chair for Chas R Mackintosh 120 Mains Street Glasgow | To be made of oak or maple—|with spring seat & stuffed back & sides*; and various other notes and measurements.
Scale, 1:12.

Virtually as executed, except that Mackintosh indicates an embroidered or stencilled pattern on both sides of the upholstered back. (*See also* D1904.55, verso).

The drawing also includes faint sketches for the bedroom mirror and alternative wash-

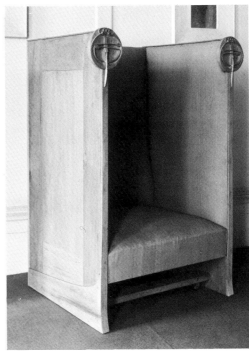

1900.5 ▷

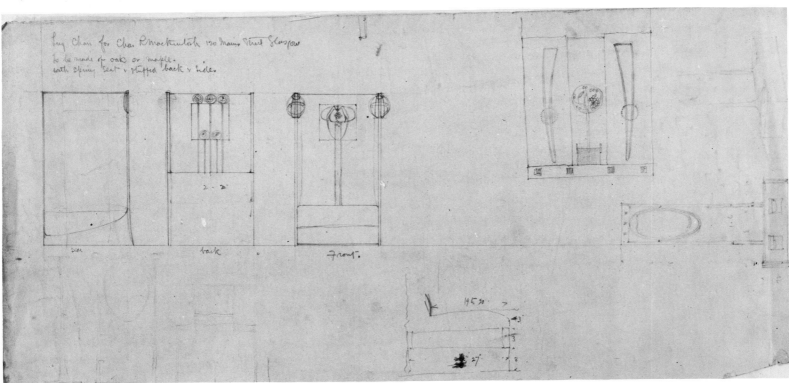

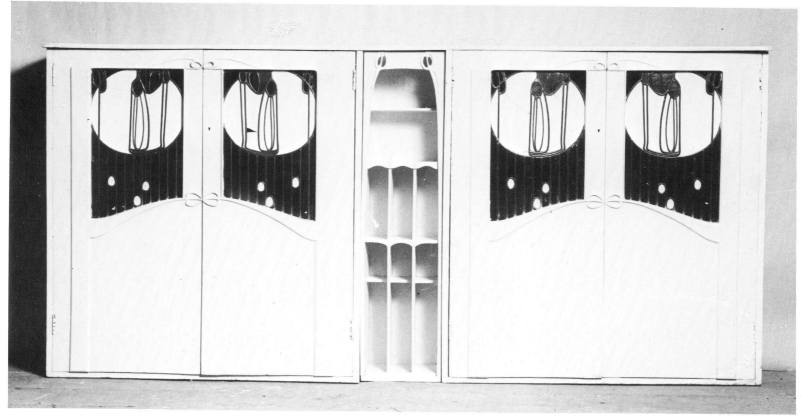

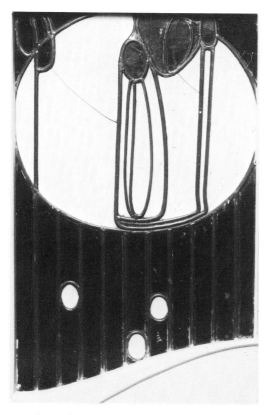

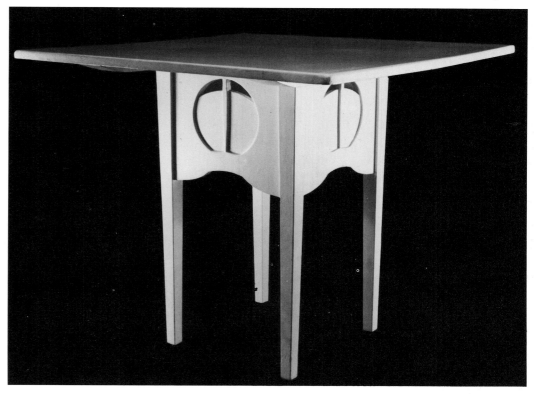

stands or dressing-tables. The drawing at the upper right, upside-down, is of the arrangement of curtains and curtain rail across the drawing-room window; with the drawing the correct way up again, Mackintosh has added the bay tree which stood in the window, but here it seems to be suspended upside-down from the curtain rail.

Provenance: Mackintosh Estate.
Collection: Glasgow University.

1900.7 Bookcase for 120 Mains Street, Glasgow

Oak, painted white, with leaded-glass doors 131.6 × 274 × 30.6cm.

The most elaborate piece designed for the Mains Street drawing-room: two identical cabinets flank a central magazine rack, the whole spanned by a top made from a single plank. The doors of the two cabinets are

quite the most elegant and adventurous design in leaded-glass for furniture that Mackintosh ever produced. A large disc of opaque white glass has a tracing of flower stems and blooms laid over it. It is reminiscent of, but far more successful than, the cabinets designed for Brückmann's house in 1898. The bookcase was repeated for Dunglass Castle in June 1900 (*see* 1900.38 and D.1900.39).

Literature: Studio Special Number, 1901, p. *115*; *Das Englische Haus*, I, 1904, plate 174; Howarth, p. 44, note 3, plate 12a.
Exhibition: Edinburgh, 1968 (219).
Provenance: Davidson Estate.
Collection: Glasgow University.

1900.8 Square card table for 120 Mains Street, Glasgow

Oak, painted white 71.3 × 80.5 × 82cm.

A white-painted version of 1897.13.

Literature: Studio Special Number, 1901, p. *115*; *Das Englische Haus*, I, 1904, plate 172; Howarth, plate 13a.
Provenance: Davidson Estate.
Collection: Glasgow University.

1900.9 Desk for 120 Mains Street, Glasgow

Oak, originally painted white, with beaten brass panels 128 × 173 × 51.6cm.

Probably the first of a series of writing desks which were to become major features of some of Mackintosh's later interiors. He paid careful attention to the design of these desks, and this and subsequent pieces are among the most successful and pleasing of all his furniture.

The layout is quite ingenious, with deep side cupboards, plenty of internal subdivisions for stationery and pens, and even cupboards facing into the foot-well. The beaten metal

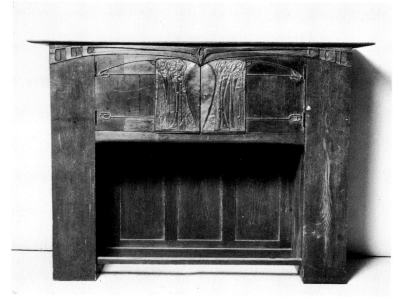

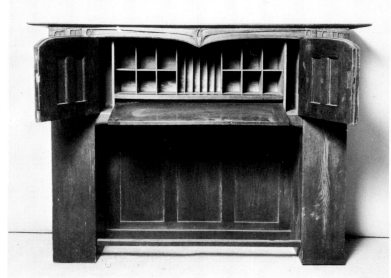

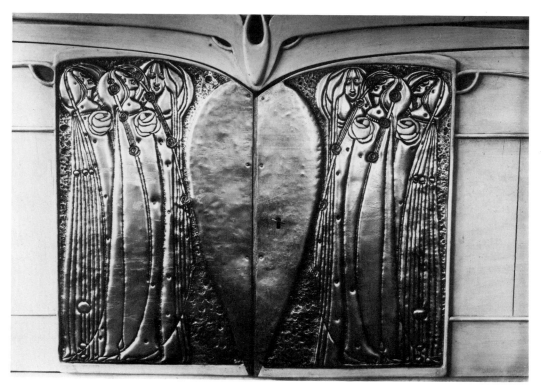

◁1900.9△

panels are probably Margaret's work, although they are unsigned. The original photographs show the desk painted white, with coloured glass (or simply painted) inlays in the shapes formed by the tracery decoration. It was probably stripped by William Davidson after he acquired 78 Southpark Avenue; the position it originally occupied there was used by Davidson for a piano and he moved this desk to the dining-room where its white paint would have been totally out of place.

Literature: Studio Special Number, 1901, p. *113*; *Dekorative Kunst*, IX, 1902, p. *217* (panels only); *Das Englische Haus*, I, 1904, plate 172; Howarth, plate 13a.
Exhibited: Edinburgh, 1968 (212).
Provenance: Davidson Estate.
Collection: Glasgow University.

D1900.10 Design for a desk for 120 Mains Street, Glasgow

Pencil 27.1 × 49.5cm.
Signed and inscribed, lower right, *Chas R Mackintosh* / *140 Bath Street* and *Note to be made of oak—plain grain* / *estimate to include 1 good lock—2 slip bolts* / *and four pair good iron hinges*;

◁1900.9 detail D1900.10 ▽

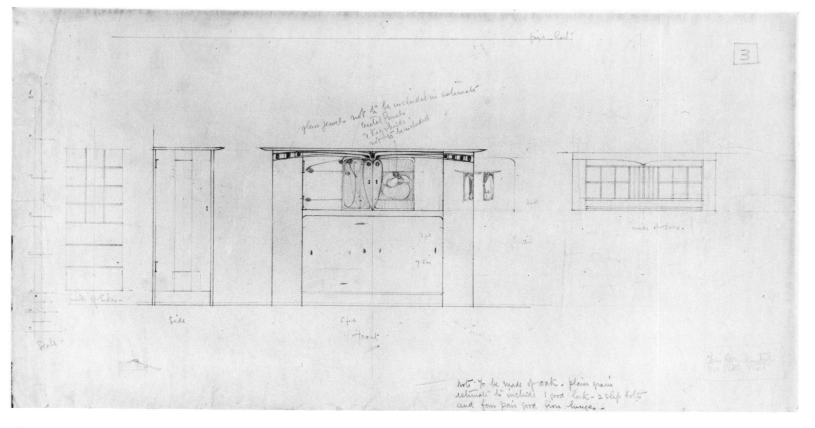

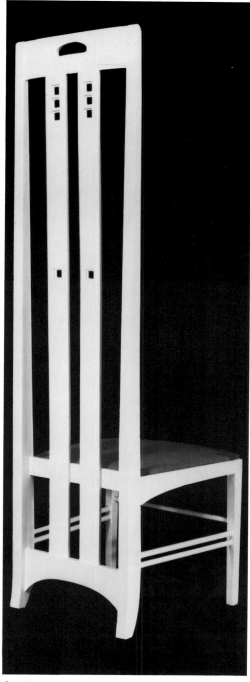

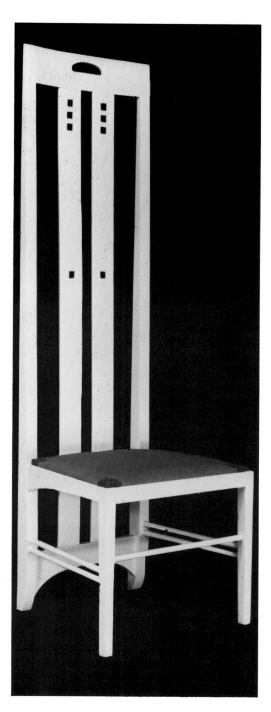

△1900.11
▽D1900.12

D1900.13▽

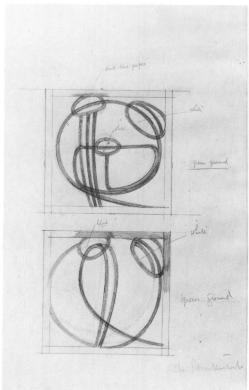

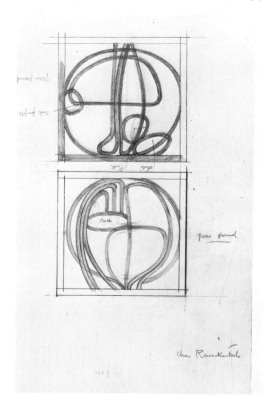

inscribed, top centre, *glass jewels not to be included in estimate | Metal Panels | & key shields | not to be included*; and *3*, and other notes and measurements.
Scale, 1:12.

The executed desk (1900.9) differs only in minor details from this drawing. Two alternative types of decorative panels are shown, that on the left being the one finally chosen. The inscription suggests that the coloured details visible in the contemporary photographs were glass, but no trace of glass can now be found.

Provenance: Mackintosh Estate.
Collection: Glasgow University.

1900.11 Chair with high back for 120 Mains Street, Glasgow
Oak, painted white, (?) originally with coloured glass inserts 151.9×48×46cm.

A white-painted version of 1900.55, as used at the Ingram Street Tea Rooms; the only difference between the two versions is that this one has a removable beading around the back of each of the square cut-outs, which was possibly used to hold a piece of coloured glass.

Literature: Studio Special Number, 1901, pp. *113*, *115*; *Das Englische Haus*, I, 1904, plates 172, 174; Howarth, plates 12a, 13a; Alison, pp. 40, *41*.
Exhibited: Edinburgh, 1968 (233).
Provenance: Davidson Estate.
Collection: Glasgow University.

D1900.12 Designs for leaded-glass or stencil panels
Pencil 35.4×23cm.
Signed, lower right, *Chas R Mackintosh*; inscribed with various colour notes.

Probably designs for the decorative squares of painted glass inserted into the wide wall-plate at frieze level in the bedroom and drawing-room at 120 Mains Street.

Provenance: Mackintosh Estate.
Collection: Glasgow University.

D1900.13 Designs for leaded-glass or stencil panels
Pencil 35.5×23.1cm. (irregular).
Signed, lower right, *Chas R Mackintosh*; inscribed, lower centre, *No 1*, and various colour notes.

See D1900.12.

Provenance: Mackintosh Estate.
Collection: Glasgow University.

1900.14 Fireplace for the studio, 120 Mains Street, Glasgow
(?)Pine, painted white.

No longer extant. The only record of the fireplace is in the photograph taken by Annan in March 1900 (*see* 1900.D). Its construction is extremely simple, consisting merely of 14 plain boards butt-jointed and painted white. It surrounds a simple cement-rendered fireplace, the steel grate of which (or a replica) was used in the attic bedroom at 78 Southpark Avenue. The fender with its candlesticks had been used in Mackintosh's bedroom at 27 Regent Park Square (*see* 1896.3 and D1896.4). The plain boards were decorated with two hanging panels of leaded-glass and a beaten lead plaque (all now in the Glasgow University collection). As Howarth points out (p. 46, note 1), electricity was used for lighting in this room; the fitting in use here was later used at the Turin Exhibition, and in the hall and staircase of 78 Southpark Avenue.

Literature: Howarth, plate 14a.
Collection: untraced, probably destroyed.

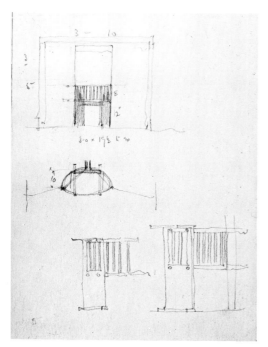

D1900.15 Design for the studio fireplace, 120 Mains Street, Glasgow
Pencil on a page of a sketchbook 17.4 × 11.2cm.

A sketch for the grate and the cement surround in the studio fireplace.

Provenance: Mackintosh Estate.
Collection: Glasgow University.

D1900.16 Drawing of a table and an hour-glass
Pencil on a page of a sketchbook 17.4 × 11.2cm.

It is not clear whether this is a design for a new piece of furniture, or a drawing of a table which Mackintosh saw on one of his sketching tours. If the former, it may well be connected with 120 Mains Street as it is on an adjacent sheet to the design for the studio fireplace (D1900.15).

Provenance: Mackintosh Estate.
Collection: Glasgow University.

◁D1900.15 D1900.16△ D1900.18▽

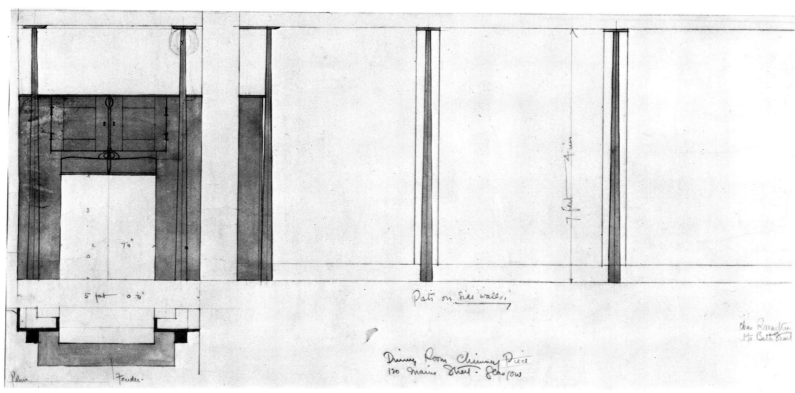

1900.17 Fireplace for the dining-room, 120 Mains Street, Glasgow
Pine, painted black, with metal finials 229 × 155 × 28.5cm.

All of the fitted woodwork in the Mains Street dining-room seems to have been painted black, in keeping with the dark-papered walls. The colour scheme was repeated at 78 Southpark Avenue. The basic design of the fireplace is quite similar to the desk (1900.9), although the emphasis here is vertical not horizontal, with its two side sections and a central upper section with doors (see 1906.C). The two posts on either side reach up to the wall-plate, with a *cyma recta* capital at the top; the metal finials match those on the candelabra, which were attached to two similar posts positioned against the wall (see Howarth, plate 15a).

Exhibited: Edinburgh, 1968 (215).
Provenance: C. R. Mackintosh; W. Davidson, from whose estate purchased 1945 (*in situ* at 78 Southpark Avenue).
Collection: Glasgow University.

D1900.19▷

D1900.18 Design for the fireplace for the dining-room, 120 Mains Street, Glasgow
Pencil and watercolour 30.4 × 59cm.
Signed and inscribed, lower right, *Chas R Mackintosh | 140 Bath Street*; inscribed, bottom centre, *Dining Room Chimney Piece | 120 Mains Street—Glasgow*, and *Posts on side walls*.
Scale, 1 : 12.

The final design, more or less as executed, and including the posts on the side walls.

Provenance: Mackintosh Estate.
Collection: Glasgow University.

D1900.19 Preliminary design for the fireplace for the dining-room, 120 Mains Street, Glasgow
Pencil 25.3 × 29.3cm.
Signed and inscribed, lower right, *Chas R Mackintosh | 140 Bath Street Glasgow*; inscribed, lower centre, *Dining Room Fire place*, and, upper right, 5.

The amount of carved decoration which Mackintosh seems to have considered using on the fireplace is similar to that on the preliminary sketch for the smoker's cabinet (D1899.3). The candelabra, also more elaborate, are shown on this drawing fitted to the fireplace as well as, or instead of, the wall posts.

Provenance: Mackintosh Estate.
Collection: Glasgow University.

1900.20 Dining table for 120 Mains Street, Glasgow
Oak, stained dark 70.5 × 198.4 × 81.6cm.

Of similar proportions and construction to those tables designed for the Luncheon Room at Argyle Street (*see* D1897.25), but with the addition of four motifs of double petals on the longer side rails. As at the Tea Rooms, the table was used here with the oval backrail chairs (1897.23). The top is made of three wide planks of oak, butt-jointed together and held by dowels—a form of construction which has not stood the test of time.

Literature: Studio Special Number, 1901, pp. *110. 111*; Howarth, plate 15a; Glasgow School of Art, *Furniture*, no 18.
Exhibited: Memorial Exhibition, 1933 (not in catalogue); Saltire, 1953 (B4).
Provenance: C. R. Mackintosh; M. M. Mackintosh; Mrs Napier, 1933, by whom presented.
Collection: Glasgow School of Art.

1900.21 Serving table
Oak, stained dark 78 × 99.2 × 51.4cm.

This table appears in one of the Annan photographs of the Mains Street flat. The series of oval holes in the gables of the table are a motif used on the serving tables for the White Dining-Room at Ingram Street (*see* 1900.60).

Provenance: C. R. Mackintosh; William Davidson; Hamish Davidson, by whom bequeathed.
Collection: Glasgow University.

1900.22 Fireplace for the bedroom, 120 Mains Street, Glasgow
Wood, painted white, with steel fire surround and grate 210 × 132 × 22.5cm.

A simpler variant of the dining-room fireplace, but this fire surround was a steel plate instead of cement as in all the other Mains Street fireplaces. The bedroom fireplace at The Hill House seems to be the only other fireplace with this feature (*see* 1903.60). Mackintosh took this fireplace with him to 78 Southpark Avenue in 1906 (*see* 1906.H).

Provenance: C. R. Mackintosh; W. Davidson, from whose estate purchased, 1945 (*in situ* at 78 Southpark Avenue).
Collection: Glasgow University.

D1900.23 Designs for bedroom furniture for 120 Mains Street, Glasgow
Pencil 30.3 × 73.6cm.
Signed and inscribed, lower right, *Chas R Mackintosh | 140 Bath Street Glasgow*; inscribed, upper left, *Bedroom Furniture* and, variously, *wardrobe, mirror table, iron fireplace, press, washstand, side of bed*, and several other notes and measurements.
Scale, 1 : 24 and 1 : 20.

The only drawing of the Mains Street bedroom which indicates the full range of furniture designed for it. Unfortunately, Mackintosh has not laid out the design as he did for the Hous'hill bedrooms (*see* D1904.64–66), and one can only guess at the positions of the furniture not shown on the contemporary Annan photographs (*see* Howarth, plate 16a; Studio Special Number, 1901 p. *112*). Nor is it clear whether the cupboards and drawers shown at the left on the upper level are meant to be the inner fittings of the wardrobe, whether they are fitted wardrobes, or simply an alternative design to that eventually chosen for the free-standing wardrobe.

The items shown which still exist are the bed (1900.28), the fireplace (1900.22), the cheval mirror (1900.26), the side table (1900.27), the washstand (1900.30) and the wardrobe (1900.24).

Provenance: Mackintosh Estate.
Collection: Glasgow University.

1900.21▽

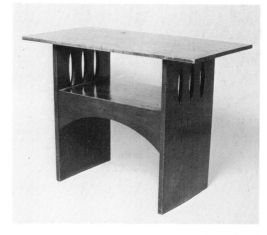

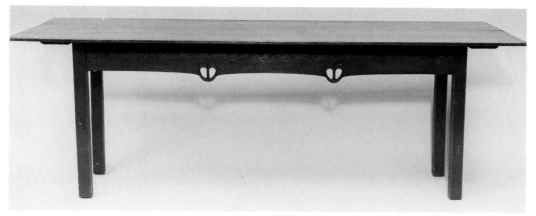

△1900.20

D1900.23▽

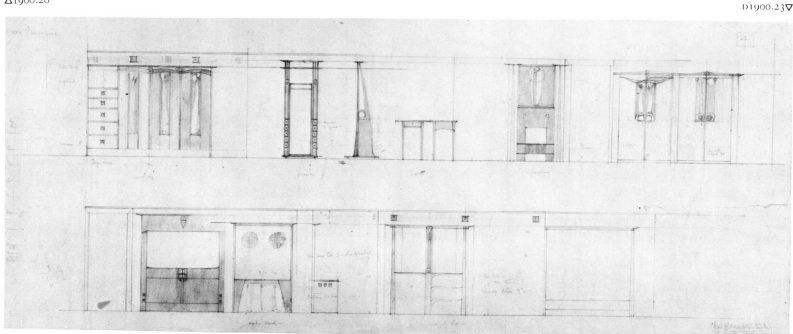

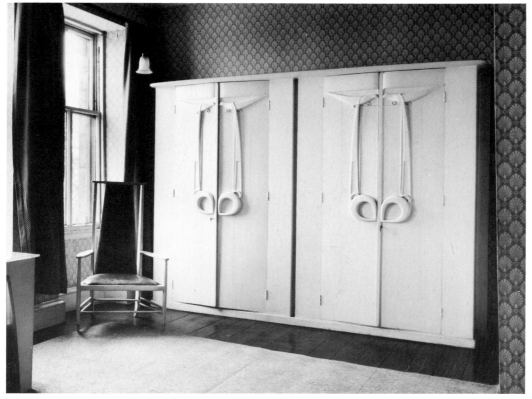

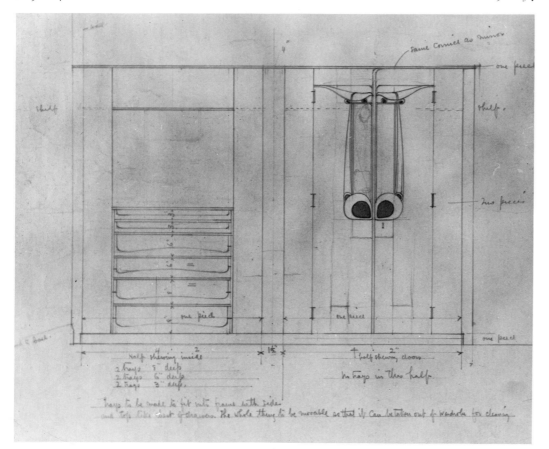

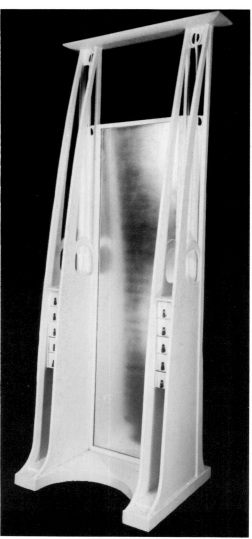

1900.24 Double wardrobe for 120 Mains Street, Glasgow

Wood, painted white 206 × 271.8 × 49cm.

A massive piece, with large expanses of flat white-painted wood, relieved by raised carvings of birds and originally inlaid with coloured glass jewels at the birds' feet and in the raised handles (though these have disappeared, they are plainly visible in the contemporary photographs, and the drawing, D1900.25, shows them as green).

Literature: Studio Special Number, 1901, p. *112*; *Dekorative Kunst*, IX, 1902, p. *204*; Howarth, p. 45, plate 16a.
Exhibited: Edinburgh, 1968 (229).
Provenance: Davidson Estate.
Collection: Glasgow University.

D1900.25 Design for a wardrobe for 120 Mains Street, Glasgow

Pencil and watercolour 28.8 × 45.5cm.
Inscribed, centre right, *Note | To be made of oak | in two pieces with base and cornice as binders | estimate to include for two locks—|6 pairs polished steel hinges | and 4 slip bolts*, lower left, *Trays to be made to fit into frame with sides | and top like chest of drawers. The whole thing to be movable so that it can be taken out of wardrobe for cleaning*; and various notes and measurements.
Scale, 1 : 12.

As executed (*see* 1900.24), but the larger panel of glass in the handle does not seem to have been incorporated in the finished piece.

Provenance: Mackintosh Estate.
Collection: Glasgow University.

1900.26 Cheval mirror for 120 Mains Street, Glasgow

Oak, painted white, with coloured glass panels and white metal handles 207.3 × 67.6 × 62.5cm.

A spectacular piece, compared by a commentator on the Vienna Secession exhibition to a giant sledge placed on its end. With the bed, this is the most stylistically advanced and successful piece designed for 120 Mains Street. Mackintosh has achieved a positively sculptural effect with the double curve of the frontal uprights, open at the top and flanking tiny drawers for cuff-links, pins and jewellery lower down. The two curved shapes which connect these uprights to the mirror frame suggest that the whole piece is made from some material other than wood, an impression reinforced by the thick, smooth coats of white paint which hide the grain of the timber and suggest some softer, more malleable material beneath.

Literature: *Ver Sacrum*, 1901, issue 23, p. *385*; *Dekorative Kunst*, VII, 1901, p. *175*; Pevsner, 1968, plate 22; Howarth, pp. 45, 152, plates 16a, 59a.
Exhibited: Vienna, 1900; VEDA, 1952 (R3); Paris, 1960 (1077); Edinburgh, 1968 (321).
Provenance: Davidson Estate.
Collection: Glasgow University.

1900.27 Bedroom table for 120 Mains Street, Glasgow

Oak, painted white, with coloured glass inlay and white metal handle 72 × 46 × 31.3cm.

A table stood each side of the cheval mirror. Two were made for Mains Street, but at least one other was made, although it is not known for which house.

Literature: Howarth, plate 16c.

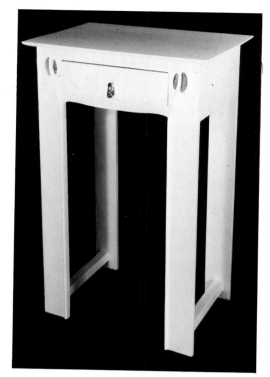

△1900.27

1900.28 ▷

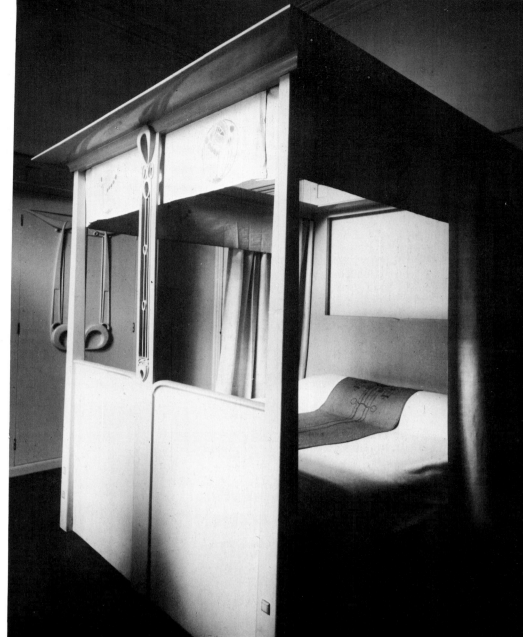

Exhibited: Saltire, 1953 (B2); Edinburgh, 1968 (232).
Provenance: a) Davidson Estate; b) unknown.
Collection: a) Glasgow University (2); b) John Jesse, London.

1900.28 Four-poster bed for 120 Mains Street, Glasgow

Oak, painted white, with coloured glass panels 205.8 × 180.3 × 202.2cm.

The first of a number of four-poster beds which Mackintosh designed; none of the later ones was as elaborate or used so much coloured glass. Originally there were stencilled and embroidered valances and curtains, as well as an embroidered panel to be stretched over the bed-covers, but these have all disappeared.

Literature: Studio Special Number, 1901, p. *112*; Howarth, plate 16a.
Exhibited: Edinburgh, 1968 (230).
Provenance: Davidson Estate.
Collection: Glasgow University.

D1900.29 Design for a four-poster bed

Pencil, pen and ink, and watercolour 18.7 × 22.7cm.
Signed and dated, lower right, *C.R.M./JANY 1900*.

The inscription on this drawing was discussed by the author in 'Glasgow University's Pictures', 1973, with the conclusion that it was added later by Mackintosh and the date confused. The date suggested then was 1903/4, but there does not seem to be any project from that period that might correspond to such a late date. An alternative possibility is that the drawing does, indeed, date from 1900 and that it is related to the Mains Street bed. January would be a likely time for Mackintosh to be producing designs for his furniture, as the pieces were installed by March 1900.

Literature: Sekler, 'Mackintosh and Vienna', introductory essay to the catalogue of Mackintosh Exhibition, Vienna, 1969, pp. 14, *17*.
Exhibited: P. & D. Colnaghi, London, 'Glasgow University's Pictures', 1973 (54).
Provenance: Mackintosh Estate.
Collection: Glasgow University.

D1900.29 ▷

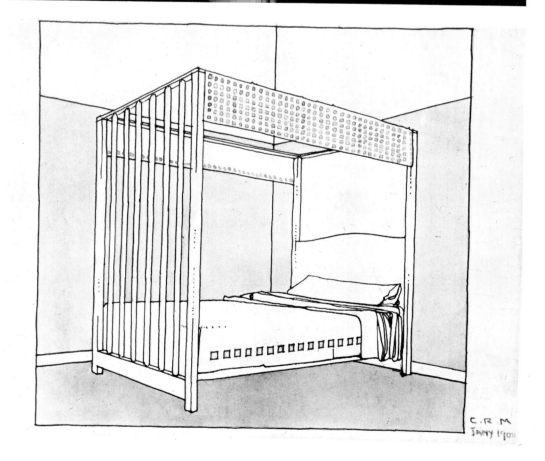

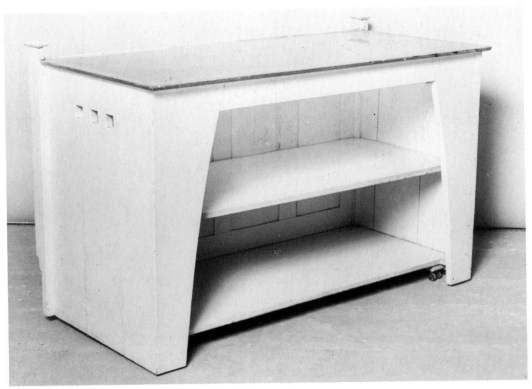

1900.30 △

1900.33 Umbrella Stand

Lead over a steel frame 75.8 × 43 × 26.3cm.

This does not appear in any contemporary photographs of 120 Mains Street, but stylistically it seems to date more from 1900 than 1906, when the Mackintoshes moved to 78 Southpark Avenue. Mackintosh used lead over a wooden frame several times in 1900, e.g. the fender at Mains Street (1900.4) and the fireplace at Ingram Street (1900.62).

Provenance: Davidson Estate.
Collection: Glasgow University.

1900.30 Wash-stand for 120 Mains Street, Glasgow
Oak, painted white 82 × 123.5 × 57cm.

A very simple design, but it has been cut down. D1900.23 shows that it was intended to have an upper section as a splashback, and the marks of the crude sawing-off of the two uprights can still be seen. Mackintosh probably did this on moving to Southpark Avenue when the stand was placed against the bedroom window where its high top would have cut out the light.

Provenance: Davidson Estate.
Collection: Glasgow University.

1900.31 Wash-stand for 120 Mains Street, Glasgow
Oak, stained dark, with black-and-white painted chequer decoration 121 × 119.2 × 53.2cm.

This wash-stand does not appear in any of the contemporary photographs of the main bedroom at 120 Mains Street. As it was not painted white, it was probably intended for the spare bedroom; its simple construction and brown stain would harmonise with the earlier bed (1896.2).

Literature: Glasgow School of Art, *Furniture*, no 21.
Provenance: C. R. Mackintosh; William Davidson; Cameron Davidson, by whom presented.
Collection: Glasgow School of Art.

▽1900.31

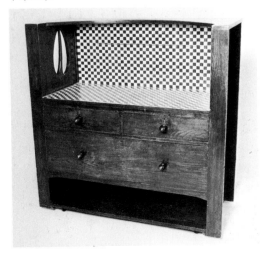

D1900.32 Design for a wash-stand for a bedroom, 120 Mains Street, Glasgow
Pencil and watercolour 20.8 × 31.5cm.
Inscribed, upper left, *Scale Drawing of Wash Stand | for Chas R Mackintosh 120 Mains Street. | Blythswood Square*, and, lower left, *Side, Front*; and various other notes and measurements. Scale, 1 : 12.

As executed (1900.31) except for the later addition of the lower shelf on which castors are mounted. There is also no indication of the black-and-white chequer decoration which is such an important feature of the finished piece. Mackintosh has also mistakenly written *13″* instead of *30″* for the height of the main shelf.

Literature: Glasgow School of Art, *Furniture*, no 21a.
Provenance: Mackintosh Estate.
Collection: Glasgow University.

▽D1900.32 1900.33 ▷

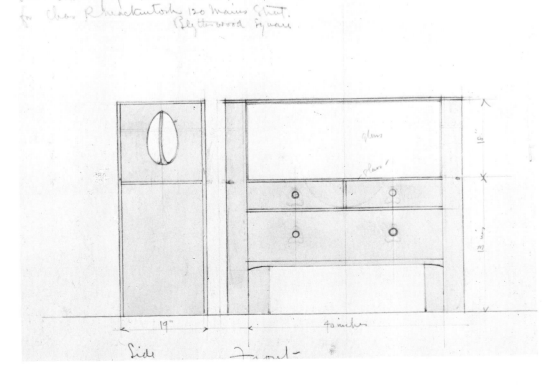

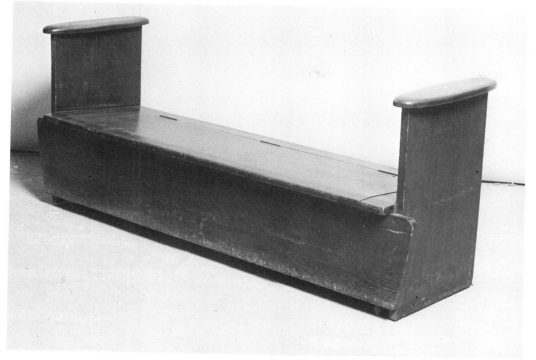

△ 1900.34

D1900.37 ▽

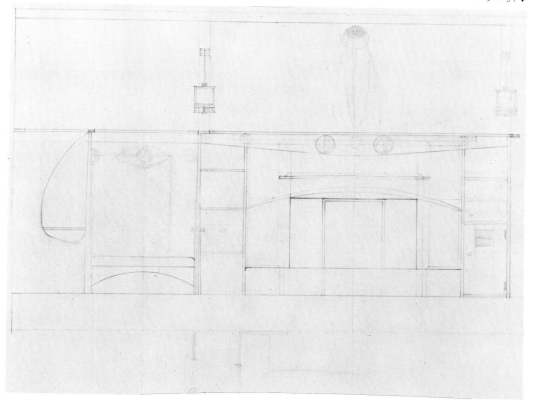

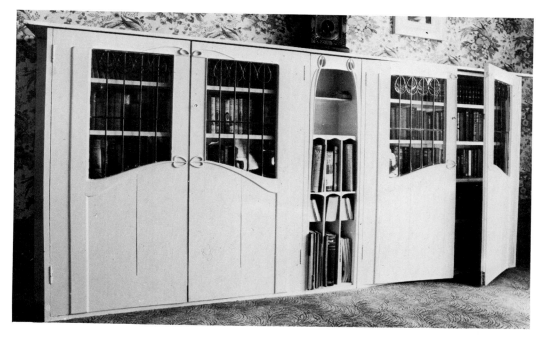

◁ 1900.38

1900.34 Hall settle
Oak, stained dark 59 × 140 × 40.5 cm.

This settle was certainly used in the hall at 78 Southpark Avenue, and it was probably designed for the same purpose at 120 Mains Street.

Provenance: Davidson Estate.
Collection: Glasgow University.

1900.35 Fitted settle for Dunglass Castle, Bowling
Oak, painted white, with stencilled linen upholstery.

A replacement for the settle shown in 1899.M. The stencilled fabric was given to Glasgow University by Mrs L. A. Dunderdale. (*See* 1900.A).

Literature: Howarth pp. 47–48, plate 11a.
Provenance: Charles Macdonald; by family descent to Mrs L. A. Dunderdale.
Collection: National Museum of Antiquities of Scotland, Edinburgh.

1900.36 Fireplace for Dunglass Castle, Bowling
Wood, painted white.

Probably later than the fireplaces at 120 Mains Street. The great width of the structure results from the need to cover the existing heavy marble fireplace, rather than from a purely aesthetic decision (*see* 1900.A). The need to hide the marble surround and the columns meant that Mackintosh could not incorporate one of his own designs for grates: there are no rendered cement surfaces, no hobs or open ashtraps, merely a simple commercial grate, rather like the Caird Parker designs he used in his later Tea Room and domestic schemes.

Provenance: Charles Macdonald; by family descent to Mrs L. A. Dunderdale.
Collection: National Museum of Antiquities of Scotland, Edinburgh.

D1900.37 Design for a fireplace and settle for Dunglass Castle, Bowling
Pencil 30.6 × 43.5 cm.
Scale, 1 : 12.

Apart from the curved canopy over the grate, the drawing is virtually as executed. Included in the design is a drawing of the original fireplace which was to be covered up by the new white structure and which seems identical with the marble fireplace shown in 1899.M.

Provenance: Mackintosh Estate.
Collection: Glasgow University.

1900.38 Bookcase for Dunglass Castle, Bowling
Oak, painted white with leaded glass doors
132 × 292 × 323 cm.

The drawing (D1900.39) shows that Mackintosh gave the Macdonald family the choice of two designs for the glazed doors: one like his own at Mains Street, and a second, simpler, design of leaves and stems, which they chose. Otherwise, the bookcase is identical with 1900.7.

Provenance: Charles Macdonald; by family descent.
Collection: L. A. Dunderdale.

D1900.39 Design for a bookcase for Dunglass Castle, Bowling
Pencil and watercolour 28.8 × 42.2 cm.
Signed, dated and inscribed, lower right, *Chas R Mackintosh | 140 Bath Street | Glasgow June 1900*; inscribed, upper left, *Bookcase for Chas Macdonald Esqr. Dunglass Bowling—*, and, lower left, *To be made in 3 pieces | Top shelf in one piece*, and, right, *Estimate to include | polished*

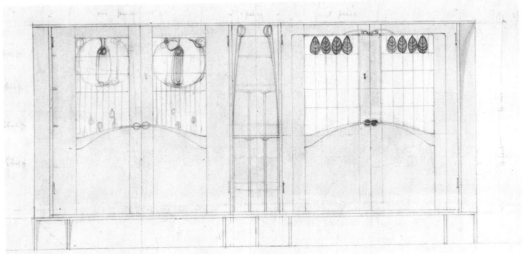

△D1900.39

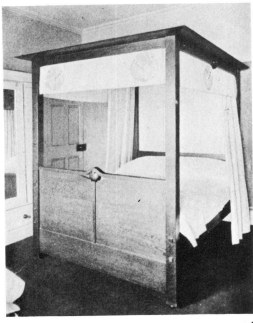

1900.40△

steel hinges | 2 locks | 2 pair slip bolts | Estimate to be given for oak or pine | but not for glass panels | or glass jewels or staining; and various notes and measurements.
Scale, 1:12.

This design gives a choice of panels for the glazed doors.

Provenance: Mackintosh Estate.
Collection: Glasgow University.

▽D1900.41

1900.40 Four-poster bed for Dunglass Castle, Bowling
Wood, stained dark, or ebonised.

Contemporary photographs suggest that this bed was either ebonised or dark-stained. This is unusual in Mackintosh's oeuvre as, with the exceptions of 1896.2 and 1904.70, all his other beds are painted white. The design is an amalgam of the beds made for 120 Mains Street (1900.28) and Windyhill (1901.51).

Literature: *Moderne Stil*, IV, 1902, plate 23.
Collection: untraced.

D1900.41 Design for a bed for Dunglass Castle, Bowling
Pencil and watercolour 31.4 × 45.3cm.
Signed and inscribed, lower right, *Chas R Mackintosh | 140 Bath Street Glasgow*; inscribed, along top, *SKETCH DESIGN OF BED FOR CHAS MACDONALD ESQR. DUNGLASS CASTLE BOWLING. C. R. MACKINTOSH DES*; with various other notes and measurements including *full size bed 5–0 × 6–6 | to be made of oak; top of bed square across | no carving or opening.*
Scale, 1:12.

Virtually as executed.

Provenance: Mackintosh Estate.
Collection: Glasgow University.

D1900.41A Design for a wardrobe for Dunglass Castle, Bowling
Pencil and watercolour 22.9 × 44.5cm. (sight).
Signed, lower right, *Chas. R. Mackintosh | 140 Bath Street Glasgow*; inscribed, upper right, *Sketch for Wardrobe for D[?unglass]* with various other notes and dimensions.
Scale, 1:12.

Similar in overall size and interior detail to the wardrobe for Mains Street (1900.24), but drawn here as a single item, not doubled as was

D1900.41A▽

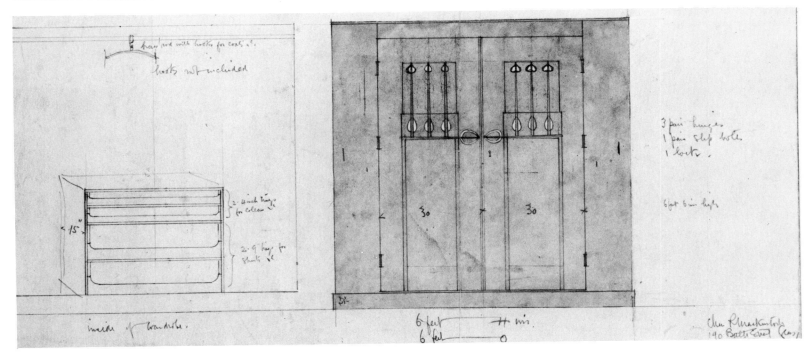

84

Mackintosh's own wardrobe. The carved detail on the doors has affinities with the book-case (1900.38). It is not known whether this wardrobe was ever made.

Exhibited: Toronto, 1967 (84).
Collection: Dr Thomas Howarth.

1900.42 Washstand for Dunglass Castle, Bowling
Oak, painted white, with tiled top 124 × 145 × 47cm.

A simple design, reminiscent of the work done for Guthrie & Wells in the 1890s.

Provenance: Charles Macdonald; by family descent.
Collection: L. A. Dunderdale.

D1900.43 Design for a wash-stand for Dunglass Castle, Bowling
Pencil and watercolour on tracing paper 29.7 × 28cm. (irregular).
Signed and inscribed, bottom right, *Chas R Mackintosh | 140 Bath Street*; inscribed, upper left, *Bedroom Furniture for | Chas Macdonald Esqr. | Dunglass Bowling*, and, lower left, *Estimate to include making in oak | 2 pair steel hinges | 1 pair slip bolts — 1 one lock | and 6″ White Tiles at Back*; and various notes and measurements.
Scale, 1:12.

Virtually as executed.

Provenance: Mackintosh Estate.
Collection: Glasgow University.

1900.44 Dressing-table for Dunglass Castle, Bowling
Oak, painted white.

Companion to 1900.42.

Provenance: Charles Macdonald; by family descent.
Collection: Mrs McLarty.

D1900.45 Design for a dressing-table for Dunglass Castle, Bowling
Pencil and watercolour on tracing paper 28.7 × 33.9cm. (irregular).
Signed and inscribed, lower right, *Chas R Mackintosh | 140 Bath Street*; inscribed, upper left, *Bedroom Furniture for | Chas Macdonald Esqr. | Dunglass Bowling—*, and, lower left, *Estimate to include making in oak | mirror— mirror hinges and 3 locks | but not handles—*.
Scale, 1:12.

Virtually as executed.

Provenance: Mackintosh Estate.
Collection: Glasgow University.

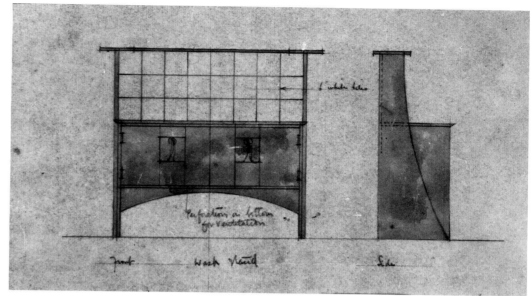

△D1900.43

D1900.45▽

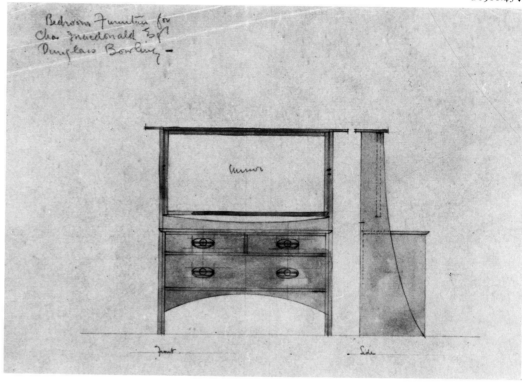

D1900.46 Sketch for a wash-stand and a dressing-table for Dunglass Castle, Bowling
Pencil 22.2 × 42.2cm.
Scale, 1:12.

Preliminary designs for 1900.42 and 44.

Provenance: Mackintosh Estate.
Collection: Glasgow University.

D1900.46▽

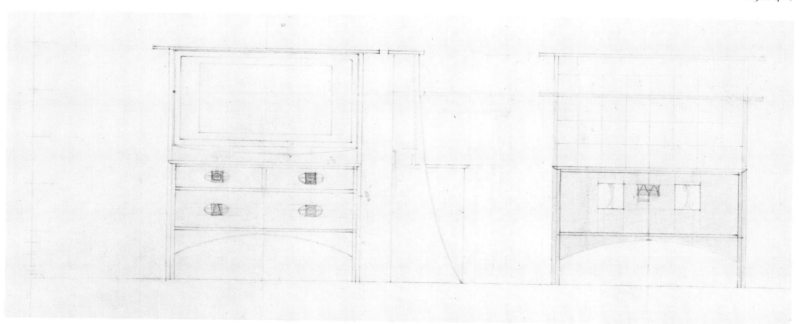

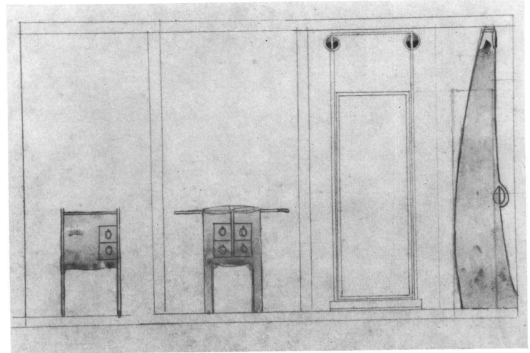

◁1900.47 D1900.48△

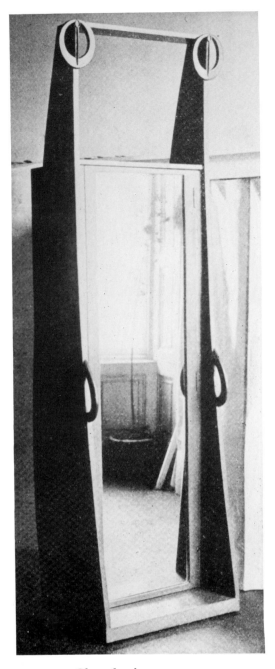

1900.47 Cheval mirror
Wood, painted white.

Possibly made for Dunglass Castle to accompany the bedroom furniture (1900.40, 42 and 44). The decorative carving is so positioned that it seems to have been intended to be used as handles for moving the mirror about.

Literature: *Dekorative Kunst*, IX, 1902, p. *208*.
Collection: untraced.

D1900.48 Design for a cheval mirror and a bedside table
Pencil and watercolour on tracing paper 26.7 × 41cm. (irregular).
Scale, probably 1 : 12.

The mirror seems to be drawn virtually as executed. There is no record of the table having been made, but it has affinities with the design for a small dressing-table for The Hill House (*see* D1903.59).

Provenance: Mackintosh Estate.
Collection: Glasgow University.

1900.G The White Dining Room, Ingram Street Tea Rooms, Glasgow
The screen (1900.66) and two of the smaller hat stands (1900.49) can be seen in their original positions. In the top right-hand corner appears part of *The Wassail*, a large gesso panel by Mackintosh.

Collection: Glasgow University.

1900 The White Dining Room, Ingram Street Tea Rooms, Glasgow
The first job for Miss Cranston where Mackintosh had complete control over both furniture and decoration. This room, where the woodwork was painted white, had a small mezzanine balcony, and kitchens, servery and Ladies' Dressing Room on the back (south) wall with access to all the other tea rooms. The main cash desk was accommodated underneath the stairs to the balcony. On the east and west walls were long gesso panels, *The Wassail* by Charles and *The May Queen* by Margaret (*see The Studio*, XXVIII, 1903, pp. *287–88*). The billiards room, with its dark-stained panelling, was in the basement.

Howarth confuses the dating of the Ingram Street Tea Rooms. The dates of the large gesso panels and the drawing (D1900.57) are definitely 1900, and Mackintosh owned one of the chairs—although it was possibly a prototype—before March, 1900. There are other similarities between this project and 120 Mains Street, such as the use of squares of stencilled coloured glass in the frieze rail, which suggest that the first half of 1900 is a likely date for this room. Therefore, Howarth's suggestion (p. 132) that work on the White Dining Room did not commence until 1901/2 cannot be true; nor indeed were the gesso panels exhibited at Turin (Howarth, p. 133, note 1); while the illustrations of the Tea Rooms in *The Studio* are in Vol. XXVIII, not Vol. XXXVI as he states. Both the White Dining Room and its billiards room below must, on stylistic grounds at least, have been completed well before midsummer 1901, when work probably began on Wärndorfer's furniture and the Turin schemes. Mackintosh did no work at this time in the central section, the so-called Scott-Morton room, or in 205 Ingram Street, which became the Chinese Room, but he worked on the Cloister Room concurrently with the White Dining Room. A contemporary photograph (1900.K) shows a screen of Mackintosh's design, as well as stencilling (*The Studio*, XXVIII, 1903, p. *287*), and furniture like that used in the White Dining Room. The original ornate plaster frieze was untouched, but the whole scheme was swept away in 1911 when the Cloister Room was totally re-designed.

All the Ingram Street fittings are now in the care of the Glasgow Art Galleries and Museums; so is much of the furniture, although some was given to the Glasgow School of Art in the 1950s. Howarth records the fate of the Tea Rooms during the 1950s (p. xxiii), but is not accurate about the events of 1971 when the rooms were dismantled. The building was not demolished, but was sold to an hotel and restaurant business which had hoped to keep the rooms; however, health and safety legislation required too many alterations to retain the atmosphere of the complex. Eventually, the Tea Rooms were removed by the Planning Department of the Corporation of Glasgow, as a listed building, and put into store. Neither Glasgow University nor the School of Art was able to take them at the time, although both were concerned with their future. No other department of the Corporation—the owners of the Tea Rooms—showed any interest in retaining them *in situ* or storing them after they were dismantled. Despite the efforts of the Planning Department, the fixtures were afterwards damaged while in store and were eventually taken over by Glasgow Art Galleries and Museums in 1977, which were by this time under a more enlightened régime. The Art School, which had paid for the necessary and thorough survey of the interiors, had intended to accommodate them, failing any other acceptable scheme, in their new Architec-

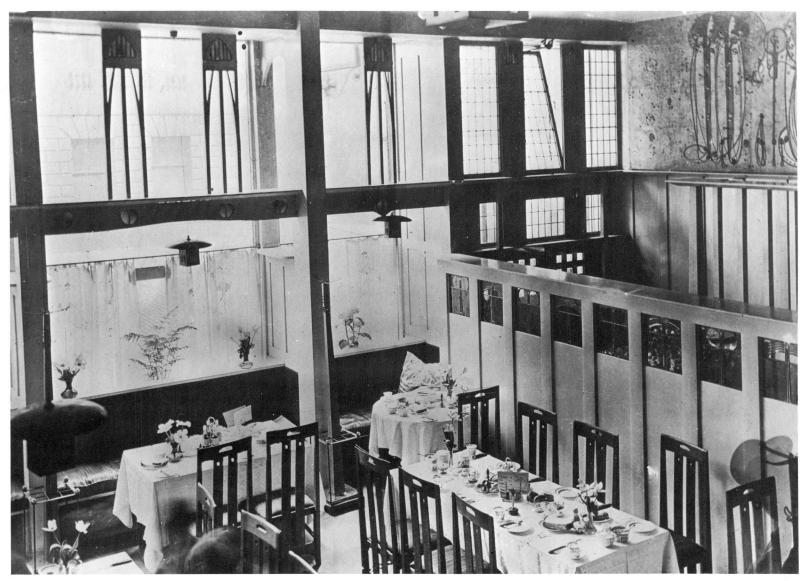

△1900.G

ture School; in 1978 it seems likely that they will forego their claim on the fittings in favour of some form of reconstruction by the Museum.

No job-books survive for this project, and there was no complete contemporary photographic survey as was made of the Willow Tea Rooms. It seems likely, however, that Mackintosh would have used Francis Smith as maker of the furniture. Numbers of items made are based upon those received by Glasgow Art Galleries and Museums, both whole and broken, plus other pieces dispersed at an earlier date.

Literature: *The Studio*, XXVIII, 1903, pp. *286–88*; Howarth, pp. 131–33, plate 50.

1900.H▽

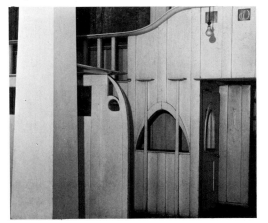

1900.H Screen and cash desk at the White Dining Room, Ingram Street Tea Rooms, Glasgow

This photograph was taken in 1950 after the Tea Rooms had closed. In the panelling above the cash desk can be seen two of the square glass panels decorated with organically-inspired motifs; these were repeated around the balcony panelling.

Collection: Glasgow University.

1900.I Balcony of the White Dining-Room, Ingram Street Tea Rooms, Glasgow

The stylised tree stencilled on the wall was repeated around this small mezzanine balcony. The leaded-glass casements screened a ventilation duct from the servery below.

Collection: Glasgow University.

◁1900.I

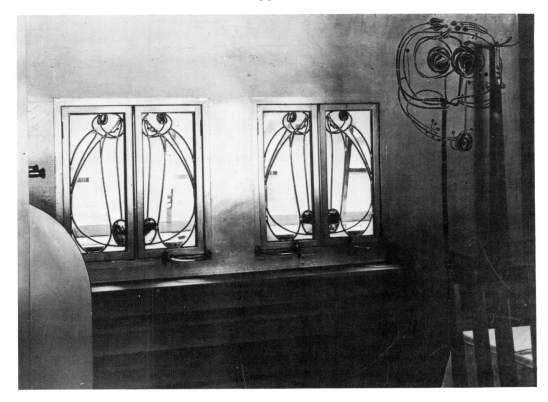

△ 1900.J detail

△ 1900.J ▷

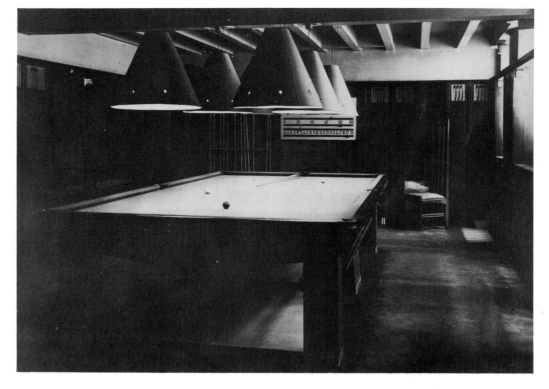

1900.J Billiards room, Ingram Street Tea Rooms, Glasgow
A contemporary photograph showing the fitted seating on the left, and the bays on the right, which received daylight from glazed grids in the pavement above.

Collection: Glasgow University.

1900.K The Cloister Room, Ingram Street Tea Rooms, Glasgow
A contemporary photograph showing how Mackintosh left untouched the ornate plaster frieze and ceiling. In 1911–12 he hid these beneath a new and lower barrel-vaulted ceiling; the stencil decoration (1900.L) was also covered over in those alterations, but the open screen at the end of the room and a glazed screen above it were retained.

Collection: Glasgow University.

1900.L Stencil decoration in the Cloister Room, Ingram Street Tea Rooms, Glasgow
Mackintosh applied his stencil over a canvas wall-covering. He left this on the walls when the new Cloister Room was installed (1911–12) and samples of the original stencil were retrieved in 1971 when the Tea Rooms were dismantled (collection: Glasgow Art Galleries and Museums and Glasgow University).

Collection: Glasgow University.

▽ 1900.K

1900.L ▷

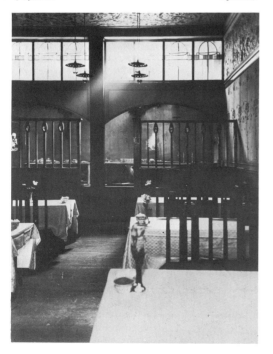

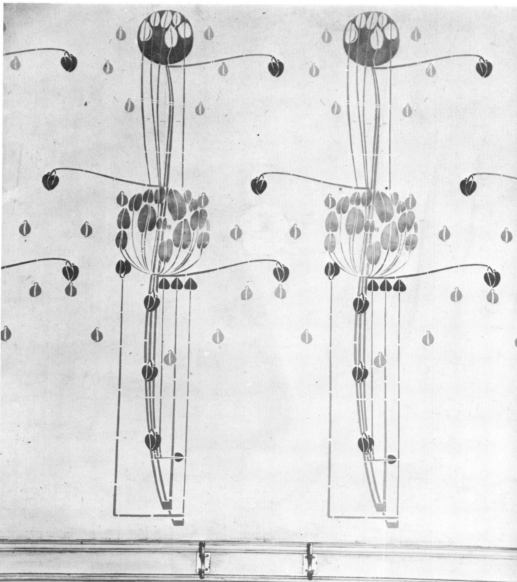

1900.49 Hat, coat and umbrella stand for the White Dining-Room, Ingram Street Tea Rooms, Glasgow
Oak and wrought-iron 196.8 × 33.6 × 32.4cm.

The drawing (D1900.51) indicated that four of these stands were made; two can be seen in contemporary photographs between the tables at the window and the drawing suggests that the others were on the balcony. Two examples survive.

Literature: Howarth, plate 50a.
Exhibited: Edinburgh, 1968 (257).
Provenance: Miss Cranston's Tea Rooms; Messrs Coopers, from whom purchased by Glasgow Corporation, 1950.
Collection: Glasgow Art Galleries and Museums (3).

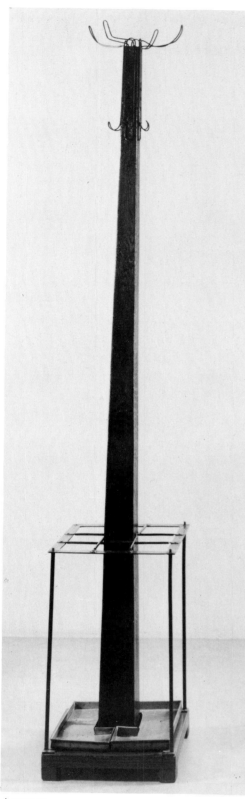

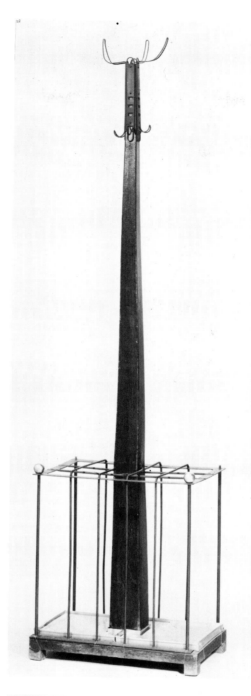

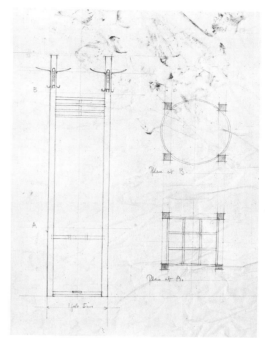

D1900.52△

1 large); and, lower right, *Plan of Small Stands at Window Tables / and on Balconies*; and, verso, *Miss Cranston / 114 Argyle Street.*

The design for 1900.49 and 1900.50; virtually as executed.

Provenance: Mackintosh Estate.
Collection: Glasgow University.

D1900.52 Design for a coat, hat and umbrella stand
Pencil 26.3 × 29.3cm. (irregular).
Inscribed, right, *Plan at B* and *Plan at A*.
Scale, 1:12.

Possibly a preliminary design for 1900.49.

Provenance: Mackintosh Estate.
Collection: Glasgow University.

1900.53 Umbrella stand (? for the Ingram Street Tea Rooms, Glasgow)
Wrought-iron 67 × 33.5cm. (diameter).

Eight examples survive. It is not known

◁1900.50 D1900.51▽

△1900.49

1900.50 Hat, coat, and umbrella stand for the White Dining Room, Ingram Street Tea Rooms, Glasgow
Oak and wrought-iron 196.8 × 53 × 34cm.

The drawing for this stand (D1900.51) states that only one large stand was made; it stood at the central pillar of the Dining Room. The design is basically an enlargement of 1900.49.

Literature: *The Studio*, XXVIII, 1903, p. *286*.
Provenance: as 1900.49.
Collection: Glasgow Art Galleries and Museums.

D1900.51 Design for a hat, coat, and umbrella stand for the Ingram Street Tea Rooms, Glasgow
Pencil and watercolour 33 × 40.6cm.
Signed, lower right, *CHAS. R. MACKIN-TOSH. DES*; inscribed, upper left, *MISS CRANSTONS INGRAM STREET. UM-BRELLA STANDS*, and, lower centre, *Plan of Large Stand at Center* [sic] *pillar, (and 5 Stands /*

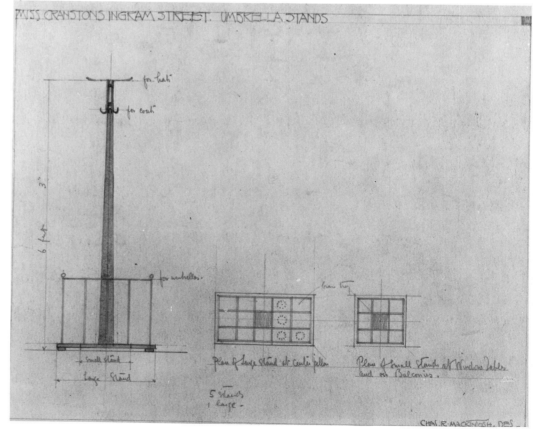

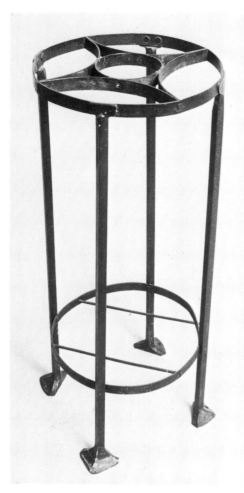

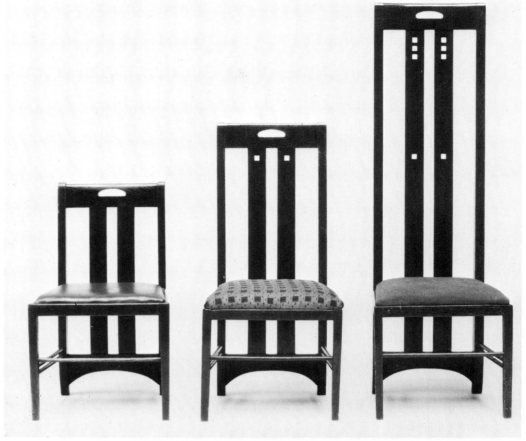

△1900.56　　　　　　　　△1900.54　　　　　　　　1900.55△
◁1900.53　　　　　　　　　　　　　　　　　　　　　D1900.57▽

whether this design was made specifically for Ingram Street, or at what date it was first used. Stylistically, it belongs to *c*1900 or before, and may even have been made for the Argyle Street premises and transferred from there when they closed *c*1920.

Exhibition: Edinburgh, 1968 (258).
Provenance: a) as 1900.49; b) as 1900.49, and then presented.
Collection: a) Glasgow Art Galleries and Museums (5); b) Glasgow School of Art (3).

1900.54 Chair for the White Dining Room, Ingram Street Tea Rooms, Glasgow

Oak, stained dark, with horsehair upholstery 106.4 × 47.7 × 43.8cm.

The basic chair used in the main dining-room and the Cloister Room in 1900. The original seat covering was probably horsehair. 43 examples survive.

Literature: *The Studio*, XXVIII, 1903, p. *286*; Howarth, p. 133, plate 50a; Glasgow School of Art, *Furniture*, no 6; Alison, pp. 40, *41*, 91–95.
Provenance: a) as 1900.49; b) as 1900.49, and then presented; c) Davidson Estate.
Collection: a) Glasgow Art Galleries and Museums (39); b) Glasgow School of Art (2); c) Glasgow University (2).

1900.55 Chair, high back, for the White Dining Room, Ingram Street Tea Rooms, Glasgow

Oak, stained dark, with horsehair upholstery 151 × 47.3 × 43.3cm.

A taller and more elegant version of 1900.54, but its higher back makes it less rigid and more liable to damage through careless use, as the two back splats were not originally attached to the seat-rail (nor were those in 1900.54, but at some time the chairs were strengthened by screwing them to the rear seat-rail). It is not known exactly where these chairs were used, although a contemporary photograph, 1900.J, shows one example in the billiards

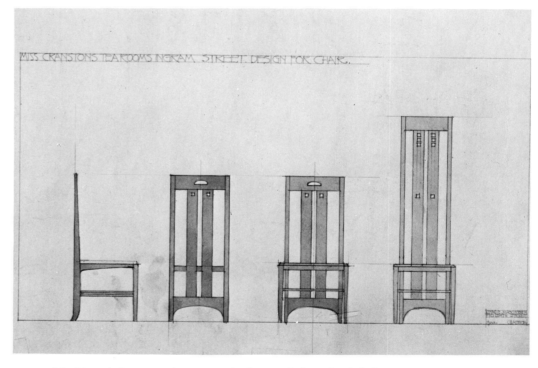

room. Mackintosh kept another example for himself and painted it white (1900.11). This was in his collection by March 1900, the date of the Annan photographs; whether or not it precedes the Tea Room chairs or is contemporary with them is not known. Four examples survive.

Literature: Glasgow School of Art, *Furniture*, no 7; Macleod, plate 77; Alison, pp. 40, *42*, *43*, 91–95.
Exhibited: VEDA, 1952 (R.7); Saltire, 1953 (B10); Paris, 1960 (1078).
Provenance: a) as 1900.49; b) as 1900.49, and then presented.
Collection: a) Glasgow Art Galleries and Museums (2); b) Glasgow School of Art (2).

1900.56 Low chair for the Ingram Street Tea Rooms, Glasgow

Oak, stained dark 84 × 47.7 × 43.8cm.

This chair is identical with 1900.54, except that the rear uprights and splats have been shortened and the top-rail refastened. Howarth (p. 135) states that the original chairs for the Cloister Room were shortened by Francis Smith in 1912, presumably because they clashed with the new low ceilings installed at that time. The chairs originally designed for the Cloister Room were like 1900.54, not 1909.14 as stated by Howarth (*see* 1900.K); there is no evidence of any alterations to 1909.14, and I believe that these chairs, 1900.56, were the ones which were cut down for the new room.

Literature: Alison, p. 40, no 11, p. *43*.
Provenance: a) as 1900.49; b) as 1900.49, and then presented.
Collection: a) Glasgow Art Galleries and Museums (13); b) Glasgow School of Art (2).

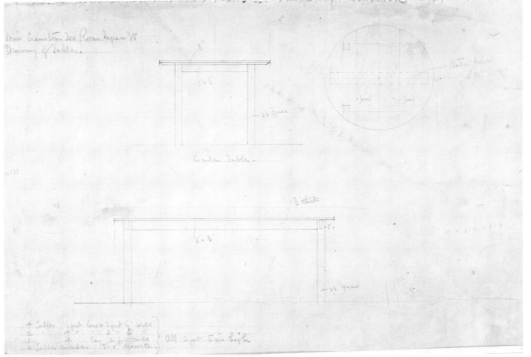

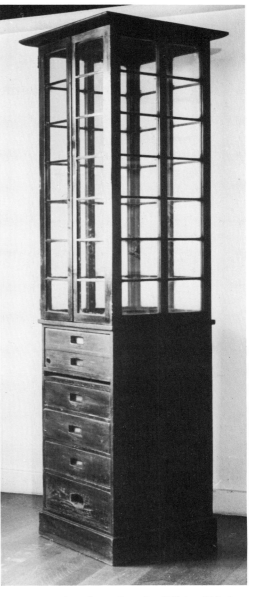

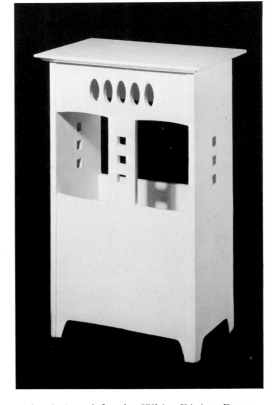

D1900.57 Design for a chair for the Dining Room, Ingram Street Tea Rooms, Glasgow

Pencil and watercolour 26.8 × 45cm.

Signed, dated and inscribed, lower right, *CHAS R MACKINTOSH / 140 BATH STREET / 1900. GLASGOW*; and inscribed, top, *MISS CRANSTONS TEA-ROOMS' INGRAM STREET. DESIGN FOR CHAIR*.

Scale, 1 : 12.

The design for a chair for 1900.54 and 1900.55; virtually as executed.

Literature: Alison, p. *42*, 77, no 5.
Exhibited: Milan, 1973 (5).
Provenance: Mackintosh Estate.
Collection: Glasgow University.

1900.58 Tables for the White Dining Room, Ingram Street Tea Rooms, Glasgow

No tables from the White Dining Room have been traced, but D1900.59 indicates that 11 were planned, some of which appear in contemporary photographs. Like the tables in the Luncheon Room at Argyle Street, they were very simple in construction with no visible decoration.

Literature: Howarth, plate 50a.
Collection: untraced.

D1900.59 Designs for circular and rectangular tables for the Ingram Street Tea Rooms, Glasgow

Pencil 34 × 39cm.

Signed and inscribed, lower right, *Chas R Mackintosh / 140 Bath Street Glasgow*; inscribed, upper left, *Miss Cranstons Tea Rooms Ingram St / Drawing of tables*, and, lower left,

4 tables 6 feet long × 2 feet 6″ wide
2 „ 4 „ „ × 2 „ 6″ „
1 „ 4 „ „ × 2 feet wide
4 tables circular 3′ 0″ diamet
All 2 feet 5 ins high
Scale, 1 : 12.

Provenance: Mackintosh Estate.
Collection: Glasgow University.

1900.60 Serving table for the White Dining Room, Ingram Street Tea Rooms, Glasgow

Wood, painted white 76.8 × 47.2 × 31.2cm.

Apart from 1900.76, this seems to be the only free-standing piece of white-painted furniture to be designed for the White Dining Room. The pierced square motif echoes that in the backs of the chairs, 1900.54.

Provenance: as 1900.49.
Collection: Glasgow Art Galleries and Museums (2).

1900/06.61 Display cabinet for the Ingram Street Tea Rooms, Glasgow

Pine, stained dark, with glazed doors 206.5 × 60 × 59cm.

This may have been used for keeping plates and food hot, or even chilled sweets cool; the shelves are slatted and the top drawer has a metal lining, presumably intended to hold hot coke or ice around which the air would circulate, thus warming or cooling the items on display. Probably designed c1900, but no contemporary photographs or other records survive.

Provenance: as 1900.49.
Collection: Glasgow Art Galleries and Museums.

1900.62 Fireplace for the White Dining Room, Ingram Street Tea Rooms, Glasgow

Lead.

Mackintosh had used lead over a wooden frame for the fender at 120 Mains Street, 1900.4, but this was the first and only time he was to use it on such a large scale. The grate was a version of that used in the Mains Street drawing-room.

Literature: *The Studio*, XXVIII, 1903, p. *288*; Howarth, p. 133.
Provenance: as 1900.49.
Collection: Glasgow Art Galleries and Museums.

1900.62▽

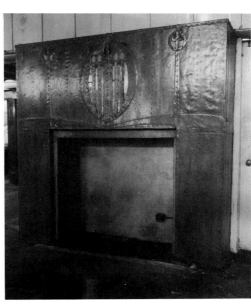

D1900.63 Design for a fireplace
Pencil 30.5 × 33.1cm. (irregular).
Scale, probably 1:24.

Almost certainly a preparatory study for the fireplace in the White Room at the Ingram Street Tea Rooms. It differs from the executed design (1900.62) in the positioning of the two decorative panels (which were eventually replaced by a single panel of stylised flowers) and other minor details, but the overall shape and scale and the two curved panels meeting over the grate are as executed.

Provenance: Mackintosh Estate.
Collection: Glasgow University.

D1900.64 Design for the fireplace for the White Dining Room, Ingram Street Tea Rooms, Glasgow
Pencil on page of a sketchbook 18.4 × 13.4cm.
A rough sketch, but showing the final arrangement of the applied decoration.

Provenance: Mackintosh Estate.
Collection: Glasgow University.

D1900.65 Design for fire-back for the White Dining Room, Ingram Street Tea Rooms, Glasgow
Pencil 26.1 × 31.5cm.

Signed and inscribed, lower right, *Chas R Mackintosh | 140 Bath Street | Glasgow.*; and inscribed, upper left, *Miss Cranstons Tea Rooms Ingram St | Scale drawing of Cast Iron Fireback.*
Scale, 1:12.

As executed; the design of the iron back panel was repeated in the Dutch Kitchen at Argyle Street in 1906.

Provenance: Mackintosh Estate.
Collection: Glasgow University.

◁D1900.64 △D1900.63 D1900.65▽

1900.66 Screen for the White Dining Room, Ingram Street Tea Rooms, Glasgow
Wood, painted white with panels of leaded-glass.

The dining tables were screened from the entrance and the stairs to the balcony by this wood and glass partition. The cash desk was positioned at the end of the screen so that clients were funnelled past it as they left their tables. The construction of the screen echoes the panelling on the walls, with broad vertical posts joined by wider panels of timber. Above these panels are squares of decorative leaded-glass—clear, coloured and mirror—of abstract pattern, although the motifs are clearly based upon organic forms.

The screen was lower than the wall panelling or staircase balustrade, presumably in order not to obscure the gesso panel on the east wall. At the cash desk end it terminated in a kind of flying buttress which follows a shape not unlike the curving front uprights of the cheval mirror at Mains Street (1900.26). The wide, flat cornice, which runs the length of the screen, turns at this end through 90° and butts against the central column. See 1900.H.

While the Tea Rooms were leased out by Glasgow Corporation in the 1950s, the screen was cut in half and the 'buttress' lost.

Literature: *The Studio*, XXVIII, 1903, p. *286*; Howarth, plate 50a.
Provenance: as 1900.49.
Collection: Glasgow Art Galleries and Museums.

1900.67 Cash desk for the White Dining Room, Ingram Street Tea Rooms, Glasgow
Wood, painted white.

Unlike the cash desks at the Willow Tea Rooms and the later Chinese Room at Ingram

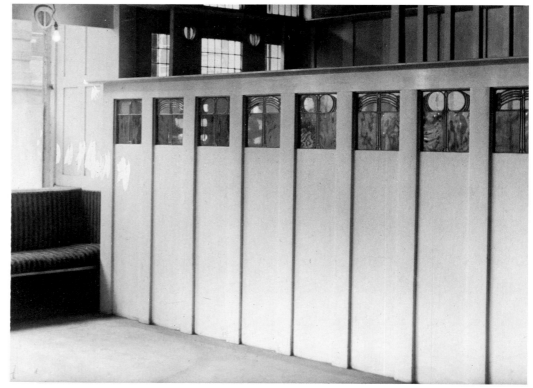

1900.66△

Street, this desk is built into the fittings of the room, in this case underneath the main staircase. It has two openings, at right-angles to each other, and one of them incorporates the access door. See 1900.H.

Literature: *The Studio*, XXVIII, 1903, p. *286*; Howarth, plate 50b.
Provenance: as 1900.49.
Collection: Glasgow Art Galleries and Museums.

1900.68 Fitted seating for the White Dining Room, Ingram Street Tea Rooms, Glasgow
As in most of the Tea Rooms, Mackintosh used fitted bench seats in the window bays. *See* 1900.G.

Literature: Howarth, plate 50a.
Provenance: as 1900.49.
Collection: Glasgow Art Galleries and Museums.

D1900.69 Design for a window, with a couch beneath
Pencil and watercolour 30.8 × 19.6cm.
Scale, 1:12.

This design cannot be identified with any executed project, but the scale of the window above suggests that it was not intended for a domestic setting. The decoration of the upholstery is similar to that on the couches for Argyle Street (D1897.17 and D1897.18), but there were no windows on this scale in that

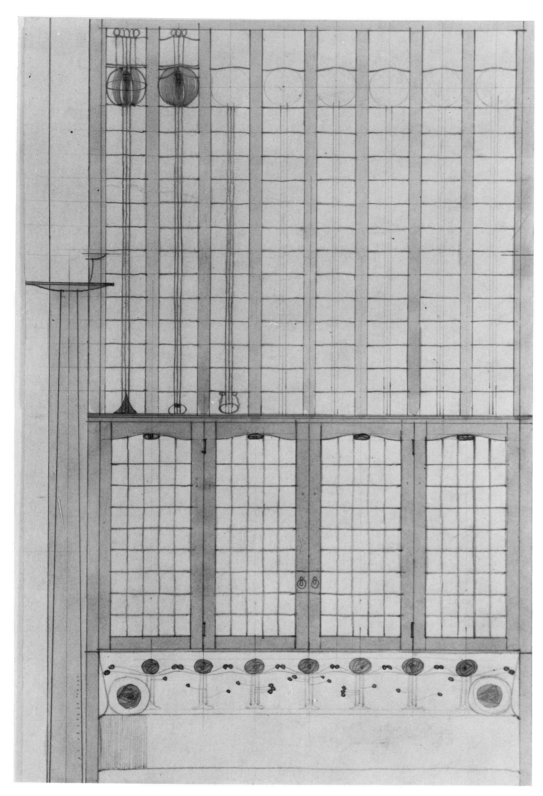

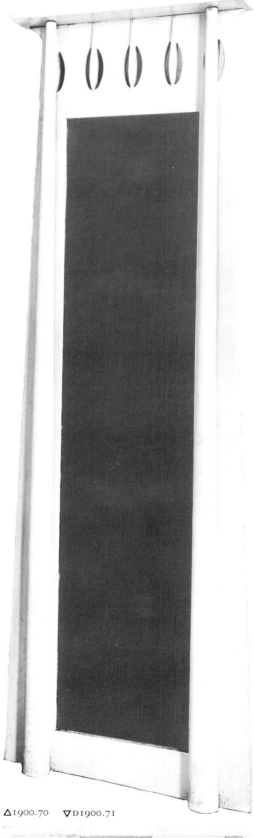

D1900.69 △

suite of rooms. The most likely identification is as a preliminary design for the treatment of the windows at the White Dining Room, Ingram Street Tea Rooms.

Provenance: Mackintosh Estate.
Collection: Glasgow University.

1900.70 Mirror for the Ladies' Dressing Room, Ingram Street Tea Rooms, Glasgow
Wood, painted white 197 × 60 × 11cm.

This mirror was fixed to the wall in the Ladies' Room; it is of a much simpler design than the movable dressing mirrors at 120 Mains Street, Windyhill, or The Hill House.

Provenance: as 1900.49.
Collection: Glasgow Art Galleries and Museums.

D1900.71 Design for a mirror for the Ladies' Dressing Room, Ingram Street Tea Rooms, Glasgow
Pencil and watercolour 26.2 × 31.2cm.

Inscribed, bottom, *MISS CRANSTONS INGRAM STREET. MIRROR FOR LADIES DRESSING ROOM*; and verso, in an unknown hand, *Dont Crush | To C. Macdonald Esq | Dunglass | Bowling*; in another hand, *Chas. R. Mackintosh Esqr* | [the following deleted by the first hand] *at Messrs Honeyman & Keppie | 140 Bath Street | City*; there is also the remains of a stamp and indecipherable postmark.
Scale, 1:12.

As executed.

Provenance: Mackintosh Estate.
Collection: Glasgow University.

1900.72 Billiards table for the Ingram Street Tea Rooms, Glasgow
This table was probably made to Mackintosh's design by Burroughs & Watt, but it has not been traced (*see* 1900.J). The billiards room was in the basement at Ingram Street, beneath the White Dining Room and the Scott Morton

△1900.70 ▽D1900.71

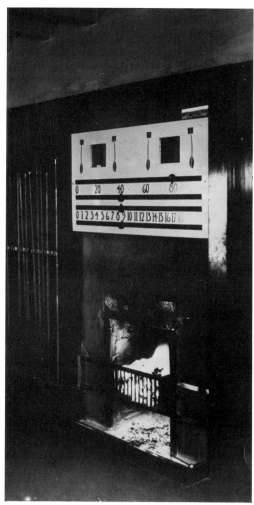

△1900.74

Room; in 1907 another billiards room was opened up under the Oak Room. The room was panelled with dark-stained pine, relieved by pale painted squares at the top of the panelling in which were stencilled motifs of stylised flowers. Fitted seating was installed facing the longer sides of the central table; in the west wall of the room was the fireplace; from the north, daylight filtered through the seating bays; behind these it illuminated the gentlemen's lavatories, tiled and fitted out in typical Mackintosh style. A pair of doors from the cubicles—of stained pine with squares of blue glass—were adapted by Glasgow University for the internal entrance to the reconstruction of 78 Southpark Avenue.

Collection: untraced.

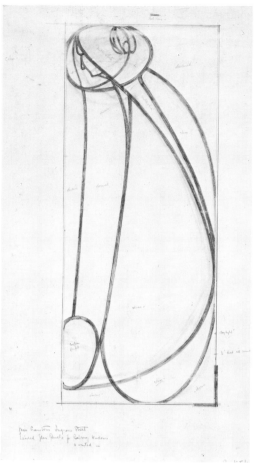

△D1900.75

1900.73 Fitted seating for the billiards room, Ingram Street Tea Rooms, Glasgow
Pine, stained dark with upholstered seats and backs.

The seats were ranged in bays along the north and south walls of the billiards room. *See* 1900.J.

Provenance: as 1900.49.
Collection: Glasgow Art Galleries and Museums.

1900.74 Billiards marker board for the Ingram Street Tea Rooms, Glasgow
Probably made by Burroughs & Watt.

The marker board was fixed above the fireplace, which was another design using black painted wrought-iron and a cement render.

Collection: untraced.

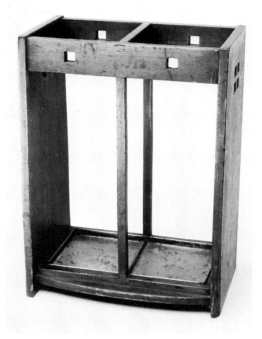

1900.76△

D1900.75 Design for a leaded-glass panel for the balcony windows, Ingram Street Tea Rooms, Glasgow
Verso, outline of same design in reverse.
Pencil 96.7 × 52.8cm.l
Signed and inscribed, lower right, *Chas. R. Mackintosh Des. | 140 Bath Street Glasgow*; inscribed, lower left, *Miss Cranstons Ingram Street | Leaded Glass Panels for Balcony Windows | 4 wanted*, and top, *6 like this*.

Used for casements on the balcony of the White Dining Room, which screened a ventilation shaft from the kitchens below. *See* 1900.I.

Provenance: Mackintosh Estate.
Collection: Glasgow University.

1900.76 Umbrella stand (? for the Ingram Street Tea Rooms, Glasgow)
Pine, painted white 66.5 × 47.3 × 27cm.

There is no record of where this umbrella stand came from, but stylistically it has elements in common with the serving table, 1900.60. The pierced square decoration, also used here in a group of four, was a frequently used motif from c1898–1901.

Provenance: unknown.
Collection: Glasgow School of Art.

1900 Room for the Eighth Exhibition of the Vienna Secession

Mackintosh's work must have been known in Austria, if not from Gleeson White's articles in *The Studio* in 1897, then from that in *Dekorative Kunst* in 1898. Fritz Wärndorfer came to Britain in the late spring of 1900, when he would almost certainly have visited Mackintosh. In July, Carl Moll wrote to Mackintosh returning some photographs and requesting permission to publish some of them in the Secession magazine *Ver Sacrum*; perhaps in the same letter he asked Mackintosh to contribute to the Eighth Exhibition. Mackintosh, in a letter to Moll of 17 December 1900, apologised for not returning the packet of photographs earlier as he had 'carefully put it away and I have been hunting for it ever since I came home' [from Vienna]. The photographs were published, along with views of Mackintosh's Secession room, in *Ver Sacrum*, issue 23, 1901.

Mackintosh's contribution to the Secession was an outstanding success, and he and his wife were fêted during their visit to Vienna. He was given a substantial space which he furnished sparsely with about ten pieces of furniture and a number of watercolours, mostly by Margaret and Frances Macdonald. The woodwork was painted white with no wall decoration other than a series of tapered square posts—like those in his Mains Street dining-room—attached to a deep horizontal wall-plate inset with square panels of coloured glass: a repetition of the same motif in his own drawing-room. But the most striking feature of the design (apart from its overall elegance and restraint) was the inclusion of the two wide gesso panels

1900.M Exhibition room at the Vienna Secession
This photograph shows the large gesso panel, *The Wassail*, designed by Mackintosh as well as the smoker's cabinet (1899.1), armchair (1899.16), and flower stand (1900.79).

1900.N Exhibition room at the Vienna Secession
The panel on the wall is Margaret Macdonald's *May Queen*; she and her sister Frances also designed the clock in the corner. The mirror is from 120 Mains Street (1900.26), and the chair is an example of the Argyle Street dining chairs (1897.23). The embroidered panel to the right of the chair was also designed and made by Margaret Macdonald; it, or a duplicate, is now at Glasgow School of Art.

1900.77 Fireplace for the Eighth Secession Exhibition, Vienna
Wood, painted white.

An extremely plain and simple structure, containing no grate. The fire-screen in front

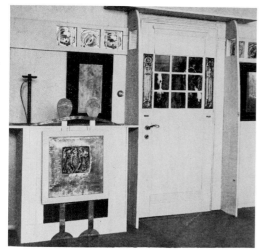

△1900.77

of it is a beaten metal panel designed and made by Margaret Macdonald.

Literature: *Ver Sacrum*, 1901, issue 23, p. *399*; *Dekorative Kunst*, VII, 1901, p. *173*; Sekler, p. *455*; Billcliffe and Vergo, fig. *5*.
Exhibited: Vienna, 1900.
Collection: untraced, probably destroyed (fire-screen panel, Glasgow University).

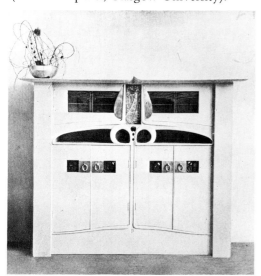

△1900.78

1900.78 Sideboard/cabinet

Oak with leaded-glass and beaten metal panels.

Similar in overall shape to the Mains Street desk (1900.9), this was called a 'drawing cupboard' when exhibited at Turin in 1902. For that exhibition it was painted white; it appears to have been bought there by a Viennese collector, probably Wärndorfer, and was shipped to Vienna after the exhibition, along with a writing desk (1902.8). The two beaten metal panels are by Margaret Macdonald (*Dekorative Kunst*, V, 1902, p. *220*).

Literature: *Ver Sacrum*, 1901, issue 23, p. *399*; *Dekorative Kunst*, VII, 1901, p. *174*, and V, 1902, p. *578*; Sekler, p. *455*; Billcliffe and Vergo, fig. *5*.
Exhibited: Vienna, 1900; Turin, 1902.
Provenance: C. R. Mackintosh; (?) F. Wärndorfer.
Collection: untraced.

1900.79 Flower Stand

A simple design, basically an enlargement of the ceramic or metal flower vases used at 120 Mains Street (*see* 1900.M).

Literature: *Ver Sacrum*, 1901, issue 23, pp. *384*, *385*; *Dekorative Kunst*, VII, 1901, p. *175*; Howarth, plate 59a; Sekler, p. *455*; Billcliffe and Vergo, fig. *5*.
Exhibited: Vienna, 1900.
Collection: untraced.

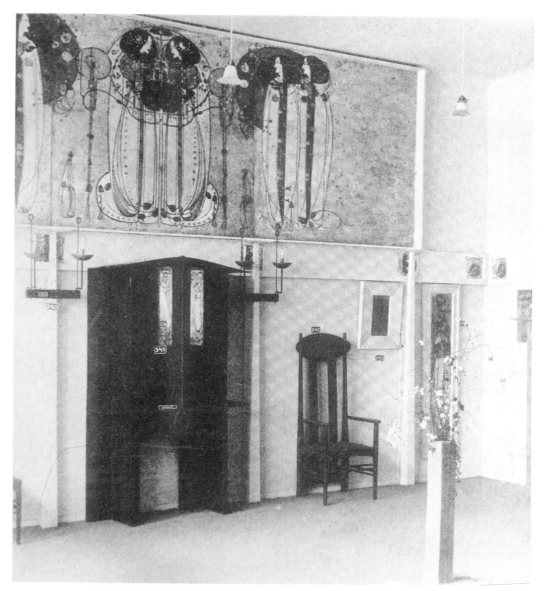

△1900.M

1900.N▽

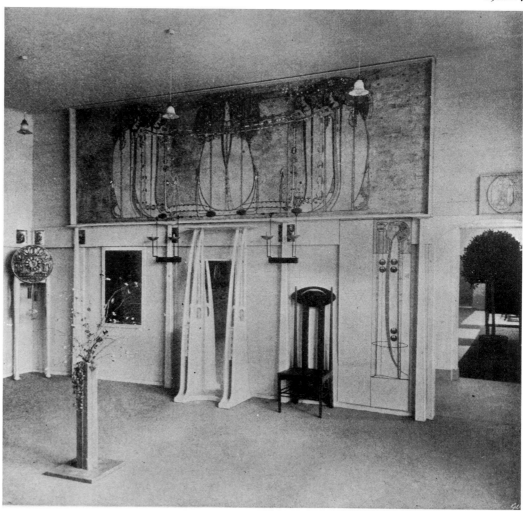

designed and made by Charles and Margaret for Miss Cranston's White Room at the Ingram Street Tea Rooms. This creation of a deep decorative frieze was to have a profound effect upon Gustav Klimt who must surely have been influenced by it in his own exhibit for the Fourteenth Secession Exhibition, *The Beethoven Frieze* (see Peter Vergo, 'Gustav Klimt's Beethoven Frieze', *The Burlington Magazine*, CXV, 1973, pp. 109–13).

With the exception of the clock by Margaret and Frances Macdonald (first shown in *The Studio*, XI, 1897, p. 95), all the furniture was of Mackintosh's design, but only the fireplace—and possibly the cabinet (1900.78)—seem to have been specially designed for the exhibition. The latter was not sold until it was sent to Turin in 1902, sporting a coat of white paint (when Wärndorfer appears to have bought it), but Kolo Moser acquired an armchair (1899.16), and Hugo Henneberg bought the smoker's cabinet (1899.1), which was incorporated by Josef Hoffmann into the house in the Hohe Warte that he designed for Henneberg.

The exhibition was an enormous critical success for Mackintosh and it forged links with men like Hoffmann, Klimt, Moser and Wärndorfer whom he might not otherwise have met. There appear, however, to have been few direct commissions arising out of the exhibition for, with the exception of the music room for Wärndorfer in 1902, the only other work which Mackintosh did in Europe was connected with competitions and other exhibition rooms. There can be little doubt that the exhibition brought other rewards, as it introduced Mackintosh's work to a generation of Viennese designers and students who were to emulate his designs for years to come. It also put him in the limelight as one of the leading British designers and architects: in future years the publishers of the German art periodicals, *Dekorative Kunst* and *Deutsche Kunst und Dekoration* devoted more space to his work than to that of any of his British contemporaries (save, perhaps, Baillie Scott), thus providing him with the acclaim that the British press denied him.

Literature: *Ver Sacrum*, 1901, issue 23; *Dekorative Kunst*, VII, 1901, pp. 171–183; Howarth, pp. 151–54, plate 59; E. Sekler, 'Mackintosh and Vienna', *Architectural Review*, CXLIV, 1968, pp. 455–56; Horst Herbert Kossatz, 'The Vienna Secession and its early relations with Great Britain', *Studio International*, 1971, pp. 9–19; R. Billcliffe and P. Vergo, 'Charles Rennie Mackintosh and the Austrian Art Revival', *The Burlington Magazine*, CXIX, 1977, pp. 739–44.

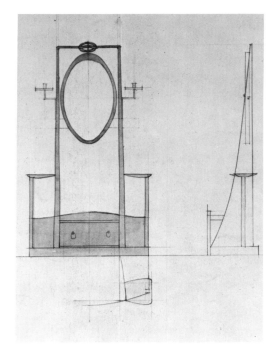

D1900.80 △

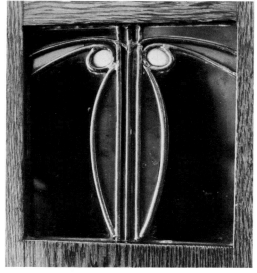

◁1900.81 1900.81 detail △

D1900.80 Design for a cheval mirror
Pencil and watercolour 35.5 × 28cm.
Scale, probably 1 : 12.

No piece corresponding with this drawing has been traced. It is probably a preparatory sketch for, or contemporary with, the mirrors designed *c*1900–01 (*see* 1900.26 and 47, and 1901.49).

Provenance: Mackintosh Estate.
Collection: Glasgow University.

1900.81 Cabinet for Michael Diack, Glasgow
Oak, stained dark, with glazed doors 132 × 158 × 387cm.

Probably designed *c*1900. The pattern of the glass in the inlaid panel resembles that in the screen at Ingram Street (1900.66). Other pieces made for Diack, a musician, include the writing desk (1901.1) and bookcase (1903.2).

Provenance: Michael Diack; by family descent.
Collection: Michael Diack, London.

D1900.82 * Design for a table
This drawing has not been available for photography and the author has not seen it. No medium or dimensions are given in the Toronto catalogue, where the date given is *c*1900.

Exhibited: Toronto, 1967 (74).
Collection: Dr Thomas Howarth.

*See addenda

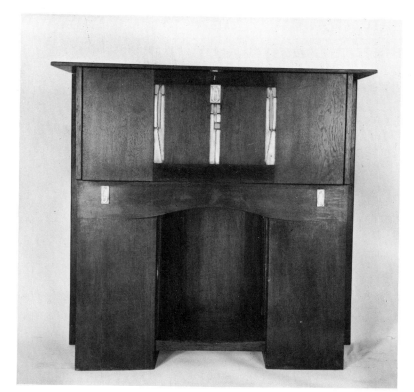

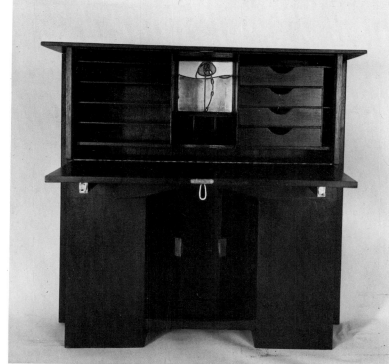

△1901.1△

D1901.2▽

D1900.83★ Design for an armchair in oak
Approx. 15.8 × 15.2cm.
This drawing has not been available for photography and the author has not seen it. No medium is given in the Toronto catalogue, where it is dated *c1900*. The drawing is possibly connected with some of the furniture designed for the Glasgow School of Art or Queen's Cross Church in 1899.

Exhibited: Toronto, 1967 (82).
Collection: Dr Thomas Howarth.

D1900.84★

1901.1 Writing desk for Michael Diack, Glasgow
Oak, stained dark, with inlays of leaded-glass and metal 121.8 × 124 × 40cm.

Michael Diack owned at least three pieces designed by Mackintosh (*see also* 1900.81 and 1903.2). This desk is the most elaborate of the three and was probably designed after Mackintosh's own desk (1900.9), but before the desk shown at the Turin exhibition (1902.8). It is the first recorded appearance of the metal and glass panels, often using the motif of a weeping rose, which appear in several later desks and cabinets.

Provenance: J. Michael Diack, by family descent; J. & R. Edmiston, Glasgow.
Private collection.

D1901.2 Design for a writing cabinet for Michael Diack, Glasgow
Pencil and watercolour 26.6 × 42.8cm.
Signed and inscribed, lower right, *CHARLES / RENNIE / MACKINTOSH / 140 BATH STR / GLASGOW*; inscribed, upper left, *SKETCH OF WRITING CABINET FOR J MICHAEL DIACK ESQR*, and, left, *DOOR AT EACH SIDE WITH SPACES FOR BOOKS*, and, right, *DRAWING SHOWING INSIDE ARRANGEMENTS*; and various other notes and measurements. Scale, 1:12.
The drawing for 1901.1, virtually as executed. The only substantial differences are the repositioning of the two slides which support the fall-front writing surface; these were moved outwards as their original position clashed with the decorative panels. The style of this drawing supports a date of late 1900 or 1901 for the desk.

Provenance: Mackintosh Estate.
Collection: Glasgow University.

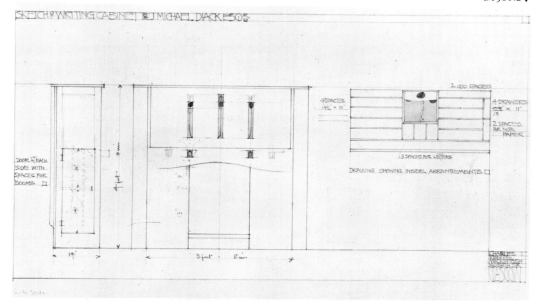

1901 The Haus eines Kunstfreundes Competition

A competition to design a house for a connoisseur of the arts was announced in the December 1900 issue of *Zeitschrift fur Innendekoration*, published by Alexander Koch. It seems reasonable to assume that Mackintosh would have heard about the competition on his visit to Vienna, where it would almost certainly have been a topic of discussion amongst the architects and designers he met at the Secession, especially as J. M. Olbrich was to be one of the judges. The closing date was 25 March, 1901, and the adjudication was set for 16 and 17 May, 1901, at Darmstadt. Mackintosh's entry was disqualified initially because he did not submit the required number of interior perspectives; but after preparing these, his drawings were awarded the purchase prize of 600 marks and reproduced in one of three folios of competition drawings issued in 1902 under the title *Meister der Innenkunst*. No first prize was awarded, the prize money being divided between more than sixteen competitors; the second prize was given to M. H. Baillie Scott; and the third was shared by Leopold Bauer and Oskar Marmorek of Vienna and Paul Zeroch of Coblenz. (For a full report on the details of the competition, *see* J. D. Kornwolf, *M. H. Baillie Scott and the Arts and Crafts Movement*, Johns Hopkins Press, Baltimore, 1972, p. 216 *et seq*.) My concern here is with the interiors of the house. The judges were most impressed by the interior planning of Baillie Scott's design, but they did not feel that his exteriors and his massing were 'modern', nor as accomplished as those by Mackintosh. The latter's interiors were more carefully controlled, as Kornwolf points out, but spatially less exciting than those by Scott. Mackintosh never built a house on this scale, so the plans and interior schemes are worth examining in some detail.

★*See addenda*

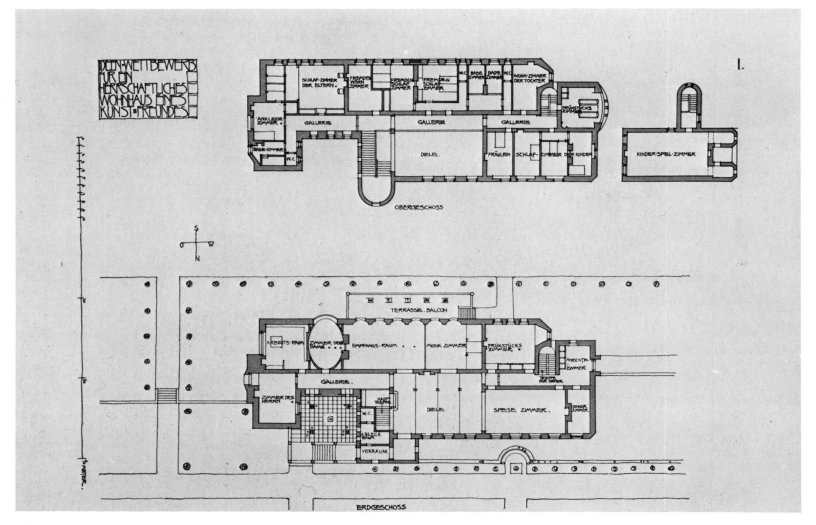

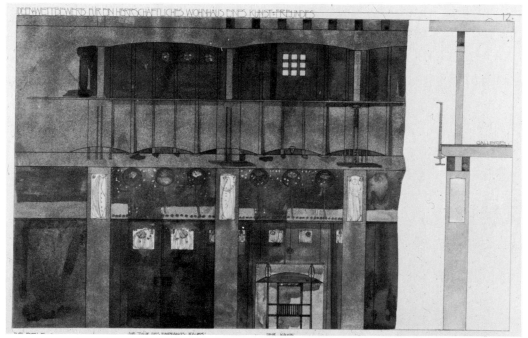

As at Windyhill, one enters from the north and turns through 90° into the dark-stained hall. Here the hall has two storeys with a gallery corridor linking the bedrooms, and with full-height windows to the north. From the hall a corridor leads to the study, an oval room for the ladies, and a (? smoking) room for the gentlemen. To the west lie the dining-room and a morning-room; a movable partition allows the dining-room and hall to be used as one room 20 metres long. To the south, doors beneath the gallery lead to the drawing and music rooms; these can also be used as one room of 16 × 5 metres.

The main staircase, with its apsidal outer wall like those at Windyhill and The Hill House, rises in two flights to the first floor. (A second staircase connects the service rooms in the basement with all the upper floors.) As at Windyhill and The Hill House, the bedrooms lead off a central corridor, which becomes an open gallery as it passes through the hall. No drawings, apart from D1901.10, seem to have been made of the individual bedrooms (or at least none has been traced), but a number of features are worth noting as they reappear at The Hill House, designed

◁D1901.4 D1901.3△

D1901.3 Plan of the Haus eines Kunstfreundes
Plate I from the folio of 14 plates issued by Alexander Koch in 1902 as part of the series *Meister der Innenkunst*.

The original drawings were acquired by the publishers as the purchase prize in the competition and cannot be traced. All the plates illustrated are from the folio at Glasgow University, but others are in the possession of the Glasgow School of Art, the Victoria & Albert Museum, and Dr Thomas Howarth.

D1901.4 Elevation of the south wall and gallery of the hall, Haus eines Kunstfreundes
Plate XII from the folio published in 1902.
The hall was stained dark and lighted from the north. Through double doors either side of the fireplace one entered the drawing-room and music room, forming a brilliant contrast to the hall with their white walls and elegant decoration. Two features are reminiscent of earlier projects: the balcony with its pendant panels echoes the gallery at Queens Cross Church; and the silver panels in the posts supporting the gallery are like those used beside the large gesso panels at Ingram Street in 1900, though Mackintosh first used this particular shape in the unfilled recesses on the columns in the entrance hall to the School of Art.

D1901.5 Elevation of the sideboard in the dining-room, Haus eines Kunstfreundes
Plate XIII of the folio published in 1902.
Like all Mackintosh's previous dining-rooms —for Brückmann, 120 Mains Street, and Windyhill—the walls were stained dark with a light-coloured ceiling. The group of nine squares, used in the doors of the cupboards, became a favourite motif in later designs.

D1901.6 Perspective of the dining-room, Haus eines Kunstfreundes

Plate XIV of the folio published in 1902.

One of the three interior perspectives which Mackintosh omitted from his original submission and for which he was disqualified from the competition; he was presumably asked to supply them to qualify for the purchase prize. Differences between them and the original elevations suggest that Mackintosh had not kept copies of his competition entry: he probably had to produce them very quickly, which may account for the fact that most of the movable furniture is simply an elaboration of already existing designs.

In this drawing, we can see that the room has a depressed barrel-vault instead of a flat ceiling, and that it springs directly from the cornice of the wall panelling, which does not, therefore, have the more usual plain frieze above it. Mackintosh has altered the arrangements of the sideboard, seen in D1901.5, and its relationship to the wall-panelling: in D1901.5, the sideboard appears recessed, with the panelling flush with the two outer columns, over which runs the edge of the table; here the sideboard is seen projecting from the wall, and the edge of the table does not cover the outer columns, which, in turn, have a different decoration at their top and project from the wall to enclose the sideboard.

The stencilled patterns on the walls are based upon the almost standard Mackintosh pattern of a woman whose dress billows out to disguise the shape of her body (as used in the balcony at the Ingram Street Tea Rooms). The decoration becomes more elaborate over the recessed fireplace, the stone surround of which is based on that in the original Board Room at the School of Art. The table and chairs are slightly more elaborate versions of the Windyhill table (1901.26), and the oval back-rail armchair (1899.16).

1902–03. The main bedroom, with a view to the south, has a row of fitted wardrobes and the beds are screened from the rest of the room in an alcove, from which there is access to a dressing-room; at the opposite side of the room is a fireplace with fireside chairs. The bedroom is isolated at one end of the house, with its own bathroom, and insulated from the other rooms by a door across the corridor; a guests' sitting room is placed between it and the next bedroom, a guest room. The children's rooms are at the far end of the corridor, as is the breakfast room with its bow window (a feature repeated at The Hill House). The schoolroom is on the attic floor above the children's bedrooms. These specific arrangements, often attributed to Walter Blackie's brief, appeared two years later at The Hill House.

Literature: Howarth, pp. 157–63, plates 61–63.

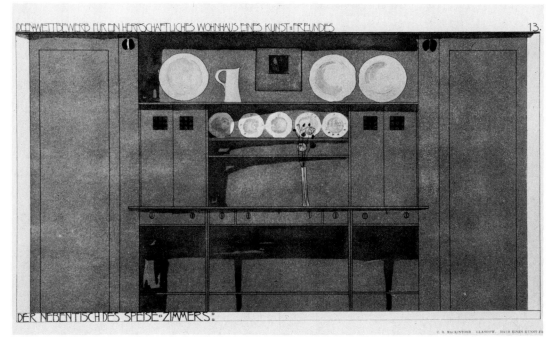

△ D1901.5

D1901.6 ▽

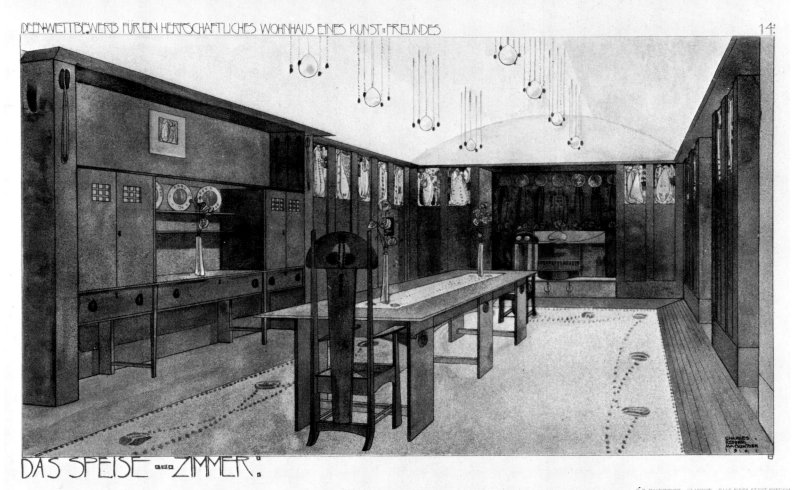

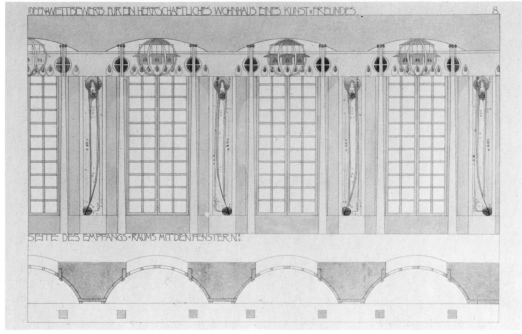

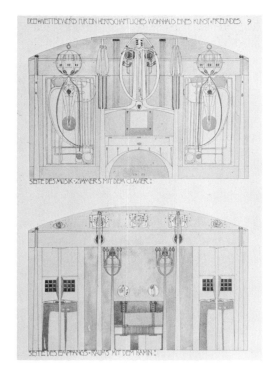

△D1901.7

D1901.8▷

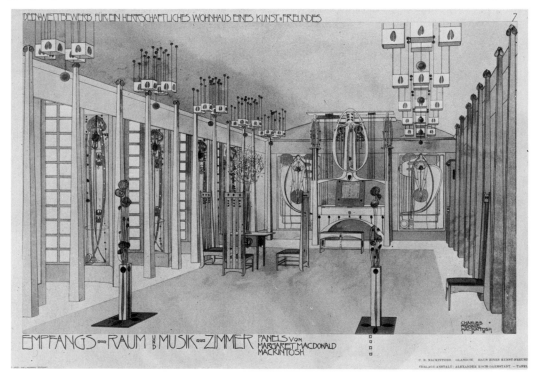

△D1901.9

D1901.10▽

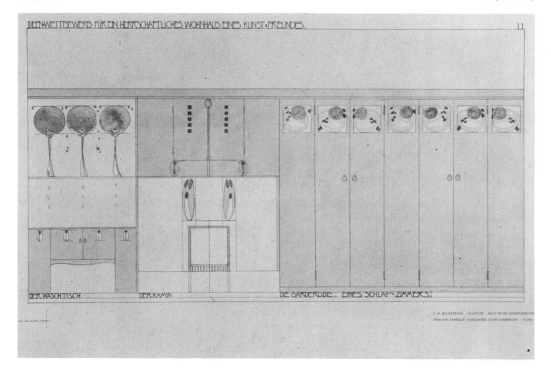

D1901.7 Elevation of the drawing-room windows, Haus eines Kunstfreundes
Plate VII of the folio published in 1902.
Although the windows appear flat on the elevations and perspectives of the exteriors, this design shows them as curved, part of a series of deep recesses behind the row of tapering posts. These posts have metal rods at the top, terminating in petal-shaped pieces of coloured glass, like those used in the dining-room at Mains Street. Between the windows are stencilled or embroidered figures, the work of Margaret Macdonald. The lighting consists of groups of four lampshades, as used at Mains Street, suspended from a canopy and enclosed inside three circular bands.

D1901.8 Elevations of the drawing-room fireplace and the music room piano, Haus eines Kunstfreundes
Plate IX of the folio published in 1902.
When the dividing partition was removed, these two elevations would have faced each other. The grate is a more elaborate version of that in the Mains Street drawing-room; the inlaid panels above are two of Margaret's designs. The two stencilled figures either side of the piano are also Margaret's work, but the piano, with its fantastic superstructure, is one of Mackintosh's most elaborate inventions, based on the organ at Craigie Hall (1897.45).

D1901.9 Perspective of the drawing and music rooms, Haus eines Kunstfreundes
Plate VII of the folio published in 1902.
One of the extra perspectives supplied by Mackintosh after the competition had been judged. It differs from D1901.7 in a number of ways, but gives a far better impression of the impact of the room than the simple elevation. Among the differences are: a different and simpler arrangement of the lighting; the positions of the posts along the south wall have been changed and the metal rods at the top of each post have been replaced by the four egg-shapes used in the Windyhill drawing-room; and the stencilled panels at the window are more elaborate and are positioned on the solid part of the curved recess, next to the windows, rather than on the walls between each recess. The movable furniture, with the exception of the piano stool, is again a development of earlier pieces: the chair is based on 1900.11, and the table on 1900.8. The two flower stands are based on the stand used at the Vienna Secession (1900.79).

D1901.10 Elevation of a bedroom wall, Haus eines Kunstfreundes

Plate XI of the folio published in 1902.

The deadline of 25 March, 1901, for the competition suggests that this design is earlier than that for the main bedroom at Windyhill, where exactly the same features are used, although there are minor differences in the stencilling.

D1901.11 Perspective of the schoolroom, Haus eines Kunstfreundes

Plate X of the folio published in 1902.

One of the three perspectives submitted by Mackintosh after the competition had been judged. The fitted furniture, benches and table are all loosely based on those designed for William Davidson at Gladsmuir and Windyhill. The most interesting features of the room are the four lighting standards with their tree-like arrangement of lamps and the large gesso panel over the fireplace—possibly depicting a scene from the Sleeping Beauty story—which is credited to Margaret Mackintosh.

D1901.12 Section through the Haus eines Kunstfreundes

Pencil and watercolour. Approx. 45.7 × 45.7cm.
Signed.

This drawing has not been available for photography and the author has not seen it.

Exhibited: Toronto, 1967 (59).
Collection: Dr Thomas Howarth.

D1901.13 Design for the Hall, Haus eines Kunstfreundes

Pencil and watercolour 25.4 × 36.9cm.
Inscribed, lower left, *BOOKCASE*, and, lower centre, *FIREPLACE*.
Scale, 1:12.

Probably a preparatory study for the final published design for the *Haus eines Kunstfreundes* project (D1901.4). The main differences are that the doors of a bookcase to the left become the actual doors of the reception room; the space between the fireplace and these doors becomes wider; and the columns supporting the gallery above are omitted in this view.

Provenance: Mackintosh Estate.
Collection: Glasgow University.

D1901.14 Design for a writing desk, bookshelves, and door

Pencil and watercolour 25.4 × 38.4cm.
Signed and inscribed, lower right, *CHAS. R MACKINTOSH | 140 BATH STREET | GLASGOW*; and inscribed, along bottom of drawing, *DOOR.; SEAT | OPENING BETWEEN ROOMS; BOOKS; WRITING DESK. BOOKS ABOVE; BOOKS; BOOKS.*

A puzzling drawing, which defies identification with any specific project. It has many similarities with D1901.13 and the final *Haus eines Kunstfreundes* designs, but cannot be located on the plans of that project. The dimensions used, and the stylistic features such as the decorative panels, seem identical with those of D1901.13, but the door on this drawing would then be over 3 metres high. Unlike D1901.13, it is signed, and none of the original competition drawings carried a signature.

It is possible that this is a very early design for the *Haus eines Kunstfreundes*—perhaps for the Ladies' Room—but, having worked to such accurate dimensions, it seems strange that the idea of the writing desk in its own ingle should be scrapped entirely. Another possibility is that it is an early design for the Wärndorfer music salon, where the fireplace is in an ingle and the design of the mantelpiece is

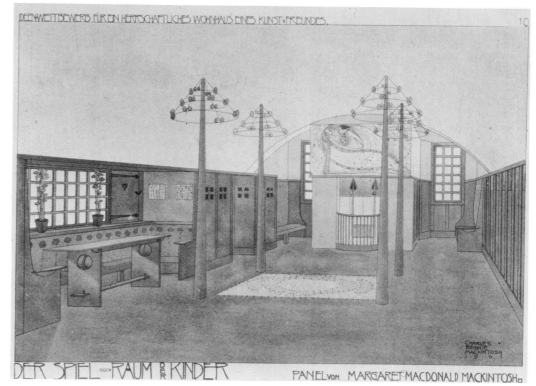

DER SPIEL-RAUM DER KINDER PANEL von MARGARET MACDONALD MACKINTOSH

D1901.11△

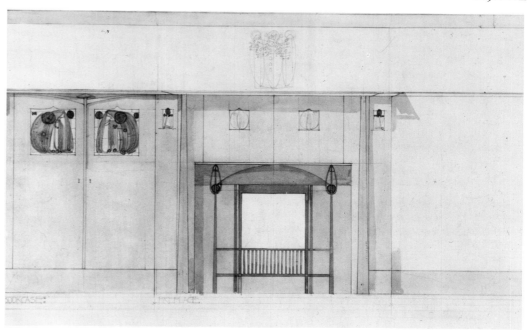

△D1901.13

D1901.14▽

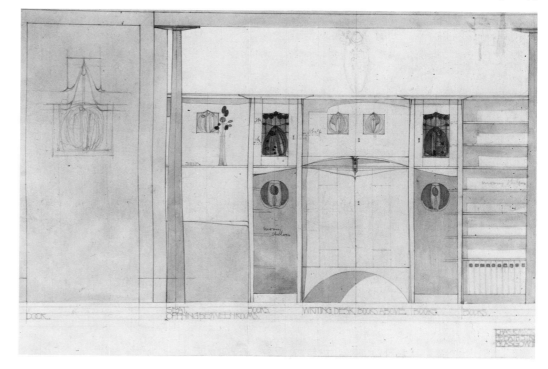

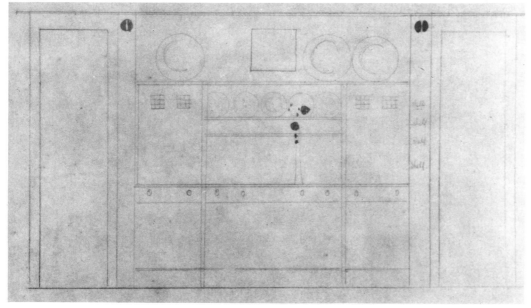

△D1901.15

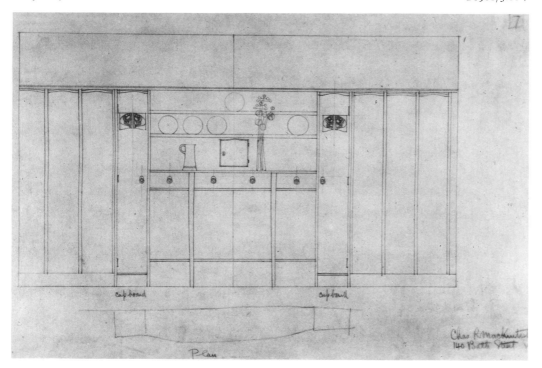

D1901/3.16▽

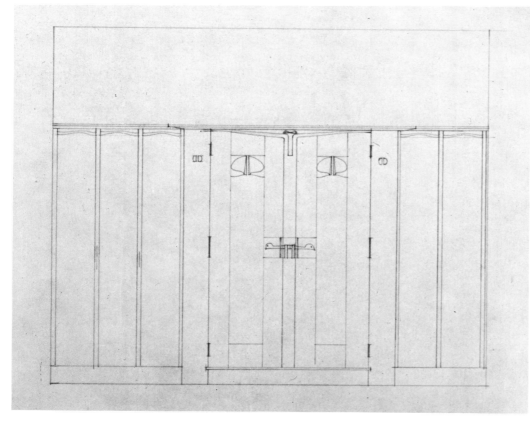

quite close to the design of the upper parts of the writing desk in D1901.14; a settle is also used, albeit on the opposite side. The bookcases are replaced by windows, but two display cabinets are incorporated at the front of the ingle.

Other motifs suggest an even earlier date, possibly 1898–99. The shapes of the leaded-glass panels are like those in the Seggie and Pickering cabinets of 1898, and the only other place that the peculiar-shaped panels in the door appear is in the doors at the Glasgow School of Art in 1899.

Provenance: Mackintosh Estate.
Collection: Glasgow University.

D1901.15 Design for a sideboard for the dining-room, Haus eines Kunstfreundes
Pencil and watercolour on tracing paper 27 × 45.8cm. (irregular).
Scale, 1 : 12.

Virtually identical with the published design for the dining-room in the *Haus eines Kunstfreundes*, this is probably the final worked-up drawing from which the competition design (D1901.5) was taken. It differs only in the arrangement of the drawers and the pairs of doors on either side of the central shelves.

Provenance: Mackintosh Estate.
Collection: Glasgow University.

D1901/3.16 Design for a sideboard
Pencil on tracing paper 30.9 × 43.5cm. (irregular).
Signed and inscribed, lower right, *Chas R Mackintosh Des—/140 Bath Street Glasgow.*; and inscribed, upper left, *SIDEBOARD*; and, upper right, *7*; and various other notes.
Scale, probably 1 : 12.

No executed piece corresponding to this design is known, but it does have affinities with the *Haus eines Kunstfreundes* project of 1901, and the dining-room designed for A. S. Ball in 1905. It probably post-dates the 1901 competition, and may be a study for an unexecuted sideboard at The Hill House—where the dining-room was panelled in a similar way to that shown here—or even for Windyhill. The handles and the decorative panels do seem to date from nearer 1900–03 than 1905: the Ball dining-room, for instance, puts greater emphasis on the square in its decoration and, although the bow-fronted sideboard (as indicated in the plan) flanked by two cupboards was repeated at Berlin, it was on a larger scale (*see* D1905.13).

Provenance: Mackintosh Estate.
Collection: Glasgow University.

D1901/3.17 Design for doors or wall cupboards
Pencil on tracing paper 30.8 × 26.1cm.
Scale, probably 1 : 12.

A design for the same room as D1901/3.16.

Provenance: William Meldrum; James Meldrum, by whom presented, 1968.
Collection: Victoria & Albert Museum, London (E.840–1968).

D1901/3.18 Design for a sideboard
Pencil 28.4 × 42.1cm.
Signed and inscribed, lower right, *Chas R Mackintosh | 140 Bath Street Glasgow*; and inscribed, upper left, *Sideboard*, and upper right, *14*.

A variant—possibly earlier—of D1901/3.16, and presumably for the same project. The addition of a signature and the office address to this drawing and D1901/3.16 suggest that they were for some office project and not a personal

◁D1901/3.17

one like the *Haus eines Kunstfreundes* (which was originally anonymous), nor the Ball dining room, the drawings for which bear his home address (*see* D1905.11–14). This is not, however, an infallible guide, since other private jobs seem to have been conducted through the office: Westdel, for instance, in 1898.

Provenance: Mackintosh Estate.
Collection: Glasgow University.

D1901.19 Design for the main bedroom, Haus eines Kunstfreundes

Pencil and watercolour on tracing paper 27 × 52.1cm. (irregular).
Inscribed, along lower edge, *Wash Stand with Glass Top, Back & Sides. Fireplace with cupboard for Medicine above. Wardrobe 9 feet long 7 feet high—in 2 divisions.*
Scale, 1 : 12.

D1901.19▷

▽D1901/3.18

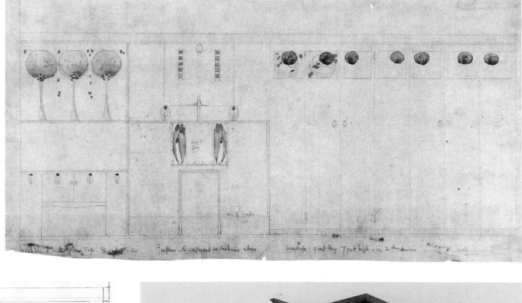

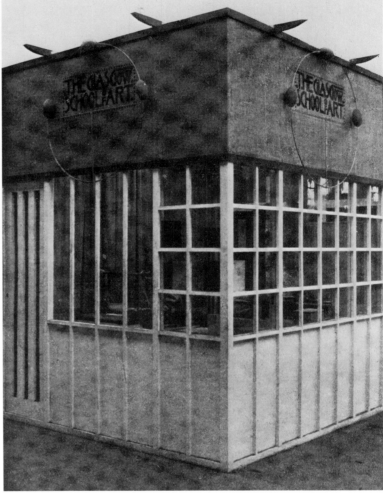

△1901.21

◁1901.20

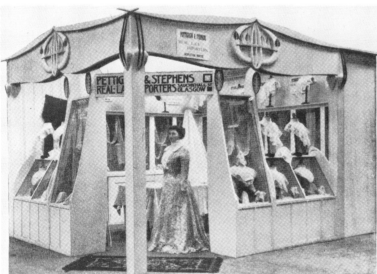

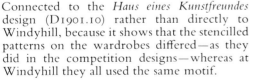

Connected to the *Haus eines Kunstfreundes* design (D1901.10) rather than directly to Windyhill, because it shows that the stencilled patterns on the wardrobes differed—as they did in the competition designs—whereas at Windyhill they all used the same motif.

Provenance: Mackintosh Estate.
Collection: Glasgow University.

1901.20 Exhibition stand for Pettigrew & Stephens for the 1901 Glasgow Exhibition

The Grand Hall of the Glasgow International Exhibition of 1901 was filled with small display stalls, of which Mackintosh designed at least four (1901.20, 21, 22, 24), all of which seem to have been office commissions. The Pettigrew stand was square in plan, open on

two sides to display laces, etc. Its main feature was an ornate entablature over the two open sides, supported at the corner by a heavy square post, with bulbous projections at capital height. Of all the designs for exhibition stalls, this is the least successful.

Literature: *The Studio*, XXIII, 1901, p. 47; Howarth, p. 173.
Collection: untraced, probably destroyed.

1901.21 Exhibition stand for the Glasgow School of Art for the 1901 Glasgow Exhibition

Matthew Henderson was paid £13.11.0d. for the stand (31 May) and Andrew Hutcheson was paid 17s.0d. for the metalwork decoration (3 June).

Cubic in shape, and composed of a simple

lattice-work of squares and oblongs, some glazed and some solid, this stand is reminiscent of the treatment of the office and shop screens in the entrance hall at the School of Art. Above the glazed screens was a broad, solid panel emblazoned with the School's name, in Mackintosh's own lettering, and overlaid with a wrought-iron emblem of a tree.

In his review of the exhibition in the *Art Journal*, Lewis Day wrote: 'The stall of the Glasgow School of Art, a sort of cage in which to confine a pair of lady bookbinders, is most severely simple. It is designed, in fact, to show how simply an erection of the sort may be built, the straight lines naturally suggested by carpentry construction being allowed to assert themselves, with no attempt at ornament beyond what is afforded by judicious distribution and proportion. A similar severity is to be observed in Mr. Mackintosh's permanent building for the Glasgow School of Art—planned apparently on lines nakedly utilitarian, yet everywhere revealing the marked in-

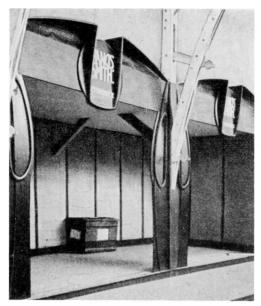

△1901.22 1901.24▷

dividuality of the artist. His symbolism, as in the case of the ring and balls framing the name of the school (adjacent), is his own, and apparently for himself, he takes, at all events, no pains to make it intelligible to the mere Southerner. So imperturbably does he work on his own lines that to eyes unsympathetic it seems like affectation; but there is honestly no doubt as to the genuineness of the artistic impulse. Whether it is quite wise in him to follow it so unhesitatingly is another question—which time will answer.'

Literature: *The Studio*, XXIII, 1901, p. *46*; *Art Journal*, 1901, p. *277*; *Dekorative Kunst*, IX, 1902, p. *214*; Howarth, p. 173.
Collection: untraced, probably destroyed.

1901.22 Exhibition stand for Francis Smith for the 1901 Glasgow Exhibition
Francis Smith paid £7.7.0d. fees for the stand on 2 April, 1903.

This stand was allocated two bays at the side of the Grand Hall, with access from the front only. The surviving photographs show it before the installation of the furniture display so that Mackintosh's sculptural treatment of the fascia panels can be clearly seen. Part of the fascia was retained by the firm—and seen by Howarth—but cannot now be traced.

Literature: *Dekorative Kunst*, IX, 1902, p. *214*; Howarth, pp. *173–74*.
Collection: untraced, probably destroyed.

D1901.23 Design for an exhibition stand for Francis Smith for the 1901 Glasgow Exhibition
Pencil and watercolour. Approx. 45.7 × 30.5cm.

This drawing has not been available for photography and the author has not seen it.

Exhibited: Toronto, 1967 (65).
Collection: Dr Thomas Howarth.

1901.24 Exhibition stand for Messrs Rae Brothers for the 1901 Glasgow Exhibition
The most elaborate of the four stands for the 1901 Exhibition. The posts along the front are white-painted replicas of those in the dining-room at 120 Mains Street, complete with the four steel rods and petal motifs at the top. The cabinet inside the stand is generally similar in its proportions and in the shape of its lower apron to the writing desk made for Turin (1902.8).

Literature: *Dekorative Kunst*, VIII, 1901, p. *495*.
Collection: untraced, probably destroyed.

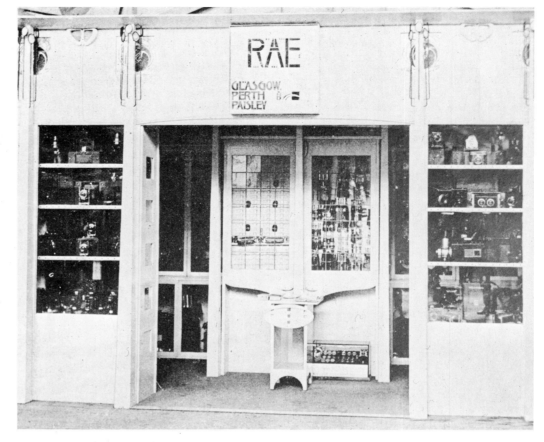

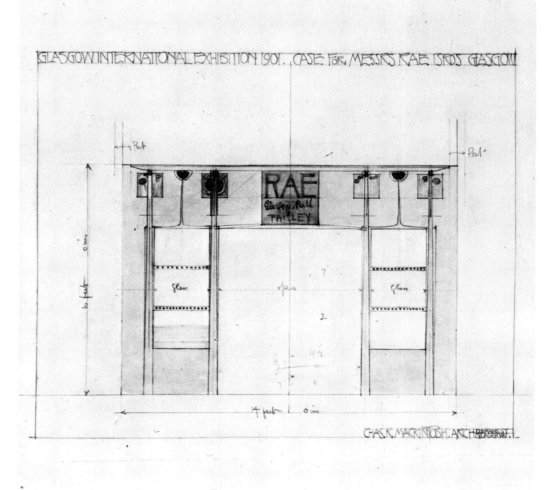

D1901.25 Design for an exhibition stand for Messrs Rae Brothers for the 1901 Glasgow Exhibition
Pencil and watercolour 28.9 × 40.6cm.

Signed and inscribed, lower right, *CHAS. R. MACKINTOSH. ARCH | 120 MAINS ST | GLASGOW*, and inscribed, above, *GLASGOW INTERNATIONAL EXHIBITION*

D1901.25△

1901. CASE FOR MESSRS RAE BROS GLASGOW.; also various notes and measurements.
Scale, 1:12.

Provenance: Mackintosh Estate.
Collection: Glasgow University.

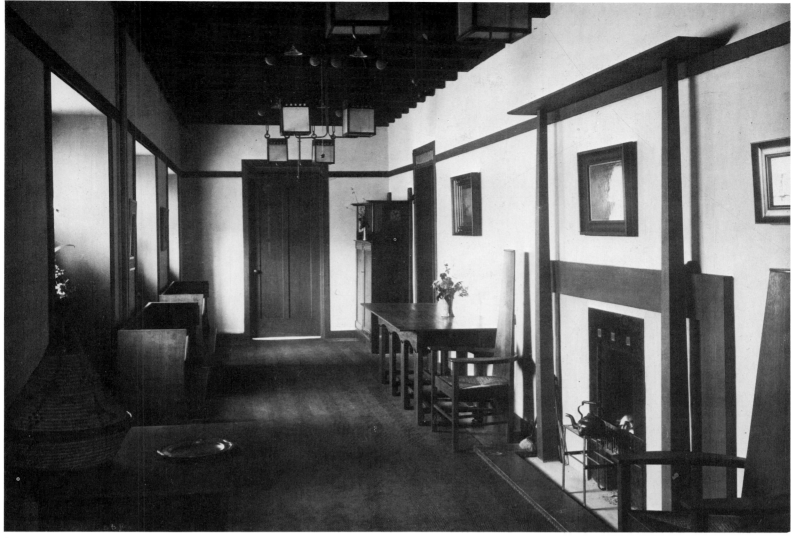

△1901.A

1901.A The hall, Windyhill, Kilmacolm

Collection: Annan, Glasgow.

1901.B The hall and staircase, Windyhill, Kilmacolm

Collection: Annan, Glasgow.

1901.C Drawing-room, Windyhill, Kilmacolm

This contemporary photograph shows the fireplace (1901.35), ladderback chair (1901.52), and one of the drawing-room light fittings (collection: Glasgow School of Art).

▽1901.C 1901.B▷

1901 Windyhill, Kilmacolm

Mackintosh designed Windyhill, c1900, for William Davidson Jr of Gladsmuir, Kilmacolm. Davidson had known Mackintosh for about five years and already owned several pieces of furniture designed by him, some specially commissioned for his parents' house, Gladsmuir. All this furniture seems to have been taken to Windyhill along with other items not designed by Mackintosh. In 1901, Davidson was in correspondence with Mackintosh about new furniture for Windyhill, but there never seems to have been any intention to furnish the house totally with pieces designed by the architect (correspondence, Glasgow University collection, bequeathed by Hamish Davidson).

The new loose furniture was confined to the hall, drawing-room, playroom and main bedroom. The hall served as the family dining-room for use at large gatherings, and existing dining furniture was presumably used in the small dining-room.

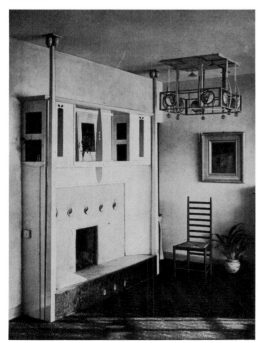

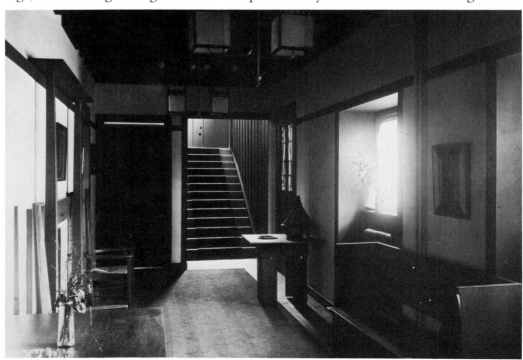

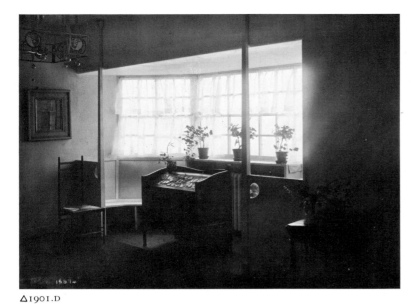

△1901.D

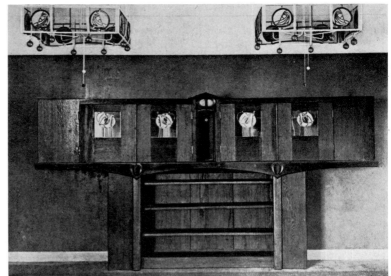

1901.E△

The wood used throughout in this furniture was oak, usually stained and polished, with the exception of the main bedroom where it was painted white. The woodwork and decorations in the house followed the same general pattern as those at 120 Mains Street. The hall has the broad plate in place of a conventional picture rail, with the walls below it divided into wide panels by similar vertical straps. All this timber—doors and skirtings included—is stained dark and, in addition, the whole of the dining-room is panelled with dark-stained timber to a height of about 2.2 metres.

The drawing-room has a white fireplace and white-painted woodwork around the window, but there was no timber panelling or strapwork. One wall of the drawing-room—the west wall—seems to have been papered in a dark colour with a white frieze above, in a style similar to the Mains Street dining-room; all the other walls, however, seem to have been one colour from skirting to ceiling (*see* 1901.C, D, and E). The staircase was broad and well-lit, and the walls were panelled level with the top of the last tread; the central panel between the flights, however, extends higher than the wall panelling to form an L-shaped balustrade with alternate panels removed and coloured glass squares inserted into the remaining boards (*Dekorative Kunst*, V, 1902, p. *196*). As at the School of Art, there was no handrail; a single tapering square newel post reaches to a simple square 'capital' fixed to the ceiling. The main bedroom is painted white and decorated with stencils.

The lighting in the house was far more elaborate than that used at Mains Street, where the fittings were simply a development of those designed for the Buchanan Street and Argyle Street Tea Rooms. As the fuel used was gas, the fittings were open to allow the easy passage of air and fumes. The hall lanterns were simple squares of glass; brackets were used in the dining-room and main bedroom. The fittings for the staircase (Glasgow School of Art *Metalwork* no 29) and the drawing-room (Glasgow School of Art *Metalwork* no 30) were much more elaborate, using patterns of leaded-glass, wrought-iron, and hanging glass plaques and balls for decoration.

Literature: *Dekorative Kunst*, IX, 1902, pp. 195–204; Howarth, pp. 98–107, plates 33–35.

1901.D Drawing-room, Windyhill, Kilmacolm
A view of the window bay showing the ladderback chair (1901.52), desk (1897.1) and, in the right foreground, the tea table (1901.36).

Collection: Annan, Glasgow.

1901.E Bookcase in the drawing-room, Windyhill, Kilmacolm
A contemporary photograph showing the bookcase (1901.38) against a dark wall in the drawing-room. This seems to have been the only dark wall in the room, as 1901.C and D show that the other walls were painted a pale colour.

1901.F The dining-room, Windyhill, Kilmacolm
The chair to the right of the fireplace is one of two made for the hall (1901.31); the watercolour over the mantelpiece is by Herbert MacNair (collection: Glasgow School of Art).

Collection: Annan, Glasgow

1901.G The schoolroom, Windyhill, Kilmacolm
This contemporary photograph shows a ladderback chair (1893.8), a bench (1901.43), and the edge of the Gladsmuir bookcase (1897.2).

Collection: Annan, Glasgow.

1901.H Staircase, Windyhill, Kilmacolm
Mackintosh designed a similar light fitting to that seen here for the hall at 14, Kingsborough Gardens, Glasgow; the Windyhill fitting, like

▽1901.F

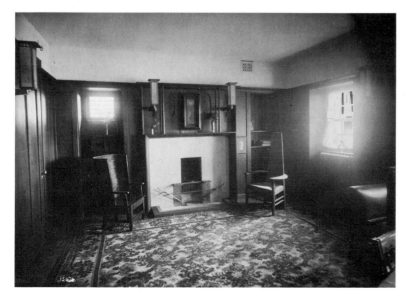

1901.G ▽

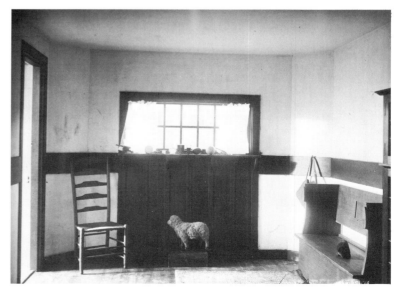

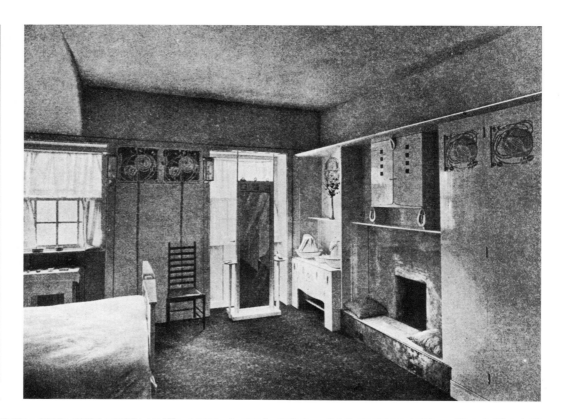

△1901.H ▽1901.26 1901.I▷

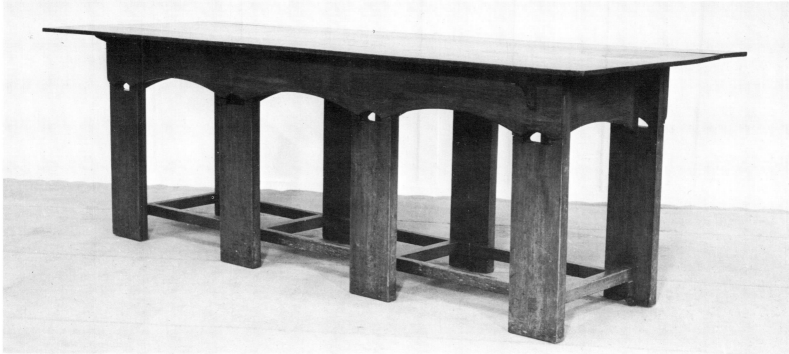

most others designed for the house, is now at Glasgow School of Art.

Collection: Annan, Glasgow.

1901.I Bedroom, Windyhill, Kilmacolm

The only contemporary photograph to show the arrangement of dressing-table (1901.44), fireplace and medicine cupboard (1901.46), and wardrobes (1901.45) on the west wall. Probably taken by Annan.

1901.26 Table for the hall, Windyhill, Kilmacolm

Oak, stained green 63 × 213.5 × 80cm.
Francis Smith quoted £4.10.0d. for the table (Mackintosh to W. Davidson, 12 June, 1901—collection: Glasgow University) and the final statement of accounts (Glasgow University) shows that this sum was paid.

The hall functioned as the dining-room at family gatherings, and this long table could even be extended by the addition of a small square table of the same pattern (1901.27). The design is simple, the accent being on the broad surfaces of the planks of oak used in the legs and the top, relieved only by the curved apron between the legs and the cut-out shapes at the junction of the legs and overlapping apron. The top, made of three long pieces of timber dowelled together, has suffered from its construction, because the weight of diners leaning on the two sides has pulled the joints apart.

Literature: *Dekorative Kunst*, IX, 1902, p. *197*; *Das Englische Haus*, III, 1905, plate 193; Howarth, plate 35b; Glasgow School of Art *Furniture* no 17.
Exhibited: Saltire, 1953 (B9).
Provenance: William Davidson, by whose family presented.
Collection: Glasgow School of Art.

1901.27 Extension table for the hall, Windyhill, Kilmacolm

Oak, stained green 73 × 81.5 × 80cm.
Francis Smith quoted £1.17.6d. for the table (Mackintosh to W. Davidson, 12 June, 1901—collection: Glasgow University), and the final account (Glasgow University) shows that this sum was paid.

Used to extend the main dining table (1901.26) at large family gatherings.

Literature: *Dekorative Kunst*, IX, 1902, p. *197*; *Das Englische Haus*, III, 1905, plate 193; Howarth, plate 35b.
Provenance: William Davidson, by whose family presented.
Collection: Glasgow School of Art.

1901.27▽

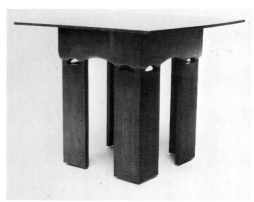

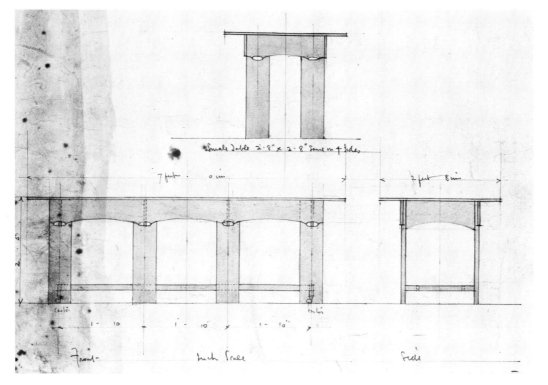

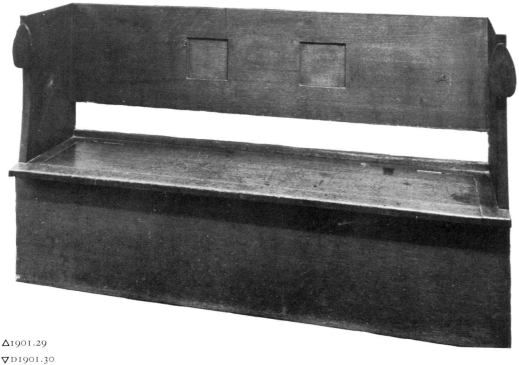

△1901.29
▽D1901.30

D1901.28 Design for the hall tables, Windyhill, Kilmacolm
Pencil and watercolour 24.7 × 30.5 cm. (sight).
Signed and inscribed, lower right, *Chas R Mackintosh / 140 Bath Street* and inscribed, upper left, *Windyhill for Wm Davidson Esqr / Scale drawing of Hall tables*; and various other notes and measurements.
Scale, 1:12.

The design for 1901.26 and 27, virtually as executed.

Exhibited: Toronto, 1967 (75).
Collection: Dr Thomas Howarth.

1901.29 Bench for the hall, Windyhill, Kilmacolm
Oak, stained green 91.4 × 187.5 × 44.5 cm.
Francis Smith quoted for two benches at £6.2.6d. each (Mackintosh to W. Davidson, 12 June, 1901—collection: Glasgow University); the final account shows that Hutchison & Grant were paid for two at £5.18.0d. each (Glasgow University).

Apart from their general use in the hall, which was virtually the social centre of the house, these benches were used down the long sides of the table instead of chairs. The design is extremely simple—almost crude—being little more than plain rectangles made of broad planks of oak, relieved only by the two flat lozenges applied to the front edge of the gables and the scalloping of this front edge.

Literature: *Dekorative Kunst*, IX, 1902, p. *197*; *Das Englische Haus*, III, 1905, plate 193; Howarth, plate 35b; Pevsner, 1968, plate 26.
Exhibited: Edinburgh, 1968 (198).
Provenance: a) William Davidson; Cameron Davidson, by whom presented; b) William Davidson; Hamish Davidson, by whom bequeathed.
Collection: a) and b) Glasgow School of Art (2).

D1901.30 Design for the hall furniture for Windyhill, Kilmacolm
Pencil and watercolour 32.4 × 70.5 cm.
Signed, lower right, *Chas R Mackintosh*; inscribed, upper left, *HALL FURNIT/URE FOR WILL/IAM DAVIDSO/NESQR*, and, along lower edge, *PLAN. CHAIR SIDE. TABLE. CHAIR FRONT. FRONT OF BENCH. SIDE* [of bench], and various other notes and measurements.
Scale, 1:12.

The original design for 1901.26, 27, and 31; changes were made to all three pieces before

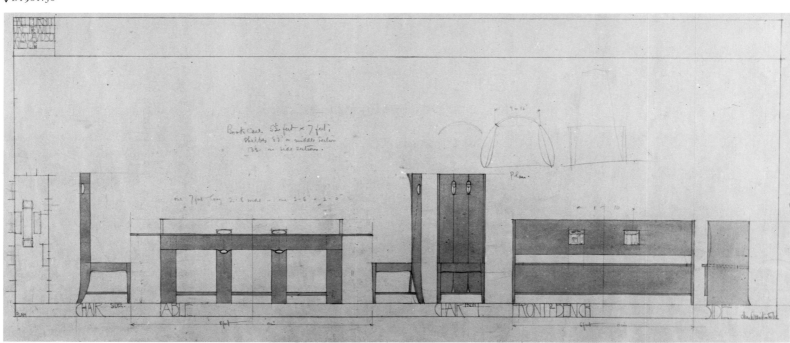

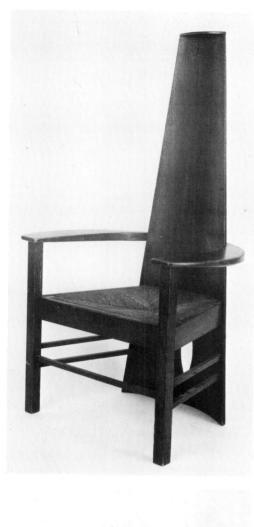

△D1901.33

execution. The table, although unchanged in design, was shortened from 2.44metres to 2.13 metres; the two squares of decoration on the back-rest of the benches were removed and replaced by the two plaques on the gables; the front edges of the gable sides of the bench were scalloped instead of rising vertically (which can be seen faintly pencilled in on the drawing). The design of the chair was changed entirely by the addition of arms and a tapering back, although even the chairs shown in the drawing had curved backs. There is also a pencilled note about a bookcase '5½ feet by 7 feet' (1.7 × 2.13m.) which probably corresponds with the early design for a toy chest, D1901.40.

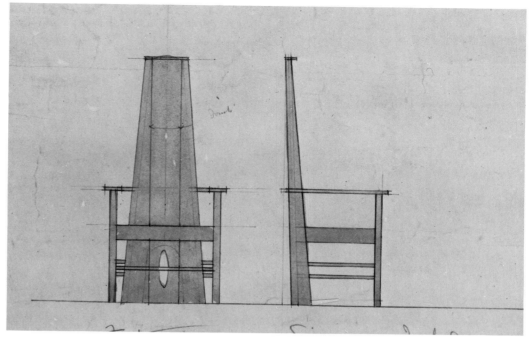

◁1901.31 D1901.32△

Literature: Glasgow School of Art, *Furniture*, no 17a; Alison, p. 77, no 6, p. *97*.
Exhibited: Milan, 1973 (6).
Provenance: Mackintosh Estate.
Collection: Glasgow University.

1901.31 Chair with high tapering back for the hall, Windyhill, Kilmacolm

Oak, stained dark 133.7 × 73.2 × 54.5cm.
Francis Smith quoted for two chairs at £1.10.0d. each (Mackintosh to W. Davidson, 12 June, 1901—collection: Glasgow University); the final account shows that each cost £2.4.0d. (Glasgow University).

One of the most striking, and certainly one of the sturdiest, of Mackintosh's designs for chairs. These two were used at either end of the table (1901.26) in conjunction with the benches (1901.29). The difference between Smith's quotation and the final price is accounted for by the change in design between D1901.30 and D1901.32. Arms were added, and the curved back extended to the ground instead of terminating on a stretcher above two short legs. There is no leaded-glass decoration on the back as indicated in D1901.30, but the back tapers and is capped by a piece of flat timber which follows the concave curve of the back and mimics it by a convex curve of the same radius on its front edge.

Literature: *Dekorative Kunst*, IX, 1902, p. *197*; *Mir Isskustva*, no 3, 1903, p. *116*; *Das Englische Haus*, III, 1905, plate 193; Howarth, plate 35b; Pevsner, 1968, plate 26; Alison, pp. *44*, *45*, 95, 97.
Exhibited: Moscow 1903; Edinburgh, 1968 (214).
Provenance: a) Davidson Estate; b) unknown.
Collection: a) Glasgow University; b) private collection.

D1901.32 Design for a hall chair for Windyhill, Kilmacolm

Pencil and watercolour 26.4 × 32.3cm.
Signed and inscribed, lower right, *Chas R Mackintosh / 140 Bath Street*; inscribed, upper left, *Davidson Windyhill / 2 wanted*; and other notes.
Scale, 1:12.

The drawing for 1901.31, virtually as executed.

Literature: Alison, pp. *44*, 77, no 7.
Exhibited: Milan, 1973 (7).
Provenance: Mackintosh Estate.
Collection: Glasgow University.

D1901.33 Design for a chair

Pencil on a page of a sketchbook 18.4 × 13.4cm.

The dating of this drawing to 1901 is tentatively based upon similarities in this and the design for the hall chairs at Windyhill. No chair seems to have been made which directly corresponds with this drawing, however, and another possible connection is with the Argyle Street Tea Room chairs of 1897.

Provenance: Mackintosh Estate.
Collection: Glasgow University.

1901.34 Fireplace for the hall, Windyhill, Kilmacolm

Wood, stained dark.
Probably made by Hutchison & Grant; the grate was supplied by Caird Parker at £4.10.0d.

The design was simpler than the fireplaces at Mains Street, consisting of a steel surround to the grate, cement around that, and then a broad, but shallow, wooden panel forming a frame around the whole. Two wooden posts, tapering like those in the dining-room at Mains Street, stand either side of the grate supporting a projecting *cyma recta* cornice. The illustration in *Das Englische Haus* must be later than those in *Dekorative Kunst* as it shows candelabra, like those used in the Mains Street dining-room, fixed to these two posts. These were removed by William Davidson and are now at Glasgow University. The fireplace was altered by a subsequent owner of Windyhill, but it has now been restored to its original appearance (minus the candelabra) by the present owner of the house (*see* 1901 A and B).

Literature: *Dekorative Kunst*, IX, 1902, p. *197*; *Das Englische Haus*, III, 1905, plate 193; Howarth, plate 35b; Pevsner, 1968, plate 26.
Collection: *in situ*, Windyhill.

1901.35 Fireplace for the drawing-room Windyhill, Kilmacolm

Pine, painted white.
The final account shows that J. Caird Parker was paid £11.10.0d. for the grate and McCulloch & Co. £2.7.6d. for the glass inlays (17 November, 1902, collection: Glasgow University).

This white-painted fireplace (*see* 1901.C) is a much more complex and elaborate composition than those at Mains Street or Dunglass Castle. Mackintosh has used a standard proprietary grate rather than devising one of his own; this is mounted with its fire-box level with the high hearth, which doubles as a

fireside seat, and air is admitted through grilles in the front of the hearth. Instead of a cement-rendered surround, small square tiles are used, inlaid with five stylised flowers in coloured glass. The wooden fireplace is the first to incorporate a subtle play of curves and flat planes that was to be a feature of several later designs (e.g. 1903.77). The lower part curves out at the edges to meet two tapering square posts—like those used in the hall fireplace—which rise to touch the ceiling. Clustered around the top of each post are four egg-shaped balls, probably a reference to those on the Gladsmuir cabinet (1894.1) which, at Windyhill, was fitted into a recess at the side of this fireplace. The upper part of the fireplace has an arrangement of 'nest-boxes' like the Dunglass and Mains Street fireplaces, but the central portion is left open. A strange paddle-like piece of timber is suspended from the underneath of the top shelf, on its edge, gradually swelling out into the space between the front and back of the fireplace, thus emphasising its depth.

Literature: *Dekorative Kunst*, IX, 1902, p. *199*; Howarth, p. 105, plate 34b.
Collection: *in situ*, Windyhill.

1901.36 Tea table for Windyhill, Kilmacolm
Oak, stained dark.
The final account shows that Francis Smith was paid £3.10.0d. for a 'tea table' (collection: Glasgow University).

This piece cannot be traced and, apart from the reference in the final account, is known only from an indistinct photograph taken by Annan (1901.D). The table had three tapering legs, with a triangular shelf at low level. The top was circular, but was hinged along the line of the top rails, the three segments thus formed dropping when not required to make a triangular top. The design is possibly based on an old table which Mackintosh drew at Willersey *c*1895 (collection: Glasgow University; *see* Billcliffe, *Architectural Sketches and Flower Drawings by C. R. Mackintosh*, 1977, p. *36*).

Collection: untraced.

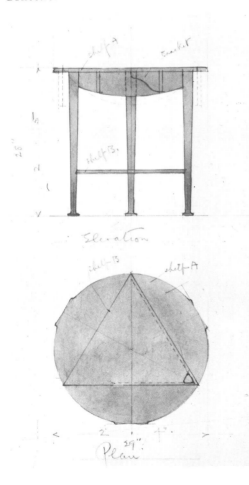

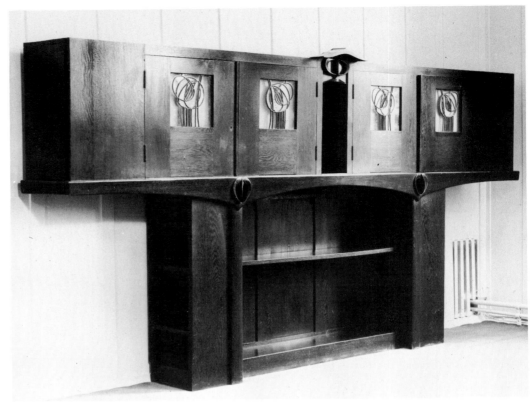

△1901.38

D1901.39▽

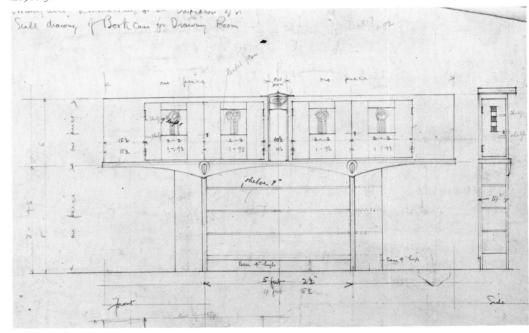

◁D1901.37

D1901.37 Design for a tea table with three legs
Verso: sketch of a wardrobe.
Pencil and watercolour 31.1 × 19.2cm.
Scale, 1 : 12.

The design for 1901.36 showing its construction. Virtually as executed (from what can be seen in contemporary photographs), except that the table top was made as a perfect circle without the three tangential projections seen in the drawing.

Provenance: Mackintosh Estate.
Collection: Glasgow University.

1901.38 Bookcase for Windyhill, Kilmacolm
Oak, stained dark, with leaded-glass panels
173 × 329.5 × 43cm.
The final account shows that Francis Smith was paid £18 for a bookcase, and McCulloch & Co. £2.10.0d. for leaded-glass for the doors (collection: Glasgow University).

A very large piece of furniture which was placed against the west wall of the drawing-room; as at 120 Mains Street, Mackintosh made use of a dominant feature for each wall: a fireplace and window bay on the north and south walls, and on the east wall a piano, just visible in 1901.C, possibly an example of the Bechstein piano designed by Walter Cave.

Literature: *Dekorative Kunst*, IX, 1902, p. *200*; Glasgow School of Art, *Furniture*, no 29.
Provenance: William Davidson, by whom presented.
Collection: Glasgow School of Art.

D1901.39 Design for a bookcase for Windyhill, Kilmacolm
Pencil 26.4 × 42cm.
Signed and inscribed, lower right, *Chas R Mackintosh | 140 Bath Street Glasgow*; inscribed, upper left, *Windyhill Kilmacolm for Wm Davidson Esqr | Scale drawing of Bookcase for Drawing Room*; and various other notes and measurements.
Scale, 1 : 12.

Final design for 1901.38, virtually as executed. *See also* D1901.40.

Collection: Dr Thomas Howarth.

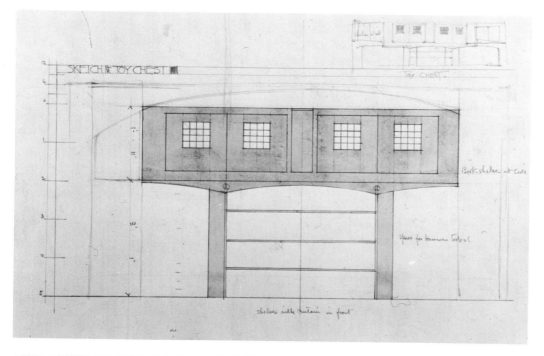

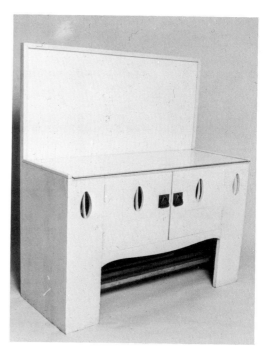

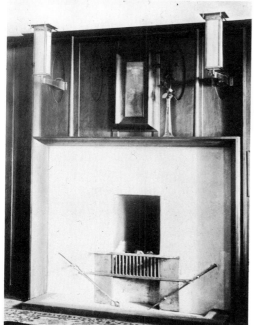

D1901.40 Design for a toy cupboard for Windyhill, Kilmacolm
Pencil and watercolour 26.4 × 36.7cm.
Inscribed, upper left, *SKETCH FOR TOY CHEST*, upper right, *TOY CHEST*; and *Book shelves at side; Space for Hammers tools &c; Shelves with curtain in front.*
Scale, 1:12.

The playroom at Kilmacolm was to accommodate all the Gladsmuir nursery furniture—the bookcase, two tables and two benches—as well as the two new benches designed specifically for it. Either Mackintosh or Davidson must have realised that this massive piece would not fit into the room, so the design was amended to make a bookcase for the drawing-room (*see* 1901.38). By the addition of leaded-glass decoration and a more sculptural treatment of the central niche, Mackintosh relieved the severe lines of a piece of nursery furniture to make an exciting and unusual design for a more public room in the house. Various additional lines, and the pencil sketch in the upper right corner, indicate the alterations which were to be made to achieve this new design.

Literature: Glasgow School of Art, *Furniture*, no 29a.
Provenance: Mackintosh Estate.
Collection: Glasgow University.

1901.41 Window seat for the drawing-room, Windyhill, Kilmacolm
Wood, painted white, and upholstered in linen.

Mackintosh provided a polygonal bay window in the drawing-room, overlooking the steeply descending garden. Into it was fitted a simple bench seat and in the centre a radiator. Two tapering posts, at the inside of the bay, terminate the seat and project up to the ceiling; they are capped by four egg-shapes, echoing the posts at the fireplaces at the opposite side of the room (*see* 1901.C).
Mackintosh varied this arrangement, with greater success, at The Hill House; there, the seat was upholstered and the radiator hidden beneath it, and more elaborately decorated posts were used.

Collection: *in situ*, Windyhill.

1901.42 Fireplace in the dining-room, Windyhill, Kilmacolm
Pine, stained dark.
The final account shows that J. Caird Parker was paid £3.17.6d. for the grate (17 November, 1902, collection: Glasgow University).

Literature: *Dekorative Kunst*, IX, 1902, p. *201*.
Collection: *in situ*, Windyhill.

1901.43 Bench for the schoolroom, Windyhill, Kilmacolm
Oak, stained green 91.4 × 156 × 44.5cm.
Francis Smith quoted for two at £5.11.6d. each (Mackintosh to W. Davidson, 12 June, 1901—collection: Glasgow University); the final account shows that Hutchison & Grant were paid for two at £5.0.0d. each (Glasgow University).
Smaller, but otherwise identical, version of the hall bench (1901.29).

Literature: *Dekorative Kunst*, IX, 1902, p. *198*.
Provenance: a) William Davidson; Hamish Davidson, by whom bequeathed; b) William Davidson; by family descent.
Collection: a) Glasgow School of Art; b) private collection.

1901.44 Wash-stand for the main bedroom, Windyhill, Kilmacolm
Oak, painted white 128 × 111.7 × 45.5cm.
Francis Smith quoted £6.6.0d. (Mackintosh to W. Davidson, 12 June, 1901—collection: Glasgow University), and the final account shows that this was the sum paid (Glasgow University).

Based upon the design for a bedroom in the *Haus eines Kunstfreundes* competition (D1901. 10). This has a more elaborate arrangement of cupboards and a lower back than the wash-stand for the main bedroom at 120 Mains Street (1900.30). The pierced motif is almost an exact repetition of that used on the other Mains Street wash-stand (1900.31).

Literature: *Das Englische Haus*, III, 1905, plate 254; Glasgow School of Art, *Furniture*, no 22.
Provenance: William Davidson; Cameron Davidson, by whom presented.
Collection: Glasgow School of Art.

1901.45 Fitted wardrobe in the main bedroom, Windyhill, Kilmacolm
Oak, painted white, with stencilled decoration 228.6 × 294.6 × 53.3cm.
Francis Smith quoted £13 (Mackintosh to W. Davidson, 12 June, 1901—collection: Glasgow University); the final account shows that Hutchison & Grant (main contract joiners) were paid £20 for all fitted furniture in the bedroom (Glasgow University).

Based on the wardrobes in the designs for a bedroom in the *Haus eines Kunstfreundes* competition (D1901.10). Unlike the wardrobes at 120 Mains Street, and later at The Hill House, there is no carved decoration on these cupboards; instead, Mackintosh applied a stencilled decoration of stylised roses in pink and green. (See 1901.I.)

Literature: *Dekorative Kunst*, IX, 1902, p. *202*; *Das Englische Haus*, III, 1905, plate 254.
Collection: *in situ*, Windyhill.

1901.46 Fireplace and medicine cupboard in the main bedroom, Windyhill, Kilmacolm
Wood, painted white.
Francis Smith quoted £7, including the medicine cabinet (Mackintosh to W. Davidson, 12 June, 1901—collection: Glasgow University); the final account shows that Hutchison & Grant were paid £20 for all fitted furniture in the bedroom (Glasgow University).

Based on the designs for a bedroom in the *Haus Eines Kunstfreundes* competition (D1901.10). See 1901.I.

Literature: *Das Englische Haus*, III, 1905, plate 254.
Collection: *in situ*, Windyhill.

1901.47 Table for the main bedroom, Windyhill, Kilmacolm
Oak painted white 76.2 × 55.8 × 35.3cm.
Francis Smith quoted £2 (Mackintosh to W. Davidson, 12 June, 1901—collection: Glasgow University); the final account shows he was paid £1.13.0d. (Glasgow University).

Mackintosh's letter (*see* above) describes the table as 'Table for mirror'; it is not clear whether he intended this to mean that the table stood

△1901.47

adjacent to the cheval mirror or that the table supported a small mirror, possibly in the boudoir. Only one table appears in contemporary photographs (1901.I), but one cannot draw any conclusions from the surviving photographs as to the position or appearance of any other tables. In this uncertain situation, it is not clear which table—1901.47 or 48—was the more expensive. Two other, dark-stained, versions of this table exist, at Glasgow University and Glasgow School of Art. The final account does not include them, and the likelihood is that they were made later for two of the children's bedrooms.

Literature: *Dekorative Kunst*, IX, 1902, p. *203*; *Das Englische Haus*, III, 1905, plate 254.
Provenance: Davidson Estate.
Collection: Glasgow University.

1901.48 Table for the main bedroom, Windyhill, Kilmacolm
(?) Oak, painted white.
Francis Smith quoted £1.10.0d. for a table for the main bedroom (Mackintosh to W. Davidson, 12 June, 1901—collection: Glasgow University); the final account shows he was paid £1.5.0d. (Glasgow University).

No table at Glasgow University or Glasgow School of Art corresponds with the meagre description of this table in the final accounts; nor does any other table appear in contemporary photographs. *See* 1901.47.

Collection: untraced.

1901.49 Cheval mirror for the main bedroom, Windyhill, Kilmacolm
Oak, painted white 228.6 × 86 × 38cm.

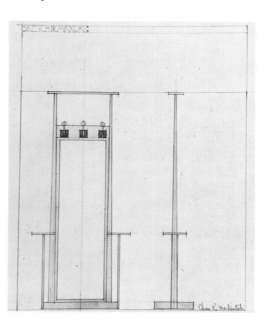

1901.49▽

Francis Smith quoted £7 (Mackintosh to W. Davidson, 12 June, 1901—collection: Glasgow University); the final account shows he was paid only £5 (Glasgow University).

A much simpler design than that of the cheval mirror at 120 Mains Street (1900.26).

Literature: *Dekorative Kunst*, IX, 1902, p. *203*; *Das Englische Haus*, III, 1905, plate 254; Glasgow School of Art, *Furniture*, no 23.
Provenance: William Davidson; Cameron Davidson, by whom presented.
Collection: Glasgow School of Art.

D1901.50 Design for a cheval mirror for Windyhill, Kilmacolm
Pencil and watercolour 31.4 × 32.8cm.
Signed, lower right, *Chas R. Mackintosh*, and inscribed, upper left, *SKETCH FOR MIRROR*.
Scale, 1:12.

Virtually as executed (*see* 1900.49), except that the mirror was finally placed forward of the centre line of the base, a heart-shaped motif was pierced in the supports for the trays, and the glass decoration over the mirror did not incorporate the lead-work as shown in this drawing.

Literature: Glasgow School of Art, *Furniture*, no 23a.
Provenance: Mackintosh Estate.
Collection: Glasgow University.

1901.51 Bed for Windyhill, Kilmacolm
Oak, painted white 91.3 × 166.2 × 198cm.
Francis Smith quoted £7 for the bed including the mattress (Mackintosh to W. Davidson, 12 June, 1901—collection: Glasgow University); the final account shows that the bed cost £7, but the mattress was extra (Glasgow University).

A heavy and solid piece, its broad areas of white paint broken only by the high relief of the sculptural decoration.

Literature: *Dekorative Kunst*, IX, 1902, p. *202*; *Das Englische Haus*, III, 1905, plate 2; Howarth, p. 108, plate 34c; Glasgow School of Art, *Furniture*, no 24.
Exhibited: Saltire, 1953, (B11).
Provenance: William Davidson; Cameron Davidson, by whom presented.
Collection: Glasgow School of Art.

1901.52 Ladderback chair for Windyhill, Kilmacolm
Oak 103 × 44 × 40.5cm.
Francis Smith quoted for two chairs at £1 each (Mackintosh to W. Davidson, 12 June, 1901—collection: Glasgow University); the

◁D1901.50

1901.51▽

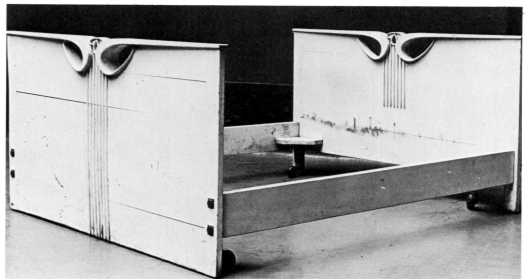

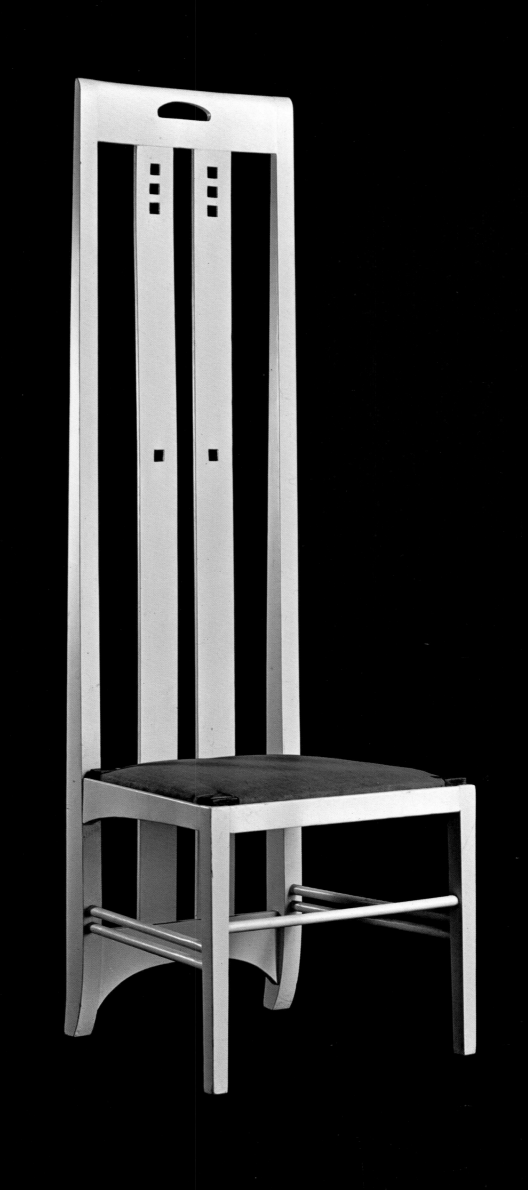

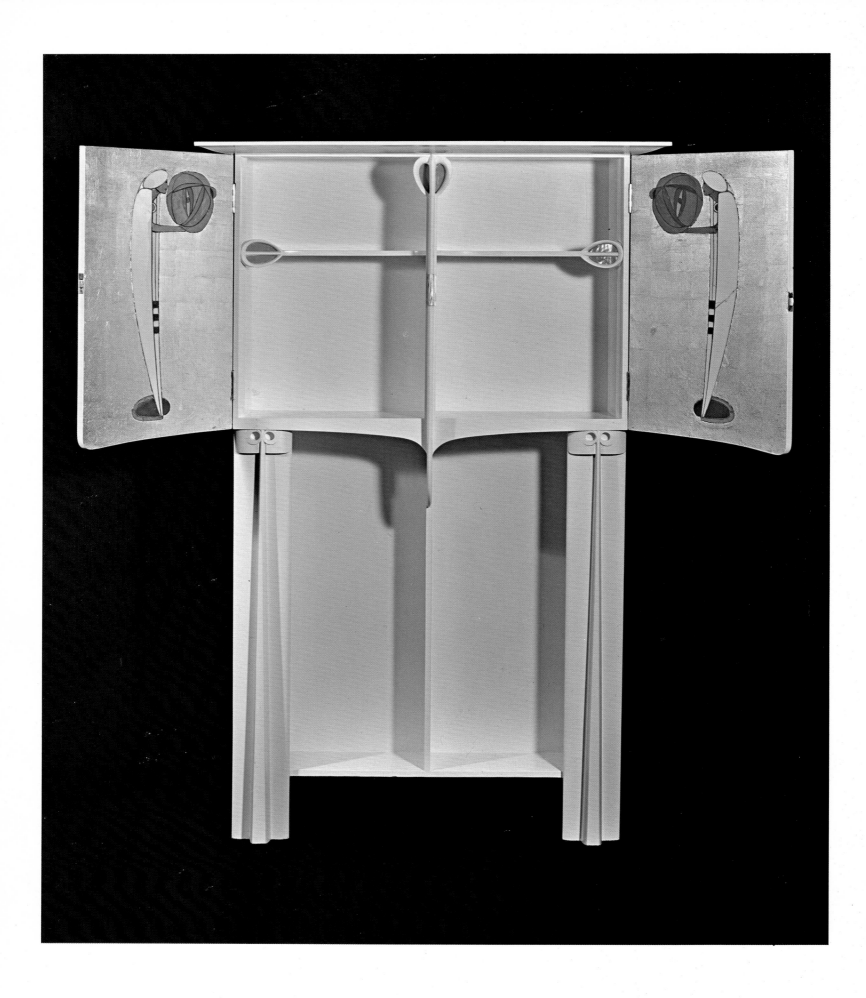

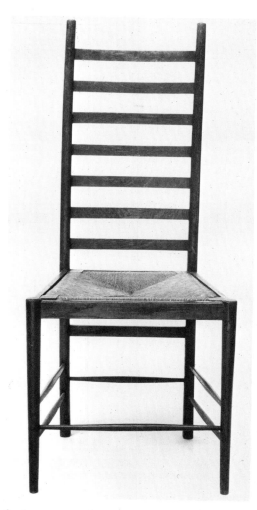

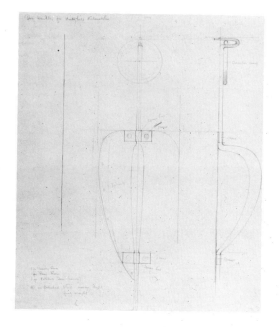

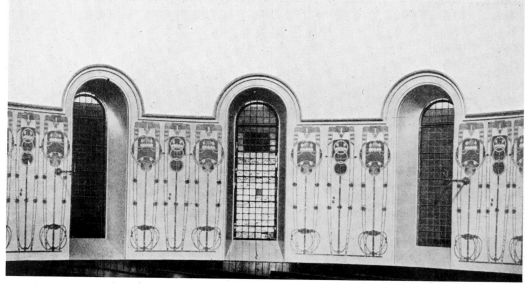

◁1901.52 D1901.55△ △1901.56 detail 1901.56 ▽

final account shows payment of £1.4.0d. each (Glasgow University).

Mackintosh's letter states that two chairs were intended for the main bedroom, but one also appears in an Annan photograph of the drawing-room.

Literature: *Dekorative Kunst*, IX, pp. *199, 203*; *Das Englische Haus*, III, 1905, plate 254; Howarth, plate 34b.
Provenance: William Davidson; Cameron Davidson, by whom presented.
Collection: Glasgow School of Art.

1901.53 Wall mirrors for the cloakroom and bathroom, Windyhill, Kilmacolm
Oak, painted white 47 × 87cm.
Francis Smith quoted for two mirrors at £1.5.0d. each (Mackintosh to W. Davidson, 12 June, 1901—collection: Glasgow University); the final account shows that Hutchison & Grant were paid for two at £1 each (Glasgow University).

Provenance: Davidson Estate.
Collection: Glasgow University.

1901.54 Tables for the kitchen and laundry, Windyhill, Kilmacolm
Pine.
Francis Smith quoted for two tables in pine at £2.5.0d. each (Mackintosh to W. Davidson, 12 June, 1901—collection: Glasgow University); the final account shows that Hutchison & Grant were paid for two at £2.11.0d. and £2.6.0d. respectively (Glasgow University).

Collection: untraced.

D1901.55 Design for door handles for Windyhill, Kilmacolm
Pencil 55.9 × 49.6cm.
Inscribed, upper left, *Door Handles for Windyhill Kilmacolm*, lower left, *1 for Drawing Room / 1 for Play Room / 1 for Vestibule Door (narrow) / all in polished steel armour bright / finely wrought*, lower right, *140 Bath Street / Glasgow*; and

various notes; verso, *Davidsons Settee—upholstery 25 ins high*.

These designs were not executed, and simpler handles were fitted to the doors at Windyhill.

Provenance: Mackintosh Estate.
Collection: Glasgow University.

1901.56 Stencilled wall decoration at St Serfs Church, Dysart, Fife
The records of Honeyman & Keppie show that Mackintosh was reimbursed expenses on 1 October, 1901, for a trip to Dysart; on October 14, the church paid £10 in fees for 'decorations'. The design depicts the dove of peace and the tree of knowledge, the latter represented by three rings—good, evil and eternity. The stencils have since been painted over.

Literature: *Dekorative Kunst*, IX, 1902, p. *210*; Howarth, p. 181.
Collection: destroyed.

1901.57 Fireplace and fender for 3 Lilybank Terrace, Glasgow
Only the fender, in steel, glass and leather,

survives 30.5 × 224 × 36.5cm.
In November 1901, W. Napier quoted £14 for the mantelpiece, Hutchison £30 for electric pendants, and McCulloch 11.9d. for glass jewels; £33.4.0d. was paid for all this work on 27 January, 1902. On 12 March, 1902, George Adam quoted £3.14.0d. for the fender, James Craig £1.13.6d. for leather cushions, and McCulloch £2 for glass; these sums were paid on 16–17 April, 1902.

R. Wylie Hill, who commissioned this fireplace, paid £12.19.0d. in fees on 17 October, 1902. His wife was a member of the Rowat family who came to know Mackintosh through Jessie Rowat, the wife of Fra H. Newbery. Mackintosh received several other commissions from the Rowat family, for instance at 14 Kingsborough Gardens, Glasgow, and Prospecthill House, Paisley. No traces of the fireplace exist in the house which is now occupied by a girls' school.

Provenance: (fender only) R. Wylie Hill, by whom presented.
Collection: Glasgow School of Art.

1901.57▽

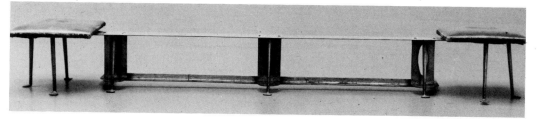

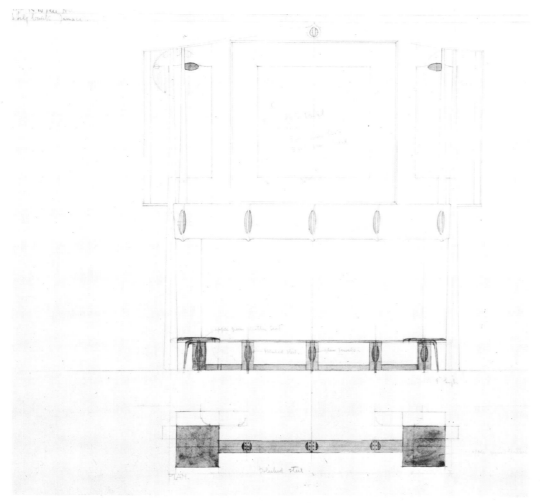

△D1901.58

1902.A ▽

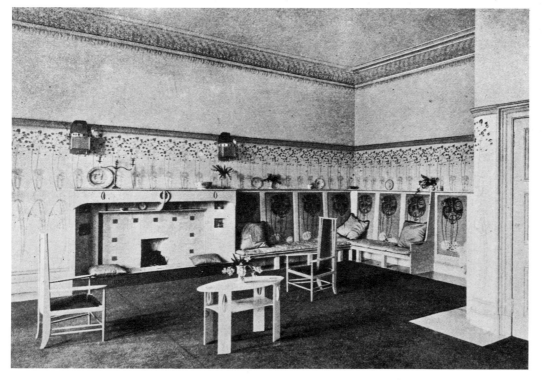

1901–02 14 (now 34) Kingsborough Gardens, Glasgow

Kingsborough Gardens is a quiet street of large terraced houses, overlooking a private garden, in the west end of Glasgow. Mackintosh was invited to decorate several rooms and remodel the dining room fireplace at number 14 for Mrs Rowat, mother of Fra Newbery's wife, Jessie. Several pieces of furniture were also made specifically for the house over a period of a few months; most of them were probably not designed and possibly not even commissioned until after the completion of the decorations. No documentary evidence can be provided for accurate dating of the house: Howarth (pp. 48–49) believes it to be contemporary with 120 Mains Street, i.e. 1899–1900, but the only dated drawing for the furniture is of 1902 (*see* D1902.4) and Mrs Rowat did not pay any fees until 5 May, 1905, although her account had been carried forward annually from 1902. Despite the appearance of her account in the financial records of Honeyman, Keppie and

D1901.58 Design for fender and mantelpiece for R. Wylie Hill, 3 Lilybank Terrace, Glasgow

Pencil and watercolour 42.5 × 42.5cm.
Signed and inscribed, lower right, *Chas R Mackintosh | 140 Bath Street*; inscribed, upper left, *Mr R Wylie Hill | 3 Lilybank Terrace*; with other notes and measurements including *Plaster panel | daylight | 3 feet 2 ins high | 3 feet 1 in broad; apple green leather seat; polished steel, glass jewels.*
Scale, 1 : 12.

Provenance: Mackintosh Estate.
Collection: Glasgow University.

1902.A Drawing-room at 14 Kingsborough Gardens, Glasgow

An earlier photograph without the furniture was published in *Dekorative Kunst*, IX, 1902, p. *205*; 1902.A is taken from the same angle, but includes the table and chairs (1902.1 and 2).

1902.B Cabinets in the drawing-room at 14 Kingsborough Gardens, Glasgow

The cabinets (1902.3) were placed against the wall opposite the fireplace which was decorated with a stencilled pattern of roses and foliage.

1902.C Cabinets at 120 Mains Street, Glasgow

A contemporary photograph of Mackintosh's own version of the cabinets he designed for 14 Kingsborough Gardens (1902.3), clearly showing the use of four hinges on each door. The photograph was taken against the panelled wall of the drawing-room.

Collection: James Meldrum.

1901.59 Fireplace for the drawing-room at Kingsborough Gardens, Glasgow

Wood, painted white, with inlaid glass decoration 156 × 243 × 48.5cm.

The grey cement render around the grate was enlivened by nine square blue tiles. The hearth was raised about 30cm. to provide fireside seats and the air supply to the grate was provided by a grille in the front of the fender, as at Windyhill. The wooden mantelpiece projected from the wall flush with the front of the hearth, but at the sides it curved back to the plane of the grate. These curved sections incorporated recesses to hold china and other objects. At the top a vertical panel spanned the width of the fireplace, strengthened at the centre by a bracket which terminated in a typical Mackintosh carved detail incorporating coloured glass. Two other details on this panel are identical with the decorative motifs on the Windyhill dressing table (1901.44) and also with the carved decoration on the legs of the oval table in the same room (1902.1). *See* 1902.A.

Literature: *Dekorative Kunst*, IX, 1902, p. *205*; *Das Englische Haus*, III, 1905, plate 212; Howarth, pp. 48–49, plate 17a.
Collection: *in situ*.

1901.60 Fitted settles for the drawing-room, 14 Kingsborough Gardens, Glasgow

Wood, painted white, with upholstered seats and stencilled backs.
Approx. 156 × 320 × 50cm.

The seats formed an L-shape, fitted against the wall running from the right-hand side of the fireplace (*see* 1902.A). The backs are divided by a broad strap, linking, at the top, into a common rail, above which was a narrow shelf running the full length of the seating and level with the top of the fireplace. The motif of the stencilled decoration is difficult to decipher from the surviving photographs, but it seems to depict birds nesting in a bush or tree. It is, however, a much more solid design than the

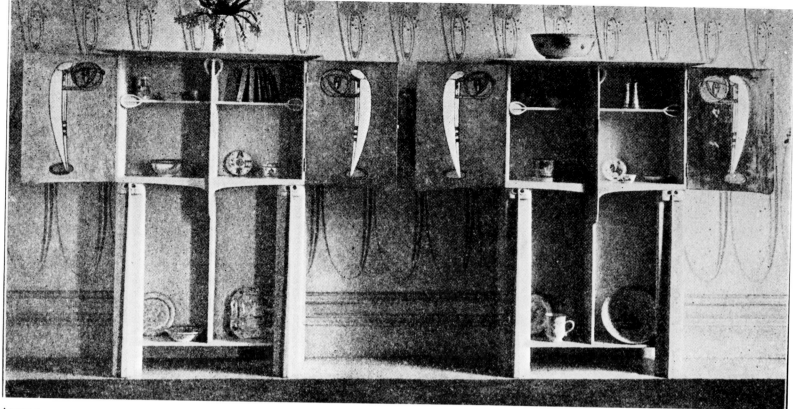

△1902.B

stylised plant forms which are stencilled on the walls of the rest of the room.

Literature: *Dekorative Kunst*, IX, 1902, p. *205*; *Das Englische Haus*, III, 1905, plate 212; Howarth, p. 48, plate 17a.
Collection: destroyed.

D1901.61 Design for a fireplace and fitted seating for 14 Kingsborough Gardens, Glasgow
Pencil and watercolour 21.6 × 65.4cm (sight).
Signed, lower right, *CRM* [*?ackintosh*] / *140 B*[*ath Street*] and inscribed with various notes and dimensions.
Scale, 1 : 12.

This drawing shows the full extent of the fitted seating in the drawing-room.

Exhibited: Toronto, 1967 (86).
Collection: Dr Thomas Howarth.

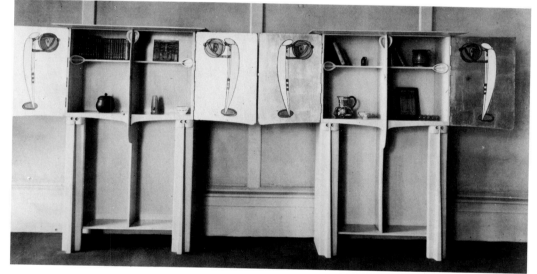

△1902.C

D1901.61▽

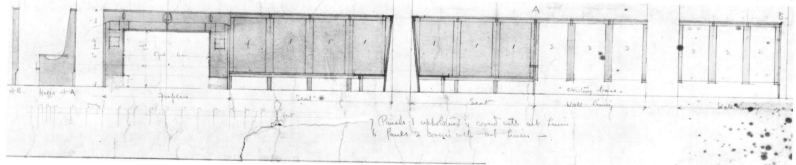

1901.62 Hall settle for 14 Kingsborough Gardens, Glasgow
Oak, stained dark, originally with purple linen panels set into the back 256.5 × 200 × 83cm.

In a totally different manner from the white-painted furniture in the room above, this settle develops the more masculine themes of the Windyhill hall furniture. No organic decoration is used at all; instead Mackintosh pierces three squares in the side post—a geometrical motif uncommon at that time. Perhaps its use was influenced by the dominant black-and-white tiled floor of the hall, arranged in a pattern of squares, oblongs and triangles. The

Mackintosh there are no details in the job-books of the various works carried out for her at 14 Kingsborough Gardens.

I believe that this commission was carried out in late 1901 and the first few months of 1902. The fireplace (1901.59) was illustrated in *Dekorative Kunst* in March 1902, but the photograph does not include the table and chairs seen in the photograph in *Das Englische Haus* (1905, III, plate 212). Like the published photographs of the unfinished interiors at The Hill House, the *Dekorative Kunst* photograph was probably taken to meet the publisher's deadline, in this case for Muthesius's article on Mackintosh and the Glasgow Style; the new white furniture cannot have been ready, otherwise such important pieces would surely have been included in the photograph, rather than the conventional chair seen in this view of the room. In fact, the photograph published in *Das Englische Haus*, also by Muthesius, is taken from exactly the same angle, but is rather wider to give more

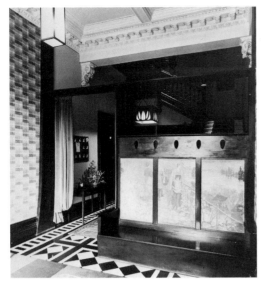

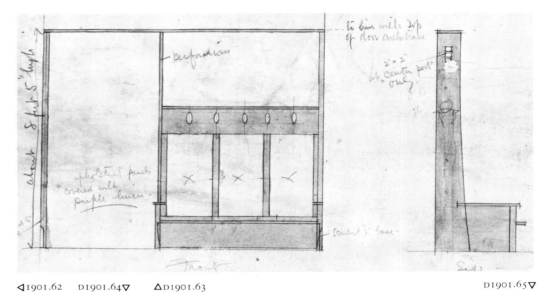

◁1901.62 D1901.64▽ △D1901.63 D1901.65▽

space around the furniture and to allow us to see more of the room. The cabinets (1902.3) based on the drawing dated 1902 cannot possibly have been ready in time to have been included in photographs to be published in March 1902.

Mackintosh seems, therefore, to have been keen to have the Kingsborough Gardens interior included in this important new article on his work. I believe it is the most recent work shown in the article, which is mainly devoted to Windyhill, but also includes such early designs (although previously unpublished) as Westdel of 1898. The drawing-room is completely different in feeling from anything else at 120 Mains Street or even Windyhill of 1901. The major change in style is the introduction of an overall pattern of stencilling on the walls and the repetition of a stencilled design on the backs of the fitted seats. At Mains Street the emphasis was on simplicity and none of the walls had such an overall, rather fussy, pattern; even at Windyhill, where the interiors and furniture are 18 months later, stencilling is only used in the bedrooms. At The Hill House in 1903 and 1904 stencilling was used extensively in the hall, drawing-room and main bedroom; Hous'hill has similar stencilled decoration in the hall and dining-room. This is a major change in Mackintosh's approach to interior decoration: the effect is less stark, almost less modern, and it brings with it a change in furniture design. Most of the pieces designed for Windyhill have clear antecedents in the Argyle Street Tearoom furniture and the items designed for Westdel and Mains Street. They are fairly solid, with broad expanses of timber and occasional decoration of *repoussé* metal, glass, or carved wood. They are strongly masculine and architectural, even the white-painted bedroom furniture has little romance about it. Kingsborough Gardens, on the other hand, is distinctly feminine: with its patterns of stylised flowers and delicate white-painted furniture it fits firmly into the works of 1901–03 in which Margaret seems to have played a distinctly identifiable part—the music room at *Haus eines Kunstfreundes*, the 'Rose Boudoir' for the Turin Exhibition, the music salon in Vienna for Fritz Wärndorfer, and the room at the Moscow Exhibition of 1903.

The elegant armchairs, with their spindly legs and stretchers, and the subtle curves of the oval table are so different from the hall furniture at Windyhill that one might be forgiven for believing them to be the work of a different artist. The

hall is very wide (3.39 metres), and to help place his settle in such a large space Mackintosh continued its top as a flat shelf until it touched the other wall where it turns through 90° and continues down the wall to the floor as a wide wall-plate.

Collection: *in situ*.

D1901.63 Design for hall settle for 14 Kingsborough Gardens, Glasgow
Pencil and watercolour 24 × 26.8cm (sight). Inscribed, lower right, *To be returned to / Chas R Mackintosh / 140 Bath Street Glasgow*; and various other notes and measurements, including *about 8 feet 5" high*; *to line with top of door architrave*; and *upholstered panels / covered with / purple linen*.
Scale, 1 : 12.

The design for 1901.62.

Exhibited: Toronto, 1967 (79).
Collection: Dr Thomas Howarth.

D1901.64 Design for wall decoration for a bedroom, 14 Kingsborough Gardens, Glasgow
Pencil and watercolour 23.1 × 29.4cm. Inscribed, upper left, *14 KINGSBOROUGH GARDENS KELVINSIDE / SUGGESTED DECORATION FOR DAUGHTERS ROOM / BEDROOM / SECOND FLOOR*, and, at bottom, *window*.
Scale, 1 : 12.

Apart from the drawing-room, Mackintosh seems to have designed stencil decorations for various other rooms at 14 Kingsborough Gardens. These designs are all based on organic motifs like those in the drawing-room, but

△D1901.66

D1901.67△

none of the executed work was ever photographed and no traces of the decorations now remain.

Provenance: Mackintosh Estate.
Collection: Glasgow University.

D1901.65 Design for a wall decoration for 14 Kingsborough Gardens, Glasgow

Pencil and watercolour 17.7 × 29.3cm.
Inscribed, lower centre, *Window.*

Provenance: Mackintosh Estate.
Collection: Glasgow University.

D1901.66 Design for wall decoration for 14 Kingsborough Gardens, Glasgow

Pencil and watercolour 23.1 × 29.2cm.
Inscribed, lower left, *Door.*
Scale, 1:12.

Provenance: Mackintosh Estate.
Collection: Glasgow University.

D1901.67 Design for stencil decoration for 14 Kingsborough Gardens, Glasgow

Pencil and watercolour 20.9 × 29.7cm.

Provenance: Acquired by William Meldrum after the Memorial Exhibition, 1933; by family descent.
Collection: James Meldrum, Esq.

1902.1 Oval table for 14 Kingsborough Gardens, Glasgow

Oak, painted white, with two inlaid ivory panels 61.3 × 94 × 50.2cm.

Designed to be used with the armchairs, 1902.2. The wide, board-like legs are set into the oval top in such a way as to suggest a continuation of the oval down to the ground. Each leg has an oval shape cut out of it, inset with a curved piece of wood, as used in the Windyhill dressing-table (1902.44) and the Kingsborough Gardens fireplace (1901.59). Just below this decoration, the legs are attached to a shelf which, unlike the top, is contained within the legs; basically rectangular, it sweeps out at each corner where it meets the legs, being fixed to each leg along its entire width. The top is inlaid with two circular panels of carved ivory.

Although only one example of this table was made for Kingsborough Gardens, Mackintosh made others for his own use. One was exhibited at Turin and remains in the Glasgow University collection; a second, without the ivory inlay, is also at Glasgow University; Howarth (p. 51, note 2) records another in the possession of Miss Nancy Mackintosh (which is possibly the example now in his own collection). The Kingsborough Gardens table was probably sold along with the chairs (see 1902.2) and could possibly have been bought by Miss Mackintosh.

Literature: *Deutsche Kunst und Dekoration*, X, 1902, pp. *586, 589*; *The Studio*, XXVI, 1902,

two cabinets, with the internal glass inlay in the shape of a girl holding a rose-ball, betray Margaret's influence as clearly as the writing desk shown at the Turin Exhibition (1902.8). The oval table, which Howarth suggests is contemporary with the Mains Street interiors, is so much an integral part of the Kingsborough Gardens design that one is compelled to believe that the photograph of it at Mains Street (first published by Muthesius in *Das Englische Haus*, 1904, I, plate 174) was taken much later than those which Annan took in March 1900.

Literature: Howarth, pp. 48–49, plate 17a.

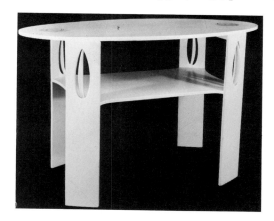

△1902.1 1902.2▷

p. *97*; *Dekorative Kunst*, X, 1902, p. *400*; *Das Englische Haus*, I, 1904, plate 174; *Das Englische Haus*, III, 1911, plate 212; Howarth, p. 51, note 2, plates 12a, 64b; N. Pevsner, *Sources of Modern Architecture and Design*, 1968, p. *138*.
Exhibited: Turin, 1902; VEDA, 1952 (R2); Saltire, 1953 (B12); Paris, 1960 (1080); Edinburgh, 1968 (222).
Provenance: a) Mrs Rowat; (?) Miss Nancy Mackintosh; Dr Thomas Howarth; b) Mackintosh Estate; c) Davidson Estate (without ivory inlay).
Collection: a) Dr Thomas Howarth; b) Glasgow University; c) Glasgow University.

1902.2 Armchair with leather or velvet upholstery for 14 Kingsborough Gardens, Glasgow

Oak, painted white, upholstered in leather 114.3 × 70.2 × 55.5cm.

Designed to accompany 1902.1. Mackintosh produced other variations of this design (see 1902.7), but the first of the series was the upholstered version designed at the end of 1901 or early 1902 for Mrs Rowat. It is difficult to identify the upholstery material from contemporary photographs, but a rose or purple velvet seems most likely, although the Glasgow University example seems always to have been covered with leather.

This chair and its companion table are far more delicate and feminine than any of the furniture designed by Mackintosh before 1902. The brilliant white paint contrasting with a soft purple or pink fabric would give the chair

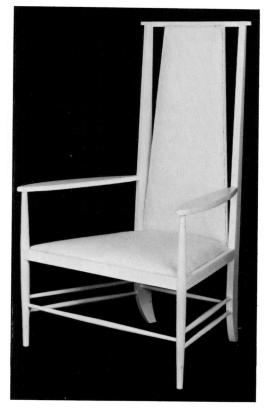

an elegance to match the pretty stencils on the drawing-room walls. During the next 30 months, Mackintosh produced several interiors using the same combination of white-painted wood, pastel upholstery and stencilled wall decoration, culminating in the bedroom and drawing-room at The Hill House, which betray the influence of his wife, Margaret Macdonald.

Some features of this chair can be traced back to the Argyle Street Tea Rooms designs; for instance the swept-back foot of the rear leg is seen in 1897.23, and the broad flat arms in the chairs for the Smoking Room (1897.11). But here the legs swell and taper much more quickly at the back to join the rear upright. The seat is very deep, wide at the front and narrowing towards the back. The six stretchers are circular in section, tapering as they enter the legs, which are hemispherical at the front and rectangular at the back.

Beneath the upholstery the back is wooden, shaped into a convex curve, but not projecting beyond the plane of the uprights. The back tapers towards the top and separates from the uprights which remain vertical. The top-rail is oval in section, echoing the curves of the wooden back and the padded upholstery. Two examples were made for Mrs Rowat, and Mackintosh also kept one for himself. All three were brought together at the Moscow Exhibition in 1903. A version in black wood with more stretchers was also made for The Hill House (1904.10).

Literature: *Mir Isskustva*, no 3, 1903, p. 117; *Das Englische Haus*, III, 1905, plate 212.
Exhibition: Moscow, 1903.
Provenance: a) Mrs Rowat, Kingsborough Gardens, Glasgow; private collection, Glasgow; Fine Art Society, London (2); b) Mackintosh Estate.
Collection: a) Private collection, USA (2); b) Glasgow University (1).

1902.3 Cabinet, with inlaid glass panels inside the doors, for 14 Kingsborough Gardens, Glasgow

Oak painted white; insides of doors painted silver and inlaid with coloured glass, with white metal hinges and handles 154.3 × 99.3 × 39.7cm.

Two cabinets were designed for Mrs Rowat to stand opposite the fireplace at Kingsborough Gardens (*see* 1901.59), but Mackintosh also commissioned two for his own flat at 120 Mains Street. One of the most spectacular of Mackintosh's designs of this period, the cabinet combines his, by now, favourite motif of white paint and coloured glass, and for the first time he introduces silver paint to his furniture. This combination gives the piece a jewel-like preciousness rarely encountered again in his furniture, except in the designs for Wändorfer's Music Salon.

Externally, with the doors closed, the cabinet appears slightly awkward and even austere (although Mackintosh relieved the starkness on his own cabinets by using four broad silver hinges—exposed on the outside of the cupboards—on each door); but with the doors open, the silver panels, with their coloured glass inlay, and the blue and white china contents combine to transform the piece. The four hinges on the Glasgow University cabinets are not merely decorative, however: the weight of the doors, which were kept open for long periods to show the inlaid pattern, has strained the hinges of the Rowat cabinets, while the four-hinged doors have not suffered in the same way.

McLaren Young (Edinburgh, 1968, no 220) states that Mrs Rowat did not accept the cabinets. In fact, those illustrated in *Das Englische Haus* are the two originally designed for Mrs Rowat, and are identifiable by the two (as opposed to four) hinges per door. (All other references, under Literature and Exhibited below, are to Mackintosh's own cabinets.)

Literature: *Mir Isskustva*, 1903, no 3, p. 117; *Deutsche Kunst und Dekoration*, XV, 1905, p. 360; *Das Englische Haus*, III, 1905, plate 184; Howarth, plates 13b and c; S. T. Madsen, *Sources of Art Nouveau*, 1956, pp. 34–35; P. Selz et al., *Art Nouveau*, 1960, p. 91; Macleod, plate V; *Scottish Art Review*, XI, no 4, 1968, p. 16.
Exhibited: Moscow, 1903; Zurich, '*Um 1900*', 1952; VEDA, 1952 (R1); Saltire, 1953 (B3); Paris, 1960 (1088); New York, Museum of Modern Art, 'Art Nouveau', 1960 (181); Edinburgh, 1968 (220).
Provenance: a) Mrs Rowat, Kingsborough Gardens, Glasgow (2); private collection, Glasgow (1); Fine Art Society, London (1); b) Davidson Estate.
Collection: a) Private collection (1); b) Glasgow University (2).

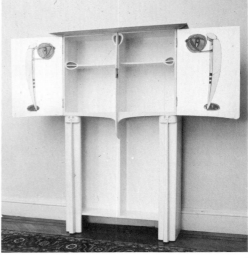

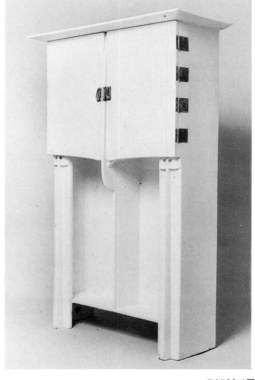

◁1902.3 detail 1902.3 △▽

DI902.4 Design for two cabinets for Mrs Rowat, 14 Kingsborough Gardens, Glasgow

Pencil and watercolour 29.4 × 45.1cm.
Inscribed and dated, lower right, *140 BATH STREET / GLASGOW 1902*; inscribed lower left, *SKETCH OF / CABINET FOR / MRS ROWAT / 14 KINGSBOR/OUGH GARDENS*, and upper right, *SILVER DOORS / INLAID WITH / COLOURED GLASS*; and various other notes.
Scale, 1:12.

As executed, except that Mackintosh has tentatively indicated a chequer-pattern decoration, either painted or inlaid, on the back panel of the cupboard which was never carried out.

Provenance: Mackintosh Estate.
Collection: Glasgow University.

DI902.4 ▽

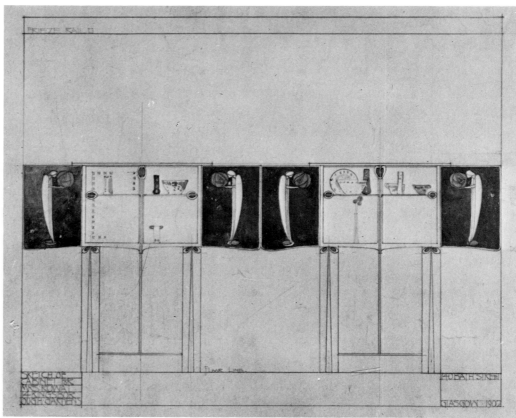

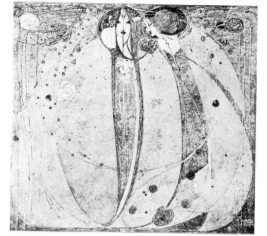

△1902.D 1902.D ▽

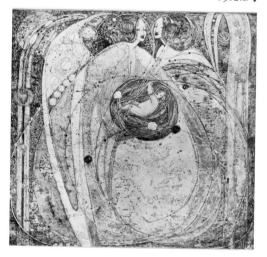

1902 The International Exhibition of Modern Decorative Art, Turin

Fra Newbery, Director of the Glasgow School of Art, was responsible for choosing the exhibits for the Scottish section of this major exhibition, held in specially constructed pavilions designed by d'Aronco. Not surprisingly, Newbery included very little work which did not originate from his own School, and for the design of the stalls and room settings in his allotted area he chose Mackintosh.

Mackintosh and Newbery visited Turin, probably in April 1902, as Wärndorfer met Mackintosh and reported their discussions to Hoffmann. The exhibition building did not please Mackintosh, and Wärndorfer quotes his belief that it was 'the basest and meanest theft from what Olbrich did at Darmstadt'. (Letter from Wärndorfer to Hoffmann, 29 April, 1902, Hoffmann Archive, quoted by E. Sekler in 'Mackintosh and Vienna', *Architectural Review*, CXLIV, 1968, p. 456.) Mackintosh broke up the space allotted to him into three units. The gallery was much too high for his needs, and the windows too large; these problems he solved by painting the walls white above about 2.5 metres, the ceiling also white, and he softened the light by filtering it through some thin, muslin-like fabric. The apartments were linked together by a series of stencilled banners 4.5 metres high, bearing the motif of a draped figure, with her head silhouetted against the moon and her gown festooned with roses. The first bay, known as 'The Rose Boudoir', was designed to house furniture and paintings by Charles and Margaret; it was painted white, silver and rose-pink. The second bay was occupied by Herbert and Frances MacNair, who decorated it as a writing-room; it was painted grey, gold and white, relieved by a MacNair frieze in pink and green. The third unit was used to house the work of students from the Glasgow School of Art and the other Scottish exhibitors; it was the largest of the three and was painted purple and white. This simple division of the vast and somewhat unsympathetic space set the whole tone of the Scottish exhibit. Mackintosh wanted the structure to stand in its own right as part of the Scottish contribution; with his stencilled banners, the tall, tapering square posts and the unmoulded timbers he easily achieved his aim.

Newbery's file on the Turin Exhibition still exists (collection: Glasgow School of Art) and, although it is not complete, it does deal fully with the items sent to Turin for display. Much of the correspondence is with the Italian agents appointed to deal with the packing, transport and sale of the works; it shows that, as with so

1902.D Margaret Macdonald Mackintosh: 'The White Rose and the Red Rose' and 'Heart of the Rose'.

These two gesso panels hung at opposite ends of the Rose Boudoir.

1902.E The Rose Boudoir, International Exhibition of Modern Decorative Art, Turin

1902.F General Scottish exhibits area, International Exhibition of Modern Decorative Art, Turin

The stalls (1902.5) and banners (1902.6) were designed by Mackintosh; all the other items shown here were made by other Scottish designers.

1902.5 Display cabinet for the Glasgow School of Art for the International Exhibition of Modern Decorative Art, Turin
Wood, painted white.

A smaller version of the cabinet designed for the School of Art bookbinding display at the Glasgow International Exhibition of 1901 (*see* 1901.21). The main differences are in the handling of the top of the cabinet, the lack of any metalwork decoration on the Turin version, and the addition of stencilled roses (following The Rose Boudoir theme) at Turin. Two were made (*see* 1902.F).

Literature: *The Studio*, XXVI, 1902, p. *91*.
Collection: untraced, probably destroyed.

1902.6 Banner for the International Exhibition of Modern Decorative Art, Turin
Linen, stencilled in green, silver, rose and black 384 × 55.3cm.
Signed and dated, lower centre, *CHARLES | RENNIE | MACKINTOSH | 1902*.

Used in the Exhibition to break up the high space allocated to the Scottish designers and to divide the three individual bays which Mackintosh created. At least eight were made, with the figure facing either left or right depending upon the position in the display; they were available for sale at £3.3.0d. each. Only one complete banner survives, but reproductions were made for the Centenary Exhibition, 1968. (See 1902.F).

Literature: *Deutsche Kunst und Dekoration*, X, 1902, pp. *588–89*; *The Studio*, XXVI, 1902, p. *91*.
Exhibited: Turin, 1902; Paris, 1960 (1098); Arts Council, 'Art Nouveau in Britain', 1965 (60); Edinburgh, 1968 (239, facsimile, frontispiece).
Provenance: Mackintosh Estate.
Collection: Glasgow University (1).

▽1902.E

1902.F ▽

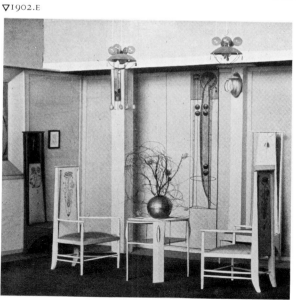

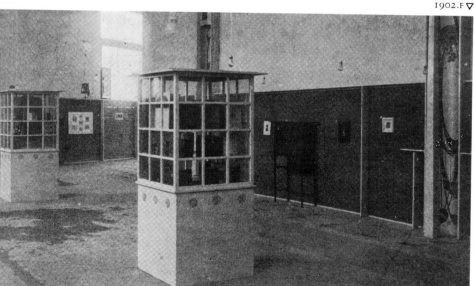

many large exhibitions of this type, not everything went as well as had been expected and the Scottish Committee eventually made a financial loss. The Mackintoshes, at least, confirmed their reputations as artists, designers and architects; although several things remained unsold, they were invited to exhibit at Budapest and Moscow and their work was awarded a diploma of honour.

Several new pieces of furniture were made especially for The Rose Boudoir. The walls were hung with small watercolours and beaten metal panels, but the most important 'pictures' were, in fact, three gesso panels designed and made by Margaret around the theme of the rose. Mackintosh's own list of items sent to Turin survives (Glasgow School of Art) and almost all the items on it can still be traced:

1 white high-back chair, £8.8.0d. (*see* 1902.12)
1 black high-back chair, £8.8.0d. (*see* 1902.11)
2 white armchairs, £6.6.0d. each (*see* 1902.7)
1 white oval tea table, £8.8.0d. (*see* 1902.1)
1 writing desk, £50.0.0d. (*see* 1902.8)
2 small green chairs, £2.2.0d. each (*see* 1901.52)
1 music and china cabinet, £26.5.0d. (*see* 1900.78)
4 pendant electric lamps, £4.14.0d. each
4 bracket electric lamps, £2.10.0d. each
1 glass panel, *Secret of the Rose*, £5.5.0d.
1 glass panel, *Spirit of the Rose*, £5.5.0d.
1 poster, £5.5.0d.
2 Christmas cards, £1.1.0d. each
2 Golden Wedding cards, £2.2.0d.
5 finger plates, £1.15.0d. each
Banners, £3.3.0d. each
Various vases at 5/-, 6/- and 15/-

Frontispiece and nine plates from the portfolio published by Alex Koch for *Haus eines Kunstfreundes* (*see* D1901.3–11)
The Wassail (collection: Dr Thomas Howarth), watercolour design for a gesso panel for Miss Cranston's Ingram Street Tea Rooms, Glasgow, 1900, £10.10.0d.

Margaret Macdonald Mackintosh:
The May Queen (collection: Dr Thomas Howarth), watercolour design for a gesso panel for Miss Cranston's Ingram Street Tea Rooms, Glasgow, 1900, £10.10.0d.
The Dew, a silvered-metal panel, also from the Ingram Street Tea Rooms. 2 designs for *Ex Libris* labels.
The Flowery Path, a gesso panel, £31.10.0d.
Heart of the Rose (collection: Glasgow School of Art), a gesso panel, £36.15.0d.
The White Rose and the Red Rose (private collection), a gesso panel, £36.15.0d.
Embroidered panel, exhibited: Vienna Secession, 1900, lent by Herr Emil Blumenfelt, Berlin

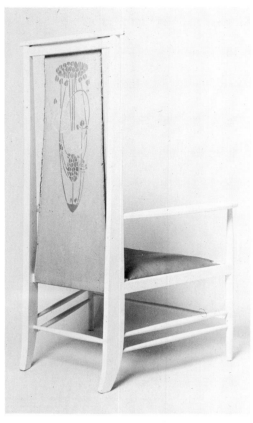

1902.7△

1902.7 Armchair with stencilled loose canvas back

Oak, painted white, with stencilled loose canvas back and upholstered seat 113.5 × 70.2 × 57cm.

A variant of 1902.2, differing only in the design of the back-rest; two were made for the Turin Exhibition of 1902. Instead of an upholstered back covering a wooden panel, Mackintosh has used only a double sheet of canvas, stretched between the top-rail and the back of the seat. This is stencilled with a floral motif, part of the Rose Boudoir theme. The removal of the wooden back weakened the structure of the chair and Mackintosh introduced an extra rail below the oval top-rail, spanning the two uprights, to provide some rigidity. It was not altogether successful, and the chair still flexes uncomfortably when sat on. The canvas

▽1902.8

▽1902.8

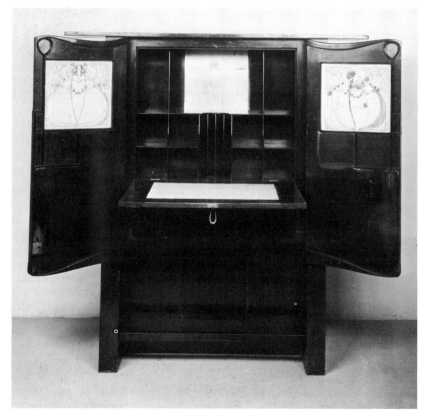

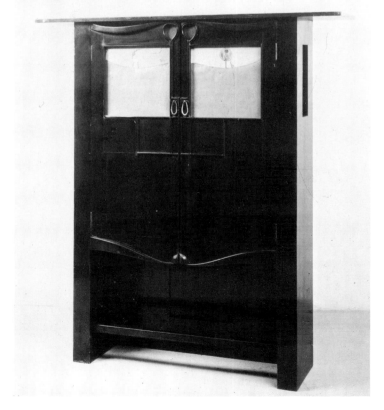

panel, however, although somewhat faded, has withstood 60 years of daily use without tearing loose or stretching. The seat was originally upholstered in rose silk.

Literature: *The Studio*, XXVI, 1902, pp. *92, 96*; *Deutsche Kunst und Dekoration*, X, 1902, pp. *586, 589*; *Arte Italiana*, XI, 1902, p. *63*, fig. *160*; Howarth, plates 16b, 64b; R. Barelli, *Il liberty*, 1966, p. *82* (in colour); Macleod, plate *79*; N. Pevsner, *The Sources of Modern Architecture and Design*, 1968, p. *138*; Alison, pp. 54–55. Exhibited: Turin, 1902; VEDA, 1952 (R4); Saltire, 1953 (B13); Paris, 1960 (1087); Munich, 'Secession', 1964 (953); Ostend, 'Europa 1900', 1967 (125); Edinburgh, 1968 (221). Provenance: Davidson Estate. Collection: Glasgow University (2).

1902.8 Writing-desk
Ebonised wood, with panels of metal and glass, and gesso designed by Margaret Macdonald. 148 × 124 × 30cm.

The most elaborate of the various writing cabinets designed by Mackintosh; the others often have decorative panels of metal and glass, but this design also incorporates two gesso panels designed by Margaret Macdonald. Indeed, Mackintosh's list of exhibits for Turin (collection: Glasgow School of Art) states that the metal panel in the body of the cabinet, *The Spirit of Love*, was also designed by Margaret; the two panels on the outside of the doors, a variant of the weeping rose motif, are therefore likely to be his design as they are not ascribed to Margaret. The gesso panels are entitled *The Awakened Rose* and *The Dreaming Rose*.

This cabinet is narrower than that made for Michael Diack (1901.1), with proportions approaching those of the Kingsborough Gardens cabinets (1902.3). However, the deep doors, with their curved bottom edge, are a less successful design than the silvered doors on the twin cabinets, and Mackintosh reduced their height on the writing cabinet for Blackie (1904.13) which he duplicated for his own use. As with much of the furniture of this period, the applied decoration is based on natural forms—the raised stems and bud-like forms and the coloured petal-shaped panels on the doors, for instance. But there are features in the desk which suggest that already Mackintosh was beginning to tire of the overtly feminine style which he had evolved in the Kingsborough Gardens furniture. The choice of black for the colour of the piece is the most obvious change, for although Mackintosh had often stained his oak furniture a dark brown shade he had never used black before. The outline of this piece is also more rectilinear than 1902.3: the front face of the leg is broad like the white cabinet, but it is unrelieved and does not have the raised, tapering spar attached to it; the legs also carry up through the top of the cabinet, the doors being hinged inside their line rather than overlapping the face of the leg; in the upper part of the sides of the cabinet Mackintosh has cut a deep rectangular niche which indicates that the legs themselves are, in fact, constructed as shallow rectangular boxes and are not just the thickness of a plank of timber; and finally, the top is a simple board, without the *cyma recta* curve on its underside like 1902.3, though, like that cabinet, it is not supported at the back by the wide vertical band of timber which is seen on so many of the earlier cabinets (e.g. 1899.1).

Mackintosh's next black pieces, the chairs for the bedroom at The Hill House and the furniture for the Willow Tea Rooms of 1903, have no organic-based decoration, but they do not appear as heavy or severe as this cabinet. It is a transitional design, probably contemporary with the Wärndorfer furniture, if not

Table cloth, £3.3.0d.
Bowl, £5.5.0d.
Vase, £1.1.0d.
Christmas card, with Frances Macdonald MacNair, £3.3.0d.

Almost all the furniture is easily identifiable from contemporary photographs, with the exception of the two green chairs. These were not sold, and no similar chairs remained in Mackintosh's house in 1914 or came under Margaret's estate in 1933; however, from the price and description, it seems possible that they were identical to the ladderback chairs designed for the Windyhill bedroom (1901.52). All the bowls were sold, and several duplicates were also sent out from Glasgow; Wärndorfer bought the writing desk (according to the credit line in the article in *The Studio*, (see 1902.8)). The other cabinet, the eight electric light fittings, and two of Margaret's gesso panels were also consigned with the desk to Vienna at the close of the exhibition. It is not known if all these were also bought by Wärndorfer, but again the credit lines in *The Studio* (XXVI, 1902, p. *93*) for *Heart of the Rose* and *The White Rose and the Red Rose* indicate that he also bought these two panels of Margaret's. In a letter to von Myrbach (4 April, 1904, quoted by Howarth, p. xi), Mackintosh referred to two panels which belonged to someone in Vienna known also to Moser: this would probably have been Wärndorfer. Margaret indicated in her list that duplicates were possible, and the Turin panels are themselves duplicates: *Heart of the Rose* hung at Mr Wylie Hill's house (see D1901.58); *The White Rose and the Red Rose* seems to have been hung at 120 Mains Street, and was certainly hung over the studio fireplace at 78 Southpark Avenue (see D1906.5), and later passed to the Macdonald family at Dunglass Castle. *The Flowery Path* was bought by a Count de Minerbi (?) from the exhibition. Everything else returned to Glasgow.

Literature: The main reviews of the Scottish Section at the Turin Exhibition appear in: *Dekorative Kunst*, X, 1902, pp. 400–15; *Deutsche Kunst und Dekoration*, X, 1902, pp. 575–98; *The Studio*, XXVI, 1902, pp. 91–104; and *Arte Italiana Decorativa e Industriale*, XI, 1902, pp. 61–68.

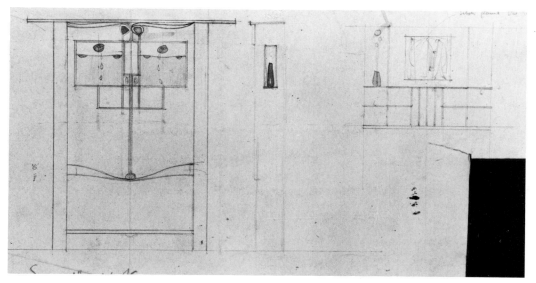

△D1902.9

earlier, and Mackintosh did not resolve the problems it posed until 1903–04.

The caption accompanying the illustration in *The Studio* suggests that Wärndorfer bought the piece. It was certainly not designed specifically for him, because Mackintosh gives its sale price, £50, in his schedule (collection: Glasgow School of Art). A letter from the agents in Turin to Newbery (15 May, 1902, collection: Glasgow School of Art) states that they have sold the cabinet and asks if it can be repeated. On 16 May they wrote again to say that they now realised 'that that room is, if we are not in a mistake, already sold' and they wished to know if any of the objects contained in it could be reproduced and at what price. Their words must not be taken literally, however, or certainly not as meaning that one client bought the complete set of fittings from The Rose Boudoir. Some of the contents do appear in the various lists of sales, but some were returned to Glasgow. This cabinet and 1900.78, two gesso panels and eight lamps were consigned

to a Herr Schmidt in Vienna; although there is no mention of Wärndorfer, Schmidt could well have been his transport agent. *

Literature: *The Studio*, XXVI, 1902, pp. *92, 94, 95* (details of gesso panels; *Deutsche Kunst und Dekoration*, X, 1902, p. *579*; *Dekorative Kunst*, X, 1902, pp. *404–05*; *Arte Italiana*, X, 1902, p. *63*, fig. *160*. Exhibited: Turin, 1902; Darmstadt, 1976–77, vol. 2, no. 67. Provenance: (?) F. Wärndorfer. Collection: Museum für Angewandte Kunst, Vienna.

D1902.9 Design for a writing cabinet
Pencil and watercolour 15.5 × 28.5cm. (irregular). Inscribed, upper right, *Silver panel the rose veil*, and, lower left, *Scale 1″ = 1 foot*. Scale, 1:12.

Virtually as executed except that the panels on the doors were transposed, left for right.

Provenance: Mackintosh Estate. Collection: Glasgow University.

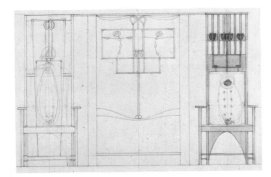

△D1902.10

D1902.10 Design for a chair and writing cabinet

Pencil and watercolour 25 × 42.6cm.
Inscribed, right centre, *cushions 27 × 1½*.
Scale, 1 : 12.

A study for 1902.8 and, like D1902.9, it is as executed except for the transposition of the metal and glass panels in the doors. The chairs shown in the drawing are obviously meant to accompany the cabinet, since they share a number of decorative features with it, such as the branching stems which terminate in petals or buds of coloured glass. Mackintosh has indicated two alternative treatments for the back of the chair, although both versions have arms. In the end he seems to have rejected both designs, for the two high-back chairs exhibited at Turin are armless, and are also taller than those in this drawing. Mackintosh has retained one important feature, however: the chair shown on the left of the cabinet has an upholstered and stencilled back, with a carved wooden panel above it inlaid with glass, and the whole of the back tapers from top to bottom. In the executed chair the same formula of carved wood above an upholstered panel is repeated, but the back now tapers upwards from the seat to the top-rail.

Literature: Alison, p. 79, no 24.
Exhibited: Milan, 1973 (24).
Provenance: Mackintosh Estate.
Collection: Glasgow University.

1902.11 Chair with stencilled high back

Ebonised (?) oak, with upholstered seat and back 152.5 × 68 × 56.2cm.

Probably designed to accompany the ebonised writing cabinet (1902.8); it has its origins in the sketches for a chair included in D1902.10. It is one of Mackintosh's most well-known designs but, like so many other pieces, its purpose seems more decorative than practical. Of all his designs for chairs it is the most plastic and its combination of two and three-dimensional organic decoration is the most successful. The tapering back, separated at the top from the rear uprights, is derived from 1902.2, but

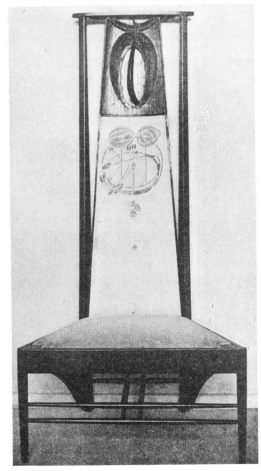

△1902.11

the back is much higher; it is, in fact, the tallest chair Mackintosh ever designed (with the exception of 1909.17). The upholstery was purple silk. One chair was sold at Turin to the Gewerbe Museum at Kaiserslautern (West Germany). It seems likely that it was this example, rather than the white-painted· version, which apparently returned to Glasgow and remained in Mackintosh's own collection. If Wärndorfer did acquire the writing desk, there is no evidence to show that he also purchased a chair; certainly no chairs were included in the furniture sent to Vienna at the close of the exhibition.

Literature: *Deutsche Kunst und Dekoration*, X, 1902, pp. *579, 586*; *Dekorative Kunst*, X, 1902, p. *400*; *The Studio*, XXVI, 1902, pp. 92, 96; *Arte Italiana*, XI, 1902, p. 63, fig. 160.
Collection: untraced.

1902.12 Chair with stencilled high back

Oak, painted white, with upholstered seat and back 152.5 × 68 × 56.2cm.
Identical with 1902.11 except for the colour, this piece seems to have returned to Glasgow.

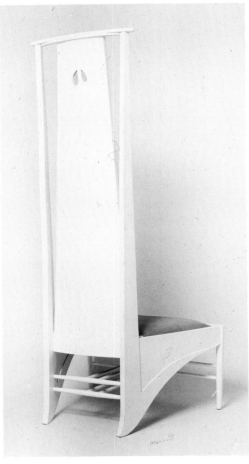

1902.12△

Although Wärndorfer does not appear to have bought the black version of the design, he certainly admired the white chair, as several were made for his music salon in Vienna. Whether he knew of the design before it was displayed at Turin is impossible to say, but if Mackintosh produced his drawings in the way he did for Westdel and The Hill House interiors, then there would have been some indication of the appearance of the movable furniture on the drawings Wärndorfer collected from Mackintosh in Turin in April 1902.

Literature: *Deutsche Kunst und Dekoration*, X, 1902, pp. *586, 589*; *Dekorative Kunst*, X, 1902, p. *400*; *The Studio*, XXVI, 1902, p. *92*; *Arte Italiana*, XI, 1902, p. 63, fig. 160; Howarth, plates 12b, 44b, 60a; R. Schmutzler, *Art Nouveau*, 1966, p. *251*; Alison, pp. *52–53, 97–99*.
Exhibited: Turin, 1902; Saltire, 1953 (B1); New York, Museum of Modern Art, 'Art Nouveau', 1960–61 (182); Edinburgh, 1968 (223); London, Royal Academy, 'Vienna Secession', 1971 (298).
Provenance: Davidson Estate.
Collection: Glasgow University.

1902 The Wärndorfer Music Salon, Vienna

Fritz Wärndorfer was a successful Viennese businessman and enthusiastic patron of the group of architects, painters and designers who formed the Secession group. He had met Mackintosh in Glasgow in 1900, and they had obviously met again during the Mackintoshes' visit to Vienna, about October or November 1900. There is no documentary evidence of any further meetings before April 1902, but at some time during this period Wärndorfer commissioned a music salon from Mackintosh and, at the same time, a dining-room from Josef Hoffmann. Mackintosh and Wärndorfer met in Turin in April 1902, and it was probably at this time that Wärndorfer bought the writing desk (1902.8), two gesso panels by Margaret, and possibly also the cabinet (1900.78). Wärndorfer wrote to Hoffmann (collection: Hoffmann Estate) on 29 April, 1902, saying that Mackintosh had just sent him the full-size drawings for the furniture and that he, Mackintosh, had asked Wärndorfer to let him have any comments that Hoffmann might have on the designs. Wärndorfer goes on to say that Hoffmann's pupil, Max Schmidt, had looked over the structural drawings and that he was confused by Mackintosh's

1902.G Photographs of The Opera of the Wind and The Opera of the Sea

The original photographs show the panels supported on an easel and held in place by drawing pins, the scale of which indicates that the panels were about 30cm. square. They were not fitted into the frieze of the Wärndorfer Salon, as suggested by Howarth, but were set into the piano (*see* D1902.18). Although dated 1903, these panels were certainly conceived and designed in 1902 but not finished until 1903, the year the piano was delivered to Wärndorfer (*see* 1902.16).

Collection: Glasgow University.

1902.H Photograph of gesso panels for the Wärndorfer Music Salon

This photograph of three gesso panels on the theme of the Seven Princesses was taken by

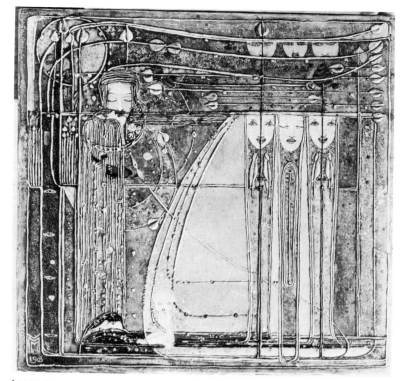

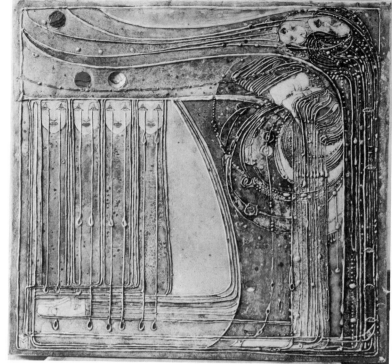

△1902.G

△1902.G

1902.H▽

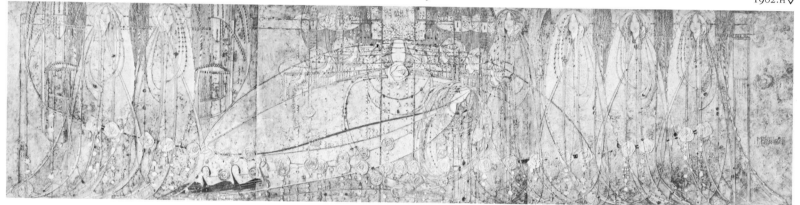

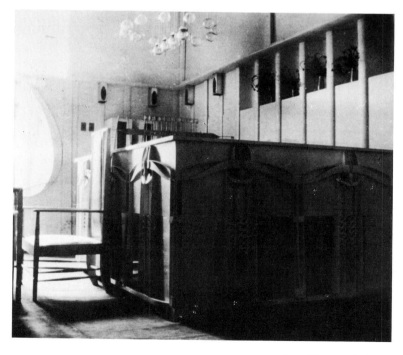

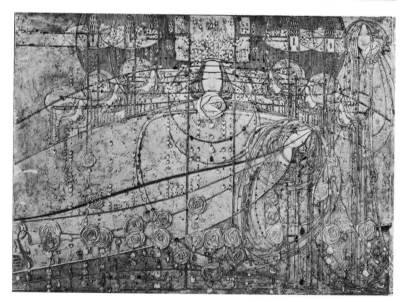

1902.H detail△

◁1902.I

Bedford Lemere in 1906, the same date as appears beside Margaret's signature on one of the panels. This is the only photographic evidence of the appearance of these panels to have survived.

Collection: Glasgow University.

1902.I Wärndorfer Music Salon, Vienna
The only surviving photograph of the piano (1902.16), with the window-seat in the background.

detailing of the projecting fireplace bay. Work probably started soon after June 1902, the date the plans were presented to the authorities for the necessary permission to build. On 23 December, 1902, Wärndorfer again wrote to Hoffmann about both rooms and he remarked that the music salon was almost finished although he was still waiting for the piano.

Mackintosh's room was square with two rectangular projections on adjacent walls, one for a fireplace ingle, the other for a large window bay with fitted seating. The fireplace bay projected beyond the line of the original wall and internally it had a low ceiling the same height as the picture rail which encircled the rest of the room; the window similarly projected beyond the line of the salon

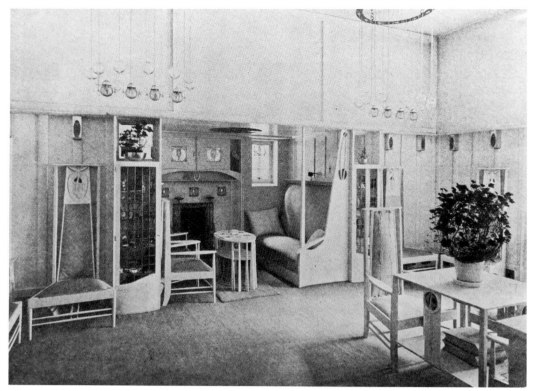

△1902.J

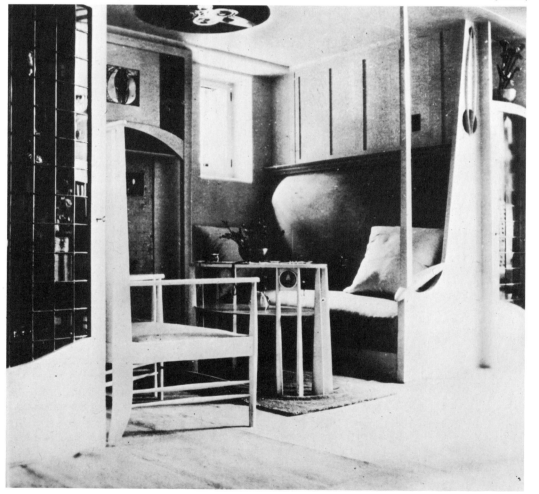

1902.K ▽

A view looking towards the fireplace ingle and showing almost all the furniture designed for the room, with the obvious exception of the piano.

1902.K **Fireplace ingle, Wärndorfer Music Salon, Vienna**
A closer view of the fireplace ingle and its furniture.

1902.13 **Fireplace for the Wärndorfer Music Salon, Vienna**
Wood, painted white.

Few of Mackintosh's fireplaces have cupboards in the mantelpiece like this design; in fact, this piece has more the proportions and—were it not for the grate—the appearance of one of his tall cabinets. The fire surround appears to have been of mosaic tiles, and the three square insets anticipate the elaborate panels in the bedroom fireplace at The Hill House (1903.60). Either side of the grate rise two steel posts, each supporting a flat circular tray; these may well be a version of the Mains Street Studio fire irons, but one cannot be certain from the evidence of the somewhat indistinct photographs. (See 1902.J).

Literature: *The Studio*, LXVII, 1912, pp. 71–72; Howarth, plate 60.
Collection: untraced, probably destroyed.

1902.14 **Fitted settle for the Wärndorfer Music Salon, Vienna**
Wood, painted white, and inlaid with coloured glass.

Fitted into the fireplace ingle, the relationship of this settle with the fireplace is very similar to that of the one at Westdel of 1898. Here it is much more open, however, and its side is decorated with coloured glass and organically-inspired carving. (See 1902.K).

Literature: *The Studio*, LXVII, 1912, pp. 71–72; Howarth, plate 60.
Collection: untraced, probably destroyed.

1902.15 **Fitted glazed cabinet for the Wärndorfer Music Salon, Vienna**
Wood, painted white, with leaded-glass doors.

Two cabinets were made, one for either side of the opening into the fireplace ingle. The shelves were very shallow and the contemporary photograph shows that they contained china and other works of art. (See 1902.J).

Literature: *The Studio*, LXVII, 1912, pp. 71–72; Howarth, plate 60.
Collection: untraced, probably destroyed.

1902.16 **Piano for the Wärndorfer Music Salon, Vienna**
Wood, painted white.

One of the largest pieces of furniture Mackintosh ever designed. It was roughly square in plan with almost solid sides, giving it a box-like appearance. The lower parts of at least two of the sides were partly open, the voids divided by posts and panels which support a solid upper section containing the strings. These solid panels were decorated by relief carvings of stylised swooping birds, a motif which Mackintosh had used frequently from 1897 to 1900, but never on the scale seen here. Above the keyboard, he placed two decorative gesso panels about 30cm. square, *The Opera of the Winds* and *The Opera of the Sea*, both by Margaret Macdonald (*see* D1902.18). Although the piano was obviously designed in 1902, it was not delivered until 1903, probably because of the late arrival of these two panels, one of which is dated 1903. (See 1902.I).

Literature: *Deutsche Kunst und Dekoration*, XV, 1905, pp. 364–65 (panels only); Howarth, plate 60.
Collection: untraced, probably destroyed.

wall and was enclosed by an arch in the shape of an inverted heart (1902.I) which linked the high backs of the fitted seats. The walls of the room were panelled to picture rail height, about 2 metres, with white-painted boards which had their butt joints hidden by a rounded cover-strip. At the top of alternate strips appear box-like features which appear to have an inlay of coloured glass and which could be lampshades, although the room is well provided with artificial light from four clusters of unshaded lamps hung with clear glass globes from an oval metal rail fixed to the ceiling. Above the picture rail is a deep frieze which is blank in the surviving photographs (taken *c*1903), but for which Margaret designed a series of gesso panels on the theme of Maeterlinck's *Seven Princesses*. McLaren Young (Edinburgh, 1968, no 325) doubted the existence of these panels, but Howarth (p. xxxiii) clearly points out Hevesi's evidence which suggests that they were

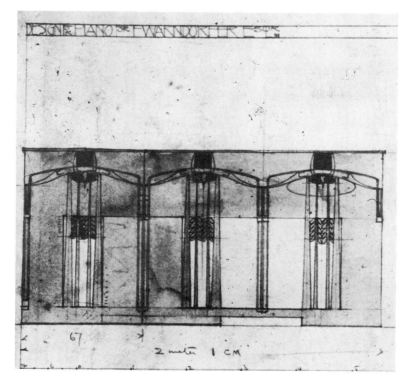

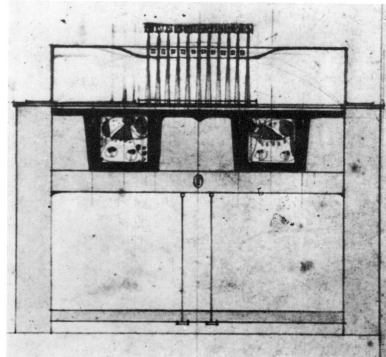

D1902.17 Design for a piano for the Wärndorfer Music Salon, Vienna
Pencil and watercolour.
Inscribed, top. *DESIGN FOR PIANO FOR F WARNDORFER ESQR.*

Virtually as executed, but showing some alternative decoration on the posts which support the great birds. This drawing is known only from a photograph in Thomas Howarth's doctoral thesis (collection: Glasgow University Library).

Collection: Dr Thomas Howarth.

D1902.18 Design for a piano for the Wärndorfer Music Salon, Vienna
Pencil and watercolour.

This drawing shows the keyboard elevation of the piano, with the projecting music stand and the two decorative panels set above the keyboard. These panels were designed and made by Margaret, and they differ in composition from the sketchy outlines shown here by Mackintosh. Like D1902.17, this drawing is known only from a photograph in Thomas Howarth's doctoral thesis (collection: Glasgow University Library).

Collection: Dr Thomas Howarth.

1902.19 * Oval table for the Wärndorfer Music Salon, Vienna
Wood, painted white, with inlaid decorative panels.

This table is similar to the oval tea table made for Kingsborough Gardens (1902.1), but it had ten legs grouped in sets of five at each end of the table (*see* 1902.J and K). Between each outer pair of these two groups of legs was fitted a decorative panel—four in all—similar to the panels fitted between the vanes of the Hous'hill screen (1904.49); contemporary photographs are too indistinct to identify the patterns of these panels. This table, or a replica, was exhibited at Moscow in 1903.

Literature: *Mir Isskustva*, no 3, 1903, p. *117*; *The Studio*, LXVII, 1912, pp. 71–72; Howarth, plate 60.
Exhibited: Moscow, 1903 (or a replica).
Collection: untraced, probably destroyed.

1902.20 Table for the Wärndorfer Music Salon, Vienna
Wood, painted white, inlaid with coloured glass.

△D1902.17 △D1902.18

This square or rectangular table is unlike any other designed by Mackintosh at this period (*see* 1902.J). It had square legs at the corners and a plain top and lower shelf, these last connected by a broad splat carrying a raised carved motif, similar to that used on the stone capitals in the aisle at Queen's Cross Church, but here inlaid with coloured glass.

Literature: *The Studio*, LXVII, 1912, pp. 71–72; Howarth, plate 60.
Collection: untraced, probably destroyed.

indeed made and installed after the latter's visit in 1905 but before 1909. Howarth is wrong, however, to suggest that the two panels, *Opera of the Sea* and *Opera of the Winds* (1902.G), are two of the wall-mounted series designed for the room. The illustrations of these two panels were, in fact, trimmed for publication and the original photographs (collection: Glasgow University) show that the panels were photographed on an easel and that they were quite small, perhaps only 30cm. square. McLaren Young also misinterpreted the inscription on the reverse of these photographs (and Howarth repeated his mistake): the inscription, *in [the] front of the piano*, indicates that they were installed *on* the piano, and in D1902.18 two such panels can clearly be seen above the keyboard. One of the reasons for the delay in the finishing of the piano is almost certainly the late arrival of these panels, as one is dated 1903. The rest of the panels by Margaret, for the frieze, seem to have been executed in 1906 which is the date on a set of three square panels, *The Seven Princesses*, of which only a photograph survives (collection: Glasgow University). As each of the four lengths of frieze appears to have been divided into three sections (*see* 1902.H) in anticipation of the panels, it seems reasonable to conclude that each wall was conceived as a self-contained episode of the Maeterlinck story and that *The Seven Princesses* is one of these four episodes.

The furniture in the room is all very similar to that designed for 14 Kingsborough Gardens and the Turin Exhibition and it was, of course, designed at almost the same time—in the first three months of 1902. The armchairs (1902.21) are identical with the Kingsborough Gardens chairs with the addition of embroidery on the back rests, while the tall white chairs are replicas of that exhibited at Turin (1902.12). Two tables in the room are new, but still very elegant and feminine designs: an oval table with ten legs is basically a more elaborate version of 1902.1, but the square table in the centre of the room is unlike any other table Mackintosh designed. It has simple square legs at each corner and a plain top and lower shelf connected by a broad vertical splat decorated with raised carving. The most impressive item in the room, however, was the piano, a massive piece about 1 metre high by 2 metres square. The upper part was solid and decorated with his favourite—but by this date uncommon—motif of a flying bird; over the keyboard seem to have been the small gesso panels and above them a music stand of slender columns each capped by a small cube.

Hevesi described the salon as 'a place of spiritual joy' and 'an artistic curiosity of the first order'. Sad, then, to relate that no trace of it—either furniture or panels—can be found. This is, without doubt, the most serious of the many acts of vandalism which seem to have pursued Mackintosh's work.

Literature: Ludwig Hevesi, *Altkunst-Neukunst, Wien 1894–1908*, Vienna, 1909, pp. 222–23; *The Studio*, LXVII, 1912, pp. 71–72; Howarth, pp. xxx–xli, 155–57, plate 60; Sekler, *Architectural Review*, CXLIV, 1968, pp. 455–56.

See addenda

1902.21 Armchair with embroidered upholstered back for the Wärndorfer Music Salon, Vienna
Wood, painted white.

A variant of 1902.2, but the embroidered back is an addition which was repeated on almost identical black-painted chairs for The Hill House (1904.10). At least four appear in contemporary photographs. (See 1902.J).

Literature: *The Studio*, LXVII, 1912, pp. 71–72; Howarth, plate 60.
Collection: untraced, probably destroyed.

1902.22 Chair with stencilled high back
Wood, painted white, with upholstered seat and back.

See 1902.12, with which this is identical; at least four examples appear in contemporary photographs. (*See* 1902.J).

Literature: *The Studio*, LXVII, 1912, pp. 71–72; Howarth, plate 60.
Collection: untraced, probably destroyed.

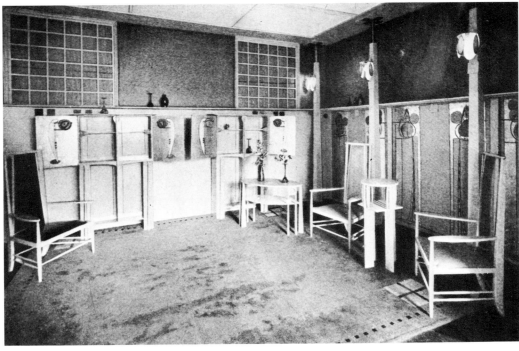

1903.A ▷

1902–03 Exhibition Room, Moscow
The room illustrated in *Mir Isskustva* contains only one new piece of furniture: the small circular table (1902.23). The remaining pieces shown at Moscow were the pair of cabinets (from Mackintosh's own collection) 1902.3, the white armchairs, 1902.2 (from Mrs Rowat's and Mackintosh's collections), the oval table, 1902.19 (from F. Wärndorfer, or a duplicate), and the hall chairs from Windyhill, 1901.31 (from W. Davidson, or duplicates).

Literature: *Mir Isskustva*, no 3, 1903, pp. 116–7; Howarth, p. xl, note 1, 168.

1902.23 ▽

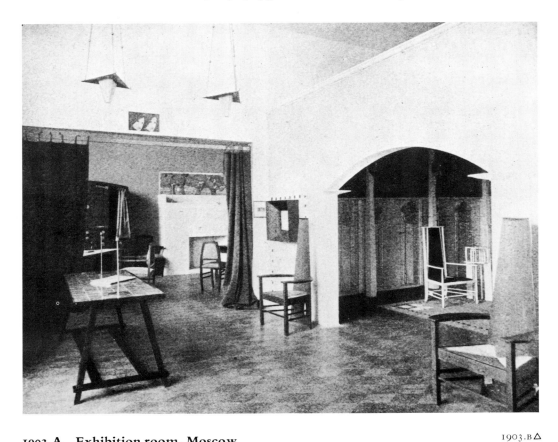

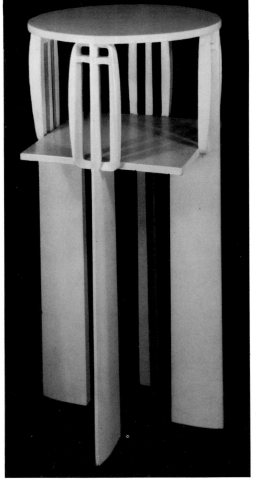

1903.B △

1903.A Exhibition room, Moscow
The cabinets (1902.3) and chairs (1902.2) correspond with the furniture designed for 14 Kingsborough Gardens. The oval table (1902.19) is identical with a table designed for Wärndorfer; the other table (1902.23) is the only new piece included in the show. Mackintosh has panelled the walls with stencilled hangings of women in pink and silver holding rose-balls, later used at the Willow Tea Rooms.

1903.B Exhibition room, Moscow
A view into Mackintosh's room from that of an adjacent exhibitor. The chairs either side of the entrance arch are from Windyhill (1901.31).

1902.23 Small circular table with square projecting shelf
Oak, painted white 81.5 × 38cm. diameter.

Literature: *Mir Isskustva*, no 3, 1903, p. *117*.
Exhibited: Moscow, 1903; Edinburgh, 1968 (224).
Provenance: Mackintosh Estate.
Collection: Glasgow University.

1903.1 Smoker's cabinet
Oak, stained dark, with beaten-copper panels by Margaret Macdonald 194.8 × 106 × 38.8cm.

A replica, for Mackintosh's own use, of the cabinet (1899.1) sold to Hugo Henneberg at the Vienna Secession exhibition.

Literature: Glasgow School of Art, *Furniture*, no 27; Billcliffe and Vergo, p. 740.
Exhibited: Memorial Exhibition, 1933 (not in catalogue); Edinburgh, 1968 (213, as smoker's cabinet for Windyhill and with incorrect provenance).
Provenance: C. R. Mackintosh; M. M. Mackintosh; Mrs Napier, 1933, by whom presented.
Collection: Glasgow School of Art.

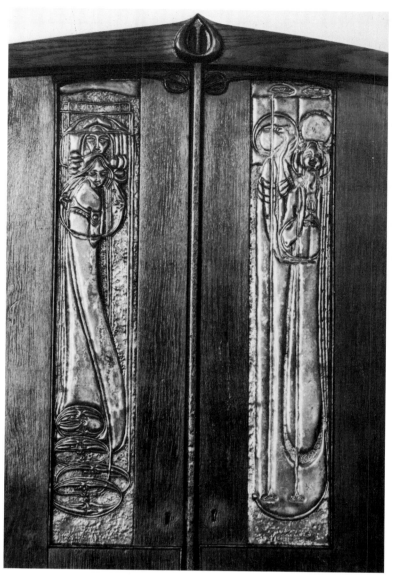

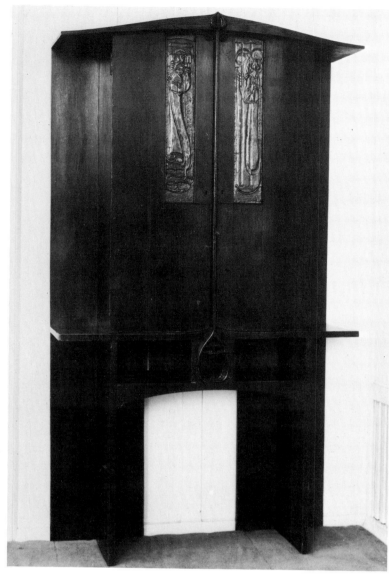

◁1903.1.details △

1903.1△

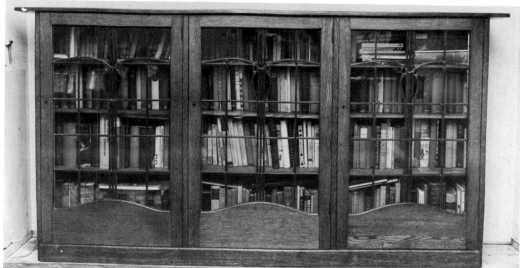

1903.2 Bookcase for Michael Diack

1903.2△

Oak, stained dark, with glazed doors 108 × 199 × 28cm.

A note in the account books of Honeyman, Keppie & Mackintosh shows that Diack paid £3.3.0d. in fees for a bookcase on 2 April, 1903. The bookcase is quite different from other work of this period, but Mackintosh probably intended it to match the cabinet (1900.82) and desk (1901.1) also designed for Diack.

It is possible that the entry in the accounts merely indicates that Diack was slow to pay for something he had received two years earlier, but there is no mention of fees for the cabinet or desk. By coincidence, on the same date Francis Smith belatedly paid his bill for

the design of the 1901 Exhibition Stand (1901.22).

Provenance: Michael Diack; by family descent.

Collection: Private collection.

D1903.3* Design for a wardrobe—full-sized detail

Approx. 38 × 84cm.

This drawing has not been available for photography and the author has not seen it. No medium is given in the Toronto catalogue, where the date is given as c1903.

Exhibited: Toronto, 1967 (78).
Collection: Dr Thomas Howarth.

★*See* addenda

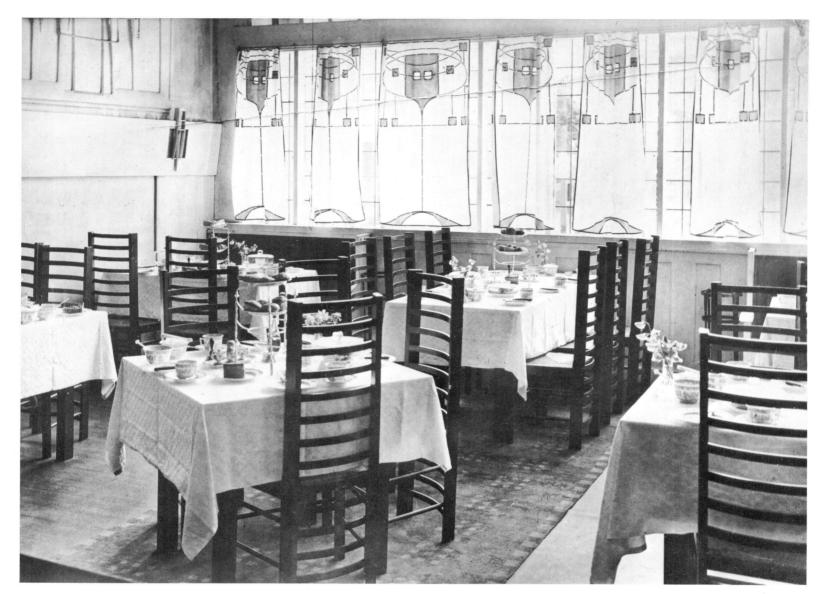

1903.C △

1903 The Willow Tea Rooms, Glasgow *

The most elegant of Miss Cranston's four Tea Rooms, the Willow Tea Rooms, in Sauchiehall Street opened in October 1904, but Mackintosh was at work designing it from the spring of 1903. Most of the furniture was designed from July to November, 1903, but some pieces were still being added in 1905. It was the last complete suite of rooms he designed for Miss Cranston, although additions and alterations at Ingram Street were carried out piecemeal until about 1912.

The site chosen for the Tea Rooms was in the heart of Glasgow's most fashionable street: 'Sauchiehall' means 'alley of willows', and the theme of young willows —both naturalistic and metaphorical—was used throughout the building. The Willow Tea Rooms were also notable as being the only ones where Mackintosh was able to design the exteriors as well as the interiors. The site had frontage only to the north and south, as it was enclosed between existing buildings. The entrance was in the north elevation which rose through four storeys; on the south side, Mackintosh extended his building beyond the line of its neighbours on the ground and mezzanine floors, but this elevation was never intended for public view.

The variety and arrangement of rooms was similar to those at the Argyle Street and Ingram Street Tea Rooms, though here there was a special dining-room, the Room de Luxe, which was at the heart of the building and was unique in Mackintosh's *oeuvre*. The entrance was at ground level in Sauchiehall Street, and visitors were channelled to the foot of the main staircase past a long white-painted panelled screen, with glass panels above, like that used at Ingram Street. At the end of this corridor was the central cash desk, and here customers had the choice of entering the front or rear saloons or ascending the staircase to the gallery and upper floors. The basement contained the cloakrooms and lavatories, and probably also the kitchens, although in 1917 Miss Cranston created another room here, the Dug-Out, and one cannot be certain where the kitchens were located after this date.

The Front Saloon

The main room on the ground floor at the front of the building was predominantly white. The panelled walls, screens, fireplace, ceiling and the plaster-relief frieze above the panelling were all painted white. The movable furniture contrasted with the white, being dark-stained oak; yet only the ladderbacked chairs were

1903.C Front Saloon, Willow Tea Rooms, Glasgow

This contemporary photograph shows the arrangement of chairs and tables, the fitted seating, and the embroidered window curtains in the Front Saloon.

Collection: Annan, Glasgow.

1903.D Front Saloon, Willow Tea Rooms, Glasgow

This photograph shows the umbrella stand (1903.10) and the screen at the entrance (1903.5).

Collection: Glasgow University.

1903.D ▷

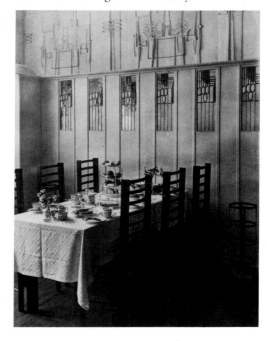

* See addenda

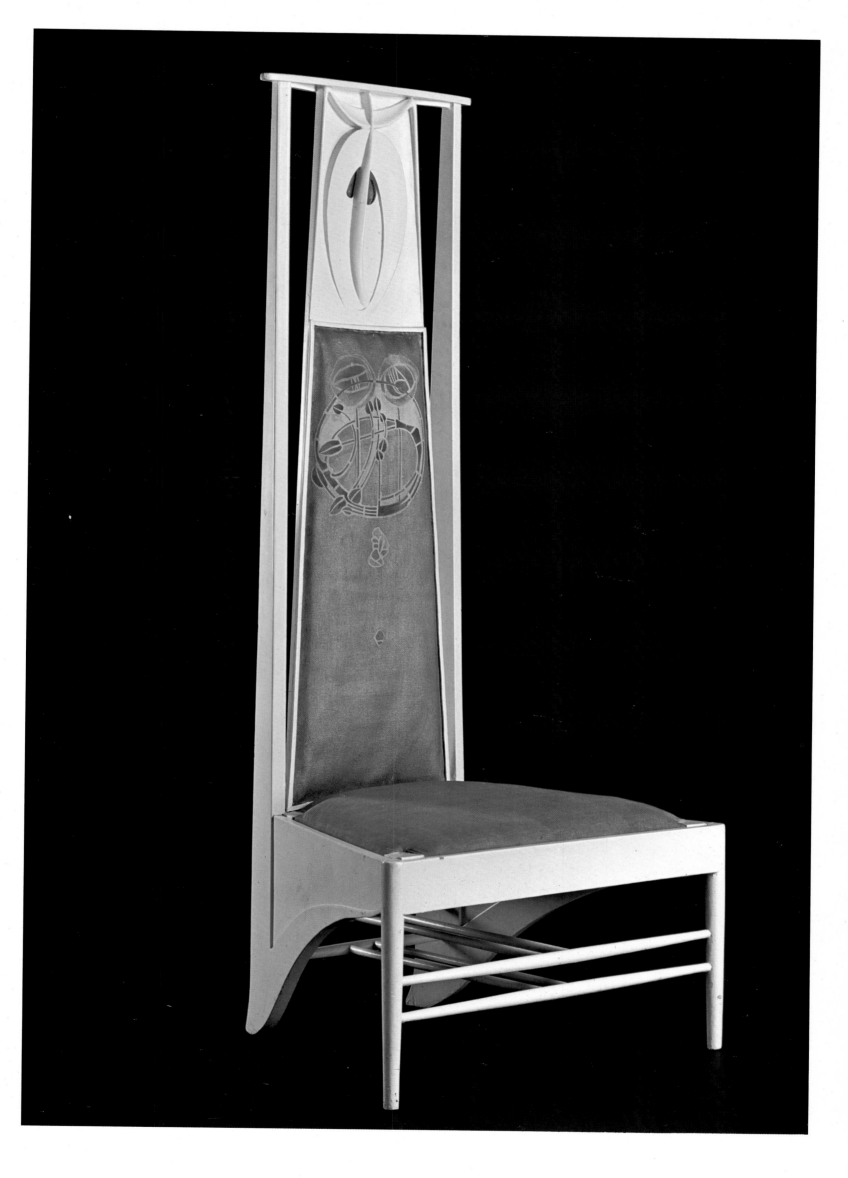

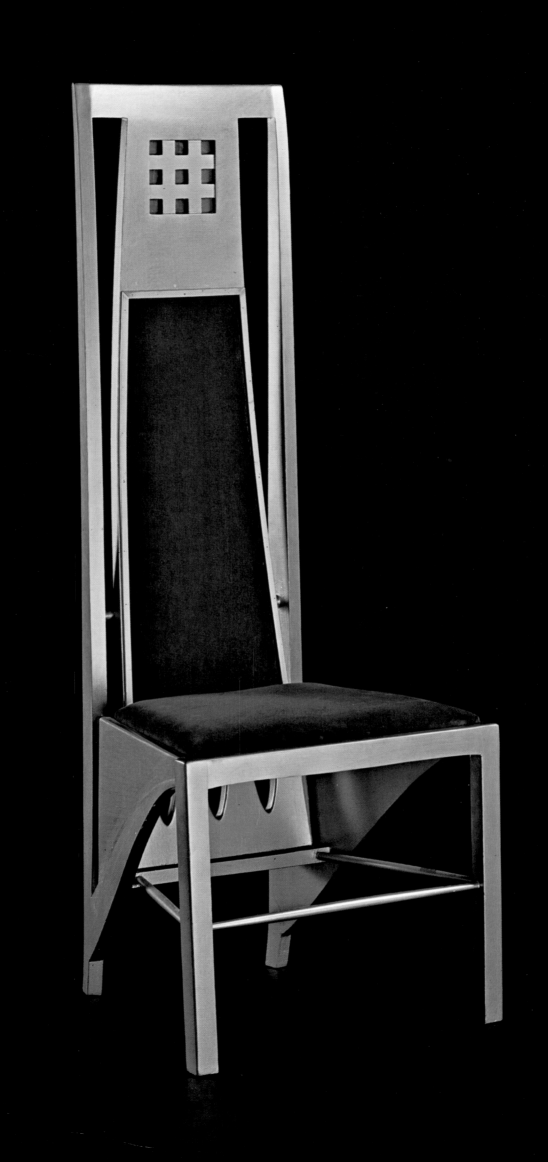

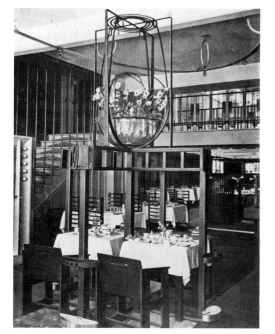

△1903.E

obvious, because the tables had white cloths which covered all but the bottom few inches of their legs, and the fitted seating—upholstered in velvet (probably purple or blue)—was also hidden by the tables. In the centre of the room, positioned between the fireplace and the entrance, was a formal construction of dark-stained timber, described by Howarth as a '*baldacchino*'. This supported a sculptural wrought-iron cage which contained a large glass bowl, about one metre in diameter, in which were suspended glass tubes for holding long-stemmed flowers. Encircling this was a broad, flat band of black-painted iron, suspended by hoops from the ceiling, to which were attached unshaded electric lamps. This play between rounded and angular shapes became a theme repeated throughout the building.

The ceiling of the front saloon was almost five and a half metres high, and between it and the wall-panelling Mackintosh introduced a series of low-relief panels in plaster as a frieze. The motif is based on willow trees, with their tendril-like branches and pointed leaves; Mackintosh turned it into a stylised pattern whose sources are obvious to the initiated, but which at first acquaintance looks like a totally abstract sculpture, nearly two metres high and just over nine metres long.

The Back Saloon
Projecting beyond the line of the upper storeys, Mackintosh built a hipped roof extension which housed two tea rooms, the Back Saloon and the Gallery. The

1903.E Front Saloon, Willow Tea Rooms, Glasgow
This photograph shows the *baldacchino* in the centre of the room (1903.6); behind it is the staircase to the upper floors. To the right of the *baldacchino* one can see into the Back Saloon; and above the entrance to this is the glazed screen separating the Gallery from the Front Saloon.

1903.F The Back Saloon, Willow Tea Rooms, Glasgow
Collection: Glasgow University.

1903.G Wall-hanging in the Back Saloon, Willow Tea Rooms, Glasgow
A detail of the Back Saloon showing the table arrangements and four of the stencilled canvas hangings which were fixed against the panelling of the room; one of these survives (collection: Glasgow University).

Collection: Glasgow University.

1903.H Gallery at the Willow Tea Rooms, Glasgow

This photograph shows the balustrade around the open well, looking down into the Back Saloon. The ceiling is supported on a series of tapering posts, some of which are themselves supported by beams across the light well.

Collection: Glasgow University.

1903.I The Gallery, Willow Tea Rooms, Glasgow
A view of the south-east corner.

Collection: Annan, Glasgow.

1903.F▽

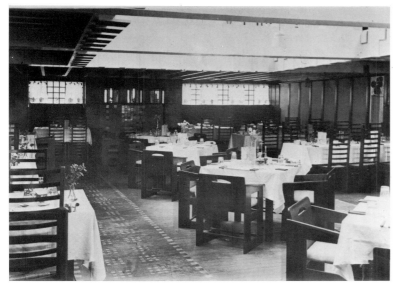

1903.G▽

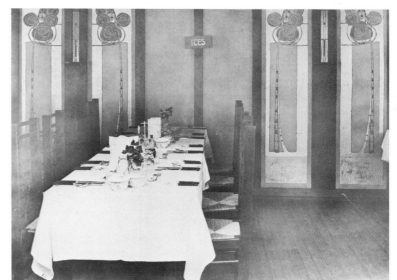

▽1903.H

1903.I▽

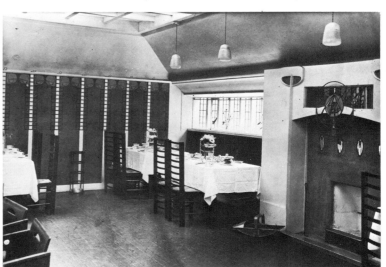

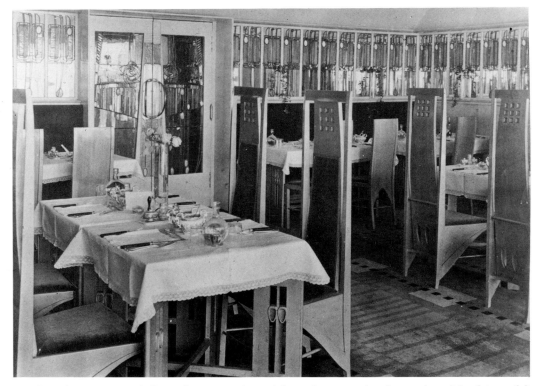

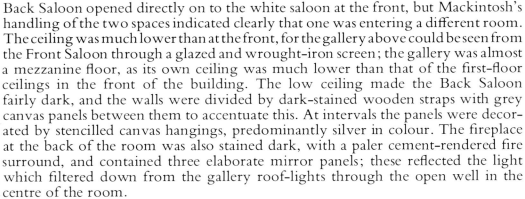

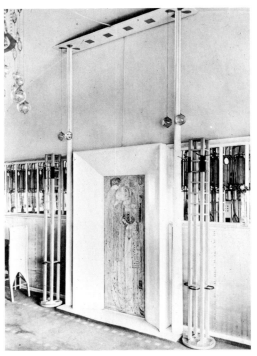

Back Saloon opened directly on to the white saloon at the front, but Mackintosh's handling of the two spaces indicated clearly that one was entering a different room. The ceiling was much lower than at the front, for the gallery above could be seen from the Front Saloon through a glazed and wrought-iron screen; the gallery was almost a mezzanine floor, as its own ceiling was much lower than that of the first-floor ceilings in the front of the building. The low ceiling made the Back Saloon fairly dark, and the walls were divided by dark-stained wooden straps with grey canvas panels between them to accentuate this. At intervals the panels were decorated by stencilled canvas hangings, predominantly silver in colour. The fireplace at the back of the room was also stained dark, with a paler cement-rendered fire surround, and contained three elaborate mirror panels; these reflected the light which filtered down from the gallery roof-lights through the open well in the centre of the room.

The furniture was also arranged to reflect the architecture: the semi-circular order desk chair sat at the junction of the front and rear saloons, its curve against the *baldacchino* in the white room. Down either side of the rear saloon the tables were placed at 90° to the walls with six dark-stained ladderback chairs at each table, ranged in two rows of three. In the centre of the room, in the gallery well and running between the fireplace and the order desk, the tables were placed at 45° to the walls with four armchairs at each table. Even the carpet emphasised this regularity: it was plain beneath the tables, but in the aisles had a chequer-work pattern.

The main staircase, rising from the cash desk in the Front Saloon, had an open balustrade looking out over the tables beneath. The risers of the staircase were stencilled with black-and-white checks in a pyramidal shape. The balustrade was formed by steel rods, about two centimetres in diameter, one rising from each tread and terminating in a rail at ceiling height. Between each rod, at the top, was fixed a panel of wrought-iron, bent into an abstract pattern, from which hung green glass balls on stout wires. From the first landing one entered the Gallery Tea Room.

The Gallery
This was situated over the Back Saloon, and the tables were grouped around three sides of the well, which gave views down into the Saloon. On the fourth side, the north, was a corridor with a glazed and wrought-iron screen at low level which looked out over the Front Saloon. The ceiling was composed of exposed beams, creating an egg-crate effect, and was supported by eight tapering columns, circular at their base but becoming square about two feet from the top. The columns were arranged in two rows of four, dividing the room into three parts; the four central columns sprang from the two heavy beams which crossed the light well. The ceiling above this well was solid, but the two aisles had open ceilings which admit light from the glazed panels in the roof. The woodwork was all painted white, including the ceiling: the fireplace, again in the south wall, was also painted white. The furniture, of the same pattern as in the ground floor saloons, was stained dark. The walls were also dark, with strips of white paint creating an effect of panelling, around which was stencilled a black trellis pattern, surmounted by two stylised roses.

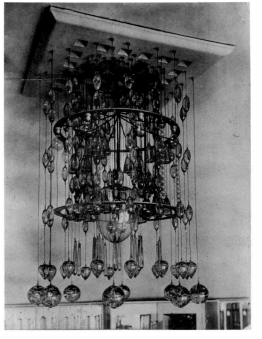

1903.J The Room de Luxe, Willow Tea Rooms, Glasgow
The tables and the patterned carpet have disappeared, but examples of both types of chair exist (1903.20 and 23).

Collection: Glasgow University.

1903.K Gesso panel, Room de Luxe, Willow Tea Rooms, Glasgow
The gesso panel was made by Margaret Macdonald; it still survives in its frame *in situ*, although the glass balls have disappeared.

Collection: Annan, Glasgow.

1903.L Crystal chandelier, Room de Luxe, Willow Tea Rooms, Glasgow
The most elaborate chandelier designed by Mackintosh; light came from a series of lamps either attached to the upper circular rail, or pendant. Sadly, it has not survived.

Collection: Glasgow University.

1903.M Billiards Room, Willow Tea Rooms, Glasgow

Collection: Glasgow University.

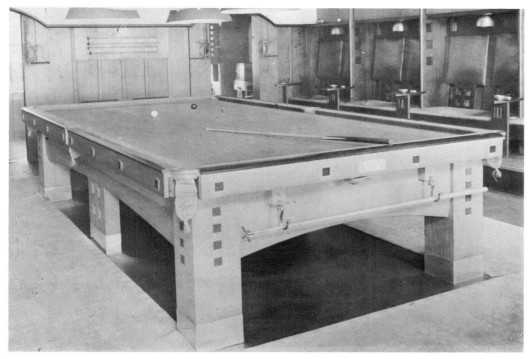

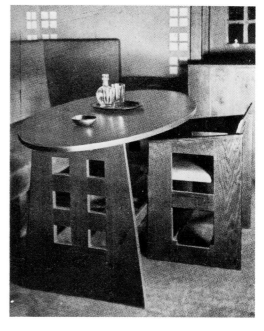

◁1903.M 1903.N△

1903.N Smoking Room, Willow Tea Rooms, Glasgow

This contemporary photograph shows the table (1903.39) and chair (1903.14) designed for the Smoking Room.

Collection: Glasgow University.

1903.4 Cash desk for the Willow Tea Rooms, Glasgow

Wood, painted white.

The cash desk was situated at the foot of the stairs and at the entrance to the ground floor saloons. Accordingly, all the patrons of the Tea Rooms had to pass it on their way out. As at the Ingram Street Tea Rooms in 1900, Mackintosh provided the cashier with a lattice-work wall at 90° to the cash tray to give a view of the entrance hall. The desk is almost free-standing, with its back to the column at the foot of the stairs. Its shape is rectangular, and the main elevation is like a huge Mackintosh picture-frame, very similar to the frames

▽1903.4

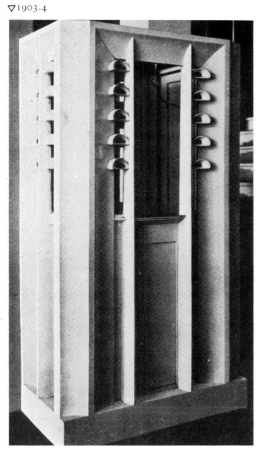

The Room de Luxe

On the first floor, overlooking Sauchiehall Street, was situated the most important of the rooms—the Room de Luxe, or Ladies' Room. It is one of the most precious interiors which Mackintosh ever designed, and if Margaret had a hand in any of his designs then it was surely this. The north wall was made wholly of a window, with panels of mirror-glass in the leaded panes. Leaded mirror-glass panels form a frieze above stretched-silk panelling on the other three walls, each wall broken at its centre by doors, a fireplace, or a gesso panel. Fitted seating against the wall was upholstered in purple and the loose chairs were painted silver, those at the centre tables having high backs with nine insets of purple glass. The double doors contain leaded-glass panels, the most elaborate Mackintosh ever designed, but the gesso panel is by Margaret and based on D. G. Rossetti's sonnet, 'O ye, all ye that walk in Willowwood'. The ceiling is barrel-vaulted; in the centre hung a crystal chandelier with balls, ovals and tear-drops of solid glass reflecting the light from the electric lamps in their midst. Here the ladies gathered for coffee, luncheon and afternoon tea in a haven of silver and purple dominated by the melancholy gesso panel and the glittering chandelier.

The Upper Floors

Howarth's description of the Willow Tea Rooms (pp. 139–141) suggests that the second floor was originally a tea room, as it was in the 1940s, with a billiards room above. Some of the drawings for furniture, however, indicate that there was a smoking room: a corner of such a room was illustrated in *Dekorative Kunst*, 1905. The smoking room could simply have been an annexe at the back of the billiards room, perhaps that seen through the open doorway in 1903.M, which bore the caption Smoking and Billiards Room. No photographs exist of Howarth's second-floor room, however, nor is it mentioned in the *Dekorative Kunst* article. There do not seem to have been enough tables ordered from the suppliers to furnish such a room and, although only about 30 of the 50 armchairs ordered from Alex Martin appear in the contemporary photographs, some of the remaining chairs could have been used in the small rear room on the first floor and in the Smoking Room. Perhaps Howarth was misled by his informants, as the top floor of the Willow Tea Rooms as it existed in 1977 appeared to have had no alterations made to it at all (other than those of fenestration to match the rest of the façade). There was no trace of any typical Mackintosh details, indeed, the panelling around the windows was based on traditional mouldings. There seems to have been little reason for Daly's (who purchased the premises from the Kensington Restaurant *c*1927) to have replaced the kind of window details from the Smoking Room (assuming it was on the top floor) with such traditional work, especially as they made no other alterations of that kind in the building. The top floor might have been used as offices for Miss Cranston and her staff and the details there, to save money, were possibly more traditional and installed at the discretion of the con-tractor rather than under Mackintosh's direct control. The Billiards Room and the Smoking Room were therefore, probably on the second floor. This view is supported by the illustration of the Smoking Room fireplace in *Dekorative Kunst*; the almost identical fireplace from the Billiards Room on the same floor is now in the collection of the Victoria & Albert Museum.

There is yet another room at the Willow Tea Rooms which cannot be explained satisfactorily: at second-floor level in the adjacent property, to the east, is a room

surrounding the fireplace and gesso panel in the Room de Luxe. This broad frame has a concave curve, and the central area—the 'picture'—is split by two slat-like uprights which narrow the access to the cashier; between these slats and the frames are fixed ten decorative carvings, scooped out and pierced to resemble stylised 'eyes' from peacock feathers.

Literature: *Dekorative Kunst*, XIII, 1905, pp. *260, 262*; Howarth, plate 54a.
Collection: untraced, probably destroyed.

1903.5 Screen in the Front Saloon, Willow Tea Rooms, Glasgow
Wood, painted white, and leaded-glass.

This screen separated the entrance door from the diners in the Front Saloon and directed customers to the staircase and the entrance to the saloons at the cash desk (*see* 1903.D). It was about two metres high and, like the screen designed for Ingram Street (1900.66), it consisted of a series of upright wooden panels joined by cover strips, with the upper sections of alternate boards replaced by a leaded-glass panel. Glasgow University acquired these glass panels, some still in their original wooden frameworks, some loose. There were more glass panels than could have been used in a screen in this position, and others may have been used in the basement. The University acquired at the same time, and from the same source, similar wood and glass panels also said to have been used at the Willow Tea Rooms. The leaded patterns of these panels, however, are totally geometrical with none of the organic references of the entrance screen panels; they do not appear in any contemporary photographs and there is no obvious place for them in any of the upper rooms. It is the author's opinion that these were used as a form of screen in the 1917 addition to the basement of the premises (Glasgow University).

Literature: *Dekorative Kunst*, XIII, 1905, p *263*.
Provenance: private collection; Morrison McChlery, Glasgow.
Collection: Glasgow University (glass only).

1903.6 *Baldacchino* for the Front Saloon, Willow Tea Rooms, Glasgow
Wood, stained dark, surmounted by a metal framework holding a glass vessel.

In the centre of the Front Saloon was a table for four, divided and enclosed by a strange structure, aptly described by Howarth as a '*baldacchino*' (*see* 1903.E). This structure consists of five square posts in the shape of a cross, linked by other square spars, with four carved wooden panels, one on each of the four outer uprights. These panels bear an organic motif, probably signifying the willow leaf, while the whole central unit was possibly intended to symbolise a group of willow trees. On each of the outer posts is fixed an umbrella rack and the framework above carries a wrought-iron construction which encloses a large glass vessel in the shape of a giant bowl. Fitted into this bowl, which was filled with water, were a series of test-tube like flower holders, each containing a single flower. This is not a functional design—it has no purpose other than decoration — but a spectacular centrepiece which should be considered as much a piece of sculpture as a piece of furniture.

Literature: *Dekorative Kunst*, XIII, 1905, pp. *260, 266*; Howarth, p. 140, plates 54a, 56a.
Collection: untraced, probably destroyed.

1903.7 Dining tables for the Willow Tea Rooms, Glasgow
Francis Smith quoted £27.13.6d. for 34 (30 July 1903); payment was included in the gross sum of £323.18.2d. (28 January, 1904).

No details are given of sizes or locations for these tables, but it seems likely from the number specified that they included only the simple and rather plain tables for the two Saloons and the Gallery. Like the tables at Argyle Street and Ingram Street, they had no decoration on them as they were designed to be largely hidden by table cloths.

Literature: *Dekorative Kunst*, XIII, 1905, pp. *260–61, 263–68*; Howarth, plates 54a and b, 56a.
Collection: untraced.

1903.8 Ladderback chair for the Willow Tea Rooms, Glasgow
Ebonised oak 104.8 × 45.5 × 41.2cm.
Alex Martin quoted 16.6d. (no quantity specified, 12 August, 1903), and was paid for 137 at 17.6d. each (1 December, 1903).

Mackintosh's succinct rationalisation of the traditional ladderback design. He had produced earlier ladderbacks (*see* 1893.8 and 1901.52), and developed the idea further in

1903.8 ▽

panelled in a typical Mackintosh style. It also has a fireplace almost identical with the Billiards Room fireplace, although its tiles are patterned rather than plain, and the windows are covered by an internal screen made up of leaded-glass in a pattern similar to that used in the Room de Luxe and the second-floor windows. It does not seem likely that Miss Cranston was able to break through the party wall in 1903 to acquire this room, nor is there any record of it being done by her at any other time. The only possible explanations I can put forward are that either the alteration was made in c1905 when the Honeyman & Keppie job-books show that Mackintosh was designing more furniture for the Willow Tea Rooms, or alternatively, that it was made c1917, when he designed the Dug-Out in the basement. This seems to have been a substantial alteration of the basement premises (*q.v.*), and possibly involved the re-location of the kitchens. Although they are not mentioned in contemporary accounts, circumstantial evidence suggests that they were originally situated in the basement—there was no other large enough space for them, other than the top floor—and 'Cranstonian' legend has it that meals were ordered in the ground-floor saloons by coded messages from the Order Desk which sat in the middle of the ground floor; apparently each meal or item was identified by the supervisor by a coloured glass ball or token which was dropped down a tube to the kitchens below. Whether or not this story is apocryphal—and there are such tokens in existence which support it—the idea would have been typical of Miss Cranston and would explain the isolation of the Order Desk in the middle of the two saloons. At all events, in 1917 any basement kitchens, which shared their premises with the cloakrooms, would have had to be moved to accommodate the new rooms; unless, that is, the new rooms in the basement were situated in the adjoining shop to the east. New lavatories seem to have been provided at this time, and although there have been many alterations to the position of walls in the intervening years, it does seem possible that these lavatories were entered from the eastern basement and not from the basement directly under the original Willow building. If that is what happened, Mackintosh might also have decorated the second-floor room in the same building if Miss Cranston had been able to acquire it at the same time.

An alternative solution to the problem is that Mackintosh had nothing to do with the new room on the second floor. It is possible that it was created by the Kensington Restaurant (which acquired the premises in the 1920s) out of panelling and glass removed from other rooms in the Willow Tea Rooms, particularly those on the second floor. This would explain the use of the patterned tiles in the fireplace as, if the fireplace is indeed the original fitting from the Smoking Room, the tiles would probably have had to be renewed. It is not even impossible that the Kensington created the fittings to harmonise with the existing Mackintosh features, as they took good care of his design, unlike their successors, Daly's.

Literature: *Dekorative Kunst*, XIII, 1905, pp. 257–75; Howarth, pp. 136–145, plates 53–57.

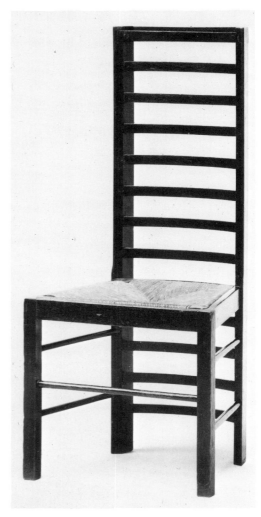

1919 (see 1919.4), but these chairs for the Willow Tea Rooms are the most successful solution of his attempts to use traditional, vernacular designs. The chair looks strong yet simple, with rear uprights and front legs of rectangular and square section. The uprights are set slightly splayed and the rungs, which are again rectangular in section, are curved along their length and set into the leading edge of the uprights. The seats were originally rush.

The chair was not, however, as sturdy in use as it appeared, and at an apparently early date all the surviving examples have had an additional cross-piece fixed to the top of the uprights, behind the ladder, to hold the uprights in position. This addition has been slavishly copied in the reproductions of the chair produced by Messrs Cassina of Milan.

Literature: *Dekorative Kunst*, XIII, 1905, pp. *260–61, 264–68*; Howarth, plates 54a, 55a and b, 56a; Macleod, plates 75, 76; Glasgow School of Art, *Furniture*, no 8; Alison, pp. 62, 63, 103.
Exhibited: Paris, 1960 (1092).
Provenance: several examples are known to the author, and others are frequently discovered in the Glasgow area. The chairs were either sold at auction in the 1920s or were acquired by the Grosvenor Restaurant.
Collection: Glasgow School of Art (2); W. McLean, 1976 (6); Dr Thomas Howarth (2).

1903.9 Fitted seats for the Front Saloon, Willow Tea Rooms, Glasgow

Francis Smith quoted (no price given, 27 September, 1903); payment was included in the gross sum of £323.18.2d. (28 January, 1904).

Fitted beneath the front window, these bench seats were probably upholstered in velvet, of which Wylie & Lochhead, Glasgow, supplied 68¾ yards (62.8 metres) for the contract. (*See* 1903.C).

Literature: *Dekorative Kunst*, XIII, 1905, p. *261*; Howarth, plate 56a.
Collection: untraced, probably destroyed.

1903.10 Umbrella stand for the Willow Tea Rooms, Glasgow

(?) Metal, painted black.
Andrew Hutchinson quoted 12/6d. each (no quantity specified, September, 1903); payment was included in the gross sum of £106.3.9d. (23 March, 1904).

These very simple stands were used mainly in the ground-floor saloons and the gallery. (*See* 1903.D).

▽1903.11

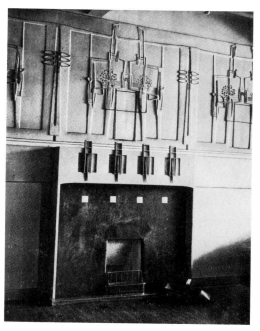

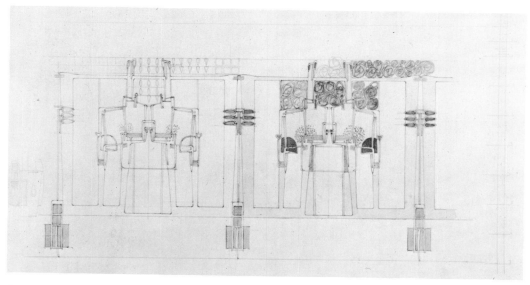

△D1903.12

Literature: *Dekorative Kunst*, XIII, 1905, p. *263*; Macleod, plate 75.
Collection: untraced.

1903.11 Fireplace for the Front Saloon, Willow Tea Rooms, Glasgow

Wood, painted white.

A simple wooden framework around a plain cement fire-surround which has four square tiles inset; the grate is a commercial model supplied by Caird Parker as were the other grates in the ground floor and Gallery. The upper part of the wooden structure was about 35cm. high and flat, but broken by four carved motifs which echo the motifs of the Smoking Room fireplace and the wall panelling in the Ladies' Rest Room adjacent to the Room de Luxe; they were also repeated in the Front Saloon beneath the plaster relief panels.

Literature: *Dekorative Kunst*, XIII, 1905, pp. *266, 273*; Howarth, plate 56a.
Collection: untraced, probably destroyed.

D1903.12 Design for a decorative relief frieze at the Willow Tea Rooms, Glasgow

Pencil and watercolour 24.2 × 45.1cm. (irregular).
Inscribed, verso, by T. Howarth, *Plaster frieze, Willow Tea Room / TH*.
Scale, 1:12.

A scale drawing for the series of plaster reliefs which formed a frieze along the east and west walls of the Front Saloon. The drawing is virtually as executed, except that the colours and the stylised roses were omitted from the finished panels; the carved motifs in the wooden panelling are included in the drawing (*see also* 1903.11).

These panels are one of Mackintosh's most imaginative designs. Their starting point is the willow tree, but the design develops into an abstract pattern in high-relief, the organic origins of which can still be discerned, though they are more easily overlooked as one becomes conscious of the intricate patterns of lines in space. Some of the motifs are repeated in the wrought-ironwork of the staircase balusters and, as Pevsner and Howarth have pointed out, the designs of both presage the paintings, sculpture and constructions of Moholy-Nagy, Picasso, Mondrian, Kandinsky, or Nicholson.

It is easy to see how Mackintosh might have ruined the final effect of the panel by a fussiness roses: this almost certainly shows evidence of Margaret's influence, with here tendency to apply pattern and decoration to every square inch of her work, thus obscuring the structure of her designs. Mackintosh finally decided against such surface distractions, and the reliefs were left unpainted. That they were one of his favourite designs is shown by his inclusion

of one panel on the staircase of his house at Southpark Avenue in 1906.

Several panels survive *in situ*, as well as one at Glasgow University, and casts have been made by Glasgow School of Art.

Exhibited: Edinburgh, 1968 (160).
Provenance: Mackintosh Estate.
Collection: Glasgow University.

1903.13 Stool for the Willow Tea Rooms, Glasgow

Ebonised oak 63.5 × 45.6 × 45.2cm.
Alex Martin was paid for three stools at 11.6d. each (1 December, 1903), and for a further one at 11.6d. (24, December).

No items appear in any of the contemporary photographs which can be identified with these stools. But the author believes that the two chairs at Glasgow School of Art known as 'waitress chairs' are, in fact, the stools made by Alex Martin. The provenance suggests that these come from the Willow Tea Rooms, since the Grosvenor Restaurant owned other Willow furniture (*see* 1904.23, 24). The compactness of the design is reflected in the chairs designed for the Hous'hill bedrooms in 1904; it also anticipates the table designed for the drawing-room at The Hill House, five years later (*see* 1908.1).

Literature: Glasgow School of Art, *Furniture*, no 4; Alison, pp. 68, 69.
Provenance: The Grosvenor Restaurant, Glasgow, from which purchased.
Collection: Glasgow School of Art (2).

1903.13▽

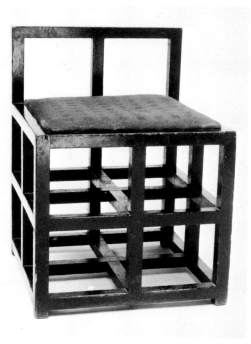

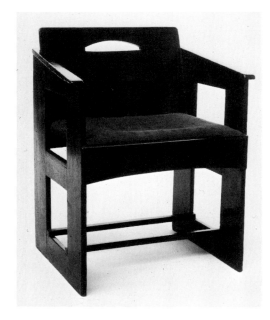

1903.14 Armchair for the Willow Tea Rooms, Glasgow

Ebonised oak 72.8 × 55.3 × 45.4cm.
Alex Martin quoted for 50 armchairs at 18.6d. (23 September, 1903) and was paid the same (1 December).

A very sturdy, but not particularly comfortable chair, used in the ground-floor saloons, the Gallery and the Smoking Room. The chair is basically three square pieces of timber—two sides and a back, the sides each having two square holes and the back a segmental hole (a hand-hold to assist in moving the chairs around). Their boxy shape contrasts with the taller and more open ladderbacks arranged alongside them in the layout of furniture which Mackintosh devised.

Literature: *Dekorative Kunst*, XIII, 1905, pp. *260, 262, 265–66, 285*; Howarth, plates 54, 55a and b, 56a; Macleod, plates 75, 76.
Collection: Several examples survive, including Sotheby's Belgravia, 3 April, 1974 (4); Benno Schotz (2).

D1903.15 Design for chairs and tables for the Back Saloon, Willow Tea Rooms, Glasgow

Pencil and watercolour 34.9 × 48.8cm.
Inscribed, upper left, *MISS CRANSTONS / SAUCHIEHALL ST / DRAWING OF / CHAIRS FOR / BACK SALOON*, and, right, *leather seat or rush*.
Scale, 1 : 12.

The design for 1903.14, but a number of changes were made in the piece as executed: the sides are upright, not splayed, and have a square hole above and below the seat and not a single curved aperture as shown here; the front apron has a less pronounced curve and the

bottom of the back panel is square, not curved; two stretchers to brace the sides have been introduced.

Literature: Alison, p. 80, no 32, p. *104*.
Exhibited: Milan, 1973 (32).
Provenance: Mackintosh Estate.
Collection: Glasgow University.

◁1903.14 1903.17▽

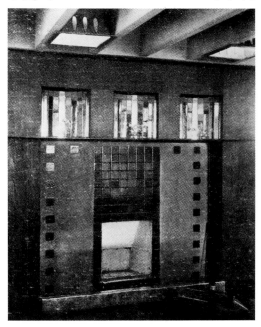

1903.16 Fitted seating for the Back Saloon, Willow Tea Rooms, Glasgow

Francis Smith quoted (no price given, 27 September, 1903); payment was included in the gross sum of £323.18.2d. (28 January, 1904).

The seating was arranged on either side of the fireplace and upholstered in velvet (*see* 1903.F).

Literature: *Dekorative Kunst*, XIII, 1905, p. *265*; Howarth, plate 55b.
Collection: *in situ*, but badly damaged.

1903.17 Fireplace for the Back Saloon, Willow Tea Rooms, Glasgow

Wood, stained dark, with inlaid glass panels. McCulloch quoted £4.10.0d. (2 September, 1903); payment was included in the gross sum of £180.18.3d. (21 January, 1904).

Like the fireplace in the Front Saloon, a simple wooden frame, stained dark in this instance, encloses a cement surround inset with ceramic tiles. Instead of carved decoration at the top, Mackintosh has introduced a series of niches inlaid with glass, mainly squares of mirror-glass which give a fragmented reflection of the room.

Literature: *Dekorative Kunst*, XIII, 1905, pp. *264–65*; Howarth, plate 55b.
Collection: *in situ*, 1977, but with some alterations.

1903.19▽

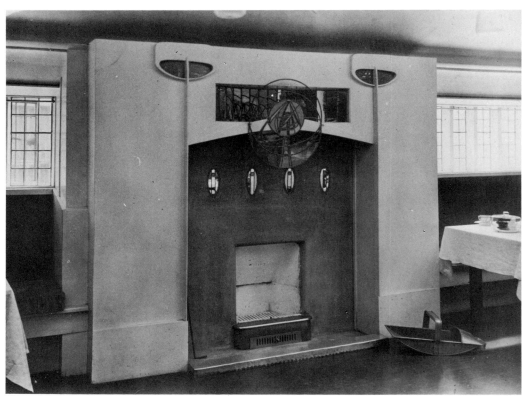

1903.18 Fitted seating for the Gallery, Willow Tea Rooms, Glasgow

Francis Smith quoted (no price given, 27 September, 1903); payment was included in the gross sum of £323.18.2d. (28 January, 1904).

Similar to the seating in the ground-floor saloons (1903.9 and 16); situated on either side of the fireplace. (*See* 1903.I).

Literature: *Dekorative Kunst*, XIII, 1905, p. *268*; Macleod, plate 75 (wrongly captioned as *ground floor*).
Collection: *in situ*, but badly damaged.

1903.19 Fireplace for the Gallery, Willow Tea Rooms, Glasgow

Wood, inlaid with glass panels.

▽D1903.15

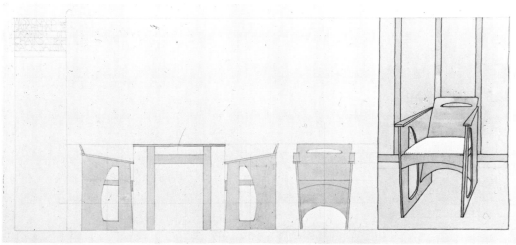

Here the timber fireplace is finished flush with the chimney-breast, the only projections being the two stylised tree uprights and the raised curve over the fire-surround. The latter was again a dark cement render with four oval panels of glass set into the cement, and a simple Caird Parker grate. Above the curved canopy was another panel of faceted mirror-glass, similar to that on the Room de Luxe fireplace, which is now lost; this panel was exhibited at the Memorial Exhibition in Glasgow in 1933 (9).

Literature: *Dekorative Kunst*, XIII, 1905, p. 268; Macleod, plate 75 (wrongly captioned as *ground floor*).
Collection: *in situ*, 1977, but with some alterations and without the leaded-glass panel.

1903.20 Chair with high back and coloured glass insets for the Room de Luxe, Willow Tea Rooms, Glasgow

Oak, painted silver, with nine coloured-glass insets, and upholstered in velvet 135 × 49.2 × 48cm.
Francis Smith quoted for eight at £2.16.0d. each (20 August, 1903); payment was included in the gross sum of £323.18.2d. (28 January, 1904).

One of the most famous of Mackintosh's chairs, this design was known only from photographs until the discovery of two surviving examples in 1971. This and other pieces for the Room de Luxe are the only furniture to have been painted in a colour other than white or black. The rear panel, which contains nine small square insets of purple glass, swells out towards the back in a concave curve, projecting beyond the line of the two uprights, and is fastened at the bottom to a stretcher. The front of the seat is wider than the back, and the side panels below

▽1903.20

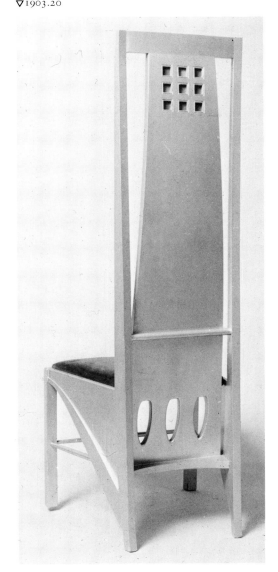

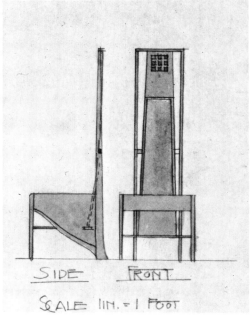

△D1903.21

it are cut diagonally by a double ogee curve. The seat and back are upholstered in a purple velvet also used on the smaller chair and the fitted seating in the Room de Luxe.

Literature: *Dekorative Kunst*, XIII, 1905, pp. 268–69; Howarth, plate 57a; Alison, pp. 64, 65, 100, 103 (inaccurate reconstruction from photographs and drawing).
Exhibited: Sheffield, Mappin Art Gallery, 'Burne-Jones', 1971 (228).
Provenance: a) and b) bought at auction in Glasgow by A. Sutherland c1926; from whom purchased 1973.
Collection: a) Graves Art Gallery, Sheffield; b) Glasgow University.

D1903.21 Design for chair with high back for Room de Luxe, Willow Tea Rooms, Glasgow

Pencil and watercolour on tracing paper 19 × 14cm. (sight).
Inscribed, below, *SIDE FRONT | SCALE 1 IN = 1 FOOT*.
Scale, 1:12.

Design for 1903.20, virtually as executed.

Exhibited: Toronto, 1967 (83).
Collection: Dr Thomas Howarth.

D1903.22 Design for tables and chair with high back for the Room de Luxe, Willow Tea Rooms, Glasgow

Pencil and watercolour 32.8 × 51.4cm.
Inscribed, upper left, *MISS CRANSTONS | SAUCHIEHALL ST | DRAWING OF | CHAIRS FOR | CENTRAL TABLE | LADIES ROOM*; and, bottom, *2' 5" square | × 2' 5" high | 4 like this | 3–3' 6" circular | Greenock Cabinet Co.*, and, right, *Leather seat & back*.
Scale, 1:12.

Virtually as executed.

Literature: Alison, pp. 64, 79–80, no 31.
Exhibited: Edinburgh, 1968 (161, plate 25); Milan, 1973 (31).
Provenance: Mackintosh Estate.
Collection: Glasgow University.

1903.23 Chair for the Room de Luxe, Willow Tea Rooms, Glasgow

Oak, painted silver, upholstered in velvet 103 × 54 × 44cm.
Francis Smith quoted for 34 chairs at £2.15.0d. each (20 August, 1903); payment was included

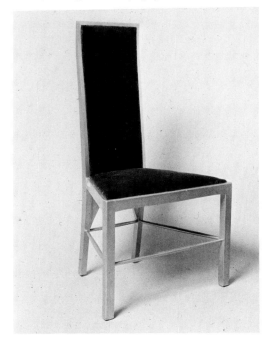

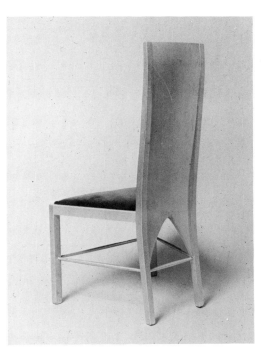

▽D1903.22 1903.23△

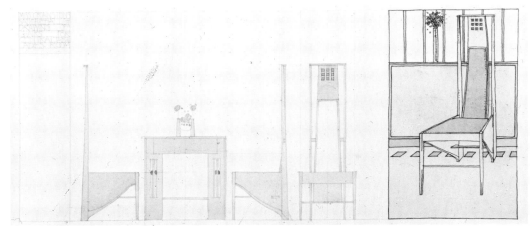

in the gross sum of £323.18.2d. (28 January, 1904).

Used in conjunction with the high-backed chair, 1903.20. Apart from its height, this chairs differs mainly in the design of the back, which is solid and attached to the uprights and describes an ogee curve. Five examples survive (1977).

Literature: *Dekorative Kunst*, XIII, 1905, pp. *269*, *271*; Howarth, plates 56c, 57a; Pevsner, 1968, plate 39; McLaren Young, plate 27; Alison, p. *100*.
Provenance: a), b) and c) bought at auction in Glasgow by A. Sutherland, *c*1926, from whom purchased, 1973.
Collection: a) Glasgow University (1); b) Victoria & Albert Museum, London (2); c) National Museum of Antiquities of Scotland, Edinburgh (2).

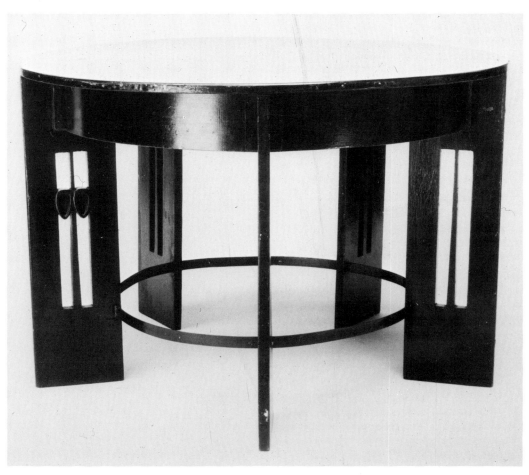

D1903.24▽

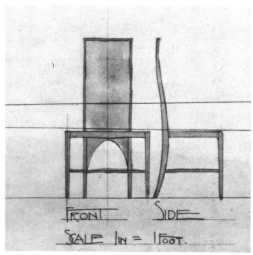

D1903.24 Design for a chair for the Room de Luxe, Willow Tea Rooms, Glasgow
Pencil and watercolour on tracing paper 14 × 14cm. (sight).
Inscribed, below, *FRONT SIDE / SCALE 1 IN = 1 FOOT*.

Design for 1903.23, virtually as executed.

Exhibited: Toronto, 1967 (83).
Collection: Dr Thomas Howarth.

1903.25 Square table for the Room de Luxe, Willow Tea Rooms, Glasgow
(?) Oak, painted silver, with coloured glass insets.
Maker and price unknown.

Used with the chairs 1903.20 and 23. Probably the only dining tables designed for any of the tea rooms to have any form of decoration. Surviving photographs show that four tables were used with the eight high-backed chairs in two groups of two. The legs of these four were on the diagonal, with crossed stretchers at the bottom; the tablecloths were left deliberately short in order to show the decoration on the legs.

The othe tables in the room, which were rectangular and used with the lower chairs and the fitted seating, had legs of the same width, but positioned along the short sides of the table forming an almost solid gable. No example of either design has been traced (*see* 1903.J).

Literature: *Dekorative Kunst*, XIII, 1905, p. *269*; Howarth, plate 57a; Alison, p. *100*.
Collection: untraced.

D1903.26 Circular table with five legs for the Room de Luxe, Willow Tea Rooms, Glasgow
Pine, originally painted silver 73.3 × 105.3cm. diameter.

The legs on this circular table are identical with those on the other tables for the Room de Luxe

(1903.25), which are all square or oblong. On a photograph taken in the Room de Luxe of the high-backed chair (1903.20) at Glasgow University, however, the edge of a round table, also painted silver, is visible. I believe this table is the same as the Glasgow School of Art example, and suggest that it was probably used in the centre of the room at the bow window; on D1903.22, Mackintosh asks for three round tables, each 3′ 6″ (106.5cm.) in diameter— this is probably one of the three. No photographs exist of this side of the room, but a circular table here would have been more in harmony with the gentle curve of the window than one of the other rectangular tables. The provenance, apart from the stylistic evidence of the legs, indicates that the table came from the Willow Tea Rooms, as the Grosvenor Restaurant acquired other Willow furniture after the closure.

Provenance: The Grosvenor Restaurant, Glasgow, from which purchased.
Collection: Glasgow School of Art.

1903.27 Fitted seating for the Room de Luxe, Willow Tea Rooms, Glasgow
Francis Smith quoted (no price given, 27 September, 1903); payment was included in the gross sum of £323.18.2d. (28 January, 1904).

The seating was positioned on either side of the doors to the Room de Luxe, and probably upholstered in the same velvet as the chairs.

Literature: *Dekorative Kunst*, XIII, 1905, *269*; Howarth, plate 57a; Alison, p. *100*.
Collection: untraced, probably destroyed.

1903.28 Leaded-glass mirror panels for the Room de Luxe, Willow Tea Rooms, Glasgow
Coloured and mirror-glass in lead frames. Each panel 79.7 × 24.7cm.
McCulloch quoted for 58 at £1 each (2 September, 1903); payment was included in the gross sum of £180.18.3d. (21 January, 1904).

The mirror panels were arranged in a frieze along the south, east and west walls of the

△D1903.26 1903.29▽

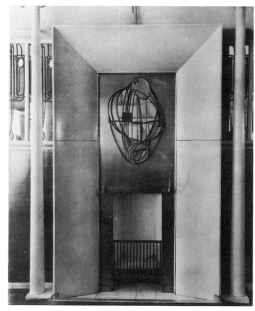

Room de Luxe. The motif is again a stylised willow. (*See* 1903.J).

Literature: *Dekorative Kunst*, XIII, 1905, pp. *269*, *271*; Howarth, plates 56c, 57a; Pevsner, 1968, plate 39; Alison, p. *100*.
Exhibited: Edinburgh, 1968 (263, plate 27).
Collection: *in situ* (1977). One separate panel from the Mackintosh Estate is at Glasgow University.

1903.29 Fireplace for the Room de Luxe, Willow Tea Rooms, Glasgow
Pine, painted white.

Simply a giant picture frame enclosing the grate, while an identical structure directly opposite framed Margaret Macdonald's gesso panel. Originally, a design in leaded-glass hung above the fireplace; it was exhibited at the Memorial Exhibition in 1933 (5) but cannot now be traced.

Literature: *Dekorative Kunst*, XIII, 1905, p. *263*.
Collection: *in situ*, 1977.

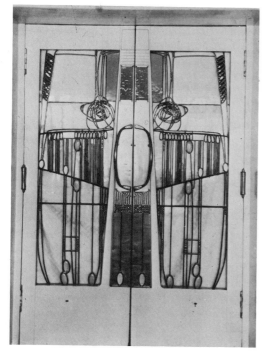

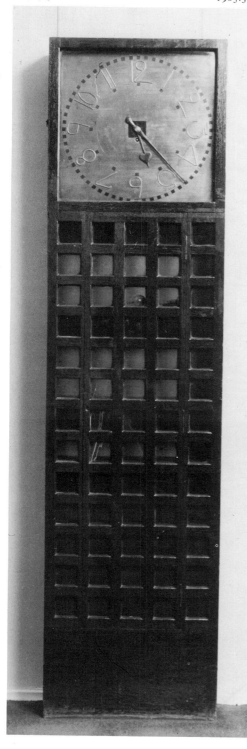

△1903.30

1903.31▽

1903.30 Doors for the Room de Luxe, Willow Tea Rooms, Glasgow

Pine, painted white, and leaded-glass with metal handles. Each leaf, 195.5 × 68.5cm.

Mackintosh's most elaborate and certainly his largest design in leaded-glass. The motif is again the willow, with stylised leaves and waving stems, with his favourite motif of an opening rose.

Literature: *Dekorative Kunst*, XIII, 1905, pp. *269, 273*; Howarth, plates 57a, 57c; Macleod, plate VII; Alison, p. *100*.
Exhibited: Paris, 1960 (1093); Edinburgh, 1968 (263).
Collection: *in situ*, 1977.

1903.31 Clock for the Willow Tea Rooms, Glasgow

Oak, stained dark, with polished steel face and brass numerals, and glazed door 188.3 × 47 × 16.4cm.
David Hislop quoted £7 for a clock (11 July, 1903) and was paid that sum (30 April, 1904).

This clock does not appear in any of the contemporary photographs but its materials suggest that it was designed for the Billiards or Smoking Rooms, or the Back Saloon, all of which had predominantly dark schemes of decoration. One of the most rigorously geometrical pieces designed for the Willow Tea Rooms, like the order desk chair (1904.24), it makes extensive use of the square in its decoration; on the front, the squares are formed by the lattice of horizontal and vertical spars, while at the sides the square takes the form of a cut-out in the solid panels. A photograph of this clock (collection: Glasgow University) taken at the Grosvenor Restaurant shows that it originally had two projecting panels at the back, running the full height of the piece and consisting of open squares, identical with the clock for the Ball dining-room (1905.6). These panels have been removed, but still survive in the Glasgow School of Art collection. The front is hinged and opens to show shelves; it does not, as might be expected from such a long case, have a pendulum.

Literature: Glasgow School of Art, *Furniture*, no 25.
Exhibited: Paris, 1960 (1091).
Provenance: The Grosvenor Restaurant, from which purchased.
Collection: Glasgow School of Art.

1903.32 Mirror for the Willow Tea Rooms, Glasgow

Francis Smith quoted for two at £2.12.6d. each (12 August, 1903); payment was included in the gross sum of £323.18.2d. (28 January, 1904).

Perhaps these relate to D1903.33.

Collection: untraced.

D1903.33 Design for a mirror for the Ladies' Dressing Room, Willow Tea Rooms, Glasgow

Pencil and watercolour 24.2 × 14cm. (sight). Inscribed, lower centre, *Cyprus* [sic] *mirrors Ladies dressing room* and, upper left, *Mirror/ Miss Cranston*, neither inscription in Mackintosh's hand.
Scale: 1:12.

The Ladies' Dressing Room was possibly one of the small rooms to the rear of the Room de Luxe. The arrangement of the decoration in the upper part of the mirror coincides with the decoration remaining in one such room. This design possibly relates to 1903.32.

Exhibited: Toronto, 1967 (71).
Collection: Dr Thomas Howarth.

1903.36▷

D1903.33△

1903.34 Billiards marking board for the Willow Tea Rooms, Glasgow

Burroughs & Watt quoted for one at £1.5.0d. (29 July, 1903) and were paid that sum (22 October, 1903).

Literature: *Dekorative Kunst*, XIII, 1905, p. *274*.
Collection: untraced, probably destroyed.

1903.35 Billiards table for the Willow Tea Rooms, Glasgow

Burroughs & Watt were paid £93.14.0d. for one (22 October, 1903).

See 1903.M.

Literature: *Dekorative Kunst*, XIII, 1905, p. *274*.
Collection: untraced, probably destroyed.

1903.36 Fitted seating for the Billiards Room, Willow Tea Rooms, Glasgow

Pine, stained dark, with rush seats and leather backs.
Francis Smith quoted for 9 rush seats and 18 leather backs for £32.17.0d. (5 September, 1903); payment was included in the gross sum of £323.18.2d. (28 January, 1904).

The basic unit was a group of four seats, fitted against the wall, the lower front apron of

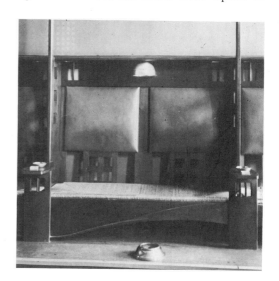

which described an ogee curve. Each group of four was divided into two bays by a central projecting panel, decorated with pierced squares, which had armrests attached at the bottom. Each bay had continuous rush seating for two people with separate leather backs, between which was a small lamp. The timber, probably pine, was stained dark. Above the seats was a continuous shelf supported on a wall-plate which had the same kind of decoration as the Front Saloon fireplace and the Ladies' Dressing Room. (*See* 1903.M).

Literature: *Dekorative Kunst*, XIII, 1905, p. 274.
Collection: untraced, probably destroyed.

▽1903.37

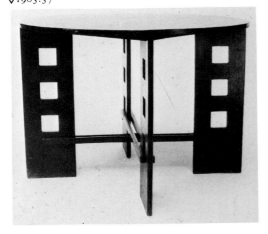

1903.37　Table for the Billiards Room, Willow Tea Rooms, Glasgow

Ebonised oak　73.2 × 99.3cm. (diameter).
Francis Smith quoted for two (no price given, 29 September, 1903); payment was included in the gross sum of £323.18.2d. (8 January, 1904).

No tables such as those quoted for by Smith appear in contemporary photographs. I believe, however, that the circular table at Glasgow School of Art, purchased from the Grosvenor Restaurant, was originally designed for the Billiards Room at the Willow Tea Rooms. It is quite different from the other circular table (1903.26), being cruder in construction and more robust, and thus has affinities with the heavier-looking furniture designed for the Billiards Room. The square cut-outs on the legs echo the similar arrangements of squares on the panels dividing the fitted seating in the Billiards Room.

Provenance: The Grosvenor Restaurant, from which purchased.
Collection: Glasgow School of Art (1).

▽1903.38　　　　　　　　　　1903.40▷

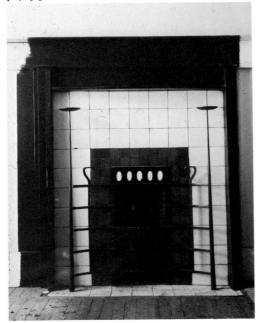

1903.38　Fireplace for the Billiards Room, Willow Tea Rooms, Glasgow

Ebonised pine, with wrought-iron grate, and tiled fire-surround.

Another simple wooden structure, but the grate, with its tall candle holders, is much more elaborate. This is virtually the only design to make such extensive use of ceramic tiles surrounding the grate; in other fireplaces the surround is usually of plaster or rough cement relieved by inlays of ceramic tile or glass. A virtually identical fireplace was used in the Smoking Room (1903.40).

Provenance: Daly's, Glasgow (owners of the Willow Tea Rooms *c*1926–1977), by whom presented.
Collection: Victoria & Albert Museum, London.

1903.39　Table for the Smoking Room, Willow Tea Rooms, Glasgow

Ebonised wood.
Francis Smith quoted for one table (no price given, 29 September, 1903); payment was included in the gross sum of £323.18.2d. (28 January, 1904).

The square cut-out motif was used in the decoration of the Smoking Room furniture as well as the Billiards Room items. This table (*see* 1903.N), although bold in its stark lines and flat surfaces, is somewhat basic; it appears in a more refined form in the hall at The Hill House (1904.7).

Literature: *Dekorative Kunst*, XIII, 1905, p. 275.
Collection: untraced.

1903.40　Fireplace for the Smoking Room, Willow Tea Rooms, Glasgow

Ebonised pine, with wrought-iron grate, and tiled fire-surround.

This differs from the Billiards Room fireplace in the decoration of the top panel of the wooden structure (the latter is undecorated) and in having one row of tiles less in the surround. It is possible that this is the fireplace which in 1977 was in the room to the east of the original Willow Tea Rooms.

Literature: *Dekorative Kunst*, XIII, 1905, p. 275.
Collection: House of Fraser, 1977 (Daly's).

D1903.41★　Design for three tables for Miss Cranston

Pencil and watercolour on tracing paper.
Dated.

This drawing has not been available for photography and the author has not seen it. Dimen-

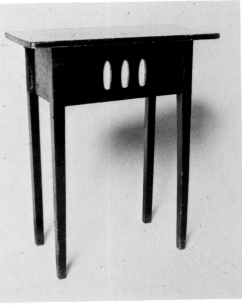

1903.41a△

sions are not given in the Toronto catalogue. The design is probably for tables for the Willow Tea Rooms, Glasgow.

Exhibited: Toronto, 1967 (76).
Collection: Dr Thomas Howarth.

1903.41a　Square table

Ebonised wood with glass inlay.

The School of Art has no provenance for this table and it does not appear to have been designed specifically for the School. Stylistically, it has much in common with some of the pieces designed for the Willow Tea Rooms; the row of glazed ovals in the apron is reminiscent of a similar feature in the fireplace in the Smoking Room, so this table may well have been designed for the Billiards or Smoking room, either in 1903 or the following year. The School of Art acquired a number of pieces from the Grosvenor Restaurant (which had in turn acquired them from the Kensington Restaurant, as the Willow Tea Rooms became *c*1920), and this table could have come into the School's collection in the same way. The oval motif was also used on the hall fireplace at The Hill House (1903); the table is not of the quality of the other pieces at The Hill House, however, and it is unlikely that a table from there would find its way so unobtrusively into the School of Art. Certainly the repetition of the oval motif does strengthen the suggestion of 1903–04 as a likely date for the table.

Provenance: unknown.
Collection: Glasgow School of Art.

1903.42　Semi-circular garden seat for Windyhill, Kilmacolm

(?) Red pine.
James Grant quoted for one 'circular' seat at £20, four mats at 10.0d., and four seats at £1.10.0d. (31 July, 1903) and was paid those sums (7 July, 1904).

This seat was installed in the lower part of the stepped garden at Windyhill, although the plan of the house in *Dekorative Kunst* in 1902 shows that it was originally intended for the upper garden to the west of the staircase bay. The seat is semi-circular in plan; it has a lattice-work back, and solid end panels giving some protection from the wind. A robust piece, rather crude in appearance, but well suited to the wild nature of this steep hill-side garden. An almost identical garden seat designed by Josef Hoffmann for a house in the Hohe Warte, Vienna, *c*1901, was illustrated in *Innendekoration*, I, 1902, p. 29. Unless Mackintosh had shown Hoffmann his plans for Windyhill on his visit to Vienna in 1900, it would seem that

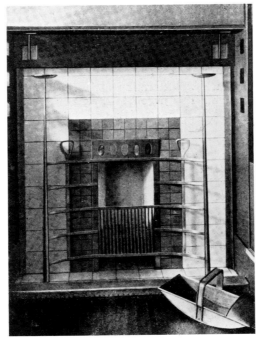

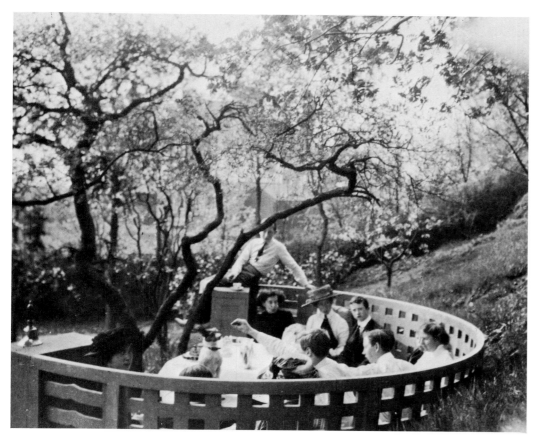

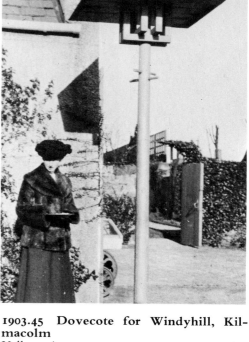

both architects devised the same motif at the same time but independently of one another.

Literature: Howarth, plate 33.
Collection: untraced, probably destroyed.

1903.43 Table for the garden at Windyhill, Kilmacolm
(?) Red pine.
James Grant quoted for a table at £5.5.0d. (31 July, 1903) and was paid that sum (7 July, 1904).

Designed to accompany 1903.42.

Literature: Howarth, plate 33.
Collection: untraced, probably destroyed.

△1903.42/43

1903.44 Trellis-work arbour for Windyhill, Kilmacolm
Red pine, painted white.
James Grant quoted for an arbour (price unknown, 31 July, 1903) and was paid for one at £5.0.2½d. (7 July, 1904); George Adam was paid £1.18.0d. for a 'trellis finial' (23 May, 1904).

A rigidly geometrical design, located in the north-west corner of the garden at Windyhill, beside the garden wall.

Collection: *in situ*, 1977.

▽1903.42/43

1903.45▷

1903.45 Dovecote for Windyhill, Kilmacolm
Yellow pine.
James Grant quoted for a dovecote (price unknown, 31 July, 1903) and was paid £5.19.10d. for one (7 July, 1904).

Collection: untraced, probably destroyed.

1903.44▽

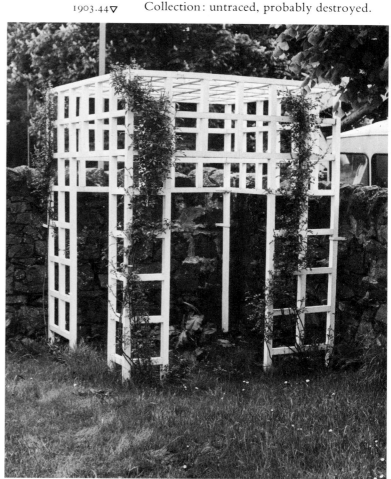

1903–04 The Hill House, Helensburgh

Designed for the Glasgow publisher, Walter W. Blackie, this house, on a hilltop with superb views of the Firth of Clyde, was Mackintosh's major domestic commission. As with the exteriors, the planning and decoration of the interiors was a refinement of themes used at Windyhill and the *Haus eines Kunstfreundes*— on a larger scale than the former, but by no means as expansive or elaborate as the German competition designs.

Blackie wanted a family house, an efficient and practical house to be lived in. Mackintosh gave him all he wanted, paying obsessive attention to the detail which transformed it from an efficient machine into a living work of art. The plan is similar to that of the *Haus eines Kunstfreundes*. One of the major differences, however, is the axial entrance on the west façade. Like the competition plans, it segregates the men from the women and children. Blackie wanted a library, which he also used as a study and business room; this is situated just off the first hall-way and, in the original plans, a billiards room and cloakroom balanced it on the opposite side of this small hall. In this way, Blackie could meet and entertain his business callers without upsetting the domestic routine of the drawing-room. Moving east along this entrance axis, visitors for the family would advance out of the small, dark hall up four steps into the main hall, a bright room with light coming from the staircase windows and its own windows which look out on to the north courtyard. It is furnished as a reception room, with chairs and table, and a splendid fireplace and panelled walls as at Windyhill. The wall between the panelling is stencilled with an abstract pattern based on geometrical and organic motifs. The main axis from the front door effectively ends in this hall, where doors lead off to the drawing-room and dining-room, for its continuation is only into the service quarters. Indeed, this axial direction which the visitor is forced to take, enticed into the hall by its brighter lighting and strong colours, is broken as soon as he decides to leave the hall, for all the main rooms are placed at 90° to it. Even the staircase involves a 180° turn, but after another four steps one encounters a small ingle with a fitted seat, overlooking the hall fireplace through an open screen. To ascend further means turning through another 90° to a half landing, apsidal as at Windyhill, and turning again through 180° to the first-floor landing where the east–west axis returns along the bedroom corridor.

1903.O The Library, The Hill House, Helensburgh
The chairs seen in this photograph have been brought into the library from the hall.

Collection: Glasgow University.

1903.P Hall at The Hill House, Helensburgh
A contemporary photograph looking west towards the main door and showing the foot of the staircase.

Collection: RCAHMS.

1903.P ▽

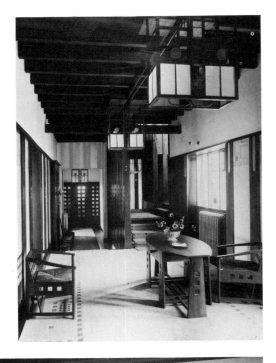

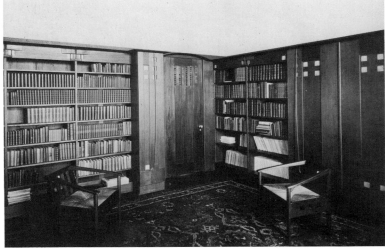

△1903.O 1903.R ▽

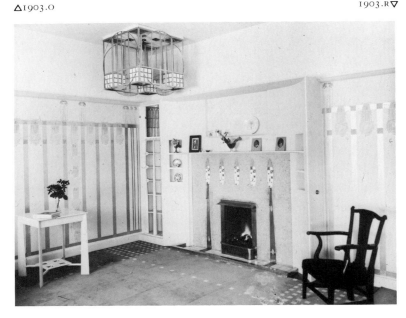

△1903.Q 1903.S ▽

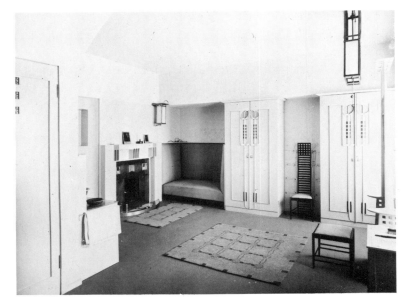

1903.Q Window bay in the drawing-room, The Hill House, Helensburgh

Collection: RCAHMS.

1903.R Fireplace in the drawing-room, The Hill House, Helensburgh

A contemporary photograph, taken before the delivery of the specially designed drawing-room furniture; the table is from the bedroom (1903.55) and the chair is one of Blackie's more conventional pieces.

Collection: RCAHMS.

1903.S Bedroom at The Hill House, Helensburgh

Collection: RCAHMS.

1903.T Bedroom, looking west, The Hill House, Helensburgh

D1903.46 Plan of the principal bedroom, The Hill House, Helensburgh, showing the position of the furniture, with a sketch of an easy chair

Pencil and watercolour 33 × 53.8cm.
Inscribed, bottom, *PLAN OF BEDROOM SHOWING POSITION OF FURNITURE. 140 BATH STREET GLASGOW*, with several other notes listing furniture.
Scale, 1:24.

This drawing, when read in conjunction with D1903.47, 48, and 49, shows Mackintosh's original layout for the main bedroom at The Hill House. The major difference from the scheme as executed is the eventual omission of the glazed and curtained screen (seen in elevation in D1903.48), situated at the east end of the bed alcove, at the point where the coved ceiling begins. This would have created a more private sleeping area, with separate access to the dressing-room, while the rest of the room, with its larger windows and the fireplace ingle, would have been more 'public'. The other minor differences are in the disposition of the

▽D1903.46 1903.T▷

The Drawing-room

In a much smaller area than he provided for the *Haus eines Kunstfreundes*, Mackintosh devised a plan which gives the drawing-room various quite separate functions. Directly opposite the door from the hall is a wide window seat, flanked by fitted book and magazine racks. This seat is contained in a bay with a lower ceiling than the rest of the room, which is expressed outside as a stark, glazed projection from the main elevation of the house. The bay has a wide view over Helensburgh and the Clyde; it was effectively a summer room, with central-heating under the seat to provide some warmth when the weather was cold. In winter, domestic life was concentrated around the fireplace on the wall opposite this bay window. With only a much smaller window to let in winter light from the south, this part of the room was warmer and the furniture, particularly the large couch, was so arranged as to shut out the colder bay and the draughts from the hall. At the far end of the room was another bay, formed by reducing the height of the ceiling, in which was kept the grand piano. This large piece of furniture had its own carefully defined territory so that it did not encroach, spatially at least, upon the rest of the drawing-room.

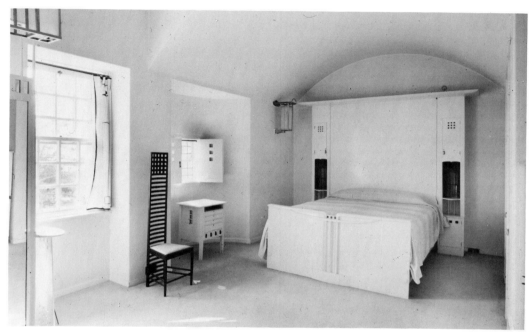

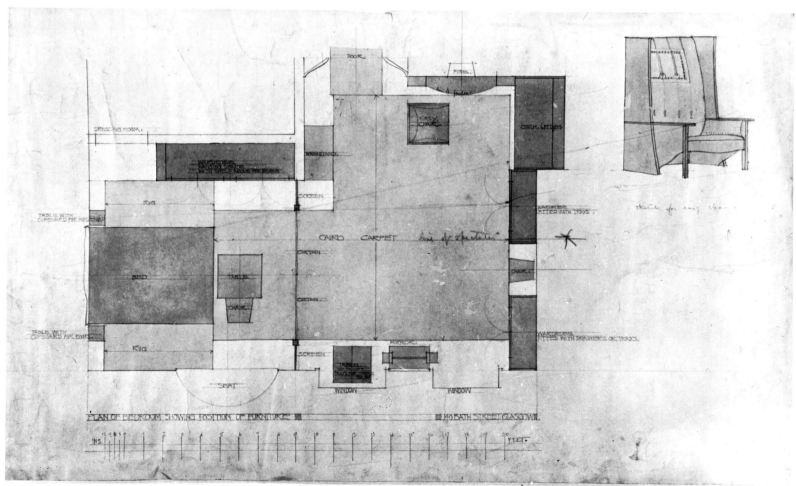

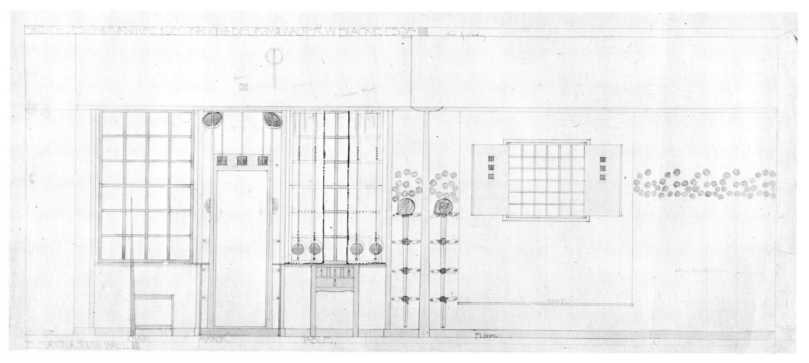

two chairs (1903.58); the absence of the dressing-table stool (1904.19); the inclusion of the table (1903.55), which was in the drawing-room in contemporary illustrations; and the inclusion of a design for an easy chair, similar

to the Argyle Street Tea Room chair 1897.19, which was never made.

Literature: Alison, p. 78, no. 19, 58.
Exhibited: Milan, 1973 (19).
Provenance: Mackintosh Estate
Collection: Glasgow University.

D1903.47 Design for the principal bedroom, The Hill House, Helensburgh—elevation of the south wall
Pencil and watercolour 34.6 × 64.7cm.
Inscribed, upper left, *SKETCH DESIGN FOR FURNITURE AND DECORATION OF BEDROOM FOR WALTER BLACKIE ESQR*; and, along lower edge, *ELEVATION OF SOUTH WALL. CHAIR. MIRROR. TABLE. FLOOR. SEAT. WALL DECORATION.*
Scale, 1 : 12.

Almost as executed, but showing the screen (*see* D1903.48) and a different dressing-table from that eventually made; the seat under the west window was also omitted. The drawing shows the simple curtains originally designed for the room, which were probably made by Margaret Macdonald.

Literature: Macleod, plate 69; Alison, p. 78, no 20, p. 58.
Exhibited: Milan, 1973 (20).
Provenance: Mackintosh Estate.
Collection: Glasgow University.

D1903.48 Design for the principal bedroom, The Hill House, Helensburgh—elevation of west walls
Pencil, watercolour, and gold paint 31.5 × 45.3cm.

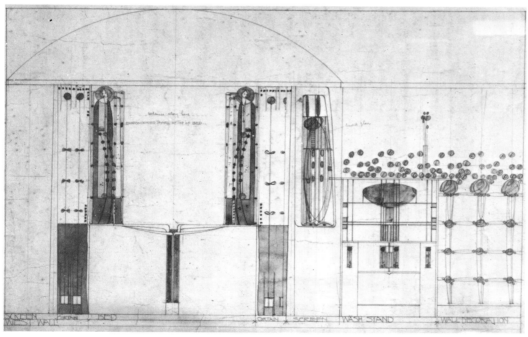

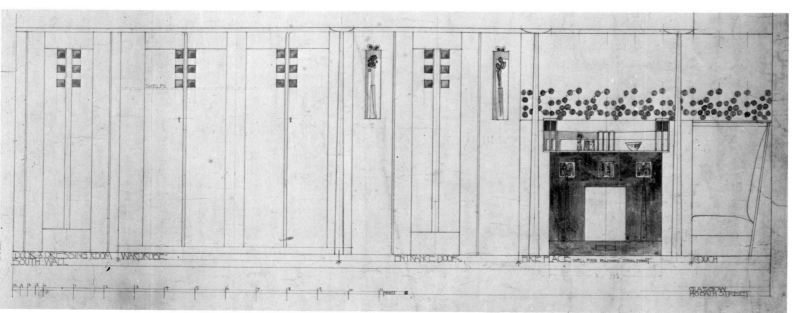

Inscribed, centre, *Valance along here | EM-BROIDERED PANEL AT TOP OF BED*, along lower edge, *SCREEN | WEST WALL, CURTAIN, BED, CURTAIN, SCREEN, WASH STAND, WALL DECORATION*. Scale, 1:12.

The bed—apart from minor details in the carved decoration—and the wash-stand are as executed, but the screen, shown here in some detail, was never made. The drawing shows two embroidered panels about 1.8 metres high, fitted above the head of the bed; two similar panels were made by Margaret (and were in Blackie's possession before he passed them to the Glasgow School of Art), but they do not appear in this position in any contemporary illustrations; they were exhibited at Edinburgh in 1968 (236).

Literature: Macleod, plate 70.
Exhibited: Edinburgh, 1968 (153, plate 23).
Collection: Glasgow University.

D1903.49 Design for the principal bedroom, The Hill House, Helensburgh—elevation of north walls

Pencil and watercolour 43 × 71.1cm.
Inscribed, along lower edge *DOOR TO DRESSING ROOM. WARDROBE. ENTRANCE DOOR. FIREPLACE, WELL FIRE. POLISHED STEEL FRONT. COUCH | SOUTH* [sic] *WALL | GLASGOW | 140 BATH STREET*.
Scale, 1:12.

Virtually as executed.

Provenance: Acquired by William Meldrum after the Memorial Exhibition, 1933; James Meldrum, by whom presented, 1968.
Collection: Victoria & Albert Museum, London (E.841–1968).

1903.50 Couch for the main bedroom, The Hill House, Helensburgh

Oak, upholstered 140.5 × 180 × 91cm.
Alex Martin quoted for a couch (price not given, 14 December 1903) and was paid £11.0.0d. for one (24 November, 1904).

At some time after the photographs were taken for *Deutsche Kunst und Dekoration*, Margaret decorated the upholstery with a pattern of *appliqué* embroidery. (See 1903.S).

Literature: *Deutsche Kunst und Dekoration*, XV, 1905, p. *351*; Howarth, plate 42; Pevsner, 1968, plate 30.
Collection: *in situ* (Royal Incorporation of Architects in Scotland).

1903.51 Fitted wardrobes for the main bedroom, The Hill House, Helensburgh

Pine, painted white, with glass inserts. East wall, each section 226 × 121 × 46cm.; north wall, 231 × 210 × 58cm.
Alex Martin quoted (no price given, 14 December, 1903) and was paid £38.10.0d. (24 November, 1904; it is not clear how many wardrobes were included in this sum).

There are two different sets of fitted wardrobes in the main bedroom, with two individual cupboards on the east wall and a range of three fitted into the north wall (see 1903.S and T). On the east wall Mackintosh has cut out a bay which runs the full length of the wall; like the bays in the drawing-room, its ceiling is at the height of the door to the bedroom, and into this he has fitted the fireside couch and two wardrobes; the latter appear to be free-standing, because their *cyma recta* moulded tops project beyond the plane of the frieze at the sides and at the front, thus disturbing the visual line of the bay. Mackintosh spaces the wardrobes about 60cm. apart, creating a niche in the depth of the bay, and in this he places the black chair (1903.58).

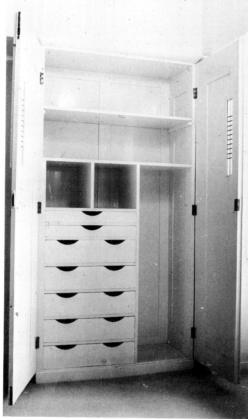

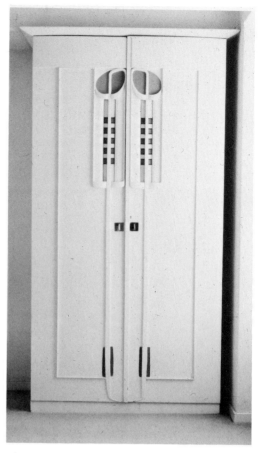

△1903.51 1903.51▷

These two wardrobes contrast strongly with the fitted range on the north wall. While the latter are extremely plain, the only decoration being three squares of leaded-glass on each of the six doors, the west wall wardrobes are decorated with carved organic motifs and inlaid with pink and green glass. Such overt references to natural forms in the decoration of the furniture is rare at The Hill House, and these are virtually the last pieces to display such decoration.

Literature: *Deutsche Kunst und Dekoration*, XV, 1905, pp. *351, 352, 353*; Howarth, plate 42; Pevsner, 1968, plate 30; Macleod, plate 67; McLaren Young, 155b, plate 23.
Collection: *in situ* (Royal Incorporation of Architects in Scotland).

The floors of the two bays were bare wooden boards, but the main part of the drawing-room, as defined by the full-height ceiling, was carpeted. The design was of squares laid out in a perimeter aisle like the hall carpet. In 1904, the lighting of the room was provided by four large glass and metal fittings, combining in each the motifs of square and circle. There was no cornice between wall and ceiling, both of which were originally painted white; below the moulding which encircled the room at door and fireplace height, the walls were stencilled with a pattern of roses in green and pink, contained in a framework of stencilled silver panels with chequered decoration.

In November 1905, quotations were obtained for wall lights to replace the four ceiling fittings; these were paid for in February 1906. They are first shown in a photograph (1905.C) in the collection of Mrs A. Walker (neé Blackie, the eldest daughter), which also shows the furniture made in 1905, the clock, the lampshade, and the easy chair. The gesso panel over the fireplace, however, had not been installed when this photograph was taken. It would be a simple matter to date the photograph if the date on Margaret's panel was more legible. It has been taken as *1909* or *1903*: if it is the former, then one can reasonably assume that the photograph dates from before 1909; if, however, it is 1903 and the panel had not been installed by 1905, then one cannot be certain when it was eventually installed, and the photograph could date from any year before 1912.

In 1912, Mackintosh's notebook (collection: Glasgow University) shows that he revisited The Hill House to advise on redecoration and the repair and recovering of some pieces of furniture. This is confirmed by the job-books at Keppie, Henderson. Mackintosh's notes quite clearly state that the drawing-room ceiling was to be painted 'plum', and Mrs Walker remembers it having a warmer tone than pure black. It has been suggested that this step was taken because of the dirty marks which were continually made by the gas wall lamps, but these can have been no worse than similar marks in rooms elsewhere in the house where ceilings were not painted a dark colour. A more likely reason for the new colour scheme was to redress the balance between the ceiling and the rest of the room after it was upset by the removal of the four large light fittings. These had been fixed to the ceiling, and their lower edges were level with the tops of the doors and the fireplace. They provided a continuation of this specific level, about 2.4 metres above the floor, especially when they were alight: as the gas jets were in the lower part of the

fitting, they would have distracted attention from the ceiling. When they were replaced by wall lamps, the ceiling was left bare, and this large unbroken plane became much more dominant in the composition of the room than had been intended. By darkening it, Mackintosh attempted to reduce the reflectiveness of the ceiling and thus distract from its impact on the rest of the room.

The ceiling at present (1978) is painted black; this has the opposite effect to what Mackintosh intended, as it is now so harsh and so obviously out of balance that one is immediately aware of it, and it again overpowers the room (which is, admittedly, also bare of its original stencil decoration, over-painted in the 1950s). Arguments for and against the black are frequently put forward; my belief is that the ceiling was painted dark red by Mackintosh in 1912, and that its recent repainting in black was due to a mistaken identification of the colour of the dirty ceiling which had not been repainted for over 50 years.

The Dining-room

Like all of Mackintosh's earlier domestic dining-rooms, the emphasis is upon dark walls, a pale ceiling, and concentrated pools of light over the table and around the fireplace. The walls are panelled here with pine, originally stained dark, but now (1978) bleached almost to its natural colour; the upper parts of the walls and the ceiling were painted white. A simple fireplace on the south wall, now painted out and covered by an ugly casing containing an electric fire is flanked by two elaborate wall lights (which are duplicated on the north wall). A single light fitting was suspended over the dining table; this now hangs on the staircase ingle.

The Service Quarters

The store, pantry, larder and kitchen all have fitted cupboards of a simple design, but unmistakably Mackintosh's own. Similar cupboards were designed for The Moss at Dumgoyne, Stirlingshire, in 1907.

The first floor corridor, like that at Windyhill, contains linen cupboards and a fitted alcove seat looking out to the north. The corridor repeats the east–west axis of the entrance hall, with the bedrooms similarly ranged off it to the south. Most of the rooms have no fittings other than very simple fireplaces, with small panels of stencil decoration on the walls. Apart from the main bedroom, the only room of interest on the first floor is the day nursery and on the second floor, the playroom. In the day nursery, which faces east, a full-height bow window echoes that of the breakfast room, similarly positioned, in the *Haus eines Kunstfreundes* designs. The playroom also refers to the competition design, with its polygonal bay window looking out over the service wing and the garden.

The Bedroom

Mr and Mrs Blackie's bedroom, like the main bedroom in the *Haus eines Kunstfreundes*, is placed at the end of the corridor, out of the way of all the other bedrooms and well away from the children's rooms. A dressing-room for Mr Blackie is attached. Mackintosh has attempted to define the different functions the main bedroom had to fulfill. As one enters, the room appears rectangular with a flat ceiling; to the left is the fireplace and, at 90°, to it, a wall of fitted furniture—settle and wardrobes. In fact, the room is L-shaped, and in the large area to the west is the bed and more fitted wardrobes. This sleeping alcove is defined by a vaulted ceiling, the curve of the vault echoed by a concave bay in the south wall through which a small window admits daylight to the bed. In his original drawing (D1903.48), Mackintosh shows a screen of glass and timber with curtains at the junction of the vault with the flat ceiling, thus effectively partitioning the bed from the more public part of the room with its fireplace and couch. This feature was never executed.

Mackintosh was designing movable furniture for The Hill House from November 1903—starting with the main bedroom—until the autumn of 1904, some months after the Blackies had moved in. From the beginning, Blackie made it clear that he could not afford to furnish his house with new pieces, so Mackintosh concentrated on designing specific areas *in toto*, rather than dilute the overall effect by designing different pieces for every room in the house. The main bedroom and the hall were the only rooms where all the furniture was made to his designs. By contrast, the dining-room had no movable Mackintosh furniture designed for it; even Blackie's library, which was fully fitted by Mackintosh with shelving, cupboards, and fireplace, had no furniture designed specifically for it, and contemporary photographs show that the hall chairs were moved in to give the appearance of a unified overall design. The photographs, published in *Dekorative Kunst* in 1905, were probably taken in July or August 1904 when much of the drawing-room furniture had not even been designed. It seems likely that in 1904 Blackie gradually extended his commission to include pieces of furniture not originally requested, like the writing desk and cabinet, designed during October and November and possibly not delivered until the spring of 1905. Other furniture was designed in 1905, and the episode of the drawing-room lamps shows

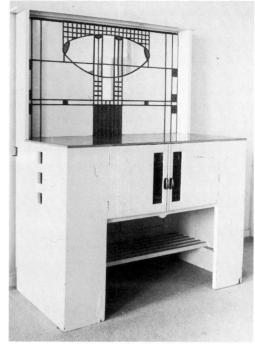

1903.52△

1903.52 Wash-stand for the main bedroom, The Hill House, Helensburgh
Wood, painted white, with a silver-painted top and a leaded-glass upstand 138.5 × 100 × 54.2cm.
Alex Martin quoted (no price given, 14 December, 1903) and was paid £10.10.0d. for one (24 November, 1904).

A simple wooden structure with an elaborately patterned upstand, this piece combines some of Mackintosh's earliest decorative motifs with new ones which became dominant in his work. The dip in the front apron below the doors is reminiscent of the projection on many of the cabinets of 1895–1900 and appears here for the last time; the shape of the mirror panel in the upstand echoes the oval panel on the high-backed chairs from the Argyle Street Tea Rooms (1897.23). The rose-patterned panels in the doors also hark back to the 1890s, but the strip of squares from which their stems spring looks forward to Mackintosh's new geometrical style; this is emphasised in the rest of the leaded-glass work in the upstand, with its subtle play of squares and rectangles in different coloured glass. These geometrical shapes dominated many of the furniture designs in 1904 for other rooms at The Hill House, but organic motifs still linger in this piece.

Literature: *Deutsche Kunst und Dekoration*, XV, 1905, p. *352*; Howarth, plate 42; Macleod, plate 66.
Exhibited: Edinburgh, 1968 (235).
Collection: *in situ* (Royal Incorporation of Architects in Scotland).

1903.53 Bedside cupboards for the main bedroom, The Hill House, Helensburgh
Oak, painted white, with leaded-glass panel. Each 231 × 31.8 × 19.8cm.
Alex Martin quoted (no price given, 14 December, 1903) and was paid £21 for two (24 November, 1904).

On the plan of the bedroom (D1903.46), Mackintosh designated one cupboard for medicines and one for books. Each cupboard includes, on a small scale, the concave bay of leaded-glass panels which appeared in several later cupboards, culminating in the series of fitted screens in the Chinese Room at the Ingram Street Tea Rooms (1911) and also in the hall screen at 78 Derngate, Northampton (1916). The concave curve of the narrow panels of glass contrasts with the shape of the outer cupboard, which is emphatically rectangular,

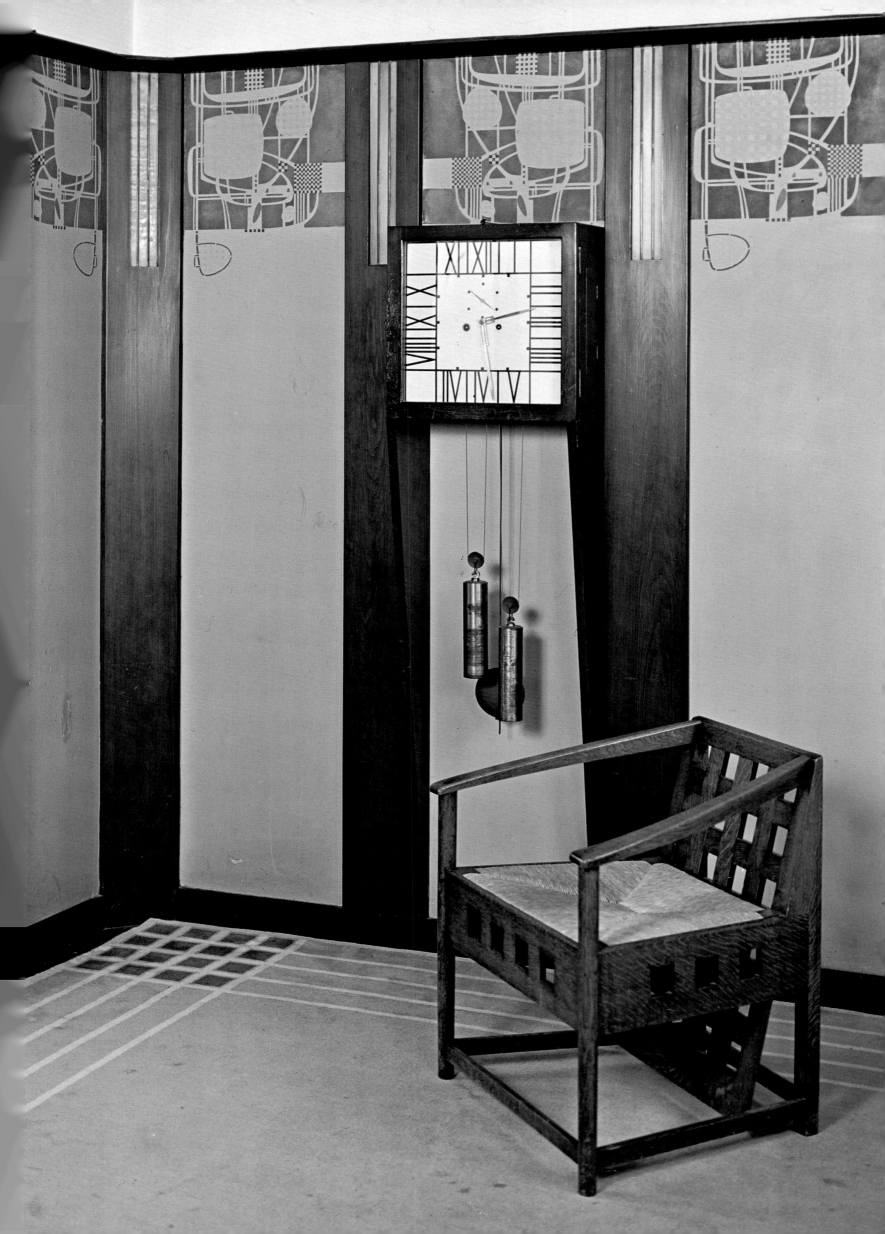

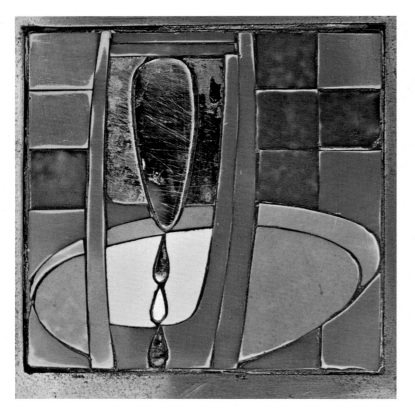

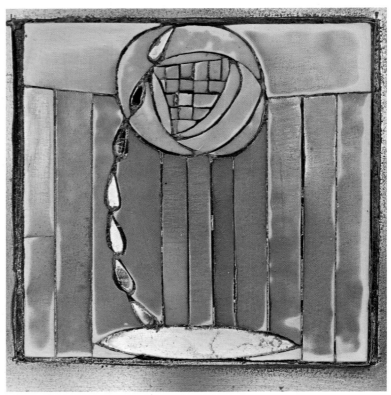

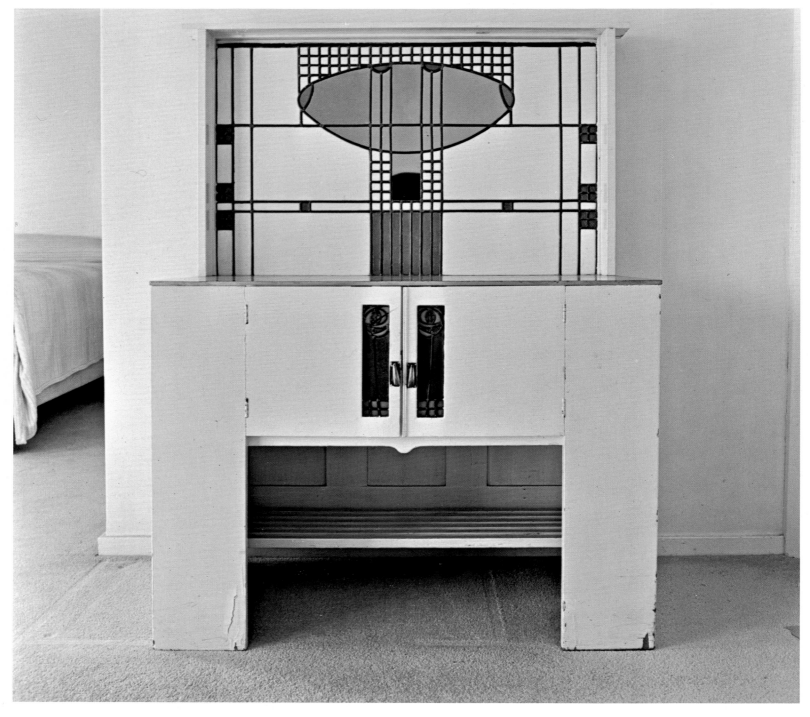

and Mackintosh repeated this same relationship in the later cabinets and screens—curves contained within squares and oblongs. (See 1903.T).

Literature: *Deutsche Kunst und Dekoration*, XV, 1905, p. *352*; Howarth, plate *42*; Macleod, plate *66*.
Collection: *in situ* (Royal Incorporation of Architects in Scotland).

1903.54 Bed for the main bedroom, The Hill House, Helensburgh
Oak, painted white 80 × 158 × 209cm.
Alex Martin quoted (no price given, 14 December, 1903) and was paid £10 plus £5.5.0d. for a mattress (24 November, 1904).

There is no headboard, as the top of the bed was designed to fit into a deep niche formed by the two bedside cupboards. The foot of the bed is relieved by an applied pattern, like the bed at Windyhill (1901.5), which is shown on D1903.48 with a coloured strip down the centre; there is no evidence, however, that the bed was ever painted any other colour than white. (See 1903.T).

Literature: *Deutsche Kunst und Dekoration*, XV, 1905, p. *352*; Howarth, plate *42*; Macleod, plate *66*.
Collection: *in situ* (Royal Incorporation of Architects in Scotland).

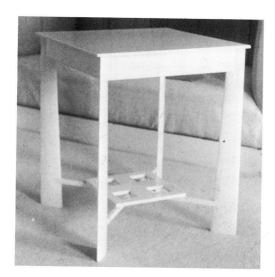

that Blackie did not consider the house to be completely furnished at that time. Even in 1908 Mackintosh was still providing furniture for the drawing-room. In 1912, when the interiors seemed absolutely finished, he turned to the garden and designed a bench for the terrace.

Literature: *Deutsche Kunst und Dekoration*, XV, 1905, pp. 337–68; Howarth, pp. 98–107, plates 36–42.

1903.55 Square table for the main bedroom, The Hill House, Helensburgh
Oak, painted white 76.5 × 61 × 61cm.
Alex Martin quoted for a table at £4.5.0d. (14 December, 1903) and was paid that sum (24 November, 1904).

In contemporary photographs, the table is shown in the drawing-room, where it would have been the only movable white-painted piece. D1903.56 and the job-books, however, indicate that it was intended for the bedroom, and on the plan, D1903.46, it is shown at the foot of the bed with the black chair (1903.58).

This was the most stable and elegant of all Mackintosh's tables to date and incorporates new features which appeared in later tables. The legs of 1902.1 and 1902.23 had all been wide, but here they also taper towards the top and are placed at an angle of 45° to the sides of the table. At low level, they are linked by diagonal stretchers over which a pierced shelf is fitted, more decorative than functional. The aprons are all set well back from the edge of the table top; this exposes the upper part of the legs and allows them to touch the table top. The shadows cast by the overhanging top and the highlights which glint off the thin edges of the legs create a spatial play which is more subtle, delicate and simple than in any of the earlier tables.

Literature: *Deutsche Kunst und Dekoration*, XV, 1905, p. *356*.
Collection: *in situ* (Royal Incorporation of Architects in Scotland).

D1903.56 Design for a table for the main bedroom, The Hill House, Helensburgh
Pencil 23.5 × 32.7cm.
Inscribed, upper centre, *W. W. Blackie Table for own Bedroom*; and various notes and measurements.
Scale, 1 : 12.

◁1903.55 D1903.56▽

The drawing shows that Mackintosh considered inlaying the four corners of the table with stylised roses, probably in ivory as 1902.1. He had allowed £2 for the four, but either he changed his mind, or Blackie could not afford them, as they were not carried out.

Provenance: Mackintosh Estate.
Collection: Glasgow University.

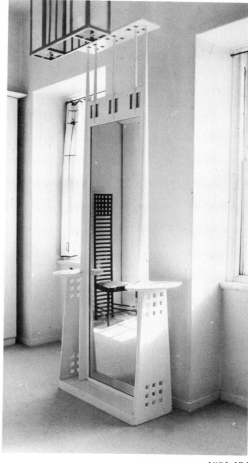

1903.57△

1903.57 Cheval mirror for the main bedroom, The Hill House, Helensburgh
Oak, painted white, with coloured glass inlay 229 × 95 × 38cm.
Alex Martin quoted for a mirror at £11 (14 December, 1903) and was paid that sum (24 November, 1904).

A development of the cheval glass made for Windyhill, the main difference being a slightly more elaborate top and wider pedestals to support the two trays. These pedestals are pierced with a grid of nine squares repeating the leaded-glass motif in the wardrobes on the north wall. The drawing (D1903.47) shows a repetition of the petal motif from the east wall wardrobes, as well as lugs on either side of the mirror frame, but these were not executed. This drawing does not show the light fitting intended for the bedroom, although it indicates the position of the mirror between the two sash windows. The light was positioned over, and slightly in front of, the mirror to cast light on to the person using it, but Mackintosh seems to have made a miscalculation in the dimensions of the lamp. When the mirror is placed in the position indicated on all the drawings—its only logical place in the room—the upper part of it is obscured by the hanging lamp and an unpleasant clash both of form and materials occurs.

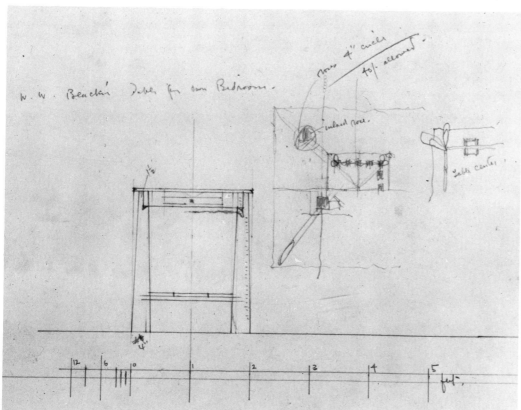

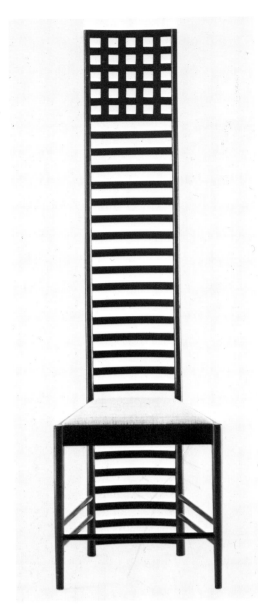

◁1903.58 1903.59△

Literature: *Deutsche Kunst und Dekoration*, XV, 1905, pp. *351, 352*; Howarth, plate 42; Pevsner, 1968, plates *30, 32*; Macleod, plates 66, 67; N. Pevsner, *Sources of Modern Architecture and Design*, 1968, p. *139*; *Scottish Art Review*, XI, no 4, p. *9*; Alison, pp. *58, 59, 100–102*.
Exhibited: Paris, 1960 (1083); Edinburgh, 1968 (241).
Collection: *in situ* (Royal Incorporation of Architects in Scotland [2]).

1903.59 Dressing-table for the main bedroom, The Hill House, Helensburgh
Oak, painted white 71.5 × 55.5 × 43cm.
Alex Martin quoted for one at £6.10.0d. (3 March, 1904) and was paid that sum (24 November, 1904).

Although the design for the dressing-table did not go out for quotation until about March 1904, it does appear on the drawings of the main bedroom (D1903.46 and 47). The final design differs somewhat from that shown in the elevation, but the size is almost the same; in the executed design, the row of small drawers is below four other full-width drawers and the top is not removable as noted on the drawing.

Literature: *Deutsche Kunst und Dekoration*, XV, 1905, pp. *351, 352, 353*; Howarth, plate 42; Pevsner, 1968, plate 30; Macleod, plate 66.
Collection: *in situ* (Royal Incorporation of Architects in Scotland).

▽1903.60 1903.61▷

1903.60 Fireplace for the main bedroom, The Hill House, Helensburgh
Wood, painted white 140.5 × 157 × 16.5cm.
William Jack quoted £3.15.0d. for the fireplace and 10.0d. for the fender (16 February, 1904) and was paid those sums (24 May, 1904).

The fireplace appears virtually unchanged from that shown in D1903.49, with the exception of the removal of the two tapering square posts and the steel straps attached to the fire-surround. This surround is one of Mackintosh's most original, being simply a well-polished sheet of steel inlaid with panels of coloured mosaic. It appears, in turn, both severe and luxurious—the bright, shiny metal coldly reflecting the white paint of the room and then the glow of the hot coals.

Literature: *Deutsche Kunst und Dekoration*, XV, 1905, pp. *351, 362*; Howarth, plate 42; Pevsner, 1968, plate 30.
Collection: *in situ* (Royal Incorporation of Architects in Scotland).

1903.61 Door jambs for the main bedroom, The Hill House, Helensburgh
Wood, painted white.
William Jack quoted £3.3.0d. (16 February, 1904) and was paid that sum (24 May, 1904).

Mackintosh designed wide, concave jambs flanking the bedroom door (visible in D1903.49). Out of each jamb he cut a rectangular niche intended to hold vases of flowers, a motif he had first used on a writing desk (*see* 1902.8).

Collection: *in situ* (Royal Incorporation of Architects in Scotland).

1903.62 Wash-stand for the dressing-room, The Hill House, Helensburgh
Mahogany with panel of leaded-glass 138.4 × 94 ×56.5cm.
John Craig quoted for a wash-stand at £4.10.0d. (25 January, 1904) and was paid that sum (11 July, 1904).

Adjacent to the main bedroom was a dressing-room for the use of Mr Blackie. Here the furniture was stained dark to match an existing chest-of-drawers (not designed by Mackintosh) and the wardrobe was also designed to accommodate this chest (*see* D1903.65). The other items in the suite of furniture (1903.63 and 64) differ only in detail from the designs included in D1903.65 and it seems reasonable to suppose that there was little difference between the design for the wash-stand (which was very simple) and the executed piece which has not been traced. In his notes in the job-book,

Literature: *Deutsche Kunst und Dekoration*, XV, 1902. pp. *351, 353*; Howarth, plate 42; Pevsner, 1968, plates 30, 32; Macleod, plate 67.
Collection: *in situ* (Royal Incorporation of Architects in Scotland).

1903.58 Chair for the main bedroom, The Hill House, Helensburgh
Ebonised oak 140 × 40.5 × 33.5cm.
Alex Martin quoted (no price given, 14 December, 1903) and was paid £7.17.0d. for two (24 November, 1904); this price included the dressing-table stool, 1904.19.

Only three items in the main bedroom were not painted white: the two chairs and the dressing-table stool (1904.19). They are delicate and spidery and their black paint acts as a necessary foil to the expanses of white woodwork and furniture and the busy stencils on the walls. The chairs are the first examples at The Hill House of a totally new style, with no reference to the organic shapes or femininity of the furniture of 1902–03, other than their slender members and graceful appearance. They have no real function other than decoration, and each has a quite clearly defined position within the room, one between the wardrobes on the east wall in its own niche and the other against the wall to the right of the dressing-table; moving either of them disturbs the careful balance of the different elements within the room. Alison has shown how delicate the design of the chair is and how controlled is the relationship between the elliptical back legs and the series of ladder-rails linking them. However, the seat is too small and the joints too weak to support anyone sitting on the chair for more than a very short period.

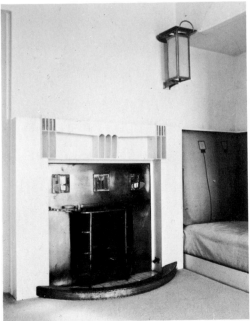

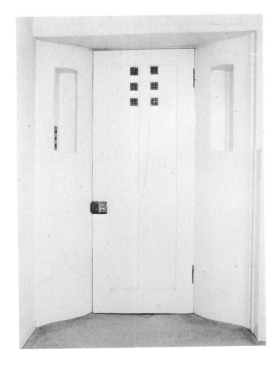

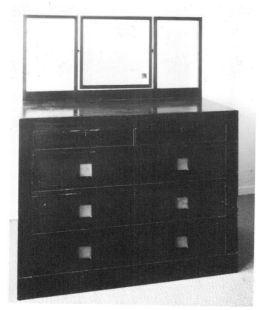

△1903.63 1903.64▷

Mackintosh has confused the furniture for the second bedroom and the dressing-room and transposed the details. Mrs A. Walker (*née* Blackie) confirmed that the inscription of D1903.65 is accurate and that there was no other Mackintosh furniture in the second bedroom, other than the bed.

Collection: Dr Thomas Howarth.

1903.63 Chest-of-drawers and mirror for the dressing-room, The Hill House, Helensburgh

Mahogany, french-polished, with coloured glass 153 × 122 × 56cm.
John Craig quoted for one at £8.10.0d. (25 January, 1904) and was paid that sum (11 July, 1904).

See 1903.62 and D1903.65.

Collection: *in situ* (Royal Incorporation of Architects in Scotland).

1903.64 Wardrobe for the dressing-room, The Hill House, Helensburgh

Mahogany, french-polished, with coloured glass 205 × 261 × 58.8cm.
John Craig quoted for one at £20 (25 January, 1904) and was paid that sum (11 July, 1904).

Designed to enclose an existing chest-of-drawers and to match it in colour and finish. *See* D1903.65.

Collection: *in situ* (Royal Incorporation of Architects in Scotland).

D1903.65 Design for furniture for the dressing-room, The Hill House, Helensburgh

Pencil 28.1 × 46.1cm. (irregular).
Inscribed and dated, lower right, *140 Bath Street Glasgow Dec 1903.*; inscribed, upper left, *Dressing Room Furniture for Walter W. Blackie Esqr.*, and lower left, *All to be made in mahogany and stained same colour as existing chest of Drawers./ Walls of this room to be Halls Patent (grey) with small stencil at level of door. / Any chair wanted for this room? What carpet? any stained border?*; and various notes and measurements.
Scale, 1:24.

The wash-stand cannot be traced, and there is no remaining indication of the original colour scheme for the dressing-room. *See also* 1903.62, 63 and 64.

Provenance: Mackintosh Estate.
Collection: Glasgow University.

D1903.65▷

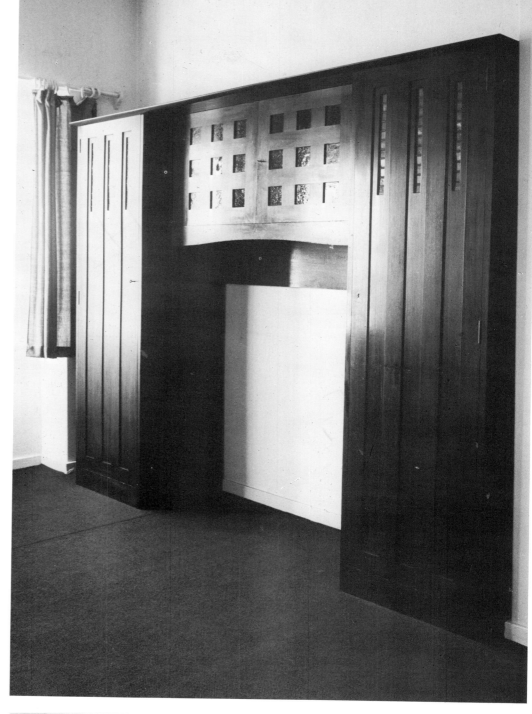

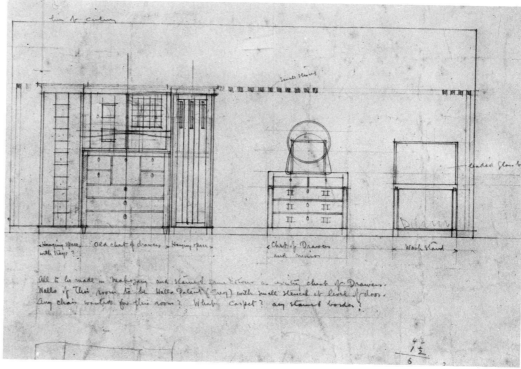

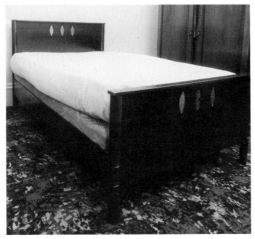

△1903.66

1903.66 Bed for the second bedroom, The Hill House, Helensburgh

John Craig quoted for one at £7.10.0d. (25 January, 1904) and was paid that sum (11 July, 1904).

Apart from the pieces for the main bedroom and dressing-room, this appears to be the only other movable item Mackintosh designed for the remaining rooms on the first and second floors.

Provenance: Walter Blackie; by family descent. Private collection.

1903.67▽

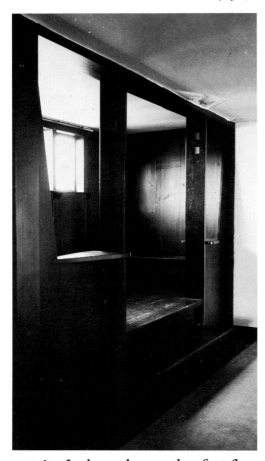

1903.67 Ingle-nook on the first-floor landing, The Hill House, Helensburgh
Pine, stained dark 227 × 311.5 × 151cm.

A repetition of a similar feature used at Windyhill, again with a view to the north.

Collection: *in situ* (Royal Incorporation of Architects in Scotland).

1903.68 Linen cupboards on the first-floor landing, The Hill House, Helensburgh
Pine, stained dark, with coloured glass 277 × 384 × 75cm.

Collection: *in situ* (Royal Incorporation of Architects in Scotland).

1903.69 Window table for the drawing-room, The Hill House, Helensburgh
Pine, painted white, with coloured glass inserts 227.5 (table top, 112) × 180.9 × 63.6cm.
William Jack quoted for one at £5.15.0d. (4 January, 1904); payment was included in the gross sum of £17.2.0d. (24 May, 1904).

This table fitted into the window opposite the fireplace. It has some similarities with drawings Mackintosh seems to have made in connection with the designs for the *Haus eines Kunstfreundes* competition in 1901 (see D1901.16) and the Ball dining-room in 1905 (see D1905.13).

Literature: *Deutsche Kunst und Dekoration*, XV, 1905, p. *359*.
Collection: *in situ* (Royal Incorporation of Architects in Scotland).

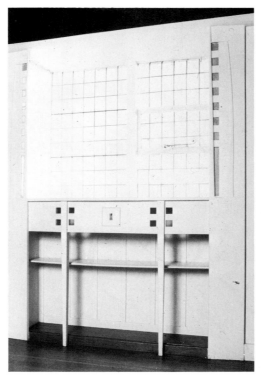

△1903.69 1903.70▽

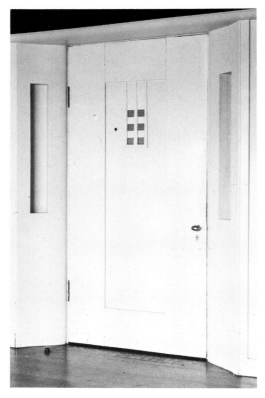

1903.70 Shelves and jambs for the drawing-room door, The Hill House, Helensburgh
Pine, painted white 227 × 31 × 35cm.
William Jack quoted £2.17.0d. (4 January,

1904); payment was included in the gross sum of £17.2.0d. (24 May, 1904).

See 1903.61.

Collection: *in situ* (Royal Incorporation of Architects in Scotland).

1903.71 Fireplace for the drawing-room, The Hill House, Helensburgh
Pine, painted white, with a gesso panel by Margaret Macdonald; steel grate with polished steel fire-dogs and fender, and mosaic surround with glass inlay 231 × 245 × 35.8cm.

There is no note in the job-books about the making of this fireplace, but it was probably executed by John Craig or William Jack early in 1904 (i.e., contemporaneously with the cabinet, 1903.72). As at Windyhill, Mackintosh has surrounded the grate with a mosaic, and the wooden structure at the sides sweeps out in a concave curve. The elaborate mantel at Windyhill is not repeated, however, but is replaced by a simple shelf and a recess for a gesso panel by Margaret Macdonald. Above the grate are five ovals of coloured and mirror-glass, fitted into the mosaic as at Windyhill; and attached to either side of it are straps of burnished steel from which the fire irons are suspended. The grate is at floor level and there is no high, and rather heavy, fitted fender as in the Windyhill drawing-room.

Literature: *Deutsche Kunst und Dekoration*, XV, 1905, pp. *356, 358*; Pevsner, 1968, plate 33; Macleod, plates IV (in reverse) and 65.
Collection: *in situ* (Royal Incorporation of Architects in Scotland).

1903.72 Fireplace cabinet for the drawing-room, The Hill House, Helensburgh
Pine, painted white, with leaded-glass panel 231 × 58 × 35.8cm.
John Craig quoted for one at £5.10.0d. (25 January, 1904) and was paid that sum (11 July, 1904)

The semi-circular niche of leaded-glass, contained in a rectangular framework, is a repeat of the same motif in the bedside cupboards (1903.53). The tapering pole beneath it with its branch-like shelves, each terminating in a 'leaf' of coloured glass, is a reference to a very stylised tree.

Literature: *Deutsche Kunst und Dekoration*, XV, 1905, pp. *356, 365*; Macleod, plates IV (in reverse) and 65.
Collection: *in situ* (Royal Incorporation of Architects in Scotland).

1903.73 Window seat for the drawing-room, The Hill House, Helensburgh
Pine, painted white, with upholstered seat 225 × 408 × 111.7cm.
William Jack quoted £7.12.0d. (4 January, 1904); payment was included in the gross sum of £17.2.0d. (24 May, 1904).

One of the most elaborate and successful features in the house, both practically and aesthetically. It completely fills the wide glazed bay which projects from the drawing-room and overlooks the garden and the distant Firth of Clyde. Either side of the upholstered seat—originally stencilled with a pattern of roses—are two low book or magazine racks with flat tops which act as side tables. Hiding the junctions between seat and tables are two broad 'columns'; these have no structural purpose, but serve to counter the dominant horizontals of floor, seat, window and ceiling. They are decorated with pierced squares and topped by one of Mackintosh's more abstract carved reliefs, again of organic inspiration. (See 1903.Q).

Literature: *Deutsche Kunst und Dekoration*, XV, 1905, p. *357*; Howarth, plate 41; Pevsner, 1968,

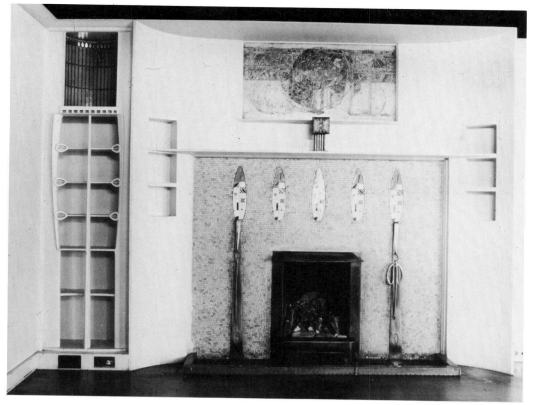

plate 31; Macleod, plate 64.
Collection: *in situ* (Royal Incorporation of Architects in Scotland).

1903.74 Fireplace for the library, The Hill House, Helensburgh

Oak, stained dark, with coloured glass inserts 228 × 246 × 53cm.

William Jack quoted £84 for library fittings (4 January, 1904) and was paid £92.13.0d. (24 May, 1904).

Like the dining-room, the library was panelled to picture-rail height with dark-stained wood; here oak was used, in the form of shelves and cupboards rather than simple planks. The fireplace was similarly treated, and the surround is again of mosaic. The row of pigeon-holes along the top is reminiscent of those in the unexecuted design for the drawing-room fireplace of 1900 at 120 Mains Street (*see* D1900.3). As befits a study/library, there is more storage space in this fireplace than one usually finds in Mackintosh's designs, with cupboards and racks, and even a small writing desk, fitted on either side of the grate.

Literature: *Deutsche Kunst und Dekoration*, XV, 1905, p. *354*; Howarth, plate 39.
Collection: *in situ* (Royal Incorporation of Architects in Scotland).

1903.75 Shelving and cupboards for the library, The Hill House, Helensburgh

Oak, stained dark, with coloured glass inserts: north wall, 228 × 300 × 50cm; east wall, 228 × 228 × 36.2cm.; west wall, 228 × 495 × 46.5cm. William Jack quoted £84 for library fittings (4 January, 1904) and was paid £92.13.0d. (24 May, 1904).

The timber is all stained dark and is relieved only by the small inserts of coloured glass and the applied organic decoration on the cupboard doors (*see* 1903.74 and 1903.O).

Literature: *Deutsche Kunst und Dekoration*, XV, 1905, p. *354*; Howarth, plate 39.
Collection: *in situ* (Royal Incorporation of Architects in Scotland).

1903.76 Fireplace for the dining-room, The Hill House, Helensburgh

Pine, stained dark, with inlaid glass and tiles 274 × 164 × 10cm.

The dining-room was treated in a very simple manner and no movable furniture was designed for it. The fireplace, with its modest grate and cement surround, is the most severe example at

△1903.71/72

1903.74▽

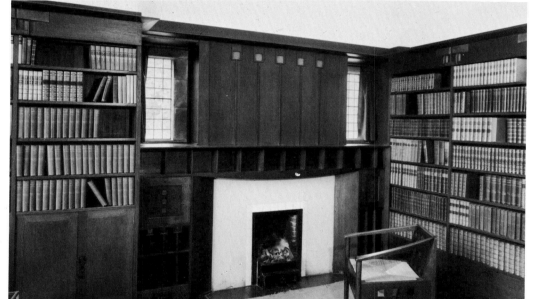

▽1903.75 detail

1903.76▷

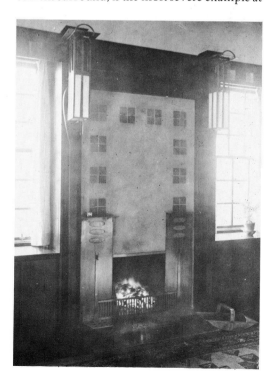

The Hill House, designed to conform with the rest of the room.

Collection: *in situ* (Royal Incorporation of Architects in Scotland).

1903.77 Fireplace for the hall, The Hill House, Helensburgh

Pine, stained dark, with coloured and leaded-glass inserts 288.5 × 186 × 20cm.

Situated in the lower part of the hall, adjacent to the library door, this fireplace is a more complicated structure and has a bigger part to play in the design of the hall than might at first appear. Seen along the east-west axis it seems relatively insignificant, as it only projects 16cm. from the wall, but from the staircase ingle, its visual importance and spatial complexity become more apparent. Although its cornice is in line with the picture-rail around the upper part of the hall, the grate itself is at the level of the entrance to the house; the fireplace thus helps link the two levels together. From the lower level it appears slightly elongated (it is over 50cm. taller than the drawing-room fireplace, for instance), and in walking past it one is more aware of this attenuation than any other feature in the design. From the staircase ingle and landing, however, the structure is more easily appreciated. The upper part of the fireplace has a concave curve, forming a curved bay the full depth of the piece. Two broad vertical splats divide the width of the bay and re-emphasise the frontal plane. The base of the bay forms a shelf, the front of which has a convex curve projecting beyond the two vertical splats. Below this is another concave bay, this time with no splats, which provides another shelf just above the grate surround; the grate has seven ovals cut out of the cast-iron lintel. Looking down on the shelves and on the play of light and shade on the dark timber, it is obvious that Mackintosh put considerable thought into creating such an interesting and changing spectacle for those who used the ingle seat. Seen through the vertical spars of the hall screen, the fireplace has a much greater visual impact than when glimpsed momentarily as visitors walk through the passageway to the main hall.

Collection: *in situ* (Royal Incorporation of Architects in Scotland).

▽1903.77

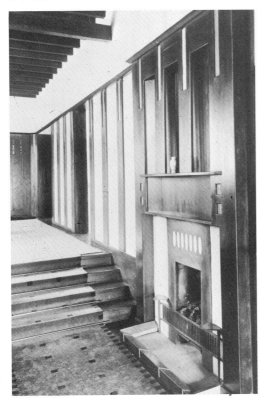

1903.U Bedroom at the Dresdener Werkstätten für Handwerkskunst

The only photograph known of this exhibition design taken before the installation was complete.

▽1903.U

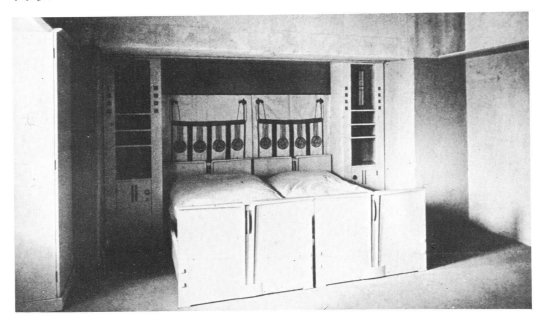

D1903.78 Plan of a bedroom designed for the Dresdener Werkstätten für Handwerkskunst

Pencil and watercolour 33.3 × 39.3cm.
Scale, 1:24.

Provenance: Mackintosh Estate.
Collection: Glasgow University.

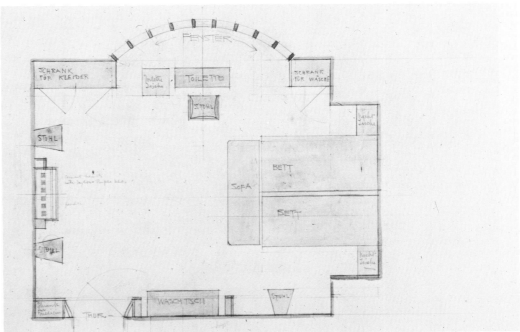

△D1903.78

D1903.79▽

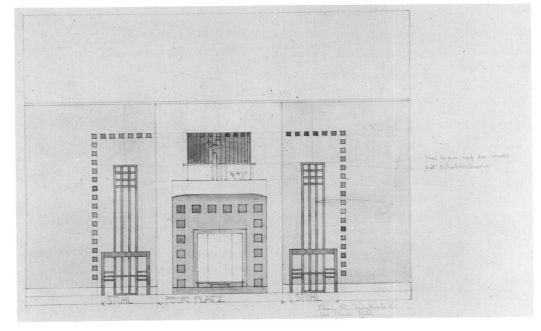

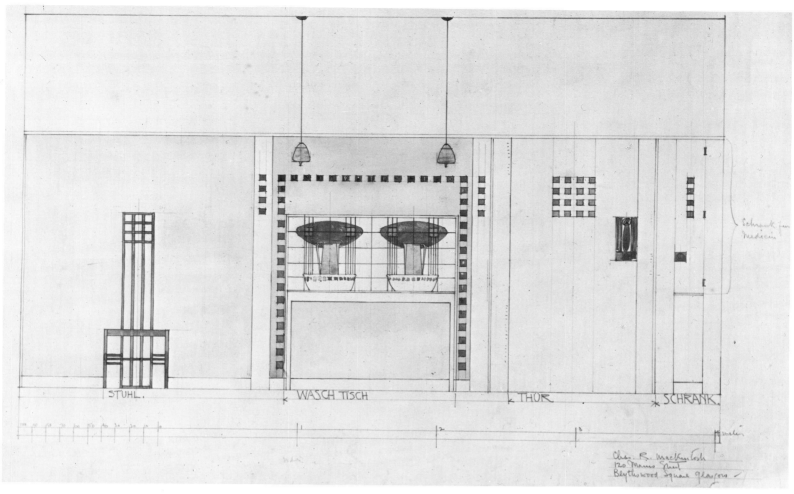

△D1903.80 D1903.81▷

D1903.79 **Design for a bedroom for the Dresdener Werkstätten für Handwerkskunst—fireplace wall**
Pencil and watercolour 33.4 × 51.3cm.
Signed and inscribed, lower right, *Chas R Mackintosh | 120 Mains Street | Blythswood Square Glasgow*; and *STUHL. FEUER PLATZ. STUHL*, and *Grau Papier auf die Wände | mit Schabloninung.*
Scale, 1 : 12.

The inscription indicates that the walls were to be hung with a grey paper and that darker squares were to be stencilled over the paper as indicated.

Literature: Alison, pp. *26*, 79, no 27.
Exhibited: Milan, 1973 (27).
Provenance: Mackintosh Estate.
Collection: Glasgow University.

D1903.80 **Design for a bedroom for the Dresdener Werkstätten für Handwerkskunst—entrance door wall**
Pencil and watercolour 35.2 × 51cm. (irregular).
Signed and inscribed, lower right, *Chas. R. Mackintosh | 120 Mains Street Blythswood Square, Glasgow*; and, *STUHL. WASCHTISCH. SCHRANK*, and *Schrank fur Medecine* [sic].
Scale, 1 : 12.

Literature: Alison, p. 79, no 28, p. *105*.
Exhibited: Edinburgh, 1968 (156); Milan, 1973 (28).
Provenance: Mackintosh Estate.
Collection: Glasgow University.

D1903.81 **Design for a bedroom for the Dresdener Werkstätten für Handwerkskunst—bed wall**
Pencil and watercolour 32.8 × 40.8cm.
Signed and inscribed, lower right but now erased, *Chas R Mackintosh | 120 Mains Street | Blythswood Square*; and, *NACHT TISCH mit Bretten oben für Caraf und Bücher. BETT. BETT. NACHT TISCH*. and, *Gestichten*

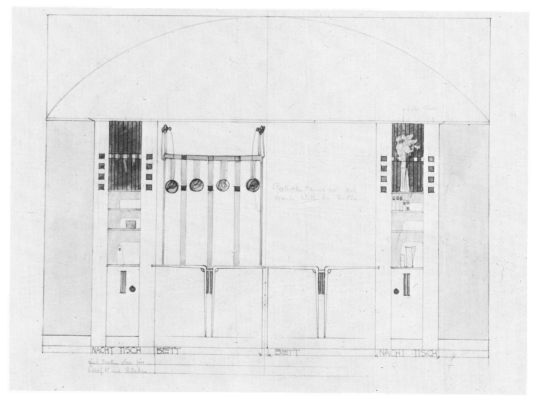

1903–04 **Bedroom for the Dresdener Werkstätten für Handwerkskunst**
This exhibition of the Dresdener Werkstätten was reviewed in *Deutsche Kunst und Dekoration* (XIII, 1904, pp. 212–22), accompanied by an indistinct photograph of the beds in the room designed by Mackintosh. No further details of Mackintosh's entry are available, other than the sole photograph (p. 246) and the somewhat terse comment, '*Mackintoshs Schlafzimmer is zur Zeit leider noch nicht fertig gestellt*' (Mackintosh's bedroom is unfortunately not yet ready for display). On the basis of the pieces shown in the photograph, one can assume that the rest of the furniture was eventually made; it may well have been purchased in Dresden, for, unlike so many other unsold items shown in continental exhibitions, it does not seem to have returned to Glasgow. The inspiration for the design, particularly the layout of the furniture and the architectural features, is the white bedroom at The Hill House. There is, however, a more definite commitment to the new

geometrical style—there are no naturalistic wall stencils and the square is the dominant decorative motif. This more rigorous decoration makes the designs appear even more severely elegant than those for The Hill House, but the wall colour, a pale grey with stencilled squares of a darker shade, would have relieved the dazzling effect of white furniture against white walls. The items contained in the room, none of which has survived, are again similar to those designed for The Hill House: two single beds, two fitted bedside cupboards, a sofa, linen cupboard, cheval mirror, dressing-table, fitted wardrobe, fireplace, medicine cupboard, wash-stand (all painted white), and three high-backed chairs and an armchair for the dressing-table (all stained black). There was a bow window, on a much larger scale than at The Hill House, and the ceiling over the bed-head, at least, was vaulted. Behind the bed was hung an embroidered panel which introduced the only note of organic decoration to the room: it was patterned with roses between a network of squares and straps, rather like the stencilling in the drawing-room at The Hill House. Other features, reminiscent of the Blackie's bedroom, are the concave glass-panelled recesses in the bedside cupboards, the decoration of the splash-back of the wash-stand, and the carved decoration at the foot of the beds.

D1903.82▽

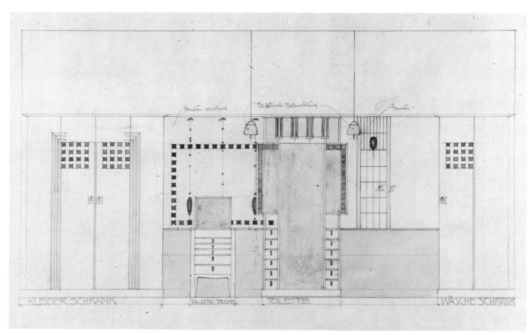

Panneaux am Wande hinter den Betten.
Scale, 1:12.

Literature: Alison, p. 79, no 29, p. *105.*
Exhibited: Milan, 1973 (29).
Provenance: Mackintosh Estate.
Collection: Glasgow University.

D1903.82 Design for a bedroom for the Dresdener Werkstätten für Handwerkskunst—window wall

Pencil and watercolour 35.4 × 49.8cm.
Signed and inscribed, lower right, *Chas. R. Mackintosh / 120 Mains Street / Blythswood Square Glasgow*; and *KLEIDER SCHRANK. TOILETTE TISCHE. TOILETTE. WASCHE SCHRANK.*; and *Fenster Gardine. Elektrisch Beleuchtung. Fenster.*
Scale, 1:12.

This drawing shows the simple glass lamp-shades intended for the room, and the embroidered curtains at the window. The wardrobe doors appear to be recessed and surrounded by a reed moulding. This kind of moulding around doorways and windows is seen again on the west elevation of the Glasgow School of Art and in the designs for Bassett-Lowke at Northampton.

Literature: Alison, p. 79, no 30, p. *105.*
Exhibited: Edinburgh, 1968 (156); Milan, 1973 (30).
Provenance: Mackintosh Estate.
Collection: Glasgow University.

1903.83 Bed for the Dresdener Werkstätten für Handwerkskunst
Wood, painted white.

The foot of the bed has a similar design to that made for The Hill House (1903.66). *See also* D1903.81. Two were made.

Literature: *Deutsche Kunst und Dekoration,* XIII, 1904, p. *246.*
Collection: untraced.

1903.84 Fitted bedside cupboards for the Dresdener Werkstätten für Handwerkskunst
Wood, painted white, with coloured glass inlay.

See D1903.81. Very similar to the cupboards designed for The Hill House, including the curved recess panelled with strips of coloured glass in lead canes.

Literature: *Deutsche Kunst und Dekoration,* XIII, 1902, p. *246.*
Collection: untraced.

1903.85 Sofa for the Dresdener Werkstätten für Handwerkskunst
Although it appears on the plan of the bedroom (D1903.78), this sofa is not shown in the photograph of the beds in *Deutsche Kunst und Dekoration.*

Collection: untraced.

1903.86 Fitted linen cupboard for the Dresdener Werkstätten für Handwerkskunst
Wood, painted white, with glass inlay.

See D1903.82.

Collection: untraced.

1903.87 Cheval mirror for the Dresdener Werkstätten für Handwerkskunst
Wood, painted white, with metal handles and glass inlay.

If the final piece followed the design in D1903.82, it showed affinities with both the Mains Street mirror (1900.26) and that at The Hill House (1903.57). The drawers for cuff-links come from the earlier design, while the arrangement of the top of the mirror is inspired by the Helensburgh piece. Some years later, in 1912, Mackintosh re-used the motif of the projecting side mirrors and their inlays of coloured glass in a design for a cheval mirror for a hair-dresser.

Collection: untraced.

1903.88 Dressing-table for the Dresdener Werkstätten für Handwerkskunst
Wood, painted white.

See D1903.82.

Collection: untraced.

1903.89 Fitted wardrobe for the Dresdener Werkstätten für Handwerkskunst
Wood, painted white, with glass inlay.

See D1903.80.

Collection: untraced.

1903.90 Chair for the dressing-table for the Dresdener Werkstätten für Handwerkskunst
Wood, (?) stained black or ebonised.

Although this chair is not shown on the drawing of the dressing-table or mirror (D1903.82), it does appear on the plan of the room (D1903.78). From this it seems possible that a more comfortable upholstered armchair was intended, rather than the simple stool provided at The Hill House.

Collection: untraced.

1903.91 Chair for the Dresdener Werkstätten für Handwerkskunst
Wood, stained black or ebonised.

In outline, very similar to the black chair in the bedroom at The Hill House. The emphasis is on the vertical, however, with no ladder-rungs and fewer horizontals in the chequer decoration at the top. If the executed piece closely followed the drawing (D1903.79), it would have been about 15cm. lower than The Hill House chairs. Three are shown on the plan (D1903.78).

Collection: untraced.

1903.92 Fireplace for the Dresdener Werkstätten für Handwerkskunst
Wood, painted white, with coloured glass inlay.

See D1903.79. Mackintosh designed an extremely simple wooden surround, providing a shelf and another of his curved recesses, panelled in coloured glass. The fire-surround appears, from the drawing, to have been a simple affair of cement relieved by insets of coloured glass or ceramic tile.

Collection: untraced.

1903.93 Medicine cupboard for the Dresdener Werkstätten für Handwerkskunst
Wood, painted white.

See D1903.80. A very simple item, fitted into the recess at the side of the door.

Collection: untraced.

1903.94 Wash-stand for the Dresdener Werkstätten für Handwerkskunst

Wood, painted white, with coloured glass panel.

If executed according to the design in D1903.80, the. pattern on the splash-back panel was a replica of the motif in the wash-stand at The Hill House (1903.52). However, the motif was repeated twice here, and the lower cupboards of the Blackie piece were not copied.

Collection: untraced.

1904.1 Clothes horse for the cloakroom, The Hill House, Helensburgh

John Craig quoted for a clothes horse at £7 (15 March, 1904) and was paid for one at £7.10.0d. (11 July, 1904).

The cost indicates a substantial piece, but it is no longer at The Hill House.

Collection: untraced.

1904.2 Umbrella stand for the cloakroom, The Hill House, Helensburgh

Ebonised pine 122 × 107.5 × 33cm.

No details of this piece appear in the job-books, but the design is unmistakably Mackintosh's and the stand harmonises with the other cloakroom furniture.

Collection: in situ (Royal Incorporation of Architects in Scotland).

The Hill House, Helensburgh

Mackintosh returned to designing the remaining movable pieces at The Hill House around mid-summer 1904, although some minor items were being sent out for quotation in the spring of 1904.

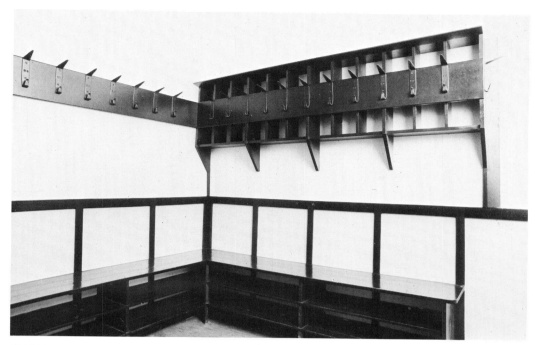

△1904.3

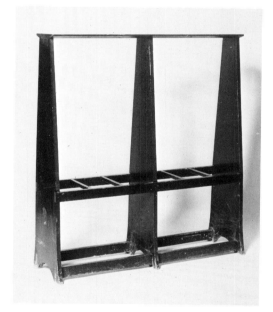

△1904.2

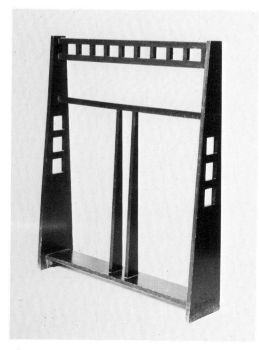

1904.5▽

D1904.4▽

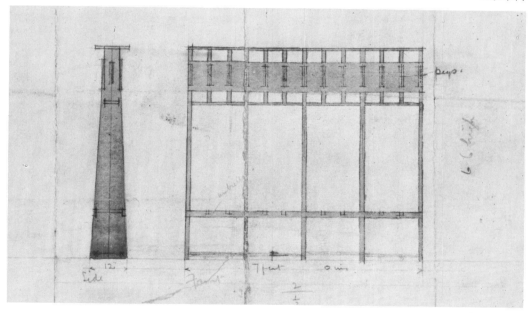

1904.3 Hat and coat rack for the cloakroom, The Hill House, Helensburgh

Ebonised pine 78 × 213 × 22cm.

The rack was attached to the wall in the cloakroom, not free-standing as in the drawing, D1904.4. It does not appear in the job-books, but it was probably made by John Craig, who provided other fittings for the cloakroom.

Collection: in situ (Royal Incorporation of Architects in Scotland).

D1904.4 Design for a coat rack for the cloakroom, The Hill House, Helensburgh

Pencil and watercolour 20.9 × 32.9cm.

Scale, 1:12.

This design was modified in execution, being altered from a free-standing piece to one that was fixed to the wall (see 1904.3).

Provenance: Mackintosh Estate.
Collection: Glasgow University.

1904.5 Towel rail for the cloakroom, The Hill House, Helensburgh

Ebonised pine 123 × 98 × 22.8cm.

John Craig was paid for a towel rail at £1.2.0d. (11 July, 1904).

Collection: in situ (Royal Incorporation of Architects in Scotland).

1904.6 Hall chair for The Hill House, Helensburgh

Oak, varnished, with rush seat 73.5 × 67 × 59cm.

John Craig quoted for four chairs at £3.10.0d. each (25 July, 1904) and was paid for three at £3.5.0d. each (19 September, 1904).

The hall at The Hill House was more than a simple reception area and was provided with its own furniture as a sitting-room. This chair, and the accompanying table, are rare examples for this date of Mackintosh leaving his timber unstained; here it was done to allow the warm tones of the oak to contrast with the darker hues of the panelling.

The geometrical motifs of the bedroom chairs (1903.58) are handled here in a bolder, more masculine way and the result is a very handsome and sturdy chair. The square cutouts around the apron of the seat are repeated more methodically in the lattice of the back-

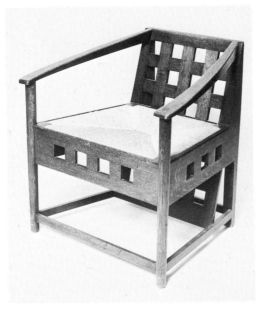

△1904.6

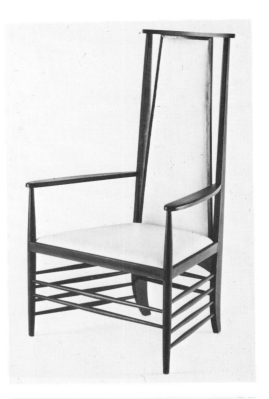

Literature: *Deutsche Kunst und Dekoration*, XV, 1905, pp. *348, 349*; Howarth, plate 40.
Exhibited: Paris, 1960 (1085).
Collection: *in situ* (Royal Incorporation of Architects in Scotland).

1904.8 Hall clock for The Hill House, Helensburgh

Pine, stained dark, with painted metal face and brass hands 174.5 × 47 × 22.5cm.
John Craig quoted for the case at £2 (25 July, 1904) and David Hislop quoted for the works at £5.10.0d. (27 July, 1904); Craig was paid £1.11.0d. (19 September, 1904) and Hislop £5.13.0d. (17 November, 1904).

Literature: *Deutsche Kunst und Dekoration*, XV, 1905, p. *349*; Howarth, plate 40.
Exhibited: Paris, 1960 (1089).
Collection: *in situ* (Royal Incorporation of Architects in Scotland). 1904.8 ▽

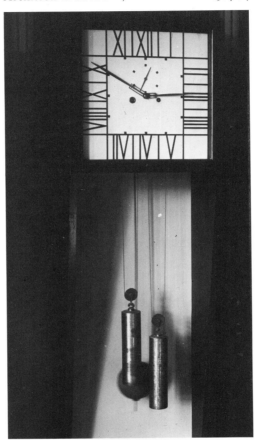

rest, which slopes forward and carries on beyond the seat to join the lower stretchers. The forward-sloping arms were repeated in the chairs designed for the Director's room at the Glasgow School of Art (1904.27 and 28).

Literature: *Deutsche Kunst und Dekoration*, XV, 1905, pp. *348, 349, 355*; Howarth, plates 39, 40; Alison, pp. 56–57.
Exhibited: Paris, 1960 (1084).
Provenance: a) and b) *in situ*; c) W. Blackie; Miss A. Blackie; Sotheby's Belgravia, 2 July, 1975, lot 234.
Collection: a) and b) Royal Incorporation of Architects in Scotland; c) untraced.

1904.7 Hall table for The Hill House, Helensburgh

Oak, varnished 74 × 153 × 75.5cm.
John Craig quoted for one at £7 (25 July, 1904) and was paid that sum (19 September, 1904).

Mackintosh has used a network of stretchers to create a rigid pattern of interlocking spars; in some later designs he added extra pieces between the stretchers to create a chequer pattern. Unlike the earlier oval table (1902.1), the legs are placed here at right-angles to each other, and do not follow the curve of the table top, which is, in any case, cut straight at the ends instead of completing the oval. The square cut-outs in the legs match similar motifs in the hall chairs.

 ▽1904.7

 1904.10 ▷

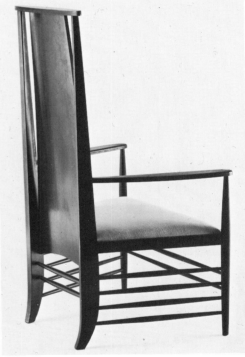

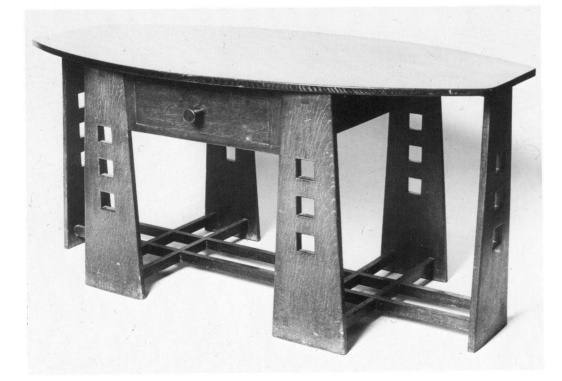

1904.9 Easy chair for the drawing-room, The Hill House, Helensburgh

Francis Smith quoted for a chair at £7 (15 September, 1904) and was paid for one at £8.10.0d. (6 December, 1904).

Mrs Alison Walker, the eldest of Walter Blackie's daughters, identified this chair as a replica of the lug chair designed for Mackintosh's flat at 120 Mains Street (*see* 1900.5). This explains the appearance of a sketch of the lug chair on the back of a drawing of *c*1904 which seems to relate to the fittings in the drawing-room at Hous'hill (D1904.55). Mrs Walker recalled that the chair had been cut down and later consigned to the servants hall after which, she thought, it was eventually destroyed.

Collection: untraced, probably destroyed.

1904.10 Armchair for the drawing-room, The Hill House, Helensburgh

Ebonised oak, with upholstered seat and back 114.5 × 69.8 × 55cm.
Alex Martin quoted for two at £5 each (15 September, 1904) and for a further two at the same price (17 November, 1904); he was paid for two at £4.5.0d. each (17 December, 1904)

1904.8A *See* addenda

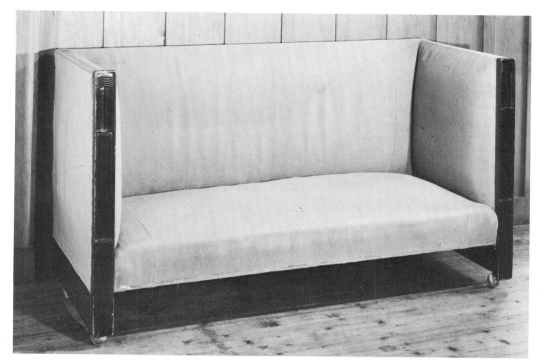

△1904.11

D1904.12▽

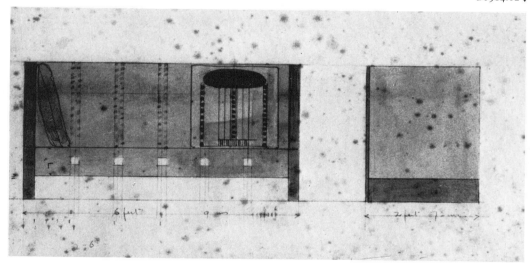

and for a further two at £4.17.6d. each (27 April, 1905). Crawford and Craig were paid £2.15.0d. for four embroidered decorative covers (8 December, 1905).

A variant of the armchair designed for 14 Kingsborough Gardens; the main difference, apart from the colour, is in the number and arrangement of stretchers.

Literature: Macleod, plate 71.
Exhibited: VEDA, 1952 (R9).
Provenance: a), b) and c) *in situ*; d) Walter Blackie, by family descent to D. Bisacre; Sotheby's, 17 April, 1967, lot 220.
Collection: a), b) and c) *in situ* (Royal Incorporation of Architects in Scotland); d) untraced.

1904.11 Couch for the drawing-room, The Hill House, Helensburgh

Mahogany, stained dark, with upholstered seat and back 99 × 182.5 × 77cm.
Francis Smith quoted for a couch at £14.10.0d. (15 September, 1904) and was paid for one at £12.10.0d. (6 December, 1904). Crawford & Craig were paid £3.14.0d. for five cushions for the drawing-room (31 March, 1905).

Not as high as the easy chair was reputed to be, but still a piece of furniture very much in the same style. The two of them, turned to face the fire, proved to be a very effective screen, thus creating a distinct winter section of the drawing-room in the area round the fireplace.

Collection: *in situ* (Royal Incorporation of Architects in Scotland).

D1904.12 Design for a couch for the drawing-room, The Hill House, Helensburgh

Pencil and watercolour 28.5 × 44.5cm.
Inscribed and dated, lower right, *140 Bath Street | Glasgow 1904*; inscribed, upper left, *Walter W. Blackie Esqr. The Hill House Helensburgh. | Scale drawing of couch for Drawing Room.*, and, lower right, *To be made in Oak or Mahogany*

Stained dark & French polished (exposed parts) | Price to include spring seat, upholstery & (covering, with material to be supplied. | 4 castors—delivering & fitting up at Helensburgh; and various notes and measurements.
Scale, 1:12.

The design for 1904.11, almost as executed but, as the original covering has disappeared, it is not known whether the chequer decorations on the back-rest were carried out.

Provenance: Mackintosh Estate.
Collection: Glasgow University.

1904.13* Writing desk for The Hill House, Helensburgh

Ebonised oak, with mother-of-pearl, metal and glass 122 × 94 × 45.8cm.
Alex Martin quoted for a desk at £19.10.0d. (28 November, 1904) and was paid for one at £20.15.6d. (27 April, 1905); McCulloch was paid £1.5.0d. for glass (also on 27 April, 1905).

There was obviously some discussion between Blackie and Mackintosh about the shape and style of this desk, as a number of alternative designs exist (D1904.14–16). There can be no doubt that Mackintosh was satisfied with the chosen design, as he made a replica for his own use. The metal and glass panel inside the desk is like several others in similar cupboards and desks, but the major innovation here is the extensive use of mother-of-pearl. Mackintosh used the material on later designs for The Hill House and 78 Derngate, Northampton, but

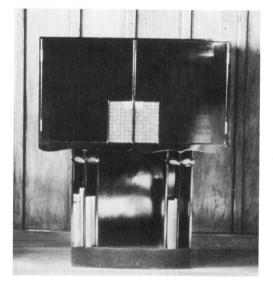

△1904.13

1904.13▽

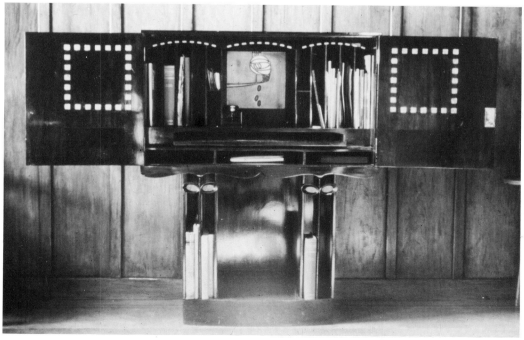

its appearance here marks the first of a number of pieces which were more consciously luxurious and well-finished.

Exhibited: b) Memorial Exhibition, 1933 (not in catalogue).
Provenance: a) Walter Blackie; b) C. R. Mackintosh; Margaret Macdonald Mackintosh, sold at Memorial Exhibition, 1933. Collection: a) Dr Thomas Howarth; b) private collection.

D1904.14 Design for a writing cabinet for The Hill House, Helensburgh
Pencil and watercolour 31.1 × 40cm. (irregular).
Inscribed and dated, lower right, *140 Bath Street | Sept 1904* and *140 Bath Street Glasgow 1904*; inscribed, upper left, *WALTER BLACKIE ESQR | THE HILL HOUSE HELENSBURGH WRITING CABINET*; and various other notes.
Scale, 1:12. D1904.14▽

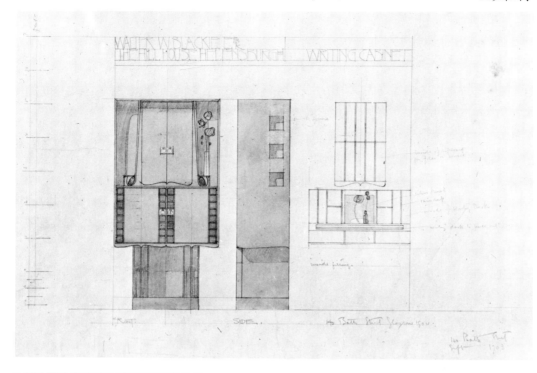

Probably the first design for a desk for Blackie which, for reasons not known, was rejected. It does seem a particularly awkward design: over 1.5 metres high and standing on a base only 60cm. wide. In the side elevation, Mackintosh has changed his original idea of a tall, narrow oblong opening (as used on the Turin desk, 1902.8) for a series of three 15cm. square cutouts. The front legs were retained in the final design, along with the double ogee curved apron above. The writing section and the upper cupboard must have struck a chord with either Blackie or Mackintosh, since they were repeated on a larger scale in the cabinet designed the following month (*see* D1904.21 and 1904.20).

Literature: Alison, p. 78, no 17.
Exhibited: Edinburgh, 1968 (154); Milan, 1973 (17).
Provenance: Mackintosh Estate.
Collection: Glasgow University.

D1904.15 Design for a writing cabinet, The Hill House, Helensburgh
Pencil and watercolour 29.4 × 43.9cm.
Inscribed and dated, lower right, *140 Bath Street Glasgow 1904*; inscribed, upper left, *Sketch for Writing Cabinet No 2. for Walter W. Blackie Esq.*; inscribed, centre right, with a description of the interior fittings, *glass mosaic panel, account files etc, note paper | & envelopes*.
Scale, 1:12.

This drawing and D1904.16 were probably presented together to Blackie for him to make the final choice. The design has antecedents in the Diack desk (1901.1) and the desk designed for the Director's room at the School of Art in January 1904; it is much more severe than either of the other two alternatives which Mackintosh gave to Blackie and, like D1904.14, it was rejected by the client.

Provenance: Mackintosh Estate.
Collection: Glasgow University.

D1904.16 Design for a writing cabinet and chair for The Hill House, Helensburgh
Pencil and watercolour 26.5 × 45.8cm.
Inscribed and dated, lower right, *140 Bath Street Glasgow. 1904*; inscribed, upper left, *Sketch for Writing Cabinet No 1 W W. BLACKIE ESQR*; various inscriptions describing interior fittings, etc.
Scale, 1:12.

This design was accepted by Blackie, and it differs only in minor details and some dimensions from the executed piece. The fluted legs and double ogee apron are both taken from the original drawing (D1904.14), but the writing section is here much lower and far more restrained than that earlier design. Also included in the drawing are the candlestick (1904.18) and the ebonised chair designed specifically to accompany the desk (1904.17).

Literature: Alison, p. 78, no 18.
Exhibited: Milan, 1973 (18).
Provenance: Mackintosh Estate.
Collection: Glasgow University.

1904.17 Chair for The Hill House, Helensburgh
Ebonised wood 111 × 40.6 × 42cm.
Alex Martin quoted for one at £2.15.0d. (30 November, 1904) and was paid £3 (27 April, 1905).

This chair was designed to accompany the writing desk (1904.13); Mackintosh also made one for himself to use with his own replica of Blackie's desk. It is similar to the black bedroom chairs (1903.58) with its simple geometrical shape and pattern, but is a more substantial chair. Mackintosh had already used the lattice square motif on bedroom chairs for Hous'hill (1904.73 and 93) and on the order desk chair

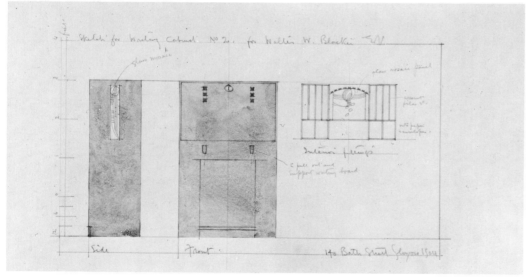

△D1904.15 D1904.16▽

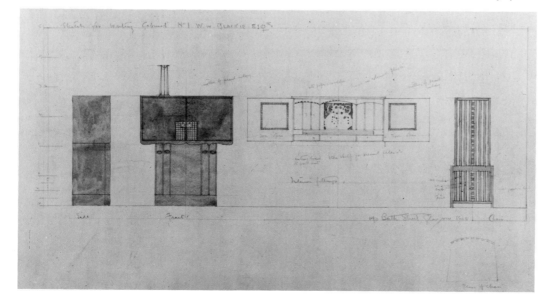

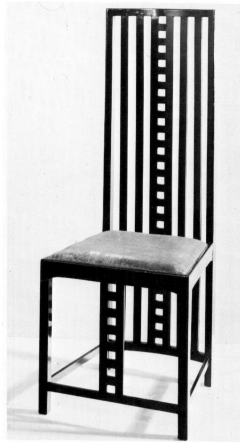

△1904.17

at the Willow Tea Rooms (1904.24); here his use of the motif is more restrained and classical in effect.

Literature: Alison, pp. *70, 71, 100*.
Exhibited: b) Memorial Exhibition, 1933 (not in catalogue); Edinburgh, 1968 (247, plate 26); Darmstadt, 1976–77, vol. 2, no. 93.
Provenance: a) Walter Blackie; anonymous sale, Sotheby's Belgravia, 2 July, 1975, lot 223; b) C. R. Mackintosh; Margaret Macdonald Mackintosh; purchased at Memorial Exhibition by W. Somerville Shanks, by whom presented.
Collection: a) untraced; b) Glasgow Art Galleries and Museums.

1904.18 Candlesticks for The Hill House, Helensburgh

Ebonised wood, with mother-of-pearl and silver 30.5 × 15 × 15cm.
Alex Martin quoted £2.10.6d. for three (4 February, 1905) and David Hislop quoted £1.17.10d. for silver cups (4 February, 1905); both were paid these sums (on 27 April and 29 March, 1905, respectively).

Although only three candlesticks were commissioned and paid for, there exists a fourth example, making two pairs. Each candlestick has a square base, four tapering legs

▽1904.18

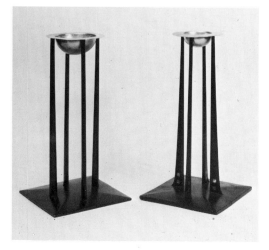

△1904.19

and circular cups, but in two of them the legs are plumb and in the other two the legs come towards each other at the top. Blackie owned two and Mackintosh the other two, but each set consisted of one example of each design. The pairs were, therefore, deliberately non-matching.

Although quotations were not received until February 1905, one candlestick appears on Mackintosh's design for the writing cabinet for Blackie (D1904.16), drawn in October 1904. All three items shown in this drawing—chair, writing desk and candlestick—were duplicated by Mackintosh for his own home.

Exhibited: pair b) Memorial Exhibition, 1933 (not in catalogue); Edinburgh, 1968 (253 and 254).
Provenance: pair a) Walter Blackie; by family descent; pair b) C. R. Mackintosh; Margaret Macdonald Mackintosh; purchased at Memorial Exhibition, 1933 by Alexander Kennedy; by family descent.
Collection: pair a) Mrs Alison Walker (*née* Blackie); pair b) private collection.

1904.19 Dressing-table stool for the main bedroom, The Hill House, Helensburgh

Ebonised wood, with upholstered seat 40.6 × 40.6 × 40.6cm.
Alex Martin was paid for one (24 November, price not given, but included in the gross sum of £7.17.6d. with two chairs, 1903.58).

This stool does not appear on any of the 1903 drawings for the main bedroom at The Hill House (*see* D1903.46), but it was made to match the two ladderback chairs.

Literature: *Deutsche Kunst und Dekoration*, XV, 1905, pp. *351, 353*; Howarth, plate 42.
Exhibited: Edinburgh, 1968 (242).
Provenance: Walter Blackie; by family descent.
Private collection.

1904.19A Oval tea table for the drawing-room, The Hill House, Helensburgh

Ebonised wood 61 × 94 × 50.8cm.
Alex Martin quoted for a table at £4.15.0d. (17 November, 1904) and was paid for one (27 April, 1905). Crawford & Craig were paid for one table centre at £2.10.0d. (8 December, 1905).

A variant of 1902.1, but by no means as subtle or elegant. The device of splitting the upper part of the leg into three parts is a repetition of the motif used in the Hous'hill table (1904.51).

1904.19A △

Exhibited: Edinburgh, 1968 (246).
Provenance: Walter Blackie; Agnes Blackie; Sotheby's Belgravia, 27 November, 1975, lot 238.
Collection: untraced.

1904.20 Cabinet for the drawing-room, The Hill House, Helensburgh

Ebonised pine, with glazed upper doors, mother-of-pearl and stained sycamore inlay 66.6 × 152.6 × 43cm.
Alex Martin quoted for one at £27 (28 November, 1904) and was paid £30.18.0d. (27 April, 1905, plus 7.0d. to McCulloch for glass).

The largest and certainly one of the most expensive movable pieces designed for The Hill House. Certain features originated in the rejected design for a writing desk (D1904.14) of September 1904. The concept of the central upper cupboard, with storage at either side, above another full-width cupboard is repeated on a larger scale. There are obvious differences —the upper cupboard has glazed doors and the lower cupboard sits only on a low plinth, not a desk-height base—but the decorative use of squares of stained sycamore is carried over, as is the ogee curve on the bottom edge of the glazed doors.

Like the fitted cabinet at Hous'hill, the sections of this piece are complicated and the spatial relationship of the different elements of the design cannot be appreciated from the elevational drawing (D1904.21). The glazed cupboard tapers towards the top and is very slightly bowed; at the same time it slopes backwards from base to top, but at no point does it project beyond the frontal plane of the cabinet. In the centre of the piece, between the pairs of drawers and directly below the

1904.20▽

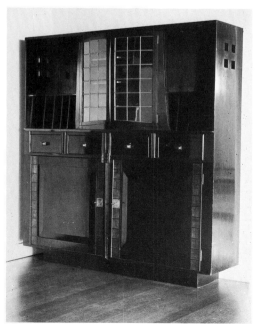

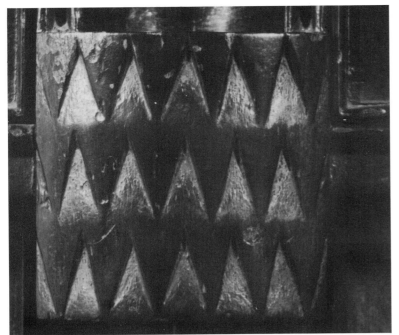

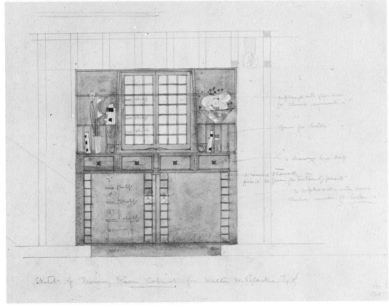

△1904.20 detail ▽D1904.21 1904.23▷

point of the ogee curve of the glazed doors, is a semi-circular niche set above a carved boss. One is reminded of the larger niches and pedestals incorporated into the west front of the Glasgow School of Art, 1907–09, and on a smaller scale, of similar features in the Northampton designs of 1915–18. The boss itself is most interesting, as its decoration takes the form of overlapping inverted triangles. Again, the triangle is a favourite motif in the Northampton designs, and Howarth (p. 202) believed that Mackintosh was inspired to use it after seeing Urban's triangular patterns in 'The Art Revival in Austria' *The Studio Special Number*, 1906. Mackintosh used the triangle on a design for a screen for Windyhill (D1905.2 and 3), and also used it in a similar manner on a carved boss at Scotland Street School, designed in 1904 and completed in 1906. Considering the gradual change to geometrical shapes and patterns in his furniture designs of 1903–04, it is not surprising that he should experiment with the triangle as well as the square, circle and ellipse and there does not seem to be any Viennese use of the triangle which would pre-date this cabinet.

Exhibited: Edinburgh, 1968 (243).
Collection: *in situ* (Royal Incorporation of Architects in Scotland).

D1904.21 Design for a cabinet for the drawing-room, The Hill House, Helensburgh

Pencil and watercolour 26.8 × 40.6cm.
Inscribed and dated, lower right, *140 Bath Street | Oct 1904*; inscribed, lower centre, *Sketch of Drawing Room Cabinet for Walter Blackie Esq*, and, centre right, *cupboard with glass doors | for china, ornaments etc, | spaces for books, 4 drawers 6 ins deep, sycamore stained | price to be given for mother of pearl, 2 cupboards with doors | shelves inside for books etc.*
Scale, 1 : 12.

Virtually as executed. The drawing does indicate, however, that Mackintosh considered using mother-of-pearl instead of the stained sycamore in the decoration of the doors. Such an extensive use would have reinforced the more luxurious appearance of this piece, like the desk for the same room (1904.13) but its high cost would undoubtedly have caused Blackie to reject it.

Provenance: Mackintosh Estate.
Collection: Glasgow University.

1904.22 Toy cupboard for the school-room, The Hill House, Helensburgh
Pine.
John Craig was paid £15 (11 July, 1904).

A functional and hard-wearing design, providing storage space and a play surface for the Blackie children in their own room on the second floor at The Hill House.

Collection: *in situ* (Royal Incorporation of Architects in Scotland).

1904.23 Hat, coat, and umbrella stand for the Room de Luxe, Willow Tea Rooms, Glasgow
Mahogany, silver painted, with steel hooks and brass drip tray 200 × 30.8cm. (diameter of base).
Francis Smith quoted for four at £1.5.0d. each (16 May, 1904) and was paid the same (8 December, 1904); Andrew Hutchinson quoted for 'hat hooks' for the Ladies' Room at £4.4.0d. (no quantity specified, September 1904) and was paid that sum (20 October, 1904).

Apparently designed some time later than the rest of the furniture for the Willow Tea Rooms. Although only two stands are visible in contemporary photographs (one either side of the gesso panel), it seems probable that another two flanked the fireplace on the opposite side of the room.

Literature: Howarth, plate 56c; Pevsner, 1968, plate 39; McLaren Young, plate 27.
Provenance: Grosvenor Restaurant, from which purchased.
Collection: Glasgow School of Art (1).

1904.24 Curved lattice-back chair for the Order Desk, Willow Tea Rooms, Glasgow
Ebonised oak 118.2 × 94 × 42cm.
Francis Smith quoted for a 'chair at Order Desk' at £4.2.6d. (1 February, 1904) and was paid that sum for one 'semicircular chair' (8 December, 1904).

One of the most impressive and novel of Mackintosh's chairs, it stood in the centre of the ground-floor saloons, isolated and defining the point at which the white Front Saloon became the dark Back Saloon. Designed six months before the curved screen at Hous'hill (1904.49), it plays the same role in acting as a transparent division between two spaces which are actually part of the same room.

The chair is not semi-circular but segmental, and the design, which appears to be straight-forwardly based upon simple geometrical forms, has other subtleties which become apparent on closer inspection. The chequer-work of the back forms a pattern of a stylised tree, another reference to willow trees, and the lattice is made from short horizontal insets between the continuous verticals, as opposed to the use of alternate checking of the slats as in the Hous'hill bedroom chair (1904.93). The front of the seat, which also serves as a small locker or chest, projects beyond the two sides and then slopes gently backwards towards the bottom until it finishes within them. The base runs along this front panel, but at either end curves out to meet the side members.

The chair was provided for the supervisor who took orders from the waitresses and passed them to the kitchen below by dropping coloured balls, coded to each dish on the menu, down a tube to the kitchen below.

Literature: *Dekorative Kunst*, XIII, 1905, p. 260; Howarth, plate 54; Bliss, fig. 63; Glasgow School of Art, *Furniture*, no 10; Macleod, plate 38; Alison, pp. 66, 67, 103.
Exhibited: Edinburgh, 1968 (264).
Provenance: The Grosvenor Restaurant, from which purchased.
Collection: Glasgow School of Art.

D1904.25 Design for the chair at the Order Desk, Willow Tea Rooms, Glasgow
Pencil and watercolour 49.5 × 44.5cm. (sight).
Inscribed, upper right, *Miss Cranstons Sauchie-hall Street | Drawing of Chair at Order Desk | 1 wanted* and, lower right, *140 Bath Street | Glasgow Jany 1904*.
Scale, 1 : 12.

The drawing for 1904.24.

Collection: Dr Thomas Howarth.

1904.22A–C *See addenda*

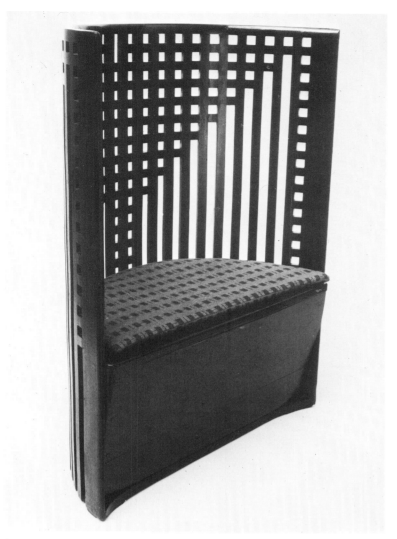

△1904.24

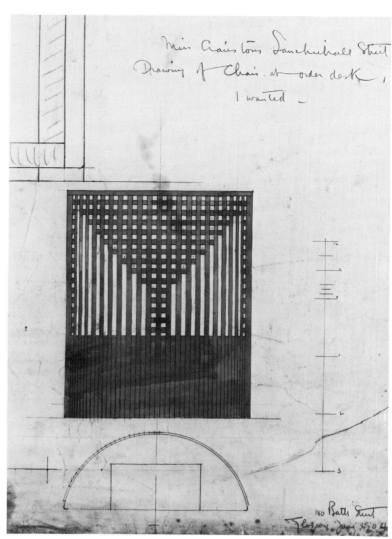

△D1904.25

1904.27▽

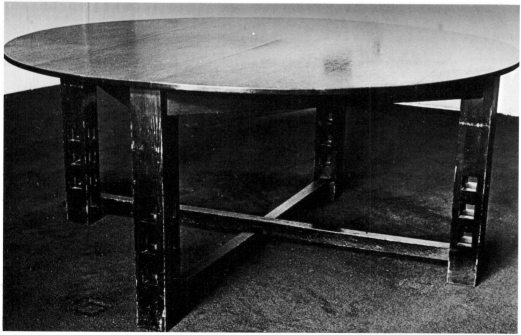

△1904.26

1904.26 Circular table for the Director's Room, Glasgow School of Art

Oak, stained dark 80.5 × 182cm. (diameter).
Alex Martin quoted for one at £10 (15 August, 1904) and was paid £7.7.6d. (21 September, 1904).

There are no records of any special furniture being designed for the Director's Room during the first phase of construction, 1897–99. Mackintosh was frequently involved in minor works at the School between 1899 and 1907, but the two major schemes involving furniture and fittings were for the Director's Room in 1904 and the Board Room in 1906.

This large table may well have been designed for meetings of the Board of Governors, who rarely used the original Board Room which was eventually taken over as a studio. It was designed with two high-backed armchairs and twelve low-backed armchairs and was photographed in 1910 in the new Board Room which Mackintosh had provided for the Governors, and not in the Director's Room for which it was designed and where it can now be seen.

The square is again the dominant motif in this group of designs. The table legs are square, but they are hollow, and square cut-outs in them indicate the construction.

Literature: Howarth, plate 90; Bliss, figs. 26, 34.
Collection: Glasgow School of Art.

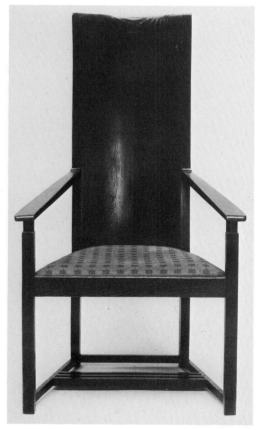

1904.27 Armchair with high back for the Director's Room, Glasgow School of Art

Oak, stained dark 130 × 68 × 65.2cm.
Alex Martin quoted for two armchairs at £4.5.0d. each (15 August, 1904) and was paid for two at £3.15.0d. each (21 September, 1904).

Literature: Howarth, plate 90; Bliss, figs. 26, 34.
Collection: Glasgow School of Art.

159

1904.28 Armchair with low back for the Director's Room, Glasgow School of Art

Oak, stained dark 81.5 × 58.5 × 52cm.
Alex Martin quoted for 12 at £1.18.0d. each (15 August, 1904) and was paid that sum for 12 (21 September, 1904).

The motif of a group of nine squares, arranged in rows of three, had been used in the bedroom furniture at The Hill House in 1903. Although 12 chairs were made for the School, William Davidson seems to have acquired a further two, with six of 1905.1, for use as dining chairs in his hall at Windyhill (see 1905.1).

Literature: Bliss, figs. 26, 34, 35; Macleod; plate 38; Alison, pp. *38, 39*.
Provenance: a) *in situ* Glasgow School of Art; b) William Davidson; Hamish Davidson, by whom bequeathed.
Collection: a) Glasgow School of Art (12); b) Glasgow University (2).

D1904.29 Design for the Director's desk, Glasgow School of Art

Verso: rough sketches of a desk or dressing-table.
Pencil and watercolour 38 × 70.2cm.
Inscribed and dated, lower right, *140 Bath*

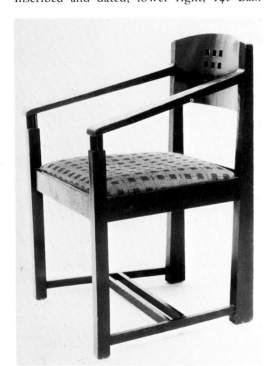

Street / Glasgow Jany 1904; inscribed, lower left, *The Glasgow School of Art / Drawing of Writing Table for Headmasters Room*, and various other notes, in another hand, *Desk not to exceed £10 P.S.D.*
Scale, 1:12.

Howarth (p. 90) relates how, when the Director's office furniture was designed in 1904, it had to be approved by Patrick S. Dunn, chairman of the Art Finance Committee of the Glasgow School of Art: this drawing bears his note of approval, with the condition that the cost of the desk should not exceed £10. No desk corresponding to this design appears in the 1910 photographs of the Director's Room, however, and Howarth (*ibid*) states that this design was never executed. (There is no record of the manufacture of the desk at present used by the Director.)

This design is probably the second in the series of three quite similar writing tables, the first being 1901.1, and the final one the desk for The Hill House, 1904.13. Larger and more elaborate than the other two, it must easily have exceeded the financial limits placed upon it by Mr Dunn (1904.13 cost £22.0.6d.)

Provenance: Mackintosh Estate.
Collection: Glasgow University.

D1904.30 Design for the light fittings for the Director's Room, Glasgow School of Art

Pencil 46.9 × 34.7cm.
Inscribed and dated, right, *140 Bath Street / Glasgow Feb 1904.*; and inscribed, lower left, *Glasgow School of Art / Electric Fittings for Headmasters Room.* and, lower right, *Plan showing position of lights.*
Scale, 1:8.

This plan indicates that Mackintosh intended to fit 9 lamps into the room, on a square plan, with one in the vestibule outside. His scheme was never carried out, probably because of the likely cost at a time when the Governors were keeping a careful eye on expenses.

Provenance: Mackintosh Estate.
Collection: Glasgow University.

D1904.31 Design for light fittings for the Director's Room, Glasgow School of Art

Pencil, pen and ink, and watercolour 42.8 × 31.2cm. (irregular).

The familiar motif of a group of nine squares is

◁1904.28 D1904.29▽

△D1904.30 D1904.31▽

repeated here, although the central row is somewhat awkwardly broken on the corners of each fitting. It is difficult to say how effective the design would have been, for, without the downward reflector which Mackintosh usually provided on these small fittings, much of the light would have been lost upwards.

Provenance: Mackintosh Estate.
Collection: Glasgow University.

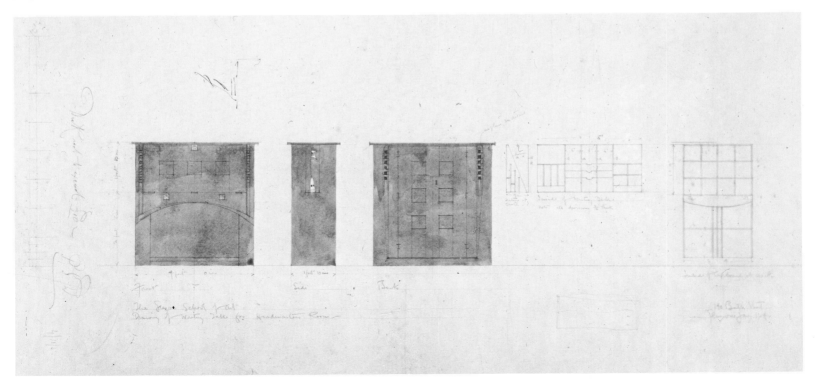

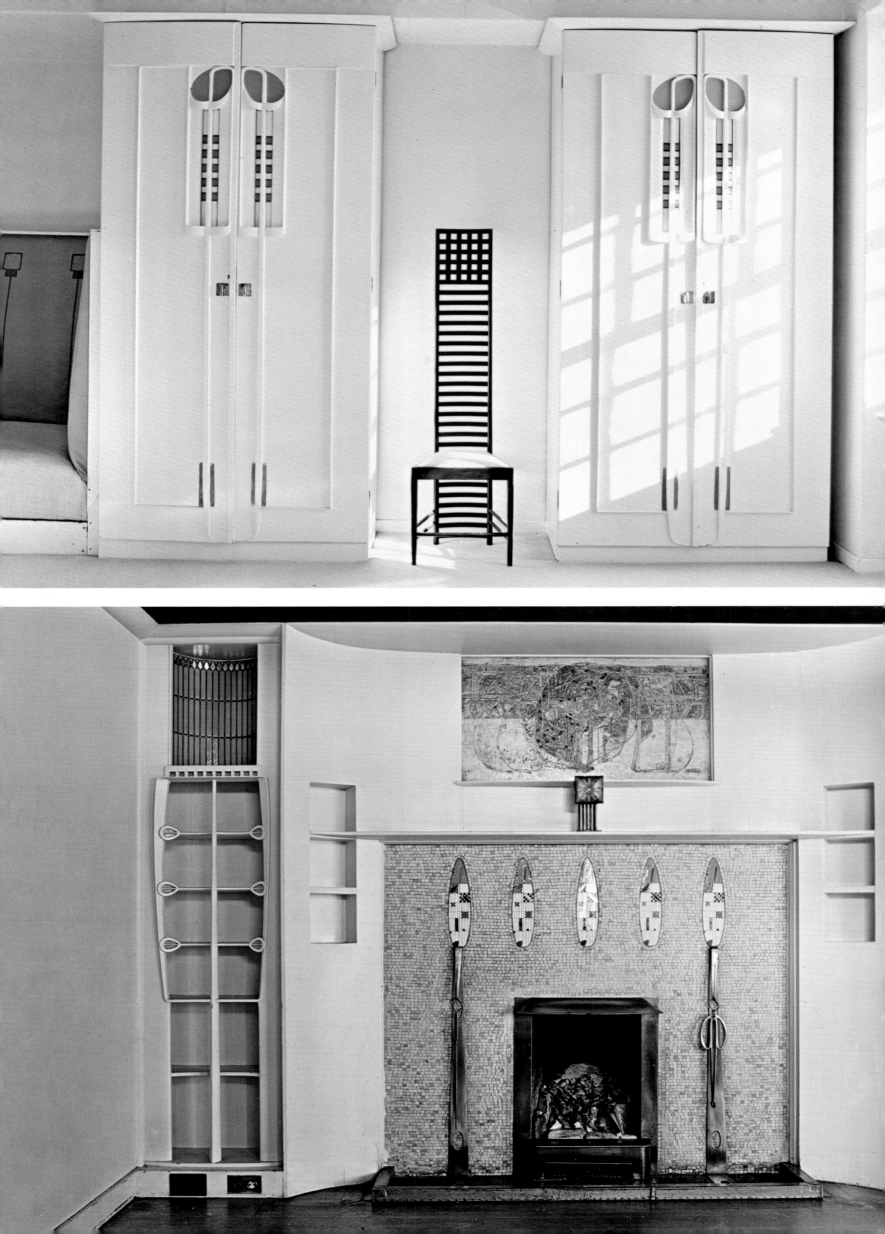

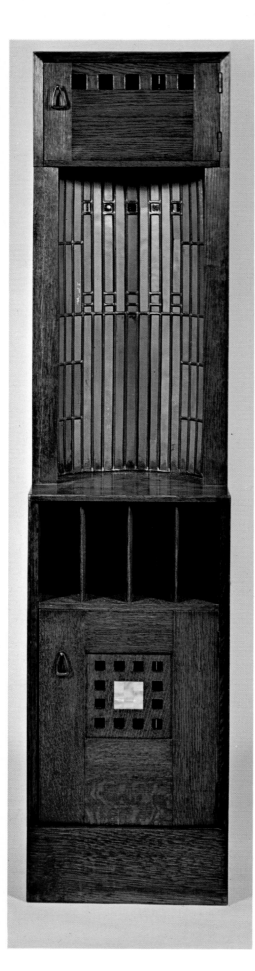
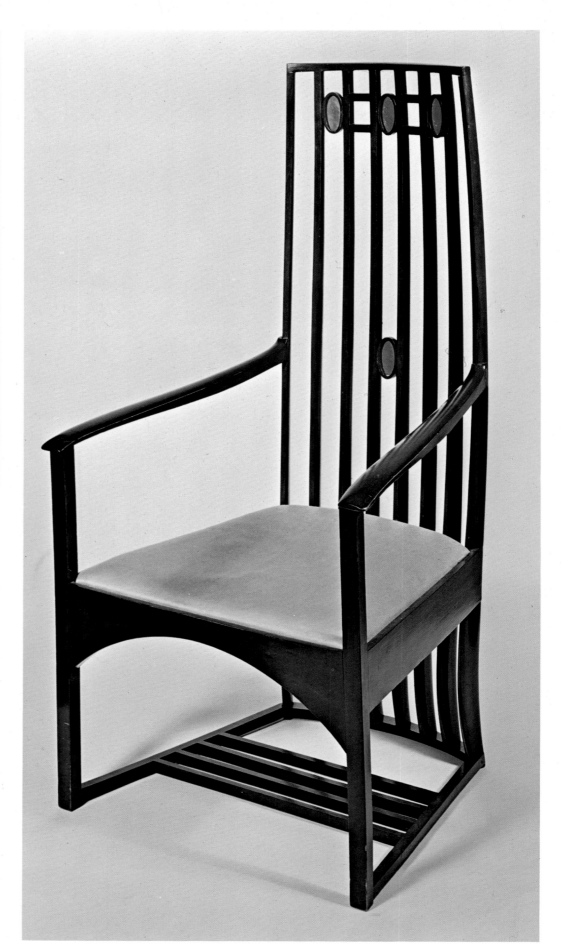

△1904.A 1904.B▽

1904 Hous'hill, Nitshill, Glasgow

Miss Cranston and her husband, Major Cochrane, lived at Hous'hill and in 1903–04 invited Mackintosh to redecorate the interiors of the house and design several items of furniture. Although Mackintosh apparently made no alterations to the outside of the house, he had an almost free hand inside and designed more furniture here than he had been able to for Walter Blackie at The Hill House. Howarth gives a good account of the house (pp. 114–17) and its eventual fate: Miss Cranston had left it in about 1920 and, after changing hands several times, it caught fire and was bought and demolished by Glasgow Corporation; the fittings were destroyed but many items were sold at auction in Glasgow on 18 August, 1933; since then, most of them have disappeared. Much of Howarth's information about the house came from William Ward who knew it well and eventually acquired some of the furniture at auction. His recollections of the house and the surviving photographs give us a very clear idea of the work done in 1904–05. The later work, such as the Card Room of 1909, was not photographed, and Howarth's account of the work at Hous'hill incorrectly suggests that it had been executed in 1904 along with the other rooms.

Hall and vestibule

Mackintosh paved the vestibule floor with stone slabs, apparently forming wide joints covered with iron straps set flush. Some of the square slabs were incised with a floral pattern; this was taken up over the walls in the stencilled decoration of stylised roses and black trellis-work. This was a motif which Mackintosh repeated in his own dining-room at 78 Southpark Avenue in 1906. Real flowers in pots or vases were arranged on a stand, again in the form of a trellis—as the square was to be the dominant motif at Hous'hill—made of wood, not wrought-iron, as stated by Howarth. On the floor stood four gas-fuelled wrought-iron lanterns, imitating braziers. The hall floor was covered by a horsehair carpet which continued up the stairs. The carpet was sewn in such a way that it imitated a picture frame, with four pieces mitred together around a central square, defined by a black band. Wrought-iron hat hooks and umbrella baskets were rather more curvilinear than the severe hall dresser. This splendid piece was a composition of squares, solid and void, relieved by the gentle convex curve of a band of drawers along one of the shelves. The stencils on the wall, at high level on the staircase, recall the motifs used in the hall stencils at The Hill House, but each unit is larger and more elaborate. Again, the square is evident, but tempered here by more organic shapes. The lantern, a series of simple metal and glass boxes, likewise echoes its counterpart at The Hill House.

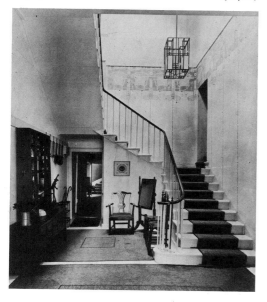

1904.A Vestibule at Hous'hill, Nitshill, Glasgow

Collection: Glasgow University.

1904.B Hall and staircase, Hous'hill Nitshill, Glasgow

Collection: Glasgow University.

1904.C Billiards Room, Hous'hill, Nitshill, Glasgow
A view looking towards the fireplace ingle with its twin screens of billiard cue-like posts.

Collection: Glasgow University.

▽1904.C 1904.D▷

1904.D Billiards Room, Hous'hill, Nitshill, Glasgow

The glazed side of the fireplace ingle is on the left. The photograph also shows the chair, high chair and table designed for the room (1904.37, 38, and 39) which have since disappeared.

Collection: Glasgow University.

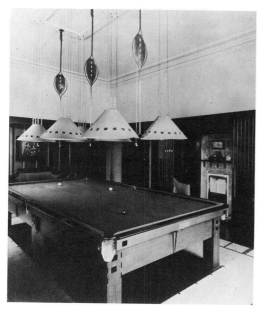

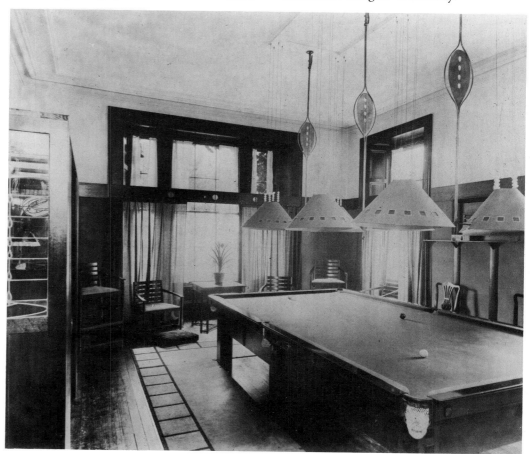

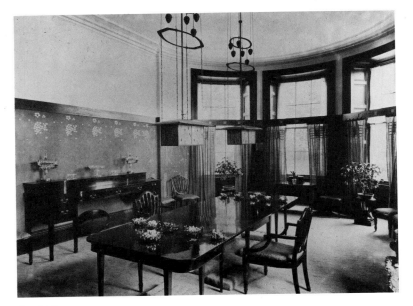

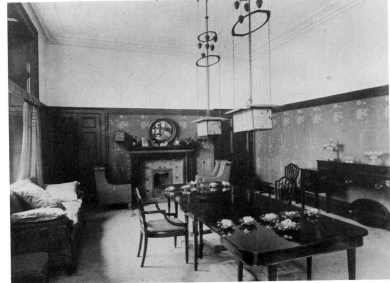

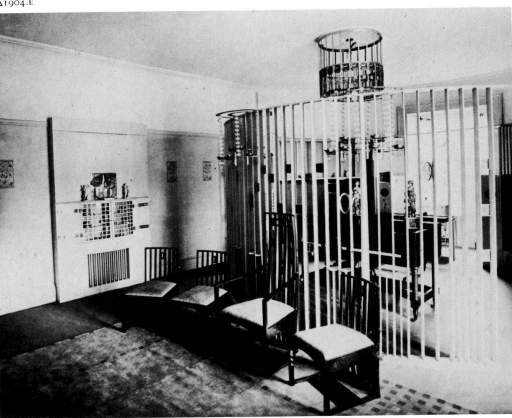

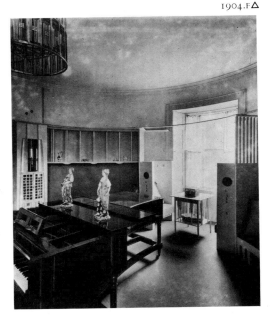

Billiards Room

Mackintosh's designs for a billiards room at The Hill House were never executed, so this was his only domestic rendering of a room much in demand in Miss Cranston's Tea Rooms. Like those more public rooms, it was predominantly dark but definitely not as spartan. The embroidered curtains and pale patterned carpet relieved the sobriety of this gentleman's retreat, and the resulting atmosphere was much more refined than that of the basement rooms at Ingram Street, for instance. The table itself was decorated with applied ceramic or coloured wood squares, and the conical shades over it had applied squares as decoration. The walls, divided by wide vertical straps, were covered with a dark paper to picture-rail height; where the rail passed across the window openings, it was inlaid with transparent glass to catch the light (a feature repeated in the studio at 78 Southpark Avenue). No fixed benches were provided, although some of the chairs were raised on longer legs to give a better view of the table. The fireplace formed an ingle, with two armchairs screened from the rest of the room by a screen of tapering rods: a play on the shape of a billiards cue. The grate itself was of the usual simple wrought-iron, here surrounded by cement inlaid with ovals of glass and inverted triangles of ceramic.

Dining-room

As at The Hill House, Mackintosh was not asked to design any furniture for this room, but he was responsible for the decorations, curtains and light fittings. The latter are very similar to the geometrical grid pattern of the leaded-glass fitting in the dining-room at The Hill House (a pre-Mondrian abstract composition); here

1904.E Dining-room, Hous'hill, Nitshill, Glasgow
Although Mackintosh did not design the furniture, the stencilled decorations, lamp-shades and curtains are all his work.

Collection: Glasgow University.

1904.F Dining-room, Hous'hill, Nitshill, Glasgow
A view looking towards the fireplace, flanked by bracket lights designed by Mackintosh.

Collection: Glasgow University.

1904.G Drawing-room, Hous'hill, Nitshill, Glasgow
A view taken from the fireplace looking through the screen, and clearly showing the fitted cabinet (1904.57) and chairs (1904.61 and 62).

Collection: Glasgow University.

1904.H Drawing-room, Hous'hill, Nitshill, Glasgow
This photograph shows the fitted furniture in the drawing-room, or music room as this section was called. George Walton designed the decorative panels for the piano.

Collection: Glasgow School of Art.

1904.I Drawing-room, Hous'hill, Nitshill, Glasgow
The only known illustration of the fireplace (1904.60), and the revolving bookcase (1904.52) which can no longer be traced.

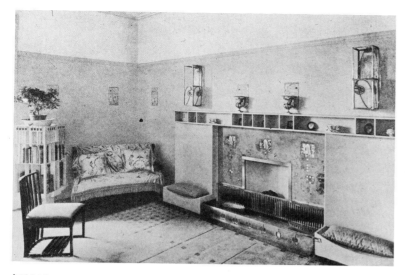

△1904.I

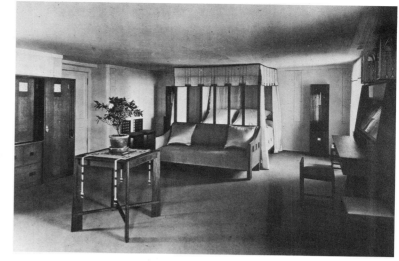

△1904.J

1904.K ▽

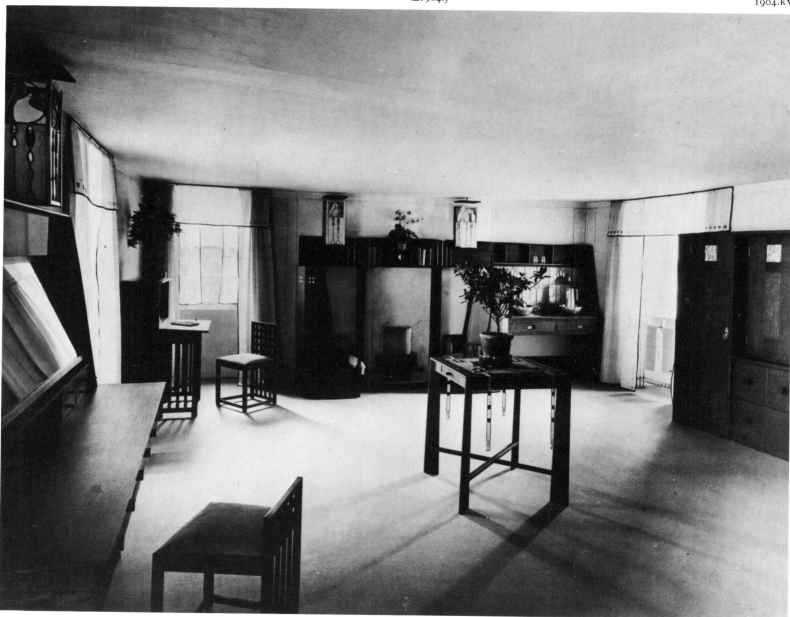

1904.J Blue Bedroom, Hous'hill, Nitshill, Glasgow
Only the dressing-table chair (1904.74), one of the upright cabinets (1904.67), and the central table (1904.72) survive.

Collection: Glasgow School of Art.

1904.K Blue Bedroom, Hous'hill, Nitshill, Glasgow
The two fireside chairs (1904.81), table (1904.72), and dressing-table chair (1904.74) are the only items to have survived the break-up of the house in 1933.

Collection: Glasgow School of Art.

they were used not only in a pair above the table, but as cubic wall lamps at the side of the fireplace and between the windows; the original intention was that these wall lights should have silk shades (*see* D1904.47). As in all Mackintosh's dining-rooms, the walls were dark, not panelled but covered with a dark paper stencilled with a floral design. A broad picture-rail, stained black like the rest of the woodwork, divided this patterned wall from the white frieze above. Gauze-like embroidered curtains were hung from this rail as it spanned the window architraves; again, there were coloured glass inserts in the rail to catch the light.

Drawing-room
The main public room at Hous'hill served various functions and, as at The Hill House, Mackintosh defined their respective areas quite distinctly. One end of the room was semicircular, but it is not known whether Mackintosh introduced this

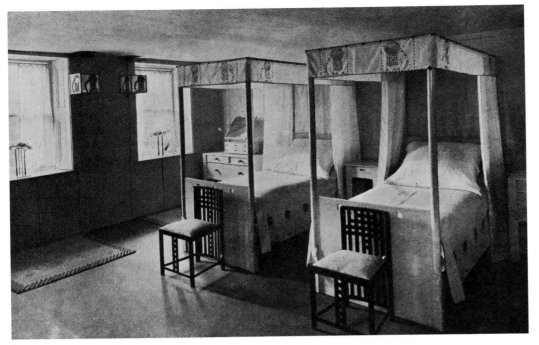

△1904.L

feature or whether it already existed. Mackintosh repeated the semicircle in an open screen, thus creating a circular space which became the music room. In it he incorporated fitted seating, not unlike that for 14 Kingsborough Gardens, with elaborate cupboards diametrically opposed to each other. At picture-rail height a flat batten described the perimeter of the room, forming the top rail of the screen and giving it stability. This wooden rail is reminiscent of the circular iron rail which Mackintosh suspended from the ceiling in the Front Saloon at the Willow Tea Rooms. At the other end of the room was the fireplace, surrounded by its own set of chairs; these were stained dark, unlike all the other white-painted furniture and woodwork in the room (except the piano, a traditional piece which had been decorated by George Walton). The open screen was a most effective method of dividing the room. Visually, it was sufficient to suggest a boundary when people congregated around the fireplace; but, as it was entirely open, one could see through it to the pianist when the room was used on more formal musical occasions. Out of a somewhat amorphous room Mackintosh created two distinct spaces—the circular music room, and the drawing-room with its convex rear wall formed by the screen; when necessary, the whole room could be used as one, the transparent screen allowing one to both see and hear the musicians. The open screen at The Hill House, dividing the hall from the lower landing of the staircase, had wide square posts; here the posts were little more than vanes, each being a tall slat, about 10cm. wide and 1cm. thick. Mackintosh used a similar module in another curved screen in the Oval Room at the Ingram Street Tea Rooms in 1909. The frieze and ceiling were painted white, but the walls beneath the picture-rail appear from the photographs to have been a little darker. Small stencilled panels of roses were placed at intervals around the walls. The lighting took the form of a large cylindrical leaded-glass fitting in the music room. The pattern of its leaded panels was the rose and the square. Above either end of the fireplace was a wall-hung fitting of silvered metal and leaded glass, again featuring the rose; this fitting was repeated in the drawing-room at The Hill House after the pendant lamps were removed (1905–06).

The Blue Bedroom

Before coming to work at Hous'hill, Mackintosh had always painted his bedrooms white, although the minor rooms at Windyhill and The Hill House occasionally had dark-stained doors and woodwork. In the Blue Bedroom, white seems to have been used only for the walls and ceiling and all the furniture was either ebonised or stained dark and waxed. Sadly, only five or six pieces survive out of almost 20 designed for this room; the bed, wardrobe, writing desk and couch seem lost forever. Mackintosh made no attempt to alter or conceal the simple rectangular shape of the room, and the furniture was all positioned against the walls, with the exception of the square table which was isolated in the centre of the room. The furniture was all rigidly geometrical in design, with simple rectangular silhouettes. The walls and the basket lamps bore the only organic-inspired decoration, in the form of 'weeping roses'; the decoration of the furniture all took the form of incised squares or inlays of coloured glass in geometrical patterns.

The White Bedroom

Smaller than the Blue Bedroom, this room fitted more recognisably into Mackintosh's usual scheme of decoration for bedrooms. As at The Hill House, the white

1904.L White Bedroom, Hous'hill, Nitshill, Glasgow
Only the two ebonised chairs (1904.93) and white table (1904.90) seem to have survived.

1904.32 Flower stand for the entrance vestibule, Hous'hill, Nitshill, Glasgow
Ebonised wood.
Francis Smith quoted (25 May, 1904, no price given) and was paid £1.4.4d. (30 November, 1904).

Unless there was another piece of furniture for the vestibule, not shown in 1904.A, this entry in the job-books must refer to the trellis-work stand. The low cost suggests that it was a very simple affair constructed from stock sizes of timber taken straight from the machines. The lattices would allow climbing plants to interlace with the timber, echoing the stencilled patterns on the wall. See 1904.A.

Collection: untraced.

(?) 1904.33 Umbrella stand for the hall, Hous'hill, Nitshill, Glasgow
Wrought-iron.

There is no reference to the stand in the job-books. Its appearance is very similar to that of the stands used in the Tea Rooms, and it is quite possible that Miss Cranston simply removed it from her business premises for her own use. See 1904.B.

Collection: untraced.

1904.34 Hat hooks for the hall, Hous'hill, Nitshill, Glasgow
Wrought-iron.

Mackintosh delighted in creating abstract shapes from wrought-iron, such as were much in evidence at the Willow Tea Rooms. Here the hooks were surrounded by a diced stencilling on the wall. See 1904.B.

Collection: untraced.

1904.35 Dresser for the hall, Hous'hill, Nitshill, Glasgow
Ebonised wood. 221.5 × 162 × 46.7cm.
Francis Smith quoted for a dresser at £10.7.6d. (19 December, 1904) and was paid that sum (28 June, 1905).

A very simple yet elegant piece, providing Miss Cranston with shelves to display her porcelain, and deep drawers beneath—possibly for hats, gloves, etc. The dresser is severely rectilinear, relieved only by the

1904.35 ▽

curves of the shelves and the band of shallow drawers beneath the first shelf. The latter seems to have been an afterthought (*see* D1904.36), and may have been added at Miss Cranston's request. The stretchers along the bottom form a linear pattern, a feature which appeared on other cabinets at Hous'hill designed earlier in the year, and on several desks and tables of later date.

Private collection.

D1904.36 Design for hall table and rack, Hous'hill, Nitshill, Glasgow

Pencil and watercolour. 38.2 × 31.8cm.
Inscribed and dated, lower right, *140 Bath Street/Glasgow Dec 1904,* and inscribed, top, *John Cochrane Esqr. The Hous'hill Nitshill/ Sketch for Hall Table & Rack.*
Scale, 1:12.

Virtually as executed, except that the band of shallow drawers below the lower shelf is not drawn in detail; it is indicated by a faint pencil line drawn somewhat hesitantly (perhaps by the client) below the shelf.

Provenance: Mackintosh Estate.
Collection: Glasgow University.

D1904.36▽

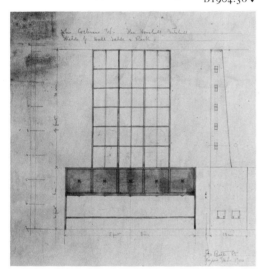

1904.37 Armchair for the Billiards Room, Hous'hill, Nitshill, Glasgow

(?) Varnished wood.
Francis Smith quoted for four armchairs at £2 each (26 May, 1904) and was paid that sum for four (15 December, 1904).

The lines of this chair are broadly similar to those of the later hall chair at The Hill House (1904.6) and the School of Art chair (1904.27) with a wide seat, tapering to the rear, and forward-sloping arms. The back, however, has rungs for its full height instead of the patterns of incised squares. *See* 1904.D.

Collection: untraced.

1904.38 High chair for the Billiards Room, Hous'hill, Nitshill, Glasgow

(?) Varnished wood.
Francis Smith was paid for two chairs at £2.5.od. each (15 December, 1904).

In the billiards rooms in Miss Cranston's Tea Rooms, Mackintosh usually provided seating raised on a low dais to enable spectators to have a better view of the table. There was no space at Hous'hill for such a device, which would have fixed the seats in one place and thus severely limited any other use of them. Mackintosh simply extended the legs of two examples of 1904.37 to provide extra height and thus give a better angle of vision over the playing surface; on these two examples, however, the ladder-back was not extended below the level of the seat. *See* 1904.D.

Collection: untraced.

beds and bedroom fittings contrasted with the black chairs, although here they had quite low backs. Organic decoration was more in evidence, in the embroidered canopy and bedspreads and the wall lamps, but the furniture was based generally on linear motifs and the square was again dominant. With the exception of the chairs, all the furniture from this room has disappeared.

Literature: *Studio Year-Book*, 1907, pp. *58–60; Artwork*, 1930, no 21, p. 25; Howarth, pp. 114–17, plates 46–47.

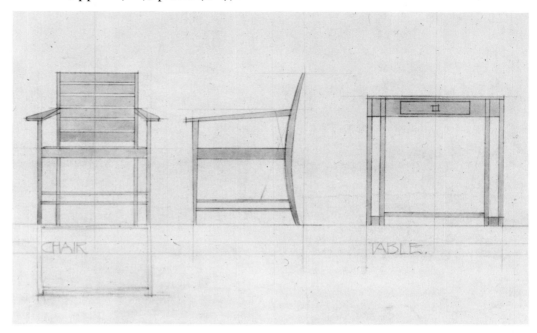

△D1904.40

1904.39 Card table for the Billiards Room, Hous'hill, Nitshill, Glasgow

(?) Varnished wood.
Francis Smith quoted for a table (May, no price given) and was paid £2.2.6d. for one (15 December, 1904).

There is no record of work on the Card Room in 1904, and it seems likely that it was not created at all until 1909. In 1904 the only mention of cards is in connection with this table, which was presumably used with the four armchairs in the Billiards Room, where it was originally photographed (1904.D).

Collection: untraced.

D1904.40 Designs for table and chairs for the Billiards Room, Hous'hill, Nitshill, Glasgow

Pencil and watercolour. 17.9 × 26.2cm.
Inscribed, lower left, *CHAIR,* and, lower right, *TABLE.*
Scale, probably 1:12.

Mackintosh made several alterations to this drawing before he arrived at the final design: the rungs of the ladder-back were extended to the ground in the finished chair (although not in the high chair); the back legs were straight and vertical, not curved as shown here; the back rungs had a concave curve and spanned the legs, because at one stage in the design Mackintosh seems to have considered using a separate sloping back, meeting the stretcher forward of the back legs (as in the hall chair at The Hill House, 1904.6); and stretchers were single down each side, with one central spar connecting them and not touching the front legs as shown here. Raising the chair to give a better view of the table was obviously an afterthought, as can be seen from the rough pencil additions to the drawing.
 The table is more or less as executed, although the complexity of the stretchers is not explained by the simple rail shown on the drawing.

Provenance: Mackintosh Estate.
Collection: Glasgow University.

1904.41 Billiards table for Hous'hill, Nitshill, Glasgow

Burroughs & Watt quoted for a table at £100 (16 May, 1904) and were paid that sum (20 October, 1904).

See 1904.C

Collection: untraced.

1904.42 Billiards marking-board for Hous'hill, Nitshill, Glasgow

Burroughs & Watt were paid for a board at £1.10.0d. (20 October, 1904); James Grant was paid 15.0d. for a shelf (11 May, 1905) and 14.1d. for joinery work (30 November, 1905).

See 1904.D.

Collection: untraced.

1904.43 Fireplace and ingle for the Billiards Room, Hous'hill, Nitshill, Glasgow

Stained wood.
James Grant quoted £24.10.0d. (16 May, 1904) and was paid £15.17.8d. (30 November, 1904); McCulloch was paid for two panels of glass at £2.8.9d. each (12 January, 1905).

The grate was a simple, traditional design, surrounded by a cement render inlaid with ovals of coloured glass and inverted triangles, possibly of ceramic. This is the only appearance of the triangle motif at Hous'hill. Either side of the fireplace the wall is panelled, with bracket lamps projecting from the panelling. Mackintosh built out an ingle from the fireplace, enclosing it at either end with a timber and glass partition. Two armchairs were positioned here, screened from the room by a phalanx of tapering poles not unlike billiard cues. *See* 1904.C and D.

Collection: untraced, probably destroyed.

1904.44 Easy chair for Hous'hill, Nitshill, Glasgow

Francis Smith was paid for two at £5 each (15 December, 1904).

There is no mention of a specific location for these chairs in the job-book, but from the photographs it seems most likely that they

were intended to fit into the ingle constructed in the Billiards Room. No other easy chairs appear in any of the photographs. The chairs in the Billiards Room ingle are upholstered and seem to follow a traditional pattern. *See* 1904.C.

Collection: untraced.

△D1904.45

D1904.45 Design for stencil decoration for the dining-room, Hous'hill, Nitshill, Glasgow
Pencil, 39 × 11.5cm.
Scale, approx. 1:7.

An early study for the stencil pattern applied at Hous'hill (*see* 1904.E). Previously, all Mackintosh's domestic dining-rooms had been either panelled with dark-stained pine, or wallpapered with a coarse dark-brown wrapping paper. At Hous'hill, the wrapping paper was used again, but this stencil was applied to it, presumably to prevent the room appearing too sombre. At 78 Southpark Avenue in 1906 Mackintosh repeated the combination, but the stencil of black lattice-work containing stylised roses was more formal than in this design.

Provenance: Mackintosh Estate.
Collection: Glasgow University.

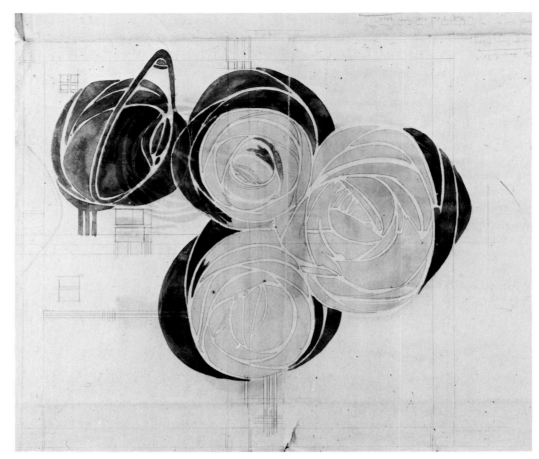

△D1904.46 D1904.47▷

D1904.46 Design for stencil decoration for the vestibule, Hous'hill, Nitshill, Glasgow
Pencil and watercolour. 59.7 × 67.2cm.
Inscribed, lower left, *The Househill* [sic]/ *Stencil for Dining Room/Please give me an impression of this on another skin/so that I can cut 2nd plate:* verso *Mr Wm Douglas/W. George St.*
Scale, full size.

Mackintosh inscribed this drawing *Stencil for Dining Room*. This could easily have been a slip of the pen, but it is not impossible that this design was originally considered for the dining-room; it was finally used only in the vestibule (*see* 1904.A), although a similar bold pattern of roses in black trellis-work was later used in the dining-room of 78 Southpark Avenue.

Provenance: Mackintosh Estate.
Collection: Glasgow University.

D1904.47 Design for a lampshade for the dining-room, Hous'hill, Nitshill, Glasgow
Pencil and watercolour. 56.2 × 39.9cm.
Inscribed and dated, lower right, *This drawing to be returned to/140 Bath Street/Glasgow June 1904;* inscribed, lower centre, *John Cochrane Esq/The Hous'hill—silk shade for Dining Room wall lantern,* and, right, *3 sides like this/plain silk on back;* and various other notes and measurements.
Scale, full size.

This design shows that Mackintosh originally considered using silk shades for the wall lamps in the dining-room. Eventually it was decided to use a leaded-glass shade which matched the pendant lamps, over the table (*see* 1904.E); these, in turn, were derived from the fitting designed for the dining-room at The Hill House.

Literature: Alison, p. 79, no 25 (as a design for The Hill House).
Exhibited: Milan, 1973 (25).
Provenance: C. R. Mackintosh; Margaret Macdonald Mackintosh; by family descent to Mrs L. A. Dunderdale, by whom presented.
Collection: Glasgow University.

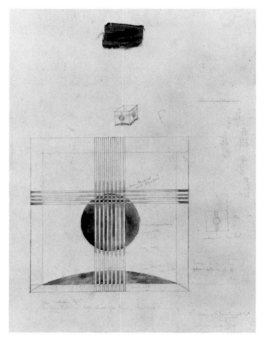

1904.48 Cabinet for the drawing-room, Hous'hill, Nitshill, Glasgow
Wood, painted white, with glazed doors and inlays of coloured and leaded-glass.
Alex Martin quoted for two cabinets at £20 each (9 August, 1904) and was paid for two at £16.5.0d. each (17 December, 1904); McCulloch was paid £11.13.0d. for 28 panels of glass for two cabinets and a cupboard, 1904.57 (12 January, 1905).
These two cabinets faced each other diametrically across the circle of the music room. They marked the point where the wall began its semi-circular curve towards the window, and were attached, on their other side, to the curved screen which divided the drawing-room into its two parts. The shape of the cabinet is quite novel and follows the design shown in D1904.53. The side of the cabinet has an elaborate niche shown on the drawing, which would have restricted the depth of the front cupboards. The upper part of the front elevation was divided into three by applied

straps of wood. The central section was occupied by a niche with a curved back made of strips of leaded-glass, like the bedside cabinets at The Hill House. Below this were two glazed doors over a cupboard; they swelled out gently towards the bottom, and were contained within two more applied strips springing from the head of the central niche and gradually moving outwards until they touched the edges of the cupboard at floor level. *See* 1904.H.

Literature: Howarth, plate 47b; Pevsner, 1968, plate 34.
Collection: untraced, probably destroyed.

1904.49 Screen for the drawing room, Hous'hill, Nitshill, Glasgow

Wood, painted white, with panels of coloured and leaded-glass, and candelabra of glass and metal.
James Grant quoted for a screen at £18.10.0d. (1 August, 1904) and was paid that sum (30 November, 1904); McCulloch was paid £10.16.0d. for glass (12 January, 1905).

The screen was semi-circular in plan and divided the music room from the rest of the drawing-room; the other half of the circle was maintained by the curved wall with its fitted seating. The top rail of the screen, a flat piece of wood about 15cm. broad, passed all the way around the circle at the top of the fitted cupboards and panelling and level with the picture-rail in the rest of the drawing-room. The screen was in three parts—two short lengths attached to the two cabinets (1904.48) and a segmental section which formed the main body; between these three sections were two openings providing access to the music room. The vertical members of this open screen were flat lengths of timber, like the top rail, about 10cm. wide and about the same distance apart. They were placed at right-angles to the top and bottom rails so that, when looked at from the edge, they appeared very thin and offered a clear view of the music room. but as one's eye moved to left or right, more of each vane could be seen and the space between them narrowed. The rhythm of the vanes was quickened in the lower part of the screen by the periodic use of intermediate, shorter vanes, each supporting an oval tray, similar to the trays used on the cheval mirrors at Windyhill and The Hill House. Between the taller vanes, square or oval panels of leaded-glass were fixed, apparently at random, but their purpose was not merely decorative, as they probably provided some slight stiffening of the structure. At two positions in the main part of the screen, Mackintosh substituted tapering circular posts for the flat vanes, and these posts formed the centres of circular candelabra. Two concentric rings of metal, centred on each round post, were laid on the top rail; from each ring hung a string of glass balls, attached at their lower ends to another flat metal ring. Each of the lower rings carried candle-holders, eight on the outer ring and four on the inner (which was a few inches higher than the outer ring). *See* 1904.G.

Literature: Howarth, p. 115, plate 46; Pevsner, 1968, plate 35; Macleod, plate 89; McLaren Young, plate 26.
Collection: untraced, probably destroyed.

1904.50 Fitted seating for the drawing-room, Hous'hill, Nitshill, Glasgow

Wood, painted white, with upholstered seat and back, and inlays of coloured glass and (?)mother-of-pearl.
James Grant was paid £13.12.1½d. for making 'circular seats' and £14.0.4½d. for 'making seats' (both 30 November, 1904); Alex Martin was paid £12.14.0d. for 'circular seats' and £2.1.0d. for 'small seats' (both 17 December, 1904).

The 'circular seats' referred to in the job-books were the two sections of fitted seating attached to the curved wall between the window seats and the cabinets (1904.48). Above them was a row of shallow niches. While these fitted seats faced into the room, the two box-like seats either side of the window faced each other; they were similarly upholstered and provided with embroidered loose cushions. In the upper part of the inside of the chair was set a row of 'teardrops', either in glass or mother-of-pearl; and, on the outer side of each chair, facing into the room, was inlaid a rose in coloured glass with more teardrops falling from it. (*See* 1904.G and H).

Literature: Howarth, plate 47b; Pevsner, 1968, plate 34.
Collection: untraced, probably destroyed.

1904.51 Square table for the drawing-room, Hous'hill, Nitshill, Glasgow

Oak, varnished (originally painted white) 75.7 × 66 × 64.6cm.
Alex Martin quoted for a table at £5.10.0d. (no date given) and was paid for one at £5.8.0d. (17 December, 1904).

This table was originally placed at the window between the two fitted seats. It is not known when the white paint was removed.

Literature: Howarth, plate 47b; Pevsner, 1968,

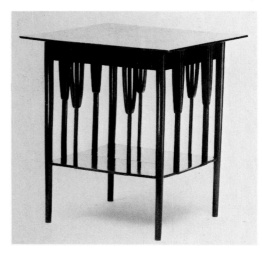

1904.51△

plate 34; Glasgow School of Art, *Furniture*, no 15.
Exhibited: VEDA, 1952 (R5); Paris, 1960 (1074); Edinburgh, 1968 (256).
Collection: Glasgow School of Art.

1904.52 Revolving bookcase for the drawing-room, Hous'hill, Nitshill, Glasgow

Wood, painted white, with inlays of coloured glass.
Alex Martin quoted £6 for a bookcase (9 August, 1904) and was paid £10 for one (17 December, 1904).

This is the only revolving bookcase known to have been designed by Mackintosh, although MacNair had designed one for the Turin Exhibition in 1902. *See* 1904.I.

Literature: *Studio Year Book*, 1907, p. 58; Howarth, plate 47c; Pevsner, 1968, plate 34.
Collection: untraced.

D1904.53 Design for the drawing-room, Hous'hill, Nitshill, Glasgow—elevations and plan, and sections through circular screen

Pencil and watercolour 36.8 × 88.6cm.
Inscribed, underneath the individual items, *REVOLVING BOOKCASE. SECTION THROUGH SCREEN. CENTERLINE* [sic] *OF SCREEN. SIDE OF CUPBOARD. CUPBOARD. SEAT. WINDOW TABLE.*
Scale, 1:12, and approx. 1:96 (plan).

The only surviving drawing showing the layout of the drawing-room; although the plan is very rough, it does give a clear indication of the relationship of the screen to the curved

D1904.53▽

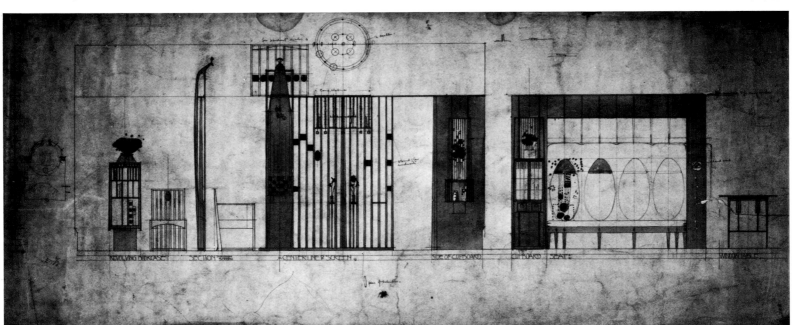

end wall and window. The chair (1904.62), bookcase (1904.52), table (1904.51), and cabinet (1904.48) all appear as executed, but the fitted seating and the screen are different from the final versions. Mackintosh had intended to embroider or stencil the backs of the curved seating; no such decoration is visible in the contemporary photograph (1904.H), although it is possible that it had simply not been completed rather than deliberately omitted. The drawing also shows that the niches above the curved seating were an afterthought, as the panelling was originally intended to run at the height of the top of the glazed recess in the cabinets. The window seats also seem to have been introduced at the same time as this modification to the panelling.

The most important alteration, however, was made to the screen. The form of the screen is shown in some detail, including a plan of the candelabra suspended from the top rail. The most dramatic element of the design was eventually omitted—a central section in the form of a stylised peacock. This structure, about 30cm. wide, rose above the top rail, tapering towards a carved image of a peacock's head; the lower part was to have been filled with inlays of coloured glass in imitation of the bird's tail. It was never carried out, but a series of drawings show that the peacock had taken other forms in designs probably intended for Hous'hill. It seems strange that, after devoting so much time to finding a suitable location for this massive image, Mackintosh should discard it completely.

Literature: Macleod, plate 88.
Exhibited: Edinburgh, 1968 (163).
Provenance: Mackintosh Estate.
Collection: Glasgow University.

D1904.54 Design for a peacock settle
Pencil and watercolour 32.4 × 45.2cm.

The only other reference to a peacock in Mackintosh's furniture is in the screen at Hous'hill as first designed (see D1904.53). The shape and size of this peacock, which in section and in the upper part of the elevation is almost identical to that in the drawing for the Hous'-hill screen, suggests that this drawing was also connected with Hous'hill. Perhaps this was Mackintosh's first idea for the drawing-room/ music room seating; two preliminary sketches (D1904.55 and 56) show oval decorative panels on the backs of this settle not unlike those visible in D1904.53.

Literature: Alison, p. 77. no 8.
Exhibited: Milan, 1973 (8).
Provenance: Mackintosh Estate.
Collection: Glasgow University.

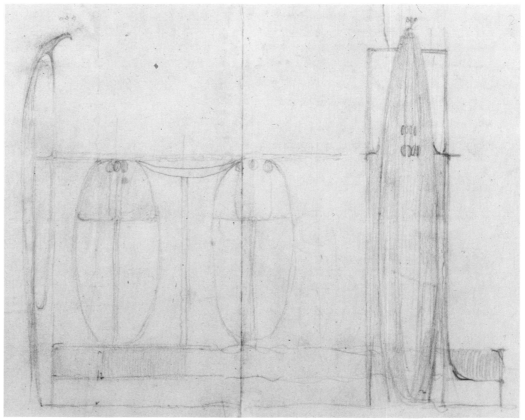

D1904.55△

◁D1904.54 D1904.55 verso △

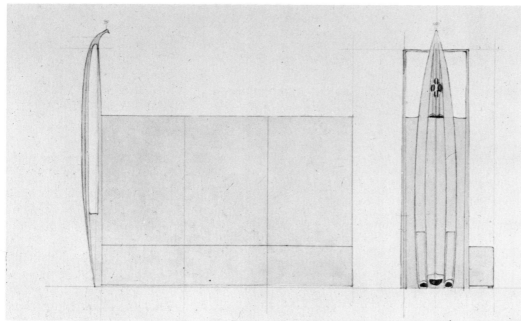

D1904.55 Sketch design for a peacock settle; verso: Sketch of a lug chair
Pencil 17.4 × 22.4cm.
Watermark: *ROYAL Parchment* around a head of Henry VIII.

An earlier version of D1904.54. The drawing on the reverse, of a lug chair, probably relates to that made for The Hill House (*see* 1904.9); it is unlikely that it refers to the earlier lug chair for Mains Street (1900.5), as the peacock motif on the settle cannot be as early as 1899–1900, when the Mains Street furniture was made.

Provenance: Mackintosh Estate.
Collection: Glasgow University.

D1904.56 Design for a peacock settle; verso: Design for an oval table
Pencil 56.4 × 19.8cm.
Scale, 1:12.

Related to D1904.54 and 55. The job-books indicate that Mackintosh also designed an oval tea table for Hous'hill (1904.59). It does not

△D1904.56

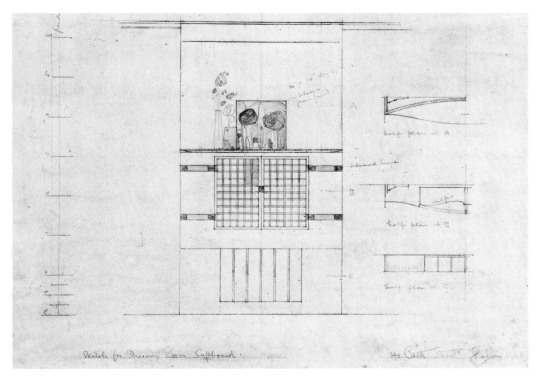

△D1904.58

appear in any photographs and has not been traced, but perhaps the sketches on the reverse of this drawing relate to it.

Provenance: Mackintosh Estate.
Collection: Glasgow University.

1904.57 Cupboard for the drawing-room, Hous'hill, Nitshill, Glasgow
Wood, painted white, with panels of clear and coloured glass, and metal hinge plates.
James Grant quoted £8.10.0d. (16 August, 1904) and was paid that sum (30 November, 1904); McCulloch was paid £11.13.0d. for 28 panels of glass for this cupboard and two cabinets, 1904.48 (12 January, 1905).

See 1904.G and D1904.58.

Literature: Howarth, plate 46; Pevsner, 1968, plate 35; Macleod, plate 88; McLaren Young, plate 26.
Collection: untraced, probably destroyed.

D1904.58 Design for a cupboard for the drawing-room, Hous'hill, Nitshill, Glasgow
Pencil and watercolour 30.4 × 34.1cm.
Inscribed, and dated, lower right, *140 Bath Street Glasgow 1904*, and inscribed, lower left, *Sketch for Drawing Room Cupboard*.
Scale, 1:12.

The drawing for 1904.57, almost as executed except for minor differences in the size of the glass doors and the number of vertical rods in the bottom section. The three half-plans also indicated in the drawing show the subtlety of what appears, in the surviving illustration (1904.G), to be a very simple piece of furniture. The top third of the cupboard, with its two silver and glass panels, is concave; the centre section is convex, with ogee shelves inside the doors (a detail later used on the shelves in the hall dresser, 1904.35); and the lower open section is flat with vertical openings, formed by spars the full depth of the piece. (In the executed piece, the number of openings was increased from six to ten; the spars, instead of reaching from back to front, were divided into three equal parts, the central third being open space, thus increasing the spatial complexity of what was otherwise the least satisfactory part of the design.) Similar use of convex and concave curves in an otherwise shallow piece of furniture can be seen in the hall fireplace at The Hill House (1903.77). No adequate plan of this

room exists (see D1904.53), so one can only speculate as to the reasons why this rather strange piece was provided. It fits rather awkwardly into the room, breaking both the line of the skirting and the picture-rail, and cannot have been very practical as the shelves are only a few inches deep. There are no photographs of the opposite wall, but it seems likely from the lighting of the contemporary photographs that it contained a very wide window. The cupboard wall had no openings or projections other than the door (to the left of the cupboard), so the cupboard must be seen as an attempt (albeit rather unsuccessful) to articulate this wall: perhaps this accounts for the repetitive play upon flat and curved surfaces which it incorporates.

Provenance: Mackintosh Estate.
Collection: Glasgow University.

1904.59 * Oval tea table for the drawing-room, Hous'hill, Nitshill, Glasgow
Alex Martin was paid £6.10.0d. for one (29 December, 1904).

This table does not appear in any contemporary photographs. Perhaps it was related to the drawing on the reverse of D1904.56. The tea table at The Hill House (1904.19) is a more likely comparison, as this repeated the same motif on its legs as the square table from the Hous'hill drawing-room (1904.51).

Collection: untraced.

1904.60 Fireplace for the drawing-room, Hous'hill, Nitshill, Glasgow
Wood, painted white, with a cement or mosaic render inlaid with coloured glass.
James Grant was paid £8.10.0d. (30 November, 1904).

The row of boxes along the top of the piece echoes the early design for the Mains Street fireplace (D1900.3), but there the similarity ends. The wooden structure contrasts concave curves with straight lines: the two fireside seats are formed by a simple downward curve and the expanse of white-painted wood behind each also has a concave curve. It is difficult to tell from the original photograph whether the surround to the grate is simply cement, or a mosaic like that at The Hill House. The three square panels of coloured and mirror-glass certainly resemble those in the drawing-room and bedroom fireplaces at Helensburgh.

Nothing remains of the fireplace, although the wrought-iron panel of the grate was rescued at the time of demolition. See 1904.I.

Literature: *Studio Year Book*, 1907, p. 58; Howarth, plate 47c; Pevsner, 1968, plate 34. Collection: untraced, probably destroyed.

1904.61 Armchair for the drawing-room, Hous'hill, Nitshill, Glasgow
Dark-stained wood with glass inlays 119.4 × 58.4 × 55.8cm.
Alex Martin quoted for one at £2.16.0d. (1 November, 1904) and was paid that sum (29 December, 1904); McCulloch was paid 5.6d. for glass (12 January, 1905).

One of the most sophisticated of Mackintosh's designs for chairs: the subtle curve of the back-rails and elegant outline were rarely surpassed.

Literature: Howarth, plate 46; Pevsner, 1968, plate 35; Macleod, plate 88; McLaren Young, plate 26.

1904.61▽

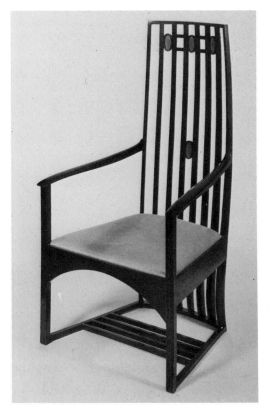

Exhibited: Edinburgh, 1968 (248).
Provenance: Major and Mrs J. Cochrane (Miss Cranston); bought at Hous'hill auction, 1933 by W. Ward; sold by his widow at Sotheby's Belgravia, 13 March, 1975, lot 53. Collection: Sidney and Frances Lewis, Virginia, USA.

1904.62 Chair for the drawing-room, Hous'hill, Nitshill, Glasgow

Stained wood, with glass inlay.
Alex Martin quoted for four chairs at £2.10.0d. each (1 November, 1904) and was paid that sum (29 December, 1904).

Companions to the armchair, 1904.61. *See* 1904.G.

Literature: *Studio Year Book*, 1907, p. *58*; Howarth, plates 46, 47c; Pevsner, 1968, plates 34, 35; Macleod, plate 88; McLaren Young, plate 26.
Collection: untraced.

D1904.63 Design for chairs for the drawing-room, Hous'hill, Nitshill, Glasgow

Pencil and watercolour 32.4 × 42.5cm.
Inscribed, and dated, lower right, *140 Bath St / Glasgow Oct 1904*, and, top, *John Cochrane Esqr, The Hous'hill Nitshill. Sketch for Drawing Room Chair*; and verso, *John Cochrane Esqr.*
Scale, 1:12.

The design for 1904.61 and 62; as executed.

Literature: Alison, p. 79, no 22.
Exhibited: Milan, 1973 (22).
Provenance: Mackintosh Estate.
Collection: Glasgow University.

1904.64 Design and layout of furniture for the Blue Bedroom, Hous'hill, Nitshill, Glasgow

Pencil and watercolour 36.2 × 87cm.
Inscribed, *WASHSTAND, WINDOW, WARDROBE, TABLE, COUCH, SIDE OF BED.*
Scale, 1:12, and 1:96 (plan).

All the furniture appears more or less as executed, although the final positions of the chairs and bedside cabinets were changed from those shown on the small plan.

Provenance: Mackintosh Estate.
Collection: Glasgow University.

D1904.65 Design for the Blue Bedroom, Hous'hill, Nitshill, Glasgow—elevation of two walls showing layout of furniture

Pencil and watercolour 36.4 × 87.1cm.
Signed and inscribed, verso, *From. Chas. R. Mackintosh / 140 Bath Street / Glasgow*; inscribed, recto, underneath the individual items, *CHAIR. CUPBOARD. COUCH–BED BEHIND. CUPBOARD. CHAIR. CORNER. WINDOW. FIREPLACE WITH SEAT ON EACH SIDE*; and various other notes.
Scale, 1:12.

Mackintosh has juxtaposed the two shorter walls in the bedroom to show the different treatment of each. The items of furniture are all substantially as executed; the lamps over the fireplace broke the line of its top because they had to be set lower on the walls to provide ventilation, and could not be placed flush with the ceiling as shown here. There was also some slight alteration to the positions of the individual pieces. The two bedside cabinets were moved away from the bed to occupy the spaces taken here by the chairs; and a wash-stand was eventually fitted to the right of the fireplace, between it and the wall.

Literature: Macleod, plate 90; Alison, p. *79.*
Provenance: Mackintosh Estate.
Collection: Glasgow University.

D1904.66 Design for furniture for the Blue Bedroom, Hous'hill, Nitshill, Glasgow

Pencil and watercolour 37.3 × 80.5cm.
Inscribed, underneath the individual items, *WINDOW, DRESSING TABLE, WINDOW, WRITING TABLE, SIDE OF WRITING TABLE.*
Scale, 1:12.

Although the dressing-table appears as executed, substantial alterations were made to the design of the writing cabinet. The sharply sloping profile to match the wash-stand and dressing table seen here, was not used; instead, Mackintosh reduced the height of the cabinet and gave it a fall-front—to act as a writing surface—supported on gate legs and not the slides shown in this drawing.

Provenance: Mackintosh Estate.
Collection: Glasgow University.

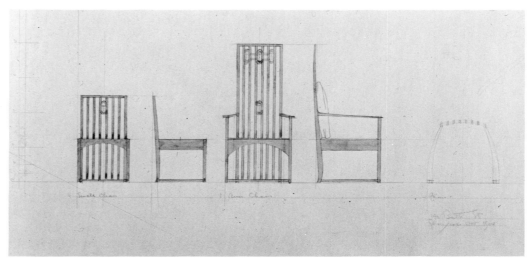

△ D1904.63 1904.64 ▽

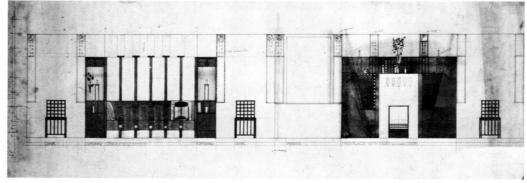

△ D1904.65 D1904.66 ▽

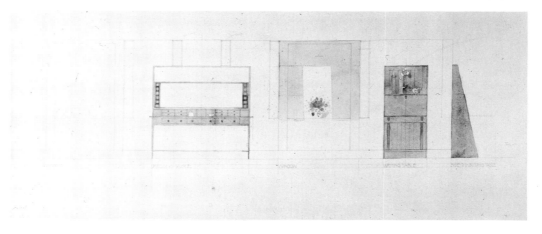

1904.67 Cabinet for the Blue Bedroom, Hous'hill, Glasgow

Stained oak, with a panel of leaded-glass 167.5 × 38 × 33.4cm.
Francis Smith quoted for two cabinets at £6.6.6d. each (21 July, 1904) and was paid that sum for two (15 December, 1904); McCulloch was paid for two panels of glass at £1.8.6d. each (12 January, 1905).

At The Hill House and in the bedroom for the Dresdener Werkstätten, Mackintosh had designed fitted cupboards for either side of the bed. Here, the cabinets were free-standing, but they took the same basic form, providing a lower cupboard, racks for books and magazines, a semicircular niche panelled with leaded-glass for candlesticks or a glass, and a small cupboard above. The square is the main decorative motif, pierced through the timber, in leaded-glass or in mother-of-pearl. Only one cabinet has been traced.
Literature: *Studio Year Book*, 1907, p. 58; *Artwork*, 1930, no 21, p. 25.
Provenance: Major and Mrs J. Cochrane (Miss Cranston); bought at Hous'hill auction, 1933 by W. Ward; sold by his widow at Sotheby's Belgravia, 13 March, 1975, lot 52. Private collection.

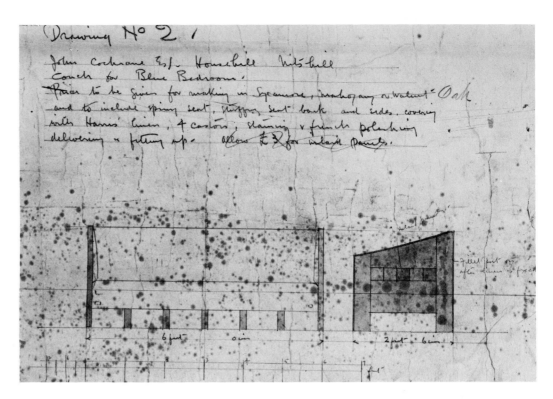

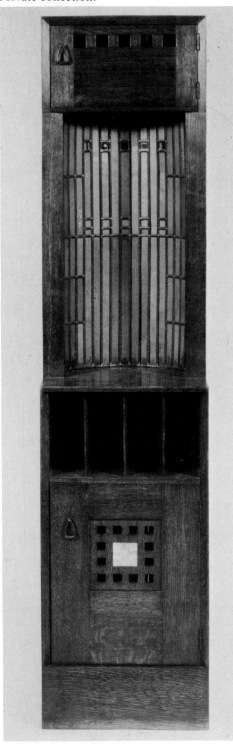

◁1904.67 D1904.69△

1904.68 Couch for the Blue Bedroom, Hous'hill, Nitshill, Glasgow

Stained oak, with upholstered seat and back.
Francis Smith quoted for one at £10.3.6d. (21 July, 1904) and was paid that sum (15 December, 1904); Crawford & Craig were paid for two cushions at £2.14.6d. each (17 April, 1905).

Mackintosh had included a couch at the foot of the beds in the Dresdener Werkstätten bedroom in 1903. As Howarth points out, his inspiration for this couch and the accompanying bed appears to have been a similar piece in Princess Victoria's bedroom in the Treasurer's House in York, illustrated in *The Architect*, 15th April, 1904, shortly before this room was designed. *See* 1904.J.

Literature: *Studio Year Book*, 1907, p. 58; *Artwork*, 1930, no 21, p. 25; Howarth, p. 116. Collection: untraced.

D1904.69 Design for a couch for the Blue Bedroom, Hous'hill, Nitshill, Glasgow

Pencil and watercolour 26 × 34.1cm.
Inscribed, top, *Drawing No. 2 | John Cochrane Esqr Househill* [sic] *Nitshill | Couch for Blue Bedroom | Price to be given for making in* [*sycamore, mahogany or walnut*, all deleted and replaced in another hand by *Oak*] *| and to include spring seat, stuffing back and sides, covering | with Harris linen, 4 castors, staining & french polishing | delivering & fitting up* [*allow £3 for inlaid panels* deleted]; and other notes and measurements.

The design for 1904.68, with an indicated size of approximately 81 × 183 × 76cm. The inlaid panels in the side of the couch seem to have been of coloured glass.

Collection: Dr Thomas Howarth.

1904.70 Double bed with canopy for the Blue Bedroom, Hous'hill, Nitshill, Glasgow

Stained oak with embroidered canopy.
Francis Smith quoted for one at £7.5.0d. (21 July, 1904) and was paid that sum, plus £2 for springs and £6 for a hair mattress (15 December, 1904).

See 1904.J.

Literature: *Studio Year Book*, 1907, p. 58; *Artwork*, 1930, no 21, p. 25; Howarth, p. 116. Collection: untraced.

1904.72▷

1904.71 Wardrobe for the Blue Bedroom, Hous'hill, Nitshill, Glasgow

Stained oak with inlays of coloured glass and mother-of-pearl.
Francis Smith quoted £21.5.6d. (21 July, 1904) and was paid £29.3.0d. (15 December, 1904); McCulloch was paid £2 for glass panels (12 January, 1905).

One of Mackintosh's most assured designs of this period. The carved decoration is confined to the edges of the piece, and plays a much smaller part in the design than in the wardrobes at The Hill House. The rectangular shape of the wardrobe is emphasised by the arrangement of doors and drawers and the alternating direction of the grain of the wood. Decoration is, on the whole, restrained, and relies mainly on the square inlays of mother-of-pearl for effect. The design is simply stated and no less successful for its reticence. *See* 1904.J and K.

Literature: *Studio Year Book*, 1907, p. 58; *Artwork*, 1930, no 21, p. 25. Collection: untraced.

1904.72 Square table for the Blue Bedroom, Hous'hill, Nitshill, Glasgow

Stained oak with mother-of-pearl inlay in handle 76 × 66 × 66cm.
Francis Smith quoted for one at £2.4.6d. (21 July, 1904) and was paid for one at £29.6.0d. (15 December, 1904); Crawford & Craig

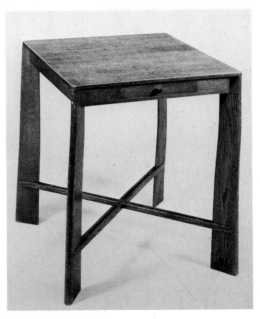

were paid 18.od. for a table centre for this table (17 April, 1905).

The design is developed from the table for the bedroom at The Hill House (1903.55), but is rather more simple, in keeping with much of the other furniture in the Blue Bedroom. The legs are again set on the diagonal, at 45° to the table top. The outer edge of each leg is rounded, and they taper across their width to a flat inner edge. Double stretchers join each diagonal pair of legs, crossing through each other to make a square in the centre. Small pieces of wood inserted between each pair of stretchers repeat this square motif near where the stretchers join the legs. Instead of simply butting up against each leg, the stretchers split either side of it and are planed to accommodate its increasing thickness

Literature: *Studio Year Book*, 1907, p. 58; *Artwork*, 1930, no 21, p. 25.
Provenance: Hous'hill auction, 1933; anonymous sale; Sotheby's Belgravia, 10 November, 1976, lot 75; bought by Fine Art Society, London.
Collection: Private collection.

1904.73 Chair for the Blue Bedroom, Hous'hill, Nitshill, Glasgow
Ebonised wood.
Francis Smith quoted for two at £1.16.6d. each (21 July, 1904) and was paid that sum for two (15 December, 1904).

Although Smith quoted only for two chairs, at least four appear in a contemporary photograph (1904.J). The design is one of Mackintosh's simplest—a cubic seat with a back-rest of vertical and horizontal square rails forming a chequer pattern; the vertical rails carry on below the seat to a rear stretcher. The actual chairs from Hous'hill have disappeared, but others were made for William Douglas, the decorator who carried out Mackintosh's schemes and painted the furniture at Hous'hill.

Douglas also acquired examples of 1904.74 and 1904.93.

Literature: *Studio Year Book*, 1907, p. 58; *Artwork*, 1930, no 21, p. 25.
Provenance: (Miss Cranston's four chairs are untraced); William Douglas; Nestor Douglas; J. & R. Edmiston, Glasgow.
Collection: untraced.

1904.74 Dressing-table chair for the Blue Bedroom, Hous'hill, Nitshill, Glasgow
Ebonised wood 60.2 × 41.5 × 34.5cm.
Francis Smith quoted for one at £1.11.6d. (21 July, 1904) and was paid that sum (15 December, 1904).

A version of 1904.73 with a lower back. The original chair is untraced, but one example was also made for William Douglas, the decorator employed at Hous'hill (see also 1904.93).

Literature: *Studio Year Book*, 1907, p. 58.
Provenance: (Miss Cranston's chair is untraced); William Douglas; Nestor Douglas; J. & R. Edmiston, Glasgow.
Private collection.

1904.75 Dressing-table for the Blue Bedroom, Hous'hill, Nitshill, Glasgow
Stained oak.
Francis Smith quoted for one at £9.6.0d. (21 July, 1904) and was paid for one at £10.11.0d. (1 December, 1904).

The sloping sides of the table were repeated in the wash-stand, and in D1904.66 we can see that Mackintosh originally intended the writing table to match. The projecting table top produces a rather inelegant profile, however, and the combination was not used again. See 1904.J.

Literature: *Studio Year Book*, 1907, p. 58.
Collection: untraced.

▽1904.74

D1904.76 Design for a dressing-table for the Blue Bedroom, Hous'hill, Nitshill, Glasgow
Pencil and watercolour 27.8 × 21.2cm. (irregular).
Inscribed, centre, *Plan of spars at centre*; and various other notes and measurements.

The design for 1904.75 showing the lattice arrangement of the stretchers. The indicated size is approximately 168 × 178cm.

Collection: Dr Thomas Howarth.

1904.77 Wash-stand for the Blue Bedroom, Hous'hill, Nitshill, Glasgow
Stained oak, with panels of leaded mirror-glass and coloured glass.
Francis Smith quoted for one at £6 (21 July, 1904) and was paid that sum (15 December, 1904); McCulloch was paid £3.5.0d. for glass (12 January, 1905).

Although displaying the same profile as the dressing-table, the wash-stand is slightly taller to maintain the horizontal lines of the fireplace on its right. Two bowls and ewers were provided (made by the Scottish Guild of Handicrafts for £1.4.0d.), and, as at Dresden, the pattern in the splash-back is repeated twice. Unlike all the other pieces with drawers in the room, which had square tapered knobs, the handles in this piece were simple cut-outs backed with glass or metal: this became Mackintosh's usual drawer-pull in later pieces, and in some of the Northampton designs he used aluminium as the backing material. (See 1904.K).

Collection: untraced.

D1904.78 Design for a wash-stand for the Blue Bedroom, Hous'hill, Nitshill, Glasgow
Pencil and watercolour 23.5 × 28.5cm.
Inscribed, *Side. Front. 4' 3"*.
Scale, 1 : 12.

D1904.76▽

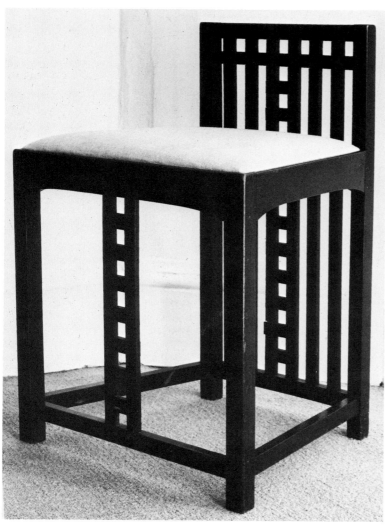

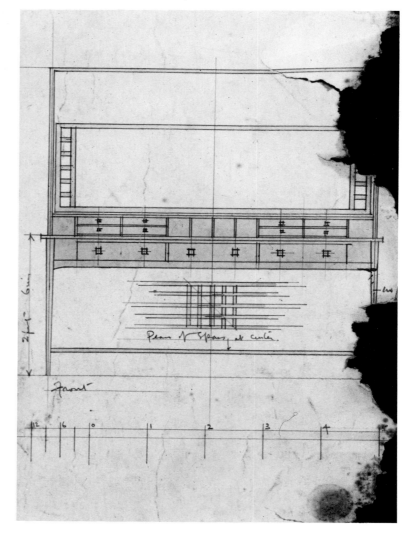

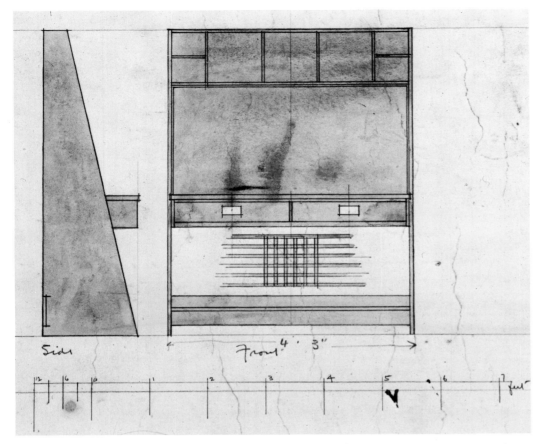

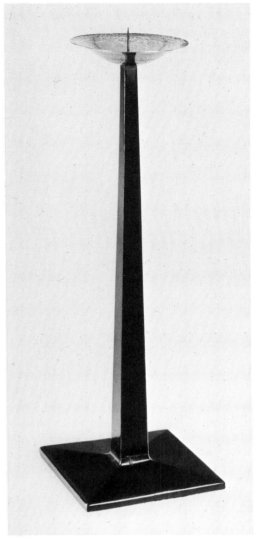

△D1904.78 1904.81▷

The design for 1904.77, without details of the
design of the splash-back, but showing the
lattice arrangement of the stretchers. The
indicated size is approximately 160 × 130 ×
53cm.

Exhibited: Toronto, 1967 (81).
Collection: Dr Thomas Howarth.

1904.79 Towel rail for the Blue Bedroom, Hous'hill, Nitshill, Glasgow
Stained wood.

Although not listed in the job-books, this item
is visible in one of the contemporary photo-
graphs in the window recess beside the wash-
stand (see 1904.K). It is interesting, in that
Mackintosh uses again the motif of full-width
stretchers joined in a central panel by cross-
pieces to form a chequer pattern—a motif
which he used several times subsequently.

Collection: untraced.

1904.80 Writing table for the Blue Bed-room, Hous'hill, Nitshill, Glasgow
Stained oak.
Francis Smith quoted for one at £4.16.0d.
(21 July, 1904) and was paid £4.6.6d. (15
December, 1904); McCulloch was paid £4
for glass (12 January, 1905).

The surviving photograph (1904.K) does not
show this piece clearly, but one can see that
Mackintosh has altered the design from that
shown in D1904.66: the table no longer has
sloping sides, but is more rectangular with a
fall-front writing flap supported on gate legs
rather than slides. McCulloch's account for
glass suggests that the table contained an
elaborate decorative panel.

Collection: untraced.

1904.81 Armchair for the Blue Bedroom, Hous'hill, Nitshill, Glasgow
Stained oak, with mother-of-pearl inlay, and
upholstered seat and back 129.5 × 63.5 ×
69cm.
Francis Smith quoted for two at £9.10.0d.
each (11 April, 1905) and was paid for two at
£8.10.0d. each (28 June, 1905); David Hislop
was paid 14.3d. for mother-of-pearl inlay
(23 March, 1905).

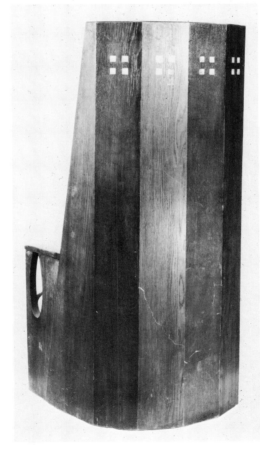

Used on either side of the fireplace. In plan,
these chairs take the form of a faceted semi-
circle, but the segments which form the sides
slope backwards as they rise, echoing the
sloping sides of the wash-stand and dressing-
table. At first glance they seem rather austere,
but the severity of line is broken by the squares
of mother-of-pearl. They are also somewhat
more comfortable than they look.

Provenance: Major and Mrs J. Cochrane
(Miss Cranston); bought at Hous'hill sale,
1933 by W. Ward; sold by his widow at
Sotheby's Belgravia, 28 March, 1973, lot 136,
bought by Fine Art Society.
Private collection.

1904.83△

1904.82 Fireplace for the Blue Bedroom, Hous'hill, Nitshill, Glasgow
Stained oak.
James Grant quoted £6.10.0d. (21 July, 1904)
and was paid £6 (30 November, 1904).

The wooden part of this fireplace consisted
simply of a deep shelf at high level, sub-divided
vertically, and broad straps attached to the
cement render of the surround which framed
the grate. It is difficult to see clearly in the
surviving photograph (1904.K), but there
appears to be a convex bow to the shelf where
it passes over the wall straps.

Collection: untraced, probably destroyed.

1904.83 Candlestick for the Blue Bed-room, Hous'hill, Nitshill, Glasgow
Ebonised wood, with silver cup 38.8 × 12.5 ×
12.5cm.
Alex Martin quoted for three (21 July, 1904
no price given)sand was paid for three at 12.6d.
each (17 December, 1904). David W. Hislop
made the cups, which bear his mark for 1904–05.

Two can be seen in the bedside cabinets in
1904.J. The Hous'hill examples have not been
traced, but two identical candlesticks were
in Margaret's possession at her death in 1933;
these were presumably additional to the three
made for Hous'hill, but only one has survived.

Exhibited: Edinburgh, 1968 (255).
Provenance: Acquired by William Meldrum
after the Memorial Exhibition, 1933.
Collection: James Meldrum.

D1904.84 Design for the White Bed-room, Hous'hill, Nitshill, Glasgow— elevation of two walls, and plan showing layout of furniture
Pencil and watercolour 35.2 × 87.4cm.
Inscribed, underneath the individual items,

173

WASHSTAND CLOSED. WINDOW AND MIRROR. WINDOW AND MIRROR. CORNER. CHEST OF DRAWERS. BED AND CHAIR. TABLE. BED. CHEST OF DRAWERS; and various other notes. Scale, 1:12, and 1:96 (plan).

This drawing provides a plan and shows the proposed design of all items in the room except the writing table. Only one photograph of the room survives: this shows the beds and drawers, but not the wash-stand and writing table. Only one or two minor alterations to the layout are distinguishable, the main one being the placing of the small drawers with attached mirrors on the tops of the chests-of-drawers rather than on the window sills. The candlesticks had four legs, not one, and the black chairs had flat top-rails instead of curved ones.

Literature: Alison, pp. 61, 79, no 23.
Exhibited: Milan, 1973 (23).
Provenance: Mackintosh Estate.
Collection: Glasgow University.

1904.85 Writing desk for the White Bedroom, Hous'hill, Nitshill, Glasgow
Wood, (?) painted white.
Alex Martin quoted for a desk at £10.5.0d. (no date given) and was paid for one (17 December, 1904).

No photograph of this desk survives; the cost of £10.5.0d. suggests, however, that it was a more elaborate piece than the writing table designed for the Blue Bedroom (1904.80).

Collection: untraced.

1904.86 Fireplace for the White Bedroom, Hous'hill, Nitshill, Glasgow
Wood, (?) painted white.
James Grant was paid £3.5.0d. for this fireplace (30 November, 1904).

No photograph of the fireplace survives, but it was probably even simpler than that designed for the Blue Bedroom (1904.82).

Collection: untraced, probably destroyed.

1904.87 Drawers for the White Bedroom, Hous'hill, Nitshill, Glasgow
Wood, (?) painted white.
Alex Martin was paid for two at 11.0d. each (17 December, 1904).

There is no indication on the plan (D1904.84) where these were located. Perhaps they were fitted into the recess at the side of the door.

Collection: untraced.

1904.88 Wash-stand for the White Bedroom, Hous'hill, Nitshill, Glasgow
Wood, (?) painted white, inlaid with coloured glass.

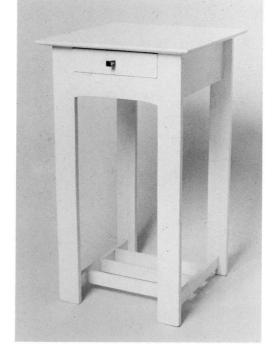

Alex Martin quoted for two at £11.7.6d. each (no date given) and was paid for two at £10.15.6d. each (17 December, 1904); McCulloch was paid £2.10.0d. for glass (12 January, 1905).

The design shown in D1904.84 is unlike any other wash-stand by Mackintosh. It is entirely enclosed, with double doors hiding the shelf for the basin and ewer.

Collection: untraced.

1904.89 Single bed with canopy for the White Bedroom, Hous'hill, Nitshill, Glasgow
Wood, painted white, with embroidered canopy.
Alex Martin quoted for two at £7.15.6d. each (no date given) and was paid for two at £6.10.0d. each, plus £3.13.0d. each for two sets of springs and £1.10.1d. each for two hair mattresses (1 December, 1904).

A very simple design, the only decoration (apart from the embroidered linen) being three square holes pierced in the foot of the bed. The embroideries mix both organic and geometrical motifs. *See* 1904.L.

Literature: *Studio Year Book*, 1907, p. 60.
Collection: untraced.

1904.90 Square bedside table for the White Bedroom, Hous'hill, Nitshill, Glasgow
Wood, painted white, with ebony handle inlaid with mother-of-pearl 76.3 × 43.3 × 42.7cm.
Alex Martin was paid £2.16.0d. for one (17 December, 1904).

McLaren Young tentatively dated the table at Glasgow University to c1903 on stylistic grounds; although one cannot see the stretchers in the contemporary photograph (1904.L), the visible upper half of the table and the handle correspond with the table at Glasgow University. The stretchers, also, certainly match other arrangements which Mackintosh designed for furniture at Hous'hill. It is not known, however, how this piece entered the Davidson collection; perhaps it was purchased at the 1933 Hous'hill auction.

Literature: *Studio Year Book*, 1907, p. 60.
Exhibited: Edinburgh, 1968 (234).
Provenance: Major and Mrs J. Cochrane (Miss Cranston); (?) Hous'hill auction, 1933; Davidson Estate.
Collection: Glasgow University.

1904.91 Mirror for the White Bedroom, Hous'hill, Nitshill, Glasgow
Wood, painted white.
Alex Martin quoted for two at £6.15.0d. each (no date given) and was paid that sum for two (17 December, 1904).

Each mirror was attached to a base consisting of six small drawers; Mackintosh had intended to place them on the window sills, but 1904.L shows them on top of the chests-of-drawers. The finished pieces follow the drawing (D1904.84) except that the tall frame, extending above the mirrors, was omitted.

Literature: *Studio Year Book*, 1907, p. 60.
Collection: untraced.

1904.92 Chest-of-drawers for the White Bedroom, Hous'hill, Nitshill, Glasgow
Wood, painted white.
Alex Martin quoted for two at £9.10.0d. each (no date given) and was paid for two at £8.6.6d. each (17 December, 1904).

Literature: *Studio Year Book*, 1907, p. 60.
Collection: untraced.

1904.93 Chair for the White Bedroom, Hous'hill, Nitshill, Glasgow
Ebonised sycamore 68.3 × 41.8 × 34.5cm.
Alex Martin quoted for two at £2.12.6d. each (no date given) and was paid for two at £2.15.0d. each (17 December, 1904).

A more subtle and successful variation of 1904.73. Although Mackintosh shows the chair with a curved top-rail in the drawing (D1904.84), a faint alteration indicates that he considered changing this to a flat top at quite an early date. The top and bottom rails of the back have a

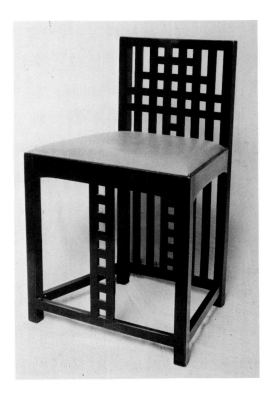

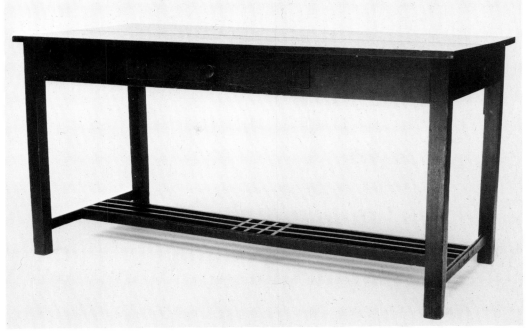

◁1904.93 1904.96▽ 1904.95△

slight concave curve, emphasised by the vertical slats. The rear central pair of slats, below the seat, have short crosspieces connecting them which create a column of squares; this is repeated at the front of the chair. In the upper part of the back, Mackintosh creates a pyramid of squares by using crosspieces of different lengths. In one pair of chairs (height 71.2cm.), these are half-checked into the rising slats, so that, when looked at from the front, the verticals are unbroken, but from behind the horizontal slats are dominant, cutting through each of the verticals. In the other pair, the arrangement is reversed.

William Douglas had four of these chairs, two pairs of slightly differing height. He also owned other duplicates of Hous'hill furniture (1904.73 and 74), but one pair of these chairs (1904.93) were possibly the original Hous'hill chairs, while the other taller pair (71.2cm.) were duplicates for his own use.

Literature: *Studio Year Book*, 1907, p. *60*; Alison, pp. *60, 61*.
Provenance: William Douglas; Nestor Douglas; sold at auction at J. & R. Edmiston, Glasgow, in two lots.
Private collection (2, 68.3cm. high); Glasgow University (1, 71.2cm. high); private collection (1, 71.2cm. high).

1904.94 Candlestick for the White Bedroom, Hous'hill, Nitshill, Glasgow
Wood and metal.
Alex Martin quoted for three (no details given) and was paid for two at 11.0d. each (17 December, 1904).

The candlestick shown in D1904.84 has only a single stem; those which appear in 1904.L have four legs supporting a single cup, a design not unlike the candlesticks for The Hill House (1904.18).

Literature: *Studio Year Book*, 1907, p. *60*.
Collection: untraced.

1904.95 Writing table
Pine, dark stained 76 × 145 × 67.7cm.

No provenance exists for this piece, and no writing table listed in the job-books corresponds with it. The arrangement of the stretchers is like those of a number of items designed *c*1904–06 for The Hill House, and Hous'hill, so a date of *c*1904 seems most likely.

Collection: Glasgow School of Art.

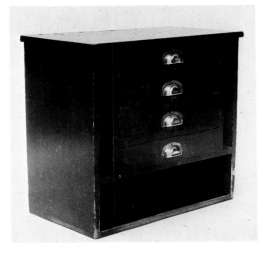

1904.96 Chest-of-drawers
Pine, stained dark 61 × 66.2 × 36.2cm.

A very simple piece which seems to have been designed specifically for the School of Art. A certain amount of furniture was made for the Director in 1904, so this could have been produced for some minor office at about the same time. However, Mackintosh did further work at the School in 1906 and again in 1907–09, so it is possible that this piece dates from as late as 1909.

Collection: Glasgow School of Art.

1904.97 Lug chair for the Willow Tea Rooms, Glasgow
Francis Smith quoted for two chairs at £2.12.6d. each (later amended to £4.14.0d. each, 26 January, 1905) and was paid for two at £4.14.0d. (31 August, 1905). McCulloch quoted for glass at £2.10.0d. (26th January, 1905) and was paid that sum (5 September, 1905).

These chairs are untraced; they may have had some resemblance to the lug chairs which Mackintosh designed for his own flat (1900.5) and for The Hill House (1904.9).

Collection: untraced.

1904.98 Tea table for Windyhill, Kilmacolm
Alex Martin was paid £4.11.6d. for a tea table, six chairs, and a screen (29 December, 1904).

See also 1905.1, D1905.2 and 3. Martin cannot have provided all the above furniture for £4.11.6d. D1905.3 shows that the screen alone would have cost over £10, and the chairs at least £1.10.0d. each. The sum in the job-books probably refers only to the tea table, but this has never been traced; another tea table was made for the drawing-room (1901.36) and it has also disappeared.

Collection: untraced.

1904 Chancel furniture for Holy Trinity Church, Bridge of Allan
The furniture at Bridge of Allan is more elaborate in its decoration than that designed for Queen's Cross Church, Glasgow, but the motifs used are just as firmly based on organic forms. In front of the organ Mackintosh designed a low screen, effectively defining the chancel; it was made of panels of light oak, sparingly ornamented with carved motifs of organic inspiration. The pulpit, heavily decorated with carved tracery and supported on pierced legs, forms part of this screen. In the chancel itself Mackintosh designed a communion table, an organ screen, and at least one chair (although there may originally have been more, as both the job-books and Howarth refer to 'chairs'). The table is a more ambitious version of that at Queen's Cross Church (1899.9) decorated in relief with carved ovals, repeating the earlier Glasgow motif. These ovals are used again in the organ screen, the most elaborately carved piece that Mackintosh ever designed, with a mixture of Gothic tracery and fluted columns; it forms three canopies behind the table and screens the organist from the view of the congregation. Pendant panels in the centre of each canopy recall those in the gallery at Queen's Cross, but, most of all, one is reminded of the carved pendants Mackintosh designed for the School of Art Library: these use the same fluted oval seen at Holy Trinity, but at the School

of Art the motif becomes an end in itself with the subtle variations in each pendant. In the church, which is otherwise rather austere, this screen stands out as a rich and exuberant example of Mackintosh's inventive genius.

Literature: Howarth, pp. 181–82, plate 74.

1904.99 Pulpit for Holy Trinity Church, Bridge of Allan
Oak 197.5 × 138 × 106cm.
John Craig quoted £179.5.6d. for all fittings (no month given, nor details of any subsequent payments), nos. 1904.99–103.

The pulpit springs out of the low screen, which surrounds and defines the chancel.

Literature: Howarth, p. 181.
Collection: *in situ*.

1904.99/100/101▽

1904.100 Communion table for Holy Trinity Church, Bridge of Allan
Oak 76 × 201 × 75.5cm.

Literature: Howarth, pp. 181–82, plate 74.
Collection: *in situ*.

1904.101 Organ screen for Holy Trinity Church, Bridge of Allan
Oak 244 × 228 × 28cm.

Literature: Howarth, pp. 181–82, plate 74.
Collection: *in situ*.

1904.102 Choir stalls for Holy Trinity Church, Bridge of Allan
Oak

Although these can be seen in Howarth's plate 74, they are no longer in the church where chairs are now used instead. They appear to have been very simple, like the pews at Queen's Cross Church, Glasgow, with a carved panel in the gable end of each pew; two appear in the photograph.

Literature: Howarth, pp. 181–82, plate 74.
Collection: untraced.

1904.103 Armchair for Holy Trinity Church, Bridge of Allan
Oak 106 × 66.5 × 59cm.

The job-books and Howarth refer to 'chairs', but only one armchair now remains *in situ*.

Literature: Howarth, pp. 181–82, plate 74.
Collection: *in situ*.

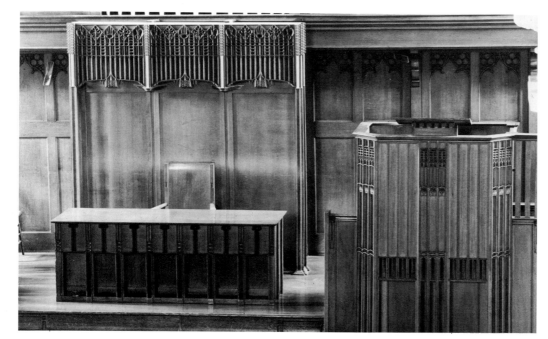

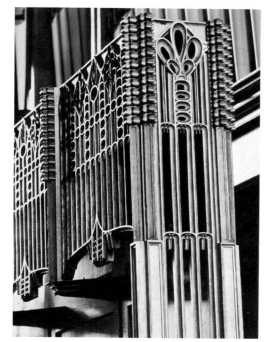

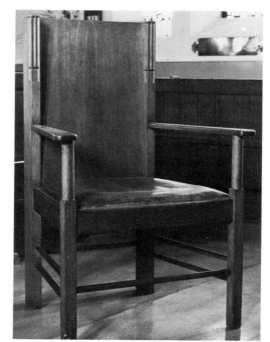

▽1904.100 1904.101 detail△ △1904.103 ▽1904.101 detail 1904.99 detail△

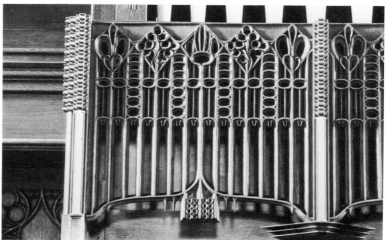

176

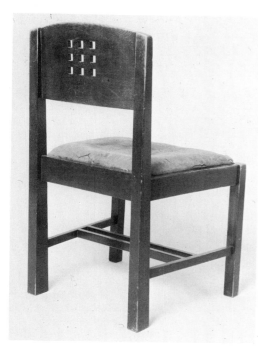

△1905.1

1905.1 Chair for Windyhill, Kilmacolm

Oak, stained dark 81.2 × 48.5 × 43.8cm.
Alex Martin was paid £4.11.6d. for six chairs, a tea table, and a screen (29 December, 1904).

Some error must have crept into Mackintosh's job-books, because Martin cannot have provided all the above furniture for £4.11.6d. It seems most likely that this sum refers only to the tea table, especially as these chairs, a variant of 1904.28, are likely to have cost at least £1.10.0d. each.

D1905.2 shows that Mackintosh did design a screen and a hall chair for Davidson. It seems likely that Davidson's family had outgrown the seating capacity of the hall benches (1901.29) which were used with the tables (1901.26 and 27) for family gatherings. The chair shown in D1905.2 is derived from the Hous'hill billiards room chair (1904.37), but it appears never to have been used at Windyhill. Instead, Davidson seems to have settled for a variant of the School of Art armchair (1904.28); eight chairs and two armchairs survive with a Windyhill/Davidson provenance; they were later used by Davidson at 78 Southpark Avenue after 1919.

▽D1905.2

Provenance: a) William Davidson; Dr Cameron Davidson, by whom presented; b) William Davidson; Hamish Davidson, by whom bequeathed.
Collection: a) Glasgow School of Art (4); b) Glasgow University (4).

D1905.2 Design for a screen and a chair for the hall, Windyhill, Kilmacolm

Pencil and watercolour 31.7 × 49.8cm.
Inscribed and dated, lower right, *140 Bath Street / Glasgow March 1905*; and inscribed, upper left, *Windyhill, Kilmacolm. for William Davidson Esq—/ Sketch drawings for Screen & chairs for Hall.*; centre left, *this filled all round / on other side / no centre strap on / other side*; centre right, *leaded glass / with some colours; 8 feet × 5 ft 6 ins, some grey central coloured / fabric such as linen or / hand woven windermere silk & linen*; and various other notes and measurements.
Scale, 1:12.

Davidson probably commissioned the chairs to provide extra seating around his dining table in the hall, and the screen would have sheltered diners from the draughts inherent in such a space, which was open to the main staircase and contained five doors to other rooms. The chair shown on the drawing is a variant of that designed for the billiards room at Hous'hill; the chairs finally made for Windyhill are totally different from this design (*see* 1905.1).

The screen does not appear to have been made: Dr Cameron Davidson, a son of William Davidson, told the author that no screen designed by Mackintosh was ever used in the hall at Windyhill. This drawing shows that Mackintosh considered using either a triangle or a square in the decoration of the 'trunk' of the tree-like feature on the panels: the later drawing confirms his preference for the triangle.

Provenance: Mackintosh Estate.
Collection: Glasgow University.

D1905.3 Design for a screen for the hall, Windyhill, Kilmacolm

Pencil and watercolour 102.6 × 72.6cm.
Inscribed and dated, lower right, *140 Bath Street / Glasgow April 1905*; inscribed, upper right, *William Davidson Esqr Windyhill Kilmacolm / Screen for Hall / To be made in oak or other hardwood—/exposed parts sycamore or Kauri pine—/price to include 9 double action electroplated hinges / stretching covering material*

(to be supplied) on framework / (inlaying stained sycamore to be separate price) staining & french / polishing all exposed parts and delivering at Kilmacolm, centre right, *Alex Martin £10.10 without inlay 30/- less / covering material say £1-10—*; and various other notes. Verso, lower left, in another hand, *Plan for screen Windyhill / Mr DAVIDSON Kilmacolm*.
Scale, 1:12, and full size.

A more detailed development of D1905.2 showing Mackintosh's use of the triangle as decoration. The only earlier piece on which the triangle was used was the cabinet at The Hill House (1904.20); there are other similarities between the two designs, such as the use of stained sycamore for decoration. The drawing also shows that the screen has been enlarged from that shown in D1905.2, and now has four panels instead of three. Alex Martin has indicated his cost of £10.10.0d., which possibly deterred Davidson from going ahead with the design.

Provenance: Mackintosh Estate.
Collection: Glasgow University. D1905.3▽

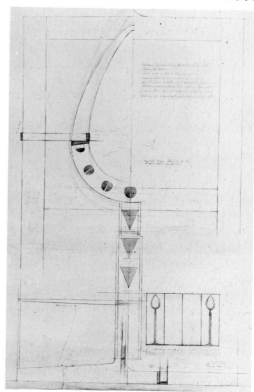

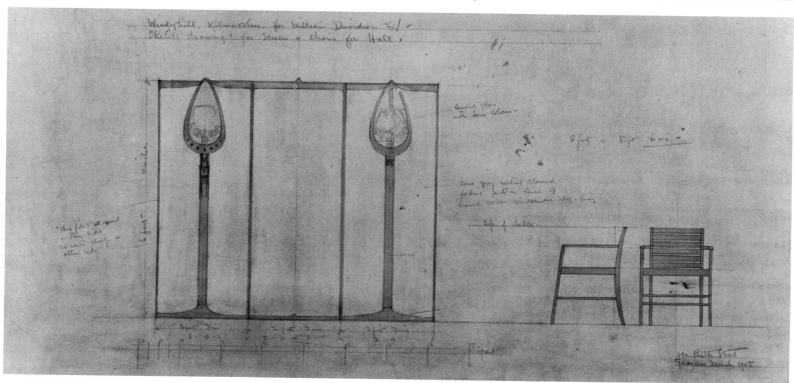

1905 Dining-room for A. S. Ball, Berlin

In 1905 a group of leading architects was asked to submit designs for furnished rooms for the A. S. Ball exhibit in Berlin. The host architect was Alfred Grenander, and among those chosen to exhibit were Olbrich and Mackintosh. As Clark has pointed out, most of the rooms were profoundly influenced by Mackintosh, not least the scheme put forward by Grenander; even Olbrich's dining-room owed much to Mackintosh but, unlike his entry, it was painted white.

Mackintosh's dining-room was L-shaped, with dark papered walls and furniture based on the tables and chairs made for the Room de Luxe at the Willow Tea Rooms in 1903; the sideboard and dresser, however, are more rigidly linear and can be related to the Hous'hill Blue Bedroom and hall of 1904. The square again dominates the scheme, with lattice-work in cupboard doors, pierced through the backs of chairs, or inlaid in ceramic or glass as in the sideboard and clock. It is a more severe design than any earlier dining-room designed by Mackintosh except perhaps, that for the *Haus eines Kunstfreundes* competition. Mackintosh was not able to design the furniture in the dining-rooms at The Hill House and Hous'hill, and at 78 Southpark Avenue in 1906 he virtually recreated his 1900 design for 120 Mains Street. The Ball dining-room, therefore, is particularly important as the only example of the genre designed *in toto* by Mackintosh between 1900 and 1916 (the Tea Rooms cannot really be considered domestic schemes). The severity of the Ball dining-room was repeated in the bedrooms designed for Bassett-Lowke in 1916 and 1917 and in the dining-room for his brother-in-law in 1919.

1905.B ▽

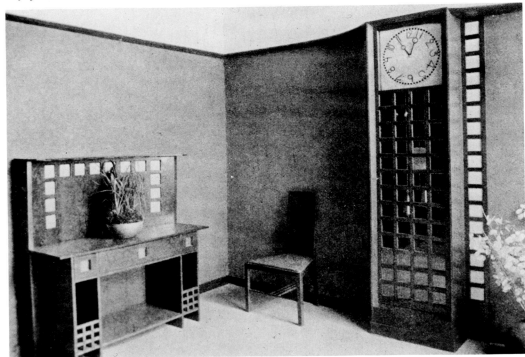

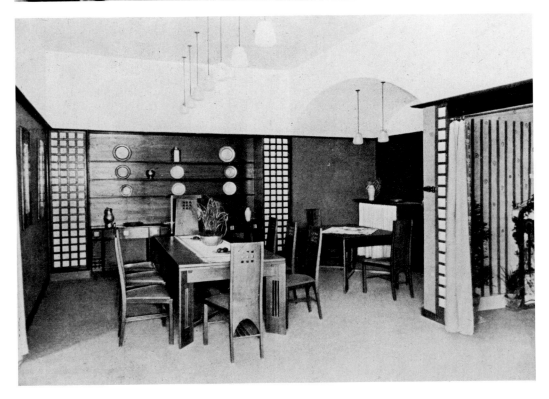

◁1905.A

1905.A **Dining-room for A. S. Ball, Berlin**

1905.B **Dining-room for A. S. Ball, Berlin**

1905.4 **Dresser for the dining-room, for A. S. Ball, Berlin**
Oak, stained grey-green.

The reviewer of the exhibition wrote in *Deutsche Kunst und Dekoration* '. . . the dining room by Ch. R. Mackintosh, Glasgow [is] easily distinguished by its very fine rhythms. It is fashioned in grey-green stained oak. The dresser, sideboard and grandfather clock are ponderously distinguished, solid pieces of built-in furniture.' This dresser can be related to the earlier design for a dresser in the dining-room of a *Haus eines Kunstfreundes*, and to some of the utilitarian kitchen and pantry fittings at The Hill House. *See* 1905.A.

Literature: *Deutsche Kunst und Dekoration*, XVI, 1905, pp. 402, *417*.
Collection: untraced.

1905.5 **Sideboard for the dining-room for A. S. Ball, Berlin**
Oak, stained grey-green, with inlay of glass, ceramic, or metal.

See 1905.B.

Literature: *Deutsche Kunst und Dekoration*, XVI, 1905, p. *417*.
Collection: untraced.

1905.6 **Clock for the dining-room for A. S. Ball, Berlin**
Oak, stained dark, with glazed door and coloured glass/tile inlay.

A version of 1903.31 from the Willow Tea Rooms, but taller and with a larger lattice module. A panel of coloured inlay flanked each side of the clock, and the picture-rail curved out to connect with its top. *See* 1905.B.

Literature: *Deutsche Kunst und Dekoration*, XVI, 1905, p. *416*.
Collection: untraced.

1905.7 **Small table for the dining-room for A. S. Ball, Berlin**
Oak, stained grey-green.

A simple design with legs similar to those used in the tables (1903.25) for the Room de Luxe. *See* 1905.A and D1905.15A.

Literature: *Deutsche Kunst und Dekoration*, XVI, 1905, p. *417*.
Collection: untraced.

1905.8 **Large table for the dining-room for A. S. Ball, Berlin**
Oak, stained grey-green.

A larger version of 1905.7, designed to take three chairs down each of its long sides and one chair at each end. *See* 1905.A.

Literature: *Deutsche Kunst und Dekoration*, XVI, 1905, p. *417*.
Collection: untraced.

1905.9 **Chair with high back for the dining-room for A. S. Ball, Berlin**
Oak, stained grey-green.

Identical to the high-backed chair in the Room de Luxe (1903.20), except that the back of this chair was not upholstered, nor was it painted silver. Only one appears to have been made. *See* 1905.A.

Literature: *Deutsche Kunst und Dekoration*, XVI, 1905, p. *417*.
Collection: untraced.

1905.10 Chair for the dining-room for A. S. Ball, Berlin
Oak, stained grey-green.

Similar to 1903.23 for the Room de Luxe, but this chair has a different arrangement of stretchers. The back is not upholstered, and a group of nine pierced squares (as used on 1903.20 and 1905.9) were incorporated as decoration. Ten appear in contemporary photographs. *See* 1905.A and B.

Literature: *Deutsche Kunst und Dekoration*, XVI, 1905, pp. *416, 417*.
Collection: untraced.

D1905.11 Plan of the dining-room designed for A. S. Ball, Berlin
Pencil 28.8 × 49.2cm.
Signed and inscribed, lower right, *Chas R Mackintosh / 120 Mains Street / Blythswood Square Glasgow*; and various notes and measurements.
Scale, 1:24.

This drawing shows the L-shaped space allocated to Mackintosh and his overall plan for it. The double doors at both entrances were not, in fact, provided, and the openings were covered by curtains. The positions of the sideboard and clock are not indicated, but they were probably intended for the area adjacent to the window (*see* D1905.12). In this plan, Mackintosh's original table accommodated a dozen chairs in addition to the small table in the alcove; a rough sketch shows the eventual arrangement, with a smaller table and only three—not five—chairs per side.

Mackintosh's partnership agreement with Keppie included a clause that all drawings must bear the name Honeyman, Keppie & Mackintosh, unless they were for competitions or exhibitions; the appearance of Mackintosh's home address on these drawings confirms that he considered this invitation a personal one.

Provenance: Mackintosh Estate.
Collection: Glasgow University.

D1905.12 Elevation of a wall of the dining-room for A. S. Ball, Berlin
Pencil and watercolour 26.1 × 37.1cm.
Signed, dated and inscribed, lower right, *Chas. R. Mackintosh / [120 Mains Street deleted] Blythswood Square / Glasgow*.

Probably an elevation of the wall opposite the dresser (*see* D1905.11). Originally, Mackintosh intended to strap the wall and insert squares of coloured glass into the straps; this was not carried out, but a clock face has been drawn between two of the straps showing the origin of the design for 1905.6.

Provenance: William Meldrum; James Meldrum, by whom presented.
Collection: Victoria & Albert Museum, London (E.839–1968).

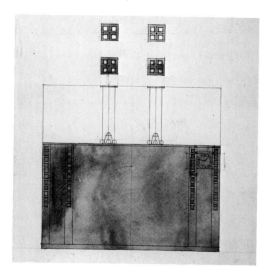

◁D1905.12

This severity is not simply caused by excessive use of the square: the Dresdener Werkstätten bedroom also emphasised the square, but the overall effect was by no means austere. There the squares were smaller, and, as well as adorning the furniture, they were stencilled on the grey walls. The furniture at Berlin also has a strong horizontal emphasis, in the wide shelves cutting across the broad expanse of timber in the upper part of the dresser, and the broad shelf above the drawers; even the table is larger than most others designed by Mackintosh and the sideboard emphasises this general horizontal feeling, being one of the few such pieces which is broader than it is high.

In the Oak Room and in the School of Art extension in 1907, Mackintosh had the opportunity to take this new style further, but nothing was as sober as the Ball dining-room. Even in the Chinese Room the rigid lattice-work was relieved by bright colours and leaded-glass in the square-framed partitions. At Northampton, however, Mackintosh returned to this arrangement, and items like the dining-room doors, the hall cabinet and chairs can all be traced back to this design.

Literature: *Deutsche Kunst und Dekoration*, XVI, 1905, pp. 402, *416, 417*; R. Judson Clark, 'J. M. Olbrich, 1867–1908', in *Architectural Design*, December 1967, p. 570.

D1905.11▽

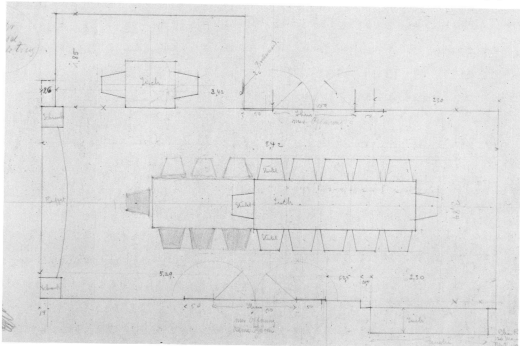

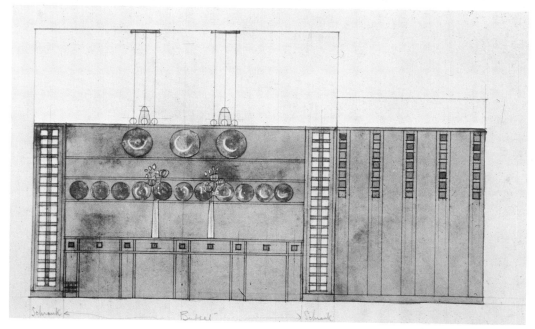

D1905.13△

D1905.13 Elevation of a dresser and wall of the dining-room designed for A. S. Ball, Berlin
Pencil and watercolour 25.8 × 38.1cm.
Signed and inscribed, lower right, *Chas. R. Mackintosh / 120 Mains Street / Blythswood Square Glasgow*, and, below, *Schrank / Buffet / Schrank*.
Scale, 1:24.

The glazed cupboards were widened and the straps removed, otherwise the drawing is as executed.

Provenance: Mackintosh Estate.
Collection: Glasgow University.

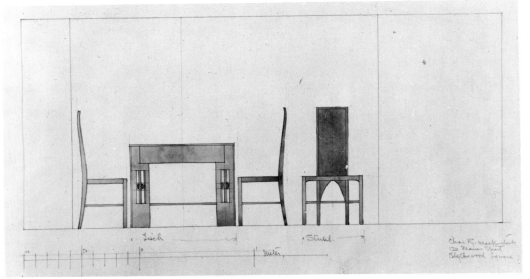

△D1905.14

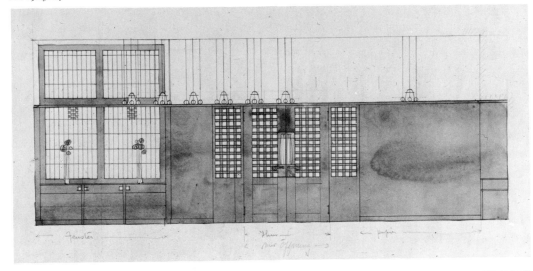

D1905.15▽

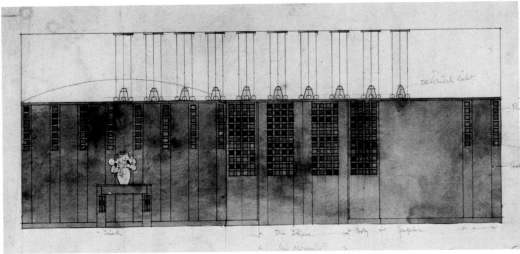

△D1905.15A

D1905.16▽

D1905.14 Design for a table and chair for the dining-room for A. S. Ball, Berlin
Pencil and watercolour 25.2×47cm. (irregular).
Signed and inscribed, lower right, *Chas. R. Mackintosh | 120 Mains Street | Blythswood Square*, and, below, *Tisch | Stuhl*.
Scale, 1:12.

Both items are very similar to tables and chairs made for the Room de Luxe; the decoration on the legs of the executed table was slightly different, however, and nine pierced squares were added to the back of the chair.

Literature: Alison, p. 79, no 26, *104* (as a design for the Willow Tea Rooms).
Exhibited: Milan, 1973 (26).
Provenance: Mackintosh Estate.
Collection: Glasgow University.

D1905.15 Elevation of a wall of the dining-room designed for A. S. Ball, Berlin
Pencil and watercolour 25.8×43.3cm.
Inscribed, below, *Fenster | Thür | papier*.
Scale, 1:24.

The glazed doors seem to have been omitted from the exhibited room, and the opening was covered by a curtain. Contemporary photographs do not show the window and table included in this drawing, and it is not known if they were executed. The table is derived from the sideboard in the *Haus eines Kunstfreundes* and the window table at The Hill House.

Provenance: Mackintosh Estate
Collection: Glasgow University.

D1905.15A Elevation of a wall of the dining-room for A. S. Ball, Berlin
Pencil and watercolour 22.9×43.2cm. (sight).
Signed and inscribed, lower right, *Chas. R. Mackintosh | 120 Mains Street | Blythswood Square Glasgow*; and various other notes.
Scale, 1:24.

This drawing shows the doors Mackintosh had intended to provide, and the table, 1905.7.

Collection: Dr Thomas Howarth.

D1905.16 Design for a table centre for the Blue Bedroom, Hous'hill, Nitshill, Glasgow
Pencil and watercolour 42×81.2cm.
Inscribed and dated, lower right, *140 Bath Street | Glasgow March 1905*, and *John Cochrane Esqr. The Hous hill Nitshill | Table Center [sic] for Blue Bedroom*.
Scale, full size.

Virtually as executed; it was not made by Margaret, but by Crawford & Craig (for 18.0d., 7 April, 1905), who also made cushions for Hous'hill (probably for the couch in the Blue Bedroom). This table centre was used on 1904.72 and shown in 1904.J.

Provenance: Mackintosh Estate.
Collection: Glasgow University.

1905.C Drawing-room at The Hill House, Helensburgh
The earliest possible date for this photograph (taken by a member of the Blackie family) is 1905, the year the lamp, the clock, and the armchair in the foreground were produced (*see* 1905.17, 24 and 20); the latest date is 1912, when Mackintosh recorded his decision to paint the ceiling a darker colour. The lighting had already been changed from the pendant fittings to the wall brackets.

Collection: Mrs Alison Walker.

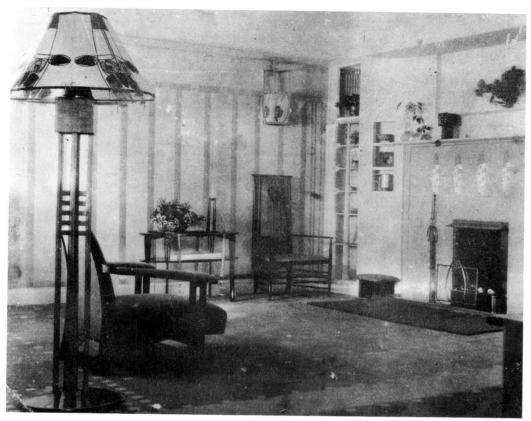

The lampshade is more in keeping with the stencils on the wall, with its repetition of the rose and trellis motif. The drawing for it (D1905.18) shows that it was made of white silk, with pink roses and green leaves all of silk and a black ribbon forming the trellis; beads were hung along the lower edge where the black ribbon touched the rim. The existing shade is not original.

Provenance: W. Blackie; by family descent. Private collection

D1905.18 Design for a lampshade for The Hill House, Helensburgh
Pencil and watercolour 60.7 × 69.9cm.
Inscribed, bottom centre, *This repeat 4 times | Lamp shade for Walter W Blackie Esqr | The Hill House Helensburgh* and, lower right, *This drawing to be returned to | 140 Bath Street Glasgow.* Scale, full size.

Virtually as executed, the motif being repeated four times on the finished shade.

Literature: Alison, p. 78, no 21.
Exhibited: Milan, 1973 (21).
Provenance: C. R. Mackintosh; Margaret Macdonald Mackintosh; by family descent to Mrs L. A. Dunderdale, by whom presented.
Collection: Glasgow University.

1905.19 Square table for The Hill House, Helensburgh
Ebonised wood.
Alex Martin quoted for one at £6.7.6d. (no

◁1905.17 1905.C△

1905.17 Standard lamp for the drawing-room, The Hill House, Helensburgh
Sycamore and mother-of-pearl, 139 × 44cm. diameter; shade: silk, linen and beads, 40 × 62cm. (diameter).
Alex Martin quoted £7 for the stand (no date given) and was paid £7.4.0d. (27 November, 1905); Miss Campbell was paid £3.10.0d. for the shade.

A piece which, if seen without its lampshade, could easily be taken for a product of the 1920s. The square members and rails relate to the easy chair, but the making of a pattern by alternating the grain of the timber is a new device for Mackintosh which he returned to in some of the pieces he designed in Northampton in 1916–20. The formality of the whole structure is relieved by the apparently fortuitous appearance of a piece of mother-of-pearl on the base, which upsets the rigorous symmetry of the design.

▽D1905.18

1905.19▽

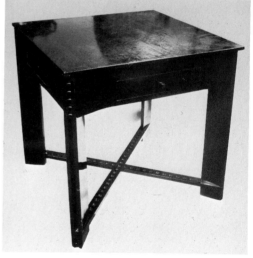

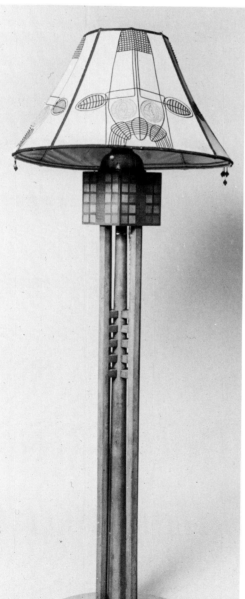

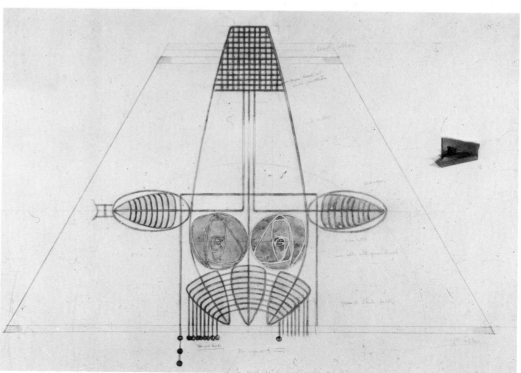

date given) and was paid that sum (8 December, 1905).

A more complex, but on the whole less elegant, version of the table for the Blue Bedroom at Hous'hill (1904.72). The diagonal stretchers are again paired, but with more frequent lateral connections making a regular chequer pattern. Again, they split on either side of the legs, which are set at 45° to the table top. The construction of the legs is completely different, for, although it repeats the wedge-shaped cross-section, this is achieved by fixing together two boards on their inner edge and splaying them out, so that when viewed from the outer edge of the table, each leg seems to consist of a pair of wide boards with the gap between them filled with small squares of wood to repeat the chequer effect of the paired stretchers.

Provenance: Walter Blackie; by family descent to D. Bisacre; Sotheby's, 17 April, 1967, lot 221.
Collection: untraced.

1905.20 Easy chair for The Hill House, Helensburgh
Ebonised wood, with mother-of-pearl inlay, upholstered seat and back 76.5 × 82.5 × 73.5cm.
Alex Martin quoted for two at £6.10.0d. each (no date given) and was paid for two at £6.14.3d. each (8 December, 1905).

A very different design from the other chairs at The Hill House, all of which impose an upright posture on the user. The use of paired rails in the construction of the chair is more obvious here than in the square table (1905.19), but Mackintosh repeated this motif on a much larger scale in his designs for the School of Art in 1907, particularly in the arrangement of wooden beams in the library and the studio above it (see 1909.L).

▽1905.20

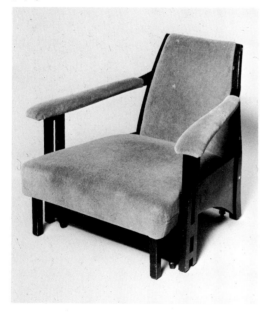

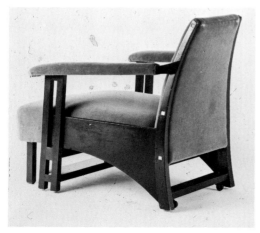

When the rails overlap or intersect each other, Mackintosh shows a wooden pin making the joint, but these pins are, in fact, only attached to the surface of the joint—their function is visual not structural. Ten years later, Rietveld designed his Red-Blue chair using similar square rails and exposed pins; it is interesting to speculate whether he could have known this chair, or even the lamp standard at The Hill House which is similar in style (1905.17).

The legs at the front edge of the chair are later additions; the chair was not stable if one sat towards the front edge, and it had a habit of throwing to the floor any unwary guest who sat politely on the edge of the chair; the legs were added by the Blackies—possibly with Mackintosh's approval—to spare their guests embarrassment.

Exhibited: Edinburgh, 1968 (245).
Provenance: a) and b) Walter Blackie; by family descent.
Collection: a) Mrs A. Walker (née Blackie); b) Mrs Ruth Hedderwick (née Blackie).

D1905.21 Design for an easy chair
Pencil and watercolour 29.1 × 30cm.

Signed, lower right, *Chas. R Mackintosh Des.*; inscribed, upper left, *SKETCH FOR EASY CHAIR*; and various other notes.
Scale, probably 1:12.

Possibly an early design for the easy chair for The Hill House (1905.20).

Provenance: Mackintosh Estate.
Collection: Glasgow University.

D1905.22 Design for an easy chair for The Hill House, Helensburgh
Pencil, pen and ink, and watercolour 24 × 35.5cm. (irregular).
Inscribed, along lower edge, *EASY CHAIR FOR DINING ROOM; SIDE; FRONT*.

There is no explanation for Mackintosh's reference to the dining-room on this drawing. Mrs Walker is quite certain that the chairs (1905.20) were always used in the drawing-room and there is, in any case, no space in the dining-room for them.

The perspective sketch on the left of the drawing shows the chair virtually as executed, but the side and front elevations have significant differences, which were not incorporated in the final design. For instance, a rail at floor level is

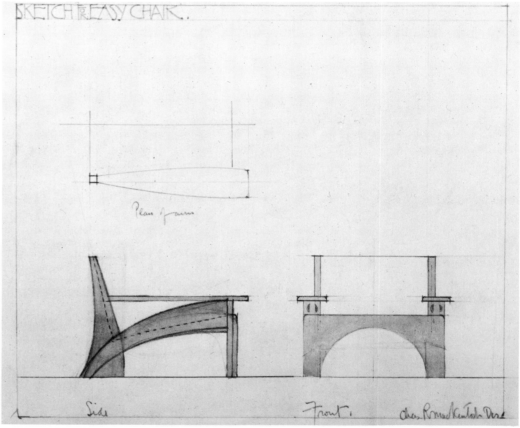

△D1905.21

D1905.22▽

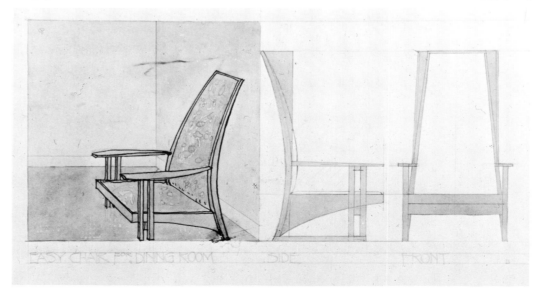

shown, connecting the front and back legs, which was eventually omitted; projecting wings are also shown, flanking the tapering back; these were also disregarded.

Provenance: Mackintosh Estate.
Collection: Glasgow University.

1905.23 Legs for the grand piano, The Hill House, Helensburgh
Alex Martin was paid £28.5.5d. (8 December, 1905).

Mrs Walker recalls Mackintosh designing a new set of legs, stained black or green, for the grand piano which the Blackies owned and which stood in its own bay in the drawing-room. The

piano was given to a Royal Air Force base during the World War II and has not been traced.

Provenance: W. Blackie; by whom presented to the RAF, c1939–45.
Collection: untraced.

1905.24 Clock for The Hill House, Helensburgh
Ebony and stained sycamore, with ivory inlay and painted numerals 23 × 11.5 × 10cm.
Alex Martin was paid £2.17.0d. for the case, and David Hislop £2.5.0d. for the movement (both 27 November, 1905).

This simple design, a cube containing the

clockwork motor supported on 16 square columns, was modified and repeated several times for W. J. Bassett-Lowke c1917–18. Mackintosh retained an example of the clock for his own collection.

Provenance: a) Walter Blackie; by family descent; b) Davidson Estate.
Collection: a) Mrs A. Walker; b) Glasgow University.

D1905.25 Design for a clock for The Hill House, Helensburgh
Pen and ink on brown tracing paper 28.7 × 33cm.
Inscribed, centre right, *silver finished matt*; and, in another hand, *the V and X are drawn with | heavier stroke in the wrong side | Make that right | Painted white.*
Scale, full size.

A drawing for 1905.24. The note about the mistake in the numerals may be in either Blackie's hand or the clockmaker's; the error was corrected.

Provenance: Mackintosh Estate.
Collection: Glasgow University.

1905.26 Pulpit, screen, font, and lights for Abbey Close Church, Paisley
Font, ebonised pine 113.8 × 53.7cm. (diameter).
John Craig quoted for a pulpit at £44 in oak or £34 in pine (27 July, 1905); James Bryce quoted for a pulpit screen at £44.10.0d. and a font at £4.7.6d. (24 October, 1905). Andrew Hutchinson quoted £2 for a silver bowl for the font (26 March, 1906) and was paid that sum (2 July, 1906); he also quoted for eight pendant light fittings at £4.15.0d. each (29 July, 1904) and was paid that sum (6 September, 1904).

The church has been demolished and the fittings

1905.26▽

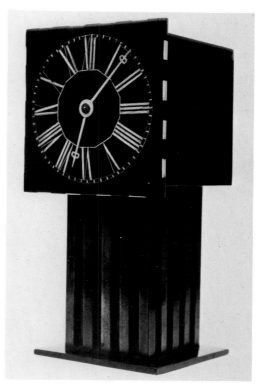

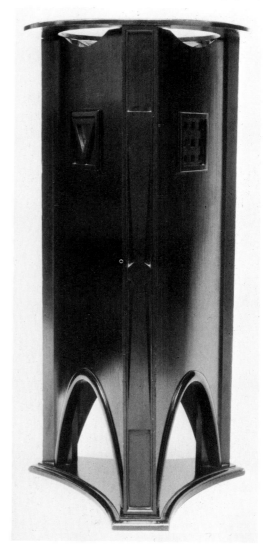

△1905.24

D1905.25▽

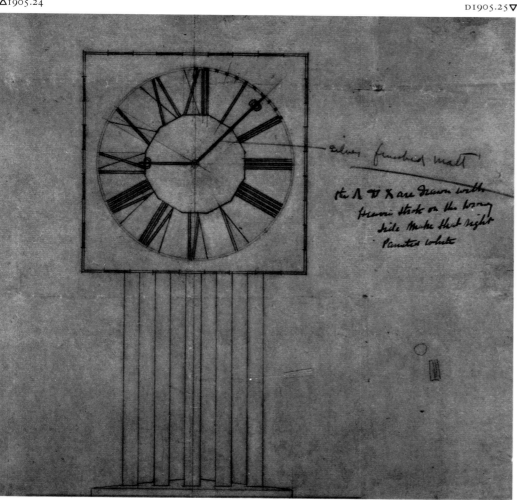

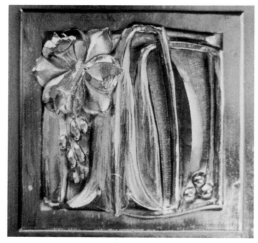

△1905.26 detail

destroyed, with the exception of the font.

Literature: Howarth, pp. 182–83.
Collection: Glasgow School of Art.

1905.27 Fireplace for Prospecthill House, Paisley

Francis Smith quoted £10.3.0d. (26 July, 1905) and was paid that sum (5 October, 1905); Caird Parker was paid £7.10.3d. for the grate (16 November, 1905).

No longer extant. See D1905.28.

D1905.28 Design for the fireplace for the morning-room, Prospecthill House, Paisley

Pencil and watercolour 32.3 × 38.4cm.
Inscribed, and dated, lower right, *140 BATH STREET GLASGOW 1905*; inscribed, top centre, *MISS ROWAT PROSPECT HILL HOUSE PAISLEY MORNING ROOM FIREPLACE*; and various other notes and measurements.
Scale, 1:12.

Although the job-books indicate that this commission was carried out, no photographs exist to indicate how closely the executed work followed this drawing. Another addition to Mackintosh's range of designs for fireplaces, this incorporates features used in other schemes,

▽D1905.28

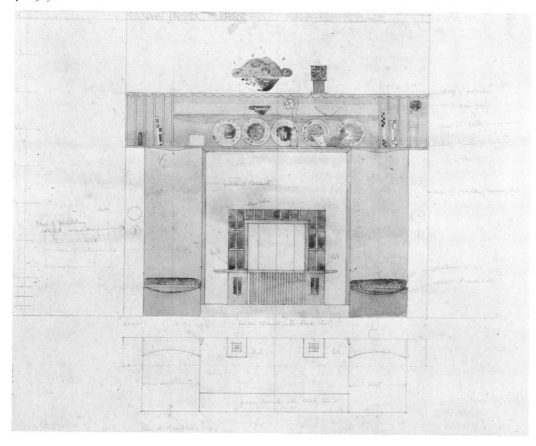

such as the seats and the wrought-iron hob, but a completely new motif is introduced in the wavy apron below the top shelf: this adds a hint of gaiety to an otherwise rigidly geometrical design and was used again on several other pieces (*see 1907.7, 1910.12*). The clock shown on the top shelf is identical with 1905.24, but it is not known whether yet another example was made for Miss Rowat.

Collection: Glasgow School of Art.

1905.29 Fireplace for 23 Huntly Gardens, Glasgow

The job-books show quotations of £11.5.0d. for grate and fender, £4.5.0d. for side seats, £1.2.6d. for steel fender, and 16.6d. for cleaning marble (6 October, 1905, no tradesmen specified), all of which was paid on 1 February, 1906.

Collection: untraced, probably destroyed.

1905.30▽

1905.30 Medallists' board for Hutcheson Girls Grammar School, Glasgow

Oak.
James Grant was paid £10.10.0d. (22 January, 1906).

Mackintosh simply provided three timber panels fitting into an existing arcade of three arches; he also designed the lettering used for the names of winners but, sadly, this has not been followed in recent years.

Collection: *in situ*.

1905.31 Candlestick with circular base

Nickel-plated brass 27.5 × 10.2cm. (diameter).

These candlesticks were probably made about 1905, but there is no record of the maker. The columns were originally diced, but this decoration has been virtually removed by constant cleaning.

Exhibited: Edinburgh, 1968 (238).
Provenance: C. R. Mackintosh; Nancy Mackintosh; from whose estate purchased.
Collection: Glasgow University (2).

1905.31▽

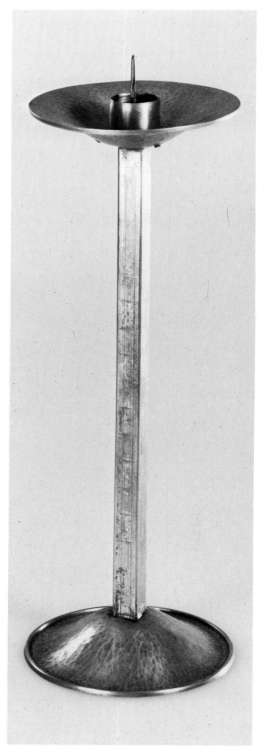

1906 The Board Room, Glasgow School of Art

The Governors did not, apparently use the Board Room provided in the east wing for very long. It was brought into use as a studio, because of shortage of space, and in 1906 Mackintosh provided the Board with a new meeting room in what had been a ground-floor studio. Relations between Mackintosh and the Governors were rarely cordial, and this no doubt coloured Mackintosh's reaction to their commission for a new Board Room. The Governors probably made it clear that they were expecting a room with a little more *gravitas* than the rest of the School and, judging by the results, they were prepared to spend more on themselves than on fitting out other rooms in the building. The new room was panelled with polished timber, the broad panels being divided by classical pilasters. These are fluted, with an idiosyncratic Ionic capital crowning each, but the top metre or so of fluting on each pilaster is decorated by an apparently random placing of squares and rectangles of timber, flush with the raised lines of the fluting. As Howarth points out, the result is like musical notation and is the first example of a theme Mackintosh returned to more successfully in the Library in 1909. Each of the pilasters has a unique arrangement of this strange decoration, a motif repeated in the gallery pendants and legs of the Library tables. The reaction of the Governors is not recorded, but John Burnet and Keppie, both Governors at this period, are not likely to have been amused.

Literature: Howarth, pp. 90–91, plate 27b; Bliss, figs. 25–29; Macleod, plate 98.

1906.A The Board Room, Glasgow School of Art
This photograph was taken in 1910; the furniture from the Director's office was specially moved into it for the occasion.

Collection: RCAHMS.

1906.1 Oval table for the Board Room, Glasgow School of Art
Pine, stained dark 81.2 × 288.5 × 153cm.

Collection: Glasgow School of Art.

1906.2 Armchair for the Board Room, Glasgow School of Art
Cypress 82.5 × 56.4 × 49.3cm.

A more elaborate version of 1899.13, made in cypress and french-polished in order to harmonise with the more august surroundings of the new Board Room.

Literature: Bliss, fig. 25.
Collection: Glasgow School of Art (12).

1906.3 Podium for a chair for the Board Room, Glasgow School of Art
Pine, stained dark 14 × 91 × 107cm.

Used to raise the chair occupied by the Chairman of the Board of Governors at formal meetings; it can be clearly seen in Newbery's group portrait of the Building Committee, c1914.

Collection: Glasgow School of Art.

1906.4 Letter-rack for the Board Room, Glasgow School of Art
Pine 14.7 × 22.8 × 40.8cm.

Collection: Glasgow School of Art.

1906.B Hall at 78 Southpark Avenue, Glasgow
The bench on the right is 1900.34. Opposite the window hung a mirror by the Macdonald

1906.A▽

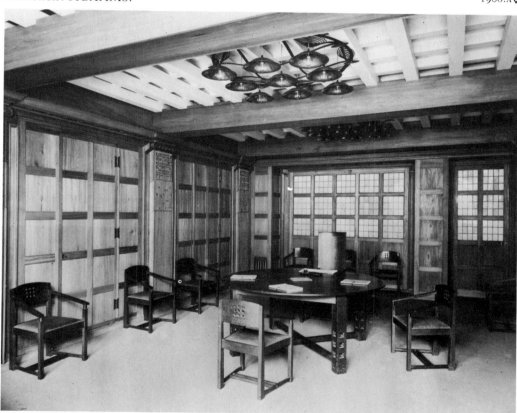

▽1906.1

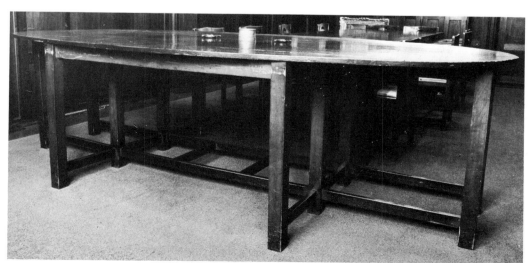

△1906.2

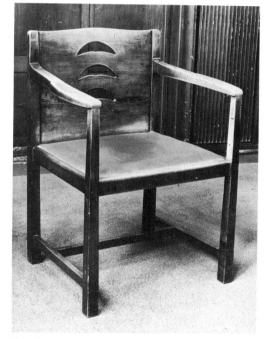

1906.B▽

1906 78 Southpark Avenue, Glasgow

In 1906 Mackintosh bought a house in the fashionable Hillhead district of Glasgow and left his flat at 120 Mains Street. The house overlooked the neo-classical Wellington Church and the grounds of Northpark House and also had a view of Gilbert Scott's buildings for the University of Glasgow. 6, Florentine Terrace was the end house of the row, with a large gable wall facing south, while the main rooms faced east. Florentine Terrace was later assimilated into Ann Street (and number 6 became number 78); more recently Ann Street was re-named Southpark Avenue.

Florentine Terrace was built in the 1850s; the stone-built houses had bay windows on ground and first floors, with a further floor and attic above. Mackintosh made a number of changes to the house, some major, some less so, but as the alterations he made have not been fully recorded elsewhere, I propose to do so here. Externally, few alterations took place except for the rearrangement of windows, mainly on the south gable, and no amendments were made to the east front with the exception of the front door. The house originally had double storm doors, folding back against the walls of a shallow porch; the main, inner door was half-glazed. Mackintosh removed the inner door completely and replaced the double storm doors with a single, narrower door. The original opening was narrowed by using a wide architrave fixed at 45° to the door. The door with a panel of four squares of purple glass, was painted white; the architraves and the fixed light above were black. As a result of removing the porch and replacing it with a narrower door, Mackintosh also had to narrow his hall; this he did by inserting two panels of butt-jointed pine planks (their joints hidden by a cover slip) on either side of the new door. These were attached at their west end to the walls, but were projected away from the walls at the eastern extremity so that the walls appeared to taper to meet the narrower door frame. The panelling was not continued on the walls of the hall, but Mackintosh repeated the arrangement of broad straps beneath a similar broad picture-rail which he had used in the drawing-room at 120 Mains Street. The picture-rail was at the same height as the top architrave of the door to the dining-room which, like all the woodwork of the hall except the front door, was stained black and waxed.

sisters and Herbert MacNair (private collection). Photographed in 1962 before the interiors were dismantled.

Collection: Glasgow University.

1906.C Dining-room at 78 Southpark Avenue, Glasgow
The fireplace from Mains Street (1900.17) was extended at either side by shelves to fill the width of the chimney breast. The fender shown here is actually that designed for the bedroom fireplace (see 1906.H). Photographed in 1962.

Collection: Glasgow University.

1906.D The Studio, 78 Southpark Avenue, Glasgow
Photographed in 1962.

Collection: Glasgow University.

1906.E The drawing-room and studio, 78 Southpark Avenue, Glasgow
Behind the chair on the left was originally a door to the front room which Mackintosh blocked up. He then opened up the wall between the two rooms to create a single L-shaped space.

Collection: Glasgow University.

1906.F The drawing-room, 78 Southpark Avenue, Glasgow
A view from the studio. The new south window is on the right, and the new screen walls across the two east windows can be clearly seen.

Collection: Glasgow University.

▽1906.C

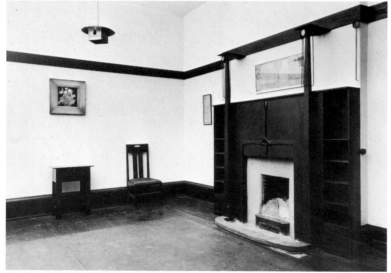

▽1906.E

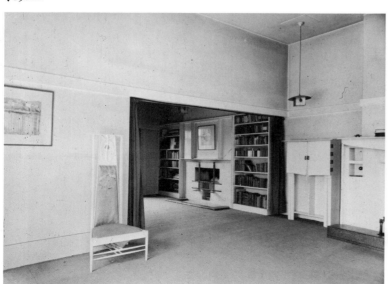

1906.D▽

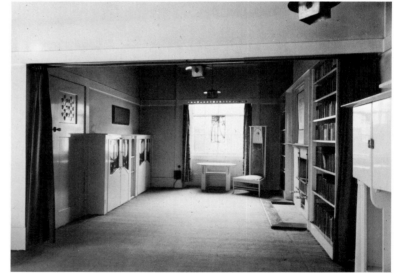

1906.F▽

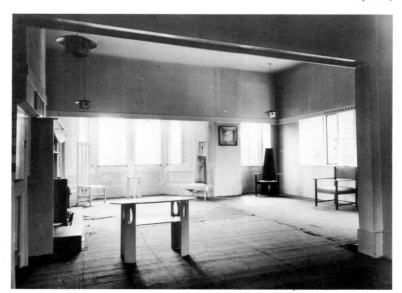

1906.G Staircase at 78 Southpark Avenue, Glasgow
This photograph was taken in 1933 and shows the panel from the Willow Tea Rooms and the black-stained panelling below it. On the side walls can be seen a coarse dark paper which ends level with the panelling: this was probably used on the rest of the staircase and in the hall.

Collection: Annan, Glasgow.

1906.H Fireplace in the bedroom, 78 Southpark Avenue, Glasgow
Removed from 120 Mains Street. The fire-surround was probably polished steel, but here it is shown painted. The fender is that from the dining-room fireplace (see 1906.C).

Collection: Glasgow University.

1906.5 Fireplace for the studio, 78 Southpark Avenue, Glasgow
Wood, painted white, with grate and cement surround 220 × 198.5 × 13.4cm.

The T-shaped grate originally used in the Mains Street drawing-room fireplace was transferred to the studio at 78 Southpark Avenue. The wooden mantelpiece was a simple structure, and a note on the drawing suggests that it was to contain a gesso panel in its upper part. There are no photographs of such a panel in place, but one of the Turin gesso panels, or a replica, was acquired by the Macdonald family; this was *The White Rose and the Red Rose* (Edinburgh, 1968, no 191), and it was the correct size to fit into the space available. According to Mrs Mary Newbery Sturrock, another panel shown at Turin, or a replica, *The Secret of the Rose* (collection: Glasgow School of Art), was installed at Wylie Hill's house in Lilybank Terrace (see

Nobody recalls the decoration of the hall clearly, and no contemporary photographs survive. A photograph from 1933, however (1906.G), shows that the staircase from first to second floor was wallpapered with a coarse grey or brown paper up to the level of the black wooden panelling on the west wall. There is no photograph which shows the lower limit of this dark wallpaper, and the only logical termination for it is the panelling at the front door, i.e. the paper would have continued down the staircase to the ground floor. Both Dr Cameron Davidson and Dr Howarth recall that their immediate impression was of a dark hall, relieved only by the window to the south and the white ceiling.

The door to the dining-room is a standard Victorian panelled door, but it is not the original. It was made by Mackintosh to the same height as the dining-room fireplace from 120 Mains Street which he had brought with him. The picture-rail connects the two, and as the doors to this room and to the press alongside the fireplace are smaller in the remaining houses in what was Florentine Terrace, one must conclude that both were replaced by Mackintosh. As he had also kept the original window frames and the panelled shutters, he designed the two new doors to match the original woodwork. The fireplace, therefore, ultimately decided the height of the front door. He did, however, remove the moulded cornice, leaving a square junction between wall and ceiling. The dining-room walls were covered in grey-brown wrapping paper as at Mains Street; a small area of the paper has survived, and it shows that the paper was covered with a stencilled design of a black trellis with pink roses in the open squares. The frieze and ceiling were painted white, and three new electric lamps were hung down the middle of the room.

To the west of the dining-room, Mackintosh created a cloakroom and maid's room; the kitchen was located in an already existing extension at the rear of the house. The original staircase was retained, stone to the first floor and wood above that, along with its cast-iron and mahogany balustrade. Here the moulded cornice—egg-and-dart pattern beneath dentils—was retained. On the half-landing was a door to a bedroom, located on the upper floor of the kitchen extension, but there were no special features in it other than a decorative band of chequerwork at picture-rail height. From the half-landing, the stairs ascend to the first-floor landing. This, like the staircase and the hall, is lighted by electric fittings like that seen in the photograph of the studio at 120 Mains Street (1900.D).

1906.H▽

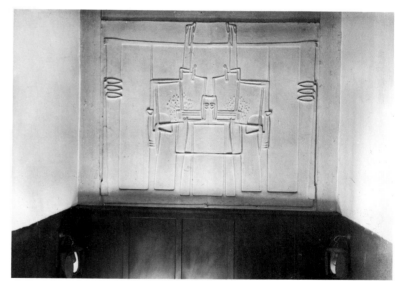

△1906G

1906.5▽

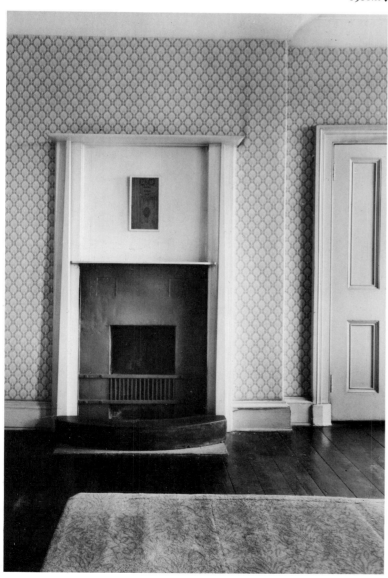

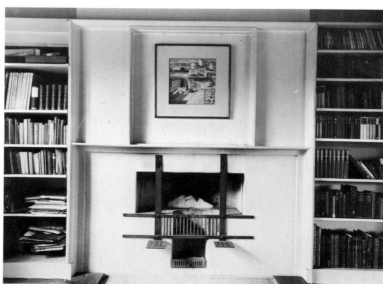

In the south wall of the landing, Mackintosh inserted a tall narrow window. A photograph of the house before he acquired it shows that this window was blind, but it still had its dressed stone surround.

The major alterations at 78 Southpark Avenue were at first and second floor levels. Originally there were two separate rooms on the first floor and two doors on the landing. Mackintosh blocked the doorway to the front room and opened up the wall between the two rooms to make one large L-shaped apartment. He designed a new door, with a panel of heart-shaped inserts of purple glass, and from the architrave of the door ran another broad plate which encircled the whole room. The front or eastern part of the room became the drawing-room, and this area was curtained-off from the rear space (through which one entered) which was called the studio or study. The major alterations all affect the position or size of the windows. On the south wall there was originally a window of similar size to that he inserted on the landing. This window was blocked up by Mackintosh, who designed instead a low leaded-glass casement stretching almost the full width of the south wall of the drawing-room. This was set in the frontal plane of the wall, which was almost 45cm. thick, thus creating a deep shelf inside the window. The soffit of the opening was slightly higher than the picture-rail and at this point Mackintosh inserted more squares of coloured glass into the rail which were back-lit by the new window.

On the east wall was a full-height, three-sided bay window flanked by another tall window similar to that which he had blocked up on the south wall. Any structural alterations to these would have disturbed the street elevation, but Mackintosh did reduce their internal height, and thus the amount and quality of light which they admitted. He continued the picture-rail across the tall window and boxed-in the space above it; at the bay window he carried the picture-rail along the plane of the wall and built a new wall above the rail, blocking out the light from the upper part of the window. The windows were all covered with muslin and Margaret's embroidered curtains hung from the picture-rail, thus giving the impression—from the inside at least—that the windows in the room were all the same height, finishing level with the door and picture-rail. This elaborate arrangement had a considerable effect on the new room: the daylight came predominantly from the south and was much warmer in tone; the eastern light was filtered and softened by muslin; the height of the room appeared much lower because of the continuous line of the picture-rail and the deep artificial frieze newly

1901.57), so a precedent exists for such an arrangement.

Provenance: C. R. Mackintosh; W. Davidson, from whose estate purchased, 1945 (*in situ* at 78 Southpark Avenue).
Collection: Glasgow University.

D1906.6 Designs for panelling on the staircase, and for the fireplace and shelves in the studio, 78 Southpark Avenue, Glasgow
Pencil on tracing paper 47.5 × 73.4cm. (irregular).
Inscribed, lower left, *6 Florentine Terrace, Hillhead | Scale Drawing of Fireplace & shelves | for back part of Drawing Room*; and various notes and measurements.
Scale, 1:24.

Provenance: Mackintosh Estate.
Collection: Glasgow University.

1906.7 Chest-of-drawers for 78 Southpark Avenue, Glasgow
Pine, stained dark, with aluminium-backed hand pulls 129.6 × 122 × 60.8cm.

A larger version of the chests-of-drawers used in the White Bedroom at Hous'hill (1904.92); it was placed at the end of the wide corridor which Mackintosh made at the side of his new bathroom on the second floor.

Provenance: C. R. Mackintosh; William Davidson, by family descent.
Private collection.

1906.8 Kitchen dresser for 78 Southpark Avenue, Glasgow
Pine, stained black 211.5 × 219 × 58cm.

A much more utilitarian version of a traditional dresser than the hall rack designed for Hous'hill

D1906.6 ▽

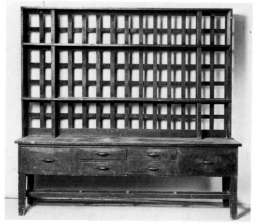

△1906.8 D1906.9▷

(1904.35), this piece was made for the kitchen or scullery at 78 Southpark Avenue.

Provenance: Davidson Estate.
Collection: Glasgow University.

D1906.9 Design for a dresser and shelving for the kitchen, 78 Southpark Avenue, Glasgow

Pencil and watercolour 40 × 63.3cm.
Inscribed, lower right, *Dresser on East Wall | Notes. To be made in two pieces and screwed together | from underside | The table top to be covered with vermilion American | Cloth before pieces are screwed together. | Handles Robert Adams No 2382 black iron | The tops of all shelves to be stained ebony with | one coat varnish & one coat bees wax well rubbed | all vertical surfaces to be painted 3 coats bright blue oil paint | back of dresser & sides & insides of drawers to be stained & beeswaxed*; and various other notes and measurements.
Scale, 1:12.

The design for 1906.8, but narrower than executed.

Provenance: Mackintosh Estate.
Collection: Glasgow University.

1906.10 Meat-safe for 78 Southpark Avenue, Glasgow

Wood, painted 231 × 114.5 × 102cm.

This rather crude piece of furniture stood in the

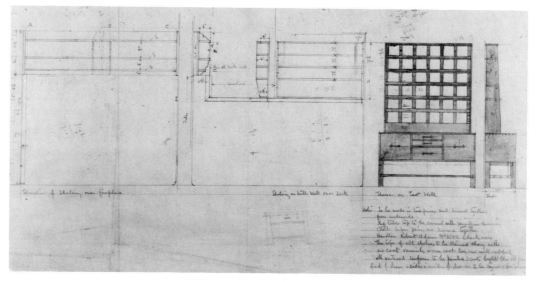

yard outside the kitchen extension. It is basically a traditional design, but the handling of the decorative features and the shape of the piece are similar to other meat-safes at Glenlyon, Perthshire. These were designed by J. Maclaren (or his successors Dunn & Watson), whose work Mackintosh seems to have known well.

Provenance: Davidson Estate.
Collection: Glasgow University.

1906.10▽

created by the windows, and this effect was reinforced by hanging the new electric lamps on long flexes so that they were level with the new rail.

In the back room, the studio, Mackintosh again carried his picture-rail around the room, but he did not build a false wall across the west window. The reasons were both practical and aesthetic: the room did not receive a lot of light during the day, because the pitched roof of the rear extension was close to it and shaded it for much of the day; and, unlike the front windows, which were simple sashes without astragals and with transoms at about the same height as the picture-rail, the rear window had small panes with several astragals and the sash transom was below the height of the rail. To have blocked off the upper half, therefore, would have meant excluding a great deal of necessary light and would have resulted in an unsightly juxtaposition of sash transoms and picture-rail. Mackintosh simply carried his broad rail across the window and inserted coloured glass into it to take decorative advantage of the extra light.

Both rooms were painted white; the moulded cornice in the drawing-room (which, if it matched the others in the terrace, was a Victorian extravaganza of fruit and leaves) was removed, but the more classical cornice of the studio was retained. The white fireplace from the Mains Street drawing room (1900.1) was transferred with slight modifications to allow for the deeper chimney-breast; however, the T-shaped grate was not repeated in the drawing-room, and the irons and grate from Mains Street were used in a new fireplace in the studio. There are no reliable recollections of the appearance of the drawing-room fireplace (it was altered in 1945 without a record being kept of its original appearance), but in all probability it was similar to those designed for Windyhill and The Hill House. The fireplace in the studio was a simple wooden structure, flanked by rather crude bookcases built into the recesses created by the chimney-breast.

Electric lighting was used in both rooms, and the square metal fittings were slightly different versions of those used at Mains Street, which were made originally for gas. Although a wiring plan suggests Mackintosh had intended grouping them again in clusters of four, there is no evidence that he ever used more than one fitting at each outlet (four in the drawing-room, two in the studio).

On the staircase to the second floor, Mackintosh repeated the hall panelling on the west wall, raked along its lower edge to follow the line of the steps. Above this he fixed one of the plaster panels in relief designed for the Willow Tea Rooms. When he acquired the house, there was a large skylight in the roof over the stairwell; this was the only source of daylight for this part of the staircase, because the small window in the south wall on the second-floor landing was originally intended to light a tiny bathroom and lavatory on the landing. Mackintosh swept away this room and blocked the skylight. The existing rear bedroom was partitioned, forming a small corridor-like closet and a larger bathroom. At the front of the house, the two bedrooms were joined together to make another L-shaped room. Mackintosh made no alterations to the windows, other than removing their splayed shutters and replacing them with squared-off reveals.

The fireplace from the Mains Street bedroom was transferred, as was most of the furniture. The wash-stand, which could only have been placed against the windows, was probably cut down at this date so as not to obscure the light (*see* D1900.23). The artificial lighting was again from the square metal fitting used in the rest of the house.

From the second-floor landing a twisting staircase rose to an attic bedroom with french windows overlooking the University. The fireplace in this bedroom was identical with, if it was not actually the same as, that in the studio at 120 Mains Street. But the most striking feature of this new room was the decoration of the staircase leading up to it: the walls were painted with alternate black and white stripes, 5cm wide, a motif which Mackintosh returned to in the guest bedroom at 78 Derngate in 1916-17.

The Mackintoshes left Glasgow in 1914 and closed their house, although they may have returned to it for short periods, either singly or together (Mackintosh's diary for 1921 (collection: Glasgow University) records visits made by Margaret to Glasgow, although these may have been connected with the death of her sister, Frances). In about 1919, William Davidson bought the house along with some of the furniture which had belonged to Mackintosh; he also brought with him some furniture from Windyhill. He lived there alone with his wife, since two of his sons had set up homes of their own and a third had been killed during World War I. On his death in 1945, Glasgow University bought the house from his sons, Hamish and Cameron, who presented much of the furniture which had been used in it.

The University's intention in acquiring the house was to open it to the public as a museum. Various factors prevented this plan being carried out, however, and although the house could be visited by appointment, it was used principally as a residence for senior members of the University. Fire and health regulations, and possibly a slight reluctance by the University to spend more money on museums, meant that the house was never seen properly by the general public. Much of the surrounding property was also acquired by the University in preparation for its next ventures in expansion and the future of the house became critical in the late 1950s. It occupied ground allocated in the University Plan to the new refectory, and demolition was inevitable. Andrew McLaren Young drew up plans to incorporate the interiors in the new University Art Gallery, designed by William Whitfield. As Mackintosh had made so few additions to the exterior, it seemed feasible and sensible to try to re-create his handling of the interior spaces inside a secure and air-conditioned building. Accordingly the interiors were photographed, measured, dismantled, and stored for more than ten years before being re-erected inside the new concrete shell of '78 Southpark Avenue'.

The old house was demolished, to an outcry from the admirers of Mackintosh's work and from those people who viewed the University's encroachment on Hillhead with justifiable unease. McLaren Young bore the brunt of the blame, but his intentions were laudable and few who criticised the University's actions bothered to check what the alternatives to demolition were, or what the future held for the stored interiors. Hillhead was built on a warren of 18th century coalmines, uncharted and with insecure workings and shafts. 78 Southpark Avenue, as the end house of the terrace, acted as a buttress to the others and it was beginning to show signs of subsidence. To have left the interiors there would have been folly; to have shored up the house would have been expensive; and to have incorporated extra toilet accommodation and fire staircases to comply with building regulations would have ruined the interiors. McLaren Young's intention was not just to re-create the dining-room and drawing-room out of context, as his critics accused: he had a site, an architect and a sympathetic University administration which would ensure that, if anything, the final reconstruction would surpass any improvement which could have been made *in situ*.

The site of the new Hunterian Art Gallery is in Hillhead Street, one block to the west of Southpark Avenue. The reconstruction of the house occupies the south-east corner of the building, thus giving it the same orientation and, because of the slope of the ground, virtually the same level as the original. The exterior is Whitfield's design, accepting Mackintosh's windows where they are required and perhaps paying some homage to Mackintosh. Inside, with the exception of the rear extension, the maid's room, the bathroom and attic bedroom, the reconstruction is complete on three floors. Panelling, doors, fireplaces, window sashes, even the balusters and handrail are almost all original. Internally, the visitor is back in Mackintosh's own home with almost the same views from the windows and the same furniture surrounding him. Perhaps the sceptics who doubted McLaren Young's intentions or his powers of persuasion will react the same way as Dr Thomas Howarth, who visited the reconstruction before it was complete in the summer of 1977: he had not set foot in 78 Southpark Avenue for over 20 years, though he had known it well in Davidson's time—he saw little difference and, but for the bare plaster and paintwork, he felt he could have been back in the house he knew so well.

Literature: T. Howarth, 'A Mackintosh House in Glasgow', *Journal of the RIBA*, LIII, 1946; T. Howarth, *Architectural Review*, C, 1946, 'Some Mackintosh Furniture Preserved'; Howarth, pp. 117–19, 292–93.

1906.11 Exhibition stand for Wilkinson, Heywood & Clark Ltd, Glasgow
The clients, a firm of painters and decorators, paid £3.3.0d. in fees (24 December, 1906), but it is not known whether the stand was made, or for what exhibition it was intended. *See* D1906.12.

D1906.12 Design for an exhibition stand for Wilkinson, Heywood & Clark Ltd
Pencil and watercolour 32.8 × 53.6cm.
Inscribed and dated, lower right, *140 Bath Street/Glasgow Sept 1906*, and various notes and measurements, including *wood framing covered with canvas; This part of screen/might be filled in/with panels of various/varnishes/open panels.*
Scale, 1:24.

It is not known whether this stand was ever made, or for what exhibition it was intended. However, the design is important because of its extensive use of lattice panels as a structural and decorative device. Mackintosh repeated this pattern in his wall panelling in the Chinese Room in 1911, and in 1916–17 he returned to the coloured panels in the screen at Derngate. In this stand, Mackintosh intended to colour the square panels at random to indicate the range of varnishes and finishes which his clients offered; at Derngate, random panels were fitted with leaded-glass in different patterns.

Provenance: Mackintosh Estate.
Collection: Glasgow University.

1906.13 Flower stand for the Willow Tea Rooms, Glasgow
Francis Smith was paid for four stands at 18.0d. each (19 November, 1906).

Collection: untraced.

D1906.14* Flower stand for the Room de Luxe, Willow Tea Rooms, Glasgow
Pencil and watercolour. Approx. 30.3 × 49.5cm.
Signed and dated.

This drawing has not been available for photography and the author has not seen it.

Exhibited: Toronto, 1967 (70).
Collection: Dr Thomas Howarth.

1906.15 Chair for the Willow Tea Rooms, Glasgow
Francis Smith was paid for four chairs at £1.4.0d. each (19 November, 1906).

These were probably replacements or extra chairs for one of the Saloons, but precise details are not known.

Collection: untraced.

1906.I The Dutch Kitchen, Argyle Street Tea Rooms, Glasgow

Collection: Annan, Glasgow

1906.J The Dutch Kitchen, Argyle Street Tea Rooms, Glasgow

Collection: Annan, Glasgow.

1906.16 Screen for The Dutch Kitchen, Argyle Street Tea Rooms, Glasgow
'The Crafts', Sauchiehall Street, Glasgow, was paid £11.10.0d. for a 'draught screen' (27 March, 1906).

Collection: untraced.

1906.17 Tables for The Dutch Kitchen, Argyle Street Tea Rooms, Glasgow
Wood, (?) stained dark.
Francis Smith quoted for six tables (26″ × 24″) at 10.6d. each, five (48″ × 24″) at 11.6d. each and six (36″ × 36″) at 12.9d. each (28 February, 1906) and was paid those sums for a total of 17 tables (3 September, 1906).

*See addenda

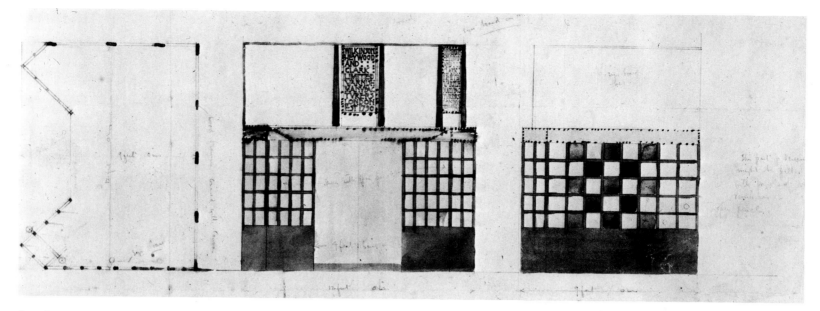

△1906.12 1906.I▷

These tables were undoubtedly extremely simple with no decoration, probably like the tables in D1900.59.

Literature: *The Studio*, XXXIX, 1907, pp. *35–36*; Howarth, plate 49a; Pevsner, 1968, plates 36, 37.
Collection: untraced.

1906.18 Windsor chairs for The Dutch Kitchen, Argyle Street Tea Rooms, Glasgow
Wood, enamelled green.
Francis Smith quoted for 36 at 15.0d. each (28 February, 1906) and was paid for 28 at 15.0d. and two at 17.0d. (3 September, 1906).

A traditional and sturdy design, these chairs are the only known examples of Mackintosh's use of green paint. He had often used a green stain on earlier pieces of furniture, but by this date his chairs were usually painted black or left natural; white and silver were the only other coloured paints, as opposed to stains, which he used. *See* 1906.I.

Literature: *The Studio*, XXXIX, 1907, pp. *35–36*; Howarth, plate 49a; Pevsner, 1968, plates 36, 37.
Collection: untraced.

1906.19 High-backed chairs for The Dutch Kitchen, Argyle Street Tea Rooms, Glasgow
Wood, (?) enamelled green.
Francis Smith quoted for eight chairs at £1 each (13 March, 1906), amended to two at £1.2.0d. each, and two with lower backs at 17.6d. each (5 July, 1906), and was paid for two at £1.2.0d. each and two at £1 each (3 September, 1906).

These chairs, two with and two without arms, were used in the fireplace ingle-nook. *See* 1906.J.

Literature: *The Studio*, XXXIX, 1907, pp. *35–36*; Howarth, plate 49a; Pevsner, 1968, plate 37.
Collection: untraced.

1906.20 Dresser for The Dutch Kitchen, Argyle Street Tea Rooms, Glasgow
Wood, stained dark, with mother-of-pearl panel.
Francis Smith quoted for one at £7.10.0d. (7 April, 1906) and was paid that sum (3 September, 1906).

From the narrow angle of the contemporary photographs, it is difficult to assess the appear-

1906.J▷

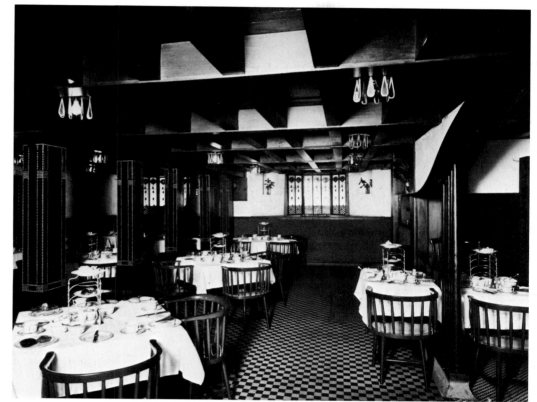

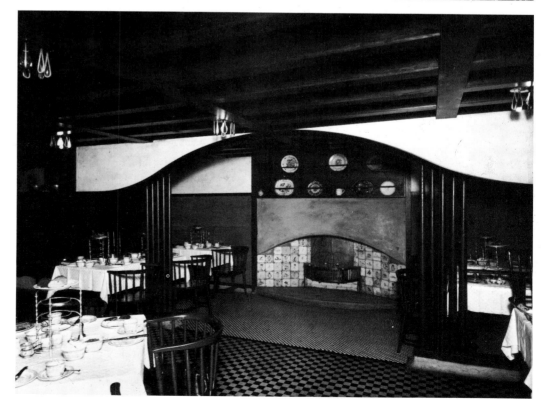

1906 The Dutch Kitchen, Argyle Street Tea Rooms, Glasgow

Miss Cranston recalled Mackintosh to her Argyle Street premises to convert a square basement room into a new tea room to be called 'The Dutch Kitchen'. Walton had left Glasgow and Mackintosh was to have total control of the design, unlike the earlier rooms designed in 1897.

Mackintosh chose the square as his theme, a chequer pattern of differing sizes in black and white. This was relieved by curved-back Windsor chairs, enamelled in emerald green, and by the ogee curve of a wide lintel creating an ingle by the fireplace. The decorative motif of the square was replaced by a rose in the leaded-glass panels fitted in the false window openings on the south wall, where they filtered the daylight from the pavement grids above. The floor was covered with chequered linoleum with a similar pattern, although the squares covering the floor of the fireplace ingle were only half-sized. Bands of white stencilled squares flowed down the black-painted central columns, which also served as hat-stands. The dado was similarly covered by a small-scale chequer pattern, and even the dresser had a square mother-of-pearl panel.

The fireplace ingle was visually separated from the rest of the room by its different floor covering and by the open screen of tapering circular posts, a larger scale version of the screen in the billiards room at Hous'hill. The posts helped to support a broad ogee-curved lintel in dark-stained wood. Its curve was echoed by that of the plastered fireplace, while the grate itself was set into a tiled wall with a concave curve; this curve was reversed in the front of the cement hearth which thus had an elliptical plan. The wrought-iron back panel of the grate was identical with that in the White Dining Room at Ingram Street of 1900.

Electric lighting was used, with pear-shaped hanging panels of coloured glass shading the pendant lamps; the effect was not as successful as with the bracket lamps in his own house. The daylight coming through the borrowed lights must have been very soft and the harsh electric light would have made the enamelled chairs sparkle. Sadly, none of the movable pieces has survived and what remains of the fixtures is covered over by the fittings of the shoe shop which now occupies the premises.

Literature: *The Studio*, XXXIX, 1907, pp. *35–36*; Howarth, p. 130, plate 49a; Pevsner, 1968, plates 36, 37.

ance of this piece. The article in *The Studio*, however, indicates that it was decorated with mother-of-pearl. Its price, and the limited views of it in the photograph (1906.I), suggest that it was of a very simple design, probably similar to the Ball dresser (1905.4).

Literature: *The Studio*, XXXIX, 1907, p. *36*.
Collection: untraced.

1906.21 Hat and coat stand for the Dutch Kitchen, Argyle Street Tea Rooms, Glasgow

Wood, (?) enamelled green.
Francis Smith quoted for four at £2.5.0d. each (26 April, 1906) and was paid for six at that price (3 September, 1906).

These were similar to the hat-stands in the Room de Luxe in the Willow Tea Rooms (1904.23). The square motif is achieved here by adding an extra vertical spar to each side of the stand, thus reducing the width of each square; extra horizontal rails increase the number of squares on each side. (*See* 1906.I).

Literature: *The Studio*, XXXIX, 1907, pp. *35–36*.
Collection: untraced.

D1906.22 ★ Hat-stand for Miss Cranston

Approx. 21.5 × 29.2cm.

This drawing has not been available for photography and the author has not seen it. The Toronto Exhibition catalogue does not give its medium, or details of any inscription, but the date is stated unequivocally as 1906. Perhaps it is a drawing of one of the hat-stands for The Dutch Kitchen (1906.21).

Exhibited: Toronto, 1967 (71).
Collection: Dr Thomas Howarth.

1906–07 Auchenibert, Killearn

This house, commissioned by F. J. Shand, is the least satisfactory of the domestic designs produced by Mackintosh. The style, a form of Cotswold 'Tudor', was presumably used at Shand's request, for the result is not particularly happy. Externally, the battered chimneys with their widely projecting coping, the staircase bay, the polygonal bay to the drawing-room, and the wide leaded casements are the only indication of Mackintosh's hand in the design. Howarth records how Mackintosh resigned and how another architect, Hislop, was appointed to complete the job. There were, however, rather more internal features designed by Mackintosh before he left than have been previously recorded. The job-books show that he detailed the casements and leaded lights made by Henry Hope; the carpets (now disappeared); grates in the public rooms and bedrooms;

▽1907.A 1907.2 detail ▷

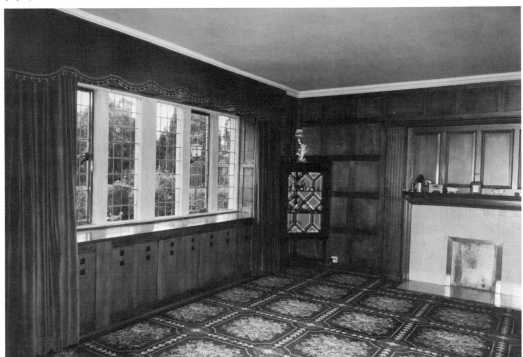

1907.A The dining-room, Auchenibert
This photograph, taken in about 1973 like all the others reproduced here, shows the panelling, the fireplace, and the wide casement. This last is very similar—except for the stone

★*See addenda*

mullions—to the window Mackintosh inserted in the south wall of his own drawing-room at 78 Southpark Avenue.

Collection: Glasgow University.

1907.B Door to the morning-room, Auchenibert
The linenfold carving on either side of the door repeats the motif from the fireplace, 1907.2.

Collection: Glasgow University.

1907.C Staircase at Auchenibert
This photograph shows the balusters of the upper part of the main staircase which resemble those used in the Oak Room staircase at Ingram Street.

Collection: Glasgow University.

1907.1 Fireplace in the dining-room, Auchenibert
Pine, stained dark.

The classical detailing resembles that adopted in the School of Art Board Room, but the pilasters here are identical.

Collection: in situ.

1907.2 Fireplace in the morning-room, Auchenibert
Pine, stained dark.

The only Mackintosh feature, apart from the grate, is the carved panel over the mantelpiece: this was Mackintosh's version of traditional linenfold carving.

Collection: in situ.

1907.B △

and the panelling in the dining-room and morning-room, and the hall staircase and upper landing, all by John Craig. These and other payments were made from March 1907 to January 1908.

Shand's influence must account for the nature of the internal panelling. It is very simple, even severe, with classical details around the dining-room fireplace. The pilasters flanking the fireplace are reminiscent of those in the 1906 Board Room at the School of Art, and the double *cyma recta* cap is reminiscent of the repeated cap motif in the Bridge of Allan church furniture. Certainly, it is not what Mackintosh would have chosen to do if left to his own devices, and it is not surprising that he parted company with his client.

The staircase shows more of Mackintosh's hand, having similarities with the nearly contemporary staircase in the Oak Room at Ingram Street. A number of fireplaces also betray their designer, but there is nothing as elaborate as those designed for The Hill House or Hous'hill, or even Ingram Street. Mackintosh was doubtless preoccupied with other matters. His move to Southpark Avenue, the extension to the School of Art, the Oak Room and The Dutch Kitchen for Miss Cranston, were all executed during this period, and Mackintosh seems to have taken the line of least resistance with this client. It is particularly unfortunate that this was so, for the house occupied a fine site, and even its exteriors could have been saved from mediocrity if he had given them a little more attention. Perhaps the fault was not all Mackintosh's, for he seems to have entrusted much of the detailed work to A. Graham Henderson, a draughtsman in the office whom he encouraged, as Keppie had in turn encouraged him. Henderson does not seem, in this project at least, to have served Mackintosh well. Indeed, he later took the full credit for other jobs he had worked on (such as the Oval Rooms at Ingram Street), and finally bit the hand which had fed him, by becoming one of Mackintosh's most severe critics and the source of many of the stories of office malpractice which were to damn Mackintosh in later years.

Literature: Howarth, pp. 109–11, fig. 8.

1907.1 ▽ ▽ 1907.2 1907.C ▷

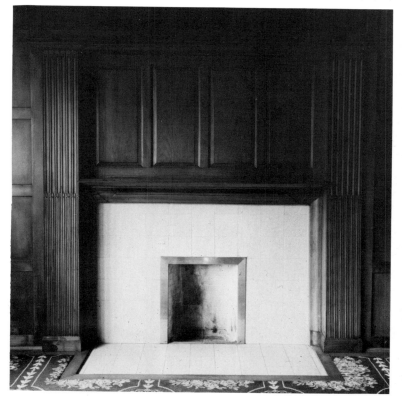

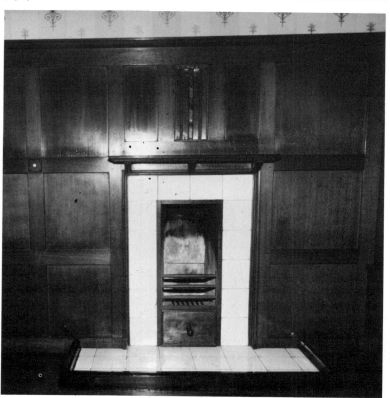

1907 The Oak Room, Ingram Street Tea Rooms

In 1900, Mackintosh had decorated the main White Dining Room and the adjoining Cloister Room, but in 1906/7 Miss Cranston acquired adjacent premises at the corner of Ingram Street and Miller Street and she again asked Mackintosh to design new furniture and interiors for her extension, the Oak Room. The room was long and narrow, and Mackintosh designed a balcony around three sides of it to provide extra accommodation for tables. This balcony is supported on a series of square timber posts which, as at the School of Art, are carried through to the ceiling. Structural support for the ceiling was not necessary here, however, so the square posts branch at balcony level into five sections. These five posts pass through the front of the balcony, and along this front Mackintosh applied seven laths bent over the protruding posts to produce an undulating lattice pattern at intervals along the plane of the balcony. There is much here in common with the design for the School of Art Library which is, of course, contemporary, but Mackintosh was faced with more serious spatial limitations here than at the School. As Howarth says (p. 134), Mackintosh would have learned much here which influenced his final design for the Library—undoubtedly a much more successful composition; however, he made here some interesting spatial arrangements within the existing structure, particularly around the staircase.

The entrance to the Oak Room was originally at the south end of the Miller Street elevation, with the staircase directly opposite. This was an open screen with studs about 20cm. apart; linking these were a series of square insets of blue glass about waist height, and below these insets extra studs were inserted, thus quickening the rhythm of the screen (this arrangement had been used in the drawing-room screen at Hous'hill in 1904). Stairs lead down to the Ladies' Cloakroom and up to the balcony. On the rising flight, Mackintosh used his stud screen again, but the rails are seen full width rather than end on. They have a common top rail, level with the floor of the balcony, and instead of the square insets of glass, the studs have oval holes pierced through them. Ovals appear in a number of different decorative details in the Oak Room, some are set into the timber panelling, some inlaid in coloured glass in the fireplace and others in mirror-glass in the door.

Underneath the Oak Room another billiards room was provided, entered from the earlier billiards room to the east. It was panelled with dark-stained pine and had a row of raised fitted seating at each end of the room. The north wall was inset with an elaborate glazed niche with a stylised tree, carved from timber, spanning its front edge (1907.G).

Exact details of the furniture made for the Oak Room are not known, and only one drawing survives. The numbers of stools and armchairs listed in the job-books cannot have filled the available space and the surviving chairs (1907.6) must have been provided at or about the same time. The Oak Room probably

1907.D The Oak Room, Ingram Street Tea Rooms, Glasgow

Photographed in 1971, before the interiors were dismantled.

Collection: Eric Thorburn, Glasgow.

1907.E The Oak Room, Ingram Street Tea Rooms, Glasgow

This photograph, taken in 1971, shows the staircase screens. The sideboard, 1907.7, was placed against the screen to the lower staircase and the blue panels were seen through its shelves. This staircase led to a cloakroom in the basement.

Collection: Glasgow University.

1907.F Billiards room, The Oak Room, Ingram Street Tea Rooms, Glasgow

Photographed in 1971.

Collection: Eric Thorburn.

1907.G Detail of carved decoration in the billiards room, The Oak Room, Ingram Street Tea Rooms, Glasgow

Collection: Glasgow University.

1907.3 Tables for The Oak Room, Ingram Street Tea Rooms, Glasgow

Francis Smith was paid £15.9.6d. for 21 tables (18 December, 1907).

These have not been traced, but their price indicates that they were likely to have been as simple and unremarkable as most of the other dining tables used in the Tea Rooms.

Collection: untraced.

1907.4 Stool for the Oak Room, Ingram Street Tea Rooms, Glasgow

Oak, stained dark 74 × 40.6 × 35cm.
Francis Smith was paid for sixteen stools at 10.6d. each (18 December, 1907).

The author believes that Mackintosh used the term 'stool' at the Willow Tea Rooms to indicate a small chair (*see* 1903.13) and that its use at The Oak Room probably refers to a small

▽1907.D

1907.E▽

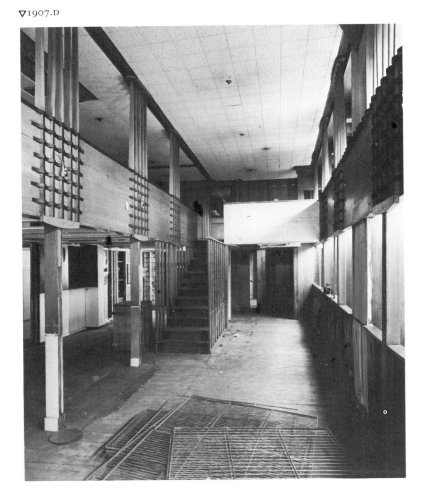

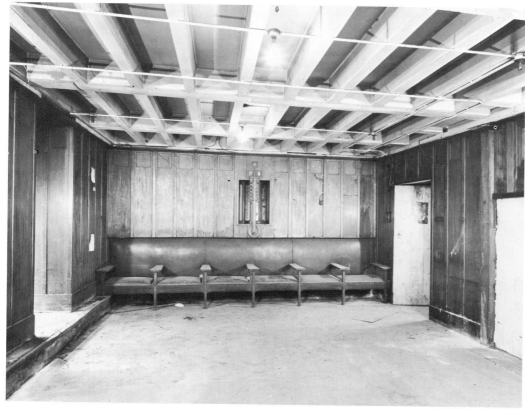

◁1907.F

1907.F detail △

chair, more recently known as a waitress chair. Far too many examples of this particular design survive for it to have been used solely by waitresses, and it is likely that it was the 'stool' referred to in the job-books. The wavy top-rail and twin back-rails echoed the bent laths fitted to the front of the balcony and also used on the dresser (1907.7). Twelve survive.

Literature: Glasgow School of Art, *Furniture*, 1968 (illustrated opposite no 9); Macleod, plate 77; Alison, pp. *72, 73*.
Provenance: a) Miss Cranston's Tea Rooms; Messrs Coopers, from whom purchased by Glasgow Corporation, 1950; b) as (a) and then presented.
Collection: a) Glasgow Art Galleries and Museums (9); b) Glasgow School of Art (3).

1907.5 Armchair for the Ingram Street Tea Rooms, Glasgow

Oak, stained dark 77.4 × 58.5 × 41.5cm.
Francis Smith was paid for 16 armchairs at £1.8.6d. each (no date given, but probably 18 December, 1907).

suffered more than any other from the vandalism of the 1950s and 60s. It was used for some years as a souvenir shop, selling cheap Scottish mementoes to tourists and others. The proprietor obviously thought he could improve on the warm tones of the dark-stained oak panelling, and proceeded to have it painted white and then applied a coat of artificial graining in a light oak stain and varnish. The door was moved to the north wall of the room, the fireplace obliterated, and the subtle open screen enclosed. The tiled walls at the servery in the south-east corner near the staircase were smashed or covered with grained plywood, and ugly electrical wiring and fittings were strewn about the room. Over the ceiling, modern acoustic tiles were placed; these, with their flecks of gold and silver, would have been the final insult to Mackintosh. Rapidly advancing dry-rot had taken hold of the panelling in the basement, and the fireplace had also been destroyed. As with the White Dining Room, all the remaining fittings were taken into store by the Planning Department of Glasgow Corporation and are now the property of Glasgow Museums.

Literature: Howarth, pp. xxiii, 134, plate 51a.

Although this chair was used in the Chinese Room in the late 1940s, there is no record of any such chair being specifically designed for it. There are no other chairs associated with Ingram Street which could be called armchairs, and I believe that the details in the job-book apply to this barrel chair.

Literature: Howarth, p. 136, plate 51b; Glasgow School of Art, *Furniture*, 1968, no 13; Macleod, plate 78.
Provenance: *See* 1907.4.
Collection: a) Glasgow Art Galleries and Museums (6); b) Glasgow School of Art (2).

1907.4▽

1907.5▽

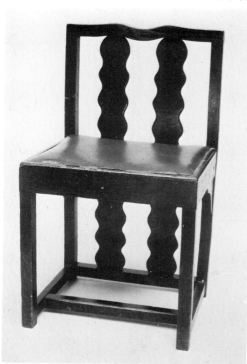

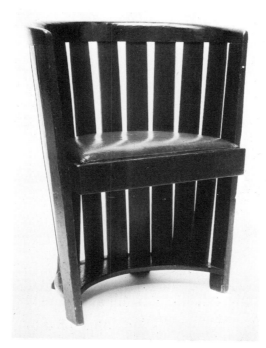

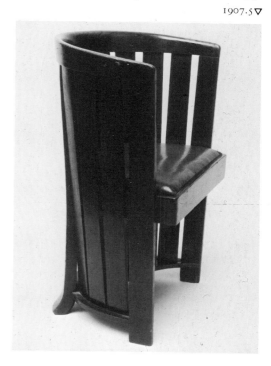

1907.6 Chair for The Oak Room, Ingram Street Tea Rooms, Glasgow

Oak, varnished 90.3 × 44.9 × 47.2cm.

The 32 seats listed in the job-books (1907.4 and 5) cannot have been sufficient either to fill the room or even to match the tables, and the author believes that this chair, which was photographed in The Oak Room in the 1940s, was originally designed to provide the basic seating unit in The Oak Room. It is, in a way, an unusual design for Mackintosh, as it has turned out to be a very strong chair and is now used in the Library at the Glasgow School of Art where it has performed much better than the Windsor chairs specifically designed for the readers' use. The chamfering along the back-rails anticipates similar waggon-chamfering in the Library balustrade at the School of Art.

Literature: Howarth, plate 51a; Macleod, plates 100, 102.
Provenance: *See* 1907.4.
Collection: a) Glasgow Art Galleries and Museums (8); b) Glasgow School of Art (24).

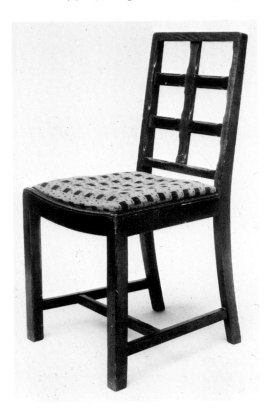

1907.7 Sideboard for The Oak Room, Ingram Street Tea Rooms, Glasgow

Oak, with panels of coloured glass 152.5 × 78.8 × 34cm.
Francis Smith was paid £7.4.6d. for one (18 December, 1907).

This piece was designed to stand against the staircase screen, and the shelves correspond with the height of the blue glass panels in the screen. At this south-east corner of The Oak Room was a servery hatch through into the room next door and the surrounding walls were covered with blue ceramic tiles, picking up the blue glass of the screen and the inlay in the sideboard.

Provenance: *See* 1907.4.
Collection: Glasgow Art Galleries and Museums.

D1907.8 Design for a sideboard for The Oak Room, Ingram Street Tea Rooms, Glasgow

Pencil and watercolour on tracing paper 33 × 34.2cm. (sight).
Inscribed and dated, lower right, *4 Blythswood Square | Glasgow Aug. 07* and inscribed, upper left, *MISS CRANSTONS INGRAM*

STREET EXTENSION | SCALE DRAW-ING OF NEW SIDEBOARD FOR GROUND FLOOR; and various other notes and measurements.
Scale, 1 : 12.

The design for 1907.7, as executed. This drawing is not in Mackintosh's hand, and is presumably by an office draughtsman working up a sketch by Mackintosh.

Exhibited: Toronto, 1967 (85).
Collection: Dr Thomas Howarth.

1907.9 Billiards table for the Ingram Street Tea Rooms, Glasgow

Burroughs & Watt were paid £10.1.6d. (18 December, 1907).

Collection: untraced.

1907.10 Fitted seating for the billiards room, Ingram Street Tea Rooms, Glasgow

This seating was installed at each end of the new billiards room below the Oak Room; the design was based on the seats in the earlier billiards room, designed in 1900. *See* 1907.F.

Provenance: *See* 1907.4.
Collection: Glasgow Art Galleries and Museums.

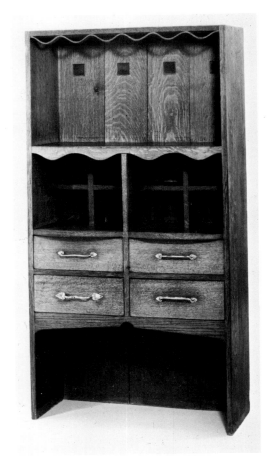

◁1907.6

▽D1907.8 1907.7▷

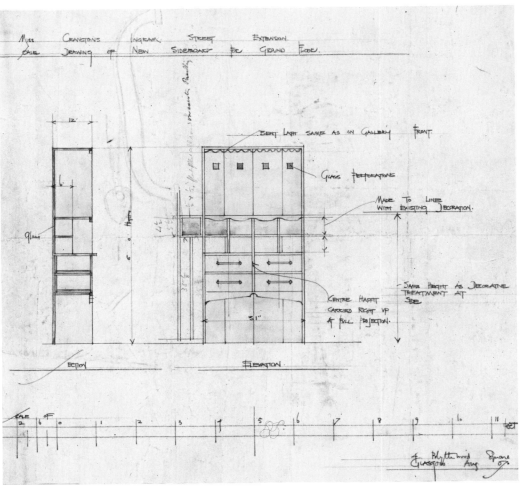

1907 The Moss, Dumgoyne

Mackintosh designed an extension for The Moss, Dumgoyne, near Killearn, but only one indistinct photograph of it survives. It is difficult to assess the quality of the design, and the only significant external detail seems to have been a mansard roof—a most untypical Mackintosh feature. This extension has been demolished, but some kitchen fittings have been retained. They follow the same basic pattern as the fittings in the service quarters at The Hill House, and the local joiner who made them seems to have repeated the design for other houses in the area, notably Auchineden on the Stockiemuir road.

1908.1 Square table for The Hill House, Helensburgh

Ebonised pine, with mother-of-pearl inlay
63.6 × 68.5 × 68cm.

One of the most elegant and complex of Mackintosh's designs of this period. Since his original work at The Hill House (1903–05), the square had come to dominate his work. In those earlier pieces, the square often appeared as a cut-out decoration, but here it provides both structure and ornament. The top is square and in the centre are four inlaid panels of mother-of-pearl. Each panel is square and is made up of nine smaller squares, each one set with its 'grain' against that of its neighbours to reflect the light in a different way. The legs take the form of a labyrinthine lattice—an open cube of intersecting square rails. Small square shelves are placed in the upper tier at the corners and, at the intersection of the vertical and upper horizontal rails, Mackintosh introduced another inlaid square of mother-of-pearl.

Literature: Billcliffe and Vergo, fig. 6.
Exhibited: Paris, 1960 (1086); Edinburgh, 1968 (244).
Provenance: Walter Blackie; by family descent.
Private collection.

1908.1 ▽

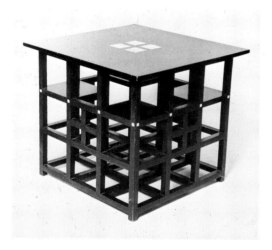

D1908.2 Design for an armchair and a table for The Hill House, Helensburgh

Pen and ink and wash on linen 29.2 × 42.3cm.
Inscribed and dated, lower right, *4, BLYTHS-WOOD SQ / GLASGOW. MAY 08*; and inscribed, upper left, *THE HILL HOUSE. HELENSBURGH. | MRS BLACKIE |* [chair] *COVERED WITH | FARNHAM FLAX SILK | SAME GREY AS SUPPLIED FOR FORMER CHAIRS*; and other notes and measurements.
Scale, 1:12.

Not drawn by Mackintosh, but obviously following his design, although there is a pencil inscription (*53 Kent Road / Mr Ferrier*) in his hand. The table is as executed, except that it is slightly larger in plan than indicated here. The chair was apparently designed for Blackie's mother who lived at The Hill House and who required something a little more traditional, and probably somewhat more comfortable to sit on.

Provenance: Walter Blackie; by family descent.
Private collection.

D1908.3 Design for an upholstered armchair for The Hill House, Helensburgh

Pencil and watercolour 27.8 × 40.5cm.
Scale, 1:12.

See D1908.2.

Provenance: Mackintosh Estate.
Collection: Glasgow University.

△ D1908.2

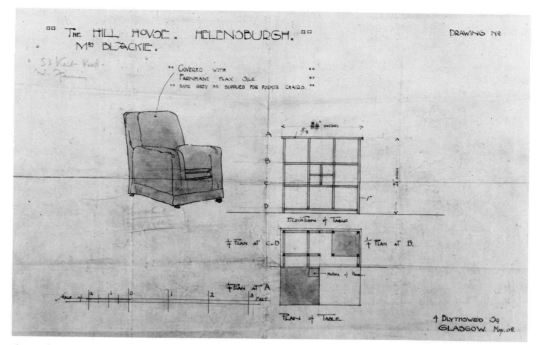

D1908.3 ▽

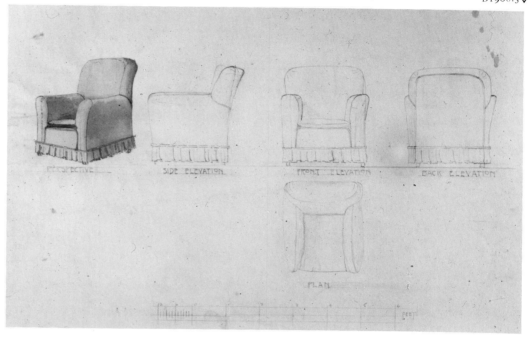

1908.4 Fireplace for the drawing-room, Warriston, Paisley

James Grant quoted £38 for fireplace and grate (15 May, 1908) and was paid £26.18.3d. (10 September, 1908).

Another commission from the Rowat family; Thomas Rowat paid £9.9.0d. in fees (13 November, 1908).

Collection: destroyed.

1908 Alterations to the Lady Artists' Club, 5 Blythswood Square, Glasgow

Mackintosh had been associated since the mid-1890s with the group of artists and designers who were members of the Lady Artists' Club. He had helped them with their pageants and masques, their fairs and other fund-raising activities arranged with the aim of amassing enough capital to purchase the premises at 5 Blythswood Square which they had rented since 1892. This object was finally achieved in 1896, and there were sufficient funds available to commission a new gallery from George Walton. In about 1898, this gallery was destroyed by fire, but it was subsequently redesigned by Walton, including a huge stone fireplace into which Mackintosh fitted tiles and a new grate and fire-irons at some unknown later date. Few other details of the early history of the Club or of any other work Mackintosh may have done for it are known, because the Club's records were destroyed in the 1898 fire and those from 1899 to 1907 were accidentally destroyed in 1936.

There is, however, a reliable account of Mackintosh's next documented commission to decorate the Club in 1908. An *ad hoc* committee was set up to arrange for redecoration; this committee was responsible to the Club Council, but it unilaterally decided to ask Mackintosh to prepare a scheme and quotation for the necessary work. Mackintosh's designs were to cost £200, and included a new front door and the decoration of the hall and staircase right up to the top flat. The Council was appalled by the estimate (not wishing to pay more than £125) and

it also queried the style of the new door, believing it would be out of character in such a classical elevation as Blythswood Square. Controversy ensued with the Decoration Committee apparently sticking to its guns and even calling on the services of a solicitor. Although Mackintosh's scheme was eventually allowed to go ahead (and it only cost £110.12.9d.), the Council chose the decorations for the drawing-room without reference to the *ad hoc* committee. As a protest, the chairman of the Decoration Committee resigned her membership of the Club. It would seem that even in the genteel surroundings of the Lady Artists' Club there could still be the bitter disputes more often associated with their male counterparts across the lane in the Glasgow Art Club.

The staircase was wallpapered in dark brown, on which some sort of dark trellis stencil seems to have been applied with touches of 'plum pink and silver'. A lattice-framed telephone box was incorporated in the hall, and Mackintosh produced one of his own neo-classical designs for the front doorway, not unlike the detailing of the Board Room at the Glasgow School of Art. In 1922 the wall decorations were covered over and no trace now remains.

Literature: *History of the Glasgow Society of Lady Artists' Club*, privately printed for the Society, 1950, with reminiscences by Jane Steven and Miss de Courcy Lewthwaite Dewar; Howarth, p. 90.

1908. A Doorway at 5 Blythswood Square, the Lady Artists' Club, Glasgow

1909.1 Table for the Card Room, Hous'-hill, Nitshill, Glasgow

Plane, maple, or (?) sycamore, stained grey. Approx. 76 × 60 × 60cm, extending to 76 × 76cm.
Wylie & Lochhead quoted for four at £5.15.0d. each (no date given); Francis Smith quoted for four at £5.13.0d. each (no date given) and was paid £115.4.1d. for tables and chairs (number not specified, 7 June, 1910).

See D1909.2 and 3. Four seem to have been made.

Collection: untraced.

D1909.2 Design for card tables for the Card Room, Hous'hill, Nitshill, Glasgow

Pencil and watercolour 69.6 × 44cm. (irregular).
Inscribed and dated, lower right, *4 Blythswood Square | Glasgow June 1909*, and *The Hous'hill Nitshill for John Cochrane Esq | Drawing of Tables for Card Room. 4 wanted | To be made in*

plane tree or plain grained maple | stained silver grey and dull polished | Price to include making and delivering; and several other notes.
Scale, 1:12, and full size.

One of the few drawings of this period actually in Mackintosh's hand; the design of the table is shown clearly. The plain wooden top was quartered and hinged along each side and, when opened, it provided a larger playing surface. This was covered in green baize and was supported on four sliding bars. In the centre were four square decorative panels, made of smaller squares of mother-of-pearl set around an oval metal dish for the counters. At the corner of each of the extended flaps was another dish for counters. This drawing shows a strangely conventional arrangement of stretchers and even suggests that the lower part of the legs were decorated with a ball-and-cube pattern; Mackintosh did use this motif on furniture for the Dug-Out in 1917, but there is no record of such an early use of this traditional decoration. See also D1909.3.

Provenance: Mackintosh Estate.
Collection: Glasgow University.

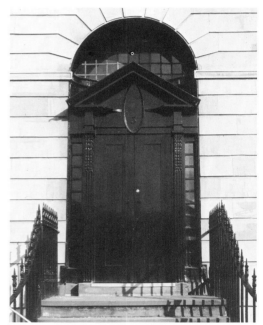

△1908.A 1908.A detail▽

1909 The Card Room at Hous'hill, Nitshill, Glasgow

Mackintosh returned to Hous'hill in 1909 to design furniture and fittings for a new Card Room for Miss Cranston and her husband. The job-books indicate the scale and the date of the works, which were not contemporary with the other rooms in the house (as inferred by Howarth). Unfortunately, no photographs of the new work survive, so we are dependent for our knowledge of it on the few remaining drawings, the details in the job-books, and the reminiscences of William Ward which were recorded by Howarth.

The drawings which survive are for the chairs, tables and fireplace, but they give little indication of the layout or decoration of the room. The tables seem to have been quite elaborate, with a complex arrangement of stretchers and a folding top which extended to provide a larger playing space. Four were made (not six as recorded by Howarth) with chairs to match, presumably 16 in all. Drawings for the fireplace only give an indication of the grate; there are no details of the glass surround described by Mr Ward. These drawings, however, confirm the date of 1909 which was to be cast into the back of the grate along with the initials of Miss Cranston and her husband (see D1909.6).

The job-books show that work was not just restricted to the Card Room. New fittings for the pantry, flooring in the kitchen, and new box lanterns between the kitchen and the Card Room were also installed. A balcony trellis is also mentioned, without any further elucidation of what this might mean, and there is also an unexplained note, 'Writing Room furniture'. It is likely that the latter refers to the furniture shown on D1909.12, which was probably accommodated in an alcove or bay window off the Card Room, rather than in an entirely separate apartment. There is no indication of the scope of the decoration, although new light fittings were also designed for the Card Room. One more unexplained item, however, is an entry for a 'centre stand for Card Room'. This cost £111.8.11d., a considerable sum when compared with the total cost of less than £100 for the drawing-room screen, cabinets and fitted seating of 1904. Nobody recalled seeing such a fixture, but it was presumably some kind of centrally-placed feature around which the card tables were grouped, possibly resembling the *baldacchino* in the Front Saloon at the Willow Tea Rooms of 1903.

The decoration of the Card Room, as described by William Ward to Howarth, was based on the use of dramatic features such as gold-leaf for the walls, enriched with four gesso panels by Margaret, entitled *The Four Queens*, and an extensive use of plate glass in the fireplace. The mention of gold and the mysterious 'centre stand' suggests that the room might have been similar to the Oval Rooms designed at Ingram Street at the same date.

Literature: Howarth, pp. 114–15.

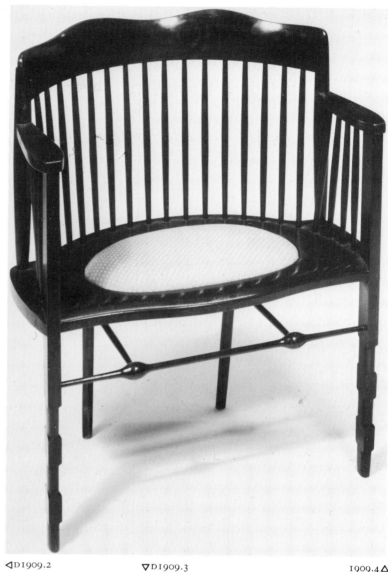

D1909.3 Design for tables and chairs for the Card Room, Hous'hill, Nitshill, Glasgow

Pencil on a page of a sketchbook 18.0 × 22.8cm.
Inscribed, upper left, *The Hous'hill, Nitshill / Card Room Tables & Chairs* and various other notes and measurements.

Probably an earlier drawing than D1909.2 which is annotated for the maker, while this design remained in Mackintosh's sketchbooks. The table is not very different from that seen in D1909.2, except for the arrangement of the stretchers, which appear most elaborate and very similar in plan to those on the table for William Douglas (1912.3). The chair (1909.4) is seen here in an earlier stage of its design; the final version had fewer legs and a different arrangement of the upright rails, but the overall design is quite close to this drawing.

Provenance: Mackintosh Estate.
Collection: Glasgow University.

1909.4 Chair for the Card Room, Hous'-hill, Nitshill, Glasgow

Beech, stained dark and polished.
Francis Smith was paid £115.4.1d. for tables and chairs (number not specified, 7 June, 1910).

Based on D1909.3, this piece is an elaborate version of a traditional Windsor chair. The executed piece has only four legs and a different arrangement of arms and vertical rails from that shown in D1909.3, but the most important differences are in the design of the legs and stretchers. The stretchers swell into ungainly bulbous shapes where they meet, a feature most untypical of Mackintosh. At the bottom of the legs, he has added a number of rectangular blocks; this almost traditional motif can be seen

on the drawing for the table, D1909.2, and was later used on some of the furniture made for the Dug-Out in 1917, usually as a ball-and-cube pattern. If four tables were made, then there were probably 16 of these chairs made, costing approximately £5 each.

Provenance: Anonymous sale, Sotheby's Belgravia, 5 May, 1976, lot 98; Michael Whiteway. Collection: Gerald and Celia Larner.

D1909.4A ★

1909.5 Fireplace for the Card Room, Hous'hill, Nitshill, Glasgow
J. Caird Parker quoted £15.7.6d., plus £8.17.6d. for 'glass, cement at sides and top including hearth' (3 July, 1909) and was paid £35.6.1d. for 'glass, grate etc.' (26 March, 1910).

★*See* addenda　　　　　　　　　199

The fireplace was almost certainly destroyed when Hous'hill was demolished in 1933. William Ward's recollections of it (Howarth, pp. 114–15) indicate that, instead of the more customary cement, mosaic or steel surround, Mackintosh used plate glass embedded horizontally in cement, thus exposing its sharp edge. The edges of the glass glinted with refracted light, especially in artificial light when its dark green tint shone out. The grate was presumably based on the designs included in D1909.6 and 7.

Collection: untraced, probably destroyed.

D1909.6△

D1909.6 Design for the grate for the Card Room, Hous'hill, Nitshill, Glasgow

Pencil on a page of a sketchbook 18 × 22.8cm. Inscribed, lower right, *The Hous'hill Nitshill | Grate for card room | in wrought iron armour bright | price to be given for grate — | for fire back & fire irons separately.*

A preliminary design for the grate in the Card Room, including firebox, front grid, fire-dogs and a plan of the hearth. In the cast-iron plate at the back of the fire, Mackintosh

D1909.7▽

intended to incorporate the initials of Major and Mrs Cochrane and the date, 1909. The design is drawn over an earlier sketch of a slate roof of some building, presumably one seen by Mackintosh on a sketching tour.

Literature: Alison, p. 96.
Provenance: Mackintosh Estate.
Collection: Glasgow University.

D1909.7 Design for the grate for the Card Room, Hous'hill, Nitshill, Glasgow

Pencil 25.5 × 31.5cm. Inscribed, along lower edge, *The Hous'hill Nitshill for John Cochrane Esq. Scale drawing of Card Room Grate*; and various other notes. Scale, 1:8.

A worked-up version of the earlier sketch, D1909.6.

Provenance: Mackintosh Estate.
Collection: Glasgow University.

1909.8 Centre stand for the Card Room, Hous'hill, Nitshill, Glasgow

James Grant quoted £111.8.11d. (no date given); payment was possibly included in his final account (November, 1910).

There is no record of this stand, and it may have been destroyed when the house was demolished in 1933. The price indicates that it was a substantial piece of work and may well have resembled, in appearance and function, the *baldacchino* at the Willow Tea Rooms (1903.6) especially as the job-books mention flower tubes, as these were also used on the Willow structure.

Collection: untraced, possibly destroyed.

1909.9 Candlestick for Hous'hill, Nitshill, Glasgow

White metal.
Wylie Davidson was asked to quote for a white metal candlestick (19 July, 1909) and was paid £8.8.0d. (no other details given, 19 February, 1910).

Collection: untraced.

1909.10 Easy chair for the Hous'hill, Nitshill, Glasgow

Francis Smith quoted for one at £5 (9 November, 1909); payment was possibly included in the sum of £115.4.1d. (4 June, 1910).

The job-books indicate that this was intended for the White Room, which was presumably the drawing-room, but there is no record of what it looked like.

Collection: untraced.

1909.11 Table for Hous'hill, Nitshill, Glasgow

Cypress, stained dark, with inlaid ebony and mother-of-pearl 76.8 × 122 × 73.6cm.
Francis Smith quoted for one at £6.15.0d. (9 November, 1909); payment was possibly included in the sum of £115.4.1d. (7 June, 1910).

A unique and most elegant design, miniaturising some of the elements of the Library timbers at the Glasgow School of Art in a writing table. The paired beams seen in the Library, almost complete at this date, are echoed in the paired legs, and the chamfering of the balusters and the bent lath around the balcony are repeated in the rails below the drawers. The table arrived at the School from an unknown house in Troon, where it was said to have been fitted into a deep window bay between fitted seats; could this muddled history refer to a window bay in the Card Room at Hous'hill, similarly fitted with bench seats? D1909.12 shows the table located between two chairs in a bay off the Card Room; this could well have been a window bay, although there is no actual indication on the drawing of the presence of a window. In the job-books there is also mention of 'writing-room' furniture, but no individual description of such pieces; perhaps the writing room was, in fact, a part of the Card Room as defined by this bay.

Literature: Glasgow School of Art, *Furniture*, no 16.
Provenance: Major and Mrs J. Cochrane (Miss Cranston); probably in Hous'hill sale, 1933; an unknown family in Troon.
Collection: Glasgow School of Art.

D1909.12 Design for a table for the Card Room, Hous'hill, Nitshill, Glasgow

Pen and ink and watercolour on linen 37 × 40.5cm. (sight).
Inscribed and dated, lower right, *4 Blythswood Sqr., | Glasgow 1909 | Drawing No. 52* and inscribed, upper left, *JOHN COCHRANE ESQ. THE HOUSHILL. NITSHILL.| DETAIL OF TABLE FOR CARD ROOM*; and various other notes and measurements. Scale, 1:12.

The drawing shows the table fitted into a bay (perhaps the window bay mentioned in connection with the actual table, 1909.11) and flanked by two chairs. Perhaps these three items were the 'writing room' furniture mentioned in the job-books, but not listed individually: the writing-room seems to have been a part of the Card Room itself. The drawing is by an office draughtsman working from Mackintosh's sketches.

Collection: Dr Thomas Howarth.

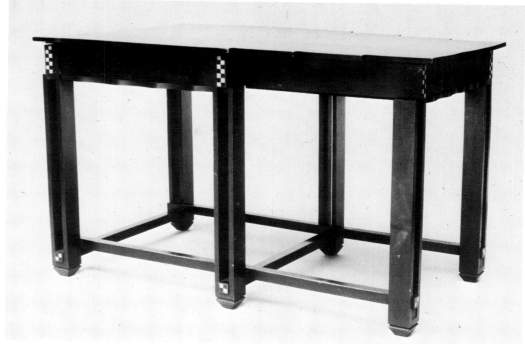

△1909.11

D1909.12▽

1909–10 The Oval Room and Ladies' Rest Room, Ingram Street Tea Rooms, Glasgow

In his account of the Ingram Street Tea Rooms, Howarth gives 1916 as the date for the Oval Room and the Rest Room, with the rider that a colleague of Mackintosh claimed them as his own design (p. 134, note 1). This colleague was in fact A. Graham Henderson, who was (in 1910) one of Mackintosh's draughtsmen and who was possibly responsible for producing some of the working drawings at the Oval Room, but certainly not the design.

In a narrow rectangular space south of the Oak Room, Mackintosh created two new rooms for Miss Cranston. Each had a bow window at the east end, through which a grey light from the internal courtyard could filter, but that is where their similarity ended. The lower room, the Ladies' Rest Room, was dark-stained and panelled, basically rectangular, but provided with a series of recesses for couches and other furniture. It had its own fireplace with a gold mosaic surround adjacent to the window, which admitted very little light. The west end of the room was open to the Miller Street elevation of the Oak Room with its full height windows, but little light came into the Rest Room through

these, because the profile of the mezzanine floor above obstructed most of it. This mezzanine, the same height as the Oak Room gallery, was supported on a series of free-standing pillars which repeated the oval plan of the room above.

Access to this Oval Room was from the Oak Room Gallery; it probably functioned as a smaller and more intimate tea or coffee shop. The east window was a bow and broken up by many astragals into a lattice-work of small square panes. To its right, the fireplace had a cement surround, and the walls of the room were divided into narrow, canvas-covered panels by thin straps. Although the overall impression given was that of an oval room, it was by no means that simple. The basic oval was only continuous at a high level in the room, and even then it was broken by two shallow projections on each of its longer sides. At the west end, the line of the oval was carried through an open screen, very similar to that in the drawing-room at Hous'hill, but without the inserts. This open screen admitted light from the Miller Street windows, but acted as an effective dividing line from the upper part of the Rest Room beneath.

The room had several affinities with the drawing-room at Hous'hill, in that it too took a curved form—here an oval, at Hous'hill a circle—and the basic line of the curve was broken by recesses or projections. At Hous'hill the cabinets and seats varied the outline of the circle described by the screen, but all the different curves were concentric. Here the walls formed curved recesses outside the line of the oval (as seen at ceiling level) or projected into it; these shallow projections contained niches, again like the cabinets in the Hous'hill circular music room. Even the bow window took a different line from the basic oval, the shape of which was retained in a narrow band of canvas panelling above the window. It was a complex room, and Mackintosh possibly tried to fit too many subtle variations into such a small space.

It is difficult now to know how the room would have appeared on its completion. The original colour schemes have long been painted out, and the layout of the furniture was never recorded; in fact, the only photographs taken of these rooms were in 1971.

The interiors, with the rest of the fittings designed for Ingram Street, were removed in 1971 and are now in the care of Glasgow Museums.

1909.A Fireplace and bow window, Ladies' Rest Room, Ingram Street Tea Rooms, Glasgow
Photographed in 1971.

Collection: Eric Thorburn, Glasgow.

1909.B Ladies' Rest Room, Ingram Street Tea Rooms, Glasgow
Looking towards the Miller Street windows. The columns support the mezzanine Oval Room above. Photographed in 1971.

Collection: Eric Thorburn, Glasgow.

1909.C Fireplace and bow window, the Oval Room, Ingram Street Tea Rooms, Glasgow
Photographed in 1971.

Collection: Eric Thorburn, Glasgow.

1909.D The Oval Room, Ingram Street Tea Rooms, Glasgow
Looking towards the curved screen. Photographed in 1971.

Collection: Eric Thorburn, Glasgow.

1909.E Chair for the Oval Room and Ladies' Rest Room, Ingram Street Tea Rooms, Glasgow
This photograph, taken at the Memorial Exhibition in 1933, shows the chair 1909.17, along with other items from the Mackintosh Estate or lent by other owners to the exhibition.

Collection: Annan.

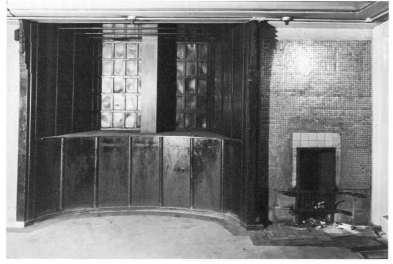

△1909.A

1909.C ▽

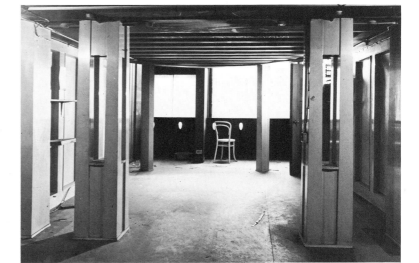

△1909.B

1909.D ▽

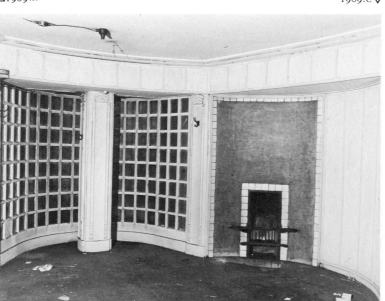

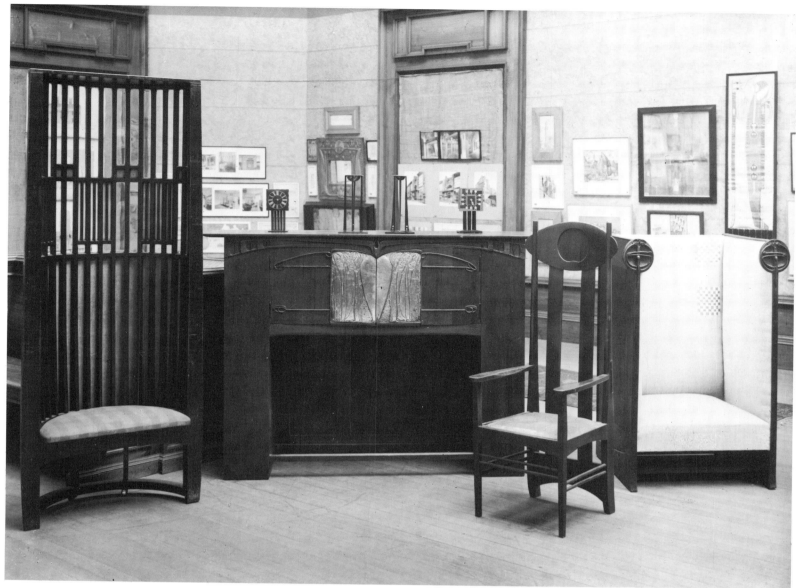

△1909.E 1909.14▷

1909.13 ★ Table for the Ingram Street Tea Rooms, Glasgow

John Craig was paid for six tables at £2.3.8d. each (7 June, 1909).

None has been traced, but the price indicates that these tables must have been more elaborate than the tables designed for the Oak Room (1907.3). It is possible that the reference in the job-books is to the domino table (1911.5) of which five survive. Certainly, that table is probably of the right scale for the room, but it has in the past been associated with the Chinese Room where it would have had more in common with the fittings, stylistically.

Collection: untraced.

1909.14 Chair with wavy back splat for the Ingram Street Tea Rooms, Glasgow

Oak, stained dark 72 × 40.6 × 34.5cm.
John Craig was paid for 28 at 17.9d. each (30 June, 1909).

The only chairs which survive in sufficient numbers at Ingram Street to fill this room (and which do not have a more specific place elsewhere in the building) are these wavy back splat chairs. It is possible that the order for 28 chairs refers to some other, perhaps lost, design but, on balance, it is probable that this chair was used in both the Oval Room and Ladies' Rest Room and in the White Cockade Tea Room in 1911.

Literature: Glasgow School of Art, *Furniture*, 1968, no 3; Macleod, plate 77.
Provenance: *See* 1907.4.
Collection: a) Glasgow Art Galleries and Museums (54); b) Glasgow School of Art (2).

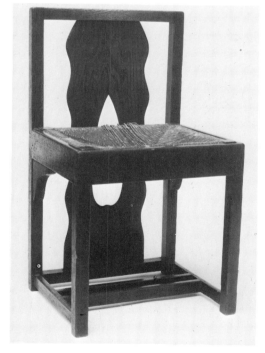

1909.15 Square writing desk for the Ingram Street Tea Rooms, Glasgow

Francis Smith quoted for one at £2.2.6d. (14 September, 1909) and was paid for two at £2.2.6d. each (10 March, 1910).

No writing desks corresponding with this item have been traced. The low price suggests that the desk must have been very simple, perhaps on the scale of that shown in one of the drawings for the Dug-Out (D1917.29).

Collection: untraced.

1909.16 Circular writing desk for the Ingram Street Tea Rooms, Glasgow

Francis Smith quoted for one at £3.10.0d. (14 September, 1909) and was paid that sum (10 March, 1910).

See 1909.15.

Collection: untraced.

D1909.16A ★

1909.17 Chair for the Ingram Street Tea Rooms, Glasgow

Wood, stained dark, with insets of coloured glass.
Francis Smith quoted for two, upholstered in corduroy, at £7.5.0d. each (14 September, 1909) and was paid that sum (10 March, 1910).

The cost of these two chairs indicates that they must have been quite elaborate, and the author believes that they were possibly like the chair exhibited at the Memorial Exhibition in 1933 (*see* 1909.E). This chair, almost semicircular in plan, had its back formed from narrow vertical rails; in the lower part the inter-mediate spaces were filled with fabric, but the upper half was open, save for the insertion of panels of glass between some of the rails. There are distinct similarities between the form of this chair and the curved screen at the Oval Room (for which project the two chairs in the job-books were intended) and even with the staircase screen in the Oak Room, which one had to pass to gain access to the Oval and Rest Rooms.

Unfortunately, the records of the Memorial Exhibition do not specifically indicate who lent this chair, but among the names of lenders appears that of Miss Drummond. She had been

★ *See* addenda

Miss Cranston's assistant and had been given Ingram Street when Miss Cranston retired. Perhaps she had kept this chair when she sold the property to Messrs Coopers (who owned the Tea Rooms in 1933).

Literature: Alison, p. *94* (at Memorial Exhibition, 1933).
Exhibited: Memorial Exhibition, 1933 (not in catalogue, (?) lent by Miss Drummond).
Collection: untraced.

1909.18 Couch for the Ingram Street Tea Rooms, Glasgow

Francis Smith quoted for two, in oak upholstered in corduroy, at £9.17.6d. each (14 September, 1909) and was paid that sum (10 March, 1910).

See D1909.19.

Collection: untraced.

D1909.19 Design for a couch for the Ladies' Rest Room, Ingram Street Tea Rooms, Glasgow

Pencil on a page of a sketchbook 18 × 22.8cm. Inscribed, bottom, *Miss Cranston's Miller Street. Couch in Rest Room*, and, upper right, *wood frame with strong webbing with strong sacking about / upholstered mattress loose & fixed to wood frame as shown.*

Provenance: Mackintosh Estate.
Collection: Glasgow University.

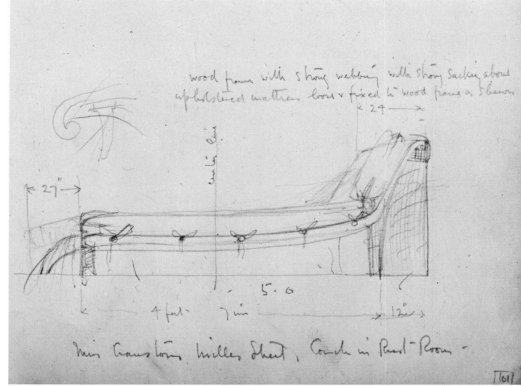

△ D1909.19

1909 Interiors in the western half of the Glasgow School of Art

The second phase of the School of Art, extending west from the Museum to Scott Street, was designed between September 1906 and May 1907; work commenced on site later that year. It is without doubt Mackintosh's greatest and most famous work. The Renfrew Street elevation was continued in the same vein as the existing, eastern, bays, but the west wing was totally redesigned to produce a dramatic composition contrasting totally with the east wing of the 1897 design (*see* Howarth, pp. 75–77, 81–84). The interiors were completed in 1909, and the details were almost certainly decided—if Mackintosh followed his usual practice—that same year; certainly, much of the furniture for the library was not delivered until 1910: Bedford Lemere's photographs of that year show the library incompletely furnished, and drawings for other furniture in the School are also dated 1910. The interiors followed much the same pattern as those completed in 1899, although a number of major changes were made. The most important of these were the provision of an extra storey of classrooms, refectory and professors' rooms, linked by the 'hen-run' and provided with two new staircases; the concentration of lectures into one new theatre in the basement of the west wing (the 1897 drawings show this theatre in addition to a theatre in the north-east corner of the ground floor); and the re-location of the library on the first floor, with a gallery and mezzanine above it, instead of on the ground floor.

The lecture theatre is in the basement, adjacent to the west door in Scott Street and is panelled with stained timber. It is, on the whole, unremarkable, except for a

1909.F Lecture Theatre, Glasgow School of Art

Collection: RCAHMS.

1909.G Architecture School, Glasgow School of Art

The architecture department was housed in a long studio on the ground floor of the west wing, with three of the large north light windows and three further windows on the west elevation.

Collection: RCAHMS.

1909.H Life modelling room, Glasgow School of Art

A basement room projecting out at the back of the building with its own roof-lights. This was the room in which Mackintosh devised a series of knot-like patterns for the ends of the T-girders supporting the roof beams.

Collection: RCAHMS.

1909.I Library, Glasgow School of Art

Photographed in 1910, before the delivery of the tables (1910.8) and upper part of the periodical desk (1910.5). This photograph clearly

▽1909.F

1909.G▽

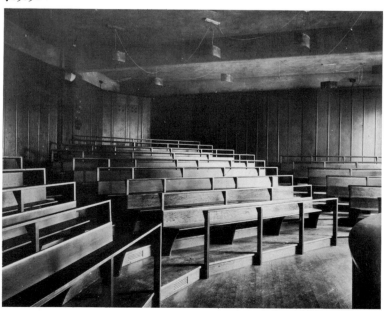

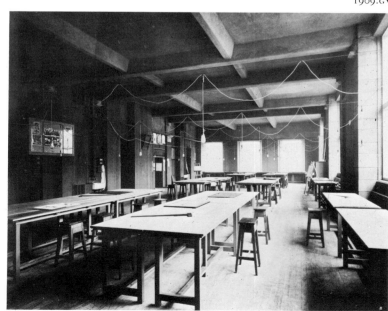

shows the construction of the casements, with their hinged central panels which create a rhythmic pattern in the vertical expanse of leaded-glass; this pattern was dismantled during the Second World War.

Collection: RCAHMS.

1909.J Gallery of the Library, Glasgow School of Art

A view along the west side of the gallery showing the waggon-chamfered balusters around the window bays on the left.

Collection: RCAHMS.

1909.K West staircase, Glasgow School of Art

One of the two new staircases introduced in 1909. The cement rendered finish follows the rise of the stair in an ogee curve and above it the brickwork is exposed. Two of the tiled panels can be seen on the landings.

Collection: RCAHMS.

sectional curved table and stage which can be removed piecemeal, and for the curved rows of benches with seats so narrow that generations of students have, in fact, remarked continuously upon their discomfort. Outside the lecture theatre is one of the two new staircases introduced in 1907. In 1899 the School had only one staircase, a breach of the fire regulations which seems quite incredible, and in this second phase two fireproof staircases were added to the building (the eastern one being fitted in the re-entrant angle of the east wing by the side of the old Board Room). Mackintosh used the flat, smooth surfaces offered by the cement render on the staircases to introduce some decoration in the form of ceramic tiles. In the basement, oblong tiles are set vertically to embellish the corners of the walls, but for the landings he devised an arrangement of square tiles, playing off the coloured surfaces against blank squares of cement and never repeating any particular combination. At the top of the staircases, where the dividing wall between

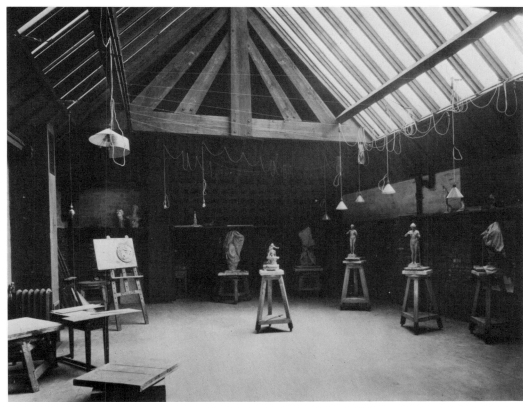

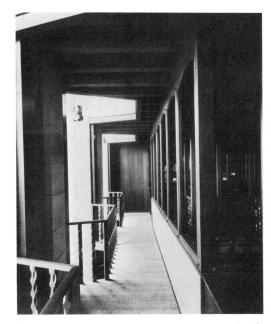

▽1909.I 1909.J△ △1909.H 1909.K▽

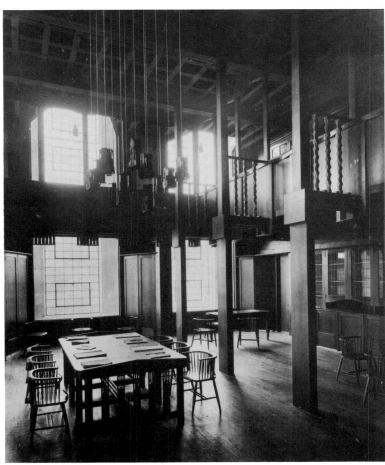

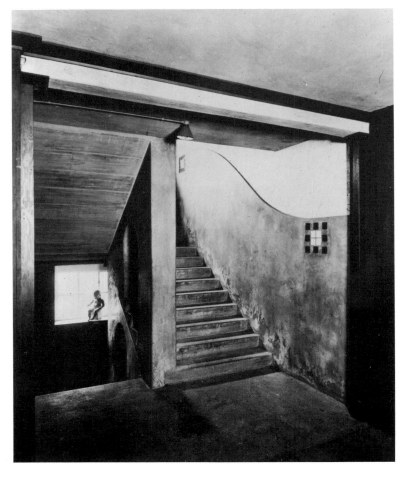

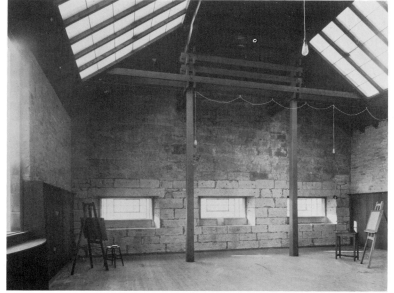

△1909.L

△1909.M 1909.N▽

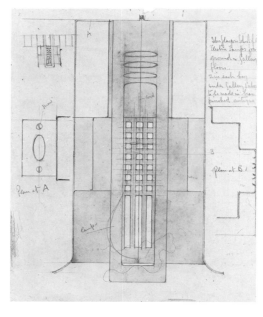

1909.L Composition room, (?) formerly flower painting room, Glasgow School of Art

Collection: RCAHMS.

1909.M The loggia, Glasgow School of Art
Much of the new work on the top floor was executed in brick, which was left exposed in 1909. This loggia formed a corridor behind the Professors' studios (on the right of the photograph) and led to the 'hen run', a wood and glass structure supported on brackets over the roof of the museum to link up with the refectory, which was built in 1910 on top of the existing eastern half of the School.

Collection: RCAHMS.

1909.N The refectory, Glasgow School of Art
The refectory was built on top of the first-floor studios of the east wing in 1907–09. The windows on the left look out over Renfrew Street, but are not visible from the ground because of the projection of the overhanging eaves. The timber structures on the south brick wall are the ventilation ducts which were clad with stained pine boards. Although this contemporary photograph shows the area laid out as a refectory, Mackintosh's plans define the space as 'Diploma Studios'.

Collection: RCAHMS.

D1909.20 Design for a light fitting for the Library, Glasgow School of Art
Pencil and watercolour 31.9 × 25.6cm.

D1909.20▽

flights disappears, he introduced a wrought-iron grille terminating at the ceiling in an elaborate composition of trellis and curves.

The library on the first floor was treated in a totally different manner from any other room in the School of Art. It followed the same basic arrangement as that shown in the 1897 drawings (see Howarth, fig. 15) with a gallery over the main floor, a repetition of the design for the Museum in the Queen Margaret Medical College. Mackintosh's stroke of genius was to set back the front of the gallery from the posts which support it, creating a narrow gallery walk-way, but dramatically improving the appearance of the whole room and creating a spatial masterpiece. Mackintosh was committed to placing his supporting posts on the line they take because of the supporting beams below: if his gallery had extended out to reach them, the main floor would have been oppressively low-ceilinged and gloomy. At balcony height, the posts divide into three parts, the central section rising to the ceiling while the two outer posts turn through an angle of 90° to support the gallery. Its front is set back from the line of the centre post, so the arrangement of the twin beams is clearly exposed. In between the main post and the gallery front are a series of square balusters, scalloped (or waggon-chamfered) along their corners, with the exposed timber painted in bright red, green, or white. The gallery front is solid with alternate panels having a downward projection like the pendant panels in the gallery of Queen's Cross Church. Alternate pendants on the east–west axis pass through the twin beams supporting the balcony and the remainder are decorated with a series of pierced ovals arranged in columns. This is a motif which had appeared at Holy Trinity Church in 1904, but here each pendant

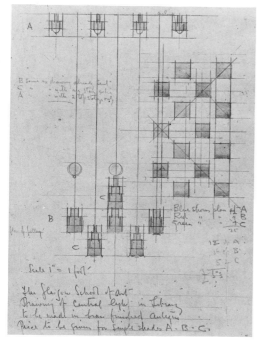

D1909.21

has an arrangement of the ovals which is totally individual and unrepeated. This same motif, again in differing combinations, is used on the legs of the library tables and the central periodical desk. Around the top of the balcony a timber lath is fastened, bent over the raised panels to form a gently undulating wave over its length. This was a feature which had been used in the Oak Room at Ingram Street in 1907; here the wave is repeated at ceiling height directly over the gallery front and on a much larger scale in the ogee curves of the aprons of some of the bookcases. The ceiling takes the form of a boldly detailed lattice and it, like the rest of the woodwork, is stained a deep warm brown.

The furniture for the library comprises only four or five designs: the periodical desk; the tables with pierced legs; Windsor chairs, similar to those used at The Dutch Kitchen, provided for readers; another magazine stand, possibly used in the mezzanine store; and circular newspaper racks, which may even have been designed in 1899. There appear to have been no special fittings designed for the Librarian's office or for the gallery, access to which was gained via the new escape stair rather than by the turret-stair shown in the 1897 design (the present internal staircase at the side of the Librarian's office is a more recent addition). Above the gallery, again reached from the west staircase, is a book store.

Literature: Howarth, pp. 69–92, plates 21–31.

◁D1909.21 1909.22▽

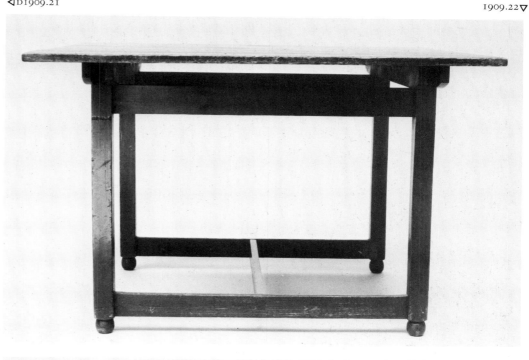

Inscribed, upper right, *The Glasgow School of Art | Electric Lamps for | ground & Gallery | floors. | 2 in each bay | under Gallery | above | to be made in brass | finished antique*; and various other notes. Scale, full size.

Very similar to the executed design, which was so made as to direct light down on to the tables with very little escaping through the coloured glass side inserts. This lamp was used both under and on the gallery, while a more elaborate version was used in the centre of the room.

Literature: Alison, p. 80, no 34.
Exhibited: Milan, 1973 (34).
Provenance: Mackintosh Estate.
Collection: Glasgow University.

D1909.21 Design for the central group of light fittings in the Library, Glasgow School of Art

Pencil and watercolour 36.1 × 22.5cm.
Inscribed, lower left, *The Glasgow School of Art | Drawing of central light in Library | to be made in brass finished Antique | Price to be given for single shade A-B-C*, and, upper left, *B same as drawing already sent | C* [ditto B] *with one storey extra | A* [ditto B] *with 2 top storeys only*; and various other notes.
Scale, 1 : 12.

This drawing shows the arrangement of the different types of fitting used in the Library. Some were fixed to the centre of the ceiling, some to the ceiling over the gallery and underneath it, and the remainder arranged as shown in this drawing, suspended at varying heights over the centre of the room.

Literature: Alison, p. 80, no 35.
Exhibited: Milan, 1973 (35).
Provenance: Mackintosh Estate.
Collection: Glasgow University.

1909.22 Table

Ebonised pine 76 × 114.4 × 113cm.

Probably designed for the School of Art, perhaps for use in the Museum or Library.

Collection: Glasgow School of Art.

1910.1 Side table with wavy edge for the Director's Room, Glasgow School of Art

Cypress, stained dark 76 × 109.5 × 45.5cm.

A table combining two of the most common motifs of Mackintosh's work of this period: a wavy line to the edge of the table top, and a lattice grid for the stretchers. *See* D1910.2.

Collection: Glasgow School of Art. 1910.1▷

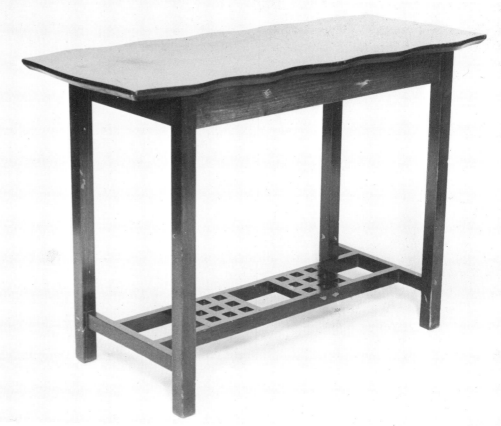

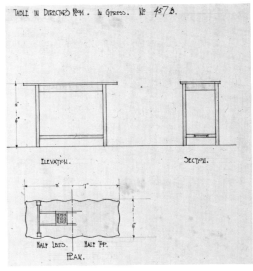

TABLE IN DIRECTORS ROOM. IN CYPRESS. No 457B.

ELEVATION. SECTION.

HALF LEGS. HALF TOP.
PLAN.

△DI910.2 1910.3▷

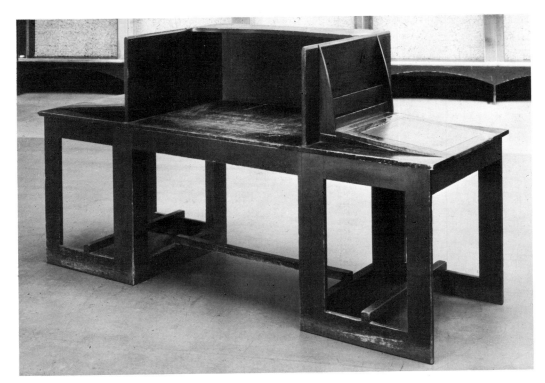

DI910.2 Design for a side table in the Director's Room, Glasgow School of Art
Pen and black ink and watercolour on linen 38.7×35.8cm.
Inscribed and dated, lower right, *4 BLYTHS-WOOD SQUARE | GLASGOW. MARCH 1910*; inscribed, upper left, *THE GLASGOW SCHOOL OF ART | TABLE IN DIREC-TOR'S ROOM. IN CYPRESS. No 457B.*
Scale, 1:12.

The design for 1910.1, as executed. The draw-ing is by an office draughtsman working from Mackintosh's sketches.

Collection: Dr Thomas Howarth.

1910.3 Writing desk for the Masters' Room, Glasgow School of Art
Ebonised cypress 117×211.2×75.7cm.

The teachers at the School of Art did not have individual offices but shared common rooms, one each for the men and the women. This ingenious design provides a writing desk for three teachers within the confines of one piece of furniture. Its construction and appearance are very simple and bold, as are the other pieces of this period which were not intended for public rooms or display.

Collection: Glasgow School of Art.

DI910.4 Design for a table for the Masters' Room, Glasgow School of Art
Pen and ink and watercolour on linen 37×48cm. (sight).
Inscribed and dated, below, *THE GLASGOW SCHOOL OF ART | DESK IN MASTERS ROOM. IN CYPRESS. No 464D | 4 BLYTHS-WOOD SQUARE | GLASGOW APRIL 1910*; and other notes and measurements.
Scale, 1:12.

Design for 1910.3; drawn by an office draughts-man from sketches by Mackintosh.

Exhibited: Toronto, 1967 (87).
Collection: Dr Thomas Howarth

1910.5 Periodical desk for the Library, Glasgow School of Art
Cypress, stained dark, with coloured glass inserts 136×231.5×114cm.

This piece appears in the 1910 Bedford Lemere photographs without the upper rack (*see* 1909.I), but even in those photographs it served as a reading desk for periodicals. The arrange-ment of stretchers, with a small lattice-work area in the centre of each section, is typical of the period; each of the intermediate vertical stretchers, at both ends of the table, is pierced with a unique design similar to the carved pendants on the balcony. The upper rack is simply slotted over the desk. Each end has an

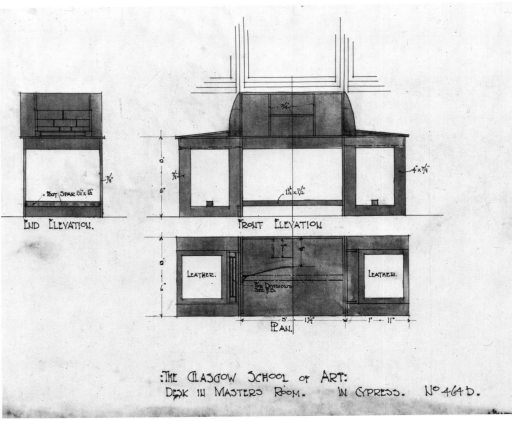

END ELEVATION. FRONT ELEVATION

LEATHER. LEATHER.

PLAN.

:THE GLASGOW SCHOOL OF ART:
DESK IN MASTERS ROOM. IN CYPRESS. No 464D.

△DI910.4 1910.5▷

exaggerated play on the wedges and toggle fasteners which hold the structure together.

Literature: Howarth, plates 30, 31; Pevsner, 1968, plate 47; Macleod, plate 100; Glasgow School of Art, *Furniture*, no 20.
Exhibited: Edinburgh, 1968 (204).
Collection: Glasgow School of Art.

1910.6 Magazine stand for the Glasgow School of Art
Pine, stained dark 153.5×137×137cm.

McLaren Young suggested that this was used in the Library before the periodical desk (1910.5), but it seems unlikely that a decision to design a new stand to replace this would have been taken so soon after completion of the Library. There can be little doubt that this piece dates from 1909–10, since the paired legs and stretchers were used on other furniture of this date as well as in the structural posts of the Library itself. The deep, sloping rests suggest

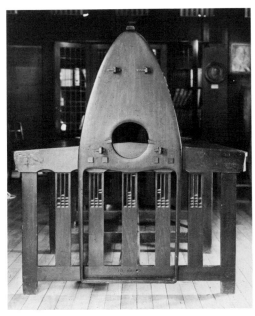

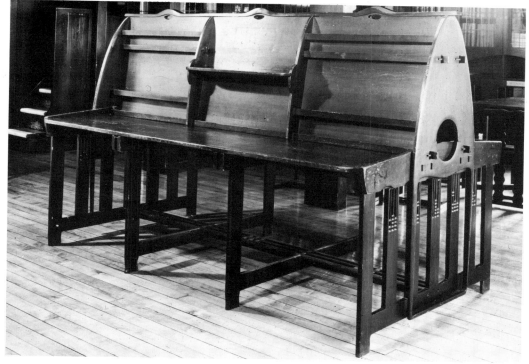

△1910.5

1910.6 ▽

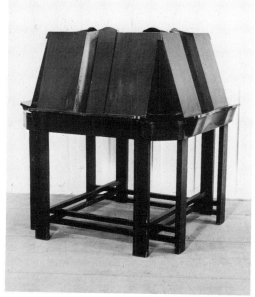

▽1910.8

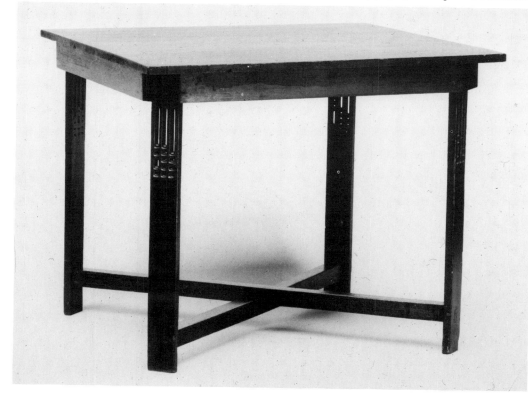

that they were intended to support large bound volumes such as newspapers or folio books too large for the readers' tables (1910.8). If this is so, perhaps the stand was kept in the mezzanine book store next to the volumes themselves.

In the centre of the piece is a deep zinc-lined well which was presumably used as a receptacle for pot plants. This seems an unusual feature for a piece of Library furniture, and suggests that the stand may have had a different use. One possibility is that it was used in the studio above the Library; this is called a composition room on the plans of the School, but, as it is adjacent to the cantilevered conservatory, perhaps it was also used for plant drawing (a possibility supported by notes on the Bedford Lemere photographs at Glasgow University which say 'Composition Room, originally flower painting room'). Plants could have been placed in their pots in the central well and four students could have worked at drawing boards propped against each of the four sides of the stand. Stylistically it would have suited this studio well, as Mackintosh had designed a *tour de force* of paired roof beams supporting the roof itself (1909.L). The paired stretchers

1910.7△

would have echoed in miniature the arrangement of the roof.

Exhibited: Edinburgh, 1968 (203).
Collection: Glasgow School of Art.

1910.7 Newspaper racks for the Library, Glasgow School of Art
Pine, stained dark 180 × 76cm. (diameter).

Simple, sturdy racks which are now kept on the landing outside the doors to the Library gallery; originally this landing was the only access to the gallery and it seems unlikely that they would have been allowed to take up any of its restricted space: perhaps they were kept in the book store on the mezzanine floor above the Library. Nothing about their appearance could be said to date specifically from c1910, so it is possible that they were made at the time of the first phase of the School (c1899) to provide temporary storage.

Collection: Glasgow School of Art.

1910.8 Square table for the Library, Glasgow School of Art
Cypress, ebonised or stained dark 76.3 × 91.2 × 88.2cm.

Delivered after the Bedford Lemere photographs were taken, these tables incorporate yet more variations on the themes of the gallery pendants. Like the vertical stretchers on the periodical desk (1910.5), none of the patterns is repeated. The tables must have been designed specifically for the School, and not for one of the tea rooms as suggested in Glasgow School of Art, *Furniture*. Ten examples survive.

Literature: Glasgow School of Art, *Furniture*, 1968, no 19; Macleod, plates 100, 102.
Exhibited: Edinburgh, 1968 (205).
Collection: Glasgow School of Art (10).

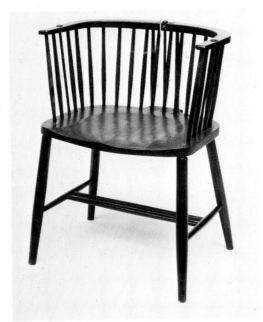

△1910.9

△1910.10

1910.11△

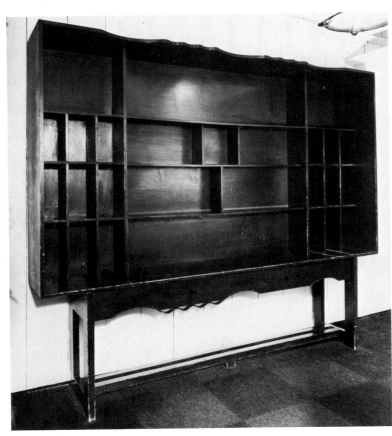

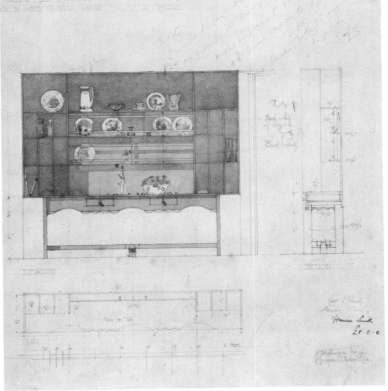

◁1910.12

D1910.13△

1910.9 Windsor chair for the Library, Glasgow School of Art

Pine, varnished 66.7 × 50.5 × 44.5cm.

A more elegant version of the Windsor chair designed for The Dutch Kitchen (1906.49), these do not seem to have been enamelled green at any time. There are a number of other differences which contribute to the greater lightness of the design: the rails are tapered at each end and are placed closer together; the legs have a wider splay and are similarly more tapered at the ends; two rails project down and outwards from the top rail to connect with a short projection from the back of each seat. This latter device was probably intended to give the back rest greater stability, but it did not succeed; in a piece which should have been designed to withstand a considerable amount of student abuse, Mackintosh used individual members with an inherent lack of strength. Sadly, many of the chairs have failed in use and all those surviving have had to be reinforced. If four chairs were provided for each table surviving (1910.8), then a total of 40 would have been made; nine survive.

Literature: Howarth, plates 30, 31; Pevsner, 1968, plate 47; Glasgow School of Art, *Furniture*, (after 27A).
Exhibited: Edinburgh, 1968 (206).
Collection: Glasgow School of Art (9).

1910.10 Easel for the Glasgow School of Art

Wood, originally varnished.

An exaggeratedly tall design which complements the vast interior spaces of the studios. Quite a number of easels must have been provided at the time of completion of the School, but very few now survive.

Literature: Macleod, plates 97, 104.
Collection: Glasgow School of Art.

1910.11 Clocks for the Glasgow School of Art

Wood, with stencilled numerals.

A number of square wall clocks were made for the School, where they were scattered around the studios, corridors, Library, and the Museum. The faces are square, often decorated with stencilled squares around the perimeter, and the numerals are silhouetted against larger squares of a lighter colour. *See also* 1910.20.

Literature: Macleod, plates 35, 100.
Collection: Glasgow School of Art.

1910.12 Dresser for the Ladies' Common Room, Glasgow School of Art

Cypress, stained dark 226.6 × 259.2 × 44.7cm.
Probably made by Francis Smith.

Mackintosh's version of a traditional dresser/ bookcase, making extensive use of the curved or scalloped edging which was used at the Oak Room in 1907 and the School of Art Library in 1909.

Collection: Glasgow School of Art.

D1910.13 Design for a rack and bookcase in the Ladies' Common Room, Glasgow School of Art

Pencil and watercolour 44.8 × 51cm.
Inscribed and dated, lower right, *4 Blythswood Square / Glasgow October 1910*; inscribed,

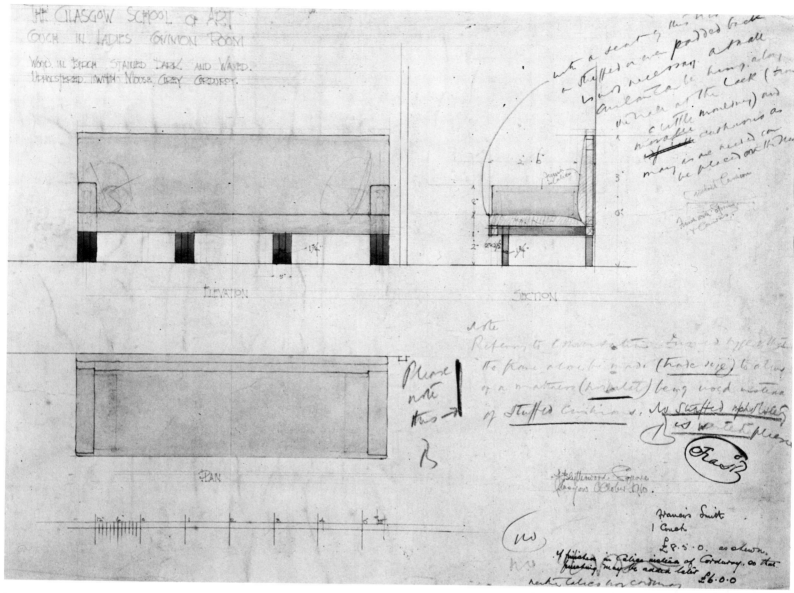

upper left, *THE GLASGOW SCHOOL OF ART | RACK IN LADIES COMMON ROOM IN CYPRESS*; and various other notes and measurements including, in Newbery's hand, *Note | I would suggest that as far | as possible a greater space | might be given to books | & a lesser space to plates | etc | something like I have suggested*; and in another hand, *For 1 Rack | Stained & waxed | Francis Smith | £8.0.0.* Scale, 1 : 12.

Newbery's annotations were heeded by Mackintosh who, although he did not personally produce this measured drawing, was closely controlling the design of the dresser (*see* 1910.12).

Provenance: Mackintosh Estate.
Collection: Glasgow University.

DI910.14 Design for a couch in the Ladies' Common Room, Glasgow School of Art

Pencil and watercolour 35.4 × 52.6cm.
Inscribed and dated, lower right, *4 Blythswood Square | Glasgow October 1910*; and *Francis Smith | 1 couch | £8.5.0 as shown* (in red ink) | *if finished in Calico instead of Corduroy, so that | finishing may be added later £6.0.0* (in green ink); this deleted in pencil, and a pencil inscription added by Fra Newbery *No | neither calico nor corduroy*. Inscribed, upper left, *THE GLAS-GOW SCHOOL OF ART | COUCH IN LADIES COMMON ROOM | WOOD IN BIRCH STAINED DARK AND WAXED | UPHOLSTERED WITH MOUSE GREY CORDUROY*; other notes in Fra Newbery's hand, right, *With a seat this width | a stuffed or even padded back | is not necessary at all | cushions can be hung along | the wall at the back (from | a little*

moulding) and | movable cushions as | many as are needed can | be placed on the seat; and *Please | note | this | FN | Note | Referring to conversation (.......?) suggested | the frame alone be made (trade size) to allow | of a mattress (hospital) being used instead | of stuffed cushions. No stuffed upholstery | is wanted please | FN |*, followed by Fra Newbery's stamp, *Fra N* inside a palette.
Scale, 1 : 12.

Like DI910.13, this drawing is by an assistant who was presumably working up one of Mackintosh's sketches. Newbery's notes and suggestions, if accepted, would have meant an almost complete redesign, but no piece corresponding to this drawing is recorded.

Provenance: Mackintosh Estate.
Collection: Glasgow University.

1910.15 Bed for Fra Newbery, Glasgow
Wood.

Newbery commissioned two single beds from Mackintosh, the only furniture which he seems to have designed for Newbery's own house.

The carved decoration on the front of each is reminiscent of that on the bed at The Hill House of 1903. Only the foot of each bed now survives.

Provenance: Fra Newbery; Mrs Mary Newbery Sturrock.
Collection: Dr Thomas Howarth.

DI910.16 Design for beds for Fra Newbery, Glasgow

Pen and black ink, red ink and watercolour on linen 21.5 × 35.5cm. (sight).
Inscribed and dated, lower right, *4 BLYTHS-WOOD SQUARE | GLASGOW. NOV. 1910* and inscribed, upper left, *BEDS FOR FRA. H. NEWBERY ESQ. 6 BUCKING-HAM. STREET HILLHEAD*; and below, *NOTES —. 2 BEDS WANTED.* the following deleted *PRICES TO BE GIVEN FOR MAKING IN MAHOGANY & IN ASH OR BIRCH | STAINED TO A DARK COLOUR TO BE APPROVED & FINISHED WITH 2 COATS FLAT VARNISH | (BEES WAX EGG SHELL GLOSS) & TO IN-*

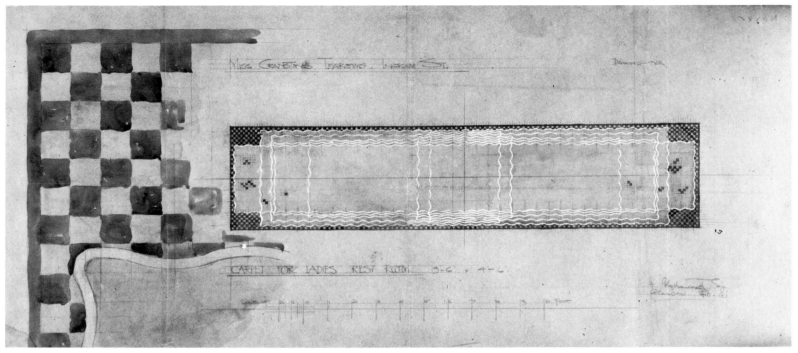

△D1910.18 D1910.19▽

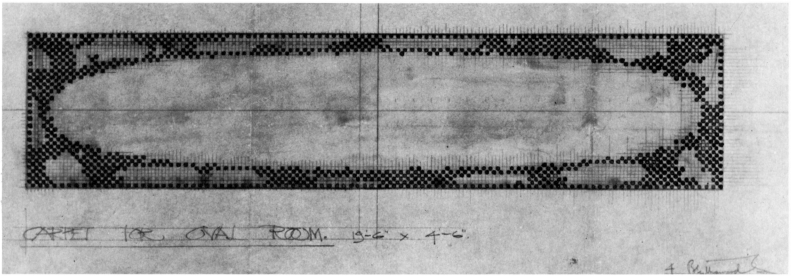

CLUDE 4 FRENCH CASTORS & / SPRING
MATTRESS / FOR EACH BED. PRICE
TO INCLUDE DELIVERY & FITTING UP.
Scale, 1:12.

The design for 1910.15, presumably as executed.
Like so many drawings of 1910, this is not in
Mackintosh's hand; it was probably worked
up by one of the office draughtsmen from
sketches by Mackintosh.

Exhibited: Toronto, 1967 (77).
Collection: Dr Thomas Howarth.

1910.17 Candlestick for Hous'hill, Nitshill, Glasgow

Wylie Davidson was paid £14.10.0d. for
making and fitting one white metal candlestick
(8 November, 1910).

Possibly for the Card Room and likely, from
the price, to have been a substantial piece.

Collection: untraced.

D1910.18 Design for a carpet for the Ladies' Rest Room, Ingram Street Tea Rooms, Glasgow

Pencil and watercolour on tracing paper
41.7 × 84.8cm. (irregular).
Inscribed and dated, lower right, *4, Blythswood
Sq / Glasgow. Feb. 10.*, inscribed, top, *MISS
CRANSTON'S TEAROOMS. INGRAM
ST. DRAWING NO.*, and, bottom, *CARPET
FOR LADIES REST ROOM 19' 6" × 4' 6".*
Scale, 1:12, and full size.

Worked out by a draughtsman from a sketch
by Mackintosh.

Provenance: Mackintosh Estate.
Collection: Glasgow University.

D1910.19 Design for a carpet for the Oval Room, Ingram Street Tea Rooms, Glasgow

Pencil and watercolour on tracing paper
38.3 × 67.9cm. (irregular).
Inscribed, and dated, lower right, *4 Blythswood
Sqr / Glasgow. Feb 10.* and inscribed, upper left,
*MISS CRANSTON'S TEAROOMS—
INGRAM ST.* and, lower left, *CARPET
FOR OVAL ROOM 19'–6" × 4'–6".*
Scale, 1:12.

Worked out by a draughtsman from a sketch
by Mackintosh.

Provenance: Mackintosh Estate.
Collection: Glasgow University.

1910.20 Clock for William Douglas, Glasgow

Oak, stained dark, with stencilled decoration
on face, weights and pendulum 38 × 38cm.,
plus pendulum, 39.5cm. long.

A clockwork version, with weights and a
pendulum, of the electric clocks designed for
the School of Art. The square dominates the
decoration, appearing not just on the clock

1910.20▷

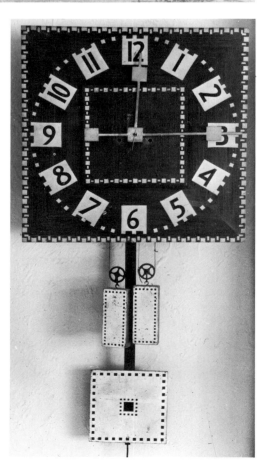

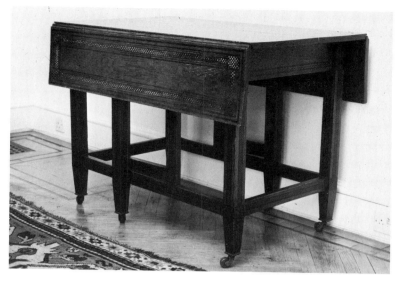

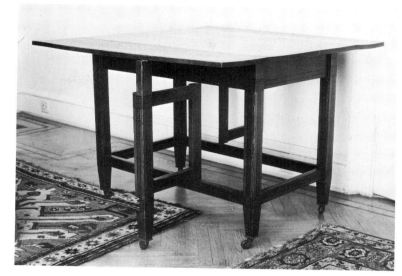

△1910.21 1910–12.23▷ 1910.21△

face, but also around the perimeter of the weights and on the pendulum. In some respects, the piece anticipates the later experiments in clock-case design for Bassett-Lowke in 1916–17.

Provenance: William Douglas; Nestor Douglas; J. & R. Edmiston, Glasgow. Private collection.

1910.21 Pembroke table for William Douglas

Oak, with chequer decoration 75.8 × 105 × 107cm.

Designed for William Douglas, c1910. It is unusual to see such chequer stencilling actually applied to a piece of furniture, although it was a frequently used motif in Mackintosh's schemes for wall decoration.

Provenance: William Douglas; Benno Schotz; Mario Amaya; Christopher Gibbs. Private collection.

1910.22 Draughtsman's table for William Douglas

Mahogany, with chequer decoration.

Supposedly a companion piece to 1910.21, but it has not been seen by the author.

Provenance: William Douglas; Benno Schotz; Mario Amaya; James Coats; Sotheby Parke Bernet, New York, 30 January, 1970, lot 150. Collection: untraced.

1910–12.23 Sample cabinet for William Douglas, Glasgow

Sycamore, stained dark 168.3 × 111 × 42cm.

Reputedly designed by Mackintosh, but some of the detailing suggests that he did not closely supervise the execution. The cabinet was made for William Douglas, a decorator and friend of Mackintosh who worked on several of the latter's jobs, notably Hous'hill in 1904. Each drawer holds samples of different woods, stains, paints and finishes. The bases of the drawers project beyond their sides and fit into a groove cut into each upright; in this way they slide in and out without the need for runners, so there are no transverse spacers between the individual drawers.

Provenance: W. Douglas; Benno Schotz, by whom presented. Collection: Glasgow School of Art.

1910–12.24 Desk for William Douglas, Glasgow

Ebonised oak 79 × 115 × 62cm.

This draughtsman's desk (the top lifts up to form an angled drawing board) has some details in common with the Masters' desk (1910.3), and was probably designed for

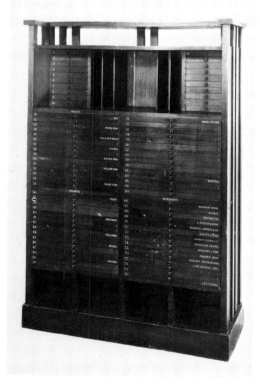

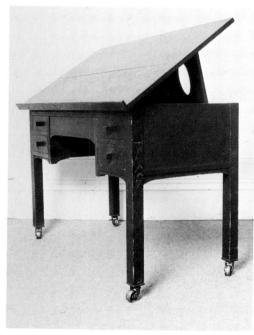

△1910–12.24

Douglas c1910–12, when Mackintosh seems to have designed other pieces for him.

Provenance: William Douglas; Benno Schotz. Collection: Isi Metzstein.

1910–12.25 Dining chair for William Douglas, Glasgow

Sycamore, stained dark 100.5 × 46.5 × 46.5cm.

Although almost conventional in appearance, this chair corresponds with the other furniture designed for Douglas at about this date.

Provenance: William Douglas; Benno Schotz; Jack Coia. Collection: Jacqueline Coia (6).

1911.1 Plate-rack for the White Cockade Tea Room, Glasgow

Pine, stained dark.

One of these racks can be seen in a photograph of the terrace of the White Cockade (Glasgow Libraries). D1911.2 suggests that four were made, but none has been traced.

Collection: untraced.

1910–12.25▽

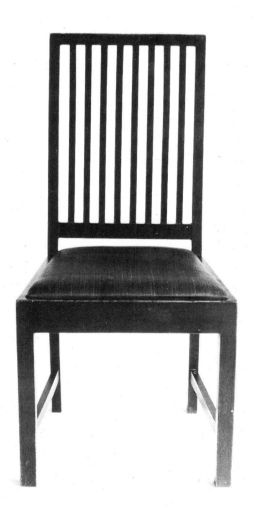

1911 The White Cockade Tea Room at the Glasgow Exhibition

No informative photographs of this temporary tea room exist, and only one drawing (D1911.2) has survived. The job-book suggests that there was internal panelling similar to that used in the Chinese Room later in the year; other entries infer that the pay desk was transferred to Ingram Street for the Blue, or Chinese Room, later in the year after the closure of the Exhibition.

It is possible that the large quantity of wavy-back chairs (1909.14) were made for this tea room and transferred to Ingram Street afterwards; only 28 were required for the Oval Room, but another 29 survive, and there is no record of such a large number of chairs being made specifically for any room at Ingram Street.

The job books show that William Douglas was paid £256.5.0d. for painter-work (26 July, 1911); Francis Smith £4.15.0d. for balcony railings etc.; Hutchison £20.4.0d. for 47 lamps and glass; Baird & Tatlock £3.19.10d. for flower tubs; Brown & Beveridge £18.10.0d. for 38 pairs of screens; and James Grant £20.9.8½d. for a pay desk; all were paid on 26 June, 1911.

1911 The Chinese Room, Ingram Street Tea Rooms, Glasgow

205 Ingram Street does not appear to have been worked on by Mackintosh before 1911 when it was turned into the Blue or Chinese Room. Mackintosh left the original ceiling in place, but painted it dark and then screened it from view using a series of horizontal lattices painted bright blue, like most of the woodwork in the room. These screens were supported at the walls on projecting panels of lattice construction and in the centre of the room by free-standing lattice screens. Between the projections, the walls were covered with a heavy canvas, painted blue, and more lattice-work was applied on top of this. The central screens had tall posts at each end which rose above the horizontal screens; at the top of each post was fitted a wooden pagoda-shaped sculpture. Other identical structures were suspended from the ceiling through the voids in the lattice, and beneath them were hung light shades. At the door stood a large square pay desk, which also supported the overhead screens, and at the south end of the room a timber and mirror-glass screen partitioned the area from the servery and ante-room to the Cloister Room. Over the opening in this screen, Mackintosh devised an elaborate canopy of fretwork in the Chinese style.

In contrast to the refurbished Cloister Room designed later in 1911 and opened in 1912, the Chinese Room is severely rectilinear. The emphasis is wholly on the square and the relationship between the solid and open panels of the lattice-work. This linear style is relieved by the fretwork decoration of the door canopy, the chairs, coat-hooks and pay desk, but Mackintosh introduces a curved feature in the lattices which project from the wall; these are about 20cm. deep, and the spaces between the lattice frame are filled with concave niches of leaded mirror-glass, or a plastic substance, or simple flat leaded panels. The niches were used in many pieces of furniture and fittings from about 1903, but the material used to decorate them was usually a coloured glass. Here Mackintosh used mirror-glass, or one of the new casein-based plastics, Lactolith or Galalith (*see also* D1912.4). The job-books show that James Grant was paid £90.0.0d. for joiner-work in Kauri pine

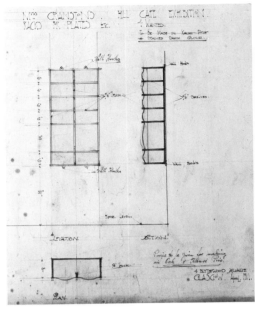

D1911.2△

D1911.2 Design for plate-racks for the White Cockade Tea Room, Glasgow
Pencil and watercolour 38.1 × 29cm.
Inscribed and dated, bottom right, *4 BLYTHS-WOOD SQUARE | GLASGOW APRIL 1911* and upper left, *MISS CRANSTONS HILL CAFE EXHIBITION | RACKS FOR PLATES ETC 4 WANTED | TO BE MADE IN KAURI PINE | & STAINED DARK COLOUR*; and various other notes and measurements.

An extremely simple design; the central spar and the fronts of the shelves, as seen in the section, were cut to a wavy pattern along their edges. The drawing is not in Mackintosh's hand; the design has been worked-up from his sketches by an office draughtsman. The Hill Cafe was another name for the White Cockade.

Collection: Dr Thomas Howarth.

1911.A The Chinese Room, Ingram Street Tea Rooms, Glasgow
Photographed *c*1950 before the central lattice screens were removed.

Collection: Glasgow University.

1911.B Chinese Room, Ingram Street Tea Rooms, Glasgow
Photographed *c*1950, this view shows how the cash desk supported the overhead lattice-work.

Collection: Glasgow University.

◁1911.A 1911.B▽

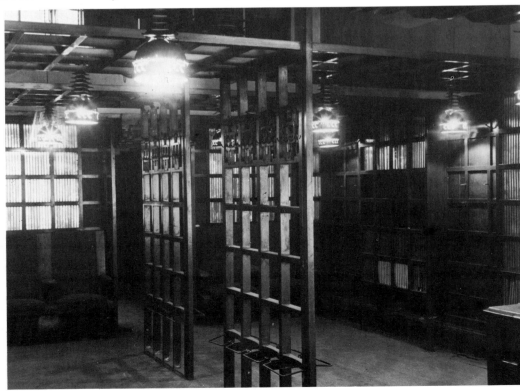

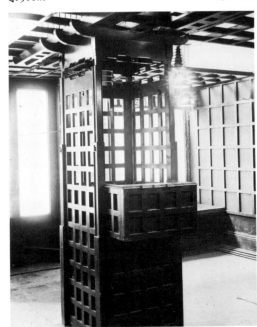

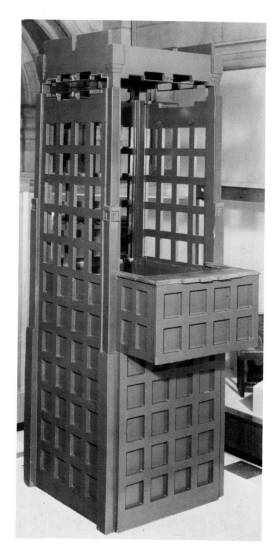

Literature: Howarth, pp. 135–36, plates 51b, 52; Macleod, p. 145; McLaren Young, no 259.

◁1911.3 1911.C△

1911.C Detail of door canopy, Chinese Room, Ingram Street Tea Rooms, Glasgow

Collection: Glasgow University.

1911.3 Pay box for the Chinese Room, Ingram Street Tea Rooms, Glasgow
Wood, painted blue 236.5 × 73 × 102cm.

The cash desk was positioned near the street entrance to the Chinese Room and acted as a support for some of the overhead lattice-work. The lattice theme is repeated with both open and solid panels, and the upper part of the piece is decorated with fretwork Chinese-style motifs matching those on the canopy over the door from the Cloister Room (*see* 1911.C). The desk may have been used first of all at the White Cockade as, although it is listed in the job-books, no price was quoted and no payments made.

Exhibited: Edinburgh, 1968 (259).
Provenance: *See* 1907.4.
Collection: Glasgow Art Galleries and Museums.

1911.4 Chair for the Chinese Room, Ingram Street Tea Rooms, Glasgow
Ebonised pine 82.4 × 43.8 × 40.7cm.
Francis Smith quoted for 36 at £1.2.6d. each, plus '2.6d. extra if enamelled' (June 1911, no other details given).

The fretted back and side rails match the Chinese style motifs of the Blue Room, as it is called in the job-books; these chairs have always been associated with the Chinese Room, and so must be identified with the entry for 36 chairs in the job-books. Much of the woodwork in the Chinese Room was painted bright blue or red, and these chairs, if they ever were enamelled, would have been painted to match. There is no trace, however, of any other finish having been applied to them than the ebonising

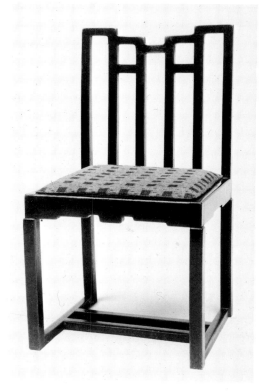

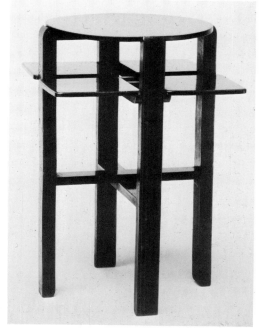

◁1911.4 1911.5△

which most of them still display. There is also a curious note in the job-books: Francis Smith reported that he had made an allowance for reducing the height of the chairs at front and back, yet the existing chairs do not appear to have had any alterations made to their dimensions since their original manufacture.

Literature: Bliss, plate 45; Macleod, plate 102; Alison, pp. 74, 75.
Exhibited: Edinburgh, 1968 (261).
Provenance: *See* 1907.4.
Collection: a) Glasgow Art Galleries and Museums (21); b) Glasgow School of Art (9).

1911.5 Domino table for the Ingram Street Tea Rooms, Glasgow
Ebonised oak 77.5 × 50 × 50cm.

There is no record of any tables being made for the Chinese Room, but it is generally believed that these domino tables were designed to be used there. They are a stylistic up-

dating of the domino table made for the Argyle Street Tea Rooms and would not have looked out of place if used with the low chairs (1911.4).

Literature: Glasgow School of Art, *Furniture*, 1968, no 12; Macleod, plate 78.
Provenance: *See* 1907.4.
Collection: a) Glasgow Art Galleries and Museums (3); b) Glasgow School of Art (2).

D1911.6 Design for curtains for Miss Cranston's Tea Rooms ★
Pencil and watercolour. Approx. 30.3 × 39.3cm.

This drawing has not been available for photography and the author has not seen it. The date is given unequivocally as 1911 in the Toronto catalogue, although there is no mention of any inscription on the drawing. If the date is accurate, then the drawing is probably related to the designs for the Chinese Room at Ingram Street, Glasgow.

Exhibited: Toronto, 1967 (101).
Collection: Dr Thomas Howarth.

★*See addenda* 215

1911　The Cloister Room, Ingram Street Tea Rooms, Glasgow

In 1911 Miss Cranston asked Mackintosh to prepare plans for altering the small rear tea room which linked the Scott Morton Room and the Chinese Room. The job-books show that this was sent out to tender late in 1911 and the estimated cost of £350 was recorded on 27 December. The only remaining entries for the project are undated payments to James Grant of £95 and a payment for umbrella stands of £27.11.9d. No furniture seems to have been designed specifically for the new room, although Howarth (p. 135) states that Francis Smith was paid to cut down 31 chairs. The author believes that the chairs referred to were examples of 1900.54 which were used in the Cloister Room before these alterations were made.

In contrast to the Chinese Room, which was dominantly rectilinear in style, the new Cloister Room made a great play on curves, both in line and surface treatment. The height of the ceiling was reduced by introducing a fibrous plaster barrel vault, decorated with raised panels imitating in low relief the waggon-chamfering used on the balusters at the Library of the School of Art. The chamfering was translated into a flat diaper pattern which was stencilled on the walls in long ribbons, each diaper painted red, green, or blue and outlined in black. The walls were covered with smooth, waxed timber. This was arranged in a series of superimposed panels, each smaller than that beneath, making a shallow projection out into the room. A diaper pattern was continued around each panel, imitating the superimposed orders of a Romanesque doorway. At the east end of the room, Mackintosh retained the screen designed in 1900; opposite this, the wall was divided into narrow panels with a central concave niche of mirror-glass. On either side of the central niche were smaller niches each with a tracery in wood of distinctly Chinese appearance. Above the central niche was an elaborate canopy made of strips of wood, each with its leading edge scalloped or chamfered; the strips were so arranged one above the other that the concave scallops contrasted with convex chamfering in adjacent pieces, and each one projected in front of the other to produce an overhanging canopy; this was repeated over the door.

The room was one of the most mysterious ever designed by Mackintosh, as moodily atmospheric as the rooms at the Willow Tea Rooms in Sauchiehall Street are light and airy. It was his last major work in Glasgow before World War I; the themes and motifs used in it were taken up again at 78 Derngate in 1916.

Literature: Howarth, pp. 134–35, plate 51c.

1911.D　The Cloister Room, Ingram Street Tea Rooms, Glasgow

Photographed in 1971; the panels of leaded-glass on the floor at the left are not by Mackintosh.

Collection: Eric Thorburn, Glasgow.

1912.1　Garden seat for The Hill House, Helensburgh

Pine, stained dark　89.6 × 203 × 58cm.
William Jack quoted various prices: full length, teak £9.15.6d., pine £7.5.0d.; ¾ length, teak £7.15.6d., pine £5.5.0d.; ½ length, teak £5.15.0d., pine £4.7.6d. Payment was possibly included in the sum of £29.10.4½d. for 'joiner work' (6 November, 1912).

Collection: *in situ* (RIAS).

1912.2　Garden table for The Hill House, Helensburgh

William Jack quoted for one at £3.7.6d. in teak, or £2.5.0d. in red pine; payment was possibly included in the sum of £29.10.4½d. for 'joiner work' (6 November, 1912).

If made, this was presumably intended to match 1912.1.

Collection: untraced.

1912.3　Table

Mahogany　71.4 × 83.8 × 83.8cm.

Commissioned by William Douglas, who requested that it be made of mahogany, a timber rarely used by Mackintosh. The corner legs are set on the diagonal and twin stretchers span opposite pairs. These stretchers spread apart towards the centre, enclosing another four legs placed at mid-point between the corner legs and the centre of the table. From each stretcher, midway between this inner leg

1911.D▽

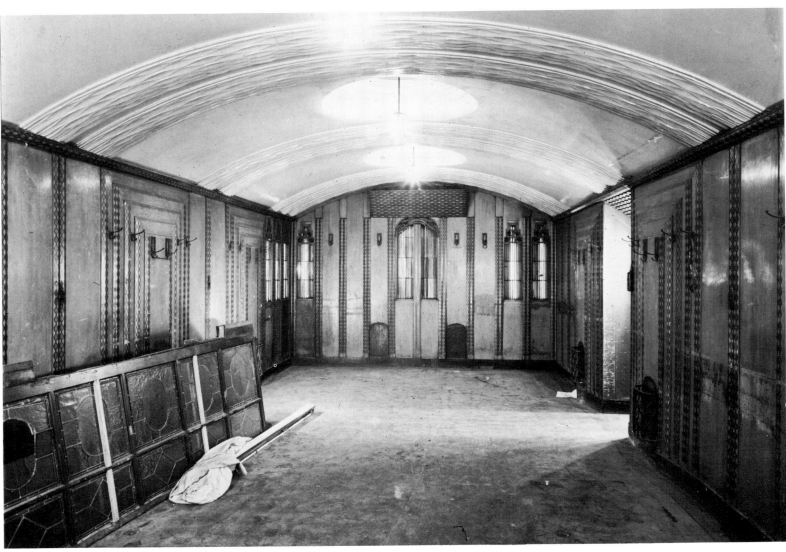

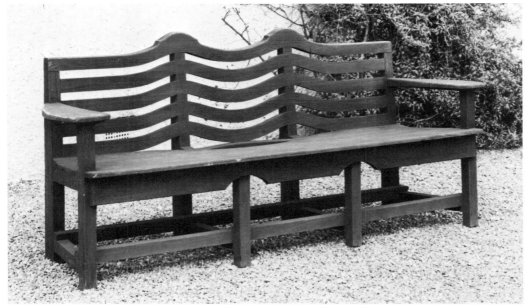

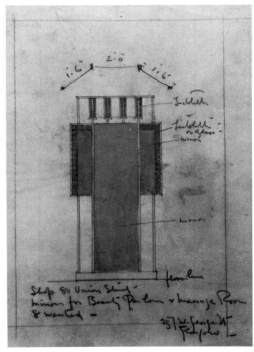

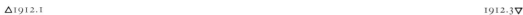

△1912.1

1912.3▽

△D1912.4

D1912.5▽

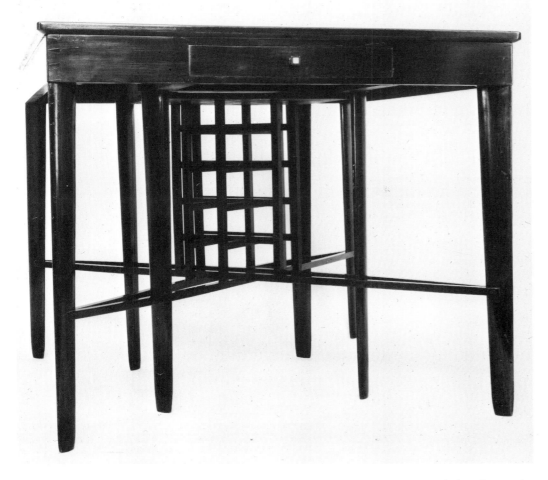

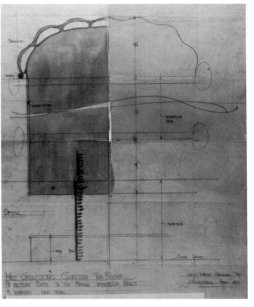

and the centre of the table, rise two spars; these are connected by a series of horizontal spars, which form a three-dimensional lattice in the centre of the table. It is one of Mackintosh's most complicated spatial constructions and one of his most elegant.

Exhibited: Edinburgh, 1968 (268).
Provenance: William Douglas; acquired from his family by the present owner in 1967.
Private collection.

D1912.4 Design for full length mirror for hairdressers, 80 Union Street, Glasgow
Pencil and watercolour on tracing paper 28.6 × 21.8cm.
Inscribed, below, *Shop 80 Union Street | Mirrors for Beauty Parlour & Massage Room | 8 wanted*, and, lower right, *257 W. George St | Glasgow.*
Scale, 1:16.

This is the only surviving design for furniture for this commission—from a Mr Ritchie—

although several architectural drawings exist (collection: Glasgow University); one of these is dated April 1912. Little is known of the design, which was executed but has long since disappeared. This mirror is very similar to that designed for the Dresdener Werkstätten (1903.87), but more important is a note in Mackintosh's hand about its construction. The inlaid decoration is described as 'Lactolith or glass' the earliest surviving documentary evidence of Mackintosh's use of plastics as decorative inlay. He had in fact used a plastic in 1911 in the Chinese Room panelling, but no drawings survive for that job and there is no mention of the materials used in the firm's records. Tests have shown that the plastic used there was a by-product of casein, probably a German plastic called Galalith, but here Mackintosh specifically mentions a substance he knew as Lactolith. The author has been unable to trace this material; it was almost certainly of the same chemical composition as Galalith, and it may be that

Lactolith was simply the British trade name for the same product.

Exhibited: Edinburgh, 1968 (169 (b)).
Provenance: Mackintosh Estate.
Collection: Glasgow University.

D1912.5 Design for a wall protection plate behind umbrella rails for the Cloister Room, Ingram Street Tea Rooms, Glasgow
Pencil and watercolour on tracing paper 68.4 × 50.9cm.
Inscribed and dated, lower right, *257 WEST GEORGE ST | GLASGOW, APRIL 1912.*; and inscribed, upper right, *DRAWING NO 23*, and, lower left, *MISS CRANSTON'S CLOISTER TEA ROOM. | PROTECTION PLATE TO GO BEHIND UMBRELLA RAILS | 8 WANTED LIKE THIS | PRICE TO BE GIVEN FOR COPPER AND BLACK IRON*; and various other notes.
Scale, full size.

The umbrella stands in the Cloister Room were simple wrought-iron structures, like baskets, which were fastened to the wooden walls; these plates were attached to the walls inside the baskets to prevent umbrellas and sticks damaging the waxed timber as they were placed in or taken out of the stand.

Provenance: Mackintosh Estate.
Collection: Glasgow University.

1915–20 Mackintosh in Northampton and Glasgow

After leaving Glasgow in 1914, the Mackintoshes settled in Walberswick. For about a year Mackintosh spent his time painting watercolour studies of flowers, and he began to develop a new style of landscape painting in the hope of making a living as an artist. It is said that he had hoped to go to Vienna, but the War prevented his departure; eventually he and his wife decided to settle in London, where they rented studios in Glebe Place, Chelsea. Mackintosh received a number of commissions from friends and neighbours in Chelsea for studios, a block of studio–flats, and even a theatre, but most of these proved abortive; none of the executed commissions appears to have contained any significant interiors or furniture. One client from outside London, however, provided Mackintosh with the opportunity to recapture the flair of 1900–07 in a series of interiors for houses in and around Northampton.

This was Mr W. J. Bassett-Lowke, a manufacturer of scale models and one of the early members of the Design & Industries Association. He was recommended by an unknown friend to use Mackintosh: in a series of notes dated 22 August, 1939 (Glasgow University) he wrote '. . . during a holiday in Cornwall I met a friend from Glasgow who held forth to me on the merits of the artist architect Chas. Rennie Mackintosh'. His search for Mackintosh evidently took him to Glasgow, because Mrs Newbery Sturrock remembers him staying with or visiting the Newberys. This was after the outbreak of war; Bassett-Lowke probably made contact with Mackintosh towards the end of 1915. The most important of the Northampton projects was the renovation of a small terraced house in the centre of the town, 78 Derngate, which Bassett-Lowke intended to move into after his marriage in 1917. Although by no means as big a job as The Hill House or the renovations at Hous'hill, it offered a considerable challenge to Mackintosh: not only the personal one of whether he could again carry through such a commission, but also the challenge of working within such tight confines and of producing a design to manipulate the available space and impose on it his complete aesthetic control. Basset-Lowke proved a demanding client, perhaps more knowledgeable in the field of design than any of his other clients. He was certainly unlike the others in one major respect: his house and later his country cottage, were to contain furniture designed by the client as well as by the architect; he was not afraid to make specific, as well as more sweeping, criticisms of the architect's proposals and it says much for Mackintosh that he was able to leave so strong an aesthetic imprint on so small a job for such a demanding client.

1916 78 Derngate, Northampton*

At the time he made contact with Mackintosh, Bassett-Lowke was living with his parents in Northampton. He had acquired 78 Derngate as a home for himself and his bride, Miss Jones, whom he was to marry in March 1917. It was brick-built, with three floors facing the street and, because of the steeply sloping site, a lower floor at garden level. A photograph survives of the house before conversion, showing Mackintosh's pencilled intentions (1916.A). These were the additions of a bay window, about two metres wide; the insertion of a small window for the lavatory in the existing blind recess; a new window, the same size as the existing one, for the new first-floor bathroom; and a new front door and dead-light, although the existing architraves were not altered. At the back of the house the alterations were more spectacular and, as Howarth has pointed out (p. 200), the finished elevation pre-dates any other modern movement work in Britain. An extension almost the full width of the house was built, about 1.3 metres deep and three storeys high, providing the top-floor bedroom (the third floor on this elevation) with an open balcony, the main bedroom with an enclosed balcony, and the dining-room and basement kitchen with much needed extra space. The whole of the rear wall of the house and this extension were finished in white cement; with its sharp angles, broad openings and the use of sun blinds it seems very prophetic of the International Style (1916.C).

Internally, the major alteration was the re-location of the staircase. Originally, the front door opened into a narrow hall with the staircase on the left, severely restricting the size of the parlour. Mackintosh placed a new staircase parallel to the dividing wall between front and back rooms, thus increasing the size of the hall. The front door then opened straight into the new hall-parlour which Mackintosh originally intended to screen with a curtain. Bassett-Lowke, in a letter to him of 31 July, 1916 (the day he gained possession of the house), suggested that the door be rehinged to open flat against the wall, and a folding screen be substituted for the curtain; Mackintosh seems to have readily concurred, but the screen cannot now be traced (see 1916.D). The new front door was painted black, with panels of leaded-glass displaying a triangle motif; above it the dead-light was surrounded by a miniature version of the stepped architrave of the door in the west elevation of the Glasgow School of Art.

Black paint and triangles were the keynote of the new hall. All the furniture was black, and the walls were black, relieved only by a chequered band of black and

△1916.A

1916.B▽

1916.C▽

1916.A 78 Derngate, Northampton — street elevation

A photograph showing the street elevation before alterations. Mackintosh has pencilled in the alterations he intended to make to the windows.

Collection: Glasgow University.

*See addenda

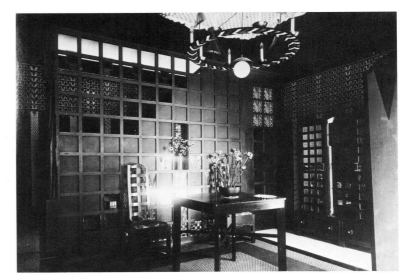

△1916.D 1916.F▽ △1916.E 1916.G▽

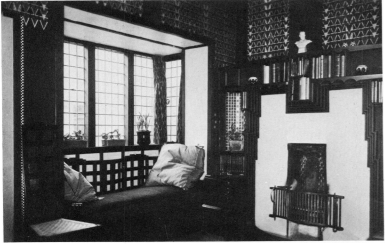
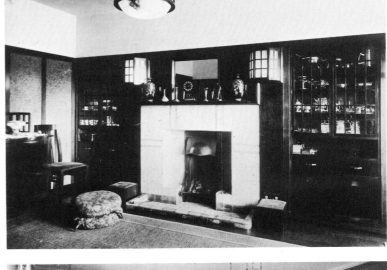

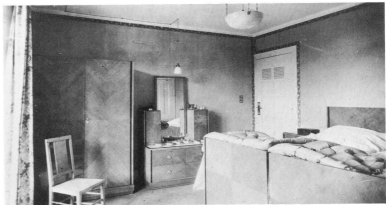

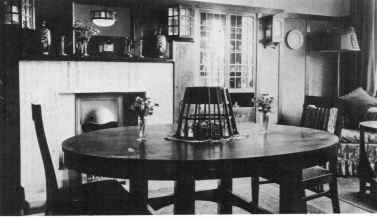

△1916.H

1916.I△

1916.B 78 Derngate, Northampton — street elevation
Taken after the work was completed in 1917. Mrs Bassett-Lowke is standing in the doorway.

Collection: Glasgow University.

1916.C 78 Derngate, Northampton — garden elevation

Collection: Glasgow University.

1916.D Hall at 78 Derngate, Northampton
The photograph shows a Bassett-Lowke family party, but is also the only illustration of the door screen fully extended. The curtains are made from material designed by Mackintosh.

Collection: Glasgow University.

1916.E Hall at 78 Derngate, Northampton
Looking towards the staircase screen with the

door to the dining-room in the far corner. The untraced table (1916.15) is in the foreground.

Collection: Glasgow University.

1916.F Hall at 78 Derngate, Northampton

Collection: Glasgow University.

1916.G Dining-room, 78 Derngate Northampton

Collection: Glasgow University.

1916.H Dining-room, 78 Derngate, Northampton
This photograph shows the table lamp (1916. 33) and the standard lamp (1916.32), both of which have disappeared.

Collection: Glasgow University.

1916.I Main bedroom, 78 Derngate, Northampton

Collection: Glasgow University

white squares; but above this band, forming a frieze around the room, was a stencilled pattern consisting of overlaid triangles in yellow, grey, vermilion, blue, emerald green and purple. Even the ceiling was black, and the carpet a pattern of black and grey. The triangle motif also appeared in the lattice screen, in panels of leaded-glass placed in the lattice at random; some other panels were open, some solid wood, a motif Mackintosh had used in the Chinese Room at the Ingram Street Tea Rooms in 1911, and earlier in the stand for Wilkinson, Heywood & Clark in 1906. The furniture in the room was also based on the lattice square,

△1916.J

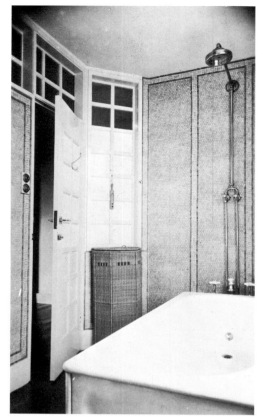

1916.K ▷

although the smoking cabinet (1916.16) was decorated with triangles, as was the door screen. The fireplace, a black wooden mantel around a cement render with a simple wrought-iron grate, again echoed the west front of the School of Art with its stepped outline. The lattice screen masked the flights of stairs up to the bedrooms and down to the kitchen.

Beyond it on the ground floor was the dining-room. Bassett-Lowke seems to have designed much of the movable furniture in here, including the tables, chairs, and sideboard, and a curious circular tea table with an inlaid top. Mackintosh seems to have been responsible for the decorations, the fittings, a table lamp and a standard lamp. The walls were divided into panels with walnut straps beneath a wide picture-rail; between the straps, Mackintosh used a dark wallpaper with a leaf and berry motif, the only instance known to the author of his use of patterned wallpaper, as opposed to stencilling. The ceiling and frieze were white. On either side of the fireplace he fitted cupboards, the upper sections glazed for crockery, the lower with drawers and shelves and pivoted boxes for wood and coal. The surround to the grate was tiled, introducing an oblong blue tile for pattern. All the woodwork was walnut, finished matt, with a large mirror over the fireplace and two lanterns, one at each side of the mirror. Howarth (p. 202) suggests a source for these in Josef Urban's work in Vienna, illustrated in an article in a *Studio* Special Number, 1906: 'The Art Revival in Austria'.

The main bedroom and bathroom occupied the first floor. French windows in the bedroom gave access to a covered verandah, open on the south and west with views over the garden. A photograph of this verandah (1916.J) shows it furnished with two wooden armchairs and a round table supported on four square legs with a square base, all painted white and all probably to Bassett-Lowke's design. The bedroom itself was wallpapered in grey, with no picture-rail but with a narrow mauve figured edging (*see* 1916.I). The woodwork was enamelled white, and Mackintosh designed the movable furniture in grey sycamore making extensive use of quartered panels, turning the direction of the grains to produce a pattern. A black inlay, about 2cm. wide, was used along the vertical edges of all the pieces, defining the outer dimensions of what is otherwise a very bland design. There is no record of how many items were designed for this room, but the surviving photograph (1916.I) shows twin beds, bedside tables, a dressing-table and a wardrobe as well as a chair (probably not to Mackintosh's design). A wash-stand was not required, because the room had a fitted basin; the only other likely item would have been a dressing mirror, but there is no trace of any such item. Indeed, none of the furniture for this main bedroom seems to have survived.

The staircase from first to second floors continued the lattice theme, but here Mackintosh used white paint. All the square panels were open to admit light, with the exception of those at the ends of the treads (1916.L). The cupboard doors, and the bathroom wall and door all repeated the lattice motif, the upper two rows of the bathroom wall being glazed to provide borrowed light for the stairwell. Bassett-Lowke was proud of his technologically advanced bathroom; he wrote '. . . the bathroom is finished in enamel and imitation mosaic paper. The equipment is entirely American and most modern in character, including as it does a Kohler Bath and Pedestal Wash Basin with nickel fittings, drying cupboard and such labour saving devices as glass shelves, etc.'

1916.L △

1916.J Main bedroom verandah, 78 Derngate, Northampton
The furniture was designed by W. J. Bassett-Lowke.

Collection: Glasgow University.

1916.K Bathroom, 78 Derngate, Northampton

Collection: Glasgow University.

1916.L Staircase from first to second floor, 78 Derngate, Northampton

Collection: Glasgow University.

D1916.1 Design for the entrance door to 78 Derngate, Northampton
Pencil and watercolour 39.2 × 26.9cm. (irregular).
Inscribed, lower left, *Elevation | J. Bassett-Lowke Esqr Northampton | Scale drawing of Entrance Door—*; verso, *BASSETT LOWKE*.
Scale, 1:12.

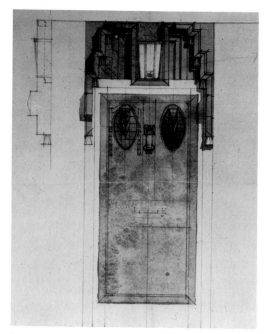

△DI916.1

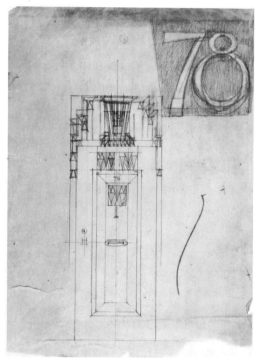

△DI916.2 DI916.3▷

A preliminary study: although the stepped moulding around the dead-light is very close to the final design, the arrangement of the central light is different here; the two oval panels of leaded-glass with their chevron patterns were replaced by three square panels based on a triangle motif. The door is inexplicably given the number 16.

Exhibited: Edinburgh, 1968 (170a).
Provenance: Mackintosh Estate.
Collection: Glasgow University.

DI916.2 Design for the entrance door, 78 Derngate, Northampton

Pencil and watercolour on tracing paper 32.5 × 22.2cm. (irregular).
Scale, 1:12.

A scrappy drawing showing alterations to the dead-light and its lamp, but otherwise as executed. The drawing obviously post-dates Bassett-Lowke's letter to Mackintosh of 31 July, 1916 (Glasgow University) where he suggests that the door be re-hung on the right, as shown here, to accommodate a draught screen. The door is still *in situ* and a spare panel of leaded-glass is at Glasgow University.

Provenance: Mackintosh Estate.
Collection: Glasgow University.

On the top floor was the guest bedroom, but this did not originally contain the furniture and decorations shown in the illustrations in *Ideal Home* and repeated since by all writers on Derngate. According to Mrs Cutting, a niece of Mrs W. J. Bassett-Lowke, the guest bedroom was originally furnished in mahogany inlaid with mother-of-pearl. This suite was *in situ* early in 1919 before she went away to boarding school; in 1925 she stayed with the Bassett-Lowkes again (shortly before their move to New Ways) and by this time the oak furniture had been installed. In fact, the oak suite must have been made towards the end of 1919, or early in 1920, as it was illustrated in *Ideal Home* in 1920. McLaren Young was told of such a mahogany suite by Mrs Bassett-Lowke (ms. collection: Glasgow University), but his notes imply that it was made for her husband before he married and while he was still living at his parents' house. She said that he had sold it to a local furniture dealer, Mr Cave, when they moved to New Ways because there was no space for it there. It seems likely that she was slightly confused about this suite, as the only dated drawing for it is of September 1917, after they had moved into Derngate; if the oak suite had been designed in 1916–17, there certainly would have been no space for this mahogany furniture in that tiny house. The likelihood, therefore, is that the mahogany suite was designed first (it is certainly more in keeping with the main bedroom furniture) and that it was replaced *c*1919–20 by the oak furniture. Mr Cave left the original suite to his daughter (also a dealer) who sold it without recording the name of the new owner.

Stylistically, the mahogany furniture has much in common with the main bedroom designs. It relies for its effect upon broad unmodelled planes of timber, relieved by mother-of-pearl or aluminium inlay rather than the black edging applied to the perimeter of the sycamore pieces. It is also very similar in mass and outline to items designed for the main bedroom. Even the decorations appear to have been similar: D.1917.21 shows a figured wallpaper with a stencilled vertical border in the corners of the room.

No photographs of the original guest bedroom survive, but the furniture was probably laid out in a similar way to that adopted in 1919. Photographs of an

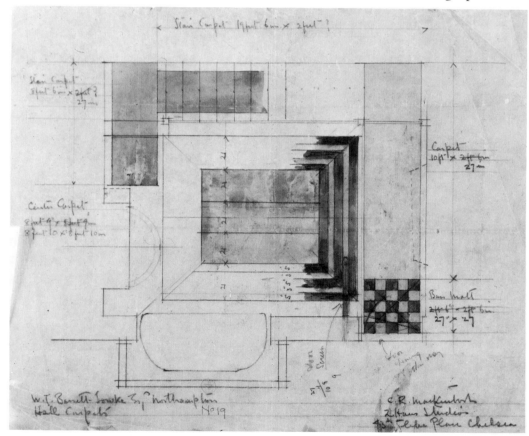

DI916.3 Design for carpets for the hall, 78 Derngate, Northampton

Pencil and watercolour on tracing paper 31 × 26cm.

Signed and inscribed, lower right, *C. R. Mackintosh | 2 Hans Studios | 43A Glebe Place Chelsea*; inscribed, lower right, *W. J. Bassett-Lowke Esqr Northampton | Hall Carpets No 19*; and with various notes and measurements, and comments by Bassett-Lowke.
Scale, 1:12.

The arrangement of the carpets was changed slightly from that shown here, but the principle

of a checked square in the centre surrounded by black bands was adhered to. Bassett-Lowke wrote on 31 July, 1916 (collection: Glasgow University) suggesting that different widths should be used on the stair carpet, and Mackintosh has deleted '2 feet' and substituted '27 ins.', not 21 ins. as suggested by the client. Bassett-Lowke, in the same letter, suggested re-hanging the front door so that it opened against the wall; he drew this over Mackintosh's design, and also sketched in the position of a draught screen by the door.

Provenance: Mackintosh Estate.
Collection: Glasgow University.

identical suite made for Bassett-Lowke's friend, Sidney Horstmann, for his house in Bath confirm this (*see* 1917.A–C). Perhaps Mackintosh also used the more elaborate stencilling seen in the Bath commission at Derngate, but all the decorations were obliterated by the new scheme in 1919. The Horstmann furniture was reputedly made by German craftsmen interned as enemy aliens on the Isle of Man, and the Derngate furniture probably came from the same source. The drawing, D1917.21, also suggests that the furniture for Derngate was not designed until some months after the Bassett-Lowkes moved into the house in the spring of 1917.

Pevsner considered Mackintosh's work at Derngate mannered, but that criticism surely cannot be justified. Mackintosh seems to have wanted to break with his Glasgow style, and even with that of the School of Art Library or the Chinese Room, and this was his first attempt—just as *Anemones* and *Begonias* were to be the first stages in his new career as a watercolourist. Derngate anticipated the work of the next decade in Europe; it surpassed most of the designs of the 1920s and equalled the best of them but, sadly, there was little to follow it. The other Northampton commissions were slight and of Mackintosh's last major interior work, The Dug-Out in the Willow Tea Rooms in Glasgow, nothing survives other than a few pieces of furniture. Many people find the later work heavy and uncharacteristic of the Mackintosh they know best, that of 1900–05. In fact, he was returning to some of the ideas he first developed at Argyle Street: broad planes and natural timber, but with the heaviness replaced by careful geometrical motifs to emphasise the simple shapes of the furniture and, on occasions, to give it a bold, bright impact. The interiors and furniture at Derngate should not be regarded as the culmination of a fine career—they were only the start, in a man not yet 50, of a new one.

Literature: *Ideal Home*, August 1920, pp. 53–55 and September 1920, pp. 92–95; Howarth, pp. 199–204, plates 76c, 77; Pevsner, 1968, p. 172, plates 51, 55.

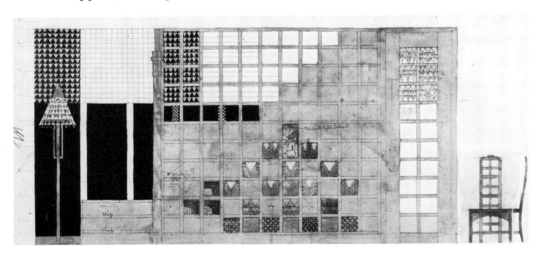

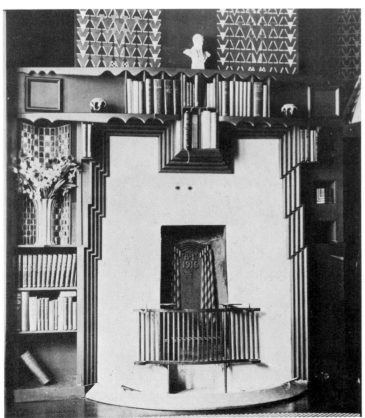

◁1916.7 D1916.6△

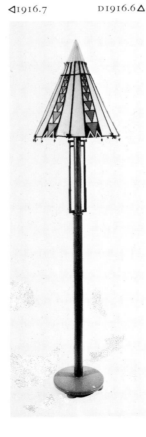

◁1916.5

1916.4 Staircase screen and newel post for the hall, 78 Derngate, Northampton
Wood, painted black, with panels of leaded-glass 264 × 264cm.

Mackintosh re-located the staircase across the middle of the house and hid both up and down flights behind this lattice screen. At the right-hand side, the lattice-work is fitted at the top with leaded-glass panels and the lower panels formed a door to the dining-room. At the left, a spirally-carved newel post determines the end of the screen; all the panels adjacent to it are solid. As the staircase climbs, however, the lattice is left open, emphasising the square spars. The rest of the screen is a more or less random arrangement of panels of leaded-glass contrasting with solid panels of timber. The glazed panels, using motifs of squares or triangles, are not merely decorative, but provide daylight to the flight of stairs behind which descends to the kitchen and garden. Mackintosh had used lattice-work in considerable quantities at the Chinese Room in Ingram Street, again contrasting leaded panels (of plastic as well as glass) with solid timber. Here he introduced voids as a third option, and even shallow shelves with a beaded frame as yet another. (See 1916.E.)

Literature: *Ideal Home*, August 1920, p. 54; Howarth, p. 201, plate 77; Pevsner, 1968, plate 53.
Exhibited: Edinburgh, 1968 (276).
Collection: *in situ* (but repainted).

1916.5 Lamp standard and shade for 78 Derngate, Northampton
Standard, walnut, height 170.2cm; shade, silk on metal frame, 55.8 × 45.5cm. (diameter).

The silk shade is a recent reconstruction carried out by a colleague of T. Osborne Robinson. Walnut was used extensively in the dining-room, and this was the only piece of furniture in the hall not painted black. The rods which protrude from the stem of the lamps and then run parallel with its upper part recall the metal rods on the Mains Street dining-room fireplace, which have a similar decorative function on the two posts flanking the mantelpiece.

Literature: Howarth, plate 77; Pevsner, 1968, plate 53.
Exhibited: Edinburgh, 1968 (271).
Provenance: W. J. Bassett-Lowke; his widow, by whom presented.
Collection: Northampton Museum.

D1916.6 Design for the staircase screen in the hall, 78 Derngate, Northampton
Pencil and watercolour 34.3 × 51.6cm.
Inscribed, lower left, *J Bassett-Lowke Esq Northampton | Scale drawing of Staircase Screen in Hall No 11*, and, lower left, *2 Hans Studios | 43A Glebe Place | Chelsea*; and various other notes and measurements.
Scale, 1:12.

Virtually as executed, showing an early stage of the stencilled decoration.

Literature: Alison, p. 82, no 44.
Exhibited: Edinburgh, 1968 (170b); Milan, 1973 (44).
Provenance: Mackintosh Estate.
Collection: Glasgow University.

1916.7 Fireplace for the hall, 78 Derngate, Northampton
Wood, painted black.

The grate is a simple wrought-iron fitting, similar to the earlier grates designed by Mack-

intosh and was provided with its own fire irons (private collection). The wooden mantelpiece has a stepped, moulded pattern which has its antecedents in the west door of the Glasgow School of Art, but more immediately is an enlarged version of the original design for the dead-light at the front door (D1916.1). The cubic recesses, the curved niche, and the wavy pattern of the upper shelves are all favourite fireplace motifs brought up to date.

Literature: *Ideal Home*, August 1920, p. 54; Howarth, plate 77; Pevsner, 1968, plate 52; Macleod, plate 107.
Collection: *in situ*.

D1916.8 Design for the fireplace and coat-press for the front hall of 78 Derngate, Northampton
Pencil and watercolour 37.2 × 53 (irregular). Scale, 1:12.

The fireplace is virtually as executed, but the decorative painting or panel above it was never installed. It was probably intended to represent a gesso panel, perhaps one by Margaret; these had been used over the drawing-room fireplace at The Hill House and in the studio at 78 South-park Avenue. This tiny watercolour representation of the panel is painted on a separate piece of paper which has been stuck on to the drawing, so it is possibly Margaret's own work.

The coat-press was altered in detail from the design shown here. The main change was the inclusion of a clock in the centre and the substitution of the long sneck-type latches on the two doors.

Exhibited: Edinburgh, 1968 (170c).
Provenance: Mackintosh Estate.
Collection: Glasgow University.

1916.9 Cabinet for the hall, 78 Derngate, Northampton
Wood, painted black 177.8 × 156.2 × 27cm.

The lattice theme was repeated here on a smaller scale, but the mirrors, by reflecting the the rest of the hall, made this tiny room seem that much larger.

▽1916.9

Literature: *Ideal Home*, August 1920, p. 54; Pevsner, 1968, plate 54.
Provenance: W. J. Bassett-Lowke; his widow, by whom presented.
Collection: Victoria & Albert Museum, London.

D1916.10 Design for a cabinet and chair for the hall, 78 Derngate, Northampton
Pencil and watercolour 29.8 × 39.9cm.
Inscribed, lower left, *J. Bassett-Lowke Esqr Northampton / Scale drawing of cupboards for coats etc in Hall No 14* and, lower right, *2 Hans Studio / 43A Glebe Place / Chelsea*; and various other notes and measurements.

Scale, 1:12.

Virtually as executed; the door knobs seen on D1916.8 are still here, but a pencil alteration shows the curved bar on the right-hand door which Mackintosh used as a latch.

Literature: Alison, p. 82, no 43.
Exhibited: Milan, 1973 (43).
Provenance: Mackintosh Estate.
Collection: Glasgow University.

D1916.8 ▽

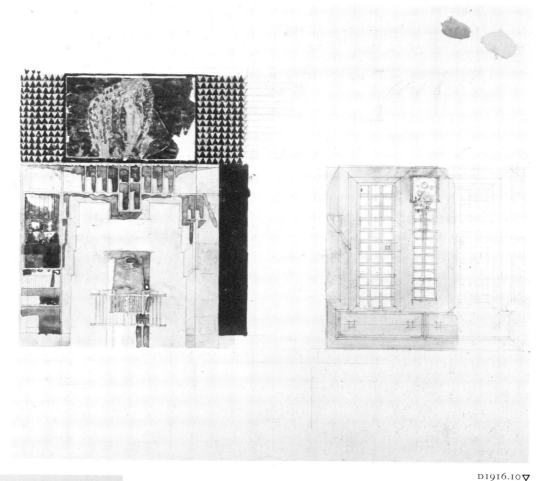

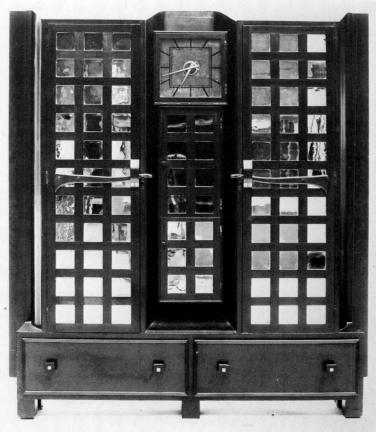

D1916.10▽

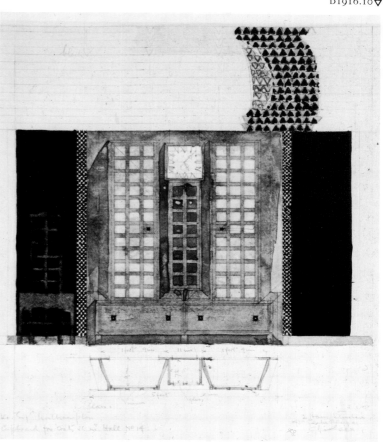

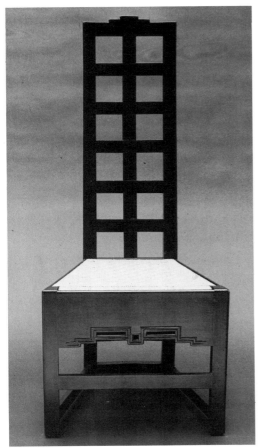

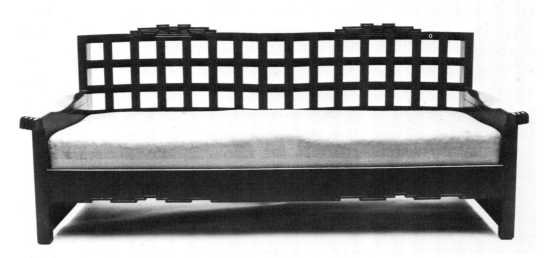

△1916.13

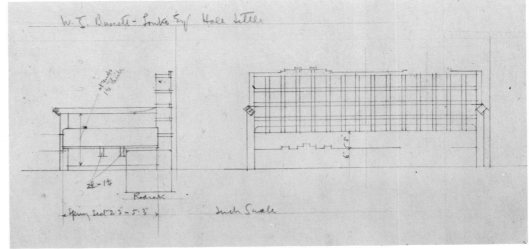

D1916.14▽

△1916.11

1916.11 Chair for the hall, 78 Derngate, Northampton

Ebonised wood 110.5 × 45.7 × 45.7cm.

The chair repeats the lattice theme used throughout the hall, but the curved profile of its back relieves the rigid geometry of the design. The top rail and the front apron rail are decorated with incised lines describing a ziggurat-like shape; this type of decoration appears in some of the Ingram Street chairs (1911.4) and some of the decorative wood-work in the Chinese Room. Four were made.

Literature: *Ideal Home*, August 1920, p. 54; Howarth, plate 77; Pevsner, 1968, plates 53, 54. Exhibited: Edinburgh, 1968 (270).
Provenance: W. J. Bassett-Lowke; his widow, by whom presented.
Collection: a) Northampton Museum (2); b) Victoria & Albert Museum (2).

1916.12 Hall screen, 78 Derngate, Northampton

Wood, painted black, with silk panels.

Bassett-Lowke asked Mackintosh to provide a screen for the door in a letter of 31 July, 1916 (Glasgow University); Mackintosh had originally suggested a curtain across the door to reduce draughts. This screen folded back against the wall between door and window bay and, when extended, formed a corridor between the main door and the dining-room door in front of the cabinet (*see* 1916.D). The screen appears to have been covered in purple material with an inverted triangle of yellow silk at the top of each of the four panels.

Literature: *Ideal Home*, August 1920, p. 54.
Collection: untraced.

1916.13 Settle for the hall, 78 Derngate, Northampton

Wood, painted black 77.5 × 182.8 × 77.5cm.

Designed to match the chairs, 1916.11, this settle has the same lattice pattern, decorated top-rails and front apron. The radiator for the hall was hidden in the bay window beneath the seat. Loose cushions, upholstered in petunia to match the screen were used on the settle.

Literature: *Ideal Home*, August 1920, p. 54.
Provenance: W. J. Bassett-Lowke; his widow, by whom presented.
Collection: Victoria & Albert Museum, London.

D1916.14 Design for a hall settle for 78 Derngate, Northampton

Pencil on tracing paper 26.9 × 39.5cm. (irregular).
Inscribed, upper left, *W. J. Bassett-Lowke Esqr Hall Settle*; and various notes and measurements.
Scale, 1:12.

An early sketch for the settle, 1916.13, showing the position of the radiator in the bay window.

Provenance: Mackintosh Estate.
Collection: Glasgow University.

1916.15 Square tea table for the hall, 78 Derngate, Northampton

Wood, painted black.

The design is similar to other tables such as 1904.72 and 1905.19, where diagonally placed legs and paired stretchers are used. Inserts between the latter formed a repetitive square pattern along the length of the stretchers. (*See* 1916.E).

Literature: *Ideal Home*, August 1920, p. 54; Pevsner, 1968, plate 54.
Collection: untraced.

1916.16 Smoker's cabinet for 78 Derngate, Northampton

Wood, painted black, with plastic inlay 59 × 33 × 58.4cm.

Bassett-Lowke made a passing reference to a 'cigarette box' in a letter to Mackintosh of 2 November, 1916 (Glasgow University). In a later letter, 12 January, 1917, he asked Mackintosh in reply to some remark made by the

latter in untraced correspondence—whether he had thought of using Erinoid as a decorative inlay in furniture. Mackintosh had, in fact, used a similar casein-based plastic at the Chinese Room in Glasgow and must have mentioned it to Bassett-Lowke, possibly in connection with the design of this piece or the door screen (1916.12). As the material used at Glasgow was probably German in origin, Mackintosh may have mentioned to his client that he would have liked to use it again, because in Bassett-Lowke's January letter he says, 'I presume the material you mention is similar to Erinoid which is now made in England and which I can obtain in almost any colour, an unpolished sample of which I enclose'. Because of the War, the German supplies of this plastic would have

1916.16▽

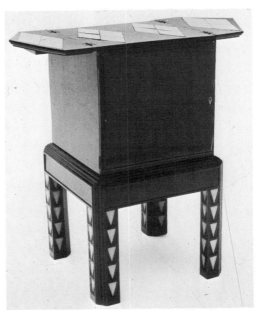

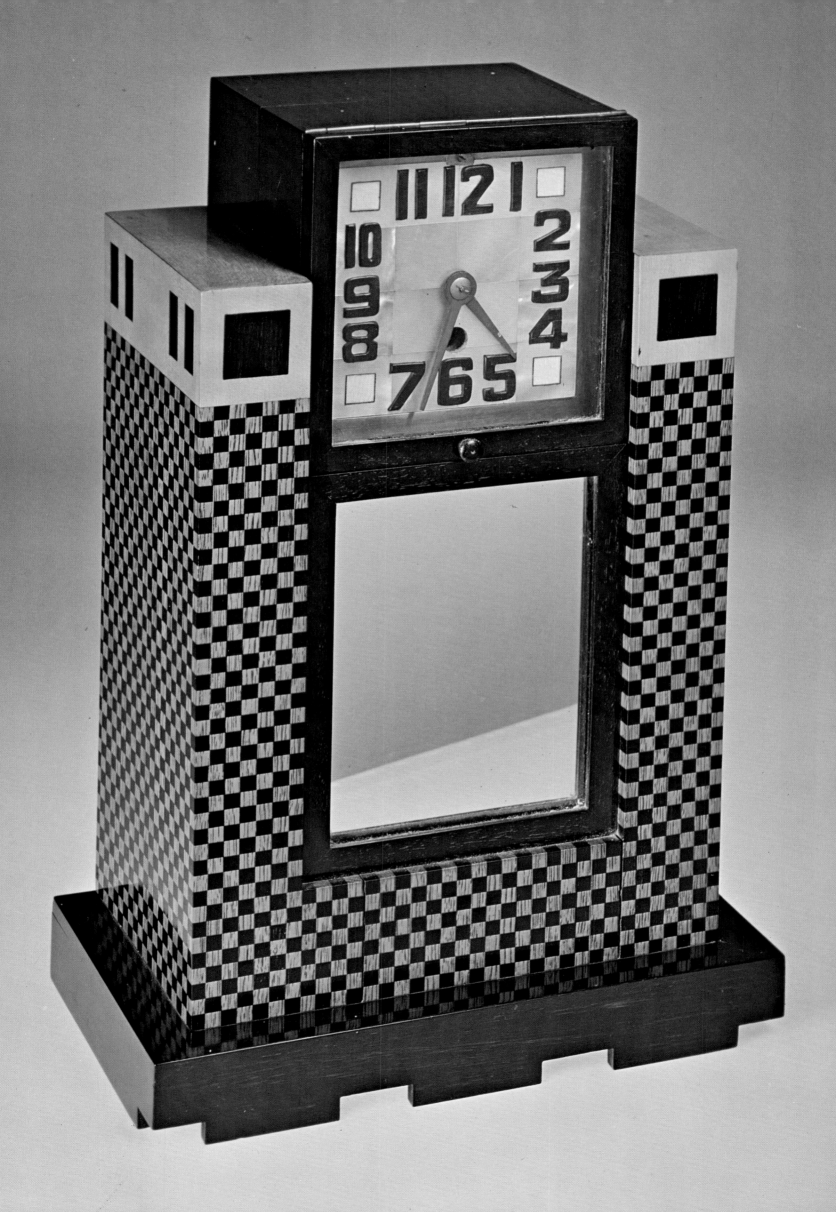

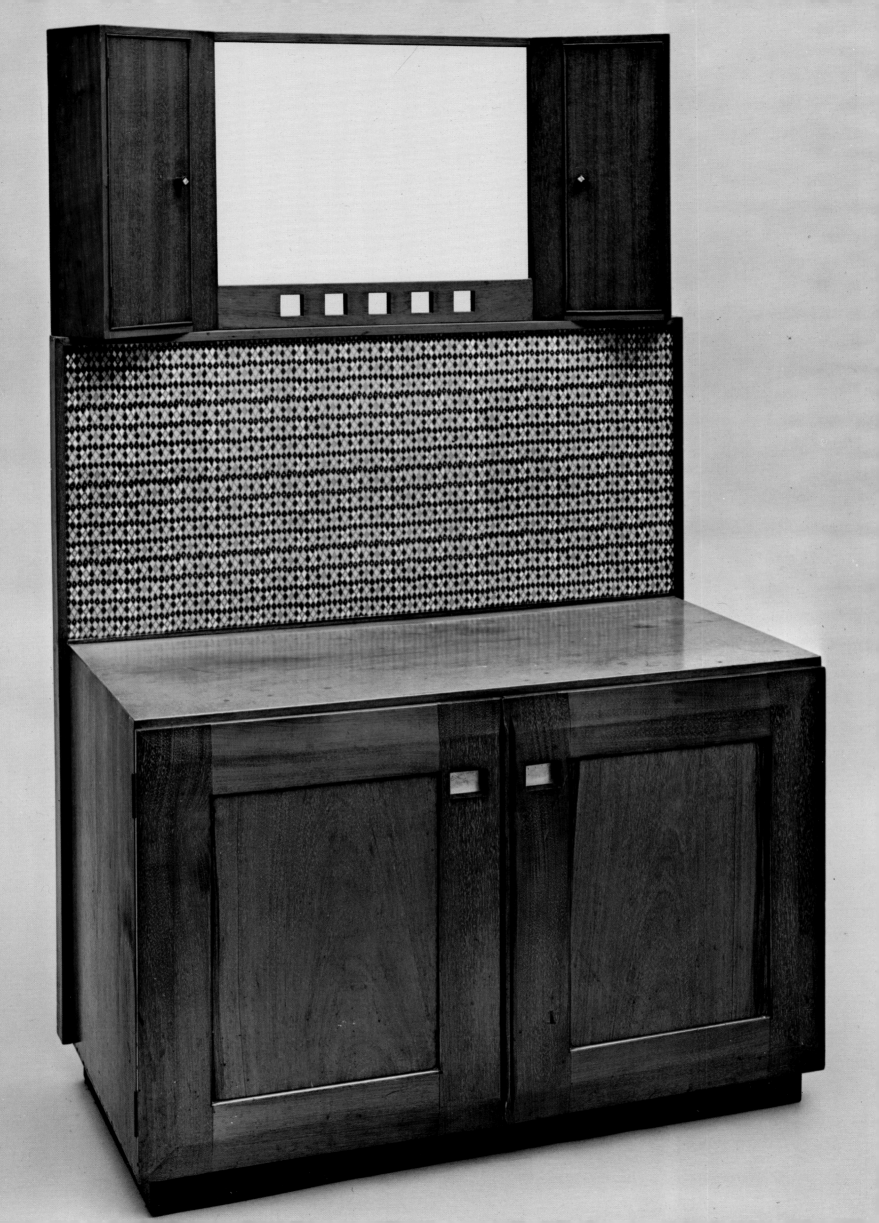

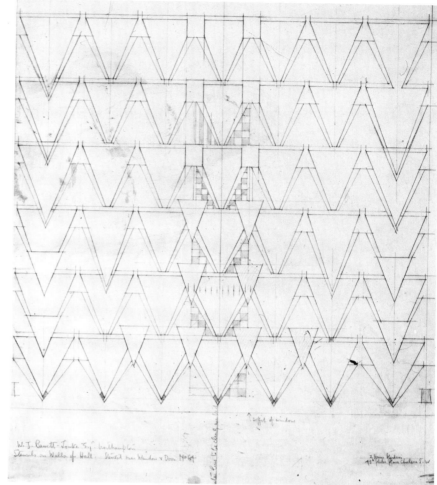

△D1916.18 ▽D1916.20 D1916.21▷

D1916.19△

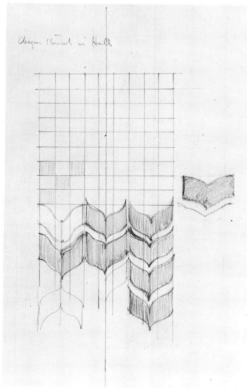

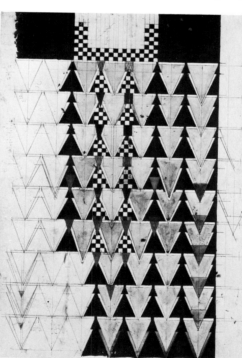

D1916.19 Design for stencil decoration over window and door in the hall. 78 Derngate, Northampton
Pencil 61.6 × 56.5cm.
Inscribed, lower left, *W. J. Bassett-Lowke Esqr. Northampton / Stencils on Walls of Hall. Stencil over Window & Door No 64* and, lower right, *2 Hans Studios / 43A Glebe Place Chelsea S.W.*; and various notes and measurements.
Scale, full size.

Provenance: Mackintosh Estate.
Collection: Glasgow University.

D1916.20 Design for wall decoration of the hall, 78 Derngate, Northampton
Pencil on paper 28 × 19.1cm.
Inscribed, upper left, *chequer stencil in Hall.*

This pattern seems closer to the chevron stalk used at Derngate in 1920 (*see* D1920.11), but the inscription and the width of the panel seem to relate to the black and white chequerwork used in 1916. Presumably, this is a very early sketch which Mackintosh coincidentally returned to in 1920.

Provenance: Mackintosh Estate.
Collection: Glasgow University.

D1916.21 Design for a stencil for the hall, 78 Derngate, Northampton
Pencil and watercolour 80 × 56.5cm.
Scale, full size.

A full-sized printing of all the stencils as a trial before the final application to the walls at 78 Derngate.

Provenance: W. J. Bassett-Lowke; T. Osborne Robinson, by whom presented.
Collection: Glasgow University.

D1916.22 Design for stencils for the hall, 78 Derngate, Northampton
Pencil 78.5 × 52.5cm.
Inscribed, upper left, *W. J. Bassett-Lowke Esq Northampton / Stencils for Walls of Hall / Stencil*

ceased and Mackintosh was probably unaware of its recent production in England under the name 'Erinoid', so the credit of re-introducing it to him is almost certainly due to Bassett-Lowke.

Literature: *Ideal Home*, August 1920, p. 54; Pevsner, 1968, plate 50; Macleod, plate 107.
Exhibited: Bethnal Green Museum, London, '50 Years of Modern Design', 1966; Edinburgh, 1968 (269).
Provenance: W. J. Bassett-Lowke; his widow, by whom presented.
Collection: Victoria & Albert Museum, London.

D1916.17 Design for a curtain for the hall windows, 78 Derngate, Northampton
Approx. 15.2 × 15.2cm.

This drawing has not been available for photography and the author has not seen it.

Exhibited: Toronto, 1967 (94).
Collection: Dr Thomas Howarth.

D1916.18 Design for stencil decoration over the fireplace in the hall, 78 Derngate, Northampton
Pencil 79 × 54.7cm.
Inscribed with various notes and measurements; verso, *W. J Bassett-Lowke / Northampton.*
Scale, full size.

Provenance: Mackintosh Estate.
Collection: Glasgow University.

◀1917.18

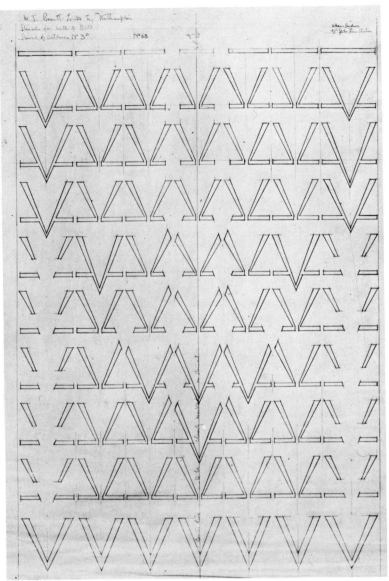

◁ D1916.22

D1916.23 △

◁ D1916.24

D1916.25 ▽

of outlines. No 3B; upper right, *2 Hans Studios | 43A Glebe Place Chelsea.*
Scale, full size.

Provenance: as D1916.21.
Collection: Glasgow University.

D1916.23 Design for a stencil for the hall, 78 Derngate, Northampton

Pencil 79 × 54cm.
Inscribed, right, *W. J. Bassett-Lowke Esq Northampton Stencils for Hall Walls | Stencil Plate No 3 Above fireplace and other parts of wall (see Scale drawing) No 63 All Yellow. | Note. 2 impressions should be made on stencil paper one for coloured shapes (3A Stencil) and one for outlines (3B Stencil).*
Scale, full size.

Provenance: as D1916.21.
Collection: Glasgow University.

D1916.24 Designs for a stencil for the hall, 78 Derngate, Northampton
Pencil 78.7 × 55cm.
Inscribed, lower left, *W. J. Bassett-Lowke Esq. Northampton | Stencils for Hall Walls. Stencil No 4 Over door and window. No 64 all Yellow |*

226

△D1916.26　　　　　△D1916.27　　　　　　　　D1916.29▽

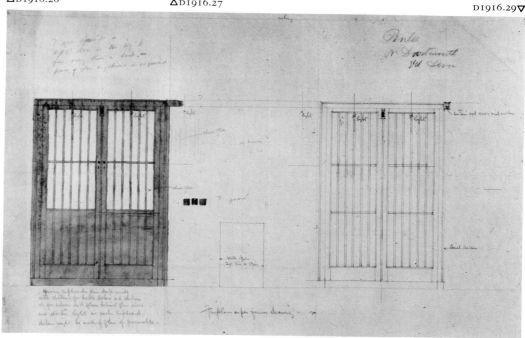

Note—2 impressions of this stencil should be made on stencil paper one for coloured shapes (stencil 4A) and one for outline (Stencil 4B).
Scale, full size.

Provenance: as D1916.21.
Collection: Glasgow University.

D1916.25　Design for stencils for the hall, 78 Derngate, Northampton

Pencil and watercolour　59 × 51.5cm.
Inscribed, lower left, *W. J. Bassett-Lowke Esq Northampton Stencils on Hall Walls | Stencils No 4A over door and above window No 65*; lower right, *2 Hans Studios | 43A Glebe Place Chelsea.*
Scale, full size.

Provenance: as D1916.21.
Collection: Glasgow University.

D1916.26　Design for stencils for the hall, 78 Derngate, Northampton

Pencil and watercolour　59.5 × 51cm.
Inscribed, lower left, *W. J. Bassett-Lowke Esq. Northampton Stencils for Walls of Hall | Stencil over door and windows. Stencil No 4B No 66*; lower right, *2 Hans Studios | 43A Glebe Place Chelsea SW.*
Scale, full size.

Provenance: as D1916.21.
Collection: Glasgow University.

D1916.27　Design for stencils for the hall, 78 Derngate, Northampton

Pencil and watercolour　78.2 × 52.5cm.
Inscribed, upper right, *W. J. Bassett-Lowke Esqr Northampton | Stencils for Walls of Hall | Stencil 3A coloured shapes No 67*; and *2 Hans Studios | 43A Glebe Place Chelsea.*

Provenance: as D1916.21.
Collection: Glasgow University.

1916.28　Fitted cabinets and fireplace for the dining-room, 78 Derngate, Northampton

Walnut.

Mackintosh designed these cupboards to fit into the original recesses on either side of the fireplace; by bringing them out flush with the grate and also bringing forward the frieze above them, he created a single plane, the line of which was continued in the extension to the dining-room. Walnut was not a common wood for Mackintosh to use, and it was probably chosen by the client. (*See* 1916.G & H).

Literature: *Ideal Home*, August 1920, p. 55.
Collection: *in situ.*

D1916.29　Design for the fireplace wall of the dining-room, 78 Derngate, Northampton

Pencil and watercolour　36.5 × 51.2cm.
Inscribed with various notes and measurements; also comments by Bassett-Lowke.
Scale, 1:12.

The earliest of the surviving drawings for the dining-room, but a note in Mackintosh's hand indicates that this is not the first design. The basic concept of cupboards flush with the fireplace and lanterns either side of the mirror are present even at this early date. Bassett-Lowke suggested doors two metres high would be too heavy to open every time some minor item was required; they disappear from later drawings.

Provenance: Mackintosh Estate.
Collection: Glasgow University.

D1916.30　Design for the fireplace wall of the dining-room, 78 Derngate, Northampton

Pencil and watercolour　31.5 × 50.7cm.
Inscribed with various notes and measurements; also several comments by Bassett-Lowke, including a sketch, verso.
Scale, 1:12.

On this drawing Mackintosh has substituted open shelves above closed cupboards for the tall glazed doors of D1916.29; Bassett-Lowke asked for glazed doors over the shelves. A mirror over the fireplace, flanked by two

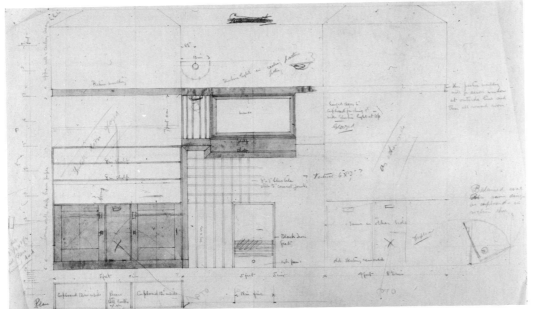

△DI916.30

DI916.31▽

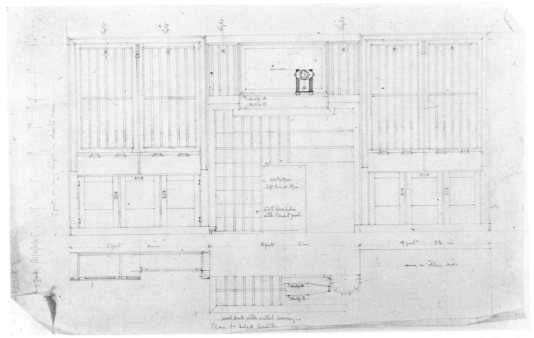

lanterns, is also shown in some detail. Howarth believed the final semi-hexagonal lanterns to be inspired by Josef Urban, but it is just as likely that the two semicircular lanterns shown here are simply a convex version of the curved-back niches which appear next to several of Mackintosh's fireplaces, including that in the hall at Derngate (1916.7).

Provenance: Mackintosh Estate.
Collection: Glasgow University.

DI916.31 Designs for the fireplace wall of the dining-room, 78 Derngate, Northampton

Pencil and watercolour 31 × 47cm. (irregular).
Inscribed with various notes and measurements.
Scale, 1:12.

In this design Mackintosh incorporated some of Bassett-Lowke's comments on D1916.30, such as the glazed upper doors and the pivoting cupboards (hinged at the bottom) for coal and wood for the fire. The moulding around the tiled fireplace is stepped at the top to provide a second shelf and this, as well as the arrangement of three lower cupboards on either side of the fireplace, was omitted from the executed version. In most other respects, however, this drawing would appear to be the basis for the final work.

Provenance: Mackintosh Estate.
Collection: Glasgow University.

1916.32 Lamp standard and shade for the dining-room, 78 Derngate, Northampton
(?) Brass and fabric.

Bassett-Lowke commissioned this lamp in a letter of 2 November, 1916 (Glasgow University), in addition to the table lamp for the dining-room already requested and being made in walnut (1916.33). Bassett-Lowke was uncertain whether he wanted a 'plain brass one in antique finish or one in walnut similar to the table lamp you are designing for me'. Mackintosh seems to have underlined *plain brass* in the letter, but from the surviving photographs one cannot be sure of the material. Howarth suggests that the circular table lamp is like the ventilation duct protectors shown in the perspective of Scotland Street School; surely he meant to draw attention to the close similarity between the construction of this lightshade and those covers, not the table lamp. *See* 1916.H.

Literature: *Ideal Home*, August 1920, p. 55.
Collection: untraced.

1916.33 Table lamp for the dining-room, 78 Derngate, Northampton
Walnut and inlay (?Erinoid).

Referred to in Basset-Lowke's letter of 2 November, 1916 (*see* 1916.32). In a letter of 12 January, 1917 (Glasgow University), in which he describes Erinoid to Mackintosh, he adds as a postscript 'What about trying a little

Erinoid inlay in the dining room table lamp?' Mackintosh presumably accepted the suggestion, as some substance can be seen in the top tier of the fitting and the lamp is described thus in the *Ideal Home* article: 'This is made of walnut, and the top is fitted with translucent green erinoid, which encloses an electric lamp for light effect or a bowl of flowers'. The lamp has not been traced, however, to confirm the use of the synthetic material. *See* 1916.H.

Literature: *Ideal Home*, August 1920, p. 55.
Collection: untraced.

1916.34 Twin beds for the main bedroom, 78 Derngate, Northampton
Sycamore, stained grey and polished with black inlay.

Of a most severe design, the only decoration was achieved by quartering the foot-boards and transposing the grain of the timber; a narrow band of black inlay was applied to the outer edge of each foot-board, which became effective when the two beds were pushed together. (*See* 1916.I).

Literature: *Ideal Home*, September 1920, p. 93.
Collection: untraced.

1916.35 Dressing-table and mirror for main bedroom, 78 Derngate, Northampton
Sycamore, stained grey and polished, with black inlay.

Like the beds (1916.34), this piece was extremely simple and severe, relying for its effect on its stark lines and the pattern of the grain of timber on the drawers and cupboards. The black inlay was only used in vertical strips, to emphasise the outer edges of the piece, and not horizontally or in such profusion as the linear stencilling on the guest bedroom furniture of 1919.

Literature: *Ideal Home*, September 1920, p. 93.
Collection: untraced.

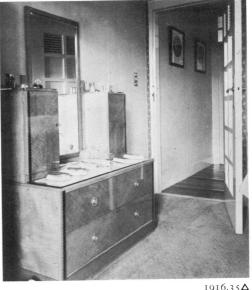

1916.35△

1916.36 Bedside table for the main bedroom, 78 Derngate, Northampton
Sycamore, stained grey.

This table was mentioned in the *Ideal Home* article, but it is difficult to discover anything about its appearance from the photographs. Presumably two were made.

Literature: *Ideal Home*, September 1920, p. 93.
Collection: untraced.

1916.37 Wardrobe for the main bedroom, 78 Derngate, Northampton
Sycamore, stained grey and polished, with black inlay.

Designed to match the beds and dressing-table (1916.34 and 35). *See* 1916.I.

Literature: *Ideal House*, September 1920, p. *93*.
Private collection.

1916.38 Plant tubs for 78 Derngate, Northampton
Wood, painted black and white.

Used in the garden and outside the front door. (*See* 1916.B & C).

Literature: *Ideal Home*, August 1920, p. *53*; Howarth, plate 76b.
Collection: untraced.

D1916/17.39 Sketches of clocks (? by W. J. Bassett-Lowke)
Pencil 11.2 × 18cm.
Inscribed with various notes and measurements.

The clock with the elliptical face supported on two columns appears in D1916.31; this sketch, however, is not in Mackintosh's hand and it may have been Bassett-Lowke's first suggestion to Mackintosh of a design for a dining-room clock. The design does not appear to have been carried out, although Mackintosh's drawing for the dining-room cupboards does show that he worked up the drawing in some detail. The photographs of the dining-room taken some time between 1917 and 1920 show a different clock in the dining-room, 1917.I. This clock bears some resemblance to a drawing on the back, probably in Bassett-Lowke's hand again, which suggests that Mackintosh simply developed an original idea put to him by Bassett-Lowke. This would have more credence had Mackintosh not already designed a very similar clock for The Hill House several years earlier (*see* 1905.24). Perhaps this drawing is simply a comment by Bassett-Lowke on a drawing which Mackintosh had previously sent him. Whatever the answer, the overall form of the clock is Mackintosh's own design no matter what part Bassett-Lowke had in the choice of the decoration.

Provenance: Mackintosh Collection.
Collection: Glasgow University.

1917.I Clock with ten columns for 78 Derngate, Northampton
Ebonised wood, inlaid with ivory and green Erinoid 23.5 × 12.7cm. × 11.4cm.

This clock appears in contemporary photographs of the dining-room and was probably made in 1917 after the rejection of the clocks shown in D1916.31 and on the back of D1916/17.39. Mackintosh had produced a clock of almost identical shape and size for himself and The Hill House in 1905; this clock follows a similar format, except that the legs are fewer in number and the decoration of the face and legs is rather more bold than the simple ivory and white paint of 1905.24. The dial and numerals are all in ivory, not simply painted, and the face is inlaid with diamond shapes of green Erinoid. The stepped base is also inlaid with ivory and each leg bears an ivory triangle at its base. The movement is French and the case was made by German craftsmen interned in the enemy aliens camp on the Isle of Man.

Another version has longer legs but is otherwise identical. It was bought, without a provenance, by Charles Handley-Read. Whether it was made with Mackintosh's knowledge and approval is unknown.

Literature: *Ideal Home*, August 1920, p. *55*; Howarth, pp. 203–04, plate 77.
Exhibited: Northampton Art Gallery, 'Historical Clocks', 1966; Edinburgh, 1968 (252, plate 29).
Provenance: W. J. Bassett-Lowke; T. Osborne Robinson; Colin Robinson; Sotheby's Belgravia, 20 July, 1977, lot 130.
Collection: Sidney and Frances Lewis, Virginia, USA.

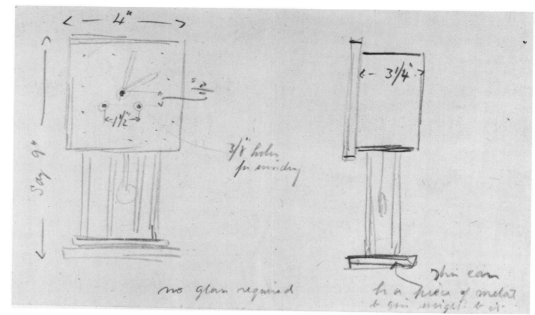

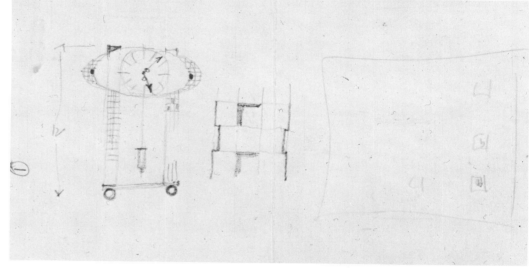

△D1916/17.39

D1916/17.39 verso▽

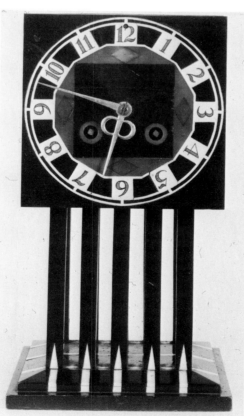

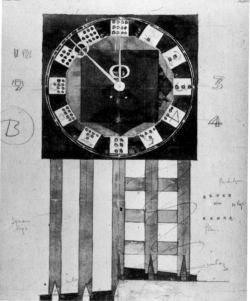

◁1917.I

D1917.2△

The drawing for 1917.I. Various alternatives are included on the drawing, including shorter legs with crosspieces and the use of domino spots instead of numerals.

Provenance: Mackintosh Estate.
Collection: Glasgow University.

D1917.2 Design for a clock for W. J. Bassett-Lowke
Pencil and watercolour 26.1 × 20.6cm.
Inscribed, left, *B*; and with various notes. Scale, full size.

D1917.3 Design for a clock face for W. J. Bassett-Lowke
Pencil and watercolour 17.8 × 16.5cm. (sight).
Inscribed, bottom, *Drawing of face showing*

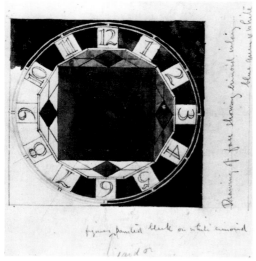

△D1917.3

erinoid inlay / blue, green & white and other notes. Scale, full size.

Final design for 1917.1.

Exhibited: Toronto, 1967 (73).
Collection: Dr Thomas Howarth.

1917.4 Clock with six columns and domino figures for W. J. Bassett-Lowke
Ebonised wood, inlaid with ivory and green and purple Erinoid 25.5 × 13 × 12.8cm.

This clock does not appear in contemporary photographs of 78 Derngate; it was used in the study at New Ways and may also have been kept in the study (on the second floor) at the Derngate house. The three drawings for clocks for Bassett-Lowke (D1917.5, 2 and 6) are inscribed *A*, *B* and *C*, which suggests that they were all produced at the same time, probably in 1917.

Compared with 1917.1, this design is more consciously 'modern', with its bold patterned face and extensive use of coloured inlays looking ahead to the designs of the 1920s. Mackintosh was obviously pleased with it, since he made another example which was given to Mary Newbery as a wedding present. Like 1917.1,

▽1917.4

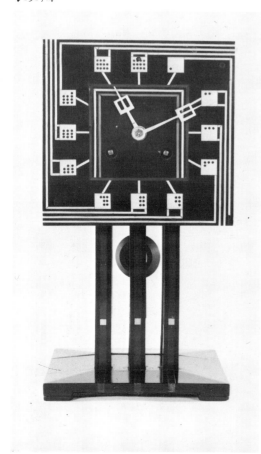

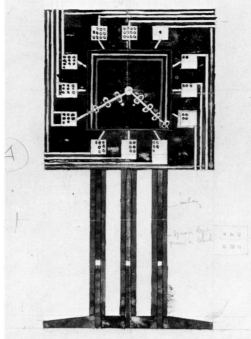

△D1917.5

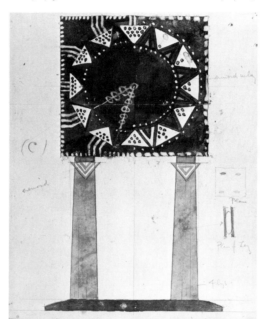

D1917.6▽

the movement is French and the case was made by German craftsmen interned on the Isle of Man.

Literature: *Ideal Home*, January 1927, p. 25; Howarth, pp. 203–04, plate 77.
Exhibited: a) Edinburgh, 1968 (274); b) Edinburgh, 1968 (275).
Provenance: a) W. J. Bassett-Lowke; by family descent; Sotheby's Belgravia, 10 November, 1976, lot 74; b) a wedding present from Mackintosh to A. R. Sturrock and Mary Newbery.
Collection: a) private collection; b) Mary Newbery Sturrock.

D1917.5 Design for a clock for W. J. Bassett-Lowke
Pencil and watercolour 26.1 × 20.6cm.
Inscribed, left, *A*; and with various notes. Scale, full size.

For 1917.4; as executed, except for changes to the hands.

Provenance: Mackintosh Estate.
Collection: Glasgow University.

D1917.6 Design for a clock
Pencil and watercolour 26.1 × 20.5cm. (irregular).
Inscribed, left, *C*; and with various notes.

This design was presumably produced for W. J. Bassett-Lowke along with drawings *A* and *B* (D1917.5 and 2), but the clock does not appear to have been executed.

Provenance: Mackintosh Estate.
Collection: Glasgow University.

D1917.7 Designs for clock faces for W. J. Bassett-Lowke
Pencil on a page of a sketchbook 18 × 22.8cm.
Inscribed, upper left, *W. J. Bassett-Lowke Clock Faces*.

Various designs, including an early version of the 'domino' clock (D1917.4), with the strips of inlay around the numerals.

Provenance: Mackintosh Estate.
Collection: Glasgow University.

D1917.7▽

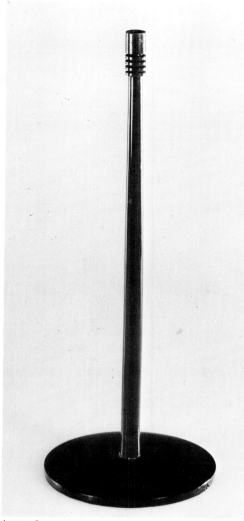

△1917.8

1917.8 Candlestick with circular base
Plastic (?Erinoid) 41 × 15.2cm. (diameter).

This candlestick was not listed in the inventory of Margaret's estate in 1933, but that was by no means accurate, and this piece was probably among her possessions returned to Glasgow in 1933. Although Mackintosh had used plastics, usually Galalith or Erinoid, since 1911, it had always been as an inlay. This is the only known item designed by Mackintosh made wholly out of the new material. Probably made *c*1917–18.

Exhibited: Edinburgh, 1968 (280).
Provenance: Acquired by William Meldrum after the Memorial Exhibition, 1933.
Collection: James Meldrum.

1917.9 Barometer for 78, Derngate, Northampton
Ebonised wood and mother-of-pearl 18.8× 18.8 × 5.1cm.

Designed to fit into one of the panels of the staircase screen in the hall at 78 Derngate.

Provenance: W. J. Bassett-Lowke; by family descent.
Private collection.

1917.10 Wardrobe for the guest bedroom, 78 Derngate, Northampton
Mahogany, with ebonised wooden base and mother-of-pearl inlay 179.7 × 130.1 × 52cm.

Exhibited: London, Bethnal Green Museum, '50 Years of Modern Design', 1966; Edinburgh, 1968 (272).
Provenance: a) Sidney Horstmann, Bath; his widow, from whom purchased; b) W. J. Bassett-Lowke; Mr Cave, Northampton.
Collection: a) Victoria & Albert Museum, London; b) untraced.

1917.11 Dressing-table for the guest bedroom, 78 Derngate, Northampton
Mahogany, inlaid with aluminium and mother-of-pearl 172.8 × 106.8 × 50.8cm.

Provenance: *See* 1917.10.
Collection: a) Victoria & Albert Museum, London; b) untraced.

1917.12 Ladderback armchair for the guest bedroom, 78 Derngate, Northampton
Mahogany, with upholstered seat 103.5 × 48.3 × 41.3cm.

Exhibited: London, Bethnal Green Museum,

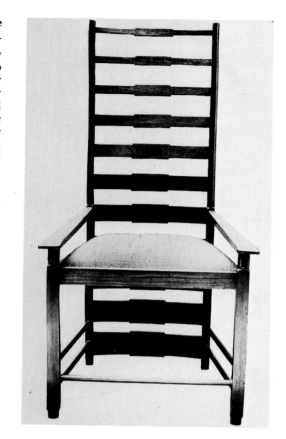

1917.12△

'50 Years of Modern Design', 1966; Edinburgh, 1968 (273).
Provenance: *See* 1917.10.
Collection: a) Victoria & Albert Museum, London; b) untraced.

1917.13 Ladderback chair for the guest bedroom, 78 Derngate, Northampton
Mahogany, with upholstered seat 79.5 × 48 × 43cm.

Two were made for both Derngate and Mr Horstmann.

Provenance: *See* 1917.10.
Collection: a) Victoria & Albert Museum, London (2); b) untraced.

1917.13▽

▽1917.10

1917.9▽

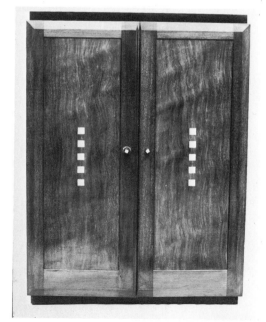

1917.11▷

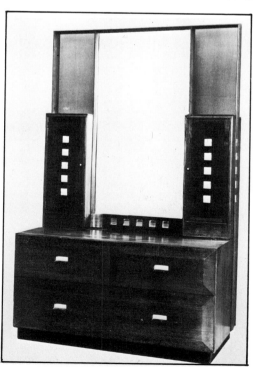

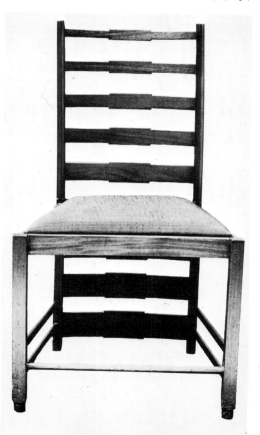

1917.10A *See* addenda

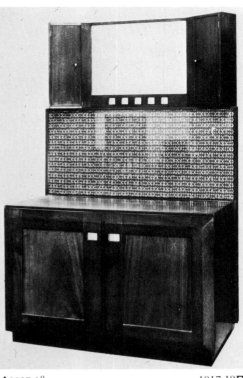

◁1917.15 △1917.14 1917.16▽

△1917.18 1917.19▽

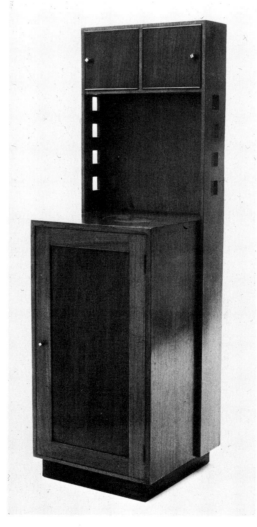

1917.14 Luggage stool for the guest bedroom, 78 Derngate, Northampton
Mahogany, with ebonised feet 35 × 70.5 × 34.2cm.

Provenance: *See* 1917.10.
Collection: a) Victoria & Albert Museum, London; b) untraced.

1917.15 Towel rail for the guest bedroom, 78 Derngate, Northampton
Mahogany, with ebonised feet 71.5 × 61 × 18.5cm.

Provenance: *See* 1917.10.
Collection: a) Victoria & Albert Museum, London; b) untraced.

1917.16 Bedside cupboard for the guest bedroom, 78 Derngate, Northampton
Mahogany with mother-of-pearl inlay 122 × 37.5 × 35.5cm.

Provenance: *See* 1917.10.
Collection: a) Victoria & Albert Museum, London; b) untraced.

1917.17 Twin beds for the guest bedroom, 78 Derngate, Northampton
Mahogany. Each 122 × 92 × 203cm.

Provenance: *See* 1917.10.
Collection: a) Victoria & Albert Museum, London; b) untraced.

1917.18 Wash-stand for the guest bedroom, 78 Derngate, Northampton
Mahogany, inlaid with aluminium and mother-of-pearl, and with a printed fabric behind the glazed splash-back 172.8 × 110 × 53.2cm.

The original Mackintosh-designed fabric used on Horstmann's stand (*see* 1917.A) had disappeared when acquired by the Museum and was replaced by a similar, contemporary piece designed by Phoebe McLeish.

Provenance: *See* 1917.10.
Collection: a) Victoria & Albert Museum, London; b) untraced.

1917.19 Hanging mirror for the guest bedroom, 78 Derngate, Northampton
Mahogany, with ebonised base and top, and inlaid with mother-of-pearl 168.2 × 57cm.

Provenance: *See* 1917.10.
Collection: a) Victoria & Albert Museum, London; b) untraced.

1917.20 Dressing-table stool for the guest bedroom, 78 Derngate, Northampton
Mahogany, with upholstered seat 45 × 37cm. (diameter).

Provenance: *See* 1917.10.
Collection: a) Victoria & Albert Museum, London; b) untraced.

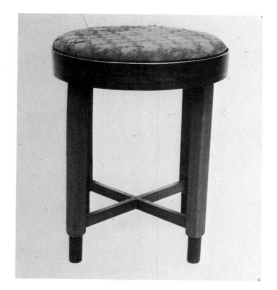

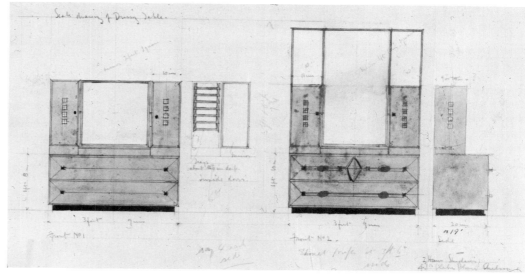

△1917.20 △D1917.22 D1917.21▽

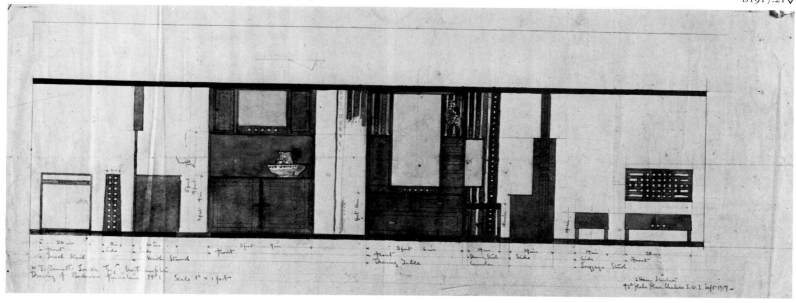

D1917.21 Design for furniture for the guest bedroom, 78 Derngate, Northampton
Pencil and watercolour 76 × 30cm.
Inscribed, lower left, *W. J. Bassett-Lowke Esqr. Northampton | Drawing of Bedroom Furniture No 1 Scale 1″ = 1 foot*; lower right, *2 Hans Studios | 43A Glebe Place Chelsea S.W.3 Sept 1917—*; and, *Towel Rail, Wash Stand, Dressing Table, Dressing Stool, Luggage Stool*; and various notes and measurements.
Scale, 1:12.

Virtually as executed. The decorations shown here are quite different from those carried out

▽D1917.23

at Bath for Sidney Horstmann (*see* 1917.B), but it is not known which scheme Mackintosh used at Derngate.

Provenance: Mackintosh Estate.
Collection: Glasgow University.

D1917.22 Two designs for a dressing-table for the guest bedroom, 78 Derngate, Northampton
Pencil and watercolour 22.1 × 45.2cm. (irregular).
Inscribed, *Scale drawing of Dressing Table, Front No 1, Front No 2, Side*, and, lower left, *2 Hans Studios | 43A Glebe Place Chelsea*. There are also notes about dimensions and construc-

tion details in Mackintosh's hand, and comments by W. J. Bassett-Lowke.
Scale, 1:12.

The taller version was made, 3′ 6″ (106.7cm.) wide as requested by Bassett-Lowke (*see* 1917.11).

Provenance: Mackintosh Estate.
Collection: Glasgow University.

D1917.23 Design for furniture for the guest bedroom, 78 Derngate, Northampton
Pencil 32 × 76.2cm. (irregular).
Inscribed with various notes and measurements.
Scale, 1:12.

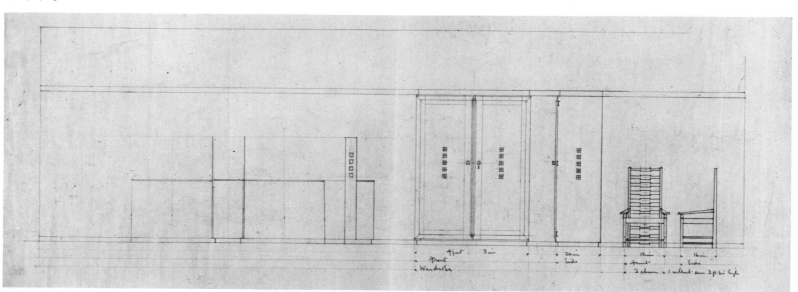

Virtually as executed, except that two chairs without arms were eventually made as well as the armchair.

Provenance: Mackintosh Estate.
Collection: Glasgow University.

D1917.24 Preliminary design for a wash-stand, bedside cupboard and chair for the guest bedroom, 78 Derngate, Northampton; verso, Design for a dressing-table for the guest bedroom, 78 Derngate, Northampton
Pencil 36.7 × 38.7cm. (irregular).
Inscribed, *Washstand; Night Table; Chair 2 one arm*; verso, ½″ *black and white inlay*; and *mirror inside*; and measurements.
Scale, 1 : 12.

Contemporary with D1917.25. Mackintosh seems to have intended to have only two chairs, one without arms; one armchair and two ordinary chairs were eventually made. The drawing on the back is interesting, because it shows that a chequer-pattern was to be used around the perimeter of the piece: in fact it was not used on the furniture in 1917, but Mackintosh returned to it in 1919.

Provenance: Mackintosh Estate.
Collection: Glasgow University.

D1917.25 Preliminary design for a wardrobe, dressing-table and mirror for the guest bedroom, 78 Derngate, Northampton
Pencil 22.1 × 60cm. (irregular).
Inscribed, *Wardrobe; Bed*; and various measurements.
Scale, 1 : 12.

Provenance: Mackintosh Estate.
Collection: Glasgow University.

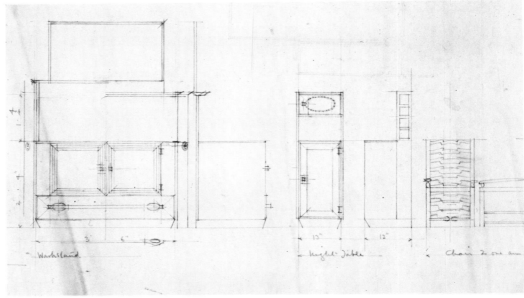

△D1917.24 D1917.25▽

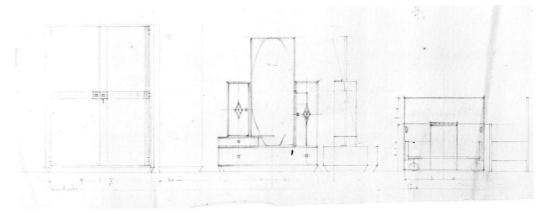

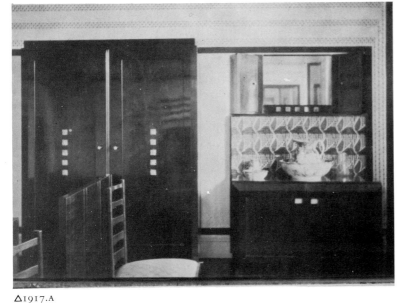

△1917.A

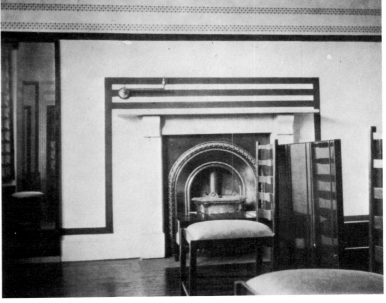

1917.B△

1917 Bedroom for Sidney Horstmann, Bath

Horstmann was a friend of Bassett-Lowke, and Mackintosh repeated for him the mahogany furniture originally designed for the guest bedroom at 78 Derngate, Northampton. The furniture seems to have been identical and, fortunately, it has survived complete and is now in the Victoria & Albert Museum (*see* 1917.10–20). At least one drawing for the decoration of this bedroom survives, as well as three contemporary photographs. Perhaps the original guest bedroom decoration at Derngate was also repeated here.

Mackintosh created a pattern out of stencilled strips, each approximately 5cm. wide; some are solid colour, and others are composed of small triangles of different hues. They seem to have been run around the room at frieze level with variations around the doors. A solid strip ran above the skirting board, which was diverted around fixtures such as the fireplace, door and beds. Behind the beds was a panel of fabric, designed by Mackintosh, which matched that used for the curtains and the splash-back of the wash-stand.

1917.A Bedroom for Sidney Horstmann, Bath

Collection: Victoria & Albert Museum, London.

1917.B Bedroom for Sidney Horstmann, Bath—fireplace wall
The decorations seem to have been executed more or less as shown in D1917.26.

Collection: Victoria & Albert Museum, London.

1917.C Bedroom for Sidney Horstmann, Bath—detail of fabric behind beds
Collection: Victoria & Albert Museum, London.

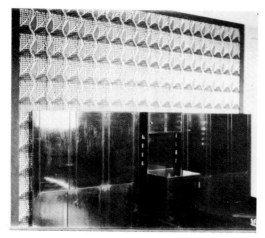

D1917.26 Scale drawing of wall decoration for a bedroom for Sidney Horstmann, Bath
Pencil and watercolour 31.5 × 47.6cm.
Inscribed, top, *W. J. Bassett-Lowke Esqr. Scale drawing of wall decoration for Bedroom at Bath— No*; bottom, *Elevation of Fireplace Wall note Black band continued above skirting on opposite wall*; and, lower right, *2 Hans Studios / 43A Glebe Place Chelsea S.W.3*; and various notes and measurements.
Scale, 1:12.

This drawing indicates that the stripes of solid colour were blue or black, and that the walls below the frieze rail were covered with white cartridge paper.

Provenance: Mackintosh Estate.
Collection: Glasgow University.

Even if this decorative scheme was not used at Derngate, it may well have inspired Bassett-Lowke's request for the alterations there in *c*1919. Several of the features seen here—like the panel behind the beds and the use of stripes—foreshadow the 1919 scheme at Derngate. The Horstmann decorations (which have since been overpainted) do not appear to have been particularly successful, and Mackintosh may well have learned much from them when he came to re-design the guest bedroom for Bassett-Lowke.

◁1917.C

D1917.26▽

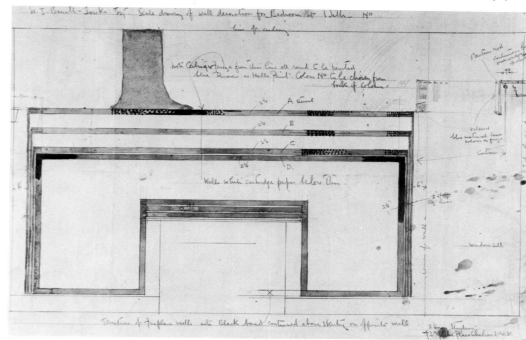

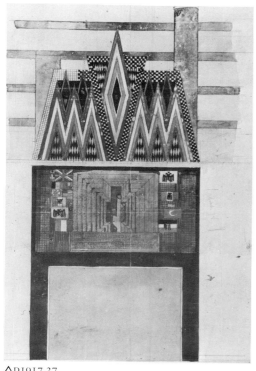

△D1917.27

D1917.27 Design for the Memorial Fireplace in the Dug-Out, the Willow Tea Rooms, Glasgow
Pencil and watercolour 49.1 × 39.6cm.
Inscribed, centre, *THIS ROOM WAS OPENED BY MISS / CRANSTON IN THE YEAR 1917 DURING THE / GREAT EUROPEAN WAR BETWEEN THE / ALLIED NATIONS AND THE CENTRAL POWERS*; and bottom, *Miss Cranston's Sauchiehall Street Glasgow / Drawing of commemorative panel over Fireplace in Back Room / Scale 1 inch = 1 foot No 112/2 Hans Studios / 43A Glebe Place Chelsea S.W.3*.
Scale, 1:12.

Exhibited: Edinburgh, 1968 (172).
Collection: Glasgow School of Art.

1917 The Dug-Out,*Willow Tea Rooms, Sauchiehall Street, Glasgow

By 1977, virtually all traces of this new tea room for Miss Cranston had disappeared; this is doubly unfortunate, because it was Mackintosh's last work in Glasgow and also an important development of the new style seen in the hall at 78 Derngate. The site was the basement of the Willow Tea Rooms but the scale of the work indicated on the surviving drawings and the positions of the few remaining features suggest that the adjacent basement, to the east, was also acquired and incorporated in the scheme. Miss Cranston chose a wartime theme for her new venture; there was no daylight in the basement and Mackintosh turned this to his advantage to create a dramatic interior by providing shiny black ceilings and dark walls highlighted by patches of strong colour in the decorations and artificial lighting. Sadly, no photographs were taken of the finished interiors and only a few drawings, a dozen pieces of furniture, and two large paintings remain to give an indication of the design. A centrepiece was the Memorial Fireplace in the back room, decorated with inlaid glass and paintings of the flags of the opposing nations; above this commemorative plaque was a panel of, probably, stencilled decoration in the form of chequers, diamonds and triangles, all in the bright colours first used in the Derngate frieze. This room possibly also housed the two large paintings, *The Little Hills* (Howarth, plate 81a). They are supposedly inspired by the words of the 65th Psalm 'Thou crownest the year with Thy goodness . . . and the little hills shall rejoice', and Mrs Sturrock remembers Margaret at work on them while the Mackintoshes were in Walberswick. As they had left the village by midsummer 1915, it seems likely that the paintings were not conceived as decorations specifically for the Dug-Out. McLaren Young (no 324) suggests, on the basis of Mrs Sturrock's evidence, that the two paintings were entirely Margaret's work, but a number of drawings—believed to be textile designs (collection: Glasgow University)—all in Mackintosh's hand, include features which appear in facsimile in these paintings; as some of them are on tracing paper, it does seem possible that Mackintosh was involved in the design of the panels, even if Margaret was responsible for the execution. In any case, the strength of the design with its rigidly controlled patterns and structure indicate Mackintosh's involvement, for such controlled work would have been thoroughly untypical of Margaret.

Two elevations of walls in the Dug-Out give an indication of the general appearance of the tea room (D1917.28 and 29). Features from Derngate have been liberally translated to Glasgow and, without Bassett-Lowke's critical eye looking over his shoulder, Mackintosh has been able to develop further some of the ideas introduced in Northampton. Whether or not these two drawings correspond with the executed work, one can see that strong linear patterns, and

*See addenda

235

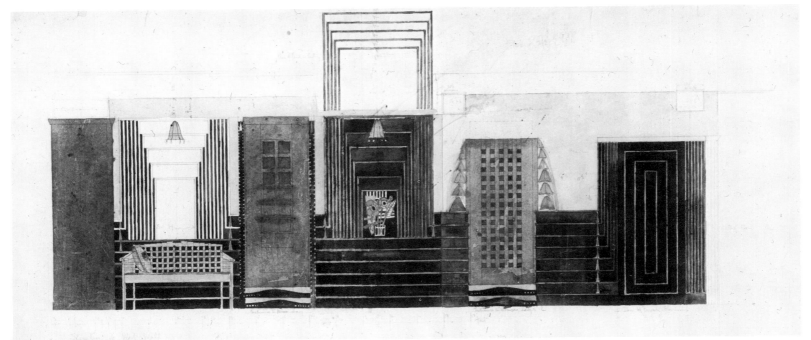

△D1917.28

D1917.29▽

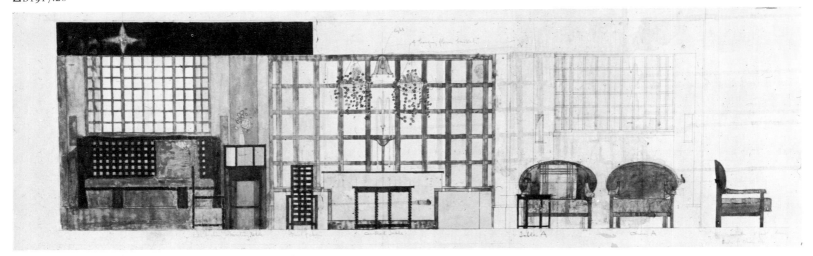

dark colours relieved by small patches of red, blue, or green, were to dominate the decorations. The triangle appears in a less obvious role, around the door to the ladies' lavatories, but the square lattice is as prominent as ever. The furniture shown in these designs seems simpler and less elegant than the Derngate pieces, partly because of Mackintosh's use of a square section larger than that usually found in his furniture. This gives the chairs, in particular, a heavier, slightly ungainly appearance, but it was almost certainly necessary for them to stand out against the distracting decorations. It is particularly disappointing that these decorations have not survived, because the rooms were on a much larger scale than those at Derngate, and while the latter—particularly the hall and guest bedroom—were successful because of the sustained impact of such small rooms, it would have been interesting to see how Mackintosh tackled the problems of using the same decorative style on a larger scale.

D1917.28 Design for the Dug-Out, Willow Tea Rooms, Glasgow—staircase and vestibule, elevation of west wall

Pencil and watercolour 40.2 × 76.5 cm.
Inscribed, lower left, *Elevation of West Wall | Miss Cranstons Sauchiehall Street Glasgow | Scale drawings of Staircase Vestibule etc No 52*; and, lower right, *2 Hans Studios | 43A Glebe Place Chelsea*; and various other notes and measurements.
Scale, 1:12.

The present staircase to the basement is some distance away from the surviving lavatories, the decoration of which is in keeping with the style of the vestibule and doors shown here with the legend *Entrance to men's Lavys* and *Entrance to Women's Lavys*. Perhaps a new entrance was made to the basement from the Rear Saloon above these lavatories.

Stripes are the dominant motif in the decorations, in the panels over the settle and between

the doors where they are carried over the ceiling as in the guest bedroom at 78 Derngate. The lampshades are also similar to those used in the guest bedroom.

At the right of the drawing is a faint inscription *Rest Room*; it is not clear whether Mackintosh was indicating that the Rest Room was to the north of the vestibule, or whether it was reached through the third door in this drawing which bears the legend *Door to Private Room* (see D1917.29).

Exhibited: Milan, 1973 (54).
Collection: Glasgow School of Art.

D1917.29 Design for the Rest Room for the Dug-Out, the Willow Tea Rooms, Glasgow—north elevation

Pencil and watercolour 30.8 × 77.7 cm.
Inscribed, and dated, lower right, *2 Hans Studios 43A Glebe Place | Chelsea S.W. Feby 1917*; inscribed, lower left, *Miss Cranstons Sauchiehall Street Glasgow | Scale drawings of Rest Room. North Elevation Drawing No 66 | Notes Green shows Plaster Yellow shows Wood*; and various other notes and measurements.
Scale, 1:12.

The lattice-work seen in the hall at Derngate is repeated here, but apparently as an open screen without the solid or glazed panels used so effectively at Northampton. Of the furniture shown in the room, none has been traced other than the chair at the writing desk (1917.31) and the small table (1917.32). The large table is very similar to 1917.33 and 34, although the former has ball-and-cube legs and the latter a round top. The writing desk appears to be very simple; perhaps those designed for Ingram Street in 1909, which were very cheap, were just as elementary.

Exhibited: Milan, 1973 (53).
Collection: Glasgow School of Art.

1917.30 Settle for the Dug-Out, Willow Tea Rooms, Glasgow

Ebonised wood 79.5 × 137 × 70.4 cm.

According to D1917.28, this settle was in the staircase vestibule at the Dug-Out. It is a smaller variant of the Derngate hall settle (1916.13) with similar decoration on the top edge of the back-rail, but a flat, not curved, back, and without the incised decoration on the front apron.

Literature: Glasgow School of Art, *Furniture*, no 11.
Provenance: (?) Grosvenor Restaurant, Glasgow.
Collection: Glasgow School of Art;
Dr Thomas Howarth (1).

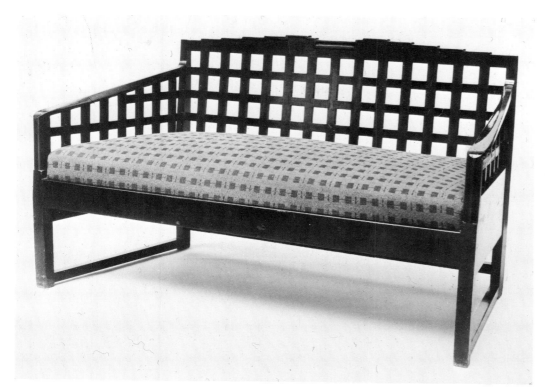

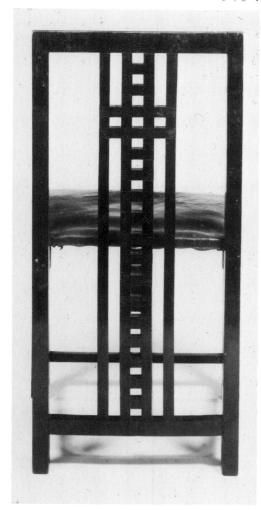

△1917.30

1917.31▽

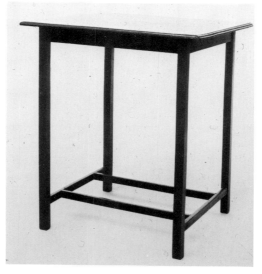

△1917.32

1917.33▽

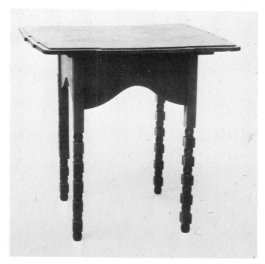

Cube-and-bobbin legs are a traditional motif not used by Mackintosh before this date. Several of the pieces made for the Dug-Out, however, incorporate such traditional features; for instance, the round table with bobbin legs (1917.34) and the stepped ladder-backs of the chairs (1917.35 and 36). The shaped top of the table, which narrows in steps, recalls the writing desk (1909.11) and, also at the Dug-Out, the patterns of the panels of decoration in the staircase vestibule (D1917.28).

Provenance: (?) Grosvenor Restaurant, Glasgow.
Collection: Glasgow School of Art.

1917.34 Circular table with bobbin legs for the Dug-Out, Willow Tea Rooms, Glasgow
Ebonised wood.

A square table with bobbin legs is shown in D1917.29. Could this have been substituted for it, or was the square table also made?

Provenance: (?) Grosvenor Restaurant, Glasgow.
Collection: untraced (known from a photograph probably taken by Thomas Howarth and included in his thesis, now in the Glasgow University Library).

1917.35 Ladderback armchair for the Dug-Out, Willow Tea Rooms, Glasgow
Ebonised wood 81.5 × 52 × 42.2cm.

Mackintosh designed similar ladderbacks for the guest bedroom suite for Bassett-Lowke,

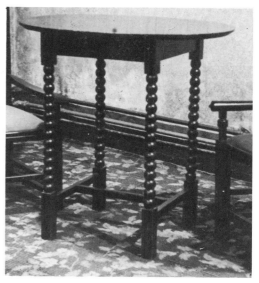

△1917.34

1917.35▽

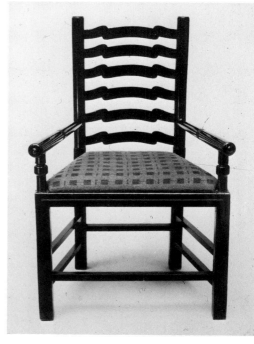

1917.31 Chair for the Dug-Out, Willow Tea Rooms, Glasgow
Ebonised wood 81.8 × 42.6 × 42.6cm.

Three chairs similar to that shown in D1917.29 have survived. The timber used is similar in section to that in the settle and these broad dimensions are typical of much of the furniture produced at this date (see, for example, D1918.12, and the furniture made from this design by Cassina of Milan).

Provenance: private collection, Glasgow; Sotheby's Belgravia, 27 November, 1975, lots 235, 236.
Collection: Fine Art Society, 1977.

1917.32 Set of tea tables for the Dug-Out, Willow Tea Rooms, Glasgow
Wood, stained dark.

One of the tables is possibly that shown in D1917.29.

Provenance: unknown.
Collection: Glasgow School of Art.

1917.33 Tea table with cube-and-bobbin legs for the Dug-Out, Willow Tea Rooms, Glasgow
Ebonised wood 76.1 × 76.1 × 76.1cm.

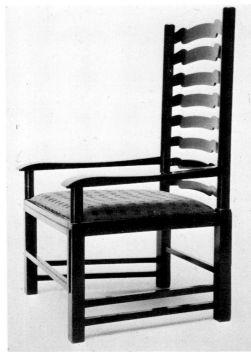

△1917.36

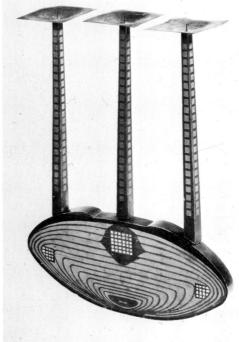

△1917.37

and a preliminary drawing (D1917.24) for this suite shows that Mackintosh had originally considered using for the ladderback a stepped rung identical to that used here. This chair was possibly used in the Private Room indicated in D1917.28, or elsewhere in the Dug-Out; six survive and one was included in a photograph of other Willow and Dug-Out furniture taken by Howarth at the Grosvenor Restaurant and included in his thesis (Glasgow University Library).

Provenance: Grosvenor Restaurant, Glasgow.
Collection: Glasgow School of Art (6).

1917.36 Large ebonised ladderback arm-chair for the Dug-Out, Willow Tea Rooms, Glasgow
Ebonised wood 93.7 × 58.5 × 52.2cm.

Similar to 1917.35, but on a larger scale, with flat instead of turned arms.

Provenance: Grosvenor Restaurant, Glasgow.
Collection: Glasgow School of Art (1).
Dr Thomas Howarth (1).

1917.37 Wall-mounted candelabra for the Dug-Out, Willow Tea Rooms, Glasgow
Wood, painted in pink, black, brown, white and green, with metal bowls. Approx 61 × 45cm.

A note in William Meldrum's list of unsold material from the Memorial Exhibition, 1933, describes these as being from Miss Cranston's Tea Rooms. The most likely, indeed probably the only, tea room in which such a design would harmonise was the Dug-Out. The colours and the pattern of 'contour' lines conform with the decorative schemes shown in D1917.28, but it is not known in which room they were used. Nor is it clear whether this pair formed part of Margaret Mackintosh's estate in 1933; labels on the back show they were handled by McClure who was responsible for storing and framing many works from the estate, but they do not tally with the descriptions of candlesticks given in the inventory of Margaret's possessions made after her death. This inventory was not wholly accurate, however, so it is at least possible that this pair of candelabra, although designed for the Dug-Out, were surplus to needs there and were kept by Mackintosh.

Exhibited: Edinburgh, 1968 (281).
Provenance: acquired by William Meldrum after the Memorial Exhibition, 1933.
Collection: James Meldrum (2).

▽1918.A

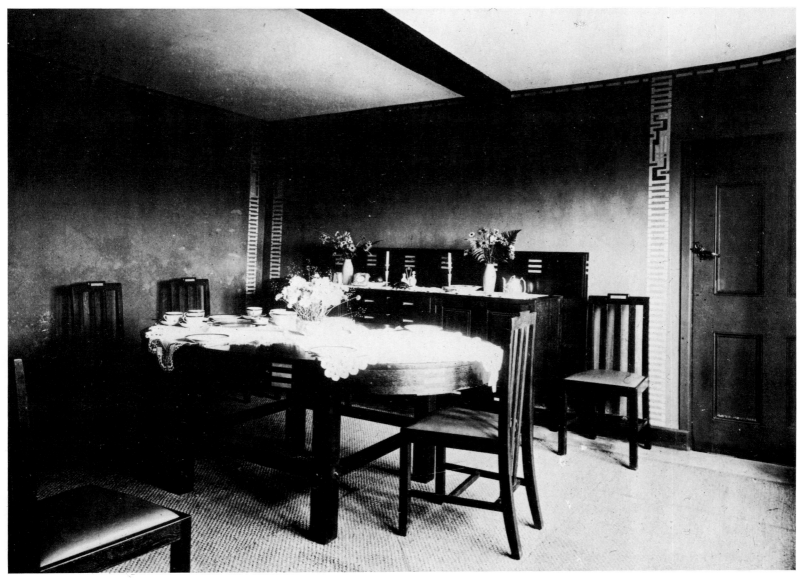

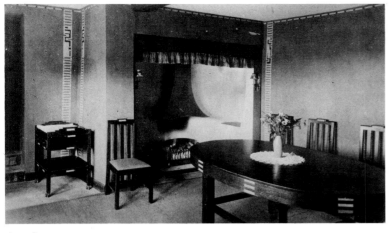

△1918.B

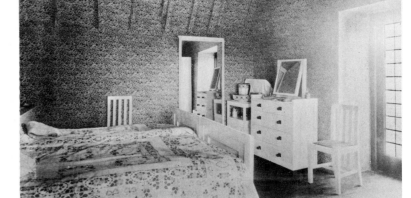

1918.C▷

1918.A Dining-room, Candida Cottage, Roade

Collection: Glasgow University.

1918.B Dining-room, Candida Cottage, Roade

Collection: Glasgow University.

1918.C Bedroom, Candida Cottage, Roade
The furniture for the bedrooms seems to have been designed by Bassett-Lowke.

Collection: Glasgow University.

D1918.1 Design for a stencil decoration for Candida Cottage, Roade
Pencil and gouache 75.9 × 55.4cm. (irregular).
Inscribed, *Stencil A | Stencil B | Stencil C | Stencil D.*

A preliminary study for the stencils used at Candida Cottage (1918) and The Drive (1919), showing alternative colourways.

Provenance: Mackintosh Estate.
Collection: Glasgow University.

D1918.1▽

1918–19 Furniture and decorations at Candida Cottage, Roade, near Northampton, for W. J. Bassett-Lowke, and for F. Jones at The Drive, Northampton*

According to the article in *Ideal Home* in 1920, Bassett-Lowke had acquired two cottages at Roade in 1914 with the intention of converting them into a single house; as it turned out, the 'cottages' were discovered to have been originally built as one, and Bassett-Lowke was merely returning them to their original form. Work was apparently finished in 1919, but Mackintosh's involvement seems to have been no more substantial than the design of the dining-room furniture and decorations. For the latter, he reverted to his customary scheme of dark-brown paper for the walls and a white ceiling. The walls, however, were decorated with a stencilled pattern: a line consisting of dark square 'dots' and paler long 'dashes' encircled the room just below the ceiling; and at re-entrant corners and by the door Mackintosh introduced a ladder pattern consisting of blue rungs with an abstract pattern of black and red linear shapes. The rungs of the ladder were formed by using three stencils of different shapes which, when brought together, formed a ladder; these stencils were reversed or inverted to create nine variations, and no two ladders appear to have been assembled in exactly the same way.

The furniture is probably the most modern and utilitarian Mackintosh ever designed. The carved organic decoration of the early Glasgow period has gone altogether, as has much of the deliberate, almost mannered, lattice-work and geometricality of the later Glasgow and Derngate designs. Shapes are simple and robust; the decoration is quiet; and the materials are basic: stained oak and the new substances Erinoid and Rexine. It is, perhaps, the closest Mackintosh ever came to the furniture of such English designers as Gimson or Barnsley. Certainly it anticipated much of the best in English design of the 1930s by men such as R. D. Russell, looking forward almost to the utility designs produced during and after the Second World War. Its genesis, however, is long and complicated, and several of the drawings produced for this commission are lost; without them much of what follows depends upon conjecture and opinion.

The surviving drawings, which seem to be related to Candida Cottage, fall into three groups. The first series consists of designs for sideboards, culminating in D1918.10, which includes a design for a gramophone cabinet. Although two of these drawings are dated February 1918, it seems that Bassett-Lowke did not accept them, or seriously press for alternatives, until late June. In a letter of 29 June, 1918 (Glasgow University) he agreed to visit Mackintosh and discuss the designs for the dining-room suite before work commenced on the detailed drawings. He went on: 'I shall also want a gramophone cabinet of the same style and enclose you herewith details . . .'. If this was the first mention of the gramophone, then D1918.10 must post-date Mackintosh's receipt of the letter and possibly Bassett-Lowke's visit. A development of the requirements noted by the client on D1918.10 is seen in D1918.13; this drawing, however, is dated *June 1918*— could Mackintosh have been mistaken about the date and was the drawing therefore made in early July? The sideboard on this drawing incorporates features from that of D1918.10, but not the four drawers which Bassett-Lowke seems to have requested earlier; it also includes a table and dining chair similar to those eventually made. From these two designs Mackintosh produced an amalgam, D1918.14, which also includes a service trolley, requested for the first time in Bassett-Lowke's letter of 29 June.

All this would be quite straightforward were it not for the existence of two drawings for a quite separate suite of dining furniture, D1918.11 and 12. These appear to be connected with Bassett-Lowke, because the earlier design includes calculations (presumably of fees, as the sums involved are too low to be manufacturing costs) which list two items specifically mentioned in Bassett-Lowke's

*See addenda

letter: a gramophone, and an overmantel. This earlier drawing incorporates glazed lattice cupboards seen in previous designs for the sideboard, but here they are full height. They were removed from the later drawing, which includes not only a sideboard but also a dining table, chair, armchair, a coffee table and an easy chair. This last is so similar to the easy chair shown on the drawing for the Dug-Out (D1917.29), that it even seems possible that the drawing might be for furniture intended for the Private Room in that scheme. The notes on the drawing, however, listing numbers of chairs and the possibility of replacing the table by two coffee tables, suggest that the design is for a domestic setting. If Bassett-Lowke was also presented with this design on his visit to Mackintosh (as well as D1918.13), then it is difficult to understand why it was rejected. Perhaps he wanted something for his weekend retreat different from the lattice patterns used at Derngate. This design is certainly much more sophisticated than any of the others connected with Candida Cottage, and that may have been the reason for its rejection; the cottage was kept deliberately simple—even rustic—and such elegant pieces would surely have seemed out of place. But Mackintosh must have known the setting and his client's intentions and wishes. Was this an attempt to persuade him to accept a more elaborate design (which Mackintosh was obviously pleased with, for the drawing is carefully detailed) or, notwithstanding the calculations, was it not a design for Candida Cottage, or Bassett-Lowke, after all?

The only other modern pieces in the cottage were the bedroom furnishings. They have the look of the dining furniture at 78 Derngate designed by Bassett-Lowke, although the bedroom chairs seem very similar to the dining chairs, but without the inlay on the top rail. The *Ideal Home* described this furniture as 'made to standard at a local joinery works and enamelled white', and in the author's opinion it was all the work of Bassett-Lowke himself, not Mackintosh.

The following year Mackintosh was asked to repeat the dining-room design for Bassett-Lowke's brother-in-law, F. Jones. This appears to have been the only work he did at Jones's house in The Drive, Northampton. The walls and ceiling were treated exactly the same as at Candida Cottage, but the ladder stencil was repeated in the middle of the wall on either side of two bracket lamps fitted over the sideboard. These were semicircular in plan, very close to the design originally proposed for the Derngate dining-room (*see* D1916.30). The furniture was an exact reproduction of that at Candida Cottage, although no coffee table is visible in the contemporary photographs. None of this furniture has been traced, but of the Candida Cottage furniture, which was taken to New Ways in 1923, everything has survived except the sideboard.

Literature: *Ideal Home*, October 1920, 'Ancient and Modern', with 12 illustrations.

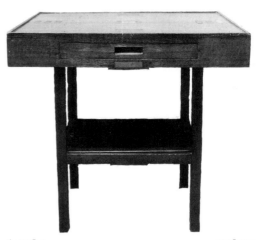

△1918.3 1918.4▽

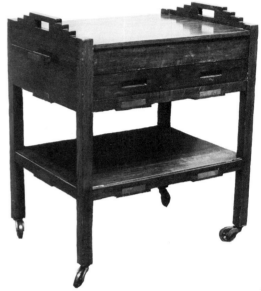

1918.2 Sideboard for Candida Cottage, Roade

Oak, stained and waxed, inlaid with Radolith.

See D1918.14. The blue inlay is Radolith, according to Mackintosh's notes; this was another proprietary casein plastic like Erinoid and the pre-war Galalith, which was made in Germany. The furniture is darker than the natural wood designs made for the Derngate bedrooms.

Literature: *Ideal Home*, October, 1920, fig. 6. Collection: neither Bassett-Lowke's nor Jones's examples has been traced.

1918.3 Coffee table for Candida Cottage, Roade

Oak, stained and waxed, inlaid with Radolith 76 × 76 × 76cm.

The table does not appear in contemporary photographs, but the drawing, D1918.14,

shows that it was designed as part of the dining furniture. It was probably used in the hall/drawing-room at Candida Cottage.

This table does not appear in the photographs of Jones's house, either, and again (if it was made at all) it was probably kept in the drawing-room rather than the dining-room.

Provenance: a) W. J. Bassett-Lowke; his widow; T. Osborne Robinson; Colin Robinson, his brother, from whom purchased; b) (?) F. Jones.
Collection: a) Brighton Museum & Art Gallery; b) untraced.

1918.4 Service trolley for Candida Cottage, Roade

Oak, stained and waxed, inlaid with Radolith, and supported on castors 84 × 66 × 51cm.

See D1918.14. Mackintosh took his dimensions from those suggested by Bassett-Lowke in his letter of 29 June 1918 (Glasgow University). Indeed, the overall arrangement of the trolley is Bassett-Lowke's and Mackintosh was really responsible only for the decoration.

Literature: *Ideal Home*, October, 1920, fig. 6.
Provenance: a) as 1918.3; b) F. Jones.
Collection: a) Brighton Museum and Art Gallery; b) untraced.

1918.5 Dining table for Candida Cottage, Roade

Oak, stained and waxed, inlaid with Radolith 73 × 183 × 120cm.

A design strangely like Bassett-Lowke's own design for his Derngate dining table, but the stretchers here are square, not arched.

Literature: *Ideal Home*, October 1920, fig. 6.
Provenance: a) W. J. Bassett-Lowke, from whom purchased on his move to New Ways, 1923, by T. Osborne Robinson; Colin Robinson, from whom purchased; b) F. Jones.
Collection: a) Brighton Museum & Art Gallery; b) untraced.

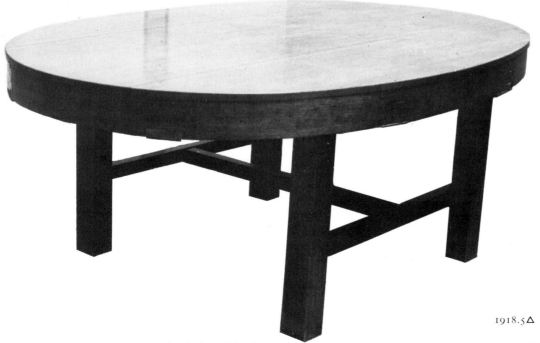

1918.5△

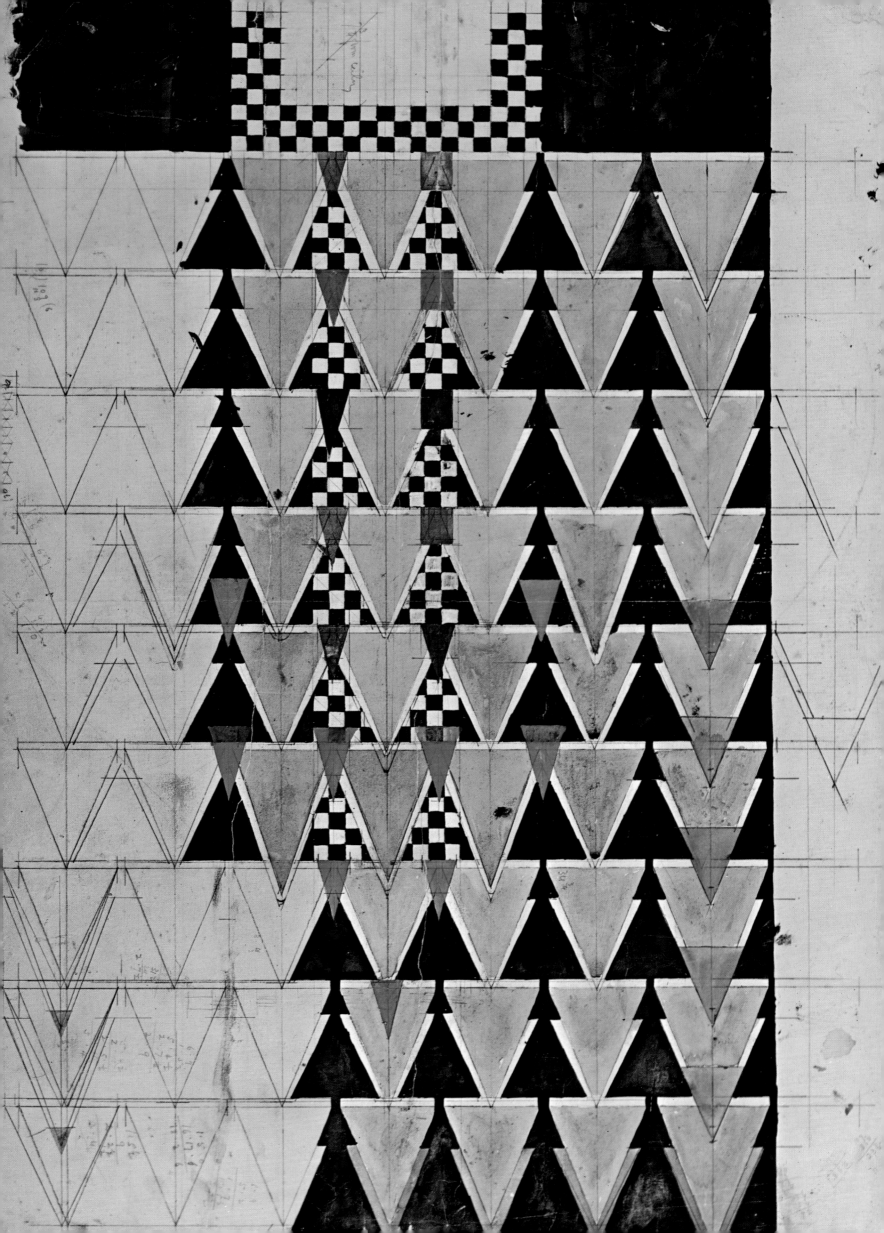

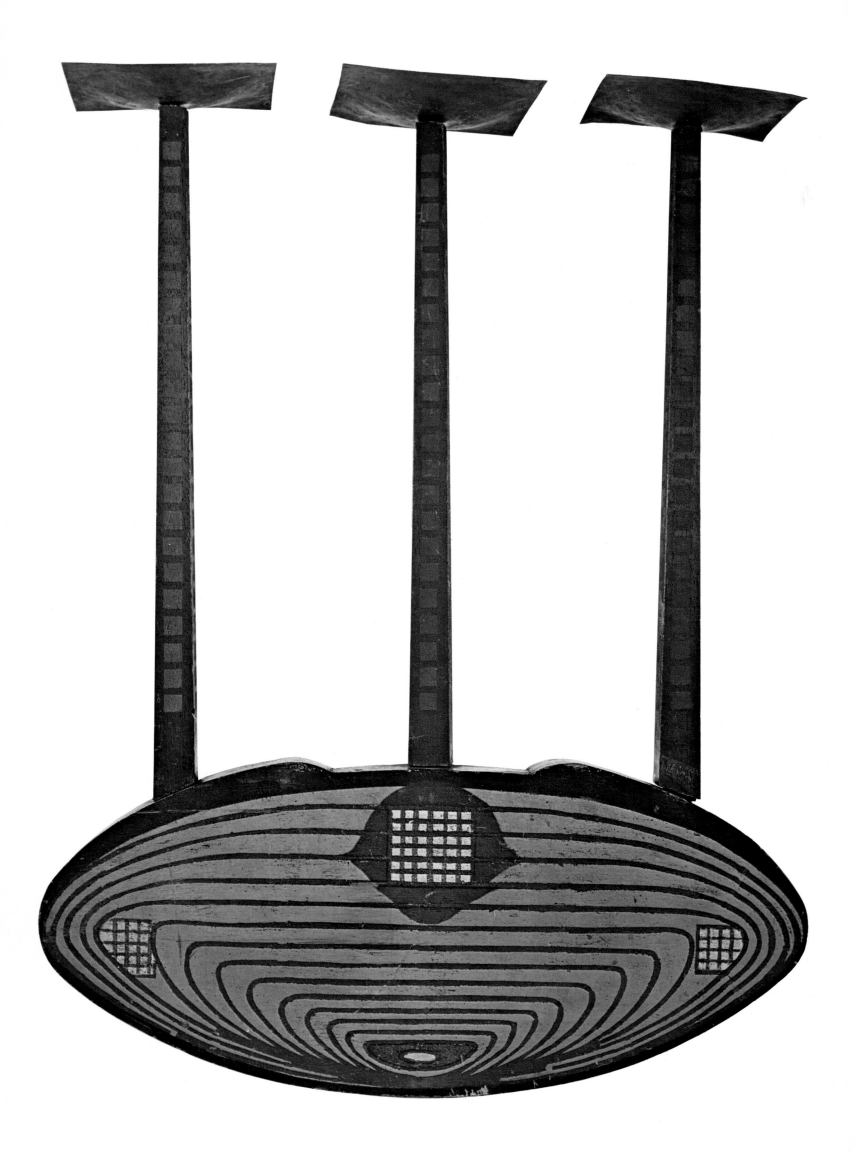

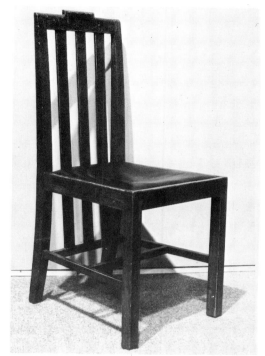

1918.6 Dining chair for Candida Cottage, Roade

Oak, stained and waxed, inlaid with Radolith, and with a Rexine covered seat 95 × 41 × 49cm.

See D1918.13. A sturdy and compact design, with none of the usual Mackintosh features other than the raised inlaid panel in the top-rail, and the way the three splats are fixed to a rear stretcher which connects, not the back legs, but the side stretchers. Bassett-Lowke appears to have imitated the design in the bedroom chairs for Candida Cottage. Six appear in photographs of the Roade house and at least another four in Jones's house in Northampton.

Literature: *Ideal Home,* October 1920, fig. 6.
Provenance: a) as 1918.5; b) F. Jones.
Collection: a) Brighton Museum & Art Gallery (6 only); b) untraced.

D1918.7 Design for a sideboard for W. J. Bassett-Lowke; verso, Sketch of a sideboard (in another hand, possibly Bassett-Lowke's)

Pencil and watercolour 21.5 × 39.1cm. (irregular).
Inscribed, upper left, *Scale drawing of Sideboard,* and dated, lower right, *2 Hans Studios | 43A Glebe Place Chelsea SW.3 | Feby 1918*; and various notes and measurements.
Scale, 1:12.

Almost certainly the first of the drawings for Candida Cottage: the upper part has a central mirror with shelves across it, flanked by two cupboard doors, each inlaid with a decorative panel; in the lower part is a central bank of drawers with cupboards either side. Although there are no written comments by Bassett-Lowke on this drawing, the sketch on the back shows a mirror flanked by two projecting glazed cupboards, each having an arrangement of astragals resembling a lattice. This feature is repeated in several of Mackintosh's subsequent drawings.

1918.8 Design for a sideboard for W. J. Bassett-Lowke; verso, measured drawing of cutlery

Pencil and watercolour 21.6 × 39.2cm.
Inscribed, upper left, *Scale drawing of Sideboard No 5,* and dated, lower right, *2 Hans Studios | 43A Glebe Place | Chelsea S.W.3 | Feby—1918.*
Scale, 1:12.

The dimensions of this sideboard are virtually

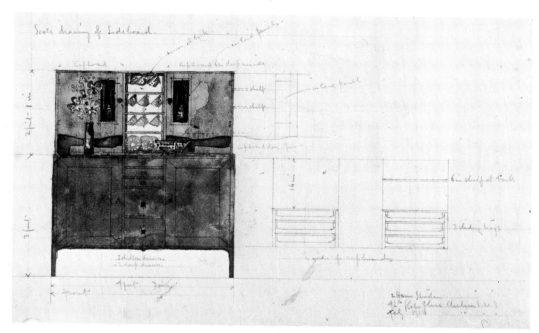

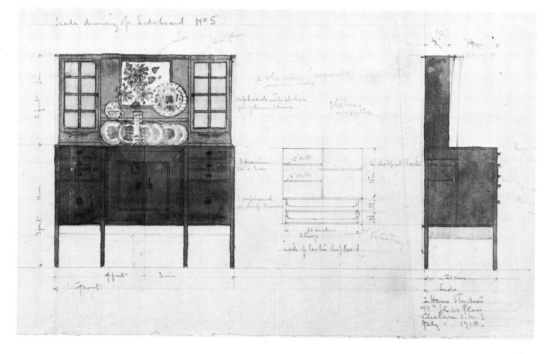

the same as that in D1918.7, but the design incorporates the glazed cupboards suggested by Bassett-Lowke on that earlier drawing. Rows of drawers now flank a central cupboard in the lower portion of the sideboard, presumably another Bassett-Lowke requirement, as it is retained in most of the subsequent designs. An alteration to the design shows that an extra drawer must also have been requested, again an arrangement repeated in the later drawings.

Provenance: Mackintosh Estate.
Collection: Glasgow University.

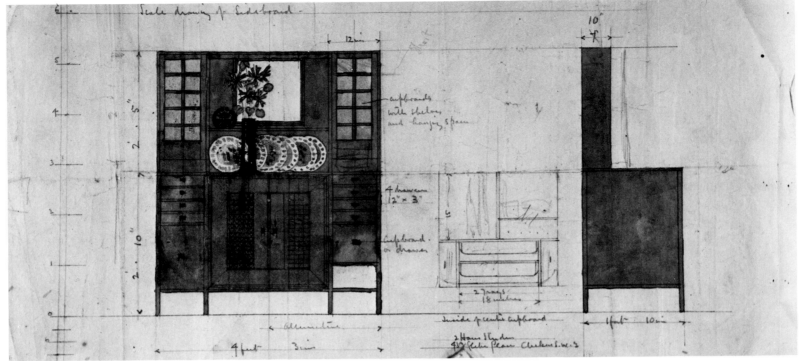

△D1918.9 D1918.10▽

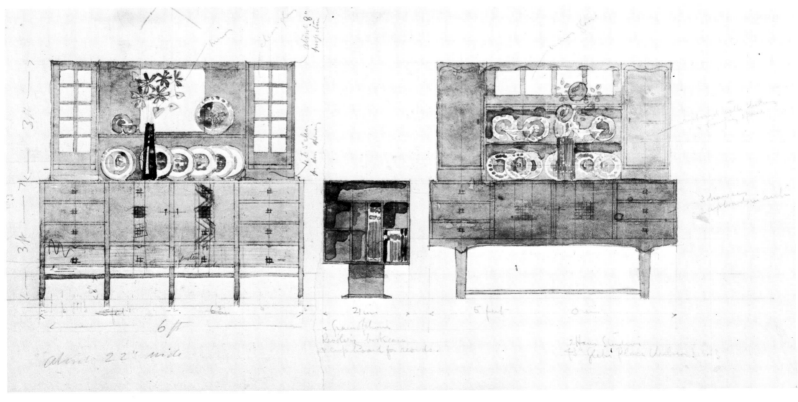

D1918.9 Design for a sideboard for W. J. Bassett-Lowke

Pencil and watercolour 21 × 39cm.
Inscribed, upper left, *Scale drawing of Sideboard*, and, lower right, *2 Hans Studios / 43A Glebe Place Chelsea S.W.3*; and various notes and measurements.
Scale, 1 : 12.

The same overall dimensions as the sideboard in D1918.8, but the proportions of top and bottom sections have been changed. The fourth drawer is included, and a suggestion is made for decoration of the cupboard doors using an inverted triangle motif.

Provenance: Mackintosh Estate.
Collection: Glasgow University.

D1918.10 Two designs for a sideboard, and a design for a gramophone cabinet, for W. J. Bassett-Lowke

Pencil and watercolour 20.8 × 45.8cm. (irregular).
Inscribed, lower right, *2 Hans Studios / 43A*

Glebe Place Chelsea S.W.3; and various notes and measurements, also comments by Bassett-Lowke.
Scale, 1 : 12.

This drawing was presumably made after 29 June 1918, the date of Bassett-Lowke's letter requesting a gramophone cabinet. Mackintosh also provided alternative designs for the sideboard: that on the left being basically a wider version of D1918.9, while the design on the right has a different arrangement of drawers and cupboards, no glazed doors, and is supported on longer legs. Bassett-Lowke has made a number of comments on the left-hand design, suggesting that it be made 6 feet (182.9 cm.) square and 1′ 10″ (55.9cm.) deep, with four drawers and a deeper cupboard. The design has been marked with a cross in a circle at the top and was at one time torn off the sheet, leaving the alternative design and the gramophone cabinet.

Provenance: Mackintosh Estate.
Collection: Glasgow University.

D1918.11 Preliminary sketch for dining-room furniture for W. J. Bassett-Lowke

Pencil 29.5 × 55.5cm. (irregular).
Inscribed with various notes and prices.

The notes down the side are presumably indicative of Mackintosh's fees for designing the various pieces of furniture; they must post-date 29 June, 1918, as they include a gramophone and overmantel, both mentioned for the first time in Bassett-Lowke's letter of that date.

This appears to be the first design to include a table and chairs. The sideboard is roughly sketched but incorporates two full-height glazed cupboards at each side, with a plate rack in the middle over more cupboards and drawers.

Provenance: Mackintosh Estate.
Collection: Glasgow University.

D1918.12 Design for dining-room furniture for W. J. Bassett-Lowke

Pencil and watercolour 31.7 × 78.5cm.
Signed and inscribed, lower centre, *C. R.*

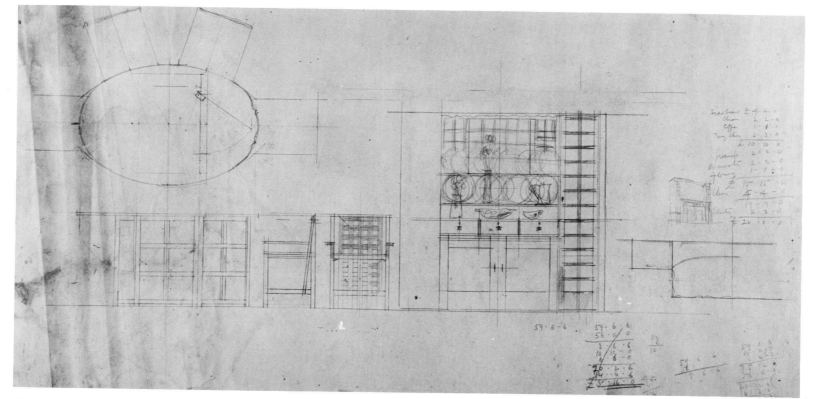

△D1918.11

D1918.12▽

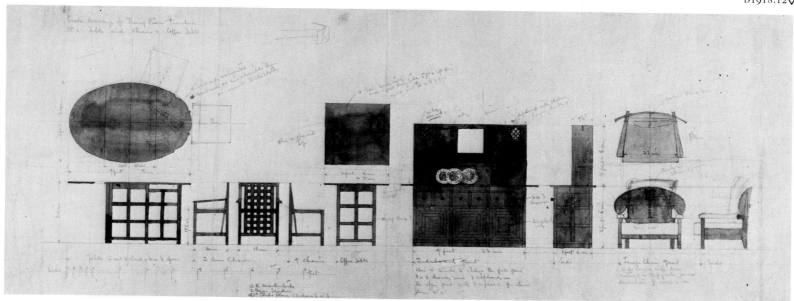

Mackintosh / 2 Hans Studios / 43A Glebe Place Chelsea S.W.3; inscribed, upper left, *Scale drawings for Dining Room Furniture / No 1 Table and chairs & Coffee Table*; and various notes and measurements.
Scale, 1:12.

This drawing is somewhat puzzling in that it does not easily fit into the chronological development of the design for the Candida Cottage furniture. The preliminary sketch (D1918.11) has calculations on it which suggests that it post-dates Bassett-Lowke's letter of 29 June 1918, but these could, of course, have been scribbled additions to a much earlier drawing. The sideboard is 4′ 3″ (129.5cm.) wide, identical with those shown in D1918.7, 8 and 9, but Bassett-Lowke had asked for a 6-foot (182.9cm.) wide sideboard in D1918.10. If the furniture *was* intended for Bassett-Lowke, could this have been one of the designs which Mackintosh showed him on his visit to London in early July? If so, perhaps he rejected it because it was too elegant a design for his country cottage. Whatever the reason, it is certainly one of the most sophisticated of these later furniture designs and Mackintosh must surely have been proud of it, hence the fairly careful execution and detail of the drawing and its comprehensive notes.

If it was not for Bassett-Lowke, could it have been a design of 1917 for the Dug-Out? A 'Private Room' is indicated in D1917.28, and this could be the design for its furniture, which is otherwise unknown; the design of the easy chair certainly corresponds with others on a drawing for the Dug-Out (D1917.29). The lattice theme—not particularly obvious in early Candida Cottage designs—was very much in evidence at the Dug-Out and this furniture would obviously have not been out of place there; against this, several of the notes suggest a domestic, rather than commercial, setting for the furniture, which brings us inconclusively back to Bassett-Lowke and Candida Cottage.

Although the furniture was not made in Mackintosh's life-time, Messrs Cassina of Milan produced a prototype in 1973 of a dining suite based as closely as possible on this drawing, and this was put into commercial production the following year. It includes all the pieces seen in the drawing except the easy chair.

Literature: Alison, p. 83, no 56; Billcliffe and Vergo, fig. 11.
Exhibited: Milan, 1973 (56).
Provenance: Mackintosh Estate.
Collection: Glasgow University.

D1918.13 Design for sideboard, table, and chair for W. J. Bassett-Lowke
Pencil and watercolour 36.4 × 78.2cm.
Inscribed, upper left, *Drawing of Sideboard Table & Chair for W. J. Bassett-Lowke Esqr*, and, lower centre, *43A Glebe Place S.W.3/June 1918*; and various notes and measurements.
Scale, 1:12, and full size.

The sideboard is almost 6 feet (182.9cm.) square, corresponding with the suggestions made by Bassett-Lowke on D1918.10. Mackintosh, however, has reversed the arrangement of drawers and cupboards in the lower section and has provided five central drawers. These have an oblong inlay in the recessed handle and a further piece of inlay projects down beyond the line of bottom-rail of the cabinet. The chair has a similar inlay in its top-rail, and the design shown here is as executed (*see* 1918.6). The table is similarly a final design, except that the inlay, consisting of a series of hexagons in the shape of an arrowhead, was rejected in favour of a series of bars of Radolith as in the drawers and chair.

The date suggests that Mackintosh had produced this design before receiving Bassett-Lowke's letter of 29 June and therefore before the client had seen D1918.10, which he had substantially amended. If the date is accurate,

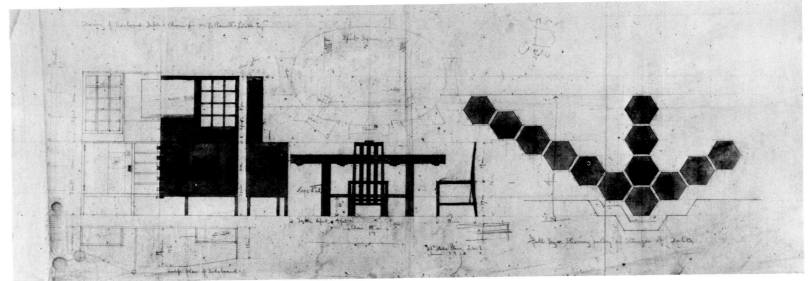

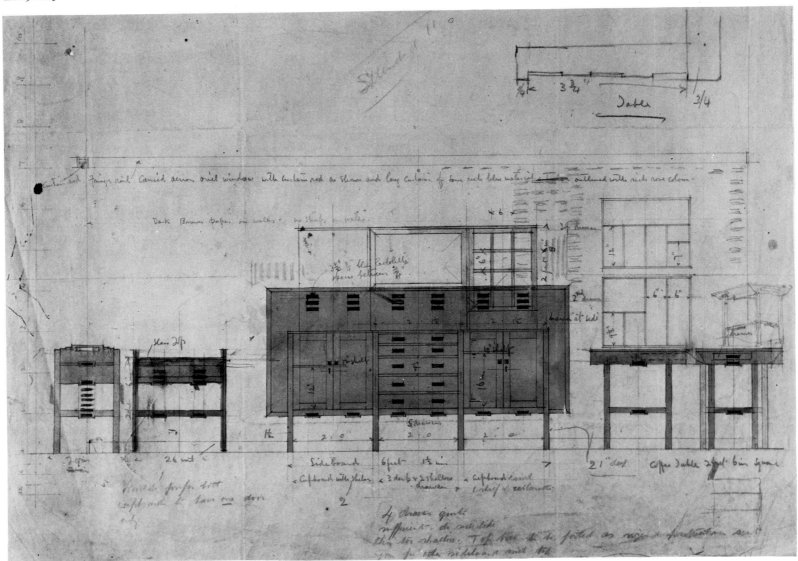

there can be no reasonable explanation for the development of this design; perhaps the drawing does post-date Bassett-Lowke's visit to London and was made in early July, Mackintosh erroneously dating it 'June'.

Literature: Alison, p. 83, no 55.
Exhibited: Milan, 1973 (55).
Provenance: Mackintosh Estate.
Collection: Glasgow University.

D1918.14 Design for service trolley, sideboard and coffee table for W. J. Bassett-Lowke

Pencil and watercolour 35.9 × 47.1cm.
Inscribed with construction notes and dimensions by Mackintosh, and with comments by Bassett-Lowke.
Scale, 1:12.

Mackintosh again amended the sideboard design, and produced this final design which has a wide surrounding panel at the back, and repeats the central drawers and flanking cupboard. Above this design is pencilled a sketch of the previous arrangement of upper glazed cupboards with a central mirror. The blue inlay, indentified here as Radolith, is repeated on the back panel, beneath the cupboards and drawers and in two handles on each drawer, not one as in D1918.13. Bassett-Lowke asked for the five drawers to be reduced to four and the cupboards to have single doors rather than double. Mackintosh either ignored him or persuaded him to accept the design as it stood, perhaps encouraged by Bassett-Lowke's pencilled approbation *Splendid!!*. See 1918.2. The coffee table and service trolley are very

similar to the executed pieces (1918.3 and 4).

Provenance: Mackintosh Estate.
Collection: Glasgow University.

D1918.15 Design for a coffee table for W. J. Bassett-Lowke

Pencil and watercolour 43.1 × 56.2cm.
Inscribed, lower left, *No 13 Scale drawing & full size details of Coffee Table for W. J. Bassett-Lowke Esqr*; and, lower right, *2 Hans Studios / 43A Glebe Place Chelsea*; and various notes and measurements, some by Bassett-Lowke.
Scale, 1:12, and full size.

The final working drawing for the coffee table, 1918.3.

Provenance: Mackintosh Estate.
Collection: Glasgow University.

D1919.1 Design for a sideboard and wall decoration for F. Jones, The Drive, Northampton

Pencil and watercolour 36.5 × 75.9cm.
Inscribed, lower left, *No 14 Scale drawing of Sideboard Wall Showing Scheme of Decoration*; and various notes; verso, *F. M. Jones / Mch 1919*, in another hand.
Scale, 1:12.

A repetition of the Candida Cottage designs of 1918 for the sideboard and coffee table, although the coffee table is not shown in any of the contemporary photographs. The wall decorations are a variation on those used at the Cottage and appear as executed.

Provenance: Mackintosh Estate
Collection: Glasgow University.

1919.A Dining-room The Drive, Northampton

Collection: Glasgow University.

1919.B Guest bedroom, 78 Derngate, Northampton
The lost commode can just be seen on the right of the photograph.

Collection: Glasgow University.

▽D1919.1 D1918.15▷

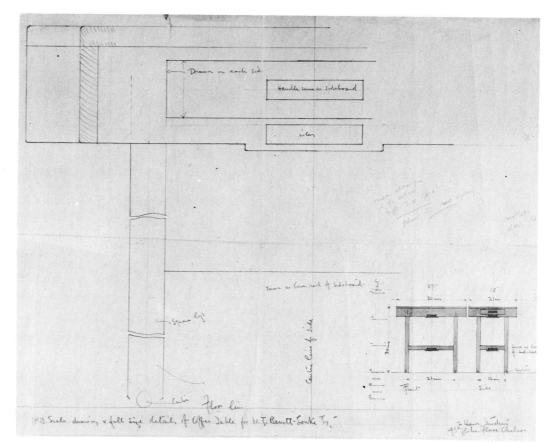

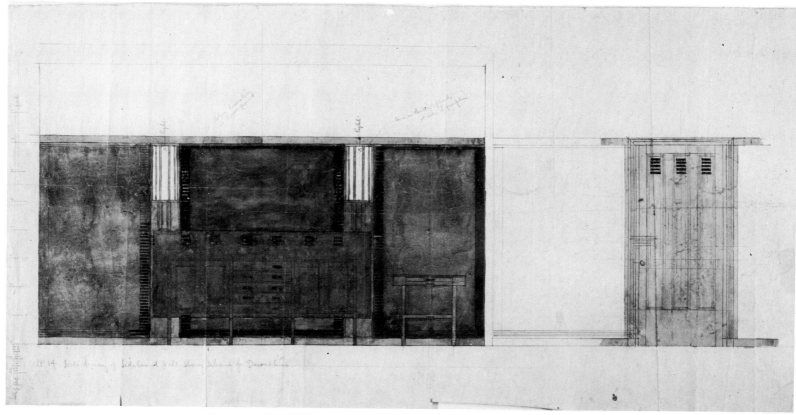

▽1919.A 1919.B▷

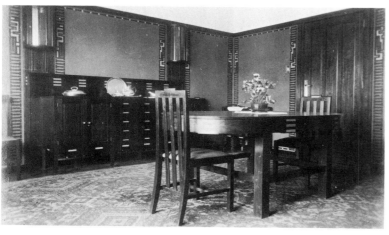

1919 The guest bedroom, 78 Derngate, Northampton

In 1917 Mackintosh designed furniture in mahogany for this room, similar in style to that in the main bedroom. Late in 1919, however, he was recalled to Derngate to redesign both the furniture and decorations for the guest bedroom. The result was the most striking of these post-Glasgow designs and Bassett-Lowke, in his notes on the house (collection: Glasgow University), called the room 'perhaps the most daring in the house'.

The walls and ceiling were painted white, but the wall behind the twin beds was covered with black-and-white striped paper extending the width of the two beds and their shared bedside table. Mackintosh had used this paper before on the attic staircase at 78 Southpark Avenue, but here he carried it up on to the ceiling where it extended the length of the beds. The outer stripes turned through an angle of 90°, mitred like a picture frame, to form the end of the ceiling panel. The perimeter stripe was, in fact, a piece of ultramarine blue ribbon, and this was also used above the bedside table and at the edges of the wall panel where it was held in place by black-headed tacks. On the ceiling, two striped panels, each about 60cm. wide, were projected at the window from each side of the large panel; these came down the walls and were again turned through 90° towards each other to meet over the window, forming another lattice pattern. The curtains matched the paper, with lattice-work at the bottom (1919.C) and *appliqué* squares of blue silk edged with emerald green. The bed spreads followed a similar arrangement.

One would have expected the furniture to have been overpowered by such a decorative scheme, especially in a room roughly four metres square. However, Mackintosh's designs for the furniture were severely simple, and the somewhat austere shapes in light oak with a narrow edging of blue squares on a black strip admirably resisted the exciting decorations. The square motif was dominant again, unlike in the more restrained main bedroom where decoration was almost non-existent. Whether pierced through the ends of the bed, or used in the bands of stencilling, it gently countered the more linear wall and ceiling decoration.

Mackintosh designed over a dozen items for this room and the surviving wide-angle photographs of them *in situ* mislead one's sense of scale. Every item is actually smaller than it appears in the photographs, but by using large areas of unmodelled timber Mackintosh prevented a feeling of claustrophobia in the room. In its context, the furniture does not seem undersized; out of it, it can look somewhat disturbing. This room was the last interior scheme of any consequence which Mackintosh produced—a striking note on which to end a brilliant career.

Literature: *Ideal Home*, September 1902, pp. 93–95; Howarth, plate 77; Pevsner 1968, plate 52; Billcliffe and Vergo, fig. 8.

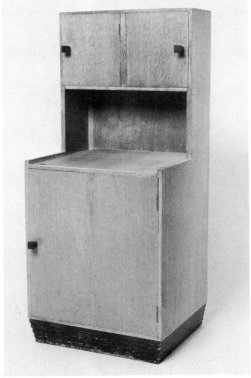

△1919.C 1919.2▽

1919.C Guest bedroom, 78 Derngate, Northampton

This photograph shows the arrangement of the ceiling decoration and the curtains.

Collection: Glasgow University.

1919.2 Bedside cabinet for the guest bedroom, 78 Derngate, Northampton

Oak, with ebonised handles 99 × 42.5 × 38.5cm.

This fitted between the two beds and provided two narrow cupboards for each guest; the extra space gained by not using two wider tables, as in the main bedroom, was given over to a commode (1919.5).

Literature: *Ideal Home*, September 1920, pp. 93, 95; Howarth, plate 77; Pevsner 1968, plate 52; Billcliffe and Vergo, fig. 8.
Provenance: W. J. Bassett-Lowke; by family descent; purchased in 1975.
Collection: Glasgow University.

1919.3 Twin beds for the guest bedroom, 78 Derngate, Northampton

Oak, with blue-and-black chequer decoration.

Although he used the direction of the grain of the wood for decoration, Mackintosh went further to produce a more lively effect in keeping with the decoration of the room. Pierced squares in the top of the foot-boards and ebonised square patches to cover the bolts are, however, subsidiary to the chequered stencil decoration in ultramarine on a black ground. This was used on many of the pieces in the room, occasionally to define structure, more often for purely aesthetic reasons. Here

the chequer line describes two narrow columns framing the bolt covers on the foot-board (repeated on the head-boards) and then travels along the base of the board. It does not define pieces of timber, indeed it cuts across the mitred joints of the panels of the foot-board, but it does emphasise the unmodelled expanse of timber.

Literature: *Ideal Home*, September 1920, pp. 93, 95; Howarth, plate 77; Pevsner, 1968, plates 51, 52; Billcliffe and Vergo, fig. 8.
Provenance: as 1919.2.
Collection: Glasgow University.

1919.4 Chair for guest bedroom, 78 Derngate, Northampton

Oak, with blue-and-black chequer decoration 77.5 × 36.3 × 35.3cm.

The stencil on the legs and rails is carried on a raised strip of wood to give it greater emphasis. The upholstery was originally in blue silk. Two chairs were made.

Literature: *Ideal Home*, September 1920, pp. 93, 95; Howarth, plate 77; Pevsner 1968, plate 52; Billcliffe and Vergo, fig. 8.
Provenance: as 1919.2.
Collection: Glasgow University (2).

1919.5 * Commode for the guest bedroom, 78 Derngate, Northampton

Oak.

This piece has not been traced and its form can only just be made out in the shadows of the contemporary photographs; it can be seen to better advantage in the illustrations of New

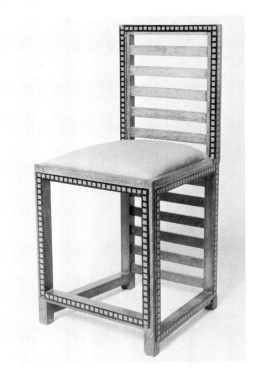

1919.4▷

246 *See addenda

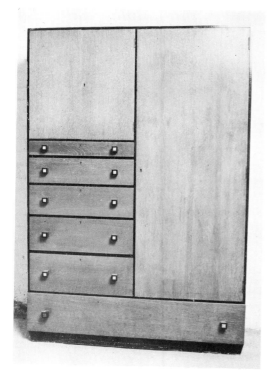

△1919.6

1919.9△

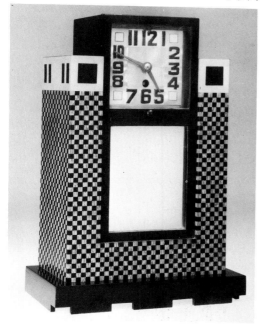

1919.7▽

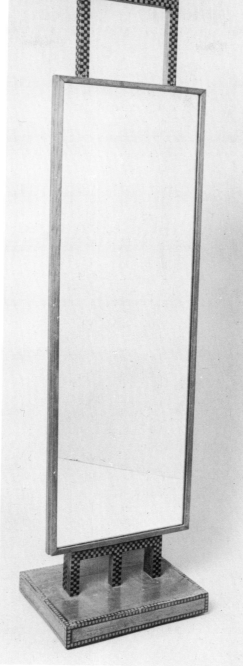

△1919.8

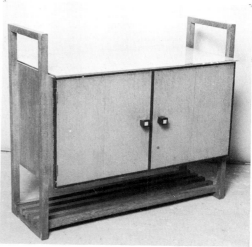

△1919.10 1919.10▽

Ways in *Ideal Home*. It was of a very simple, cubic design with an ebonised knob on the hinged top.

Literature: *Ideal Home*, January 1927, p. 27; Pevsner, 1968, plate 52; Billcliffe and Vergo fig. 8.
Collection: untraced.

1919.6 Wardrobe for the guest bedroom, 78 Derngate, Northampton
Oak, with blue-and-black chequer decoration 182.5 × 122 × 41.5cm.

This was slightly more elaborate than the main bedroom's wardrobe, with drawers and cupboards as well as simple hanging space. The strips of stencilling are applied to the perimeters of each of the three exposed sides and are also used to define the structure. In this way the rails between the drawers, the outline of the lower drawer and its position on the gables, the perimeter of the main door and the cupboard doors, all have the blue-and-black checked strip. The ebonised knobs have a square inlay of mother-of-pearl.

Literature: *Ideal Home*, September 1920, pp. *93, 95*; Howarth, plate 77; Pevsner, 1968, plates, 51, 52; Billcliffe and Vergo, fig. 8.
Provenance: as 1919.2.
Collection: Glasgow University.

1919.7 Clock for the guest bedroom, 78 Derngate, Northampton
Oak, with black stencilled decoration, and mother-of-pearl face.

The largest of the clocks designed by Mackintosh for W. J. Bassett-Lowke, this was almost certainly based on a clock designed by Otto Prutscher. This clock was illustrated in the *Studio Yearbook of Decorative Art* in 1908 (item A.27), where Mackintosh must almost certainly have seen it. Mackintosh turned the chequer-work through 45° to emphasise the horizontals and verticals, covered the pendulum with a mirror, and used a face of mother-of-pearl; otherwise the design is Prutscher's.

Literature: *Ideal Home*, September 1920, pp. *93, 94*; Howarth, plate 77; Pevsner, 1968, plate 52; Billcliffe and Vergo, p. 744, figs. 13, 14.
Provenance: W. J. Bassett-Lowke; by family descent.
Private collection.

1919.8 Cheval mirror for the guest bedroom, 78 Derngate, Northampton
Oak, with blue-and-black chequer decoration 183 × 45.8 × 35.5cm.

Literature: *Ideal Home*, September 1920, p. *93*; Howarth, plate 77; Pevsner, 1968, plate 52; Billcliffe and Vergo, fig. 8.
Provenance: as 1919.2.
Collection: Glasgow University.

1919.9 Luggage stool for the guest bedroom, 78 Derngate, Northampton
Oak, with blue-and-black chequer decoration 46.3 × 49.7 × 37.3cm.

The stencil decoration is again carried on a raised strip, as in 1919.4.

Provenance: as 1919.2.
Collection: Glasgow University.

1919.10 Dressing-table and wash-stand for the guest bedroom, 78 Derngate, Northampton
Oak, with blue-and-black chequer decoration 84 × 91.2 × 44.8cm.

The china ewer and basin seen on the wash-stand in contemporary photographs were decorated with a chequered band of blue over the white of the china. Both ewer and pitcher have vanished, but the matching china bucket is at Glasgow University.

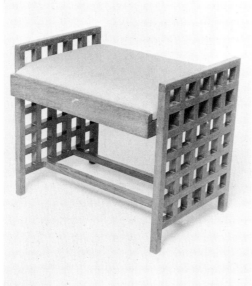

△1919.11

△1919.12

1919.13▽

Literature: *Ideal Home*, September 1920, pp. *93*, *95*; Howarth, plate 77; Pevsner, 1968, plates 51, 52; Billcliffe and Vergo, fig. 8.
Provenance: as 1919.2.
Collection: Glasgow University.

1919.11 Dressing-table stool for the guest bedroom, 78 Derngate, Northampton
Oak 42 × 45.5 × 36.5cm.

Literature: *Ideal Home*, September 1920, p. *93*; Howarth, plate 77; Pevsner, 1968, plate 52; Billcliffe and Vergo, fig. 8.
Provenance: as 1919.2.
Collection: Glasgow University.

1919.12 Wall cabinet and mirror for the guest bedroom, 78 Derngate, Northampton
Oak 45 × 86 × 7.3cm.

Fitted above the wash-stand and flanked by two shallow cupboards.

Literature: *Ideal Home*, September 1920, p. *94*; Pevsner, 1968, plate 51.
Provenance: as 1919.2.
Collection: Glasgow University.

1919.13 Dining table for 78 Southpark Avenue, Glasgow
Pine, stained dark 71 × 127 × 81.3cm.

In 1919, William Davidson moved into 78 Southpark Avenue, having acquired it and much of its furniture from Mackintosh. The original dining table used by Mackintosh in the house (1900.20) had been taken to London by him, and Davidson left his own dining table (1901.26) at Windyhill, which he rented out more or less complete with its original furniture. Accordingly, Mackintosh designed another table for Davidson, very similar in size to his own, but without the carved decoration; as at Windyhill, an extension table was also provided (1919.14).

Provenance: William Davidson; by family descent.
Private collection.

1919.14 Small table for 78 Southpark Avenue, Glasgow
Pine, stained dark 71 × 84 × 81.3cm.

This table was designed as an extension to 1919.13, a repetition of the device first used at Windyhill in 1901.

Provenance: William Davidson; by family descent.
Private collection.

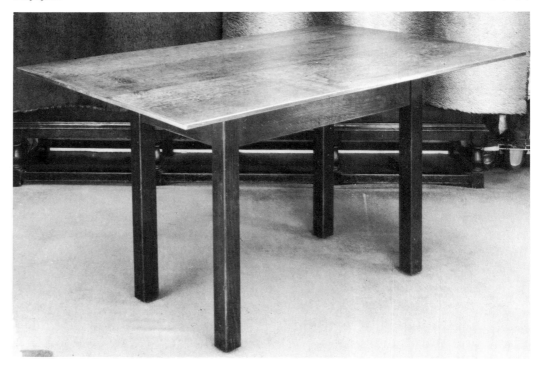

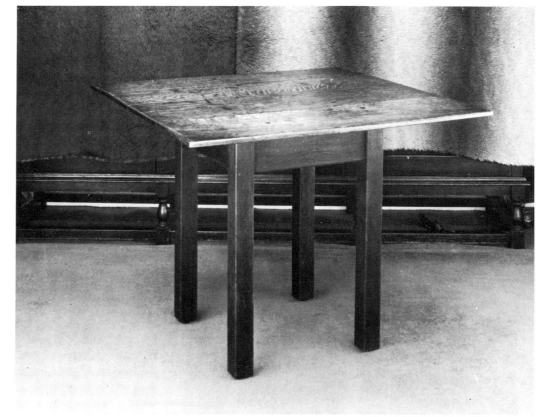

1919.14▷

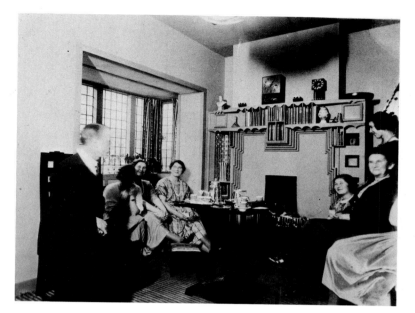

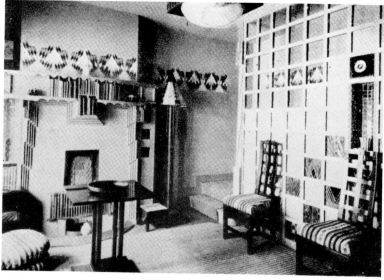

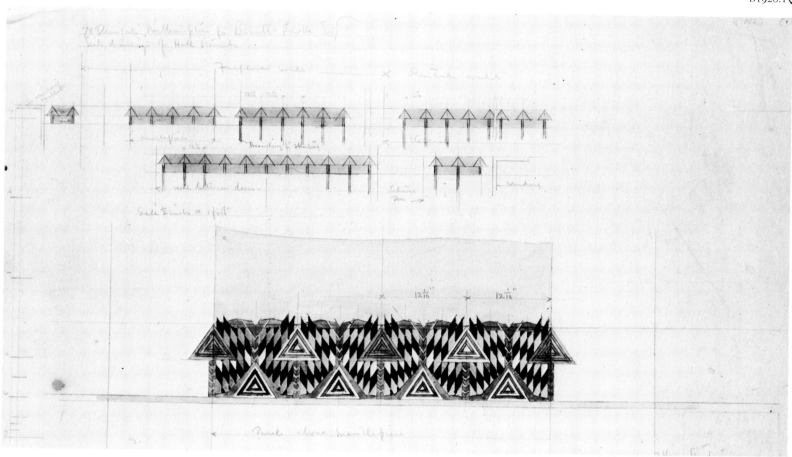

1920.A The hall, 78 Derngate, North-ampton
A photograph taken by Bassett-Lowke after the removal of the original decorations, but before the application of the new stencil patterns designed by Mackintosh.

Collection: Glasgow University.

1920.B The hall, 78 Derngate, North-ampton
The only photograph of the hall showing the second series of stencils designed by Mack-intosh.

D1920.1 Design for stencil decorations for the hall, 78 Derngate, Northampton
Pencil and watercolour 30 × 50cm.
Inscribed, upper left, *78 Derngate Northampton for Bassett-Lowke Esq | Scale drawing of hall stencils*, and, below, *Panel above mantelpiece | 2 Hans Studio | 43A Glebe Place Chelsea S.W.3*; and various other notes.
Scale, 1:24 and 1:6.

On this drawing, Mackintosh has indicated the layout of the decorations around the room;

1920 New stencil decorations in the hall, 78 Derngate, Northampton

Two photographs and a number of drawings exist which show that Mackintosh was recalled to 78 Derngate *c*1920 to make alterations to the decorations in the hall. The scheme as finalised in 1916–17 was a dramatic composition of black woodwork and walls, the latter relieved by periodic strips of black-and-white checks which ran between the skirting and a deep stencilled frieze. This frieze (*see* D1916.21) was predominantly composed of triangles of primary colours which made a dazzling contrast with the darker walls. Bassett-Lowke is believed to have been colour-blind, so much of the effect would have been lost on him, but by *c*1920 the somewhat energetic composition was beginning to have a wearing effect on both him and his wife (his friends had apparently always con-sidered the hall rather extreme).

Accordingly, the woodwork was painted grey (*see* D1920.11) and Mackintosh devised a new frieze based on the same general principles as the earlier designs. This was smaller in scale, however, and not so deep. Bassett-Lowke obviously approved of it, for he used it again in his study at New Ways. His notes on Dern-gate (collection: Glasgow University) indicate that he had hoped to commission his new house from Mackintosh. Unfortunately Mackintosh had left London for the south of France and Bassett-Lowke was unable to make contact with him, so New Ways was designed by Peter Behrens.

A number of drawings for the new stencils are in the RIBA collection, presented

by Mrs Bassett-Lowke. The RIBA catalogue confuses the dates of the two types of decoration at Derngate and mistakenly suggests that their drawings are for the original scheme and that Bassett-Lowke later altered the hall to the designs shown in 1916.E and F, and then returned to the RIBA designs in 1923 at New Ways.

△D1920.5 D1920.6▽

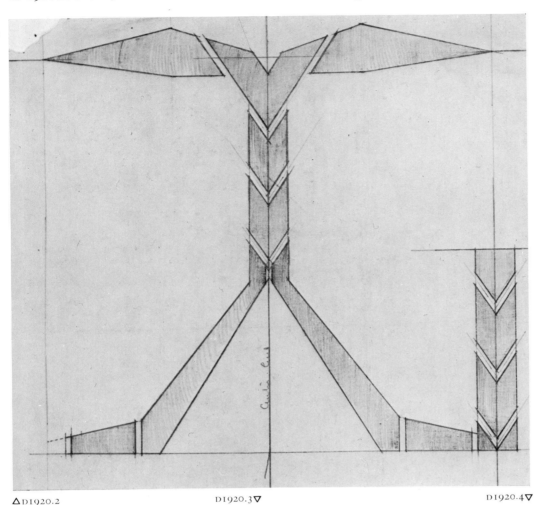

△D1920.2 D1920.3▽ D1920.4▽

right, *2 Hans Studios | 43A Glebe Place Chelsea | SW3*; and other notes.
Scale, full size.

Provenance: as D1920.1.
Collection: RIBA, London.

D1920.5 Design for stencil decorations for the hall, 78 Derngate, Northampton
Pencil 56.5 × 31cm.
Inscribed, lower left, *78 Derngate Northampton Hall Stencils | Stencil No 2 Triangle A* and, lower right, *2 Hans Studios | 43A Glebe Place Chelsea | S.W.3*; and other notes.
Scale, full size.

Provenance: as D1920.1.
Collection: RIBA, London

D1920.6 Design for stencil decorations for the hall, 78 Derngate, Northampton
Pencil 49.5 × 26cm.
Inscribed, lower left, *78 Derngate Northampton Hall Stencils | Triangle B* and, lower right, *2 Hans Studios | 43A Glebe Place Chelsea | SW3*; and other notes.
Scale, full size.

Provenance: as D1920.1.
Collection: RIBA, London.

D1920.7 Design for stencil decorations for the hall, 78 Derngate, Northampton
Pencil 46.5 × 28.5cm.
Inscribed, lower left, *78 Derngate Northampton Hall Stencils | Stencil No 2 Triangle B* and, lower right, *2 Hans Studios | 43A Glebe Place Chelsea | SW3*; and other notes.
Scale, full size.

Provenance: as D1920.1.
Collection: RIBA, London.

it also shows the cumulative effect of all the detail stencils (D1920.2–11). The design was a pattern of triangles and lozenges in grey, red, blue, yellow, white and black.

Literature: Macleod, plate XII.
Provenance: W. J. Bassett-Lowke; his widow, by whom presented, 1956.
Collection: RIBA, London.

D1920.2 Design for stencil decorations for the hall, 78 Derngate, Northampton
Pencil 47.5 × 56.5cm.
Inscribed, lower left, *78 Derngate Northampton | Stencil No 1*, and, lower right, *2 Hans Studios | 43A Glebe Place Chelsea | SW3* and various other notes.
Scale, full size.

Provenance: as 1920.1.
Collection: RIBA, London.

D1920.3 Design for stencil decorations for the hall, 78 Derngate, Northampton
Pencil 47 × 31.5cm.
Inscribed, lower left, *78 Derngate Northampton. Hall Stencils | Stencil No 1 Triangle A* and, lower right, *2 Hans Studios | 43A Glebe Place Chelsea | SW3*; and other notes.
Scale, full size.

Provenance: as D1920.1.
Collection: RIBA, London.

D1920.4 Design for stencil decorations for the hall, 78 Derngate, Northampton
Pencil 46.5 × 28.5cm.
Inscribed, lower left, *78 Derngate Northampton Hall Stencils | Stencil No 1 Triangle B* and, lower

△D1920.7 △D1920.8 D1920.9▽

D1920.8 **Design for stencil decorations for the hall, 78 Derngate, Northampton**
Pencil 46.5 × 29.5cm.
Inscribed, lower left, *78 Derngate Northampton Hall Stencils | Stencil No 3 Triangle B*, and, lower right, *2 Hans Studios | 43A Glebe Place Chelsea | SW3*; and other notes.
Scale, full size.

Provenance: as D1920.1.
Collection: RIBA, London.

D1920.9 **Design for stencil decorations for the hall, 78 Derngate, Northampton**
Pencil and yellow crayon 48.5 × 50.5cm.
Inscribed, lower left, *78 Derngate Northampton Hall Stencils | Stencil No 3 Plate 1* and, lower right, *2 Hans Studios | 43A Glebe Place Chelsea | SW3*; and other notes.
Scale, full size.

Provenance: as D1920.1.
Collection: RIBA, London.

D1920.10 **Design for stencil decorations for the hall, 78 Derngate, Northampton**
Pencil, and yellow and blue crayon 50.5 × 39cm.
Inscribed, lower left, *78 Derngate Northampton Hall Stencils | Stencil No 3 Plate 2* and, lower right, *2 Hans Studios | 43A Glebe Place Chelsea | SW3*; and other notes.
Scale, full size.

Provenance: as D1920.1.
Collection: RIBA, London.

◁D1920.10 D1920.11△

D1920.11 **Design for stencil decorations for the hall, 78 Derngate, Northampton**
Pencil 49.5 × 26cm.
Inscribed, lower left, *78 Derngate Northampton | Hall Stencil | Stencil No 4 | Grey colour same as woodwork* and, lower right, *2 Hans Studios | 43A Glebe Place Chelsea | SW3*; and other notes.
Scale, full size.

Provenance: as D1920.1.
Collection: RIBA, London

D1920.12 Design for stencil decoration in the hall, 78 Derngate, Northampton
Pencil and watercolour 35.8 × 100cm.
Scale, full size.

Exhibited: Edinburgh, 1968 (307).
Provenance: Mackintosh Estate.
Collection: Glasgow University.

D1920.13 Design for stencil decoration in the hall, 78 Derngate, Northampton
Pencil and watercolour 34.8 × 95.2cm.

Provenance: Mackintosh Estate.
Collection: Glasgow University.

1925.A Study at New Ways, Northampton
Bassett-Lowke re-used the second set of stencils designed by Mackintosh in the study of his new house, New Ways (designed by Peter Behrens). This photograph shows more clearly the stems of chevrons which replaced the black-and-white checks of the earlier design. The smoker's cabinet (1916.16) and hall cabinet (1916.9) from Derngate were also used in this room.

Collection: Glasgow University.

◁D1920.12

△D1920.13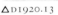

1925.A▽

INDEX

Page references, where they occur, are to the Introduction, to sections of descriptive text, or to colour plates, for which the number of the facing page is given in italics. All other references are to catalogue entries.

ADDENDA

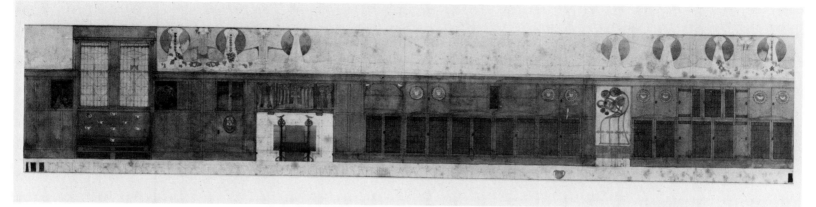

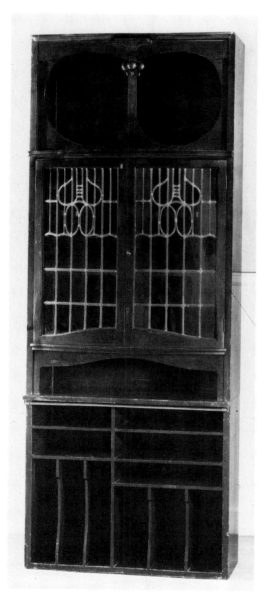

An exhibition of the collection of Mackintosh material belonging to Dr Thomas Howarth was shown at the Art Gallery of Ontario, Toronto, during November and December 1978. Included in the catalogue of the exhibition was information about certain drawings which was not previously available to the author. This additional information is noted below along with new entries for two drawings not previously recorded (D1909.4A and D1909.16A). New information contained in the exhibition catalogue about items in Dr Howarth's collection listed in the main body of the book can be found under the following

◁ 1894.1

entries in the Addenda: D1900.82, D1900.83, D1903.3, D1903.41, D1906.14, D1906.22, D1909.4A, D1909.16A, D1911.6. Other references to this exhibition can be found in the relevant entries in the Addenda as 'Toronto, 1978'.

1894.1
In 1901 the cabinet was moved to Windyhill where it remained until 1979 (but not painted white as stated).

Exhibited: Glasgow and Edinburgh. The Fine Art Society, *Glasgow 1900*, 1979 (73).

Provenance: William Davidson, at Gladsmuir and Windyhill, where it remained *in situ* until sold by Alan Ure, 1979; Sotheby's Belgravia, 28th February 1979 (lot 93).

Collection: The Fine Art Society, London (1980).

D1894.4 Design for a Library in a Glasgow House
Pencil and watercolour 30 × 102cm.
Signed and inscribed, bottom, *DESIGN FOR A LIBRARY IN A GLASGOW HOUSE. CHARLES RENNIE MACKINTOSH ARCHITECT. THIS DRAWING SHEWS FOUR SIDES OF ROOM.*

D1894.4 △

It is not known whether this design was ever executed; no mention of it exists in the records of Honeyman and Keppie or in those of Guthrie and Wells. Nor is it clear whether Guthrie and Wells commissioned the design from Mackintosh or whether they were simply sent the design to make a quotation for the stencilling and paintwork. Stylistically the design fits into the period 1894–5. As Michael Donnelly has pointed out, there are strong stylistic similarities between the stencilled figures of the frieze and the watercolours executed by Mackintosh and the Macdonald sisters during the autumn of 1894. The furniture, however, is in the simpler and more conventional style of the wardrobe (1894.3) with none of the elaborate metalwork of some of the pieces dated by the author to 1895 and 1896, e.g.: 1895.5, 1895.6 and 1896.8. The design of the overmantel panels does suggest a later date, but these possibly look more advanced, because of their sketchiness and the small scale of the drawing, than they might have done if executed in pewter or copper. The leaded glass certainly suggests a date of 1894 as it has more affinity with the glass in 1894.1 and 1894.2.

Literature: Michael Donnelly in *Charles Rennie Mackintosh Society Newsletter* No. 25, 1980, pp. 6–8.
Provenance: Private collection; Fine Art Society.
Collection: Anthony D'Offay Gallery.

1896 The Glasgow Herald Offices, Mitchell Street, Glasgow
The extent of Mackintosh's designs for the interiors of the Glasgow Herald extension is uncertain: the only attributable work still remaining is in the Editor's Room and the adjacent areas (*see* 1896.B (i) and 1896.B (ii)). The panelling uses similar motifs to those on the panels of the organ at Craigie Hall (1897.45) and is on the whole rather restrained, as might be expected in a job in which John Keppie had a strong interest (the Herald was a good client and Keppie was retained as architect for many years). The beaten metal strips in the fireplace and the leaded glass both identify Mackintosh as the designer of the room, for which 1896.6 and 1896.7 were presumably designed.

1896–97 The Buchanan Street Tea Rooms, Glasgow
The light fittings shown in 1896.H are by George Walton and are illustrated in *Dekorative Kunst*, 1900, p. *146*. This article discusses, among other commissions, Walton's work at the Buchanan Street Tea Rooms and does not mention Mackintosh's involvement. It is therefore possible that Mackintosh did not design any light fittings for this job and that D1896.14 is a drawing by Mackintosh of a Walton fitting. It is the author's opinion, however, given the evidence of the inscription on this drawing, that Mackintosh did in fact design this particular fitting, D1896.15 is without doubt a Mackintosh design, although apparently not executed at this date.

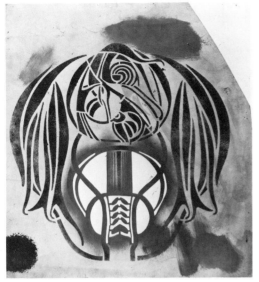

△D1896.16 D1896.19▽

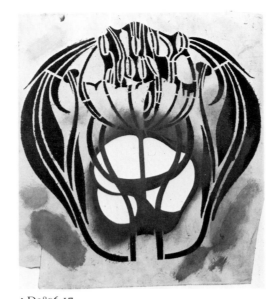

△D1896.17

△D1896.18 1896.B(i)▽

▽1896.B(ii)

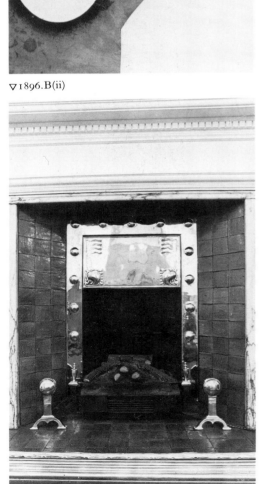

D1896.16 Stencil for the Buchanan Street Tea Rooms, Glasgow.
34 × 32.5cm. (image)

Used in the Luncheon Room at Buchanan Street. The overall design is shown in black and the cut-out areas were painted in green.
Private collection.

D1896.17 Stencil for the Buchanan Street Tea Rooms, Glasgow
34 × 32.5cm (image).

See D1896.16
Private collection.

D1896.18 Stencil for the Buchanan Street Tea Rooms, Glasgow
34 × 32.5cm.(image).

The stencilled colour here was purple.
Private collection.

D1896.19 Stencil for (?) the Buchanan Street Tea Rooms, Glasgow
38 × 28.5 (image).

Although not visible on any of the surviving contemporary photographs of the Buchanan Street Tea Rooms, this design has a number of stylistic links which date it to 1896–97. The stencilled colour was black.
Private collection.

1897.9
Exhibited: Toronto, 1978 (107).

1897.11
Exhibited: Toronto, 1978 (105).
Collection: d) The Fine Art Society, London (1980.2).

1897.15
Oak, stained dark.

Two examples have now been traced.

Provenance: Private collection, Renfrew (2); The Fine Art Society, Glasgow (2).
Private Collection (1); private collection (1).

1897.15▽

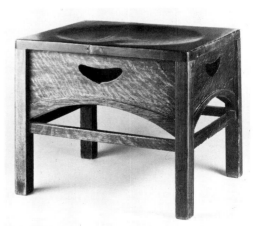

1897.20

Oak, stained dark 72.4 × 61 × 61cm.

Four examples appear in contemporary photographs, all with pierced decoration on the legs similar to that in D1897.21; the two surviving examples, although identical with each other, have a pattern on the legs different from that shown in the photographs and drawing.

Private collection (1); private collection (1).

1897.23

The author is now of the opinion that these chairs are indeed original examples, made in 1897 but that the thicker back splats are later repairs to the chairs. In such chairs the original slot in the top oval panel, into which the original slat was fixed, remains and the new slat is glued and pinned to the back of the oval panel.

1897.28

Oak, stained dark with metal hooks and drip trays 186 × 55.5 × 54.5cm.

Collection: The Fine Art Society (1980).

D1897.30

Exhibited: Toronto, 1978 (132).

1897.31

Provenance: W. Abell, Glasgow (1933); Alan Ure; Sotheby's Belgravia, 11th July 1979 (lot 79).

Collection: untraced.

1899.16

A variant of this chair, without arms, is in the collection of Dr Thomas Howarth and was exhibited at Toronto in 1978.

Exhibited: Toronto, 1978 (108 pp. *13*, *30*).
Collection: Dr Thomas Howarth.

1900.81

Exhibited: Glasgow and Edinburgh—The Fine Art Society, *Glasgow 1900*, 1979 (76).
Provenance: Michael Diack; by family descent to Michael Diack, London; The Fine Art Society.
Private collection, USA.

D1900.82 Design for a table

Pencil and watercolour 40.5 × 15.2cm.

The details given in the 1967 Toronto catalogue are so vague that the author can only

surmise that this drawing is identical with a drawing for the dining table for 120 Mains Street (1900.20) listed with the above dimensions in the 1978 Toronto catalogue. If this is indeed the case, then D1900.82 should be re-numbered D1900.20A.

Exhibited: Toronto, 1978 (121).

D1900.83 Design for an armchair in oak

Pencil and watercolour on tracing paper 16 × 15.2cm.

Exhibited: Toronto, 1978 (122).

D1900.84 Detail design for a cabinet

Pencil and watercolour 38 × 82cm.

The author has not seen this drawing but Dr Howarth has dated it c1900.

Exhibited: Toronto, 1978 (123).
Collection: Dr Thomas Howarth.

D1901.28

Exhibited: Toronto, 1978 (138).

1901.34

225 × 160 × 52cm.

1901.35

Destroyed.

1901.39

Exhibited: Toronto, 1978 (139).

1901.41

Destroyed.

1901.42

222 × 172 × 17cm.

1901.46

230 × 152 × 37cm.

D1901.63

Exhibited: Toronto, 1978 (136).

1902.1

Exhibited: Toronto, 1978 (110)

1902.8

I am grateful to Peter Vergo for pointing out that a Max Schmidt was working for Josef Hoffman on the interpretation of Mackintosh's drawings for the Music Salon for Fritz Wärndorfer. It is therefore possible that he was the consignee of the furniture sent from Turin to Vienna (although it must be admitted that Schmidt is not an uncommon name), and that he was acting on Wärndorfer's behalf. There is now no doubt that Wärndorfer owned this desk as it was presented to its current owners by his first (and estranged) wife, Lily Wärndorfer in 1938.

Provenance: F. Wärndorfer; Lily Wärndorfer, by whom presented, 1938.
Collection: Museum für Angewandte Kunst, Vienna.

1897.20 ▽

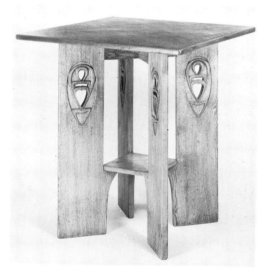

▽1897.31 1897.28 ▷

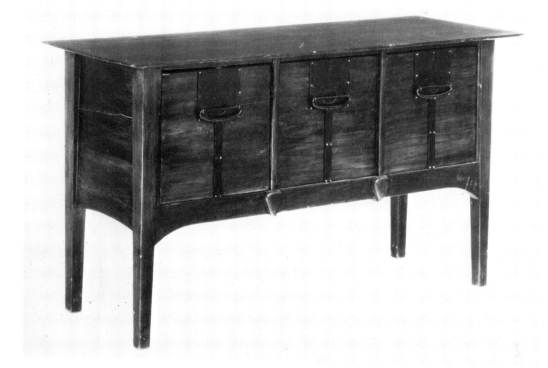

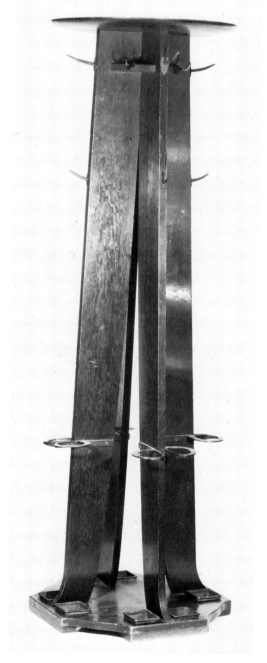

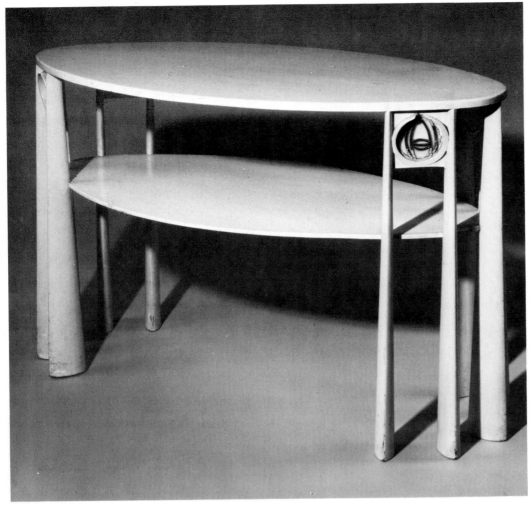

△1902.19

1903 The Willow Tea Rooms, Glasgow

In 1978, the shop Daly's, which at that time included the Willow Tea Rooms, was sold and its new owner modified the old building to provide a series of new shops in single units, one of these being the Willow. The developers agreed to make some attempt at restoration of the interiors (a condition, in fact, of Planning Permission) including the reinstatement of the original ground floor elevation which was destroyed by Daly's. The final plans approved by the Local Authority and the developers allowed for extensive restoration or reproduction of the original fittings. Most of this work was concentrated on the ground floor and involved replacement of the plaster panels at frieze level; a reproduction of the Front Saloon fireplace; remodelling of the Gallery ceiling and replacement of the beams and columns in the well; and reproduction of the stencil decoration around the Gallery.

The research carried out by the architects, Keppie Henderson (Mackintosh's old firm) and other interested parties, including the author, has shed extra light on some parts of the building whose original use or appearance was previously unclear. The most important of these concerns The Dug-Out (see p. 235 and Addenda below): drawings recently discovered in the Strathclyde Regional Archives show that this extension to the Willow Tea Rooms was actually in the basement of the building to the west of the Willow and not in the basement of the Willow itself, as previously believed. The entrance to it was created by destroying the fireplace in the Front Saloon (1903.11) and opening up the floor in front of it to provide a staircase through the basement wall to the adjoining premises. The Willow kitchens were, in fact, located beneath the Front and Back Saloons and were not relocated in 1918 when The Dug-Out was created.

The reconstruction of the Daly's building and the new work on the upper floors of the Willow confirmed the author's earlier belief that no alterations to the third floor had been made by Mackintosh in 1903 (see p. 131). I also now believe that the room on the second floor in the building to the east of the Willow was made by the Kensington Restaurant after 1920 (or less probably by Daly's after 1927) when the Billiards and Smoking Rooms were remodelled for restaurant use. I suggest that it was at this time that the Smoking Room fireplace and the built-up seating in the Billiards Room were removed—the fireplace to the new room, the seating destroyed.

The restoration in 1979–80 has helped recapture some of the original appearance and atmosphere of the Tea Rooms. The Willow is again a self-contained building as the east wall of the Front Saloon, once removed by Daly's, has been reinstated. Replicas of the plaster frieze panels have been installed along the east

1902.19

Wood, painted white and inlaid with leaded glass panels 60.6 × 91.8 × 50.2cm.

Example b) of this table is almost certainly that exhibited in Moscow in 1902/3 and was presumably unsold and returned to Mackintosh in Glasgow.

Provenance: a) Fritz Wärndorfer; untraced, probably destroyed; b) (?) C. R. Mackintosh; Macfarlane, Glasgow; Christie's, 23rd September 1980 (lot 73).
Collection: a) untraced; b) The Fine Art Society, London (1980).

D1903.3 Design for a wardrobe—full-sized detail

Pencil and watercolour 38 × 84cm.

In the 1978 Toronto catalogue, Dr Howarth suggests a new date of 1900 for this drawing; the subject is not, however, identified.

Exhibited: Toronto 1978 (123).

1903.8

Exhibited: Toronto, 1978 (109).

D1903.21

Exhibited: Toronto, 1978 (144).

D1903.24

Exhibited: Toronto, 1978 (143).

D1903.33

Exhibited: Toronto, 1978 (131)

D1903.41 Design for three tables for Miss Cranston

Pencil and water colour on tracing paper 71 × 20cm.

The 1978 Toronto catalogue gives a date of August 1903 (presumably inscribed on the drawing), which suggests that the drawing may be connected with tables designed for the Room de Luxe at the Willow Tea Rooms.

Exhibited: Toronto, 1978 (124).

1903.62

Exhibited: Toronto, 1978 (104 p. *30*).

D1904.8A Stencil for the hall, The Hill House, Helensburgh

54 × 41.5cm.

This design was also used in reverse in an alternating pattern around the hall. It is one of Mackintosh's most elaborate and successful decorative stencils. The colours used with this stencil were black, green and rose-purple.

Private collection.

D1904.8A▽

and west walls of the Front Saloon and a reconstruction has been made of the original entrance and window, although the original leaded-glass work has been omitted. The fireplaces of the Back Saloon and Gallery have been uncovered and the rear windows reinstated. Perhaps the most effective part of the restoration, however, is the rebuilding of the false ceiling above the gallery and the replacement of the beams across the light well and the tapering columns which rise from these to support the ceiling.

At the time of writing (December 1980) the future of the building is not clear as no new tenant has yet been found.

1904.13
Ebonised wood inlaid with mother-of-pearl, fruitwood, metal and coloured glass
a) 111.5 × 94 × 47cm. b) 121 × 94 × 47cm.

Mackintosh's own version of this desk is not an exact replica of the desk made for Blackie. The height of the cupboard was increased, presumably to provide taller spaces for Mackintosh's journals, drawing-paper or stationery. He also replaced the mother-of-pearl on the front of the doors with stained wood on his own desk.

Exhibited: Toronto, 1978 (103, p. *30*).
Provenance: a) Walter Blackie; b) C. R. Mackintosh; Margaret Macdonald Mackintosh; Alan Ure; Sotheby's Belgravia, 11th July 1979 (lot 78); Fine Art Society.
Collection: a) Dr Thomas Howarth; b) Glasgow University.

1904.18
Collection: pair a) Glasgow Art Galleries and Museums; pair b) Private collection.

1904.19A
Collection: Museum of Modern Art, New York.

D1904.22A Stencil for a bedroom, The Hill House, Helensburgh
16 × 16cm. (image).

Used in reversed pairs over the fireplaces of a number of bedrooms at The Hill House. The colour used here was black.

Private collection.

D1904.22B Stencil for a bedroom, The Hill House, Helensburgh
16 × 16cm. (image).

See D1904.22A. This stencil has traces of blue and brown paint but appears to have been damaged before it could be used more extensively.

D1904.22C Stencil for a bedroom, The Hill House, Helensburgh
26.6 × 11.9cm. (image).

Used in reversed pairs over the fireplaces of the bedrooms in the east wing of The Hill House.

Private collection.

D1904.59
Pine, stained dark and varnished 61 × 94 × 50.8cm.

This table was presumably designed at about the same time as 1904.61 and is a more elaborate version of 1904.19A, having eight legs grouped in four pairs.

Provenance: (?) Hous'hill sale 1933; acquired by family of present owner *c*1947.
Private collection.

D1904.69
Exhibited: Toronto, 1978 (140).
Collection: Dr Thomas Howarth.

D1904.76
Exhibited: Toronto, 1978 (142). 1904.59 ▷

D1904.22A △

▽D1904.22B

D1904.22C △

D1905.6A Window table for the dining-room for A. S. Ball, Berlin
Apparently identical with the window table designed for The Hill House (1903.69), although the legs seem shorter.

Literature: Ernst Wasmuth, *Möbel und Zimmereinrichtungen der Gegenwart*, n.d., vol I, plate 56; Gerald and Celia Larner, *The Glasgow Style*, Edinburgh, 1979.
Collection: untraced.

1905.9 Chair with high back for the dining-room for A. S. Ball, Berlin
The chair shown at the head of the table in 1905.A has arms and is thus quite different from the Room de Luxe chair (1903.20). Two of these armchairs were made, and the second example appears at the side of the window in a photograph published by Ernst

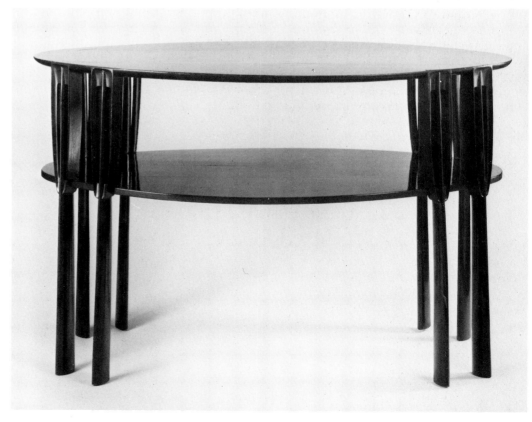

Wasmuth in *Möbel und Zimmereinrichtungen der Gegenwart*, n.d., vol I, plate 56. (This photograph is reproduced in Gerald and Celia Larner, *The Glasgow Style*, Edinburgh, 1979).

1905.31
In a chapter of an autobiography by P. Wylie Davidson (Ms., collection Glasgow University) he mentions making candlesticks for Hous'hill in 1909 which had diced column stems. It seems likely therefore that 1905.31 can be re-dated to 1909 and probably corresponds with 1909.9.

D1906.14
Details given in the 1978 Toronto catalogue include a date, July 1906.

Exhibited: Toronto, 1978 (125).

D1906.22 Design for a hatstand for Miss Cranston
Pencil and watercolour on tracing paper 24 × 32cm.

Although the details given above do not quite match those given for a similar drawing exhibited in 1967, the author believes that they relate to that item. A date of 1906 is given in the 1978 catalogue without any explanation or justification.

Exhibited: Toronto 1978 (126).
Collection: Dr Thomas Howarth.

D1907.8
Exhibited: Toronto, 1978 (130).

1908.1
Wylie and Lochhead were paid £7.15s.0d. for a table (9th December 1908).

1908.3A Upholstered armchair for The Hill House, Helensburgh
Wylie and Lochhead were paid £12.10s.0d. for a chair (8th December 1908).

This chair presumably relates to the design shown in D1908.2 and D1908.3. The inscription *53 Kent Road/Mr Ferrier* refers to Wylie and Lochhead's warehouse which was located in Kent Road, Glasgow.

D1909.4A Design for an upholstered chair and a spindle chair for the Card Room, Hous'hill, Nitshill
Pen and ink on linen 63.5 × 46cm.
Dated August 1909.

The author has not seen this drawing, but it presumably relates to 1904.4 and 1909.10.

Exhibited: Toronto, 1978 (128).
Collection: Dr Thomas Howarth.

D1909.12
Exhibited: Toronto, 1978 (133).
Collection: Dr Thomas Howarth.

D1909.13
Oak, stained and waxed
In 1979 the author discovered a table which, on stylistic and circumstantial evidence can be identified with those made for the Ingram Street Tea Rooms in 1909. The price of the tables made by Craig indicates that they were more substantial than simple restaurant tables (which cost less than £1) but less elaborate than the Hous'hill table (1909.11) which was ebonised and inlaid with ebony and mother-of-pearl. This table certainly fits such a theory, as it is sturdily made from selected oak timbers and has a repetitive motif of curved legs and aprons which would obviously cost more than a straightforward table, but less than a finer wood with a more elegant finish. Stylistically the table corresponds with much of the furniture designed in 1907–10. Its curved and

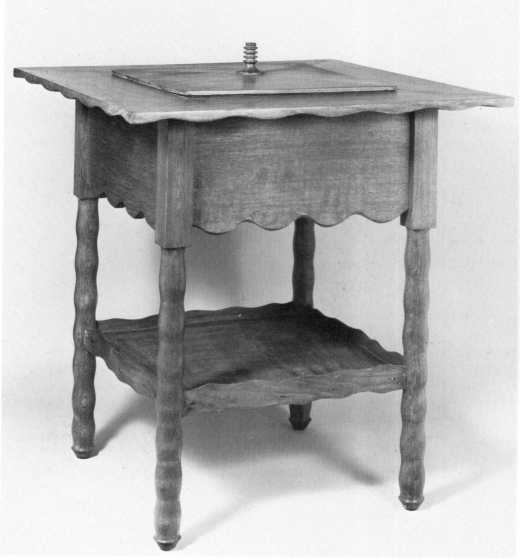

△1909.13

chamfered apron can be related to similar wavy motifs in chairs like 1907.4, 1907.6, 1909.4 and 1909.15; similar undulating patterns are also found in 1907.7, 1909.11, 1910.1 and 1910.11 as well as in many of the fittings of the Oak Room and the Library at the Glasgow School of Art (*see* 1907.D and 1909.I).

What were these tables used for? They could not have been for eating at as the shaped lid to the well is sloped to a central handle very similar to the drawers in 1904.35. It has been suggested that they were used as service tables for the waitresses and stored linen, cruet sets and similar tableware, but I believe that they were more related to the Ladies' Rest Room than to the general dining areas of the Ingram Street Tea Rooms. Although the family who previously owned this table were not sure from which Cranston Tea Room it had been acquired they believed it to have been a magazine table; while the square well is perhaps not ideal for keeping books and magazines, the author believes it to have been the most likely purpose of the design.

Provenance: Private collection, Renfrew; The Fine Art Society, Glasgow.
Private collection.

D1909.15A Designs for writing desks for the Ingram Street Tea Rooms, Glasgow
Pen and ink on linen 63.5 × 40.5cm.
Dated October 1909.

This design, which the author has not seen, probably relates to 1909.15 and 1909.16.

Exhibited: Toronto, 1978 (127).
Collection: Dr Thomas Howarth.

D1910.2
Exhibited: Toronto, 1978 (135).

D1910.4
Exhibited: Toronto, 1978 (134)

1910.15
Exhibited: Toronto, 1978 (106).

D1910.16
Exhibited: Toronto, 1978 (137).

D1911.2
Exhibited: Toronto, 1978 (141).

D1911.6
33 × 38cm.

Details in the 1978 Toronto catalogue give a date of November 1911, and an inscription apparently confirms that the drawing is related to the Chinese Room.

Exhibited: Toronto, 1978 (129).

1917.10A Wardrobe for W. Franklin Esq.
Mahogany with mother-of-pearl and Radolith inlay 180.5 × 194.8 × 52.5cm.

Provenance: W. Franklin, by family descent; bought at auction, 1980, by present owner.
Private collection.

D1917.27A Proposed alterations for the Dug-Out, Sauchiehall Street, Glasgow
52 × 69.2cm.

Not an autograph Mackintosh drawing but prepared by an architect, James Carruthers, for presentation to the Glasgow Dean of Guild Court.